"I'd like to turn people on to the fact that the world is form, not just function and money."

Claes Oldenburg[1]

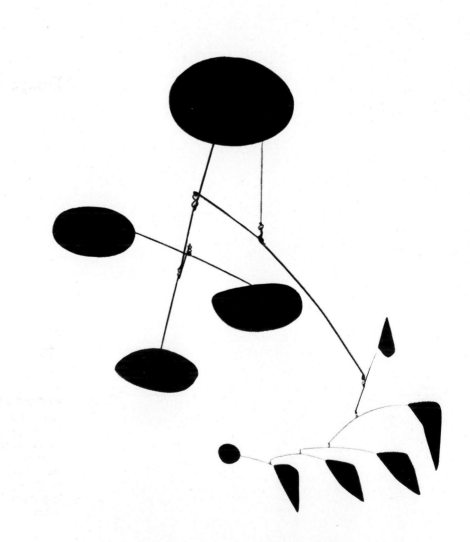

Artforms

AN INTRODUCTION TO THE VISUAL ARTS
Third Edition

Duane and Sarah Preble

1817

HARPER & ROW, PUBLISHERS, New York
Cambridge,
Philadelphia,
San Francisco,
London,
Mexico City,
São Paulo,
Singapore,
Sydney

ACKNOWLEDGMENTS

Our heartfelt thanks to the many people who have made this book possible. First among them are the artists whose works are presented here, and our colleagues at the University of Hawaii who so readily shared their ideas and knowledge. We are also grateful to the following people for their thoughtful reviews of the manuscript and for their many helpful suggestions: La Monte Anderson, Broward Community College; Michael A. Dorsey, Mississippi State University; Whitney J. Engeran, Jr., Indiana State University; Edna Garte, University of Minnesota, Duluth; Pamela Farris Lawson, Radford University; Felicia Lewandowski, Radford University; Anne H. Lisca, Santa Fe Community College; Joseph Molinaro, Broward Community College; Louis F. Mustari, Northern Illinois University; Peter L. Myer, Brigham Young University; Edward R. Pope, University of Wisconsin, Madison; Helen Redel Pullen, Towson State University; E. Max Von Isser, Elgin Community College; and Donald E. Widen, Fullerton Community College. In particular we would like to thank Hawaii colleagues Prithwish Neogy and Betty Sullivan who generously gave their time and shared their expertise during the many months of work on this edition.

All of our work was brought to final form by the careful management, generous and creative spirit of our Sponsoring Editor, Fred Henry, Production Manager, Tom Dorsaneo, and the staff at Harper & Row.

Sponsoring Editor: Fred Henry
Text Design and Cover: Design Office
 Bruce Kortebein
Text Art: Phyllis Rockne
Page Layout: Donna Davis
Compositor: TBH/Typecast, Inc.
Printer and Binder: Kingsport Press

Facing the title page:
Alexander Calder. FOUR BIG DOTS.
See page 175.

Artforms, Third Edition
© 1985 by Harper & Row, Publishers, Inc.

This book was previously published as *Artforms* © 1978 and *Man Creates Art Creates Man* © 1973.

Library of Congress Cataloging in Publication Data

Preble, Duane.
 Artforms : an introduction to the visual arts.

 Bibliography: p.
 Includes index.
 1. Composition (Art) 2. Visual perception.
3. Art—History. I. Preble, Sarah. II. Title.
N7430.P69 1985 700 84-9070
ISBN 0-06-045268-4

88 89 9 8 7 6 5 4 3

Credits begin on p. 461 and are considered a continuation of this copyright page.

To the students whose interest and
ideas helped create this book

Contents

Contents with Artists

Introduction
Steinberg

The names of some important artists are unknown, and therefore cannot be included. Many works of art from the past were made by people whose names have not been passed on because the artist's name was less important than the process or the work.

1
Why Art?

Newman
Halprin
Schulz
Handschu
Dürer
Weston
Leonardo
Zeshin
Picasso
Rodia
Matisse
Kollwitz
Bischof
Mondrian
Magritte

2
Form and Content

Rodin	Malevich	Puccinelli	de Hooch
Brancusi	Wilfred	Bellini	Orozco
Lippi	Seurat	Raphael	Holbein
Mantegna	Johns	Mi Fei	Cartier-Bresson
Picasso	Anuszkiewicz	Lorrain	Goya
Klee	Bonnard	Cézanne	Degas
Steinberg	Meret Oppenheim	Braque	Munch
Sengai	Holbein	Sassetta	Brueghel
Chagall	Rembrandt	Edgerton	Leonardo
Arp	Giacometti	Pistoletto	
Gauguin	Brancusi	Breer	
Kenoujuak	Moore	Eakins	
Escher	Modersohn-Becker	Balla	
French	Saarinen	Matisse	
Prud'hon	Mu Ch'i	Michelangelo	
Zurbarán	Shaykh Zadeh	Newman	

3
The Visual Arts: Media and Methods

Seurat	Tao Chi	Porter	Lipofsky	Rubel	Fuller
Matisse	Wyeth	Griffith	Wärff	Isola	David Wright
Giacometti	Hofmann	Mead	Bunnell	Larsen	Pearson
Campos	Close	Paik	Pierce	Bray–Schaible Design	Huygens
Oldenburg	Rivera	Emshwiller	Paley	Maloof	Peter Jefferson
Picasso	Nolde	Schlemmer	Maloof	Hoversland	Roach and Associates
Michelangelo	Dürer	Nevelson	Stocksdale	Ictinus and Callicrates	Halprin and Associates
van Gogh	Daumier	Lippold	Parrott	Richardson	Lorenzetti
Legros	Toulouse-Lautrec	Calder	Sekimachi	Sullivan	Safdie and Barott
White	Vasarely	Warhol	Floor	Le Corbusier	Soleri
Sheeler	Oda	Chino	Knodel	Gropius	Erwitt
Hokusai	Kohn	Sharbaugh	Felver	Johnson	Pei and Partners
Rembrandt	Bourke-White	Noguchi	Mies van der Rohe	Stubbins Associates and Emery Roth and Sons	
Nast	Uelsmann	Arneson	Eames	Frank Lloyd Wright	
Turner	Cooke	Voulkos	Chermayeff	Tange	
Marin	Muybridge	Takaezu	Tate		

4
Art of the Past

Fan K'uan
Yü-Chien
Ch'en Jung
Unkei
Sengai
Sōtatsu
Utamaro
Ictinus and Callicrates
Agesander, Athenodorus, and Polydorus
Giotto
van Eyck
Patiner
Masaccio
Leonardo
Botticelli

Michelangelo
Titian
Palladio
El Greco
Caravaggio
Bernini
Velázquez
Rembrandt
Vermeer
Fragonard
David
Thomas Jefferson
Goya
Revere
Constable
Delacroix

Daguerre
Durieu
Couture
Rejlander
Courbet
Gérôme
Eakins
Manet
Raimondi
Paxton
Monet
Renoir
Degas
Seurat
Cézanne
Cassatt

van Gogh
Gauquin
Toulouse-Lautrec
Munch
Rousseau

5
Art of Our Time: The 20th Century

Brancusi
Klimt
Matisse
Rouault
Kirchner
Kandinsky
Picasso
Cézanne
Stieglitz
Frank Lloyd Wright
Legér
Feininger
Lipchitz
Malevich
Tatlin
Gabo

Mondrian
Rietveld
Le Corbusier
Boccioni
Lartigue
Duchamp
Marey
Man Ray
Höch
Schwitters
Klee
de Chirico
Dali
Miró
Magritte
O'Keeffe

Wood
Lange
Hooper
Abbott
Bunshaft of Skidmore, Owings, and Merrill
Pollock
Kline
Inoue
Tanahashi
Frankenthaler
de Kooning
Diebenkorn
Bontecou
Davis
Rauschenberg

Johns
Hamilton
Kemnitz
Wesselmann
Massar
Frazier
Marisol
Warhol
Oldenburg
David Smith
Tony Smith
Noguchi
Held
Stella
Cunningham
Albers

Riley
Wilson
Chryssa
Tinguely
Kaprow
Dewey
Gilbert and George
Bell
Dennis Oppenheim
Smithson
Christo
De Maria
Sonfist
Eddy
Estes
Segal

DeAndrea
Marisol
Pineda
Jiménez
Bearden
Hockney
Hansen
Borofsky

6
Art for Today and Tomorrow

Grooms
Tooker
Dix
Michitsuji
Arneson
Jones and Associates
Eames
Halprin and Associates
Wines
Wells
Friedberg and Associates
Sasaki
Adams

A Note About the Cover

The ARTFORMS cover is a detail of Fernand Léger's painting THE CITY shown in color on page 359. By focusing attention on a small portion of the work, we celebrate the ongoing process of discovery that is the essence of art. Because the cover enlarges a portion of our reproduction of Léger's painting, the usually unseen dots of ink used in four color printing become visible, and add another element to the cover.

Introduction

ARTFORMS is designed to help you increase your understanding and enjoyment of the visual arts. We hope it will stimulate you to continue to make discoveries in this vast field of human expression, and encourage you to develop your creative abilities.

ARTFORMS is the third edition of *Man Creates Art Creates Man*. The world has changed since the book was first published in 1972. The root word *man*, meaning humanity, is now commonly taken to refer to the male of the species. Therefore *Man Creates Art Creates Man* became ARTFORMS, which contains the basic theme condensed into one word: as we create forms, we are in turn shaped by that which we have made.

This book combines in one volume ideas and images that introduce art theory, art practice, and art history. The goal is to help you become independent in your continuing experience of the arts. Chapters 4 and 5 present key works from the distant and recent past along with ideas that relate them to history. These chapters are not written as a short survey of art history, but as a means of suggesting the many ways the art of today has evolved out of the art of the past.

To limit the length rather than the scope of ARTFORMS, we have had to omit many important artists, periods, and cultures. Our primary concern is to open eyes and minds to the richness of the visual arts, and to convey some portion of our own enthusiasm for the role the arts can play in improving the quality of life.

1 Saul Steinberg.

Why Art?

To evoke in oneself a feeling one has experienced, and having evoked it in oneself, then by means of movement, line, color, sounds or forms expressed in words, so to transmit the same feeling—this is the activity of art.

Leo Tolstoy[1]

Albrecht Dürer.
Detail of THE GREAT PIECE OF TURF.
(See page 10.)

THE CONCEPT "ART"

Art, like life itself, need not be defined or understood to be enjoyed. It must simply be experienced.

Art is not something apart from us. It grows from capacities that we all possess. If you have ever experienced something intensely and wanted to share that experience with others, you have been where art begins.

To many people *art* means something created by an artist, and an *artist* is commonly thought of as a painter or sculptor. This concept of art is limited. Art is something done so well that it takes on special meaning. In a general way, almost anything we do can be art.

art (ärt), n. 1. the quality, production, or expression of what is beautiful, appealing, or of more than ordinary significance.[2]

A *work of art* is the aesthetic expression of an idea, formed with human skills through the use of a medium. A *medium* is the material from which art is made—for example, clay, oil paint, steel, or film. Depending on the way it is used, a medium can either limit or expand experience. Simply making things skillfully is not enough. Nor is it enough to make something that is merely unique. The process must lead to original forms or experiences of significance. When a medium is used so well that it expands our experience beyond ordinary consciousness, that particular use of the medium can be considered art.

The focus of this book is the visual arts. Since there is much common ground among the arts, the word *art* as used here can be taken to mean either the arts in general or the visual arts in particular, depending on the context in which it is found.

When people speak of "the arts" they are usually referring to dance, drama, music, literature, and the visual arts. Each is a unique type of human activity, and each produces forms perceived by our senses in different ways. Yet each grows from a common urge to give physical

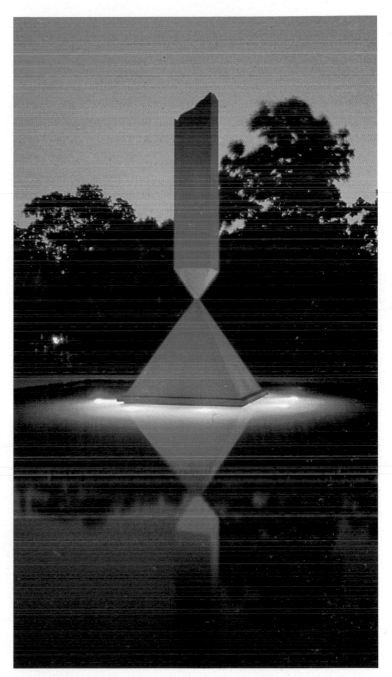

2 Barnett Newman.
BROKEN OBELISK. 1963–1967.
Cor–ten steel. 25′5″ x 10′6″.
Rothko Chapel, Houston, Texas.
Photograph: Don Getsug/TIME Magazine.

form to ideas, feelings, and experiences. This drive, shared by all artists, leads them beyond functions, facts, and explanations. The arts are a means of extending our consciousness beyond the measurable world to that larger universe whose presence we feel but cannot comprehend through ordinary awareness.

Art has a magical quality. It can relieve our doubts by merging the known and the unknown in beneficial harmony. Art has the power to change our relationship to objects and events outside ourselves and to help us comprehend their essence. Art helps us appreciate and explore the mysteries of life.

Above all, our art reflects ourselves and our relationship to our environment. An art experience can give us great joy; it can create a feeling similar to what might be described as a religious experience. Art may also lead us to discover dimensions of ourselves that are disturbing. In the ugliness and distortion of some images, we may recognize negative or destructive aspects of ourselves. Yet this very recognition can be an impetus for positive growth and change.

It is best to approach art openly, without bias. Give yourself time to react. Ask yourself questions: How does this work make me feel? Why does it make me feel this way? Did the person who made it have something particular in mind to which I can respond? How was it made? How does it relate to my life? There are no absolute standards for appraising the quality of a work of art. If it contributes to *your* experience, then it is probably art for you. You must

3 Lawrence Halprin and Associates.
Detail of AUDITORIUM FORECOURT
CASCADE (PEOPLE'S FOUNTAIN).
Photograph: Francis Oda.
(See page 438.)

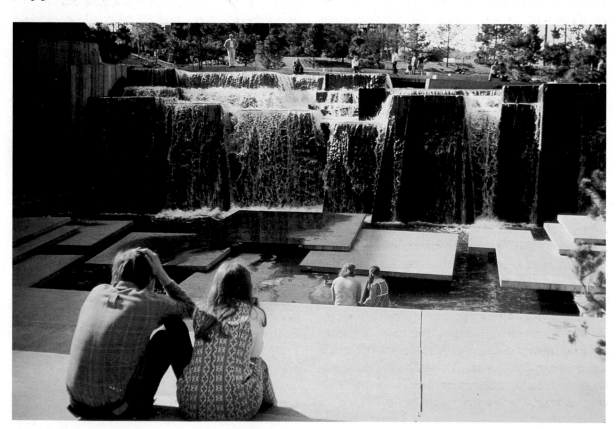

ultimately determine the quality of any work for yourself.

A meaningful response to a work of art is the result of active participation by the viewer. The experiences and words of others can help increase understanding, but the contact itself must be of one's own making. Many artists say their work is most alive for them when they are actually creating it. We recreate the life of a work of art by reassembling the parts for ourselves during the process of perception. Art cannot exist for us without our informed, sensitive response. The pleasures to be found in the arts come as a result of effort on our part. It takes alertness, concentration, and attentiveness to fully enjoy the benefits of shared experience offered by the arts.

Teachers and critics cannot determine *your* likes and dislikes in art. They can, however, offer the results of their experience and involvement with art, adding new dimensions of perception and knowledge to your own consideration of it. Works of art that add to the experience of many people over a long period of time are considered masterpieces.

It is natural to like what you understand or know. Knowing what you like is the beginning; knowing why you respond favorably or unfavorably to certain forms takes you that much further. Ultimately, the dialogue between viewer and work of art goes far beyond likes and dislikes.

Appreciation of art is sometimes difficult. Art can seem vague and indefinite, unrelated to daily life. And, to some people, the very creation of art seems frivolous. The necessity for hard labor and frugality that accompanied the settlement of North America, and the later development of industrial technology, strengthened an emphasis on efficiency, utility, and production at the expense of the natural environment and the aesthetic aspects of life. The belief that the young nation had no time for art remains with us today. In 1925, Calvin Coolidge revealed the priorities when he said, "The chief business of America is business."[3]

This is even more true today, as our all-pervasive media environment causes many to consume culture, rather than create it. Under these circumstances popular art and culture become synthetic, and expressive of some of the worst aspects of the society. Rather than lifting people out of boredom and mediocrity, such "art" becomes a means of escape—a mind-dulling, short-term drug.

Although art museums have record attendance, sales of art works increase, and much space is devoted to the arts in magazines, artists often find themselves and their work isolated from everyday life and alienated from dominant cultural values. Nonartists who are estranged from the creative process can similarly become blocked as sensitive and expressive human beings. When creativity is stifled in the majority, the culture loses its soul as well as its ability to solve its own most pressing problems.

In earlier societies, and even in some contemporary tribal societies, no separation exists between "art" and "life." In contemporary technological societies, however, few of us conceive of art as an integral part of our lives. We have a notion of a separate "high art," produced by a few gifted people, most of whom are no longer living. This attitude is commonly seen in relation to works of art found in museums, which are seen out of context, with little empathy or identity with the life experiences of those who created them.

The concept that art is created only by inspired geniuses has been with us since the Renaissance. By the eighteenth century, however, this concept had given rise to distinctions between "fine" and "applied" arts, and between artist and craftsman. Thus we had "high art" on the one side, and handmade functional objects on the other. Many people have been trapped into believing that the only "good" art was done in the past, thus losing the ability truly to see the present. For many, the art of the past has become an inhibiting burden, rather than a spark of light.

The Industrial Revolution and the invention of photography and lithography led to the proliferation of mass-produced objects and images characteristic of modern society. More recent technology has brought us an even greater abundance of manufactured materials and objects that have become both media and subject for today's artists. With all these changes, the roles of artist and craftsman are again merging. Once more there is less distinction, or perhaps fewer attempts to make the distinction, between what is and what is not "art." In the twentieth century artists aggressively questioned and pushed back what we understood were the traditional limits of art. Art, in this new sense, seems to be making its way into everyday life.

While the meaning of the word is debated and the forms and functions of art change, the fact remains that humanity continues to delight in using perception and manual skill to produce and enjoy an infinite variety of forms that extend and enrich human experience. In fact, the arts are among the interdependent factors that determine the quality of life on earth.

THE NECESSITY FOR ART

Is it necessary for us to give physical form to things we feel, think, and imagine? Must we gesture, dance, draw, speak, sing, write, carve, paint, and build? To be human, it seems we must.

Sharing experience is something we all feel

4 Charles Schulz.
PEANUTS.
©1968, United Features Syndicate, Inc.

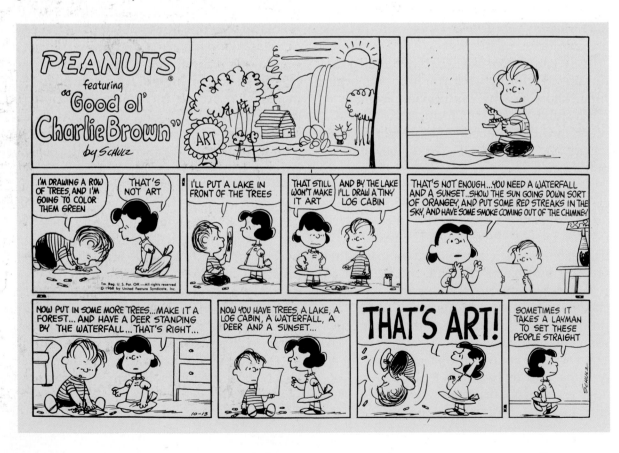

compelled to do. Studies have shown that an infant will not survive and develop if denied interaction with another human being, even though it is provided with every other necessity of life. We know how important it is to communicate an idea to someone else. If the idea is important to us and we succeed in making it known to another person, we feel confirmed and strengthened by the success. If we fail to get the idea across, we feel frustrated and diminished. As with other forms of communication, art is a special way to share human experience.

Most societies, particularly those of the past, have produced objects to meet their physical and spiritual needs. Such objects, from simple tools to vast temple complexes, were often designed to satisfy both needs simultaneously. No distinction is made between the practical function of an object and its spiritual and aesthetic significance.

NAVAJO SAND PAINTING

From between the fingers of the medicine man
Colored sand flows steadily,
Out of the hand of the Singer, tirelessly chanting,
Flows blue and white and brown, flows yellow
* and black and red,*
Covering the hogan floor with patterns,
Meaningless to unbelievers,
While the sick girl, surrounded by silent watchers,
Sits facing toward the East,
Awaiting, with quiet confidence, the Sing's sure
* end.*
"There will be dancing to-night," she tells herself,
"And I shall dance with the others!"
"There will be feasting to-night," she says in her
* heart,*
"And laughter and talk around the fires of my
* people;*
And I shall be a part of it!"

Elizabeth-Ellen Long[4]

5
NAVAJO SAND PAINTING.
Photograph: Leland Wyman
and Charlotte Frisbe.
Collection of the Wheelwright Museum,
Santa Fe, New Mexico.

Art is created by fusing skill, knowledge, intuition, and emotion with materials. Although works of art are facts because of their physical existence, they also possess inner life or spirit. Works of art are a unity of spirit and matter, and remain alive regardless of when or where created. This is why art always lives in the present, evoking human responses from those who perceive it.

A technologically explosive society needs the humanizing rewards of art experience. Science and the arts work for humanity in different ways. Science seeks and finds factual answers to questions related to our physical world. The arts help meet our emotional and spiritual needs, and help shape our physical environment as well.

AWARENESS

Of all our planet's resources, the most precious is human awareness; each new device, instrument or technique that increases our receptivity to the stimuli of our natural environment also creates new avenues for the solution of ancient problems whose solution under the pressure of growing population cannot much longer be delayed. What we mine is the mind of man; what we extract are new dimensions of human experience.

Don Fabun[5]

Art helps us to see. How we "see" determines how we live. Developing awareness and becoming personally involved in shaping our surroundings can lead to an improved quality of life.

As children we are conditioned by our culture. We are taught what is "good" and "bad," taught to accept some things and reject others—taught thereby to limit our perception.

In learning to cope with the world, we learn to conceptualize almost everything that we perceive. We place the unique elements of our experience into general classes or categories, and give names to such categories in order to think about them and communicate our ideas about them to others. The system built up by this process of classification is called a "cognitive system." Such a system provides a framework for our perception, which includes our basic values. We each have our own ways of perceiving—our own cognitive systems—yet our perceptions are largely determined by the cultural perception of our society. We could not get along without such classifications; yet, by labeling and categorizing, we ignore the unique qualities of objects and events and emphasize those qualities believed to be held in common. If they are not balanced by direct perception, these generalized categories form the basis for prejudice of all kinds. As a group, we have developed "a distinctive way of looking at the world *that is not the way the world actually is* but simply the way our group conventionally looks at our world."[6] Every society's cognitive system keeps it functioning; yet major human problems are caused by the fact that almost any group may believe that its way of seeing things is *reality*—the way the world actually is.

When we are limited to concepts and do not renew our consciousness with direct perception, we reach a dead end. We frequently confuse and limit our sensory impressions with words and concepts. When we look at things only in terms of labels or stereotypes, we miss the thing itself. We see "tree," "chair," "ugliness," "beauty," rather than *this* tree, this *particular* chair, this *unique* object, person, or situation. In fact, when we think that we thoroughly know what the world is like, we may really be most cut off from it. To some degree we are all guided in our perceptions by the people we seek to emulate. Thus we may be-

come aware only to the degree that we are stimulated to become aware by other people—our parents, teachers, and friends—and by the relative pleasantness or unpleasantness of our surroundings.

We have to learn to use our senses. The eyes are blind to what the mind cannot see. As we mentally discover new ways of seeing, we increase our perception of the world. The following story graphically illustrates this problem.

Joey, a New York City boy with blind parents, had cerebral palsy as a baby. Because of his own and his parents' disabilities, Joey was largely confined to his family's apartment. As he grew older he learned to get around the apartment in a walker. His mother thought he seemed to have normal intelligence, yet clinical tests showed him to be blind and mentally retarded. At age five Joey was admitted to a school for children with a variety of disabilities. This was his first real contact with people who could see. Although he bumped into things in his walker and felt for almost everything, as a blind person does, it soon became apparent that he was not blind. Joey simply had never learned to use his eyes. After a year of working with specialists and playing with sighted children, his visual responses were normal. Those who worked with him concluded that Joey was a bright and alert child. The combined disabilities of Joey and his parents had prevented normal visual awareness from developing.

People who are actually blind often have a highly developed tactile sense that enables them to create forms that can be enjoyed by both sighted and blind people. Blind artist Steve Handschu studied art at Cornell University School of Fine Arts and elsewhere. His carved sculpture FOREST BIRTH is a powerful evocation of the primal origins of life. Handschu's ability to "see" with his hands produced expressive statements of superior tactile sensitivity, including award-winning playground sculpture.

"Looking" implies opening our eyes in a purely mechanical way, taking in what is before

6 Steve Handschu. FOREST BIRTH. 1974. Wood. Height 42". *Collection of the artist.*

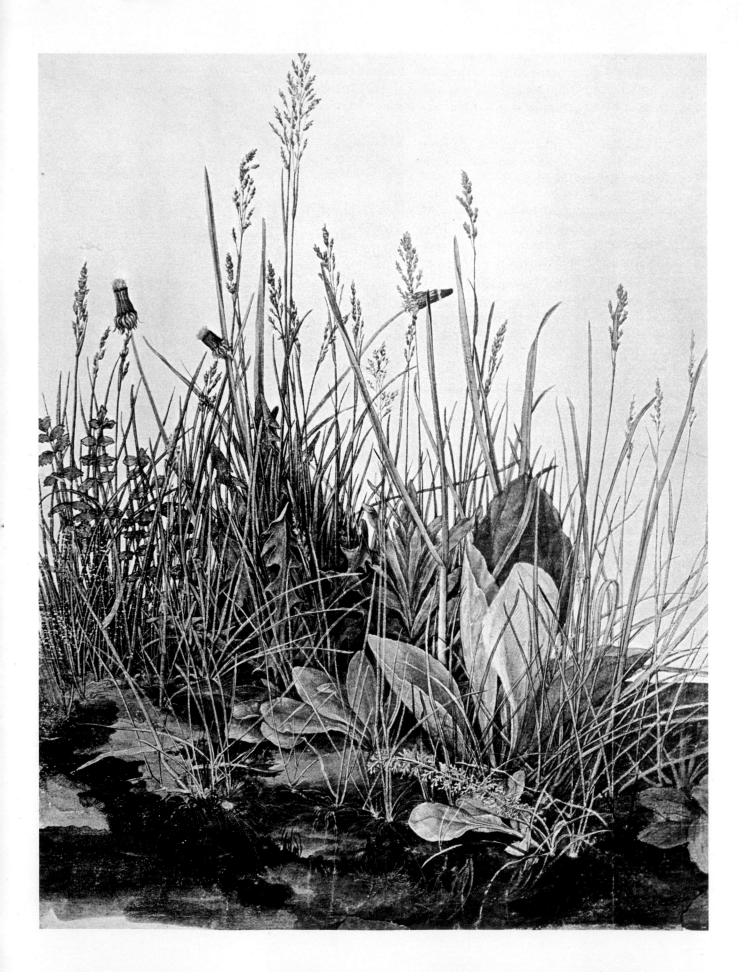

us in order to move about. "Seeing" is an extension of looking that leads to perceiving. In the world of function, one must only look at a doorknob in order to grasp and turn it. When we get excited about the shape and finish of a doorknob, the bright clear quality of a winter day, or the rich color of a sunset, we have gone beyond what we *need* to perceive and have enjoyed the perception itself. In Albrecht Dürer's watercolor painting of an ordinary patch of small wild plants, appropriately called THE GREAT PIECE OF TURF, a commonplace subject is seen as if for the first time.

In today's urban, technological cultures, we are frequently bombarded with stereotyped or "canned" images. The cumulative effects of mass media are often deadening because we block out perception when we experience sensory overload.

To see is itself a creative operation, requiring an effort. Everything that we see in our daily life is more or less distorted by acquired habits, and this is perhaps more evident in an age like ours when cinema, posters, and magazines present us every day with a flood of ready-made images which are to the eye what prejudices are to the mind. The effort needed to see things without distortion takes something very like courage.

Henri Matisse[7]

Enjoyment of visual art, and of life, can be enhanced by an understanding of the nature of seeing. We generally think of "vision" as the means by which we see either the physical environment outside ourselves or inner images such as memories and dreams. Recent research shows, however, that the difference between "outer" and "inner" vision is not distinct. Images from both outer and inner worlds are real, and the brain uses similar processes of *visualization* in becoming aware of them.[8]

The process of visualization enables a person to bring inner and outer realities into a single experience, and therefore provides a means by which ideas and images can be creatively expressed. Reverend Paul S. Osumi states the process clearly:

A horticulturalist says: "Before you can have beautiful roses on your lawn or in your greenhouse, you have to have beautiful roses in your mind." This is true of many other things. Before a stately building is built it must live in the architect's mind. Before a beautiful picture is painted it must live in the artist's mind. The controlling power of life comes from within.

Reverend Paul S. Osumi[9]

Studies indicate that vision is about one-tenth physical and nine-tenths mental. In visual perception, sensory input in the form of light patterns received by the eye is transformed by the brain into meaningful images. The interpretation depends on preconditioning, intelligence, and the physical and emotional state of the viewer.

The variety of our responses to visual stimuli is demonstrated by artists. Twelve people depicting the same subject—even from the same vantage point—will create twelve different images because of their different experiences, attitudes, interests, and eyesight. An adult will see the same subject differently from a child, as will a woman from a man, or a farmer from a developer. Even an individual will have a variety of responses to a given subject. When we look at a photograph of a house, for example, we see enclosed volume; intellectually we know it contains rooms; and emotionally we may make associations with "home."

7 Albrecht Dürer.
THE GREAT PIECE OF TURF. 1503.
Watercolor. 16¼" x 12⅜".
Albertina Collection, Vienna.

A creative person is aware of these various levels of meaning and is able to fully utilize the two basic types of human intelligence: rational and intuitive. Research initially conducted in the 1950s and 1960s by Roger W. Sperry and his students at the California Institute of Technology indicated that the left and right hemispheres of the human brain have specialized, complementary modes of functioning. The intelligence of the left hemisphere is characterized as rational, verbal, analytic, sequential, and objective; while the intelligence of the right side of the brain is evidently intuitive, nonverbal, relational, simultaneous, and subjective. It is the right side of the brain that is concerned with sensory relationships. The brain's two hemispheres appear to have, or develop, unique but mutually dependent functions.

As we become aware of our own sensory processes and related aesthetic decisions, we can begin to open up an entirely new world of awareness. Ordinary things become extraordinary when seen in a new way. Is Edward Weston's photograph of a green pepper meaningful to us because we like peppers so much? Probably not. Weston created a significant image on a flat surface with the help of a pepper. It is his sense of form that tells us how he has experienced this pepper.

August 8, 1930

I could wait no longer to print them—my new peppers, so I put aside several orders, and yesterday afternoon had an exciting time with seven new negatives.

First I printed my favorite, the one made last Saturday, August 2, just as the light was failing—quickly made, but with a week's previous effort back of my immediate, unhesitating decision. A week? —Yes, on this certain pepper,—but twenty-eight years of effort, starting with a youth on a farm in Michigan, armed with a No. 2 Bull's Eye [Kodak] 3½ x 3½, have gone into the making of this pepper, which I consider a peak of achievement.

It is classic, completely satisfying,—a pepper—but more than a pepper: abstract, in that it is completely outside subject matter . . . this new pepper takes one beyond the world we know in the conscious mind.[10]

Clouds, torsos, shells, peppers, trees, rocks, smokestacks are but interdependent, interrelated parts of a whole, which is life. —Life rhythms felt in no matter what, become symbols of the whole.

Edward Weston, April 24, 1930[11]

When something moves us so much that we lose ourselves in the total experience, our response may be called an aesthetic experience. The experience is the result of intense perception and accompanying reactions.

The word *aesthetic* refers to a sense of the beautiful and to sense perception in general. (The opposite of aesthetic is anesthetic.)

AESTHETICS

Aesthetics is the branch of philosophy that studies the affective experience of art. In the Western world, aesthetics has focused on the concept of beauty, which is equated with the sublime—something so profoundly affecting that it is divine.

Other civilizations have also studied the way we are affected by works of art. Asian aesthetic views in particular have remained traditional and stable. In India philosophers say the aesthetic experience takes place in a transaction between a prepared viewer and a work of art of excellent quality. Therefore the aesthetic experience is neither in the beholder nor in the object, but in the interaction of the two. In China the work of art is expected to express the

8 Edward Weston.
PEPPER #30. 1930.
Photograph.
©1981 Arizona Board of Regents,
Center for Creative Photography.

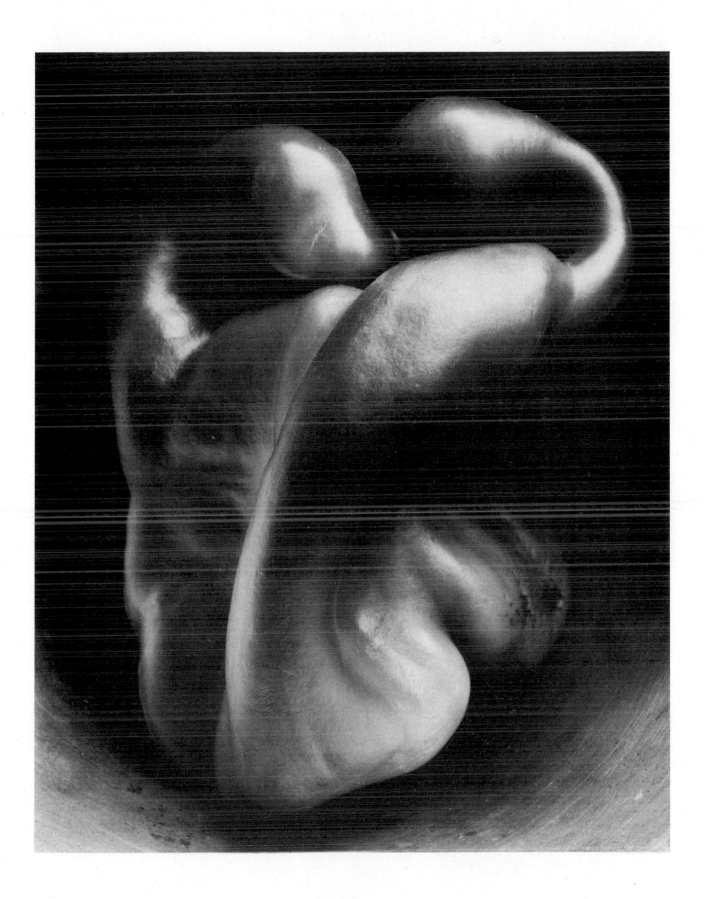

vitality of the artist, which is consistent with the energy of the universe, in order that viewers may be vitalized through their experience of the art. In Japan a work of art can provoke awe that cannot be expressed in words.

In many indigenous cultures some works of art are recognized as having greater power than others. People in such cultures can make and perceive art without the need of a theory, philosophy, or systemized examination of art. Some societies do not even have a word for art. The Balinese, one of the world's most artistic peoples by Western standards, say simply, "We have no art; we do everything as well as we can."

In the West there have arisen many problematic and contradictory views regarding "art" and "beauty." Since the time of ancient Greece, Europeans have been preoccupied with "beauty." *What* is beauty? *Where* is beauty? Is it in the eye of the beholder, or is it in the art object?

Before the Industrial Revolution everything that was made was crafted by an artist or artisan. The question "What is art?" arose only when industry created a category of objects *not* made by artists. Eventually the word "art," which originally meant "skill," lost this specific meaning and became a source of confusion.

Similarly, the word "aesthetic" has come to be equated with taste. An aesthete is now seen to be a person with refined taste, or a taste-maker. This view is currently opposed by artists and art critics who say that art has nothing to do with good taste. So-called good taste can be a limitation that interferes with one's open response. Recent developments in art can be seen as successive overturnings of what was once considered tasteful.

Too often we judge what is beautiful not so much by what we feel, but by what is commonly accepted as beautiful by the culture in which we live. Our perception of such things as flowers, sunsets, waterfalls, and human forms are defined by attitudes and values. We often reject things that other cultures consider beautiful because they do not fit our mold.

We sometimes use the word *beauty* to refer to

9 Leonardo da Vinci.
CARICATURE. c. 1490.
Pen and ink over red chalk.
Royal Library, Windsor Castle.
Copyright reserved.

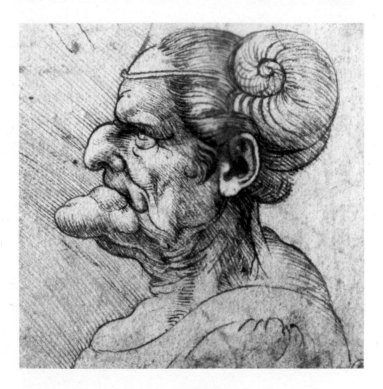

things that are simply pretty. "Pretty" means pleasant or attractive to the eye, whereas "beautiful" means having qualities of a high order, being capable of delighting the eye or engaging the intellectual and moral sense, or doing both these things simultaneously. "Beautiful doesn't necessarily mean good looking."[12]

An important dimension of awareness is the ability to open ourselves to possibilities beyond the usual limits of beauty and ugliness. Many people assume that the primary function of art is to please the senses. If this were so, ugliness would have no place in art. Let's look at the work of three artists from different times and places who chose to explore dimensions of human "ugliness."

Street life fascinated Leonardo da Vinci. He was particularly interested in studying people who were striking in appearance, either because they were very beautiful or very ugly. For him ugliness was as worthy of attention as beauty. In fact, he considered ugliness a variation of beauty. In his *Treatise on Painting* he advised others to always carry a pocket notebook in which to make quick drawings of whatever they observed. He also worked from memory, as sixteenth-century artist and biographer Giorgio Vasari described:

Leonardo used to follow people whose extraordinary appearance took his fancy, sometimes throughout a whole day, until he could draw them as well by memory as though they stood before him. Of heads thus drawn there exist many."[13]

Elegant lines, charged with energy, depict the garments and frame the ghastly head in this detail from Shibata Zeshin's DANCING RASHOMON. Zeshin created a terrifying figure from his imagination in order to dramatize a key

10 Shibata Zeshin.
Detail of DANCING RASHOMON.
19th century.
Ink and light color on paper.
Hanging scroll, 14⅝" x 20½".
Honolulu Academy of Arts.
Gift of James E. O'Brien.

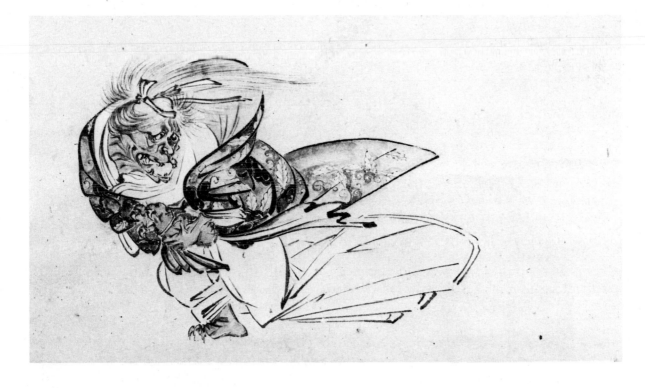

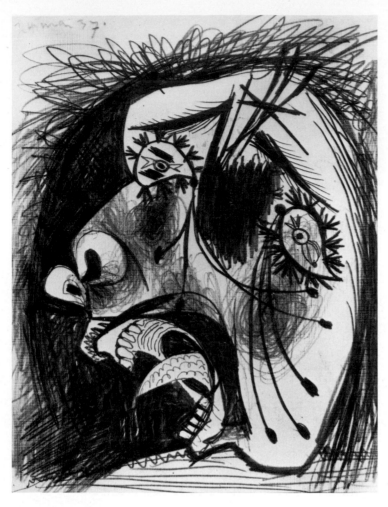

11 Pablo Picasso.
HEAD (study for GUERNICA). May 24, 1937.
Pencil and gouache. 11³/₈″ x 9¹/₄″.
The Prado, Madrid.
(See pages 380–381.)

moment in a story. Here the witch is fleeing in panic and rage after losing a fight with a warrior.

Picasso's study for GUERNICA (the complete painting is shown on pages 380–381) is both the artist's response to an incident that, to him, symbolized the brutality of war, and a political statement against the forces that caused the horror.

CREATIVITY

. . . a first-rate soup is more creative than a second-rate painting.

Abraham Maslow[14]

Imagination is more important than knowledge.

Albert Einstein[15]

The process of visualization, especially that part involving imagination, is the source of creativity. Imagining is the forming and combining in one's mind images that are not actually present to the senses, and thus creating original images not known by experience. Since art is involved with making actual images or forms, these mental images become visible in the visual arts, audible in music, and verbal in literature.

We all have the potential to be creative. Even though most of us have never been given the opportunity to develop this potential, we can do so by deliberately seeking new relationships between ourselves and life around us. Creativity is not limited to those with "inborn talent."

Artists—and creative people in general—must be dreamers, realists, and skilled workers. The creative process requires the ideas of a dreaming and imaginative mind. It also requires the ability to play, to manipulate freely and consciously the elements of perceptual experience—the ability to look at one thing and see another. The creative mind has the ability to see form in apparent formlessness, and to create order from chaos.

Creativity often begins when the creator is struck with an idea or faced with a problem. It can also be the result of playing or "fooling around." In fact, play can be as important to adult creativity as it is to child development. Playful activity is a kind of sportive, open-ended toying with possibilities. During play a creative person is alert to the unexpected, yet significant, promise of chance events.

There are as many ways to create as there are creative people, but creative processes generally have certain sequential characteristics in common. Dr. G. Wallis' thorough study of creativity led to his four-stage theory of the creative process.[16] (We include his theory here only to suggest some important components of the creative process. In actuality, the process will not necessarily follow or even include all of these stages.)

During the first stage, *preparation,* one enthusiastically collects data and media. Excitement, questioning, study, and perplexity often affect one's mood at this stage.

Incubation is the second stage. There is a shift from the conscious to the unconscious; one may relax and turn to other things. During this period the metaphorical mind takes over and visual images realign themselves. Incubation is considered to be the most important phase. One may have sudden, incomplete insights.

Wallis calls the third stage *illumination.* During this stage, the solution suddenly appears, often unexpectedly. One "knows" this is the long-awaited inspiration. A feeling of certainty and joy pervades one's entire being. The visual artist may quickly sketch the design (see page 127), the composer may record a few bars of music, the poet may write the central lines of a new poem, and the scientist may jot down notes for a whole new line of research.

Verification or *revision* is the fourth stage. The artist works out the design and completes the final form, the scientist completes experiments and presents the proven theory. This stage culminates in the presentation of the newly created form.

To be creative is to be able to put existing things together in original ways, thus producing a new object, image, or idea.

Studies of creativity have produced various descriptions of the major characteristics of creative people. These include the abilities to:

- [] wonder, be curious
- [] be enthusiastic, spontaneous, and flexible
- [] be willing to approach new experience with an open mind and to see the familiar from an unfamiliar point of view
- [] confront complexity and ambiguity with interest
- [] take advantage of accidental events in order to make desirable but unsought discoveries (called serendipity)
- [] make one thing out of another by shifting its functions
- [] generalize in order to see universal applications of ideas
- [] synthesize and integrate, find order in disorder
- [] be in touch with unconscious sources yet be intensely conscious
- [] visualize or imagine new possibilities
- [] be analytical and critical
- [] know oneself, have the courage to be oneself in the face of opposition, and be willing to take risks
- [] be willing to "lose" oneself in one's work
- [] be persistent, working for long periods in pursuit of a goal, without guaranteed results.

The towers in Watts, California, commonly known as "Watts Towers," were titled NUES-TRO PUEBLO by Sabatino Rodia, the Italian tile-setter who built them. He worked for 33 years making the fantastic structures out of such things as cast-off pipes and bed frames, held together with steel reinforcing rods, mesh, and mortar. The towers were built without the use of power tools and with no rivets, welds, or bolts. They grew from his tiny triangular back-yard like Gothic spires. He lovingly and me-

12 Sabatino "Simon" Rodia.
a NUESTRO PUEBLO. 1921–1954.
 Height 100'.
 Watts, California.
 Photograph: Duane Preble.

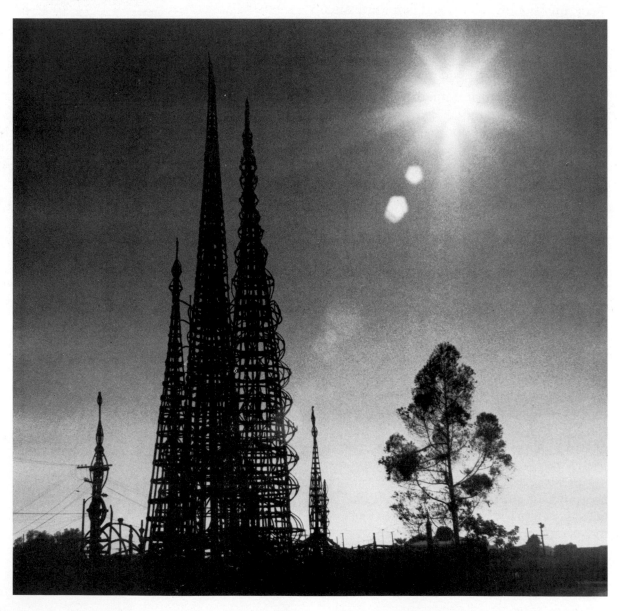

b Detail of NUESTRO PUEBLO.
Enclosing wall with construction
tool impressions.
*Photograph: Jeanne Morgan,
Santa Barbara.*

thodically covered their surfaces with bits and pieces of broken dishes, tile, melted bottle glass, shells, and other colorful "junk" that he gathered from the vacant lots of the neighborhood where he lived. Rodia's towers and thoughts are a testimony to the creative process. Here is his statement of purpose:

I no have anybody help me out.
I was a poor man.
Had to do a little at a time.
Nobody helped me.
I think if I hire a man
he don't know what to do.
A million times
I don't know what to do myself.
I never had a single helper.
Some of the people say
what was he doing . . .

some of the people
think I was crazy
and some people said
I was going to do something.
I wanted to do something
for the United States
because I was raised here
you understand?
I wanted to do something
for the United States
because there are nice people
in this country.

Sabatino "Simon" Rodia[17]

Nearly all children have rich, creative imaginations. They naturally reach out to the world around them from birth. They taste, touch, hear, see, and smell their environment, becoming part of it through their senses. All forms of expressive communication are part of that reaching out. Children who are confronted with experiences that indicate their experiments are of questionable value soon stop reaching so far.

Most of the abilities listed as being characteristic of creative people are found in children during the first few years of life. What happens to this extraordinary capacity? According to John Holt, author of *How Children Fail,*

We destroy this capacity above all by making them afraid—afraid of not doing what other people want, of not pleasing, or of making mistakes, of failing, of being wrong. Thus we make them afraid to gamble, afraid to experiment, afraid to try the difficult and unknown.[18]

Many people, including some parents and teachers, may—without realizing the consequences—ignore and even attack evidence of creative imagination in children. This destructiveness can be traced to their own underdeveloped imaginations and to a cycle of ignorance and anxiety regarding creativity that has been passed on for generations. We tend to discourage in others what has been discouraged in ourselves. Yet to ignore or to belittle expressive work is to say, "Your experience is not valid, therefore you are not valid."

For all of us, especially the very young, mental and emotional growth depends on our ability to integrate our experience of the outside world with that of our inner selves. For this reason opportunities for creative expression are extremely important. The art process helps us to discover and confirm ourselves and our relations with our world.

Obviously, all of us have been children, and most will be parents. Not so obviously, many attitudes about art are shaped during childhood. Because artistic efforts are more personal than many other kinds of work, children as well as adults tend to be particularly vulnerable to disparaging remarks about such efforts. Even comments that may not be intentionally critical or negative may be perceived as such, and thus may be very intimidating. This is why it is essential for adults to examine what happens to artistic development in children.

Young children depict the world in symbolic rather than realistic ways. Children's art is seen as inferior only when children and others want their work to look like photographs or works produced by adults. This dissatisfaction usually occurs around age nine or ten, and frequently results in a lifetime of blocked creativity. Many of those who succeed in making the transition from children's art to adult art find it painful. The majority make the transition visually, but not artistically. They learn to see the world in terms of adult conventions, but are unable to create corresponding images. They become frustrated because they cannot draw the way they have learned to see. This is a cultural tragedy.

It has long been recognized by researchers in art education that most children who have been given coloring books, workbooks, and predrawn printed single sheets at home and in school become dependent on such stereotyped, impersonal props. They lose the urge to invent unique images relevant to their own experience, as well as individual modes of expression for those images. Such devices may even block the development of discipline and skills. Without opportunities for relevant personal expression, the urge to achieve or excel can be lost.

It is important that children be given the opportunity to give honest, tangible expression to their ideas, feelings, and experiences. Adults as well as children need a great deal of encouragement to be able to express themselves without fear or hesitation.

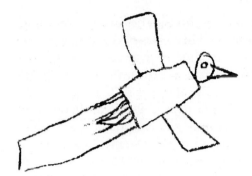

Color seven birds blue. seven birds

b Then the child colored a workbook illustration.

13 Anonymous child.
BIRDS.
a This bird shows one child's expression before exposure to coloring books.

c After coloring the workbook birds, the child lost creative sensitivity and self-reliance.

Self-assurance shows clearly in this self-portrait by a 4-year-old girl. The line drawn around the edge of her paper shows an awareness of the whole space. One hand with radiating fingers reaches out, giving strong asymmetrical balance to the composition. This was accomplished spontaneously after considerable drawing experience, but without any adult guidance or conscious knowledge of design.

Children nearly always demonstrate an innate sense of design. We lose this intuitive sense of balanced composition as we begin to look at the world from a learned, conceptual point of view. As adults, we must rediscover our innate sensitivity to design. Referring to this intuitive ability, Picasso is alleged to have said that he could always draw like Michelangelo, but it took him years to draw like a child.

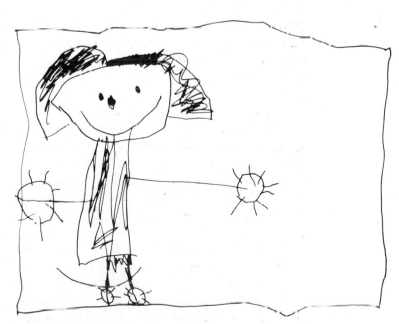

14 Malia, age 4.
SELF-PORTRAIT

At age 4 or 5 children begin drawing things they have seen. This series of drawings shows a 4-year-old's struggle to draw an elephant soon after seeing a circus for the first time. He began with the most characteristic part of the elephant—the trunk. The child tried several times. Angrily he crossed out all but one of his first drawings. He not only wanted to draw an elephant, he wanted the elephant to be placed so that his entire vision of the circus could be expressed. When he was satisfied with his elephant, he turned the drawing over and drew the full circus with an elephant, lion, juggler, and tight-rope walker in action. This scene was so real for him that he asked his father to write down the story while he told about his picture.

15. Jeff, age 4.
CIRCUS.

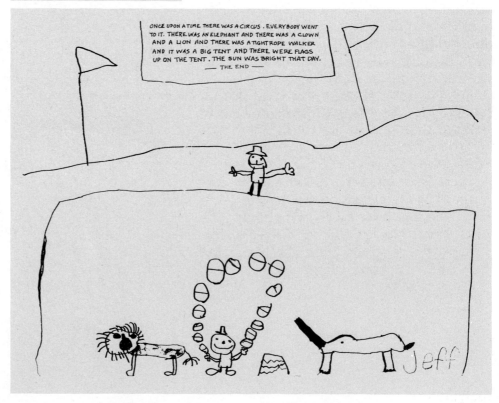

ONCE UPON A TIME THERE WAS A CIRCUS . EVERYBODY WENT
TO IT. THERE WAS AN ELEPHANT AND THERE WAS A CLOWN
AND A LION AND THERE WAS A TIGHTROPE WALKER
AND IT WAS A BIG TENT AND THERE WERE FLAGS
UP ON THE TENT . THE SUN WAS BRIGHT THAT DAY.
— THE END —

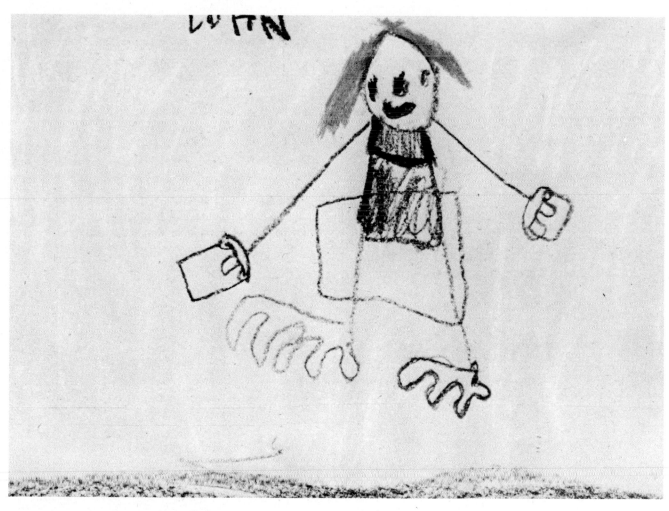

16 John, age 6.
WALKING IN THE GRASS AFTER THE RAIN.

The visual expression of children satisfies a crucial part of the universal human need to share things felt, thought, and imagined. How does it feel to walk barefoot in wet grass just after it rains? John expresses the feeling eloquently.

There is an international and timeless language of human expression in the work of children. The same basic visual vocabulary appears in children's pictures all over the world. Although typical motifs recur, their uses and personal variations are infinite.

17
Christopher, age 4.
TREE.
Gouache.
$14^{15}/_{16}$" x $9^{1}/_{4}$".

With bold colors, a 4-year-old English child painted his feelings about a tree, color, the sun, and life itself. This painting is an example of the creativity present in all human beings, not an illustration of the work of one particularly gifted child.

Pictures grow naturally from personal experience. The boy in Japan who made the painting of the BICYCLE SHOP was working from a subject he knew well. He was able to share his interest in the clutter of tools and activities with self-confidence.

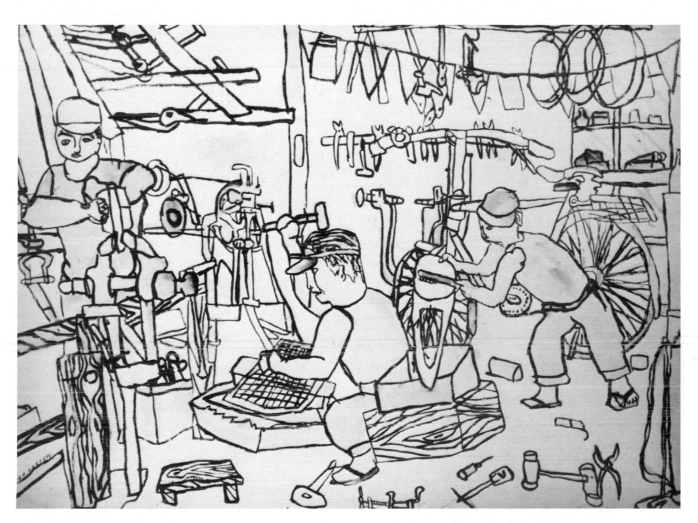

18 Anonymous child.
BICYCLE SHOP.
Painting.

For people of all ages, the creative process provides a way of objectifying personal experience and thereby building personal identity and self-confidence. Artistic problems have many equally "correct" solutions. Each person—child or adult—has the opportunity to create work that is unlike anyone else's, and different from what that person has previously created. Discovering the potential for many "right" answers is very healthy. In this way the arts complement and facilitate all other aspects of a person's education.

Our attention to art as a means of self-discovery is not intended to suggest that the purpose of art is merely self-expression, or that art is easy and therefore everyone should dabble in it. Art gives us courage to go deeper into ourselves, beyond our personalities to something universal. The potential for art is in everyone, but discipline and considerable effort are often necessary before it can be expressed. Ability is nothing unless it is developed, focused, and acted upon with commitment.

FUNCTIONS OF ART

Art reveals, clarifies, and extends experience by providing ways of perceiving things directly and intensely, as well as by giving form to such experiences. Art makes personal vision accessible to others and emphasizes our shared concerns. Art, science, philosophy, and religion are all ways in which we search for and demonstrate human concepts of reality. They are means employed in our search for ultimate truth.

Art is a form of communication between the work and its maker and between the artist and the audience or viewer. Art can advertise, beautify, celebrate, clarify, decorate, educate, enhance, entertain, entice, express, heal, inform, inspire, integrate, intensify, interpret, narrate, persuade, record, reveal, and transform. It can also arouse, attack, conceal, deceive, humiliate, incense, obscure, and terrorize.

The importance of the communicative function of art varies according to the artistic purpose. A film is more obviously communicative than a chair, yet both carry ideas about function and meaning from maker to perceiver.

The function of art begins with the intention of the artist. It is built into the original form as an artist seeks to realize a goal. As long as the work of art stays within the context for which it was created, it will function as intended. When the artwork is placed in a different context, its function changes accordingly.

Many works made in other cultures or in other times were made to serve functions of which we are generally unaware. For instance, the CANOE PROW FIGURE from the Solomon Islands (see page 262) employs symbolism very meaningful to that culture; it was made to protect travelers. Its present function, in a museum or reproduced in books, could be characterized as conveying cross-cultural information, while pleasing us with its unique form.

Functions can overlap within any context. For instance, art may be decorative, uplifting, convey moral truth, and impart information all at once (see Gauguin's VISION AFTER THE SERMON, p. 338).

The wide variety of purposes art serves can be broadly characterized as personal, social, and utilitarian.

Personal

Many of our everyday actions involve personal art-related decisions such as choosing the clothing we wear, the furnishings in our home, and the car we drive. Such choices make visual statements about who we are and the kind of world we like to see around us.

Art also fulfills personal spiritual needs for many people. The most obvious application of this function can be seen in places of worship, where the architecture itself creates an atmosphere for devotion (see page 434). Secular

works of art can also elevate our spirits much as music does (see page 78). Psychological functions of art can be closely related to spiritual functions. Living with works of art, participation in art-making processes, and the conservation or development of pleasant surroundings can be psychologically beneficial.

The personal functions of art are obscured when art is treated merely as merchandise or material possession—for example, when art functions solely as an investment. Of course, an original work of sizeable and perhaps increasing monetary value can be lived with and enjoyed, and eventually passed on to one's children, given as a tax deductible donation to a museum, or sold. The darker side of the issue involves so-called "investment art," much of which is neither a good investment nor good art. Those who want to buy art to live with, but have neither the knowledge nor the money to purchase expensive original works, would do well to buy works by artists who are not sufficiently famous to command high prices, original prints, or good quality, inexpensive photomechanical reproductions.

Social

Art serves a social function when it goes beyond serving the personal needs of the artist. Art is social in the sense that it is communication. The visual arts play a central role in such celebrations as religious observances, birthdays, and holidays of all kinds. In many cases art is made for a particular occasion, and then discarded when the festivities are over. Such art includes objects as simple as flower arrangements, and as complex as large, colorful constructions that act as focal points in religious processions.

Commercial art in the form of advertising is designed to persuade the viewer to act in a certain way. Posters, billboards, and television commercials seek to sell us everything from toothpaste to presidential candidates. Not all persuasive art is commercial, however. Art as

social or political propaganda, intended to promote social change, has been part of the history of many cultures (see Margaret Bourke-White's photograph AT THE TIME OF THE LOUISVILLE FLOOD on page 154, and Picasso's GUERNICA on pages 380–381).

Because art can make a strong statement clearly understood by a broad spectrum of people, it is often used to impart information in both literate and nonliterate societies.

Utilitarian

The visual arts help to determine the quality of our surroundings, and in this sense they are environmental arts. Well-designed utilitarian objects from chairs to buildings make their contribution to the beauty and function of our daily lives. Artistic awareness is necessary if we are going to conserve, restore, design, and build life-enhancing human environments. Aesthetic sensitivity is an essential ability for averting potential disaster, and for making survival worthwhile.

Art changes according to time, place, and circumstances, but its reasons for being remain the same. Art reveals and has the potential to guide the people and values of the culture that has produced it. It is not the artist alone, but our collective selves that we see in the art forms of past and present civilizations.

THE ARTIST'S PERSONAL POINT OF VIEW

If we look at more than one work by a given artist, we may begin to see the general intent of that artist's personal expression. Many artists have remarkable consistency in the way they see the world and in the way they view their purpose as artists; thus their works function in a consistent way. Other artists vary their purpose from work to work, or shift their attitude—and therefore their style—during whole periods.

Artists create form out of their own experience of life, including the experience of other art. In so doing, the artist is saying "This is what is important to me. This is how I see life." In this sense, all works of art are self-portraits. In another sense, even a representational self-portrait is not merely a self-image, but is also an attempt to give universal significance to one person's experience. As art contributes to the expanding consciousness of the artist and the viewer, it creates humanity.

The works of the following four artists demonstrate this concept. Although they lived during approximately the same time, they came from different countries and held very different attitudes. The first three—Henri Matisse, Käthe Kollwitz, and Werner Bischof—were primarily interested in people; thus the human figure was their most frequent subject.

In 1908 Henri Matisse wrote the following statement about his work:

The purpose of a painter must not be conceived as separate from his pictorial means, and these pictorial means must be the more complete (I do not mean complicated) the deeper is his thought. I am unable to distinguish between the feeling I have for life and my way of expressing it.[19]

Matisse wrote these words a few years before he painted NASTURTIUMS AND THE DANCE. The work illustrates his point. In this painting of a corner of his studio, he shows a chair, a sculpture stand topped by a vase of flowers, and against the wall a section of his large painting called THE DANCE. Here Matisse expresses what the French call *la joie de vivre* or "the joy of life." Every line, shape, and color radiates it. And this is true of most of his work.

The human figure had a particular importance for Matisse. He said:

What interests me most is neither still life nor landscape but the human figure. It is through it that I best succeed in expressing the nearly religious feeling that I have towards life.[20]

Matisse chose to emphasize joyful themes in spite of the fact that during his lifetime (1869–1954) there was much suffering in the world. He had definite ideas about the functions of his art:

What I dream of is an art of balance, of purity and serenity, devoid of troubling or depressing subject matter, an art which might be for every mental worker, be he businessman or writer, like an appeasing influence, like a mental soother, something like a good armchair in which to rest from physical fatigue.[21]

Matisse was well educated, and became thoroughly proficient in the traditional techniques of French art. Throughout his life he worked at adding to both his knowledge and his skills. Yet he felt that painting was an intuitive rather than an intellectual process. He studied to learn, but also worked hard to preserve his original naïveté.

For Matisse a painting was a reality of lines, shapes, and colors before it was a picture of nameable objects. He based the lyric beauty of his personal style on intuition, yet he acknowledged the importance of his years of study. He masterfully assimilated influences from the decorative arts of the Near East, African art, and other painters, such as Gauguin, who worked with colors and forms new to Western European art. Matisse sought to hide his own struggles in his works, desiring them to look effortless, light, and joyous. He feared, however, that young people would see his work as done with casual facility and even carelessness, and conclude that years of study were unnecessary.

19 Henri Matisse.
NASTURTIUMS AND THE DANCE. 1912.
Oil on canvas. 75 3/4" x 45".
Pushkin Museum of Fine Arts, Moscow.

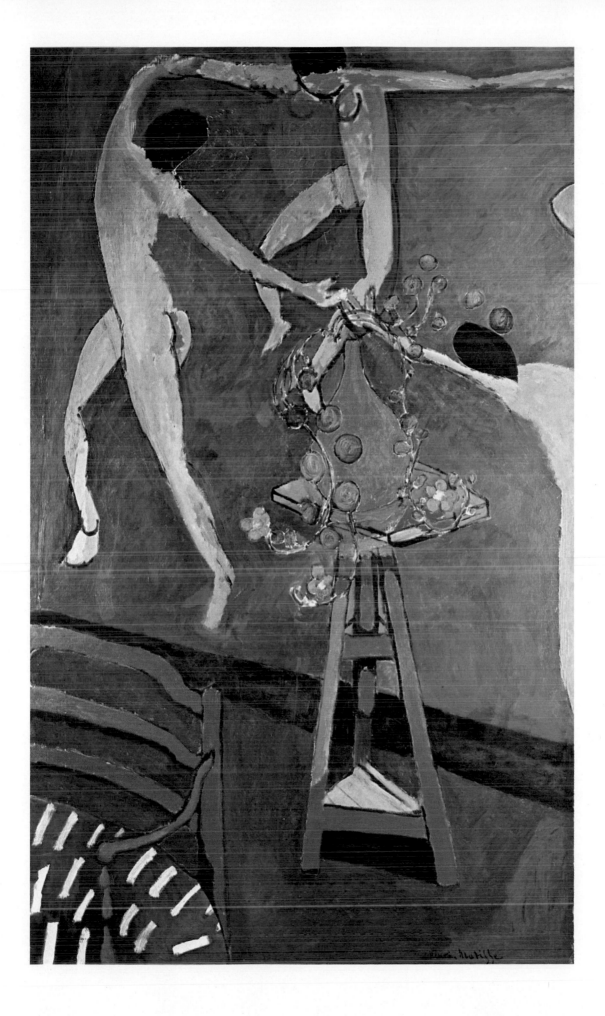

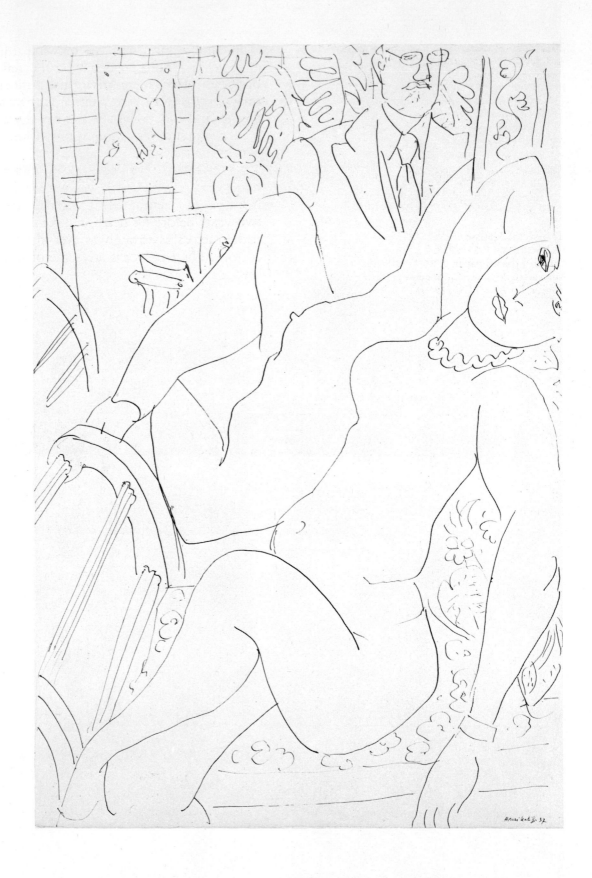

20 Henri Matisse.
ARTIST AND MODEL REFLECTED
IN A MIRROR. 1937.
Pen and ink. 24¹/8″ x 16¹/6″.
The Baltimore Museum of Art:
The Cone Collection, formed by
Dr. Claribel Cone and Miss Etta
Cone of Baltimore, Maryland.

21 Henri Matisse.
LA NEGRESSE. 1952–1953
Cut and pasted paper. 178³/4″ x 245¹/2″.
National Gallery of Art, Washington, D.C.
Alisa Mellon Bruce Fund (1973).

In this free and sensuous drawing, Matisse appears in a mirror along with the reflected back view of his model. His formal, businesslike image acts as an effective point of contrast to the model, and appears, as in other works we have seen, to remind us that the expressive lines exist because of him.

LA NEGRESSE (inspired by American entertainer Josephine Baker) was cut by Matisse from paper when he was an invalid, less than two years before his death. His feeling for life comes across as strongly as ever in this huge cut-out. His late works are some of his most joyous.

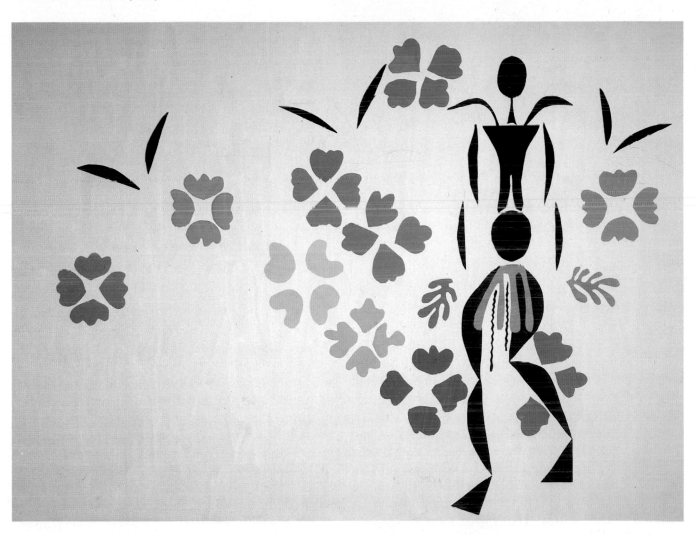

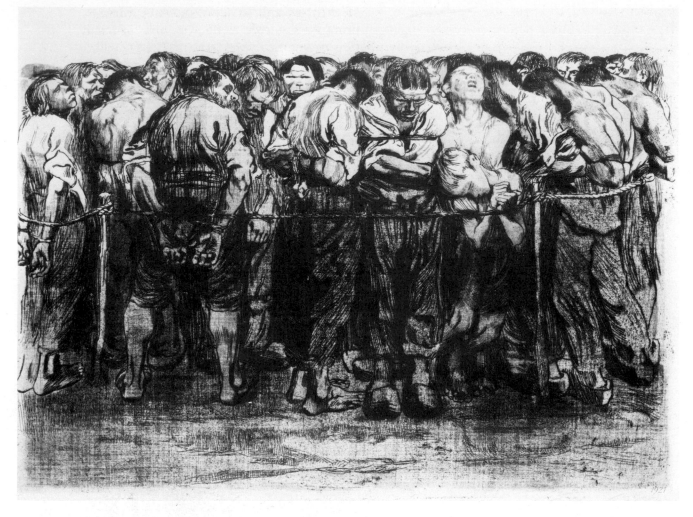

22 Käthe Kollwitz.
THE PRISONERS. 1908.
Etching and soft-ground. 12⁷/8″ x 16⁵/8″.
Library of Congress, Washington, D.C.

In contrast, the work of Käthe Kollwitz expresses a very different attitude toward life. Throughout her life, she identified with the sufferings of the poor and the oppressed who were often her neighbors. She lived in Germany during the first half of this century, and was aware that many around her were experiencing extreme anguish and pain. She and her husband, a physician, acted as social workers, welcoming people with grief and problems into their home. Her strong identity with the suffering of others is revealed in her prints and drawings, many of which appear to be self-portraits. She lost a son in World War I, and a grandson in World War II, but her personal grief was secondary to her deep concern for humanity. Kollwitz dreamed of a united mankind that would elevate human life above the misery she saw so clearly.

Kollwitz was one of the relatively few women whose greatness as an artist achieved public recognition. The tragic situation in post-World War I Germany led her to create posters, lithographs, and woodcuts in a powerful, semi-

abstract style. In 1933 she was expelled from the Berlin Academy for her anti-Nazi sympathies. Throughout her life she recorded the sorrows of downtrodden people. There is a strong sculptural quality in Kollwitz' drawings and prints that developed from her study of Rembrandt's use of light as well as her own experience in making sculpture.

The three prints reproduced here were made over a period of 26 years, yet they are remarkably consistent in mood and graphic quality. THE PRISONERS, done in 1908, was one of a series of prints inspired by Kollwitz' interest in a violent peasant revolution that occurred in southern Germany in 1525.

23 Käthe Kollwitz.
DEATH SEIZING A WOMAN. 1934–1936.
Lithograph, printed in black. 20" x 14⁷/₁₆".
The Museum of Modern Art, New York. Purchase.

The lithograph DEATH SEIZING A WOMAN, completed in 1936, was one of eight prints in Kollwitz' last major print series, "The Theme of Death." The impact of this print was achieved by reducing the idea to its essentials. The mother holding her child in a protective grasp stares ahead in terror as the symbolic figure of death presses down on her from behind. Dramatic lines focus attention on the mother's expression of fear.

The SELF-PORTRAIT of 1934 reveals a kindly, yet monumental face. In addition to being visually strong, Kollwitz' graphic images function as pleas for compassion. They touch our conscience and remind us of the problem of human cruelty. Kollwitz saw art as a tool for social change. Feeling that art should be for everyone, she chose to make inexpensive prints, which ordinary people could afford, rather than paintings, intended mainly for the wealthy. (Discussion of prints begins on page 142.)

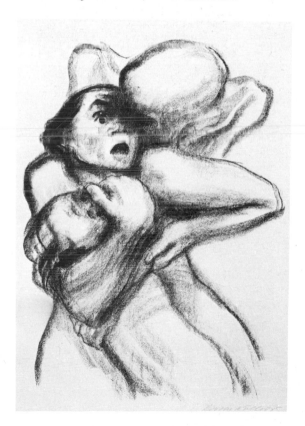

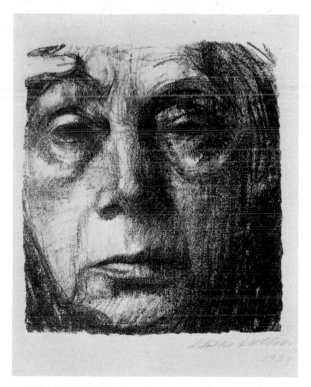

24 Käthe Kollwitz.
SELF-PORTRAIT. 1934.
Lithograph. 8¹/₁₆" x 7³/₁₆".
Philadelphia Museum of Art.
Gift of Dr. and Mrs. William Wolgin.

From his photographs, we can see that Werner Bischof also had compassion for all he saw of human suffering. Bischof began his career as a graphic artist and studio photographer, but his work underwent a gradual metamorphosis. He became well known as a portrayer of the human condition, and magazine publishers sent him on photo assignments to all parts of the world.

Bischof's 1951 photograph of a starving mother and her child, HUNGER IN INDIA, is heartrending. By coming close to his subject at a low angle, he was able to bring together the pleading hand and face of the mother. The gaze

25 Werner Bischof.
HUNGER IN INDIA.
1951.
Photograph.

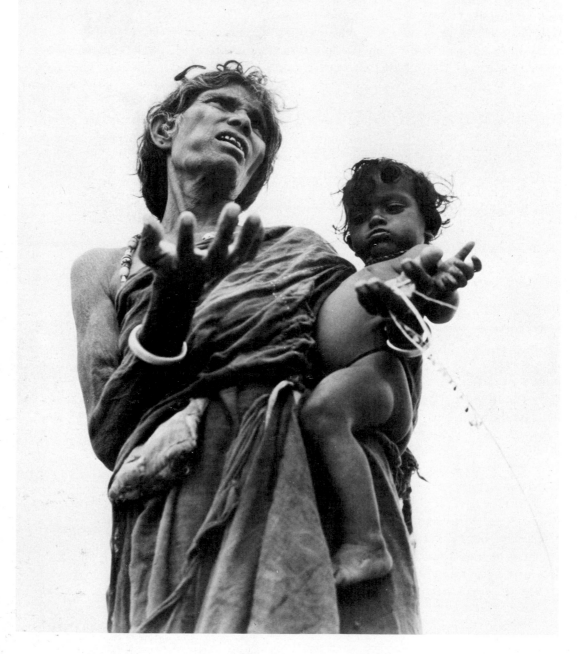

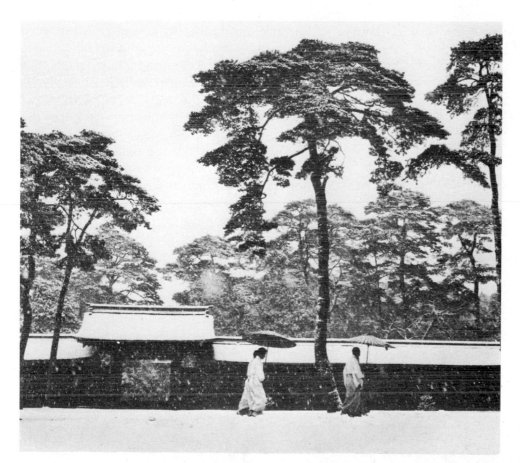

26 Werner Bischof.
SHINTO PRIESTS IN TEMPLE
GARDEN.
Meiji Temple, Tokyo, 1951.
Photograph.

27 Werner Bischof.
LONE FLUTE PLAYER.
Peru, 1954.
Photograph.

of the child brings the composition back to us.
In this image Bischof calls our attention to a
major problem of humanity—hunger—and
asks for our help in solving it. The artist's visual
statement alerts us to the need for social change.

In the same year, Bischof photographed
SHINTO PRIESTS IN TEMPLE GARDEN. By care-
fully selecting his distance from the figures, he
shows their relationship to the trees, and thus
records a classic image of a basic Asian attitude
toward humanity in nature.

One of Bischof's last photographs was LONE
FLUTE PLAYER, taken in Peru. The lilting steps
of the boy with his flute are captured with lyric
charm. A feeling for effective design, as well as a
deep human understanding, enabled him to
protest or affirm aspects of the human condi-
tion by visually saying *no!* or *yes!*

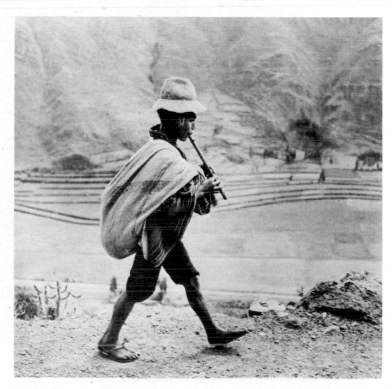

REPRESENTATIONAL AND NONREPRESENTATIONAL ART

Representational works—like those we have just seen—may seem easier to identify with and therefore less demanding than nonrepresentational works. But it is important to realize that visual forms, like audible sounds, evoke responses in us whether or not they represent subjects. In fact, subject matter is a minor element in many of the arts. Without significant form (that is, structure or design), subject is irrelevant.

Subject or *subject matter* refers to recognizable and nameable objects or themes represented in a work of art. Subject matter is the factual imagery to which the viewer responds, relying on personal associations related to his or her particular culture. Such interpretations of the subject may be relevant. However, understanding the full significance of a work of art involves more than simply recognizing the objects portrayed. Our aim is to help you arrive at the point where you can be more consciously aware of your own responses, and can respond to visual form with or without subject matter or verbal interpretation.

The three basic terms that indicate differences in the handling of visual form are *representational*, *abstract*, and *nonrepresentational*.

Representational art (also called *naturalistic*, *realistic*, or *figurative*) depicts the appearance of things. Objects in the everyday world are "re-presented"—or presented again. *Naturalism* refers to a type of representational art that is particularly realistic, or which conforms closely to the appearance of nature.

28 Piet Mondrian.
RED TREE. 1908.
Oil on canvas. 27$\frac{1}{2}$" x 39".
Haags Gemeentemuseum, The Hague.

Abstract art is based on preexisting objects, in which the natural image of the subject is changed or distorted in order to emphasize or reveal certain qualities not otherwise apparent. As a verb, "to abstract" means to take from, to extract the essence of a thing or idea. In a basic sense, of course, all art is abstract because it is not possible for an artist to reproduce exactly what is seen. According to dictionary definitions, *abstraction* can mean either (1) works that are totally nonrepresentational, without reference to natural objects; or (2) works that retain representational characteristics expressed in altered or generalized form. In this book we follow the second meaning.

Nonrepresentational art (also called *nonobjective* and *nonfigurative*) rejects the representation of appearances. It presents a visual form with no specific reference to anything outside itself. Piet Mondrian's 1908 painting RED TREE shows the artist's early concern with the visual pattern or structure created by the tree's branches and the spaces between them. At that time Mondrian was beginning his long quest for the purest means by which art can express universal truth. Through what he saw as the "essential plastic means of art"—line and color freed from any particular subject matter—he emphasized the expressive qualities of pure form.

[Non-figurative art] shows that "art" is not the expression of the appearance of reality such as we see it, nor of the life which we live, but that it is the expression of true reality and true life. . . .[22]

29　Piet Mondrian.
HORIZONTAL TREE. 1911.
Oil on canvas. 29⅝" x 43⅞".
*Munson-Williams-Proctor Institute.
Utica, New York.*

30 Piet Mondrian.
FLOWERING APPLE TREES. 1912.
30³/₄″ x 41³/₄″.
Haags Gemeentemuseum, The Hague.

Mondrian worked to free painting from the depiction of nameable objects and even from the expression of personal feelings. He wanted to lead the way toward an art that was objective, impersonal, and universal in its implications. In three paintings of trees, completed between 1908 and 1912, we see Mondrian's progression toward increasingly abstract imagery. His painting COMPOSITION WITH RED, YELLOW, AND BLUE, reproduced on page 366, is an example of Mondrian's totally nonrepresentational later work. As he moved from representation to nonrepresentation Mondrian placed greater and greater emphasis on the fundamental qualities of proportion, balance, and rhythm. Within the strict limitations he set for himself, he was able to achieve a rich variety of formal compositions that express a mystical harmony found in humanity and the universe.

The Belgian painter René Magritte presents the viewer with a clear statement about the nature of representational art. The subject of the painting is a pipe. But we see written on the painting, *"Ceci n'est pas une pipe,"* or "This is not a pipe." If this is not a pipe, then what is it? It is a painting! Magritte's title, THE TREASON OF IMAGES, gives a clue to his thinking.

Matisse once told of an incident illustrating his views on the difference between art and nature. A woman who was visiting his studio pointed out, "But surely, the arm of this woman is much too long." Matisse replied, "Madame, you are mistaken. This is not a woman, this is a picture."[23]

Artists manipulate visual form in order to express their ideas and feelings, regardless of whether or not these ideas and feelings refer to the appearance of things in the everyday world. The expressive potential of the various aspects of visual form is the subject of the next chapter.

31 René Magritte.
LA TRAHISON DES IMAGES
(THE TREASON OF IMAGES).
c. 1928–1929.
Oil on canvas. 23⁵/₈″ x 37″.
Los Angeles County Museum of Art.
Purchased with funds provided by
the Mr. and Mrs. William Preston
Harrison Collection.

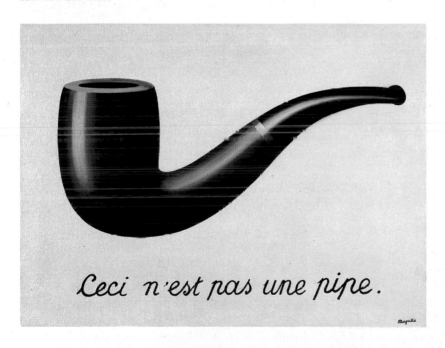

2

Form and Content

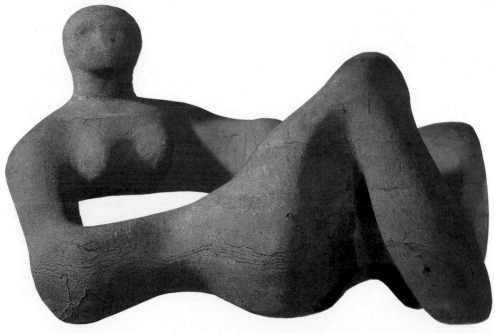

Henry Moore.
RECUMBENT FIGURE.
(See page 79.)

VISUAL COMMUNICATION

Verbal language consists of certain sounds with agreed-upon meanings that are learned through continuous repetition. Verbal language is highly abstract; it is not visually representational. Except for a learned association, word symbols have little or no connection with the things to which they refer. Therefore, when repetition stops, verbal language is soon forgotten.

The world we know through our senses has meaning for us apart from verbal language. When we speak of a "language of sound" or a "language of vision," we are referring to the elements and groupings of audible or visual phenomena to which humans react in generally similar ways. That is, there are common human responses to much sensory experience. However, there are no audible or visual languages based on specific, agreed-upon meanings that are independent of verbal languages. With the help of words, we can analyze and therefore better understand the ways in which artists work with the elements of visual form to communicate certain meanings.

Although we live at a time when there is emphasis on visual images, many of us still are visually illiterate. The first step toward becoming visually literate is to open ourselves enough to realize what our senses are telling us—to become increasingly aware of what we see and how we feel about what we see. Enjoying the visual arts requires this ability to see, yet few are given the chance to develop the art of seeing.

Everything that we see has form or is given form by our perception. Each form that we perceive evokes or is capable of evoking some kind of a response in us. In other words, *every* thing has form, and all form has some sort of content or spirit. By developing a sense for the expressive potential of all form, we encourage within ourselves the ability to enjoy and create new relationships with the things around us.

It is helpful to learn to see without practical or connotative associations in order really to see form itself. Once this is accomplished, one can tune into the important associative meanings of subject matter with renewed sensitivity to one's own preconscious responses to form.

We can learn to see form by looking at pictures upside down, because the inversion of the images allows us to get around the processes of identifying and naming things. Familiar objects become unfamiliar forms when freed from ordinary associations. The idea can be made more challenging and rewarding by searching for pictures that are similar in form, but dissimilar as nameable subjects. Such comparisons become visual metaphors.

32 VISUAL METAPHOR.

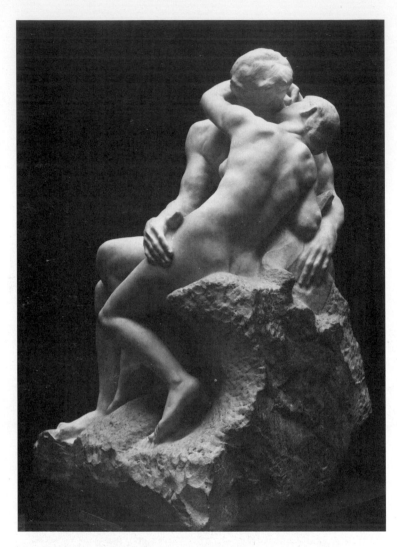

33 François Auguste René Rodin.
THE KISS. 1886–1898.
Marble. Height 5′11¼″.
Musée Rodin, Paris.

The form of a work of art is generated by the intention of the artist and the character of the materials being used. The artist interacts with the audience through the form given to the work. The artist is the source or sender; the work is the medium carrying the message. We, as viewers, must receive and experience the work if the communication is to be complete.

Clearly, effort is required to put a work of art together. Less obviously, and overlooked by many people, is the fact that responding to a work of art also requires effort. Contemporary American composer John Cage calls this to our attention:

Most people mistakenly think that when they hear a piece of music, that they're not doing anything, but that something is being done to them. Now this is not true, and we must arrange our music, we must arrange our Art, we must arrange everything, I believe, so that people realize that they themselves are doing it, and not that something is being done to them.[2]

We guide our actions by reading the content of the form of people, things, and events that make up our environment. We have an amazing ability to remember certain visual forms. We read content based on our previous experiences with the forms. A stranger who looks like someone we know may cause feelings of like or dislike depending on how we feel about the acquaintance. When we see faces and figures of people whom we have seen before, they are familiar.

Form in its broadest meaning refers to the combination of all perceivable characteristics of any given thing. In art, form is the total structure of the visual elements working together in a design. *Content* is the cause, the meaning, the life within the outer form. Content determines the form and is expressed by it. The two are inseparable.

When perceiving any physical form, we see and respond to the character of the form. Artists manipulate form in order to express certain content. Form is what we see, and content is what we interpret as the meaning of what we see. As form changes, content changes.

If we take an agreed-upon symbol for a subject, we can change its form in such a way that its generally accepted content is completely changed. For example, the valentine ♥ heart, which is used to represent the human heart, is a symbol of love. If someone were to give you a huge, beautifully made red velvet valentine, so large it had to be pulled on a cart, you would probably be overwhelmed by this gesture of love. The content would be LOVE! But if you were to receive a faded mimeographed outline of a heart on a sheet of cheap paper, you might read the content as: love—sort of—a very impersonal kind. Or, if you were to receive a shriveled, greenish-brown, slightly moldy image of the heart symbol, the content might be UGH, HATE!

One way to understand how art contributes to experience is to examine works that have the same subject, but which vary in form and content. THE KISS by Auguste Rodin and THE KISS by Constantin Brancusi show how two sculptors interpret an embrace. In THE KISS by Rodin, the life-sized human figures represent ideals of masculine and feminine form. Their implied natural softness is accentuated by the rough texture of the unfinished marble on which they sit.

Brancusi chose to use the solid quality of the block of stone to express lasting love. Through minimal cutting of the block, he symbolized the concept of two becoming one. Rodin's KISS provided Brancusi with the theme, but Brancusi chose geometric abstraction rather than naturalistic, sensual beauty to express human love.

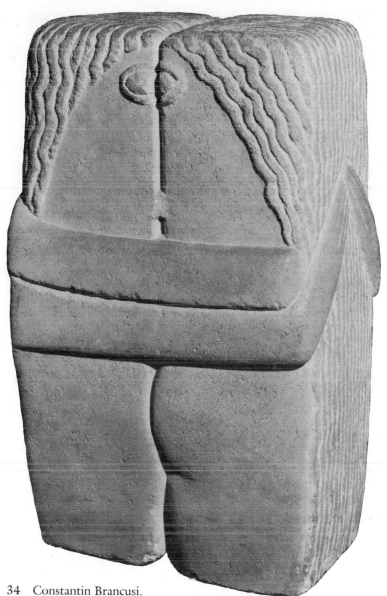

34 Constantin Brancusi.
THE KISS. c. 1912.
Limestone. 23″ x 13″ x 10″.
Philadelphia Museum of Art.
The Louise and Walter Arensberg Collection.

35 Anonymous child.
MADONNA AND CHILD.

The universal relationship between mother and child has been symbolized by artists far apart in time and space. These contrasting images of the same subject are all valid expressions of the ideals, intentions, and experiences of individual artists and their cultures.

The shy girl who painted Mary holding the Christ Child had no artistic tradition to guide her. She gave direct expression to her personal feelings and experience. She seems to have identified with both the tiny, secure child and the large, protective mother. The free, flowing lines, curving shapes, and size of the image in relation to the size of the paper contribute to the symbolic power of this painting.

As a depiction of a mother and her infant, the MADONNA AND CHILD ON A CURVED THRONE seems more remote than the preceding child's painting. The abstract Byzantine style, exemplified by this painting, developed early in the Christian era as a way to inspire the illiterate while keeping the biblical commandment forbidding the making of graven images. References to earthly existence have been carefully avoided. The figures are not drawn from observation of nature, but conform to a precise formula used throughout medieval Europe.

The painting's design is based on circular shapes and linear patterns. Mary's head repeats the circular shape of her halo, while circles of similar size enclose the angels, echoing the larger circles of the throne. The lines and shapes used in the draped robes that cover the figures give scarcely a hint of the bodies underneath. Divine light is symbolized by the gold background that surrounds the throne on which the Virgin Mary sits. The massive, architectural throne befits her position as Queen of the City of Heaven. Christ appears as a wise little man, supported on the lap of a heavenly, supernatural mother.

36 Byzantine School.
MADONNA AND CHILD ON A CURVED THRONE.
13th century. Tempera on wood. 32⅛″ x 19⅜″.
National Gallery of Art, Washington, D.C.
Andrew Mellon Collection (1937).

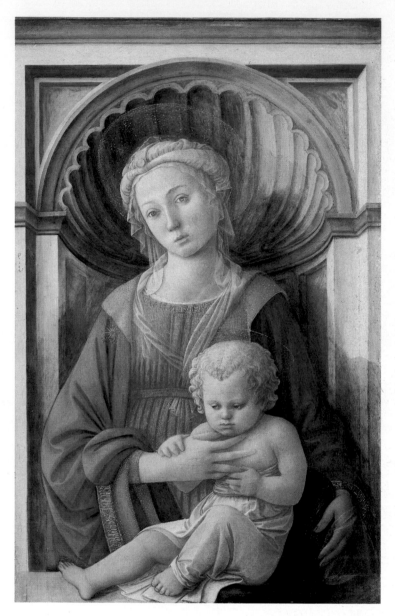

37 Fra Filippo Lippi.
MADONNA AND CHILD. c. 1440–1445.
Tempera on wood. 31³/₈″ x 20¹/₈″.
National Gallery of Art, Washington, D.C.
Samuel H. Kress Collection (1939).

About 150 years later the Italian Renaissance painter Fra Filippo Lippi painted a very different MADONNA AND CHILD. Many refinements handed down from the Byzantine tradition are visible, yet the image is now essentially representational in style. The mother is still enthroned and her child is still both child and wise man. Yet the figures and the niche behind them now appear more earthly or natural, in keeping with the Renaissance desire to humanize medieval Christianity. Both Mary and Christ appear quite three-dimensional. Light and shade are effectively employed to give the figures and their setting a solid, sculptural quality. Behind the appearance of naturalism, Lippi has given the figures quiet grandeur by placing them carefully within the simple shape of the niche.

At about the same time, Andrea Mantegna painted an even more representational picture of the Madonna that must have been a surprise to his contemporaries. Here is a fully natural-looking image of a mother and child. If it were not for the title, THE MADONNA AND CHILD, we would have no clue that this tender scene is meant to be Christ and Mary. The Madonna is now a humble, accessible woman, no longer enthroned. Christ is a sleeping infant with no suggestion of his future. Only Mary's introspective gaze suggests that there is more to come. The painting is a universal statement of the mother-child relationship.

38 Andrea Mantegna.
THE MADONNA AND CHILD. c. 1445.
Oil on canvas. 16⁹/₁₆″ x 12⁵/₈″.
Staatliche Museum, Berlin.

Pablo Picasso's conté crayon drawing has much in common with the tempera painting by Mantegna. The drawing, A MOTHER HOLDING A CHILD, was done as a study for a painting of a circus family. Picasso tried several times to capture the gesture of tenderness in the hands of the mother as she holds her baby. The relationship of love between the mother and child is emphasized by the lines of the child's upreaching arm and the mother's inclining head and fallen lock of hair.

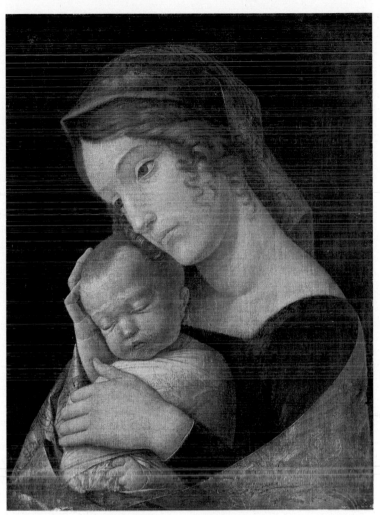

39 Pablo Picasso.
A MOTHER HOLDING A CHILD
AND FOUR STUDIES OF
HER RIGHT HAND. 1904.
Conté crayon. 13¹/₂″ x 10¹/₂″.
Fogg Art Museum, Harvard University.
Bequest of Meta and Paul J. Sachs.

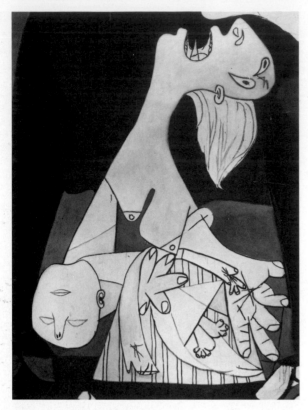

40 Pablo Picasso.
Detail of GUERNICA. 1937.
(See pages 380–381.)

The elegant calm of the mother and child in the drawing contrasts sharply with the brutal anguish of a mother holding her dead child in a detail of Picasso's painting GUERNICA. (See also a reproduction of the full painting on pages 380–381.) Not only does the breadth of Picasso's visual expression become evident, but we see the way in which the visual form is changed as the content expressed by it is changed. Picasso consciously modified the visual depiction of anatomy in order to increase the impact of his imagery.

These different images of the same theme, and our own responses to them, are the result of each individual artist's handling of the various elements of visual form. We will begin to explore the "language" of art by developing an understanding of the expressive potential of these elements.

VISUAL ELEMENTS

Visual experience is one continuous flow of complex interrelationships. However, in order to discuss visual form, it is necessary to recognize various aspects or elements and their interactions. The number of elements, the terms used to identify them, and the preferred order vary considerably among artists and teachers. All of these elements can be discussed separately, but they are actually inseparable.

Analyzing works of art may sometimes seem like killing the art. Dissection of a "living" thing usually kills it. The frog cut open in biology class, for example, will never hop again. But works of art are not biologically alive, so there is a good chance they will go back together again visually and be even more "alive" for the viewer than before they were "taken apart" by verbal analysis.

The names of the visual elements are merely terms we have found useful for describing various qualities that we see around us. These labels enable us to consider the various aspects of what we see. In actuality, such qualities overlap and merge, making it impossible to say where one element ends and another begins. Separating the elements, to present them one at a time, can be misleading. However, we will see that the sequence itself is relevant. The visual elements presented here are: point, line, shape, light, color, texture, mass, space, motion, and time. Later in this chapter we will discuss principles involved in the process of structuring or composing visual elements into significant whole forms.

Point

A *point* or dot is the smallest visual entity. Thus it is a good place to begin to discuss the dynamics of visual form. A visible point is a small attention-gathering element. It can either be presented or implied. It may be a center of

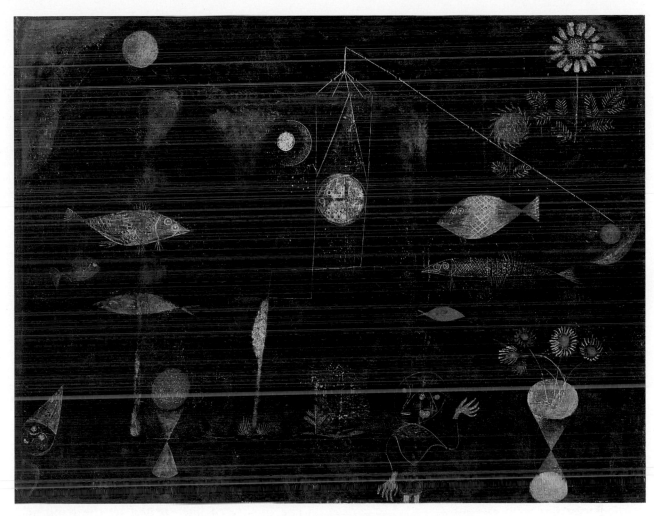

41 Paul Klee.
FISH MAGIC. c. 1925.
Oil on canvas. 30-3/8" x 38-1/2".
Philadelphia Museum of Art.
The Louise and Walter Arensberg Collection.

interest or a point of emphasis within the composition. Even a single dot on a surface is like a sound in an otherwise silent room; it activates the space, creating a relationship with its surroundings.

Paul Klee revealed his sensitivity to the visual dynamics set up by points. In FISH MAGIC, points indicating position are developed as dots and discs of color. They range in size from sprinklings of tiny, almost invisible dots that create texture; to small dots that indicate eyes; to larger dots that symbolize plants, planets, and a clock. The points act as centers of interest, calling our attention to various parts of the image. Lines of force follow the resonating energy connecting these points and forming larger patterns and implied shapes.

Line

Line can be described as the path left by a moving point. It is a visual path of action. A line expresses the energy of the person or thing that made it. A brush stroke thrust across a painting, a river meandering through a landscape, the jagged edge of torn paper, the curve of a blade of grass—each of these lines is as unique as the individually expressive lines each person writes or draws.

Lines may vary in length, width, or direction. They can be continuous or broken, thick or thin, regular or irregular, static or moving, straight or curved, or any combination of these.

42 Saul Steinberg.

On a flat surface lines can act as independent elements, define shapes, imply volumes, or suggest solid mass. Lines can be grouped to make patterns or textures or to portray shadows.

Line is a primary means for defining visual form. It is a kind of shorthand used to describe what is seen, felt, or imagined. Lines are marks with length on a two-dimensional surface, or they are the perceived edges of objects in two- or three-dimensional space. Each line or edge has its own expressive character. These expressions play a major role in visual communication.

Saul Steinberg's highly emotive line is transformed into a regular, geometric line as a result of passing through a mysterious box. The man drawing himself (see page 1) is one of Steinberg's many parodies on drawing. It was created with a delightful economy of line. The artist said, "My line wants to remind constantly that it is made of ink.... The reader, by following my line with his eyes, becomes a draughtsman."[3]

The element of line is basic to most visual communication. Linear *pictographs,* or picture writings, are among the earliest forms of written language (see page 240). *Calligraphy,* the art of fine handwriting or penmanship, has been an important art form for countless generations. The quality of line created by the hand and writing tool working together expresses something of the character and feeling of the person writing, drawing, or painting.

Writing and painting have long been interrelated in China, Korea, and Japan. Similar brushes and brush strokes are employed in both, as seen in Sengai's THE CRAB. The written part reads:

The crab, not moving back and forth between good and evil as humans do, only moves sideways.[4]

Calligraphy brings artistic expression together with handwriting; it therefore conveys both verbal and visual expression. Brush strokes are valued for their spontaneity, grace, and vigor.

Lettering was a highly developed art in Europe before the invention of the printing press. In fact "to take pen in hand" is still an important expressive act even though the ballpoint pen has removed the dimension of thick and thin line variation. Each person's writing has a unique line quality that makes one's signature an important identifying mark.

The line that simply designates the outer edge of an area or shape is called an *outline*. An outline identifies the termination of a shape, or the boundary where one shape leaves off and another begins. In Sengai's brush drawing outlines indicate the edges of the shape of the crab, and also suggest whole leaves. Each of Sengai's brush strokes is read as a line and a shape simultaneously. In ARTIST AND MODEL REFLECTED IN A MIRROR (see page 30) Matisse used line both as outline, which defines shapes, and as contour line, which indicates curving surfaces in space.

A *contour line* is a line used to describe the edge of a three-dimensional object in space. It indicates the last visible point on a surface that bends away from the viewer. Such a bend is, of course, not really a line, but only appears as an edge that may be drawn as a line.

Drawings by Sengai, Matisse, and Otto Dix have very different uses of line. In Matisse's drawing the lines are lyrical, flowing, and restful, while Dix's WOUNDED SOLDIER (see page 432) was drawn with angry, harsh lines.

Repeated lines may be used to create patterns, textures, and shadows (see Michelangelo's drawing on page 128). Contemporary painter Bridget Riley employs rhythmically undulating lines to create the illusion of vibrating folds on a flat surface (see page 408).

43　Sengai.
THE CRAB. c. 1800.
Ink on paper.
129.7 cm x 59.5 cm.
Idemitsu Museum of Arts, Tokyo.

44 Marc Chagall.
I AND THE VILLAGE. 1911.
Oil on canvas. 75⅝" x 59⅝".
The Museum of Modern Art, New York.
Mrs. Simon Guggenheim Fund.

When we talk about lines we are usually referring to visible ones; but there are also invisible or implied lines. *Implied lines* can be felt to connect points of emphasis within a work, often giving overall structure to the design. In I AND THE VILLAGE Marc Chagall used implied lines and dotted lines as important parts of the composition. Our eyes connect the incomplete sections of the circles and fill in the breaks between the dotted lines. Chagall has made it possible for the viewer to become fully involved in the composition of this painting. Without implied lines the painting would not be so interesting.

Shape

Shape refers to that aspect of form seen as a flat, two-dimensional area or plane, as in a silhouette or shadow. Shapes become visible when a line encloses an area or when an apparent change in color or texture sets an area apart from its surroundings.

The infinite variety of shapes can be approached through two general categories, organic and geometric, although there is no clear-cut division between the two. The most common shapes in nature are organic—soft, relaxed, curvilinear, and irregular. The most common shapes in the manmade world are geometric—hard, rigid, regular, and most often (at least in Western cultures) rectangular.

Marc Chagall's I AND THE VILLAGE is a subtle blend of organic and geometric shapes. Chagall has simplified and abstracted the forms of the natural objects he portrays in order to strengthen their visual impact. The major shapes implied in the resulting composition are triangles and circles. The diagram of the design makes this clear. Yet Chagall has softened the geometric severity so that there is a natural visual flow between the various sections of the painting.

The famous Rorschach inkblot test takes advantage of the evocative potential of nonrepresentational shapes in order to stimulate a personal flow of psychologically significant imagery.

The ambiguous *composite shape* or combined shapes of the figure in Jean Arp's DANCER II engages the viewer's imagination as does the inkblot test, yet Arp's beguiling image offers a few clues as to possible subject matter.

45 Hermann Rorschach.
INK BLOT TEST CARD III.

46 Jean Arp.
DANCER II. 1955.
Oil on canvas. 57⁵/₈″ x 42⁷/₈″.
*Museum of Modern Art,
Strasbourg, France.*

47 Paul Gauguin.
PARAU NA TE VARUA INO
(WORDS OF THE DEVIL). 1892.
Oil on canvas. 36⅛" x 27".
National Gallery of Art, Washington, D.C.
Gift of the W. Averell Harriman
Foundation in memory of
Marie N. Harriman (1972).

48 Paul Gauguin.
FATATA TE MITI (BY THE SEA). 1892.
Oil on canvas. 26¾" x 36".
National Gallery of Art, Washington, D.C.
Chester Dale Collection (1962).

Most artists have personal styles that include preferences for certain types of visual form. Paul Gauguin's mature style emphasized flat, curvilinear shapes. He was one of many Europeans influenced by the bold, flat shapes found in Japanese color woodblock prints, which first became important in Europe during the 1860s (see page 256). He evidently liked the unique shape that he used for the tree trunk and massive root in his painting PARAU NA TE VARUA INO (WORDS OF THE DEVIL) because he used it again in FATATA TE MITI (BY THE SEA).

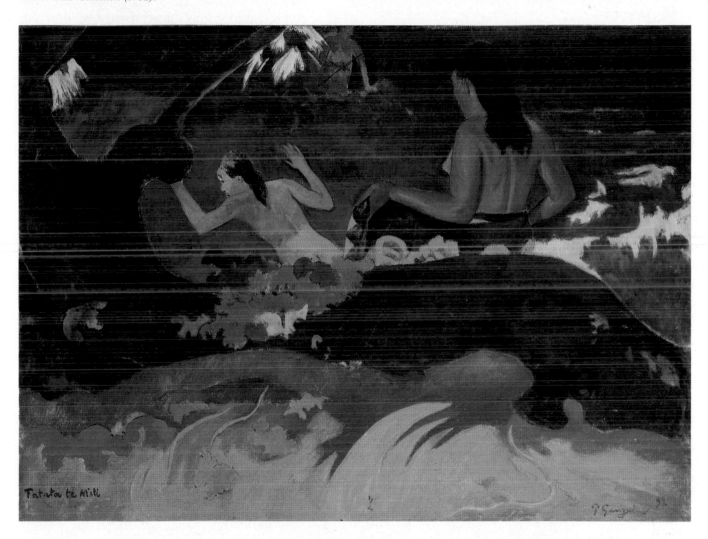

Our discussion of shape in the preceding works has focused on foreground shapes. This is only half the picture, however, because any shape appearing on a *picture plane*—that is, the flat picture surface—simultaneously creates a second shape out of the background area. The first shape, or foreground shape, is called a *positive shape,* and the neutral or passive background is a *negative shape.* The artist must consider both positive and negative shapes simultaneously and as equally important to the total effectiveness of an image. Positive shapes are called *figure* shapes, whether or not they portray human figures or objects. Negative shapes are called *ground* shapes, and are part of the background. Figure shapes create ground shapes. Interactions between figure and ground shapes are discussed as *figure-ground relationships.* Because we are conditioned to see only objects, and not the spaces between and around them, it takes a shift in awareness to see the shapes of spaces.

In THE RETURN OF THE SUN, by Eskimo artist Kenoujuak, the white negative shapes are not recognizable as subject matter, yet they contribute to the vitality of the work as a whole. By

49 Kenoujuak.
THE RETURN OF THE SUN. 1961.
Relief print. 24″ x 36″.
Dorset Fine Arts, Toronto, Canada.

50 M. C. Escher.
SKY AND WATER I. 1938.
Woodcut. 17⅛" x 17¼".
*Vorpal Galleries: San Francisco,
New York, Chicago, and Laguna Beach.*

keeping the white negative and the black positive shapes similar in size and configuration, the artist has achieved a balance and interaction between them. The flat black positive shapes are derived from shadows seen against the snowy white environment. Inspired by the rich mythological tradition of her people, Kenoujuak fills her prints with shapes symbolic of the interacting forces of nature.

While both are important, figure and ground in Kenoujuak's work retain their clear distinction. In contrast, M. C. Escher's woodcut, SKY AND WATER I depends on the interchangeability of figure and ground. With shifts in awareness, these shapes trade places or pop back and forth, a phenomenon appropriately called *figure-ground reversal*. It is not necessary for figure and ground to be as highly elaborate or as structured as they are in Escher's work. An amazing variety of images can evoke the reversal phenomenon.

51 FIGURE-GROUND REVERSAL.

Light and Value

Light is a form of radiant energy. The visual world is revealed by light. Sunlight, which is white light, contains all the colors of light that make up the visible part of the electromagnetic spectrum (see chart, page 64). Light can be reflected, bent, diffracted, or diffused, as well as directed. Various types of artificial light include incandescent, fluorescent, neon, and laser. The source, color, intensity, and direction of light determine the way things appear. Light reveals three-dimensional surfaces. As light changes, things that are illuminated by it appear to change.

A simple change in the direction of light makes a dramatic change in the way we see Daniel Chester French's sculpture of ABRAHAM LINCOLN. When the monumental figure was first installed in the Lincoln Memorial in Washington, D.C., the sculptor was disturbed by the lighting. The entire character of his figure was different from his original conception because the dominant light falling on the figure came at a low angle through the open doorway of the

52 Daniel Chester French.
Detail of ABRAHAM LINCOLN. 1916–1922.
Marble.
Lincoln Memorial, Washington, D.C.

building. This was corrected by placing artificial lights in the ceiling above the statue that were stronger than the natural light coming through the doorway. Light had changed the appearance of the form, and therefore had changed the content expressed by French in the sculpted features of Lincoln.

Light coming from a source directly in front of or behind objects seems to flatten three-dimensional form and emphasize shape. Light from above or from the side, slightly in front, most clearly reveals three-dimensional objects in space as we are accustomed to seeing them.

In art terminology, the word *value* refers to the relative lightness and darkness of surfaces. The amount of light reflected from a surface determines its value. Values range from white through grays to black, and may be seen as a property of color or independent of color. Subtle relationships between light and dark areas determine how things look. Gradual shifts from lighter to darker tones can give the illusion of a curving surface, while an abrupt value change usually indicates an abrupt change in surface direction.

The value scale shows that we perceive *relationships,* not isolated forms. The band is of uniform value, gray, yet appears quite different when the value of its background is changed.

The drawing of light falling on a sphere illustrates how a curved surface is suggested by a value gradation, or gradual shifting from light to dark. The technique that uses gradations of light and shade rather than sharp outlines in pictorial representation is called *chiaroscuro*. This technique, developed in the Renaissance, makes it possible to create the illusion that objects depicted on a flat surface are three-dimensional. Chiaroscuro, originally an Italian word, is now used in English because it clearly describes the interaction of light and shade in two-dimensional art. The derivation of the word gives its meaning: *chiaro* means light or clear, and *oscuro* means dark or obscure.

Pierre-Paul Prud'hon gives the illusion of roundness to his figure in STUDY OF A FEMALE NUDE by using black and white chalk on a

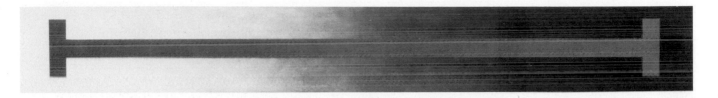

middle-value blue-gray paper. Because the paper is a value halfway between white and black, he is able to let it act as a connective value between the highlights and shadows. If you follow the form of this figure you will see how it appears first as a light area against a dark background (as in the right shoulder) and then as a dark area against a lighter background (as in the under-part of the breast on the same side). The background stays the same, appearing first dark, then light.

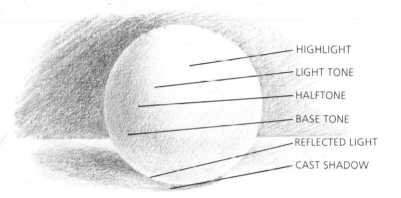

HIGHLIGHT
LIGHT TONE
HALFTONE
BASE TONE
REFLECTED LIGHT
CAST SHADOW

54 VALUE STUDY.
Illusion of light falling on the curving surface of a sphere.

55 Pierre-Paul Prud'hon.
STUDY OF A FEMALE NUDE. c. 1814.
Black and white chalk on blue-gray paper.
28 cm x 22 cm.
Collection of Henry P. McIlhenny, Philadelphia.

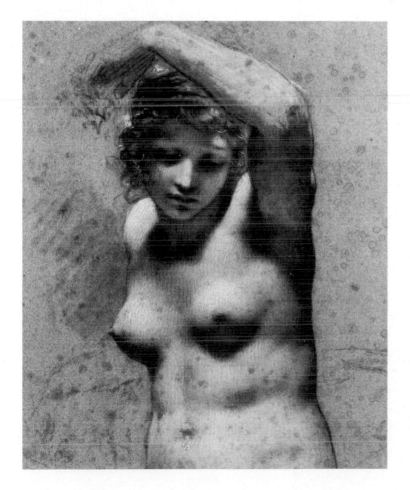

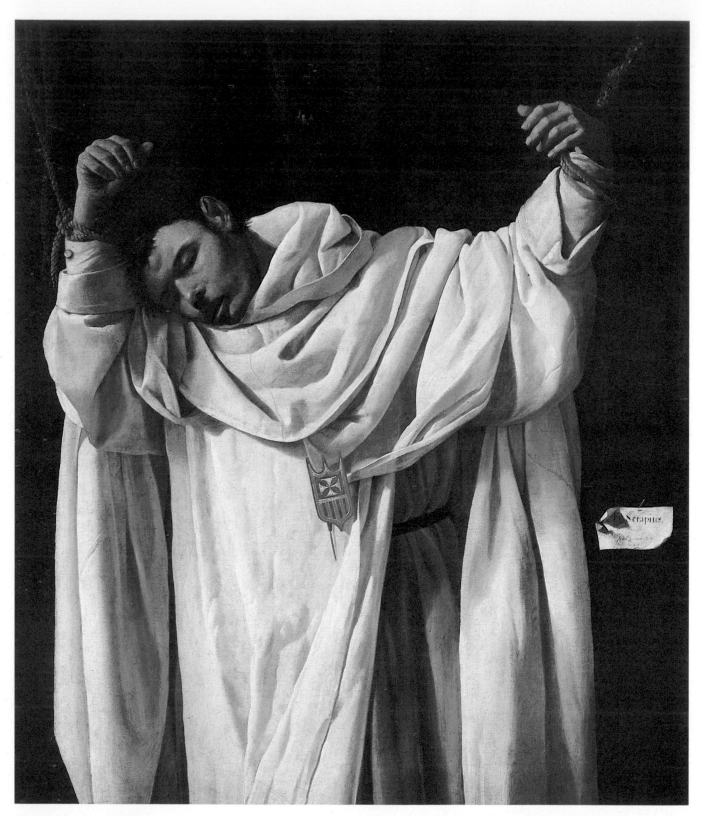

56 Francisco de Zurbarán.
ST. SERAPION. 1628.
Oil on canvas. 47½″ x 40¾″.
Wadsworth Atheneum, Hartford, Connecticut.
1951.40, The Ella Gallup Sumner and
Mary Catlin Sumner Collection.

Look around you and you will see that all objects become visible in this way. Sometimes, as in the area between the shoulder and the breast on this figure, the edge of an object will disappear when its value at that point becomes the same as the value behind it, and the two surfaces merge. Usually we do not see this, however, because our minds fill in the blanks from experience. We *know* the form is continuous, so we perceive it as continuous.

In the "real" world, values are always seen along with other color properties and textures. Works of art in which color is an important element obviously suffer when reproduced only in black and white. Most drawings and many prints are originally black and white. Photography was possible only in brown and white or black and white until 1906, when the first plates sensitive to all the colors of the spectrum were developed. Many photographers now limit their work to black and white by choice because the graphic clarity of black and white fits better with the visual statements they want to make. Black and white photographs are abstractions from the natural world of color. By eliminating the layer of information given by color, photographers can help themselves avoid one of photography's major pitfalls—too much information.

Artists sometimes use value without color in order to concentrate attention on certain content. In Zen Buddhist painting, black ink is traditionally employed on white paper because it is believed that black and white, without the sensuous distraction of color, best express essential truth (see Sengai's THE FIST THAT STRIKES THE MASTER, page 254).

Value alone can clearly express various moods and feelings. When gradations of value are eliminated, images take on a more forceful appearance. If no gray values are present, and black and white areas adjoin one another directly, the strong contrast between light and dark gives impact to the work that may be essential to its content.

Strong value contrast emphasizes the dramatic content of Francisco de Zurbarán's ST. SERA-

PION. In simple compositional terms, the major visual element is a light rectangular shape against a dark background. Light and dark qualities are powerful elements in any design.

Minimal value contrast is seen in Kasimir Malevich's WHITE ON WHITE. The simplicity of this unique painting is enhanced by the closely keyed value relationship of one white square placed on top of another. Malevich's painting calls attention to the visual quality of minimal value contrast, yet color plays a major role in the work. A very different example of minimal value contrast is Richard Anuszkiewicz' INJURED BY GREEN (see page 72). Both paintings have minimum value contrast; one has minimum color contrast and the other has maximum color contrast.

57 Kasimir Malevich.
SUPREMATIST COMPOSITION:
WHITE ON WHITE. 1918 (?).
Oil on canvas. 31¼″ x 31¼″.
The Museum of Modern Art, New York.

If a two-dimensional image with minimal value contrast utilizes light or high values exclusively, it is said to be *high key* in value; if only low values are employed, the work is *low key*. By controlling value ranges the artist creates particular moods within the work that are uniquely different from the more usual mood created by an equal balance of light and dark values. The painting WHITE ON WHITE is a high key composition. The terms high key and low key can also be used to refer to the combined effect achieved by limiting the values of wall and floor covering, furniture, and room illumination in interior design. For example, hospital rooms tend to be high key; bars tend to be low key.

Color, direction, quantity, and intensity of light have a major effect on our moods, our mental ability, and our general well-being. California architect Vincent Palmer has experimented with the effect that changes in the color and intensity of interior light have on people. He has found that he can modify the behavior of his guests by changing the light around them. Light quality affects people's emotions and physical comfort, thus changing the volume and intensity of their conversation and even the length of their visit.

Light has been an important element in art since prehistoric times. Early cave paintings were painted and viewed by flickering torchlight. The sun's changing rays illuminate the stained glass walls of Gothic cathedrals, filling their interiors with colored light. In the twentieth century we have a variety of ways to produce and control light. Some artists even use artificial light as their medium.

Light is a key element in photography, cinematography, television, stage design, architecture, and interior design. As our awareness of potential uses of light has increased, light artists have become more important. At first, lighting designers were primarily technicians or engineers. Now, that is not enough. The light artist utilizes the unique qualities of light and light mixture to produce exciting visual forms.

Thomas Wilfred was one of the first to realize the potential of colored electric light as a legitimate medium for artists. His experiments in 1905 led to the development of the Clavilux Lumia, an instrument that played projected moving light instead of music. Wilfred is noted for separating *kinetic light* compositions from dependence on music or sound. When he played his first public recitals on the instrument in the early 1920s, audiences were thrilled by his unique and beautiful presentations. A single color that covered a large screen would gather itself into a shape, then break into moving patterns of various colors, then merge again. His original compositions, such as LUMIA SUITE, OP. 158, have been recorded and are now projected on a smaller scale by automated light-projecting machines. Wilfred worked out a system for reflecting light from moving mirrors onto a translucent screen. From the front of the screen a continuously changing pattern of colored light appears.

Light used in combination with other media has become of increasing interest to contemporary artists who, working with light engineers, have created new art forms. Light art is often combined with music and dance. Light shows, influenced by Wilfred's early work, were presented with rock and other forms of contemporary popular music beginning in the mid-1960s.

58 Thomas Wilfred.
Two stages of LUMIA SUITE OP. 158. 1963.
Composition of light in form, color, and motion.
Commissioned by the Museum of Modern Art, New York.
Mrs. Simon Guggenheim Fund.

Color

Color affects our emotions directly, modifying our thoughts, moods, actions, and even our health. Some painters of the past found color so dominating that they avoided pure unmixed colors to enable viewers to see the essence of the subject without being distracted. Early in the twentieth century, pure bright colors were used very little in everyday life in the United States. The French Impressionist painters and their followers led the way to the free use of color we enjoy today.

The Hindus, Greeks, Chinese, and certain American Indian tribes are known to have used colors for symbolic purposes. Each culture makes these associations in its own way. The Italian artist Leonardo da Vinci wrote, "We shall set down white for the representative of light, without which no color can be seen; yellow for earth; green for water; blue for air; red for fire; and black for total darkness."[5]

Evidently the human ability to see color continues to expand. Some scholars believe humans have only recently—that is, within the last two thousand years—developed the ability to see hues with the shortest wavelengths, like blue, indigo, and violet. The ancient Greek philosopher Aristotle (384–322 B.C.) named only three colors in the rainbow: red, yellow, and green.

When white light passes through a glass prism it is separated into the bands of color that make up the *visible spectrum*. Because each color has a different wavelength, each travels through the glass of the prism at a different speed. Red, which has the longest wavelength, travels more rapidly through the glass than blue, which has a shorter wavelength. Rainbows result when sunlight is refracted and dispersed by the spherical form of raindrops, producing a combined effect like the glass prism. In both cases the sequence of spectral colors is red, orange, yellow, green, blue, indigo, and violet.

Our common experience with color is pro-

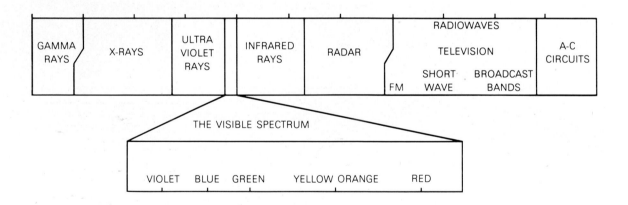

59 ELECTROMAGNETIC SPECTRUM.

vided by reflective surfaces, not by prismatic light. Therefore we shall look at color in terms of reflective surfaces and the changes on these surfaces caused by pigments and the light that illuminates them.

What we call "color" is the effect on our eyes of light waves of differing wavelengths or frequencies. Color is a property of light. The paradox of color is that, while it exists only in light, light itself seems colorless to the human eye. All objects that appear to have color are merely reflectors or transmitters of the color that must be present in the light that illuminates them.

When light illuminates an object, some of the light is absorbed by the surface of the object and some is reflected or transmitted. The color that appears to our eyes as the apparent color of the object (called *object color* or *local color*) is determined by the wavelength or frequency of light being reflected. Thus a red surface in white light appears red because it reflects mostly red light and absorbs the rest of the spectrum. A green surface absorbs most of the spectrum except green, which it reflects, and so on with all the hues of the spectrum.

If all the wavelengths of light are absorbed by an opaque object, the object appears black; if all the wavelengths are reflected, the object appears white. Completely transparent objects appear to be the color of the wavelength of light they transmit. Black and white are not true colors. A black space is a space without light. A black surface absorbs most, if not all of the light that falls on it; a white surface reflects most of the light falling on it. White, black, and their combination, gray, are *achromatic*, or *neutral*—without the property of hue.

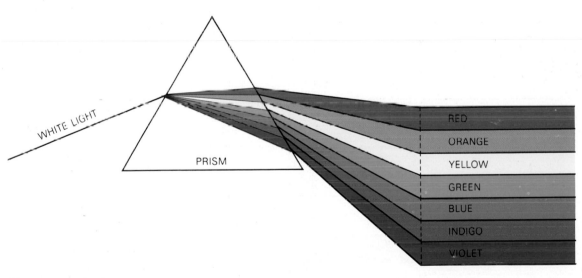

RED
ORANGE
YELLOW
GREEN
BLUE
INDIGO
VIOLET

WHITE LIGHT

PRISM

60 WHITE LIGHT REFRACTED BY A PRISM.

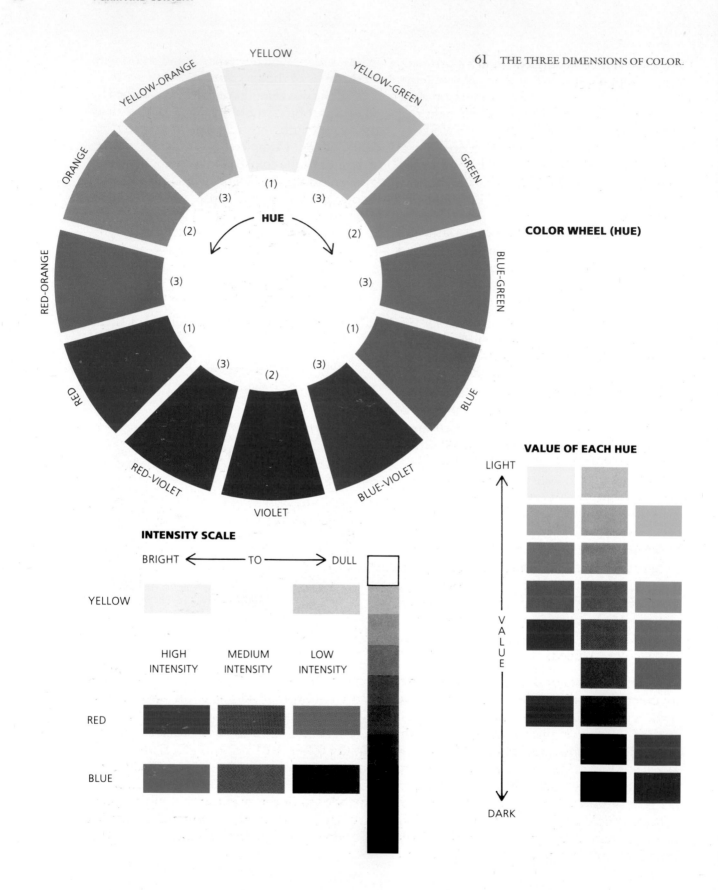

YELLOW

YELLOW-ORANGE

YELLOW-GREEN

ORANGE

GREEN

RED-ORANGE

BLUE-GREEN

RED

BLUE

RED-VIOLET

BLUE-VIOLET

VIOLET

(1) (3) (3) (1)
(3) (3)
(2) (2)
HUE
(3) (3)
(1) (1)
(3) (3)
(2)

COLOR WHEEL (HUE)

VALUE OF EACH HUE

LIGHT

VALUE

DARK

INTENSITY SCALE

BRIGHT ←——— TO ———→ DULL

YELLOW

HIGH INTENSITY

MEDIUM INTENSITY

LOW INTENSITY

RED

BLUE

Color has three major dimensions: hue, value, and intensity.

☐ *Hue*: the particular wavelength of spectrum color to which we give a name (see the prism diagram, page 65). Hue is what we commonly call color. Spectrum-intensity red is spoken of as the hue red, as distinguished from the hue orange, its neighbor on the spectrum, and so forth.

☐ *Value*: the relative lightness or darkness of a color (see the value scale, page 59). Black and white pigments can be important ingredients in changing color values. Black added to a hue produces *shades* of that hue. For example, when black is added to orange, the result is a brown; and when black is mixed with yellow the resulting dark yellow has a greenish cast due to the imperfect nature of pigment blacks. White added to a hue produces a *tint*. Lavender is a tint of violet. Pink is a tint of red.

Hues in their purest form are also at their normal value. For example, the value of pure yellow is much lighter than the value of pure violet. Pure yellow is the lightest of hues and violet is the darkest. Red and green are middle value hues.

☐ *Intensity* (also called *saturation* and *chroma*): the purity of a hue, or color. A pure hue is the most intense form of a given color; it is the hue at its highest saturation, in its brightest form. If white, black, gray, or another hue is added to a pure hue, intensity diminishes and the color is dulled.

62 PIGMENT PRIMARIES: SUBTRACTIVE COLOR MIXTURE.

63 LIGHT PRIMARIES: ADDITIVE COLOR MIXTURE.

When pigments of different hues are mixed together, the mixture appears duller and darker because pigments absorb more and more light as their absorptive qualities combine. For this reason pigment mixture is called *subtractive color mixture*. Mixing red, blue, and yellow will produce a dark gray, almost black, depending on the proportions and the type of pigment used.

Most people are familiar with the three pigment primaries: red, yellow, and blue. There are also three light primaries: red, green, and blue or blue-violet. When the three light primaries are combined, the result is white light. Such a mixture is called *additive color mixture*. Combinations of these light primaries produce lighter colors. Red and green light when mixed make yellow light, and so forth. Color television employs additive color mixture. A working knowledge of the character and mixing properties of light colors is essential to anyone working with light as an art form.

Several major pigment color systems are in use today, each with its own basic hues. The *color wheel* is one of several contemporary versions of the circle concept first developed by Sir Isaac Newton. After Newton discovered the spectrum, he found that both ends could be combined into the hue red-violet, making the color wheel possible. Numerous color systems have followed since that time. The color system presented here is based on twelve pure hues.

The color wheel is divided into:

☐ *Primaries:* red, yellow, and blue. These are the pigment hues that cannot be produced by an intermixing of other hues. They are also referred to as primary colors (see 1 on the color wheel on page 66).

☐ *Secondaries:* orange, green, and violet. The mixture of two primaries produces a secondary hue. Secondaries are midway between the two primaries of which they are composed (see 2 on the color wheel). When we mix them ourselves, the secondaries do not have the pure brilliance of oranges, greens, and violets manufactured to achieve those pure hues.

☐ *Intermediates:* red-orange, yellow-orange, yellow-green, blue-green, blue-violet, and red-violet. Their names indicate their components. Intermediates are located between the primaries and the secondaries of which they are composed (see 3 on the color wheel).

The blue-green side of the wheel is called *cool* in visual temperature, and the red-orange side is called *warm.* Yellow-green and red-violet are the poles dividing the color wheel into warm and cool hues. The difference between warm and cool colors is partly due to association. Relative warm and cool qualities can be seen in any combination of hues. A room painted a warm color becomes warm psychologically. Color affects our feelings about size as well as temperature. Cool colors appear to recede and warm colors appear to advance.

Malevich's WHITE ON WHITE (see page 61) is based on a subtle warm/cool difference. The diagonally placed square is painted a cool blue-white, which sets it apart from the warm yellow-white background.

Color sensations more vibrant than those achieved with actual pigment mixture are obtained when dots of pure color are placed together so that they blend in the eye, creating the appearance of other hues. This is called *optical color mixture.* For example, rich greens appear when many tiny dots or strokes of yellow-green and blue-green are placed close together.

This concept was developed in the 1880s by painter Georges Seurat as a result of his studies of Impressionist painting and scientific theories of light and color. His method, divisionism, popularly called *pointillism,* is related to the development of modern four-color printing in which tiny dots of printers' primaries—magenta (a red), yellow, and cyan (turquoise blue)—are printed together in various amounts with black on white paper to achieve the effect of full color. Seurat, however, used no black. Compare the detail of Seurat's SUNDAY AFTERNOON ON THE ISLAND OF LA GRANDE JATTE with the color separations and the enlarged detail of the reproduction of Botticelli's BIRTH OF VENUS (see the complete paintings on pages 332 and 300).

a Yellow.

b Magenta.

c Yellow and magenta.

d Cyan.

e Yellow, magenta, and cyan.

f Black.

g Yellow, magenta, cyan, and black.

h Color printing detail showing mechanical
dot pattern of offset photo-lithography.

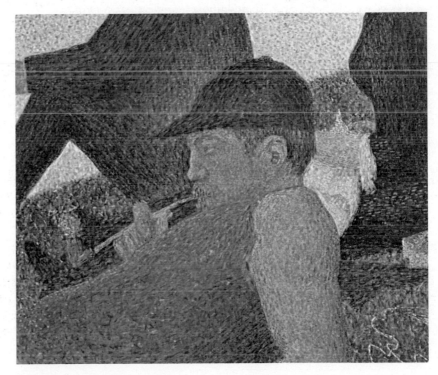

65 OPTICAL COLOR MIXTURE.
Detail showing divisionist technique developed by Seurat.
(See complete painting on page 332.)

Color groupings that provide certain kinds of color harmonies are called *color schemes*. The most common of these are:

☐ *Monochromatic:* variations on one hue only. In this color scheme a pure hue is used alone with black and/or white or mixed with black and/or white. The hue can be combined with varying amounts of white (tints) or varying amounts of black (shades). The result is a monochromatic scheme based on that hue. For example, a scheme based on red (pure hue) with pink (tint of red) and maroon (shade of red) would be called monochromatic. Victor Vasarely's untitled screen print (see page 150) is a monochromatic work that employs a pure blue and its tints and shades.

☐ *Analogous:* hues adjacent to one another on the color wheel, each containing the same hue—for example, yellow-green, green, and blue-green, which all contain the hue green. Analogous color is used in Ben Cunningham's CORNER PAINTING (see page 407). Tints and shades of each analogous hue may be used to add variations to this color scheme.

☐ *Complementary:* two hues directly opposite one another on the color wheel. When mixed together in almost equal amounts, complementary hues form neutrals or grays; but when placed side by side as pure hues, they contrast strongly, and intensify each other. Because they can be identical in value, the complementary hues red-orange and blue-green tend to "vibrate" more when placed next to each other than do other complements. The complements yellow and violet provide the strongest value contrasts possible with pure hues. The complement of a primary is the opposite secondary, which can be obtained by mixing the other two primaries. For example, the complement of yellow is violet. The complementary hues blue-green and red-orange are used in the child's painting TREE, on page 24.

☐ *Polychromatic:* use of many hues and their variations. When painters choose their palettes, they visualize color combinations in terms of their familiarity with certain available pigment colors. Most artists work intuitively when determining color choices for a particular composition.

An *afterimage* appears to the eye when prolonged exposure to a visual form causes excitation and subsequent fatigue of the retina. Color afterimages are caused by partial color blindness temporarily induced in the normal eye by desensitizing some of its color receptors. For example, staring at a red spot for thirty seconds under a bright white light will tire the red receptors in that segment of the retina on which the red spot is focused and make them less sensitive to red light, or partially red-blind. Thus, when the red spot is removed, a blue-green spot appears to the eye on the white surface because the tired red receptors react weakly to the red light reflected by that area of the surface. The blue and green receptors, meanwhile, respond strongly to the reflected blue and green light, producing an apparent blue-green dot that is not actually present on the surface. On a neutral surface, therefore, the hue of the afterimage is complementary to the hue of the image or stimulus.

A more complex example of this phenomenon can be experienced by staring for about thirty seconds at the white dot in the center of the flag at the top of Jasper Johns's painting FLAGS, then looking down at the black dot in the gray flag below.

The appearance of a given color in objects around us is always relative to adjacent colors and light conditions. A hue can appear to change as colors around it change. In INJURED BY GREEN (page 72), Richard Anuszkiewicz painted a uniform pattern of dots in two sizes. Behind these, the red-orange background appears to change, but it is the same hue throughout.

66 Jasper Johns.
FLAGS. 1965.
Oil on canvas with raised canvas.
72" x 48".
Private collection.

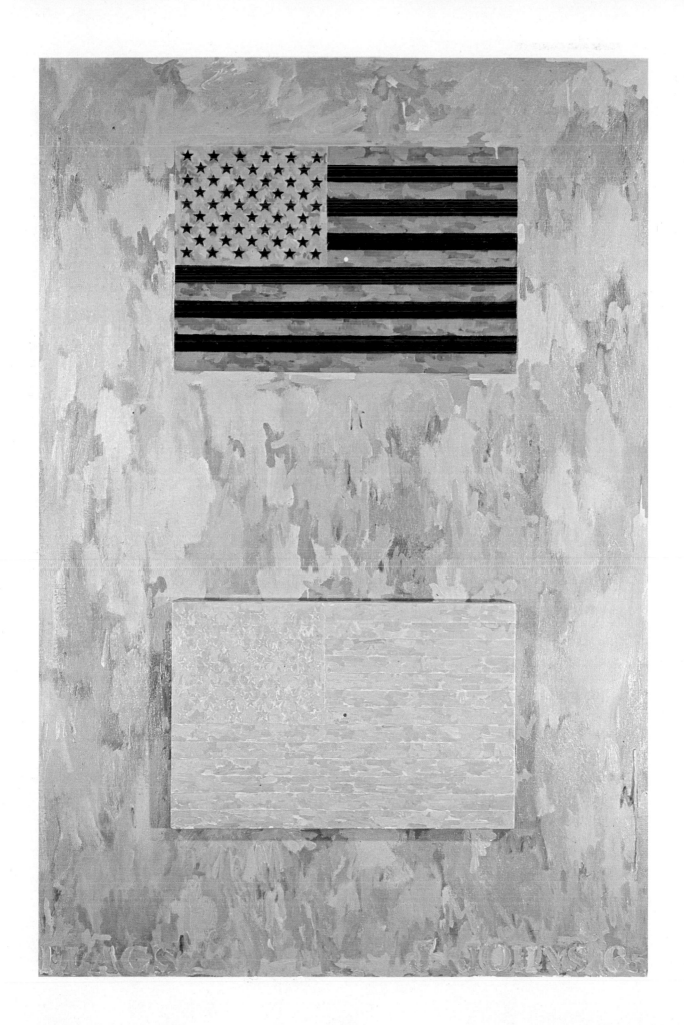

67 Richard Anuszkiewicz.
INJURED BY GREEN. 1963.
Acrylic on board. 36″ x 36″.
Collection of Janet S. Fleisher,
Philadelphia.

Intensity builds from the outer edges of the painting toward the center, where we are "injured"—or temporarily color-blinded—by a diamond-shaped area containing yellow-green dots of the same value as the red background, which are surrounded by a square of blue-green dots. These two hues are on either side of green on the color wheel—and green is the complement of red. The yellow-green and blue-green form the split complements of red. Anuszkiewicz used split complements of matching value to give this central area its pulsing energy.

My work is of an experimental nature and has centered on an investigation into the effects of *complementary colors of full intensity when juxtaposed and the optical changes that occur as a result.*

Anuszkiewicz[6]

Surface color is modified by its association with surrounding colors and by such factors as intensity, angle, and warm or cool properties of the light. As light decreases, individual colors become less distinct. In bright light, colors reflect on one another, causing changes in the appearance of local color. In his painting THE BREAKFAST ROOM Pierre Bonnard emphasized these shifts in local color and added many personal poetic color relationships of his own invention.

68 Pierre Bonnard.
THE BREAKFAST ROOM. c. 1930–1931.
Oil on canvas. 62⅞″ x 44⅞″.
The Museum of Modern Art, New York.
Anonymous gift.

Color is central to Bonnard's art. He began with a somewhat ordinary scene and intensified its effect on us by concentrating on the magical qualities of light and color on a sunny day. The painting portrays Bonnard's feelings about the mood of that day, using color that could not have been recorded with a camera.

Bonnard's color is the result of a personal search. During the 1890s he worked with subdued color. About 1900 he began to use brighter colors in what he described as a personal version of Impressionism. As his color sense matured, his paintings became filled with rich harmonies of warm and cool colors, subtly played off against each other. In these paintings the surfaces seem to shimmer with a light of their own.

69 Meret Oppenheim.
OBJECT. 1936.
Fur-covered cup, saucer, and spoon.
Cup, diameter 4⅜″;
saucer, diameter 9⅜″;
spoon, length 8″.
The Museum of Modern Art, New York.
Purchase.

Texture

Texture refers to the tactile qualities of surfaces, or to the visual representation of such surface qualities. Texture may be experienced by touching, or through suggestion by sight alone. All surfaces have texture. Sculptors and architects, who work with three-dimensional materials, work with the inherent textures of their materials and can also create textures by the way they develop surfaces. Printmakers, painters, and other artists working on flat surfaces use the textures of their materials and may also simulate or visually suggest textures that cannot be experienced through touch. Such textures can be referred to as *visual, simulated,* or *implied.* Sometimes actual (tactile) and implied (visual) textures are combined in a single work of art.

The notorious fur-lined teacup was constructed in 1935 by Meret Oppenheim. She presented an intentionally contradictory object designed to evoke strong responses ranging from revulsion to amusement. The actual texture of fur is pleasant, as is the smooth texture of a teacup, but the combination makes the tongue "crawl." Social and psychological implications are abundant and intended.

Used expressively, texture adds an important dimension to our sensory experience. Compare the eroding surfaces of Alberto Giacometti's figure on page 77 with the youthful skinlike textures of the figures in Rodin's THE KISS (see page 42), which in itself has strong textural contrast. Each artist used texture to heighten emotional impact.

In Le Corbusier's chapel at Ronchamp, NOTRE-DAME-DU-HAUT, rough and smooth concrete and wooden furnishings are contrasted to produce textural variations (see page 388). In contrast, buildings like Lever House

70 Rembrandt van Rijn.
HEAD OF SAINT MATTHEW. c. 1661.
Oil on wood. 9⅞" x 7¾".
National Gallery of Art, Washington, D.C.
Widener Collection (1942).

71 Hans Holbein.
SIR THOMAS MORE. 1527.
Oil on wood. 29½" x 23¾".
Ⓒ *The Frick Collection, New York.*

(see page 387) offer a subtle interplay of smooth textures of glass and metal, producing crisp, hard surfaces.

A painting may have a rich tactile surface as well as implied or simulated texture, as in Rembrandt van Rijn's HEAD OF SAINT MATTHEW. Rembrandt applied oil paint in thick strokes, creating both actual and implied texture. There is only a hint here of the textural difference between skin and hair, but there is a great deal of feeling demonstrated for the tactile possibilities of paint. When paint the consistency of thick paste is applied directly to a surface, as Rembrandt did in this painting, it is called *impasto*. In THE GOLDEN WALL, Hans Hof-

mann built up a thick impasto to create actual texture (see page 138).

Textures, such as the softness of fur and velvet, are implied with paint in Hans Holbein's portrait of SIR THOMAS MORE. Holbein rendered the variety of textures with great care. Notice how carefully he portrayed the textures of the face alone.

72 QENNEFER, STEWARD OF THE PALACE. c. 1450 B.C.
Black granite. Height 2′9″.
British Museum, London.

Mass

A two-dimensional area is referred to as a shape; a three-dimensional area is a *mass*. The word mass here refers to the physical bulk of a solid body of material. Actual mass is a major element in sculpture; in painting, mass is implied. Like other visual elements, mass is an aspect of total form, not a separate entity. The term mass may also be used when referring to solid or flat areas that take on visual weight because they contrast with the backgound on which they are placed. Actual mass and space are, of course, inseparable, since three-dimensional objects always exist within space.

The following contrasting pieces of sculpture demonstrate the expressive possibilities of actual mass in three-dimensional works.

One of the dominant characteristics of ancient Egyptian architecture and sculpture was its massiveness. Egyptians sought this quality and perfected it because it fit their desire to make their works last forever.

The figure of QENNEFER, STEWARD OF THE PALACE, carved from hard black granite, retains the cubic, blocklike appearance of the quarried stone. None of the limbs project out into the surrounding space. The figure is shown in a sitting position, knees drawn up, arms folded, the neck reinforced by a ceremonial headdress. The body is abstracted and implied with minimal suggestion. This piece is a prime example of *closed form,* which exists in space, but does not interact with it. It is a solid, massive sculpture, and a strong symbol of permanence. A common function of Egyptian portrait sculpture such as this was to act as a symbolic container for the soul of some important person, to give eternal life.

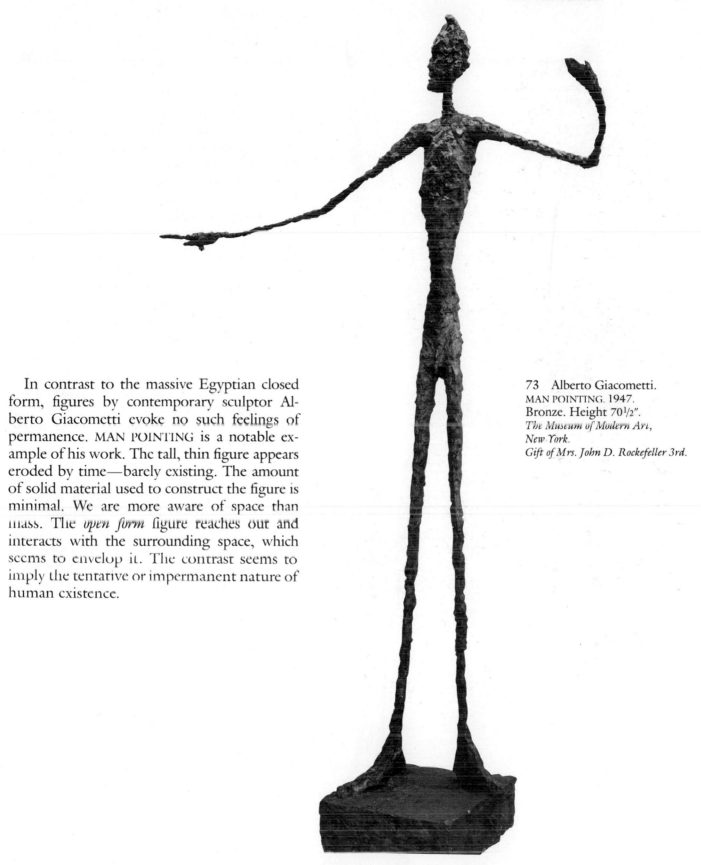

In contrast to the massive Egyptian closed form, figures by contemporary sculptor Alberto Giacometti evoke no such feelings of permanence. MAN POINTING is a notable example of his work. The tall, thin figure appears eroded by time—barely existing. The amount of solid material used to construct the figure is minimal. We are more aware of space than mass. The *open form* figure reaches out and interacts with the surrounding space, which seems to envelop it. The contrast seems to imply the tentative or impermanent nature of human existence.

73 Alberto Giacometti.
MAN POINTING. 1947.
Bronze. Height 70½".
The Museum of Modern Art, New York.
Gift of Mrs. John D. Rockefeller 3rd.

74 Constantin Brancusi.
BIRD IN SPACE. 1928 (?).
Bronze (unique cast).
Height 54".
The Museum of Modern Art, New York.
Anonymous gift.

Another kind of experience is presented in Constantin Brancusi's BIRD IN SPACE. Here mass is drawn out in a dramatic thrust into space. The "bird" embodies the essence of an idea about flight as a particular kind of movement through space. Brancusi started working on this concept about a decade after the Wright brothers' triumph initiated the age of flight and long before the world was filled with streamlined aircraft and cars.

Henry Moore's RECUMBENT FIGURE is massive in quite a different way from Egyptian solidity and seems to have nothing in common with Giacometti's work. Moore's abstract figure refers to the windworn stone and bone forms that impressed him in his youth. Moore made his figure compact in its mass and at the same time opened up holes in the figure that allow space to flow through as well as around the mass. An interactive relationship between mass and space was thus created.

Compare the sturdy sculptural quality of Paula Modersohn-Becker's MOTHER AND CHILD with the actual three-dimensional form of Henry Moore's RECUMBENT FIGURE. Modersohn-Becker's figures appear solid because of the way she used gradual shifts from light to dark, giving the appearance of light from above falling on curving surfaces. The texture of the thick paint emphasizes the solid qualities of the figures.

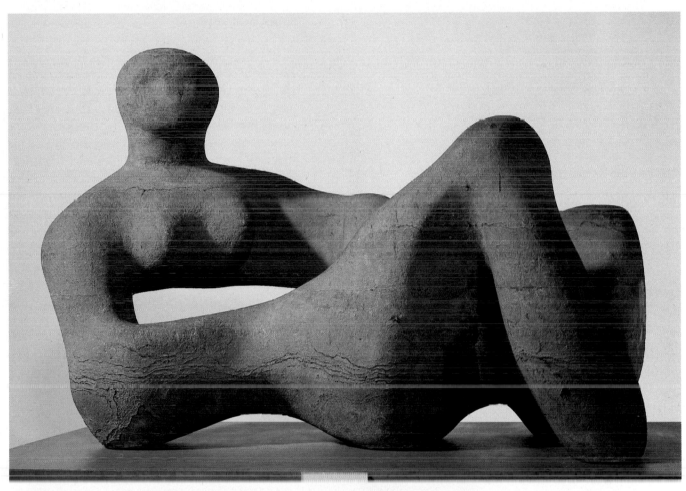

75 Henry Moore.
RECUMBENT FIGURE. 1938.
Green hornton stone. Length 54″.
The Tate Gallery, London.

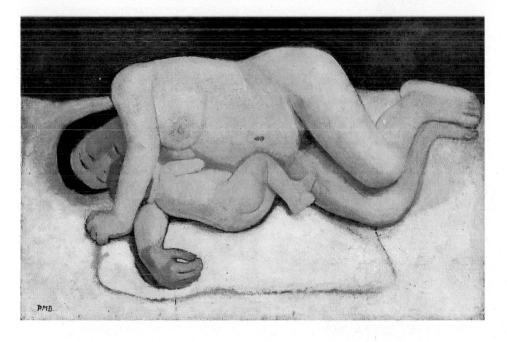

76 Paula Modersohn-Becker.
MOTHER AND CHILD. 1907.
Oil on canvas. 18 cm x 24 cm.
Private collection, Bremen.

77 Pablo Picasso.
YOUNG MAN'S HEAD. 1923.
Grease crayon. 24³/4" x 19".
The Brooklyn Museum, New York.

The drawing titled YOUNG MAN'S HEAD by Pablo Picasso shows a use of lines that seem to turn around in space, implying a solid mass. The edge is drawn with light, broken lines to imply that the form is continuous in space. The drawing gives the appearance of mass because the lines act to define the surface directions and build up areas of light and shade. Picasso's control over the direction and grouping of his lines makes it seem as if we are seeing a fully rounded head. Yet the vigor of Picasso's lines shows clearly that the work is a drawing on a flat surface before it is anything else.

Space and Volume

The concept of *space* is important not only in art, but in our daily lives. For example, we each have a sense of personal space—that area surrounding our bodies, which others may not enter unless invited. The dimensions of this space do not extend equally in all directions. Strangers are tolerated more closely at our sides than directly in front of us. The distances of these invisible boundaries vary from person to person and from culture to culture.

Our personal space, or "breathing room," is violated in such places as crowded buses and elevators. In these situations we attempt psychologically to keep our distance by escaping with our eyes, looking out the windows of the bus or at the changing numbers above the door in the elevator. It is useful to develop an understanding of how we use our sense of personal space in expressive ways, and how in turn we are affected by the spatial qualities of our surroundings. A timid drawing in the corner of a piece of paper and a timid person standing in the corner of a large room are expressing similar feelings.

The visual arts are sometimes referred to as *spatial* arts because visual form is organized in space. Music is a *temporal* art because musical elements are organized in time. Film and television organize form in both time and space. Space is the indefinable, great, general receptacle of things. It is continuous and infinite and ever present. It cannot exist by itself because it is part of everything.

In Eero Saarinen's TWA TERMINAL mass encloses volume in such a way that people moving through the terminal are involved in dramatically flowing horizontal space. Four huge shells of reinforced concrete make up the basic structure of this highly sculptural building. Two of these shells stretch out like the wings of a bird. Space moves in, around, and through the structure, uniting interior and exterior in a continuous flow of undulating rhythms.

Saarinen made the exterior of the building a symbol of the excitement of air travel. In the interior he carried through this idea with emphasis on expressing as well as facilitating the constant flow of people. For Saarinen, architectural form was meant to lift the spirits as well as accommodate utilitarian functions.

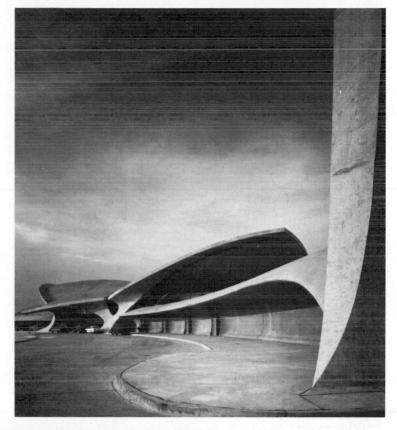

78 Eero Saarinen.
TWA TERMINAL. 1956–1962.
Kennedy Airport, New York.
Photographs: Ezra Stoller / © ESTO.
a Exterior.
b Interior.

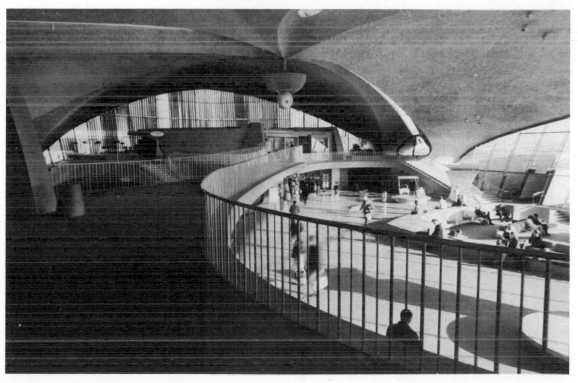

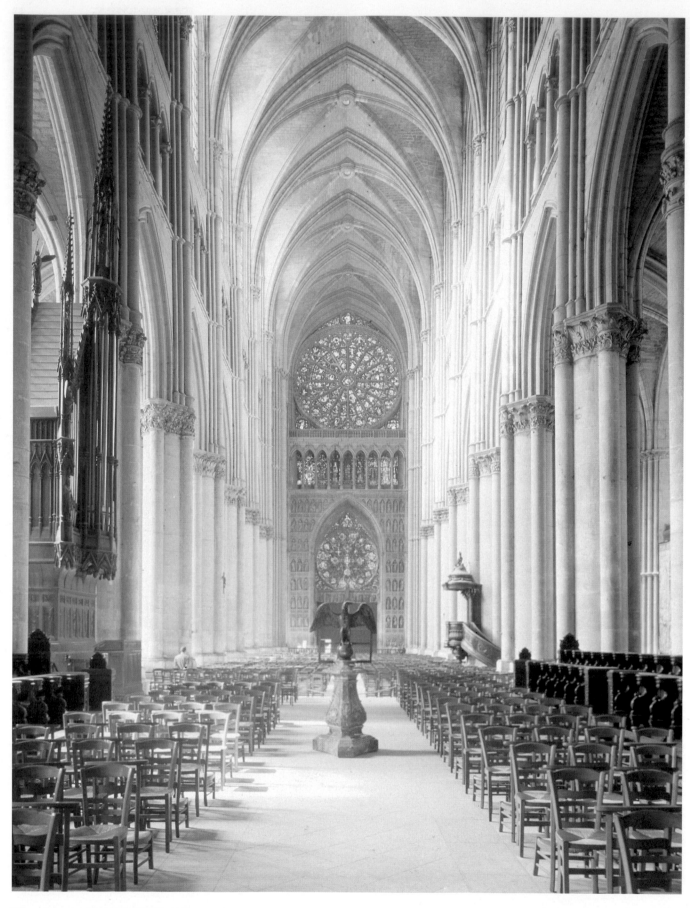

79 REIMS CATHEDRAL. 1225–1229.
Arcades and vaults of Nave.
Reims, France.

Space enclosed by mass is called *volume*. The huge interior spaces created by Gothic builders are some of the most impressive in the history of architecture. Volume is a major expressive element in the Gothic REIMS CATHEDRAL. The vast vertical space dwarfs human scale, intensifying the difference between the infinite nature of God (or Heaven) and the finite quality of man. Art and engineering merge in this and similar structures. This is ritual architecture— architecture in which the emphasis in the design is on celebrating an idea rather than simply enclosing a function.

In Japan, space is dealt with on a different scale. On the edge of the city of Kyoto there is a small garden within a garden that is part of Ryōan-ji Temple. In this famous garden, there are no plants—vegetation is all around, but it is separated from the garden by a low wall.

RYŌAN-JI GARDEN is a flat, rectangular area of raked gravel punctuated by five groups of rocks. It is not possible to see all the rocks at once from any viewing position. In this way the garden illustrates the Zen concept of incompleteness or potentiality. The garden is mostly empty space—a void.

RYŌAN-JI GARDEN is a place for quiet meditation. Its quality of "no-thing-ness" promotes inner reflection, and is designed to foster spiritual enlightenment. The apparent emptiness of the garden is intended to induce an egoless state in which the outer world of form and the inner world of formless intuition are recognized as one.

80 RYŌAN-JI GARDEN. c. 1490. *Kyoto, Japan.*

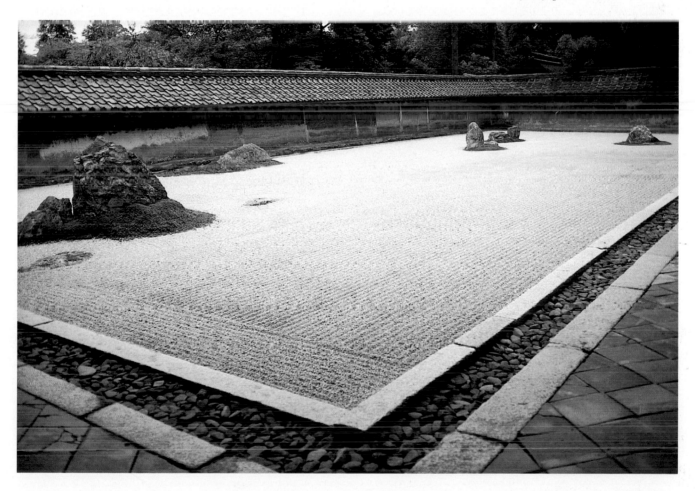

81 Mu Ch'i.
SIX PERSIMMONS. c. 1269.
Ink on paper. 17⁵/₁₆″ x 14¹/₄″.
Ryoko-in, Daitoku-ji, Kyoto, Japan.

82a OVERLAP.

b OVERLAP AND DIMINISHING SIZE.

The usual surfaces for drawings, prints, photographs, and paintings are flat or two-dimensional. Artists working on a *picture plane* are dealing with actual space in two directions or dimensions; across the surface up and down (height), and across the surface side to side (width). Yet almost any mark or shape on a picture plane begins to give the illusion of depth or the third dimension.

For centuries, Asian painters have handled relatively flat or shallow pictorial space in very sophisticated ways. Mu Ch'i's SIX PERSIMMONS, like RYŌAN-JI GARDEN, embodies and communicates many qualities, such as intuitive spontaneity and the brusque and enigmatic simplicity that are central to Zen Buddhism.

The persimmons appear against a pale background that works both as flat surface and infinite space. The painted shapes of the fruit punctuate the open space of the ground or picture surface and remind us of the well-placed rocks in the garden at Ryōan-ji.

Imagine what would happen to this painting if some of the space at the top were cut off. Space is far more than just what is left over after the important images have been placed. It is an integral part of total visual form.

Some depth is indicated by Mu Ch'i. When shapes overlap, we immediately assume from experience that one is in front of the other. This is the most basic way to achieve the effect of depth on a flat surface.

In the first diagram the spatial effect of overlap is shown. In the second this effect is reinforced by diminishing sizes, which give a sense of greater intervening distance between the shapes.

Another method of achieving the illusion of depth is with position. When elements are placed low on the picture plane, they appear to be closer to the viewer. This is how we see most things in actual space.

Paintings from ancient Egypt show little or no depth. Painters of that culture made their images clear by portraying objects from their most clearly identifiable or characteristic angle

83 A POND IN A GARDEN. c. 1400 B.C.
Fragment of a wall painting from a tomb in Thebes.
British Museum, London.

and by avoiding the visual confusion caused by overlap and the appearance of diminishing size. Objects are shown with their most characteristic shapes at right angles to the viewer's line of vision. Thus, in A POND IN A GARDEN, the pond, viewed from overhead, is seen as a rectangle, while the trees, fish, and birds are all pictured in profile (or side view). The Egyptians felt no need for a single point of view or vantage point.

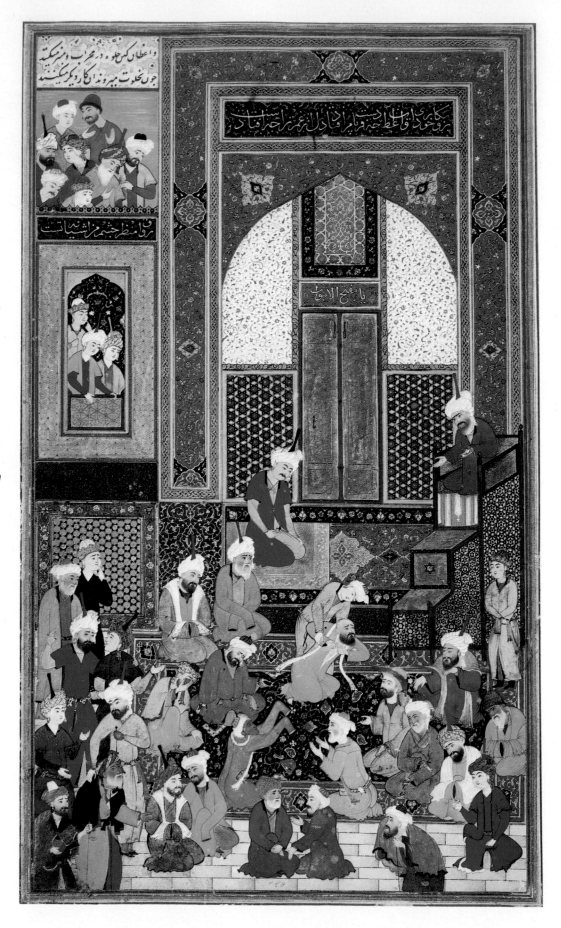

84 Shaykh Zadeh.
INCIDENT IN A MOSQUE.
c. 1527.
Persian miniature
painting,
opaque watercolor
on paper.
28.9 cm x 17.8 cm.
Private collection.

Shaykh Zadeh, a Persian painter who created the miniature painting INCIDENT IN A MOSQUE, was also interested in showing all the significant details of his subject without confusing things with illusions of deep space. Each figure and architectural form is presented from the angle that shows it best. The result is an intricate organization of flat planes knit together in shallow, implied space.

Islamic painters have typically shown human activity going on both inside and outside architectural spaces in order to clarify important aspects of the story being depicted. In this painting we see people looking through a window, and others looking over a wall, as well as people inside the mosque. The floor, with its tile pattern and richly decorated carpets, is seen as if from above. Figures are shown from the side, carefully placed against a pattern of rectangles. The floor is seen as an extension of the inlaid tile and painted decorations on the wall. There is no diminishing size in the figures or in the steps to the raised chair to indicate distance from the viewer. Depth is shown by overlap and position, with those figures farthest from us

placed highest in the composition. The painting has its own spatial logic consistent with the Persian style. Persian perspective emphasizes narrative clarity and richness of surface design.

Medieval pictorial space was symbolic and decorative, not intended to be logical or look "real." Looking closely at Angelo Puccinelli's painting of TOBIT BLESSING HIS SON, can you tell whether the angel is behind or in front of the son? It does not really matter, of course; angels do not live in logical, earthly space.

In general usage, the word "perspective" is used to refer to point of view. In the visual arts *perspective* refers to any method of representing the appearance of three-dimensional objects in space on a two-dimensional surface. It is correct to speak of the perspective of Persian miniatures, Japanese prints, Chinese Sung Dynasty paintings, or Egyptian paintings, although none of these styles uses a system that is in any way similar to the linear perspective system of the Italian Renaissance. It is a difference in intention rather than skill that results in various methods for depicting depth.

85 Angelo Puccinelli.
TOBIT BLESSING HIS SON.
c. 1350–1399.
Tempera on wood.
14⅞" x 17⅛".
*Philbrook Art Center,
Tulsa, Oklahoma.
Samuel H. Kress Collection.*

Linear perspective is a geometric system based on what one eye sees at one moment in time, fixed at one position in space. The position in space is determined by the location of the artist—and thus the viewer—and is called the *vantage point,* a term that relates to point of view. Linear perspective is based on the observation that parallel lines appear to converge toward a common point—the *vanishing point*—and that objects appear to grow smaller as they recede into the distance.

The concept of linear perspective was used to some extent by the ancient Romans more than 1000 years before it was perfected as a system by Italian artists of the fifteenth century. Architects and painters of the Renaissance developed linear perspective as a method for achieving the illusion of actual three-dimensional space on a flat surface. Linear perspective is based on the idea of visualizing a picture's surface as if it were a window between the viewer and the subject. Artists of the Renaissance established the idea of a painting as a window onto nature.

86 Jacopo Bellini.
ANNUNCIATION. c. 1440.
Drawing.
The Louvre, Paris.

A preliminary drawing for Jacopo Bellini's fifteenth-century painting ANNUNCIATION is based on one-point perspective. The subject (the Annunciation) is almost lost in this very detailed drawing of imagined Renaissance architecture. Bellini was obviously more concerned with the newly developed concept of linear perspective than he was with the traditional subject matter.

Recognition of eye level is basic to the ability to see and draw objects and spaces in terms of linear perspective. *Eye level* is the height of the viewer's eyes above the ground plane. If you look at furniture in a room while lying on the floor on your stomach, you will see the bottom sides of chairs and tables. You then have a very low eye level—a "worm's eye view" of the room. If you sit on the floor, then on a chair, and then stand, your eye level rises accordingly. Sitting on the floor you will probably see the tops of chair seats and may notice that a table top is right at your eye level so that you see only an edge. When you sit on a chair you see the top of the table, but its shape may be difficult to distinguish. When you stand, the table top is far below your eye level. Now it appears more rectangular than it did when you were sitting on the chair. You can get a "bird's eye view" of the room and its furnishings by climbing to the top of a stepladder.

Eye level extends as an imaginary plane parallel with the ground plane to the *horizon line,* where the two planes appear to converge. When actual distance is implied on the two-dimensional picture plane, the artist's (and therefore the viewer's) eye level is equivalent to the horizon line.

The height of the horizon line in relation to other objects is determined by the eye level of the artist. Although the horizon is frequently blocked from view, it is necessary to establish the combined eye level–horizon line in order to construct images using linear perspective.

87 LINEAR PERSPECTIVE.

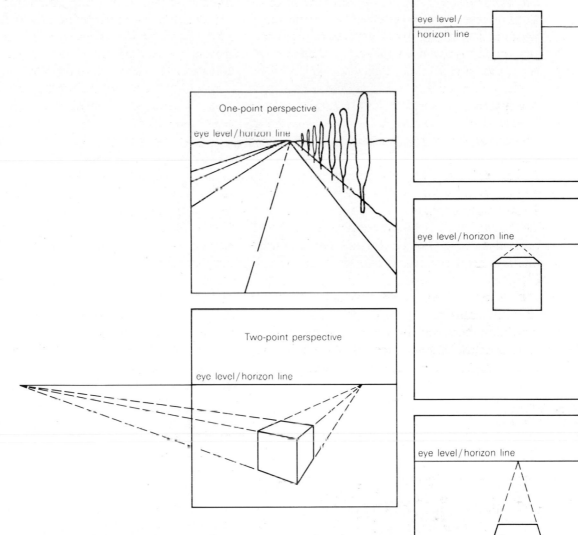

One-point perspective

eye level/horizon line

Two-point perspective

eye level/horizon line

eye level/
horizon line

eye level/horizon line

eye level/horizon line

Horizontal parallel lines moving away from the viewer above eye level appear to go down to the horizon line, while those below eye level appear to go up to the horizon line. See if you can find the eye level in Bellini's drawing from this description.

In a *one-point perspective* system (such as Bellini used) all the major receding "lines" of the subject are actually parallel, yet visually they appear to converge on a single vanishing point at the horizon line. In a *two-point perspective* system two sets of parallel lines appear to converge at two points on the horizon line. There can be as many vanishing points as there are sets of parallel lines.

88 Raphael Sanzio.
THE SCHOOL OF ATHENS. 1509.
Fresco. Approx. 18' x 26'.
Stanza della Segnatura. Vatican, Rome.

In Raphael Sanzio's THE SCHOOL OF ATH-
ENS we see architecture in the Renaissance
style, providing a grand setting for the figures.
Raphael has achieved balance here between in-
terest in the group of figures and the pull into
implied deep space created by linear perspec-
tive. The size of each figure is drawn to scale
according to its position in space relative to the
viewer; thus, the entire group seems natural.
Lines superimposed over the painting reveal
the basic one-point perspective system used by
Raphael. (Some objects, such as the cube in the
foreground, are not parallel to the walls of the
building, and therefore are not in one-point
perspective.)

An artist can use perspective for symbolic
emphasis. For example, the great teachers of the
School of Athens were Plato and Aristotle. We
know that they are the most important figures
in this painting because they are placed at the
center of the series of arches and are framed by
the one farthest away. Perhaps more important
is the fact that they are placed on either side of
the vanishing point. They are in the zone of
greatest implied depth. At the point at which
the viewer is pulled farthest back in space, the
two figures come forward, creating a dynamic
tension between push and pull in implied deep
space.

M. C. Escher's lithograph HAND WITH RE-
FLECTING GLOBE uses linear perspective in-
ventively. By reflecting his own gaze, Escher
emphasizes the origin of a linear perspective
view. The mirrored surface of Escher's globe
distorts normal perspective, giving a more
complete view of his room than could normally
be seen from a single position without eye
movement. Four walls, the floor, and the ceiling
are compressed into a single image. The lines
defining these planes curve with the sphere's
surface. The absolute center is the point be-
tween the artist's eyes. Whichever way he turns,
he is still the center.

89 M. C. Escher.
HAND WITH REFLECTING GLOBE. 1935.
Lithograph. 32 cm x 21.5 cm.
Escher Foundation, Haags Gemeentemuseum, The Hague.

90 Paul Klee.
UNCOMPOSED OBJECTS IN SPACE. 1929.
Watercolor. 12⅝" x 9⅞".
Private collection.

Linear perspective is simply a device an artist may or may not choose to use. Swiss artist Paul Klee rarely employed it; but when he did, he used perspective in imaginative ways. In UNCOMPOSED OBJECTS IN SPACE he created a dreamlike mood in which objects seem to be moving into, or emerging from, the dark space framed by the tallest rectangle.

Another kind of perspective developed during the Renaissance is called *atmospheric perspective*. As the distance between us and large objects like buildings and mountains increases, the quantity of atmosphere between us and the objects changes their appearance. Atmospheric perspective is based on the fact that as objects get farther away from us, they appear less distinct, cooler, or bluer in color. Color saturation is lessened and value contrast is reduced.

Artists of the Orient have used atmospheric perspective differently from their European counterparts. The soft, rolling shapes of mountains stack up in rhythmic layers of suggested space in this Chinese painting in the style of Mi Fei. The famous Sung Dynasty master and connoisseur Mi Fei developed a technique of daubing the ink on the silk surface to build up forms layer by layer without outline. Atmosphere is implied by the way the mist seems progressively to dissolve the lighter hill shapes.

This painting was created from memory, away from the subject. Therefore the implied high vantage point of the viewer is not an actual observation point, but a device offering a detached view of distant hills in a subtle, relatively flat pattern. Traditional Chinese landscape paintings are poetic symbols of experience with landforms, rather than representations of physical reality. See page 251 for a discussion of the philosophical concepts behind "space" in Chinese paintings.

The Renaissance idea of a painting as a window onto nature is readily apparent in Claude Lorrain's painting THE HERDSMAN. As we observe this work, our vantage point is low. In this position we feel that we could walk right into the painted landscape, as though its implied space were an extension of our own space. However, the sun and its light come toward us from the distance, stopping us from mentally stepping into this space. Atmospheric perspective is effectively employed in the painting to heighten the illusion of deep space, yet our interest is held in the foreground by the figure of the herdsman and his flock.

In Lorrain's painting, the direction of implied movement is into, or through, the painting, suggesting three-dimensional deep space. In contrast, the implied movement in the Mi Fei-style Chinese landscape painting is primarily up and down, across the two-dimensional space of the picture plane. Mi Fei, working in the Chinese tradition, acknowledged the two-dimensional nature of the picture plane; Lorrain, working in the Renaissance tradition, sought to dissolve the picture plane in order to achieve a greater sense of realism.

91 Attributed to Mi Fei.
MISTY LANDSCAPE: ROUNDED
MOUNTAIN PEAKS AND TREES.
c. 1090.
Hanging scroll, ink on silk.
Length 60".
*Courtesy of the Freer Gallery of Art,
Smithsonian Institution, Washington, D.C.*

92 Claude Lorrain.
THE HERDSMAN. c. 1655–1660.
Oil on canvas. 47³/₄" x 63¹/₈".
*National Gallery of Art, Washington, D.C.
Samuel H. Kress Collection (1946).*

94 Georges Braque.
HOUSES AT L'ESTAQUE. 1908.
Oil on canvas. 73 cm x 59 cm.
Kunstmuseum, Bern.
Herman and Margit Rupf Foundation.

93 Paul Cézanne.
THE TURN IN THE ROAD. 1879–1882.
Oil on canvas. 23⁷/₈″ x 28⁷/₈″.
Museum of Fine Arts, Boston.
Bequest of Robert Treat Paine, 2nd.

In Paul Cézanne's THE TURN IN THE ROAD another kind of pictorial space is constructed. Because our vantage point is high above the ground plane, we are not led into this painting as we were in Lorrain's landscape. Cézanne intentionally tipped up the road plane, making it a major shape in the composition. He also changed other planes in order to strengthen the dynamics of the picture surface. The space implied in THE TURN IN THE ROAD is relatively shallow and ambiguous. Cézanne did not rely on the window view from one vantage point. Although he did not use linear perspective, the suggestion of depth within his paintings is a major element. Color helps determine the implied spatial position of the various planes. Cézanne's goal was to reconcile in his own way the three-dimensional quality of nature with the two-dimensional reality of the picture plane on which he worked. After 400 years of the painting-as-a-window tradition, Cézanne's approach led first artists and then viewers to a total reexamination of pictorial space.

About 1907 Georges Braque and Pablo Picasso began developing a new kind of spatial configuration in their paintings. The new style, influenced by Cézanne, completely abandoned the use of sequential progression into deep space that had been the foundation of painting since the Renaissance.

Their style is called Cubism. HOUSES AT L'ESTAQUE is an early Cubist painting done by Braque in 1908. In this landscape painting the abstract geometric shapes define a rush of forms that pile up rhythmically in shallow space. Buildings and trees seem interlocked in an active spatial system that pushes and pulls across the picture surface.

Logical, step-by-step progression into pictorial space was abandoned in Cubism. Painters used multiple vantage points to show more of a subject at one moment than was possible from a single, fixed position.

Instead of denying the two-dimensional limitations of the picture surface, twentieth-century artists have accepted these limitations and used them advantageously to create spatial configurations relevant to the changing insights and concerns of our age.

Changes in science paralleled changes in the concepts of time and space in art. Major discoveries, such as Einstein's theory of relativity, the splitting of the atom, and the invention of the airplane gave us new ways of thinking and perceiving. These discoveries accompanied the first major revolution in Western spatial concepts in art since the Renaissance invention of linear perspective.

Time

We live in a time/space environment; *time* is a continuum that is different from space, yet inseparable from it. Time itself is invisible, yet it can be made visible in art. Some artists design form in time, either actual or implied, with as much care as they bring to the ordering of their forms in space.

In art, for example, time can be seen as a progression or sequence that takes time. Such sequences are designed to take place in actual time—as in film, television, and kinetic (moving) sculpture. Time can also be implied, as in Marcel Duchamp's NUDE DESCENDING A STAIRCASE (see page 371) or Sassetta's THE MEETING OF SAINT ANTHONY AND SAINT PAUL. In addition, art can capture a moment that is part of a larger sequence of events, as in Edgar Degas's PLACE DE LA CONCORDE (see page 113) or Goya's THIRD OF MAY, 1808 (see page 316).

In Western culture we commonly think of time as linear, continually moving forward. Sassetta implied the passage of linear time in THE MEETING OF SAINT ANTHONY AND SAINT PAUL. The painter depicted certain key moments during Saint Anthony's progression through time. Saint Anthony begins his journey far back in time and space at the city barely

95 Sassetta and assistant.
THE MEETING OF SAINT ANTHONY
AND SAINT PAUL. c. 1440.
Tempera on wood. 18¾" x 13⅝".
National Gallery of Art, Washington, D.C.
Samuel H. Kress Collection (1939).

visible behind the trees. He comes into view as he first approaches the wilderness. Next we see him as he encounters the centaur. Finally he emerges into the clearing in the foreground, where he meets Saint Paul. The road implies continuous movement in time.

Comics are a more recent example of an art form that relies on implied sequential time as a major element. When we see the comic strip PEANUTS (see page 6) we understand that the

96 Harold Edgerton.
MILK SPLASH RESULTING FROM
DROPPING A BALL. 1936.
Photograph.

story is read from left to right, and that each panel frames a segment of the action through time. Continuity in the dialogue and consistency in the identifying features of the figures make the illusion of passing time believable.

The art of animation developed from the same urge to portray time and motion that motivated painters such as Sassetta and the comic strip artists of today. An animator relies on slight changes in a figure's position, rather than jumps in time and space, to give the illusion of motion to superimposed sequential images.

For many cultures the experience of time is cyclic, like the wheel of time in Buddhism and Hinduism. The cyclic view of time is seen in the cycles of the seasons; in the cycle of birth, death, and rebirth; and in longer cycles of celestial creation and destruction. This view of time is expressed in SHIVA NĀTARĀJA on page 243.

The various interpretations of time suggest that time itself may be a human invention. In any case, the desire to occasionally stop time or at least to preserve images out of the flow of time goes back to prehistoric cultures. This urge was part of the inspiration for the development of photography. Initially, only static, inanimate objects could be recorded because the photosensitive material required a long exposure time. By 1839 technological improvements made it possible to photograph people standing or sitting very still; and by 1853 images of people, animals, and things could be captured in motion (see Eadweard Muybridge's work on page 158).

Harold Edgerton's high-speed photograph of a milk splash "freezes" an event in time that would not be visible otherwise. Edgerton bounced a tiny ball off the milk surface and lit the event with the flash of a stroboscopic lamp for a mere 1/1,000,000 of a second. Edgerton was a pioneer in the development of stroboscopic photography, in which pulsed light flashes on a moving subject at regular intervals in order to "stop" the action on film. Through such means we have greatly increased our understanding of the unseen changes in objects as they move through time and space.

97 Michelangelo Pistoletto.
NUDE WOMAN TELEPHONING
1965.
Paint on highly polished steel.
Life-size.
Private collection.
Photographs: Basil Langton.
a With male viewer.
b With Girl Scouts.

Time as suggested in single, two-dimensional works, such as drawings, photographs, and paintings, is usually implied. The image can be seen instantly and wholly; the total work is like a still moment out of moving time. The physical experience of actual time in motion pictures is sequential. The term *movies* derives from the central feature of the filmmaker's art: the appearance of motion from one photograph or frame to the next that introduces sequence and the illusion of motion. (The concept of time in cinema is discussed in detail under Cinematography, page 163.) With the development of television it became possible to transmit images of present time. In both film and television, clock time can be expanded or compressed. Past, present, and future time can be implied and intermixed, and events that occur too quickly or too slowly to be visible to the human eye can be made visible by slowing them down or speeding them up.

In NUDE WOMAN TELEPHONING, Michelangelo Pistoletto has contrived to capture events in actual time on a flat surface. He created the figure with paint on paper. Then the painting was glued to a reflective, stainless steel surface, which mirrors the surroundings.

The only way to suggest the effect of time in a reproduction is to show the work in two different photographs as seen at two different times. The woman goes on telephoning whether she is alone or with, for example, the Girl Scouts who are observing the work. If we were there viewing it, we would see a variety of different groupings over time and would be able to see actual motion—perhaps our own.

Motion

Motion is action created by actual or implied change of position. Traditionally, the visual arts have been considered as primarily spatial arts. Now a growing number of artists and architects working with new and traditional media are expanding the temporal dimension of the visual arts.

Dance is a major temporal and spatial art. In dance, the human body itself becomes the expressive three-dimensional medium in space. The live motion of bodies, their mass, their changing shapes, and the changing shapes of the spaces among them form the basic vocabulary of dance.

Fountains have long been a favorite kind of moving or *kinetic sculpture*. Kites, banners, and flags are forms of art in motion activated by the movement of air. Alexander Calder's *mobiles* also rely on air movement to perform their subtle dances (see page 175). Many artists are now devoting their energies to designing forms in motion.

98 Robert Breer.
FLOATS. 1966.
Motorized styrofoam.
Photograph: Francis Breer.

Artist Robert Breer has worked with movement in both film and sculpture. Imagine walking along a country road and suddenly coming upon a herd of small white blocks moving slowly along, powered by battery-operated motors. Breer made the apparitions he calls FLOATS out of shaped blocks of styrofoam. (See also Tinguely's work, page 410.)

To experience fully the total form of any three-dimensional work of art, it is necessary for either the viewer, the object, or both to move. Single photographs of sculpture and architecture do not have this dimension, since they limit the viewer to one point of view. When seeing the actual object in space, we become involved with the dramatic interaction of the various planes of the mass, which ultimately resolve into the memory image of a total integrated form. (See Saarinen's TWA TERMINAL, page 81 and KANDARYA MAHADEVA TEMPLE, page 243.)

Architect and urban designer Lawrence Halprin in his book *R.S.V.P. Cycles*[7] describes how he interweaves designed spaces into a performance with the indeterminant elements of people moving and at rest. His firm's FORECOURT CASCADE, in Portland, Oregon, is an excellent example of this concept of chance human movement interacting with planned water movement in designed space (see page 4).

"Op" paintings (short for "optical") such as Anuszkiewicz' INJURED BY GREEN (see page 72) and Bridget Riley's CREST (see page 408) are designed to produce involuntary eye movement. Emphasis on optical sensations such as these is the common factor in Op paintings.

Both actual and implied motion have become increasingly important in the visual arts during the past one hundred years. Implied motion in works such as drawings, paintings, and photographs is linked with the action of lines and the repetitions of shapes or other rhythmic elements. Painter and photographer Thomas Eakins used a single camera and a movable photographic plate to capture sequential images that show the movements of a pole-vaulter. Such photographs influenced painters Marcel

Duchamp (see page 371) and Futurist Giacomo Balla. In DYNAMISM OF A DOG ON A LEASH, Balla shows the simultaneous movement of forms in space as seen from a fixed vantage point over a period of time. Through rhythmic repetition, Balla captured the visual excitement of motion. His image depicts the concept presented in the *Futurist Painting: Technical Manifesto* of 1910:

In fact, all things move and run, all things change rapidly. The profile before our eyes is never static but constantly appears and disappears. Given the persistence of the image in the retina, moving objects are multiplied, changing their shapes as they pursue one another like lively vibrations across space.[8]

Balla's method for showing motion with repeated shapes and lines was soon adopted by cartoonists. In Charles Schulz's comic strip (see page 6) such lines tell us that Linus flipped when Lucy shouted "THAT'S ART!"

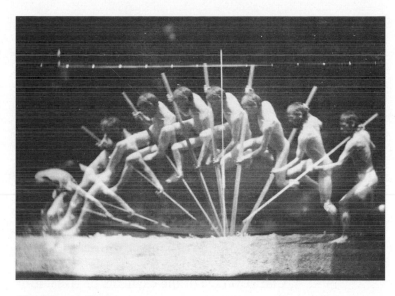

99 Thomas Eakins.
POLE VAULTER. 1884.
Multiple exposure photograph
of George Reynolds.
The Metropolitan Museum of Art, New York.
Gift of George Bregler.

100 Giacomo Balla.
DYNAMISM OF A DOG ON A LEASH. 1912.
Oil on canvas. 35³⁄₈" x 43¹⁄₄".
Albright Knox Art Gallery, Buffalo, New York.
Bequest of A. Conger Goodyear to
George F. Goodyear, life interest,
and Albright Knox Art Gallery (1964).

Artists have been depicting motion since prehistoric times (see the WARRIORS on page 425). In Asia painters have found the traditional handscroll particularly well suited for showing movement through time (see BURNING OF THE SANJO PALACE on page 255). It wasn't until the invention of the motion picture camera in the late ninteenth century that artists had the tools to create a fully convincing sense of motion.

In film, rapid sequences of still pictures are shown at the rate of twenty-four per second, creating the illusion of actual motion. In this sense, the motion of a movie can also be said to be implied rather than actual.

Our coverage of the elements of visual form included the dominant aspects of what we see. *Point* was presented first because it represents the beginning—the emergence of something in space. As a *point* moves, it creates or implies a *line*. When a line turns back on itself, it defines a *shape*. Shapes also appear because of changes in *light, color,* and *texture*. Light reveals color and texture. Color is an aspect of light as well as a surface quality. Texture is a tactile surface quality. The three-dimensional qualities of *mass* are revealed by light, and by the tactile sense as stimulated by touch or by the visual memory of tactile experience.

Mass is always within *space* and interacting with it, both enclosed by it and enclosing it in infinite ways. The full dimensions of space are experienced through *motion* occurring in *time* as well as space. The process of structuring these aspects of form into works of art is design. When we know something about the expressive potential of the visual elements and how they can be effectively organized using the *principles of design*, we can evaluate the results with a greater sense of knowing why we respond the way we do.

PRINCIPLES OF DESIGN

In the context of art, *design* is both the process of structuring visual form and the product of that process. We perceive design as well as create design. In both cases design grows from the basic human need to find and make meaningful order. The important steps in a growing understanding of design are learning to see it, to work with it, and to live with it. Any good planning is "designing." Here, however, we are concerned with the kind of designing that shapes visual form.

By giving order to form, we clarify and intensify experience. The result of such action is called a design or composition. *Design* is a broader term than *composition*. Composition is the older term; it is used in all the arts, particularly writing and music.

The way in which something is organized is called design. Artists seek to achieve quality in their work by evaluating their own design efforts. In his finished paintings Matisse showed the results of a long search, not the search itself. Thus many of his paintings look easy—as if they were done with little effort.

The effort involved in his long, patient quest for the right design can be seen in the six working stages of PINK NUDE shown here. Matisse attached pieces of colored paper to the surface of the picture to determine how the possible changes would look before he began repainting. In each stage Matisse selected and strengthened those aspects of the image that contributed most to the overall design. Finally, when he felt that everything worked together, he stopped.

The rhythm of the background grid contrasts with the sweeping, sensuous shapes of the figure. The awkwardness of the spacing and the rather disjointed proportions in the earliest version of the figure are problems that have gradually been resolved. In the final painting, the bold distortions of the figure add up to a calm and elegant abstraction of the subject.

101 Henri Matisse.
Photographs of six stages of PINK NUDE.
Oil on canvas.
The Baltimore Museum of Art: The Cone Collection.

a State 1, May 3, 1935;

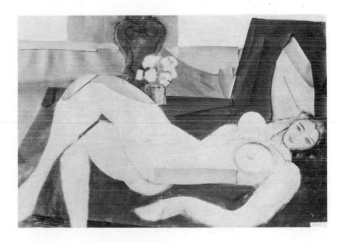

b State 6, May 23, 1935;

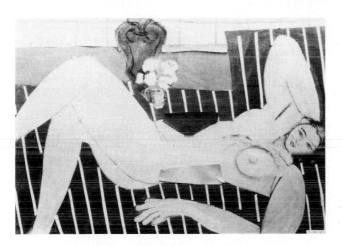

c State 9, May 29, 1935;

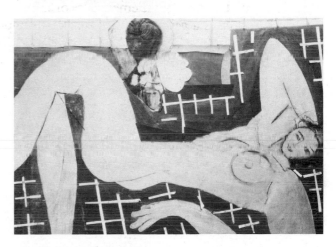

d State 11, June 20, 1935;

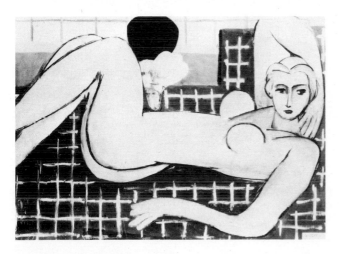

e State 13, September 4, 1935;

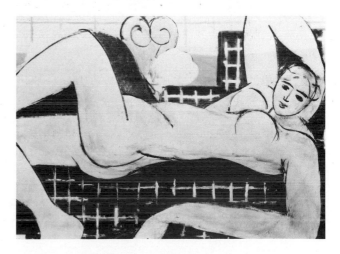

f State 23, September 15, 1935.

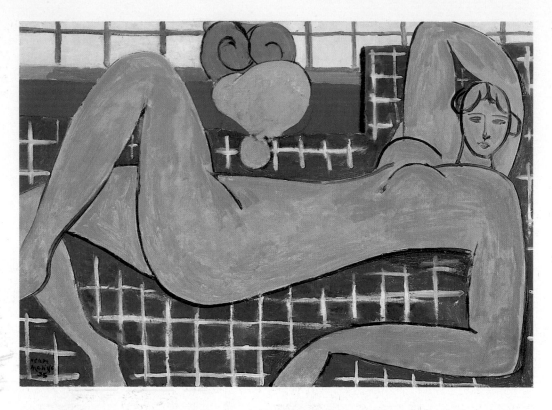

*Then a moment comes when every part has found
its definite relationship and from then on it would
be impossible for me to add a stroke to my picture
without having to paint it all over again.*

Henri Matisse[9]

The urge to design is inherent in all of us.
Through the processes of selecting, arranging,
and form-making, we determine the quality of
our lives. Even if we actually design very few
objects, we are continually involved in the pro-
cess to some degree, and are affecting and being
affected by the designs of others. The design
process in both life and art is at its best when it is
a lively, open dialogue between the intention
and intuition of the designer and the character-
istics of the medium he or she is using. We
design when we do such things as select cloth-
ing or arrange furnishings in a room. If we do
not consciously consider design, then we are
designers by default or neglect. Good design
solves problems; bad design creates problems.

Effective design involves making the most of
a particular set of circumstances. In nature we
call this natural selection. Design is always rela-
tive to the context—what is right in one context
can be totally wrong in another. In nature sur-
vival depends on the relationship between form
and function. This relationship creates the
beauty we perceive in the natural world. Design
by humans is intentional and cultural, and may
help us become aware of the wonders of "de-
sign" seen in nature.

The following discussion will demonstrate
some of the fundamental principles of basic
design. These principles can be applied to all
visual design problems.

The *principles of design* refer to the character
or quality of relationships within the work and
between the work and its surroundings. The
principles we discuss are *scale, proportion, unity,
variety, repetition, rhythm, balance, directional
forces, emphasis, subordination,* and *contrast.* There
are various ways to categorize design princi-
ples, just as there are with the visual elements.
However, regardless of the terms we use to
describe it, a single design exists as a totality

and, when successful, is far greater than the sum of its parts.

It is impossible to give rules for composition. If design excellence could be achieved by following rules, great artists would be commonplace. To become an effective designer one must develop one's own sense of design. It is a matter of awakened intuition of awakened feeling and awareness—rather than formulas. For this reason design cannot be taught like math, history, or language. Ultimately, design cannot even be fully explained. In fact it is precisely that dimension which cannot be explained that makes successful designing an art process, and makes the results into art.

Scale

The scale of a work of art affects the viewer immediately. *Scale* refers to size in comparison to the size of a constant, such as the human body or the usual size of an object. This is a primary consideration for the designer. Responses to objects change as the relationship of an object's size to our size changes. Claes Oldenburg's CLOTHESPIN (see page 403) is much larger than human scale, and enormously larger than one expects a clothespin to be. Oldenburg uses scale and proportion to transform an ordinary object into something monumental. He has redesigned the form of a clothespin, giving the work a dynamic elegance that mere enlargement would not have produced. Scale contrast within a work can be seen in Oldenburg's clothespin drawing on page 126.

When the size of any work is modified to be reproduced in a book, its character changes. The sizes of almost all the works in this book have been changed in order to fit them on the page. One of the few exceptions is Rembrandt's SELF-PORTRAIT IN A CAP, OPEN MOUTHED AND STARING. This tiny etching, which he did when he was 24 years old, is reproduced here in the actual size of the original print. It captures a fleeting expression of intense surprise. At this

103 Rembrandt van Rijn.
SELF-PORTRAIT IN A CAP,
OPEN MOUTHED AND STARING.
1630.
Etching. 2^1/$_{16}$″ x 1^7/$_8$″.
British Museum, London.

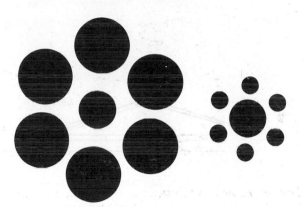

104 SCALE RELATIONSHIPS.

scale it reads like an intimate notation of human emotion. On the other hand, Michelangelo Buonarroti's sculpture of DAVID (page 301) and Picasso's GUERNICA (pages 380–381), as shown in this book, have been reduced to tiny fractions of their actual size, thereby greatly changing their impact.

Visual design is concerned with the qualities of visual relationships. In fact, it has been said that we see only in terms of relationships. One-to-one scale relationships demonstrate this universal concept. When a short person stands next to a tall person, the short one seems shorter and the tall one seems taller. Their relationship exaggerates their relative height difference. In the diagram, the inner circles at the center in both groups are the same size, but appear different.

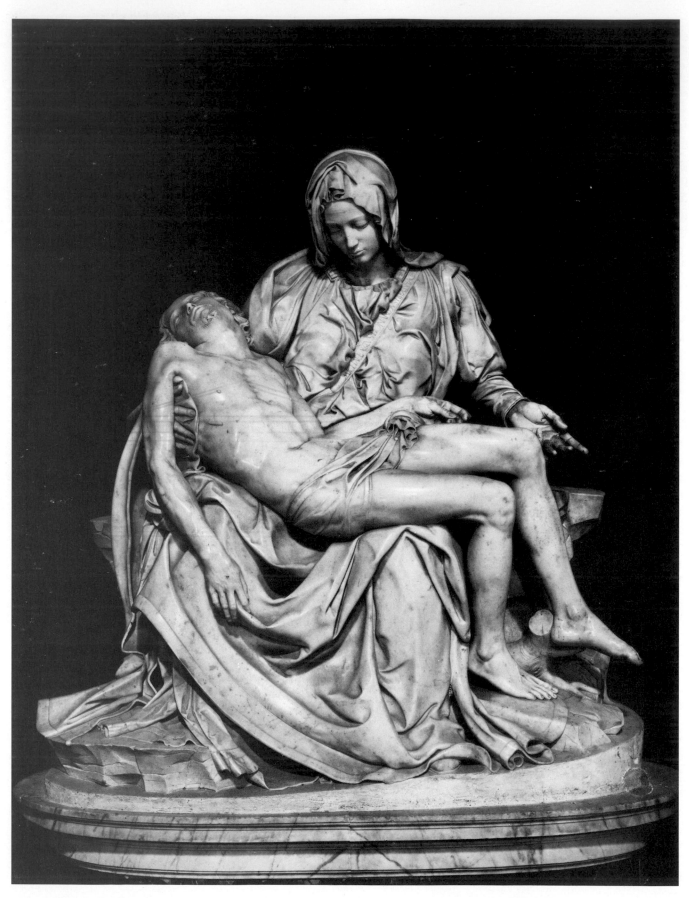

105 Michelangelo Buonarroti.
PIETA. 1501.
Marble. Height 6′8½″.
St. Peter's Basilica, Rome.

Proportion

Proportion is the size relationship of parts to a whole and to one another. Artists design proportions within a work to best express content.

When Michelangelo was 26 years old he carved the famous PIETÀ, which can be seen at St. Peter's Basilica in Rome. *Pietà* is Italian for "pity," and refers to depictions of Mary holding and mourning over the body of Jesus.

Creating a composition in which a baby appears on its mother's lap is much easier than showing a fully grown man in such a position. Michelangelo solved this design problem by changing normal human proportions. He greatly enlarged Mary's body in relation to that of Jesus and concealed her immensity beneath folds of drapery. Her seated figure spreads out to accommodate the almost horizontal curve of Christ's limp body. Imagine what Mary would look like if she stood up. Michelangelo made Mary's body into that of a giant. She may be nine feet tall! Her hands are about twice normal size. Yet we may not notice the unique proportions of Mary's figure because Christ's figure has normal proportions and because Mary's head is the same size as Christ's. We are so taken with the natural-appearing relationship between the figures that the distortion of human proportions is unnoticed. Yet this distortion is essential to the way we experience the content of the work.

Here we compare an earlier PIETÀ done by an unknown sculptor with Michelangelo's work. In the earlier work the proportions are true to life, yet at first they seem unnatural. Christ's body appears to hang uncomfortably and unsupported in space. The discomfort caused by the more normal proportions in this version has given the work an added sense of suffering and despair appropriate to the subject, and quite different from the serene stability of Michelangelo's design.

Much later in life Michelangelo carved the DUOMO PIETÀ, in which the proportions and size of Mary on the right and Christ in the

106 Master of the Beautiful Madonna. PIETA. c. 1415. Polychromed stone. *St. Mary's Church, Gdansk.*

107 Michelangelo Buonarroti. DUOMO PIETA. 1555. Marble. Height 7' 5". *Florence Cathedral.*

center are closer to normal scale. In this late work Christ's body takes a sagging, vertical position, giving a feeling of collapse, much different from the calm security of Michelangelo's earlier sculpture.

GOLDEN SECTION

CONSTRUCTION OF GOLDEN RECTANGLE

PARTHENON IN GOLDEN RECTANGLE

GOLDEN PROPORTIONS OF HUMAN FIGURE

The Pythagorean concept that "all is number," and the idea that certain numerical relationships demonstrate the harmonic structure of the universe, led the ancient Greeks and others to use mathematical systems of proportion. One such pattern of proportion found in the structure of living organisms and in art is the Golden Section. This "Divine Proportion" can be seen most clearly in the relative segments of a single line as follows: divide a line (AC) at a particular point that will yield unequal sections in which the smaller one (AB) is to the larger one (BC) as the larger one is to the entire length (AC). (See diagram.) This "golden" proportion is thus expressed as $\dfrac{AB}{BC} = \dfrac{BC}{AC}$.

A rectangle with sides proportioned in accordance with the Golden Section is known as the Golden Rectangle. Such a rectangle is easy to construct. The side AB of the square ABCD is bisected at E (see diagram). With E as center and EC as radius, draw an arc cutting the extension of AB to produce F. Draw FG perpendicular to AF to meet an extension of DC to produce G. AFGD is a Golden Rectangle.

Those who discovered and developed this proportional concept thought of it not as a mechanical formula but as an ideal basis for their art and architecture. For example, the Greeks designed their temples with this harmonic proportion as a guide. Expressed in numbers, the Golden Proportion is 1 to 1.618. But 1.618 is only an approximation of what is ultimately an irrational number.

108 GOLDEN PROPORTIONS.
a Parthenon.
b Main shrine at Ise.
c Human body.

Unity within Variety

Consistency of concept causes various elements within a work to appear as part of a unified form. An artist develops a sense of design as part of a personal way of seeing. Each work of art derives its unity from an idea operating within it. This does not mean that every work must have an intellectual idea behind it. The unifying concept often begins as a strong, motivating feeling within the artist.

Unity is the appearance of oneness. All artists work within self-imposed limitations that provide unity in their work. *Variety* is diversity; but, without design continuity, it is confusion.

Unity results in part from uniformity of visual characteristics within design, while variety is provided by dissimilar elements or properties. A balance between similar and dissimilar qualities gives interest and vitality to both art and life.

Many artists have severely limited the kind and number of elements in their work in order to concentrate on the expressive possibilities of a single element or phenomenon. Barnett Newman, for example, worked primarily with vertical bands or lines for more than a decade. In the work reproduced here, DRAWING, two vertical lines balance one another as the plain white background of the paper on the left interacts with the active dry brush textures, setting off the negative-space line on the right. In this drawing, unity is found in the similarity of the dominant vertical straight lines. The inventive contrast between the way these simple elements are presented provides interesting variety within the basic unity.

109 Barnett Newman.
DRAWING. 1959.
Brush and ink.
21¼″ x 24¼″.
Collection of Cleve and Francine Gray.

Repetition and Rhythm

The recurrence of a design element provides continuity, flow, and dramatic emphasis. *Repetition* may be exact or varied and it may establish a regular beat. Visual *rhythm*, like audible rhythm, operates when there is an ordered repetition of elements. Rhythm may be simply *repetitive*. It may give alternating variations on a basic theme or indicate a *progressive* development.

The repetitive, rhythmic pattern in Andy Warhol's GREEN COCA-COLA BOTTLES (see page 402) produces an endless succession of shapes, with no variation to provide relief. Warhol employed insistent rhythm to make a statement about the manufactured objects and images so prevalent today.

A different kind of statement about the character of an environment is expressed through the rhythmic structure of Pieter de Hooch's INTERIOR OF A DUTCH HOUSE. Here the definite rhythm set up by the rectilinear pattern of the floor and windows is played off against the larger rectangles representing the map, painting, fireplace, and table. The overall rectilinear theme repeats the horizontal and vertical directions that begin with the edges of the picture plane.

In Raphael's MADONNA OF THE CHAIR, the curved shapes echo the circular format of the painting. But this repetition of curving elements—convex and concave, large and small—does not establish a rhythmic pattern. Instead, the repeated curves provide flow and continuity. The vertical axis of the chair post stabilizes the entire composition.

A progressive visual rhythm is set up across the picture plane in José Clemente Orozco's ZAPATISTAS. The line of related figures is a sequence of alternating light and dark diagonal shapes grouped in a rhythmic pattern that expresses the aggressive force of oppressed humans in revolt. The strong visual beat of this design is established by the marchers and by the repeated, yet varied, shapes of the sombreros.

Duchamp's NUDE DESCENDING A STAIRCASE is an example of rhythmic progression, indicating movement and change in a dynamic sequence of interacting lines and shapes (see page 371).

110 Pieter de Hooch.
INTERIOR OF A DUTCH HOUSE. 1658.
Oil on canvas. 29″ x 35″.
Reproduced by courtesy of the Trustees,
The National Gallery, London.

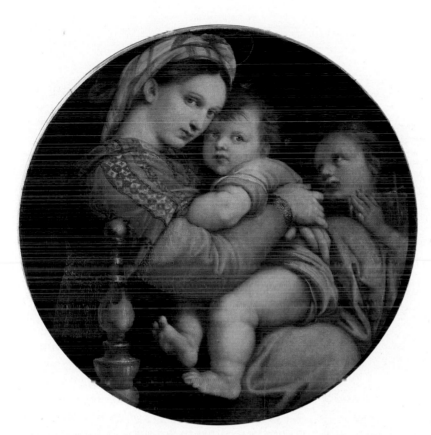

111 Raphael Sanzio.
MADONNA OF THE CHAIR. c. 1514.
Oil on wood. Diameter 2′4″.
Pitti Gallery, Florence.

112 José Clemente Orozco.
ZAPATISTAS. 1931.
Oil on canvas. 45″ x 55″.
The Museum of Modern Art, New York.
Anonymous gift.

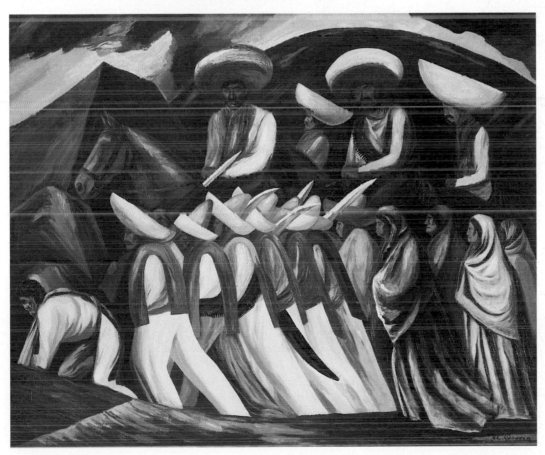

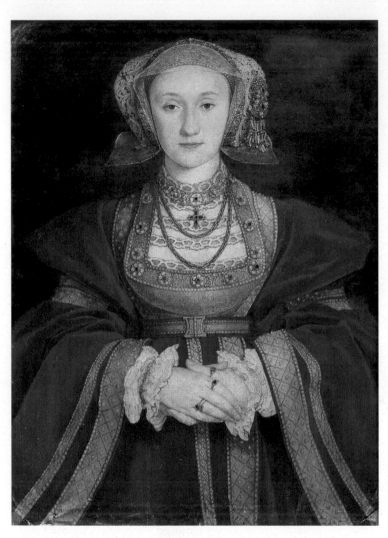

113 Hans Holbein.
ANNE OF CLEVES. 1539.
Oil on wood panel.
The Louvre, Paris.

Balance

The attraction and tension of opposing forces is one of the basic conditions of life. Equally basic is the dynamic process of balancing these dualities—seeking equilibrium. *Balance* is the ordered relationship of opposing forces. Lack of balance is contrary to our sense of order.

There are two general types of balance: symmetrical, and asymmetrical. *Symmetrical balance*, sometimes called axial balance, is the more obvious of the two. It is achieved by the equal distribution of identical or very similar parts on either side of a central axis. Symmetrical balance is easier to achieve than asymmetrical balance. It creates the feelings of stability, formality, and dignity found in Hans Holbein's portrait ANNE OF CLEVES. There is always a danger that symmetrical compositions will become static, obvious, and boring—though that is certainly not the case with Holbein's painting. Slight variations in the basic symmetry add life and interest to the formal pose.

A variation of symmetrical balance is *radial balance*, in which opposing forces rotate around, radiate from, or converge on an actual or implied central point. Richard Lippold's sculpture of the sun (see page 174) has radial balance.

In *asymmetrical balance,* sometimes called informal balance, a felt or implied center of gravity brings opposing or dissimilar elements into equilibrium. It is more difficult to achieve, but is more flexible, subtle, and dynamic.

In the asymmetrically balanced child's drawing (see page 21) the single figure is placed far to the left of center. The whole image feels balanced because the figure's left arm is made long enough to place the radiating finger lines of the circular hand in the center of the almost square background area. This placement balances the visual weight of the figure. If the left arm were the same length as the right, the drawing would be weak and incomplete because its balance would have been lost. Visual unity is achieved by repetition of the radials of the

hands and feet, and the repeated curves of the mouth, chin, and the line through the legs. The line that surrounds the figure, roughly parallel to the outer edges of the paper, reveals the child's unconscious awareness of balance on the picture plane.

Active, asymmetrical balance is achieved between the triangular gray shapes in the lower right and the dark figure of the cyclist moving to the left in Henri Cartier-Bresson's photograph HYÈRES, FRANCE. The bicycle rider would lead our eyes out of the picture in the direction of movement were it not for his relationship to the rest of the design. Cartier-Bresson skillfully balanced stationary and moving elements of his subject to create a dynamic tension that gives life and interest to his picture.

Selection is a major part of the creative process in all the arts, and it is particularly crucial in photography. A photographer may take hundreds of shots or frames in order to realize a memorable image. Cartier-Bresson speaks of the "decisive moment," when the significance of an event is captured through the "precise organizaton of forms" (see page 154).

Because of the acuity of his vision, his technique, and his awareness of design, Cartier-Bresson is highly regarded by other photographers. He neither directs his subjects while shooting, nor crops or manipulates his photographs during the printing session.

114 Henri Cartier-Bresson.
HYÈRES, FRANCE. 1930.
Photograph.

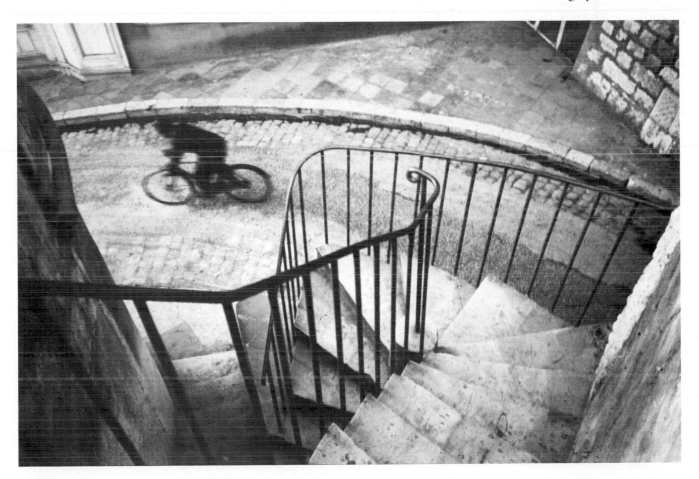

Directional Forces

Implied or actual lines produce *directional lines* or *directional forces*, which determine the basic structure of a work. Designed objects or works of art often have dominant directional linear forces operating within them, tying them together into a unified composition. *Implied lines* are those which we feel, rather than see. They may be suggested by the imagined connection between similar or related adjacent forms. An implied line may also be the unseen *axis* line that indicates the dominant direction of a single form. As we look at a work of art our eyes tend to follow both implied and actual directional lines. Artists use such lines to help guide the eye movement of the viewer and bind the works into a single entity.

Vertical and horizontal lines repeat the human experience of standing and lying down. A horizontal line has a feeling of rest and inaction and provides a ground plane for a vertical. A vertical line is one of poise. The two together provide a sense of composure. Both horizontal and vertical lines, either implied or actual, are relatively motionless or static.

Diagonal lines are lines of action. They often seem to want to fall to horizontal or rise to vertical. Diagonal lines cause tension because they disrupt our sense of vertical balance. Gravitational pull provides the feeling of motion. We may feel their dynamic tension because we identify with their likeness to the human figure—generally moving when diagonal, and still or at rest when vertical or horizontal.

When designing an image on a picture plane, the *format* or basic picture shape and the dominant direction of *implied movement* within the design are sources of expressed mood or content. The rectangle formed by the edge of the picture plane in Holbein's portrait (see page 110) provides a vertical format in which the implied axis line is also vertical. The mood of verticality is one of alert poise, attention, or standing. This is true whether we are looking at an actual standing figure, a sculpture of a standing figure, or actual or implied vertical lines or forms, as in the facade of a building.

Francisco Goya's remarkable etching BULL FIGHT is a good example of dramatic asymmetrical balance. Most of the subject is concentrated in the left two-thirds of the rectangle. We

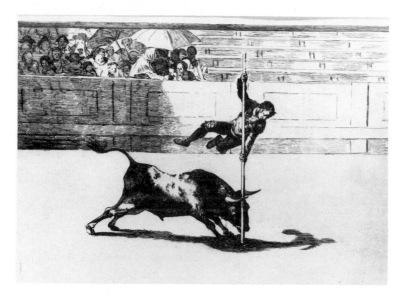

115 Francisco Goya.
BULL FIGHT. 1810–1815.
Etching. 12¼″ x 8⅛″.
Fine Arts Gallery of San Diego.

are drawn to the *point of emphasis* by the intersecting horizontal and vertical lines behind the lower hand of the man on the pole. This linear movement seems to hold the design together in spite of the tension and movement implied by the diagonal force lines of the bull and the man. Through design, Goya emphasized the feeling of suspense and potential danger.

Implied lines are also called "subjective lines" because they exist only in terms of the viewer's response. The implied lines of sight between people or animals depicted in a work of art are usually important "lines" in the total design of that work because they can connect major figures and create significant directions of movement within the work. Edgar Degas' PLACE DE LA CONCORDE has many such unifying and energizing hidden lines.

During the nineteenth century, Degas was a member of the Impressionist group in Paris, but he saw things in his own way and remained independent in his depiction of contemporary life. Degas was intrigued by the way in which the camera fragmented objects seen in actual, continuous space. In PLACE DE LA CONCORDE we see people grouped by chance on a street. Degas based his composition on the accidental quality of normal visual experience, as well as on spontaneous poses captured in snapshots. He enjoyed "freezing" a moment from the continual flow of passing events. His work causes us to look at apparent randomness and find unity beneath the chance juxtaposition of people and objects.

The implied lines set up by the directions in which the dog, the girls, and the man are looking act as unifying forces in the composition. Everyone is looking in a different direction. A man appears at the far left, cut off by the top and side edges of the picture plane, giving the impression of a candid photograph. If we study the composition carefully, we realize that Degas has ultimately called our attention to the empty area just in front of the dark doorway in the distant wall (see diagram).

116 Edgar Degas.
PLACE DE LA CONCORDE. c. 1873.
Oil on canvas. 31³/₄" x 41³/₈".
Location unknown.

Emphasis and Subordination

By emphasizing certain features in a work and subordinating others, artists establish centers of interest that focus the viewer's attention. In this way the communication of intended content is strengthened. If the content is expressed by monotonous repetition, emphasis will not be an active principle in the design because all elements will be given relatively equal weight.

Mu Ch'i's painting of SIX PERSIMMONS (see page 84) is a straightforward example of the principle of *emphasis and subordination*. The group is like a family, with one persimmon emphasized and therefore recognized as dominant. Each of the other five persimmons has its own individual character in diminishing sequence of importance within the group, thus providing a rich variation on a simple theme.

A more oblique version of the principle of emphasis and subordination is seen in Degas' PLACE DE LA CONCORDE. Objects, people, and a dog lead the viewer on a circuitous route past the gentleman with the top hat on the right, who is the expected point of emphasis, to the blank area, which cannot hold our attention. Our eyes continue to explore the intricate and unusual composition.

Contrast

Visual interest, emphasis, and expressions of content can be achieved through contrasts. *Contrast* is the interaction of contradictory elements that express the duality seen in opposites such as large and small, rough and smooth. In line, it can be the contrast between the thick and thin areas of a single brush stoke. With shapes, it may be between regular geometric and irregular organic shapes, or between "hard" and "soft" edges of shapes. Value contrasts occur between adjacent light and dark areas on a surface.

Color contrasts are seen in a variety of ways, including contrast of hue, contrast of complements, contrast in saturation (between bright and dull), or contrast in temperature between warm and cool qualities of color.

The contrast between solid mass and empty space is a major factor in Henry Moore's RECUMBENT FIGURE (see page 79). In two-dimensional works dynamic tension is often set up between the push and pull in implied space. This happens in Raphael's SCHOOL OF ATHENS, where the major figures are emphasized by their implied forward motion in the area of contrasting implied depth (see page 90).

TOTAL FORM

As noted earlier, we see visual elements and principles of design simultaneously, as a totality, yet we can only deal with aspects or parts of total form when we speak or write. By analyzing works of art we find that some of the elements and principles in a given work are more prominent than others. The following analysis of three works with the same subject done by one artist suggest the ways elements and principles of design work together.

In the 1890s Edvard Munch, a young Norwegian painter, developed an intensely expressive way of depicting human passions and tragedies (see also page 340). Three works, all of which show a couple embracing, were completed over a period of six years. By studying these images and comparing them, we find it possible to understand the evolution of Munch's symbolic portrayal of love.

In the painting KISS BY THE WINDOW a couple stands to the side of the window, their figures joined. Munch's scheme for showing a couple's feeling of oneness is already present in the greatly simplified composite shape of the embracing figures. The outline that follows the collar and shoulder of the man parallels the directional force of the textural brush strokes that fill in the dark part of the figures. This curving energy is picked up by the lines of the curtain, and leads the eye to the forceful vertical

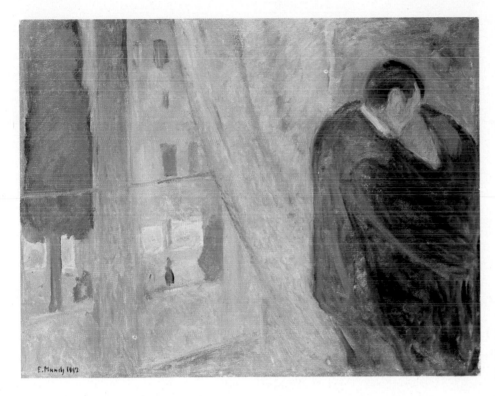

117 Edvard Munch.
KISS BY THE WINDOW.
1892. Oil on canvas..
72.3 cm x 90.7 cm.
National Gallery, Oslo.

118 Edvard Munch.
THE KISS. 1895.
Drypoint and aquatint.
343 mm x 278 mm.
Albertina Collection, Vienna.

mass of the tree outside the window. The tree balances the couple, and creates an asymmetrical tension. The nearly monochromatic blue-green tends to cool an otherwise passionate subject. Simple curves play off against straight edges, contrasting figure and curtain with the lines of the window. Intersections of lines cause our eyes to move throughout the painting.

The second work is a drypoint print in which the couple is nearly centered in front of the window. Munch boldly emphasized the outlines of the nude figures and again made them into one relatively simple shape. By removing the line that would normally indicate the division between the faces, he has emphasized their unity. Drawn lines create a texture on the figures that adds to the rhythmic movement and energy of their outlines. The shapes of the dark curtains frame the embracing couple and add dramatic emphasis by providing strong contrast with the light of the window. This strong

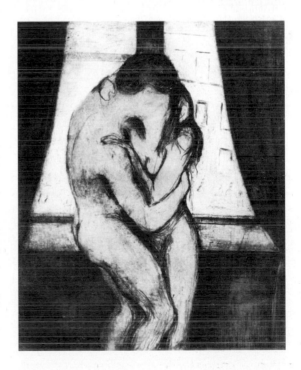

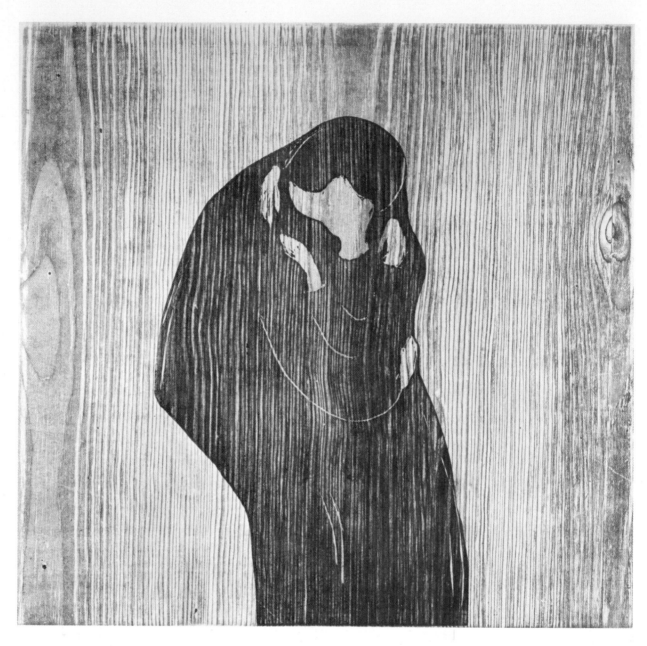

119 Edvard Munch.
THE KISS. 1897–1898.
Woodcut. 467 mm x 465 mm.
Albertina Collection, Vienna.

value contrast contributes to the feeling of passion, which is not present in the other two images. Subtle shifts between light and dark areas within the figures give a suggestion of mass to the bodies.

For the painting Munch chose a dominantly horizontal picture surface (format), which offsets the many vertical directional lines and

active diagonal curves within the frame. The drypoint's format is vertical, which gives this image a more active quality in spite of its almost symmetrical composition. In the third work, a woodcut, the nearly square format produces a relatively quiet balance of directions. Here shapes have become flattened and even more simplified than the shapes in the painting. The entire image is very abstract. Wood texture, from an uncut second block, provides a vertical rhythmic sequence, which offers a counterpoint to the gently curving lines and single shape of the embracing couple. By removing indications of light and shadow and eliminating suggestions of spatial depth, location, and all unnecessary details of anatomy, Munch created a solid image of enduring love.

In the third version Munch simplified his concept to its essence. He did not achieve this result all at once; it evolved from one work to the next. Of the three versions, the woodcut is the best known, perhaps because it so effectively symbolizes the idea.

STYLE

Style refers to a consistent and characteristic handling of media, techniques, elements of form, and principles of design that make a work identifiable as the product of a particular person, movement, period, or place. A personal or group style emerges naturally as artists assimilate influences and move toward their intended expression. This intention forms their style, as noted in the discussion in Chapter 1 of the works of Matisse, Kollwitz, Bischof, and Mondrian. Of course, an individual artist may also work in a variety of styles. This can be seen in the works of Picasso (pages 80 and 361) and Kandinsky (pages 350 and 351). Many individual, group, and national styles are described in Chapters 4 and 5.

EVALUATION

Evaluation and selection are important features of the creative process from the beginning. Once a potential work of art is completed, the artist may be the first to question its validity. Value judgments in art involve subjectivity. Objective considerations usually miss the point. Factors such as permanence are easily measured but meaningless unless the work is worth preserving. Quality in art has little to do with complexity of technique, degree of difficulty, training, or the education of the artist. Often the art process and accompanying experience are far more significant than the resulting work. This is noticeably true in the creative expressions of children. How can we evaluate the quality of another's personal or creative experience?

Quality is relative. Concepts of what is valuable in art or anything else change from person to person, from age to age, and from culture to culture. Changes in taste are not the same as changes in value. Preference and evaluation are quite different. We can recognize aesthetic quality in works we do not like.

The whole subject of evaluation is both complicated and enriched by the fact that in today's world we are often responding to reproductions rather than original works. The recent practice of selling photomechanical reproductions at very high prices has confused people about the value and quality of original art, and the value and quality of reproductions. Both have important functions, but it is essential to know what the differences are. In our discussion of printmaking on page 142, we explore the difference between original prints and reproductions.

Our present knowledge of the world's art is gained primarily from reproductions seen in magazines, books, slides, films, and on television. To purchase a reproduction of a "good" work of art may be preferable to purchasing a "bad" original. A reproduction enables us to live with a work even when the original is in a museum or private collection. But there is no

reason for even the highest quality photomechanical reproduction to cost more than a moderately priced book.

Theories of art criticism are related to theories of aesthetics (see page 14). In the Western world these can be categorized as subjective, objective, or a balance of the two. A subjective approach holds that judgment is personal, changeable, and unchallengeable, and that all individual responses are equally valid. Here the value of a work is in the response of the viewer rather than in the work itself.

Objective theories are based on an assumption that there are unchanging standards upon which absolute judgments can be made regarding all art, from any time and place. Nearly any such fixed set of standards results in rejection of the art of many cultures.

Between these extremes are relativist theories, which hold that value stems from the interaction between the subjective response of the viewer and the intrinsic qualities of the art object. With this approach, each culture forms its own standards.

Published art criticism can influence the output of today's artists. It is believed by some that art critics and gallery owners can promote and make "successes" of the artists they choose to favor. In recent years we have seen some artists rebelling against art that can be bought, sold, and collected as investments. Happenings, environmental works, and conceptual art are related to this attitude.

As long as there have been art patrons and critics, the relationship between them and artists has been problematic. We are looking over the artist's shoulder in Pieter Brueghel's drawing THE PAINTER AND THE CONNOISSEUR. Or are we? Maybe we do not wish to be identified with the "connoisseur" who clutches his money pouch as he peers through his spectacles with what appears to be false fascination at Brueghel's work-in-progress. Of course, since Brueghel did the drawing, he gave us the story from the artist's point of view. The drawing has been done in such a way that, if we identifiy with anyone, it is Brueghel.

True connoisseurs, patrons, or critics do not have to feign understanding. Their astute sense of discrimination has been formed through study and experience. Such people play an important role in keeping the arts alive.

Professional criticism is based on the educated response and evaluation of the critic. The professional critic generally has a wide knowledge of art, and frequently has worked as an artist. The critic's knowledge and experience include an awareness of art's functions, styles, social and historical contexts, and a familiarity with particular artists and their work. With a broad knowledge of art, one generally acquires the ability to relate to a wide range of creativity.

Written art criticism appears in periodicals, exhibition catalogs, and books; spoken criticism is heard in classrooms and in the statements of artists and art historians. Art writers generally inform people about exhibitions and events. *Reviews* are most often evaluations and

120 Pieter Brueghel.
THE PAINTER AND THE CONNOISSEUR. c. 1568.
Pen and bistre. 10″ x 8⅜″.
Albertina Collection, Vienna.

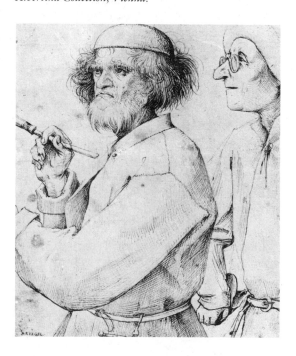

summaries of exhibits, much like theater reviews. Such reviews may influence the sale of an artist's work. Criticism in the classroom is intended to help students develop aesthetic sensitivity. More important than passing judgment on works is a teacher's or critic's ability to help others make their own evaluations.

Ideally, each person viewing a work of art will determine his or her own idea of its quality. This is difficult to achieve because each of us brings preconceptions to everything we see. We have heard that Leonardo da Vinci's painting MONA LISA is a great work of art. If this is foremost in our minds when we see the MONA LISA, our own direct experience of the painting becomes conditioned by acceptance of the idea that it is great.

Almost all of us have critical opinions on works of art, regardless of how familiar we are with art or theories of art criticism. There are no absolutely correct evaluations of art, although there are many procedures for analyzing, interpreting, and evaluating. When we look at art and find that we are pleased or displeased, we may seek to find out why. We may derive added pleasure from understanding more about those qualities of a work that evoke our responses. We all tend to like what we are familiar with; to increase our enjoyment it is necessary to expand our knowledge and awareness. Trained viewers can contribute their own experience and add to the satisfactions others may derive from a given work. Reading and hearing comments by critics can expand our capacities for understanding. In this sense, art criticism is a sharing of discoveries about art and life.

121 Leonardo da Vinci.
MONA LISA. c. 1503–1506.
Oil on wood. 30¼″ x 21″.
The Louvre, Paris.

3

The Visual Arts:
Media and
Methods

*Each art exists because the ideas
special to it cannot be transmitted
otherwise. . . .*

Vernon Blake[1]

Henri de Toulouse-Lautrec.
JANE AVRIL.
(See page 148.)

A *work of visual art* may be defined as anything of significance made by humans in which appearance is a primary consideration in its creation. Between the intention of the artist and the realization of the work there is a decisive interaction between the will of the artist, the qualities of the medium or material being worked, and the character of the developing design.

Materials such as wood, stone, plastic, metal, glass, paper, and paint each have their own unique form-making possibilities. For instance, wood has a natural warmth that is quite different from the hard and brittle yet fluid character of glass. In any work of art the maker shapes the material; and the material, in turn, contributes its own unique character to the work.

Certain materials and ways of working with them have long been favorites. A particular material, along with its accompanying technique, is called a *medium*. Popular media include carving in stone or wood, shaping clay by hand or on a potter's wheel, weaving with fibrous material, and oil painting on stretched canvas. When artists combine or mix materials and techniques in one work, the result is referred to as *mixed media*.

The human body itself becomes the basic material for visual expression in performing arts such as mime, dance, and drama. Recently developed media such as photography, film, and video, and materials such as polyester resin and electric light, offer new ways to express our insights and concerns.

There are certain things a medium does naturally, and other things it simply cannot do. The craftsman/artist must develop a keen sensitivity to the character and limits of the material used. It is self-defeating, for example, to try to make glass do what clay can do better. In each case the artist uses the medium that best suits the ideas and feelings to be expressed. The starting point may simply be a desire to work in a particular way with certain kinds of materials.

In the Western tradition the visual arts have been divided into two categories: fine arts and applied arts. *Fine arts,* such as painting and sculpture, are intended primarily for contemplation or visual enjoyment. *Applied arts,* such as furniture design and advertising art, are intended to serve utilitarian purposes as well as to be visually pleasing.

The terms fine arts and applied arts were coined before the Industrial Revolution, when artists or artisans were the sole suppliers of utilitarian objects for everyday use. The arts of painting, sculpture, and architecture were considered to be of a "higher" order, since they were thought to be involved primarily with aesthetics and the intellect. This traditional list of "fine arts" is problematic. The inclusion of architecture in the fine arts is confusing, since most successful architecture is utilitarian as well as beautiful and intellectually stimulating. What could be more utilitarian than putting a roof over one's head?

Craftsmen, no longer charged with the responsibility of providing all of our household goods, are now free to use "craft" media to create visual forms whose only purposes are to delight the eye or stimulate the mind. Thus there is no clear line separating fine and applied arts.

For example, this traditional Japanese RICE-STRAW EGG CONTAINER is clearly designed as a useful and beautiful solution to a mundane problem. But how do we classify Gerhardt Knodel's woven form on page 189, or Toshiko Takaezu's pot on page 182? Are they fine or applied art? They are made from materials traditionally associated with applied art, but they are certainly fine art by intention and result.

Technological advances have led to an increase in the number of jobs for artists and designers in many areas of industry and communications; artists now have the opportunity to use highly complex equipment—new media—to get the jobs done. As always, however, the ultimate criteria for success are the artist's own awareness, creativity, professional commitment, and skill. This chapter surveys the traditional visual arts, and also looks at some of the newer disciplines such as environmental design and computer graphics.

The arts presented in this book have a common bond in their visual form. In this chapter we have divided these arts into drawing, painting, printmaking, camera arts, performing arts, sculpture, crafts, design disciplines, architecture, landscape architecture, and urban/regional design. The sequence starts with drawing because artists working in other media often begin their work with drawings, and because it is a relatively simple and accessible means of developing and sharing ideas visually. It is a logical progression from drawing through painting to printmaking, camera arts, performing arts, and sculpture.

Although today's sculpture and crafts overlap, the crafts have traditionally been concerned with utilitarian objects. Therefore, in the remainder of the chapter covering crafts, design disciplines, architecture, landscape architecture, and urban/regional design, there is a gradually increasing concern for function in addition to communication through appearance.

122 RICE-STRAW EGG CONTAINER.
Yamagata Prefecture, northern Japan.
Photograph: Michikazu Sakai.

DRAWING

Drawing is one of the most immediate and accessible means of visual communication. Line is the fundamental element of drawing. Any person who can learn to write can learn to draw. In fact, learning to draw is in some ways easier than learning to write because it is less abstract. The most important factors in learning to draw are interest, integrity, and the ability to see. We must all begin in our own way, with our own vision and our own sense of line.

To draw, in the most elementary sense, means to pull, push, or drag a marking tool across a surface to leave a line or mark. Many other kinds of marks are also employed in draw-ings, including dots, shapes, and light to dark tones or values. It is even possible to make a drawing without lines. Georges Seurat relied on value gradations (chiaroscuro) in this draw-ing of his mother sewing.

Notice the different types of marks made by drawing tools. Some lines, like those made by the flexible brush and crow quill pen, are varied and fluid. Others, like the lines made with crayon and charcoal, are soft and textured. Lines made by sharp pencils and rigid pens are crisp. Compare the various qualities of the drawings reproduced in this section, noting the character of the medium used for each.

Drawing is practiced as a basic means of ex-pressing ideas quickly by artists working in most of the visual arts. Although drawing and

123 Georges Seurat.
THE ARTIST'S MOTHER (WOMAN SEWING). c. 1883.
Conté crayon on paper. 12¼" x 9½".
The Metropolitan Museum of Art, New York.
Joseph Pulitzer Bequest (1955).

124
DRAWING
TOOLS AND
CHARACTERISTIC
LINES.

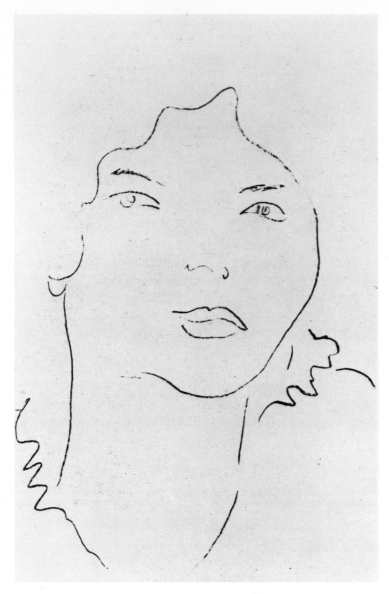

125 Henri Matisse.
PORTRAIT. c. 1916.
Crayon.
Location unknown.

painting are separate disciplines, the differences between them are sometimes vague. In one sense, painting is drawing with paint. However, painting is rarely used as a preliminary step in the process of creating works in other disciplines. Things as diverse as stamps and transportation systems both begin with drawings. A drawing can function in one or all of these ways:

☐ as a notation or record of something seen, remembered, or imagined
☐ as a study for something else, such as sculpture, film, or painting
☐ as an end in itself

Good drawing may appear deceptively simple. It can take years of hard work to be able to draw easily and effectively. According to one account, a person viewing a portrait drawn by Matisse with a great economy of line asked the painter with some disgust, "How long did it take you to do this?" "Forty years," replied Matisse.

Alberto Giacometti drew his face as he saw it reflected in a mirror, using the materials at hand—a ball-point pen and a napkin. The idea of exhibiting or selling this SELF-PORTRAIT was undoubtedly far from his mind. His primary impulse was to satisfy his compulsion to record what he saw and felt.

Anyone who is intrigued by the rich complexity of the visual world can develop that interest by drawing. Once involved, we draw whatever catches our eye or imagination. Many people keep a sketchbook to serve as a visual diary. From it, ideas may develop and reach maturity as complete works in drawing or other media.

In his book *The Zen of Seeing*, Frederick Franck describes drawing as an excellent awareness tool.

I have learned that what I have not drawn, I have never really seen, and that when I start drawing an ordinary thing I realize how extraordinary it is, sheer miracle: the branching of a tree, the structure of a dandelion's seed puff.[2]

126 Alberto Giacometti.
SELF-PORTRAIT. 1959.
Ballpoint pen on paper napkin.
7¼" x 5".
Private collection.

The process of learning how to draw from observation becomes a means for learning to see. Nowhere is this fact more visible than in the contrast between drawings produced by people who have not drawn from observation, and drawings made by those same individuals a few weeks later, after they learned to really see. Betty Edwards, through her teaching and her book, *Drawing on the Right Side of the Brain,*[3] helps people discover how to see and draw. The drawings from her book, reproduced here, show typical changes in drawing ability as a result of using Edwards' approach.

127
a Gerardo Campos. September 2, 1973.
b Gerardo Campos. November 10, 1973.
From Drawing on the Right Side of the Brain
by Betty Edwards.

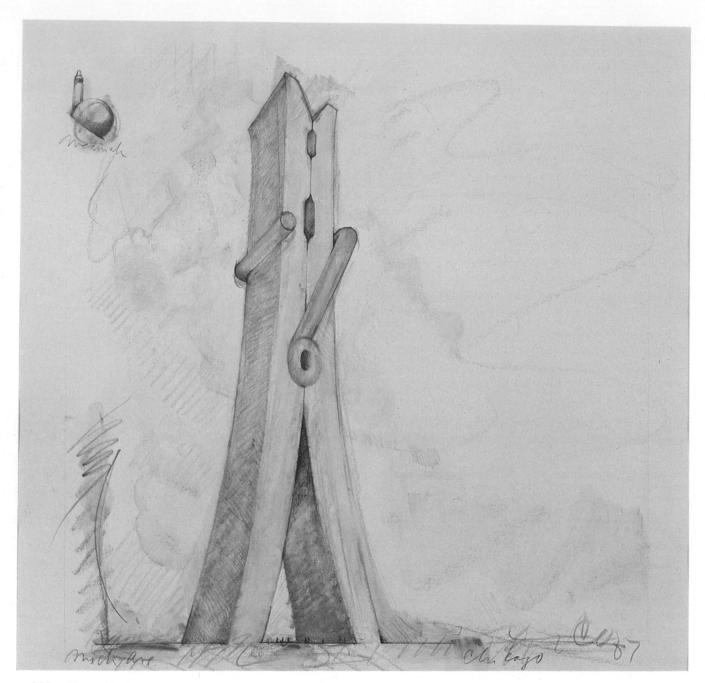

128 Claes Oldenburg.
LATE SUBMISSION TO THE CHICAGO TRIBUNE
ARCHITECTURAL COMPETITION OF 1922:
CLOTHESPIN (VERSION TWO). 1967.
Pencil, crayon, watercolor. 22″ x 23¼″.
*Des Moines Art Center. Gift of Gardner Cowles by exchange
and partial gift of Charles Cowles, New York (1972).*

The potential of drawing as a means for developing and presenting ideas seen in the imagination is apparent in Claes Oldenburg's drawing for a monumental building in the shape of a clothespin. All three functions are fulfilled in this drawing. It documents something imagined, it is a study for a work in another medium, and it is an end in itself. The monument's size was first visualized by Oldenburg, then defined on paper. Tiny figures and

casual use of linear perspective help to give awesome scale to the giant, somewhat humanized clothespin. Although the proposed building will probably never be built, it could be. As a drawing, the image stays in the realm of imagination. One result of the artist's drawings of monuments is the CLOTHESPIN sculpture in Philadelphia shown on page 403.

A simple drawing can act as the embryo of a complex work for which it was a study. Picasso did many preliminary drawings in preparation for the painting GUERNICA, a very large work measuring more than 11 feet high by 25 feet long. Forty-five of these drawings are preserved, all but one dated to a particular day. The overall concept of this complex work is contained in the very first drawing. If GUERNICA had never been painted, this drawing might have little significance. But as a study for such a painting, the drawing takes on added meaning.

The first drawing for GUERNICA is dominated by a woman with a lamp, apparently an important symbol to Picasso. The woman leans out of a house in the upper right. Below her, the lines indicate a horse lying on the ground with its head thrown up in a gesture of agony. On the left a bull appears with a bird on its back. These major elements in the final painting are indicated with Picasso's rapid, searching lines. Although this study was probably drawn in a few seconds, it captures in sudden gestures the essence of the final painting.

Two years before doing this drawing, Picasso wrote:

It would be very interesting to preserve photographically, not the stages, but the metamorphoses of a picture. Possibly one might then discover the path followed by the brain in materializing a dream. But there is one very odd thing to notice, that basically a picture doesn't change, that the first "vision" remains almost intact, in spite of appearances.[4]

131 Pablo Picasso.
GUERNICA. 1937.
Oil on canvas. 11′ 5½″ x 25′ 5¼″.
The Prado, Madrid.

129 Pablo Picasso.
First composition study for GUERNICA. May 1, 1937.
Pencil on blue paper. 8¼″ x 10⅝″.
The Prado, Madrid.

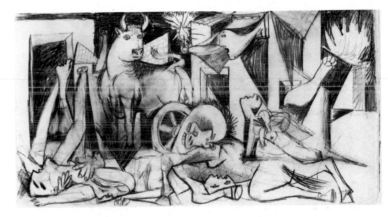

130 Pablo Picasso.
Composition study for GUERNICA. May 9, 1937.
Pencil on white paper. 9½″ x 17⅞″.
The Prado, Madrid.

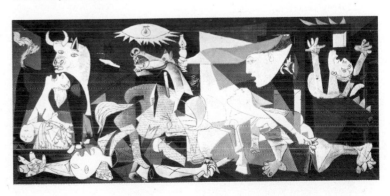

When Michelangelo made detailed studies for the LIBYAN SIBYL, he had no idea that reproductions of the sheet of working drawings would be seen and loved by perhaps as many people as have enjoyed the finished painting of the figure on the ceiling of the Sistine Chapel.

This magificent drawing of a mythical female figure was drawn from a male model. The studies are a record of search and discovery made as

Michelangelo carefully drew what he observed. His understanding of anatomy helped him to define each part. The rhythmic flow between the head, shoulders, and arms of the figure is based on Michelangelo's feeling for visual continuity, as well as his attention to anatomic accuracy. The parts of the figure that he felt needed further study were drawn more than once.

132 Michelangelo Buonarotti.
Studies for the LIBYAN SIBYL
on the Sistine Chapel ceiling.
c. 1508. Red chalk. 11⅜″ x 8⅜″.
*The Metropolitan Museum
of Art, New York, Purchase (1924),
Joseph Pulitzer Bequest.*

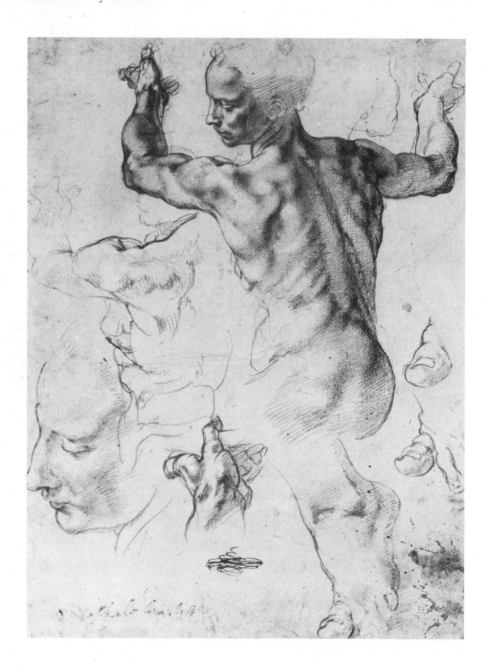

Vincent van Gogh, like Michelangelo, learned a great deal about visual form by drawing. Michelangelo had fully developed his artistic ability when he drew the studies for the LIBYAN SIBYL. Van Gogh was just beginning his short career as an artist when he completed this drawing of a carpenter. Although clumsy in proportion, his drawing reveals the careful observation of a persistent, hard-working man. Both van Gogh and Michelangelo remained true to themselves in their work, each leaving an account of their individual feelings and perceptions.

In the following drawings, the artists' individual points of view as well as the use of different media and techniques produce unique images that contrast in both appearance and mood. Each drawing tool and each type of paper has its own characteristics.

The portrait study by Alphonse Legros, HEAD OF A MAN, gives the appearance of low relief sculpture (see the Greek coin, page 169). The medium used was *silverpoint*. No variation in width of line or gradation in value is possible with this medium. Tones, or values, are built up with parallel lines called *hatching*, or with *cross-hatching* of various types. Silverpoint will only mark a specially coated surface. Lines are made of actual silver, which produces an even gray line that soon darkens with oxidation.

133 Vincent van Gogh.
CARPENTER. c. 1880.
Black crayon. 22″ x 15½″.
*State Museum Kröller Müller,
Otterlo, Netherlands.*

135
a. HATCHING. b. CROSS-HATCHING.

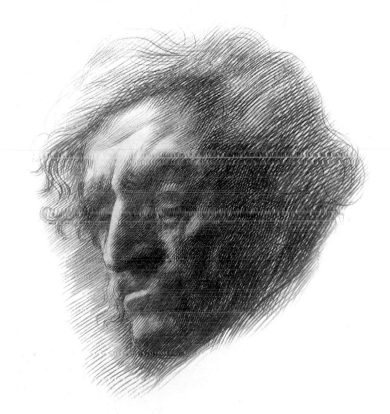

134 Alphonse Legros.
HEAD OF A MAN. 1892.
Silverpoint. 8¾″ x 7″.
*The Metropolitan Museum of Art, New York.
Gift of the artist (1892).*

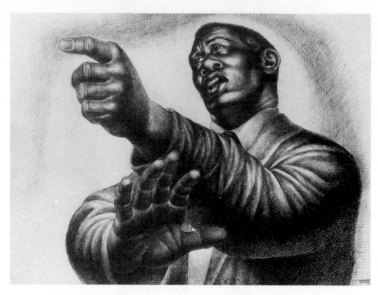

136 Charles White.
PREACHER. 1952.
Ink on cardboard. 21³/₈″ x 29³/₈″.
Whitney Museum of American Art, New York.
Purchase.

137 Charles Sheeler.
FELINE FELICITY. 1934.
Crayon. 14¹/₈″ x 13¹/₄″.
Fogg Art Museum, Harvard University,
Louise E. Bettens Fund.

Charles White used crosshatched ink lines in PREACHER to build up the figure's mass and gesture in a forceful manner. The drawing has sculptural solidity as well as softness. The strongly foreshortened right hand and forearm add to the drawing's dramatic impact.

Charles Sheeler drew FELINE FELICITY with artist's crayon on fairly rough paper (such paper is said to have *tooth*). The result is a very detailed image, rich in value changes. Light and shade work together in an intricate pattern. This is a good example of drawing done as an end in itself, although drawings do not have to be this refined or detailed to be considered finished independent works.

Nineteenth-century Japanese artist Hokusai was a skilled draftsman. It is estimated that he created about 13,500 prints and drawings. Yet his humorous statement about the development of his own ability reveals a person who has experienced the feelings of self-doubt known to many of us, and has prevailed against them.

I have been in love with painting ever since I became conscious of it at the age of six. I drew some pictures which I thought fairly good when I was fifty, but really nothing I did before the age of seventy was of any value at all. At seventy-three I have at last caught every aspect of nature—birds, fish, animals, insects, trees, grasses, all. When I am eighty I shall have developed still further and will really master the secrets of art at ninety. When I reach one hundred my art will be truly sublime and my final goal will be attained around the age of one hundred and ten, when every line and dot I draw will be imbued with life.

(signed) Hokusai
The art-crazy old man[5]

In TUNING THE SAMISEN the expressive energy of Hokusai's lines was made possible by the responsiveness of his brush. He played the uniformly thin lines detailing head, hands, and instrument against the bold, spontaneous rhythms indicating the folds of the kimono. With humor and insight he captured a moment of concentration.

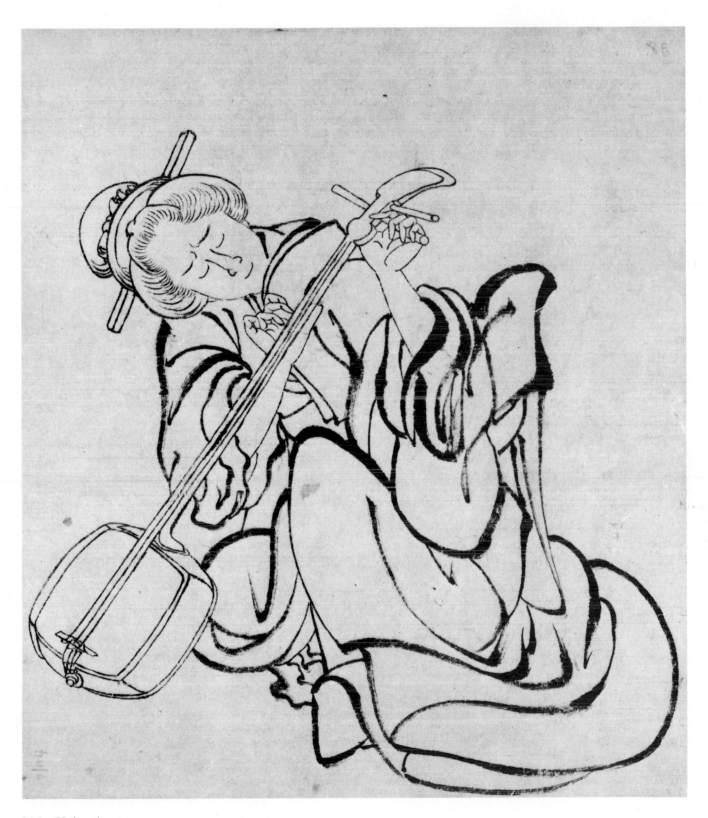

138 Hokusai.
TUNING THE SAMISEN. c. 1820–1825.
Brush drawing. 11″ x 87/8″.
Freer Gallery of Art, Smithsonian Institution,
Washington, D.C.

Rembrandt also used brush and ink to draw his wife, Saskia. The result, SASKIA ASLEEP, is at once bold and subtle, representational and non-representational, finished and unfinished. As a total image, it is complete. His technique bears comparison to the Oriental brush painting tradition, as seen in the work of Hokusai.

A *cartoon* is an illustrative drawing in which humorous or satirical content is emphasized (see pages 1 and 6). The term is also used to refer to a full-sized drawing made as a guide for a finished painting, particularly a fresco painting (see page 141).

Although drawing involves relatively simple means, the impact of ideas expressed in drawings can be great. Art used as a means for bringing about social change is seen in this caricature, A GROUP OF VULTURES WAITING FOR THE STORM TO "BLOW OVER"—"LET US PREY," by nineteenth-century American political cartoonist Thomas Nast. Through his visual indictments of "Boss" Tweed and his henchmen, Nast

139 Rembrandt van Rijn.
SASKIA ASLEEP. c. 1642.
Brush and wash. 9½″ x 8″.
British Museum, London.

PAINTING

140 Thomas Nast.
A GROUP OF VULTURES WAITING
FOR THE STORM TO "BLOW OVER"
—"LET US PREY."
Wood engraving.
From Harpers Weekly, September 23, 1871.

effectively aroused public indignation that led to the downfall of the Tweed Ring, a corrupt group of politicians and city officials who held absolute power in New York City from 1857 until their demise in 1871. Nast's drawings were probably copied by a skilled engraver in order to reach the public by way of the press.

The nature of paint makes it possible to do certain things that cannot be done with other media. Painting media consist of three components: pigment, binder, and vehicle. *Pigments* provide the range of colors, the *binder* holds the pigment together, and the *vehicle* is the dispersing agent for spreading the pigments.

With oil paints, turpentine is the vehicle that spreads or disperses the pigment particles and linseed oil is the binder that holds the pigment particles together for permanence. With acrylic-based paints, water becomes the vehicle and acrylic polymer medium is the binder. With one type of tempera, water is the vehicle and egg yolk is the binder. In fresco water is the vehicle, and the chemical action of lime in the lime-plaster wall acts as the binder.

Pigments are dry coloring agents in powder form. The same pigments used in paint media are also the coloring agents for dry media such as crayons and pastels. Until recently, pigments were earth colors and natural dyes. Today many pigments are synthetically produced.

Paints are usually applied to a flat *support*, such as stretched canvas for oils and paper for watercolors. The surface of the support may be prepared by sizing and priming to achieve a *ground* (the surface on which a painting is made) that will have the proper absorbency and permanence.

Size is a substance, usually made with glue, that is used to penetrate and fill in the pores of material such as paper or canvas to protect it from the corrosive action of some kinds of paint. To *prime* a surface means to prepare it for painting by covering it with size, primer, or other undercoat. For watercolors, sizing and priming are unnecessary; a paper surface provides both the support and the ground.

To a large extent the evolution of various kinds of visual images has been determined by the development of painting media. Each painting medium has its own characteristics that influence resulting images.

Watercolor

Watercolor paintings are made by applying pigments suspended in a solution of water and gum arabic to white paper. Rag papers are the preferred supports. Paper quality is important because the whites or highlights in the paintings depend on the lasting whiteness of the paper. Paint is laid on in thin transparent *washes*. Sometimes *opaque* (nontransparent) watercolor is added for detail. When employed skillfully, watercolors provide a medium well suited to spontaneous application. In spite of the simple materials involved, it is not an easy medium to handle because it does not readily allow change or correction. Watercolor paint must be applied quickly; it cannot be reworked without losing its characteristic freshness.

The fluid spontaneity possible with watercolor makes it a favorite medium for landscape painters, who use it to catch quick impressions

141 Joseph Mallord William Turner.
THE BURNING OF THE HOUSES OF PARLIAMENT. 1843.
Watercolor from a sketchbook. 9¼" x 12¾".
British Museum, London.

of outdoor light. Transparent washes are masterfully combined in William Turner's watercolor sketches, as in THE BURNING OF THE HOUSES OF PARLIAMENT. This immensely prolific English painter was fascinated by the atmospheric qualities of light and color and their effect on space.

Both transparent and opaque areas are used in John Marin's MAINE ISLANDS. Foreground and background interact, giving a sense of energy and flow in nature. Marin developed his own fusion of representational and abstract elements. In MAINE ISLANDS he combined suggestions of a panoramic view with diagonal lines that fragment the picture plane, giving the feeling of seeing through transparent planes into deep space. The look of transparency is consistent with the major characteristic of the medium.

Chinese watercolor painting employs ink as well as color. The artist and the viewer are expected to know the basic precepts of Chinese painting and the attitudes that animate them. Paintings may be developed with opaque, individually significant brush strokes, as well as with washes of ink or color. When ink is diluted with water it can be applied transparently, as in watercolor, making a wide range of gradation possible.

Tao Chi probably painted A MAN IN A HOUSE BENEATH A CLIFF with a single brush. The vigorous strokes indicate a mountain cliff filled with the *ch'i*, or energy force, that Tao Chi must have felt within himself and perceived in nature. Areas of light color provide a balance to the dynamic power of the brush-drawn lines.

142 John Marin.
MAINE ISLANDS. 1922.
Watercolor. 16³/4″ x 20″.
The Phillips Collection, Washington, D.C.

143 Tao Chi (Shih Tao).
A MAN IN A HOUSE BENEATH A CLIFF. c. 1800.
Ink and light color on paper. 9¹/2″ x 11″.
Collection of Mr. and Mrs. C. C. Wang, New York.

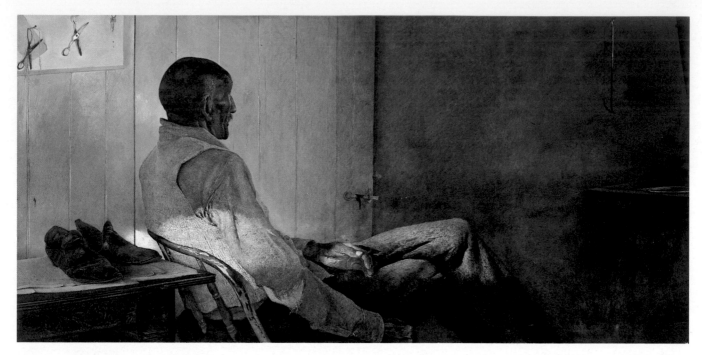

144 Andrew Wyeth.
THAT GENTLEMAN. 1960.
Egg tempera on board. 23¼″ x 47¾″.
Dallas Museum of Fine Arts.
Dallas Art Association purchase.

Gouache is opaque watercolor commonly known as *poster paint* and occasionally incorrectly called "tempera." Effects similar to those obtainable with oil painting can be achieved with less trouble and expense, yet gouache is not as permanent as oil, and colors dry much lighter in value than they appear when wet. Many leading artists have enjoyed the simplicity and versatility of gouache, often using it to make quick studies for paintings done in other media. It is also a good medium for children and other beginners (see the child's painting, TREE, on page 24).

Tempera

Today the word *tempera* is used to include water soluble paints with binders of glue, casein, egg, or egg and oil in emulsion. Tempera paints are water-thinned, and have a *matte* (nonshiny) surface when dry. They are good for working in precise detail, and will not darken with age. Their main disadvantages are color changes during drying and difficulty in blending and reworking. Another problem with tempera is the necessity for a rigid support that will not contract and expand with humidity changes. Such movement of the support would cause the gesso ground and the pigment to crack and flake off the support. *Gesso* is a preparation of chalk or plaster of Paris and glue used as a base for paintings done in various media.

Tempera, in historical terms, refers to *egg tempera*. Its brightness and durability cannot be matched by any other traditional painting medium. The use of egg tempera was widespread in Europe until it was largely replaced during the Renaissance by oil paints. (See Fra Filippo Lippi's MADONNA AND CHILD, page 46.) Andrew Wyeth is a contemporary American artist who works in egg tempera. In his painting THAT GENTLEMAN, Wyeth created an interweaving of rich detail and subtle color to evoke a quiet mood of inner reflection. In George Tooker's THE SUBWAY (see page 431) egg tempera was used to create a haunting image.

Oil

Linseed oil has been a favorite painting medium for five hundred years. Pigments mixed with various vegetable oils, such as linseed, walnut, and poppyseed, were used in the Middle Ages for decorative purposes. But it was not until the fifteenth century that Flemish painter Jan van Eyck and others first used oil medium for representational paintings on wooden panels. In this early period oils were applied to a panel covered with smooth layers of gesso, as in the older tradition of tempera painting. Van Eyck began on the panel with a brush drawing that was followed by underpainting in tempera. He finally built up the luminous quality of the surface with successive, thin, transparent coats of oil paint called *glazes* (see GIOVANNI ARNOLFINI AND HIS BRIDE, page 294).

Oil made from flaxseed, called linseed oil, became the standard binder for oil paint. Oil offers more flexibility than other traditional media. One of its greatest advantages is its slow drying time and its capacity to be reworked repeatedly. Colors can be smoothly blended. In contrast to tempera, gouache, and acrylics, oil colors change very little when drying, and high color saturation is possible even at low values. Traditional representational paintings are generally begun with a monochromatic underpainting to establish the pattern of light and dark areas. This is followed by additional color often applied in glazes. Glazes are made with transparent oil colors thinned with turpentine. Through the use of glazes, subtle effects can be created, giving a feeling of rich luminosity and atmosphere. After the paint dries, varnish may be applied to heighten the color and protect the surface.

In the sixteenth century Venetian painters began using stretched canvas primed with a mixture of glue and white pigment as a way to provide a larger lightweight support for oil paintings. The bolder imagery of these Italian painters was achieved directly in oil without underpainting in tempera. Venetian painting of the Renaissance is characterized by a sensuous use of color and light, achieved partly through the use of glazes (see Titian's BACCHANAL OF THE ANDRIANS on page 303).

Oil can be applied thickly or thinly, wet into wet or wet onto dry. Applied thinly, mixed with varnish, it is excellent for building up transparent glazes; when applied thickly it is called *impasto*. In Rembrandt's HEAD OF SAINT MATTHEW on page 75 the head is molded with an impasto of heavy daubs of light and dark pigment, creating a solid-looking figure.

145 Hans Hofmann.
THE GOLDEN WALL. 1961.
Oil on canvas. 60″ x 72¼″.
The Art Institute of Chicago.

To see the wide range of approaches possible with oil paint, compare Vermeer's rich detail and subtly glazed colors on page 311 with the thick impasto of Hans Hofmann's THE GOLDEN WALL.

In both his art and his teaching Hofmann emphasized the translation of personal states of being into nonrepresentational form. Rather than imitate physical life, Hofmann created pic-torial life. In THE GOLDEN WALL he worked with the dynamics of advancing and receding color, movement and counter movement. Static hard-edge rectangles assert their presence in a field of vigorous, irregular shapes. The painting is a visual environment in which the paint records Hofmann's gestures.

Acrylic

Synthetic painting media are now in wide use. The most popular are *acrylics*, in which pigments are suspended in acrylic polymer medium, providing a fast-drying, flexible film that can be opaque or transparent. Acrylics are relatively permanent and may be applied to a wider variety of surfaces than can traditional painting media. Most acrylics are water-thinned and water-resistant when dry. Unlike oil paint, acrylics are not likely to darken or yellow with age, and they dry more rapidly than oils.

When dry, acrylic paint is inert and will not damage cloth fibers over a long period of time the way oil paint does. Thus acrylics can be applied directly to unprimed canvas. This quality has resulted in a variety of staining techniques in which the paint, thinned with water, acts more as a dye than as a coating on top of the canvas. Helen Frankenthaler's painting INTERIOR LANDSCAPE (see page 393) was achieved this way.

In recent years a large number of painters have used *air brushes* to apply their paint. An air brush is a refined, small scale paint sprayer capable of projecting a fine, controlled mist of paint. It creates a smooth, even surface, well-suited to the impersonal imagery found in many paintings of the 1960s and 1970s (see Don Eddy's painting PRIVATE PARKING X on page 418).

The huge portrait of FRANK by Charles Close was painted on primed canvas using only a few tablespoons of black acrylic paint. Close worked from his own photograph, enlarging it to monumental scale and adding the surface qualities of thin paint applied with a fine brush. The final image has the cool, detached quality of a photographic recording of the subject as an object, without revealing the inner life of either the artist or the person portrayed. Compare FRANK with the somewhat warmer portrayal of another curly-haired young man painted in wax about 1800 years ago in Egypt (next page).

146 Charles Close.
FRANK. 1968–1969.
Acrylic on canvas. 7' x 9'.
Minneapolis Institute of Arts.

147 MUMMY PORTRAIT OF A MAN. 160–170 A.D.
Encaustic on wood. 14″ x 8″.
From Fayum, Egypt.
Albright-Knox Art Gallery, Buffalo, New York.
Charles Clifton Fund (1938).

Encaustic

Encaustic, in which pigments are suspended in hot beeswax, is an ancient painting medium. Encaustic paintings have a lustrous surface that brings out the full richness of colors. Due to the difficulties involved in keeping the wax binder at just the right temperature for proper handling, encaustic is not a popular medium. The results seem to justify the effort, however. The PORTRAIT OF A MAN from Egypt was painted in encaustic on wood. Its lifelike vigor and individuality remain strong. (See also Jasper Johns' TARGET WITH FOUR FACES on page 398.)

Fresco

True fresco or *buon fresco* is an ancient wall-painting technique in which pigments suspended in water are applied to a damp lime-plaster surface. Generally, a full-size drawing called a *cartoon* is completed first; this is transferred to the freshly laid plaster wall before painting. Since the plaster dries quickly, only the portion of the wall that can be painted in one day is prepared, with joints usually arranged along the edges of major shapes in the composition. The painter works quickly in a rapid staining process similar to watercolor, in which the "paint" seeps into the fresh plaster. The pigment becomes chemically bonded with the plaster, resulting in a smooth, extremely durable surface. It may take 12 to 14 hours of work in a day just to complete two square yards of a fresco painting. Since no changes can be made after paint is applied to the fresh plaster, the artist must have the design completely worked out before beginning to paint.

Secco fresco, another ancient wall-painting method, is done on finished, dried, lime-plaster walls. With this technique tempera paint is applied to a clean, dry surface, or over an already dried buon fresco. Another technique involves saturating the fully dried plaster with lime

water, and then painting with *casein*, a milk-base paint.

Fresco has been used in diverse cultures and geographical areas for thousands of years. It became the favored medium for decorating church walls in Italy during the Renaissance. Giotto's LAMENTATION in the Padua Chapel (see page 293) is representative of frescoes from this period. After the Renaissance, the medium fell into disuse, eclipsed by the more flexible medium, oil. A revival of the fresco technique began in Mexico in the 1920s, encouraged by the new revolutionary government's support for public murals. Diego Rivera was a major figure in the group of artists who revived fresco mural painting. His personal style is related to that of others in the group in its blending of European and native art traditions with contemporary subject matter. The murals for the Palace of Cortez show his sense of architectural form in the handling of images. The detail of Rivera's painting ENSLAVEMENT OF THE INDIANS dramatizes a tragic chapter in Mexico's history.

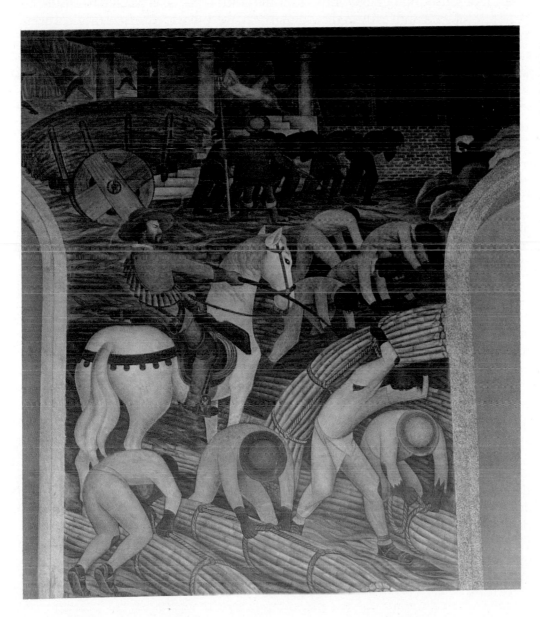

148 Diego Rivera. ENSLAVEMENT OF THE INDIANS. 1929–1939. Fresco. Lower width of panel 2.10 m. *Palace of Cortez, Cuernavaca, Mexico.*

PRINTMAKING

In the West, printmaking began with the need for artists to keep up with the demand caused by the invention of movable type. It is now a creative medium in its own right. Because our lives are full of images that are printed as multiples, it is difficult for us to imagine a time when the only pictures ever seen were one-of-a-kind originals.

This book was reproduced by a mechanical printing method called offset lithography. Lithography was not developed until early in the nineteenth century, but other forms of multiple printing were used in China as early as 200 B.C. and in Europe by the fifteenth century A.D.

Until the twentieth century, multiple image-making procedures usually included artists, artisans, and laborers. As photomechanical methods of reproduction developed, handwork by artists played an increasingly minor part in the process. Images of original works were no longer drawn or cut into the printing surface by hand copying. Artists, however, have continued earlier printmaking processes in order to take advantage of the unique properties inherent in printmaking media. They also make their works less expensive and more readily available to the public by designing and printing multiple originals.

A *print* signifies an artist's handmade multiple original; and a *reproduction* signifies a photomechanical copy of an original. Original prints, regardless of type, are printed by the artist or under the artist's supervision from plates, blocks, stones, or stencils produced by the artist. Any original art work reproduced photographically or by a purely mechanical process is not an original print. If close scrutiny, perhaps with a magnifying glass, reveals a regular pattern of small dots of the type shown on page 69, then the work is a reproduction, not a handmade print. Original *serigraphs* (screen prints) have a layer of ink that looks like paint on top of, rather than absorbed by, the paper. *Etchings* and *engravings* are produced with a printing press, which causes the edge of the plate to leave an indentation in the paper.

As part of the printmaking process, sample prints or *proofs* are made at various stages to indicate how the block, plate, stone, or screen is developing.

Most original prints are signed in pencil in the margin indicating personal involvement and approval by the artist, of the original print. Original prints are generally produced in limited *editions*. Artists usually destroy the plate after the edition has been printed to ensure the integrity of their work. Nearly all original prints are numbered with a figure that indicates the number of prints *pulled*—that is, printed—in the edition, and the number of the individual print in the sequence. The figure 6/50, for example, indicates that the edition totaled 50 prints and that this was the sixth print pulled.

The concept of original prints may be difficult to maintain at a time when good reproductions are readily available. Although they are only mechanical copies, modern reproductions make the art of the world available to us as never before. As French critic André Malraux stated, "A museum without walls has been opened to us. . . ."[6]

Some artists use photomechanical means to reproduce their own works; these are then sold as signed prints, sometimes called "art prints." This action is based on the feeling that it is most important to get one's work seen and to be able to make a living from selling it. The practice raises interesting ethical questions about the value of the original and the extent to which art should be governed and motivated by profit.

There are four basic printmaking methods: relief, intaglio, lithography, and screen printing. All but screen printing will produce a reversed version of the original image as drawn on the plate, block, or stone. As printmakers combine traditional methods and add new ones, the possibilities inherent in print media become endless.

Relief

In a *relief* process the parts of the printing surface not meant to carry ink are cut away, leaving the design to be printed in relief at the level of the original surface. The surface is then inked and the ink is transferred to paper with pressure. Relief processes include *woodcuts, wood engravings, linoleum* (or *lino*) *cuts,* and *metal cuts.*

The woodcut process lends itself to designs with bold contrasts of black and white. Color can also be printed by this method if blocks for each color are cut and carefully *registered*—lined up—to ensure that colors on separate blocks are exactly placed.

Color block printing was developed in Japan in 1741 and eventually evolved into a complex process capable of achieving subtle color effects. During the century since his death, Hokusai's color woodcut prints have become well known around the world. Hokusai worked in close collaboration with highly skilled craftsmen to realize the final prints. For each of his woodcuts, specialists transferred Hokusai's free brush painting in watercolor to as many as 20 blocks, then cut the blocks. A different block was used for each color to be printed. WAVE AT KANAGAWA is one of Hokusai's THIRTY-SIX VIEWS OF MT. FUJI. A clawing mountain of water dwarfs the tiny fishermen in their boats, climaxing the rhythmic curves of the churning ocean. The only stable element is the distant peak of Mt. Fuji. A more realistic rendering would not have been as effective in capturing the awesome power of the sea.

149
RELIEF BLOCK.

150 Hokusai
WAVE AT KANAGAWA
from the series
THIRTY-SIX
VIEWS OF MOUNT FUJI.
c. 1830. Color woodblock
print. 10¼" x 15⅛"
*Honolulu Academy
of Arts. Gift of James
A. Michener.*

The detail found in Hokusai's print is quite different from the bold simplicity of PROPHET, a woodcut print made by German artist Emil Nolde in 1912. Each cut in the block reveals the expressive image of an old man and also the natural character of the wood itself. The resulting light and dark pattern is striking.

Intaglio

Intaglio is from the Italian word *itagliare* meaning "to cut into." Intaglio printing is the reverse of relief, because the areas below the surface hold the ink. The design to be printed is either etched into a metal surface by "biting" with acid or incised by "engraving" the lines with sharp tools. The plate is coated with viscous printer's ink, then wiped clean, leaving ink only in the cuts. A print is made by transferring the ink to damp paper with the pressure of a printing press. Intaglio processes most frequently used are etching and engraving.

An *etching* is made by drawing lines through a protective ground material made of beeswax and lampblack, which covers a copper or zinc plate. The plate is then placed in acid. Where the drawing has exposed the metal, acid eats into the plate, making a groove that varies in depth according to the strength of the acid and the length of time the plate is in the acid. *Aquatint* is an etching process used to obtain uniform areas of differing values.

In metal *engravings*, the lines are cut into the plate with a graver or burin. This process takes strength and control. The precise lines of an engraving do not appear as casually drawn as etched lines due to the differences in the two processes. In the United States paper money is printed from engraved plates. The precise smooth curves and parallel lines of engraving are apparent in the portraits on paper currency.

Compare the line quality in Rembrandt's etching CHRIST PREACHING with the line quality in Albrecht Dürer's engraving KNIGHT, DEATH AND DEVIL. The precision of Dürer's lines seems appropriate to the subject—an

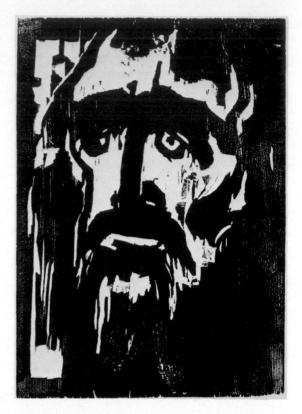

151 Emil Nolde.
PROPHET. 1912.
Woodcut. 12⅝″ x 8⅞″.
National Gallery of Art, Washington, D.C.
Rosenwald Collection.

152
ETCHED PLATE.

153
ENGRAVED PLATE.

154
EXAGGERATED CHARACTERISTICS OF AN ETCHED LINE AND AN ENGRAVED LINE.

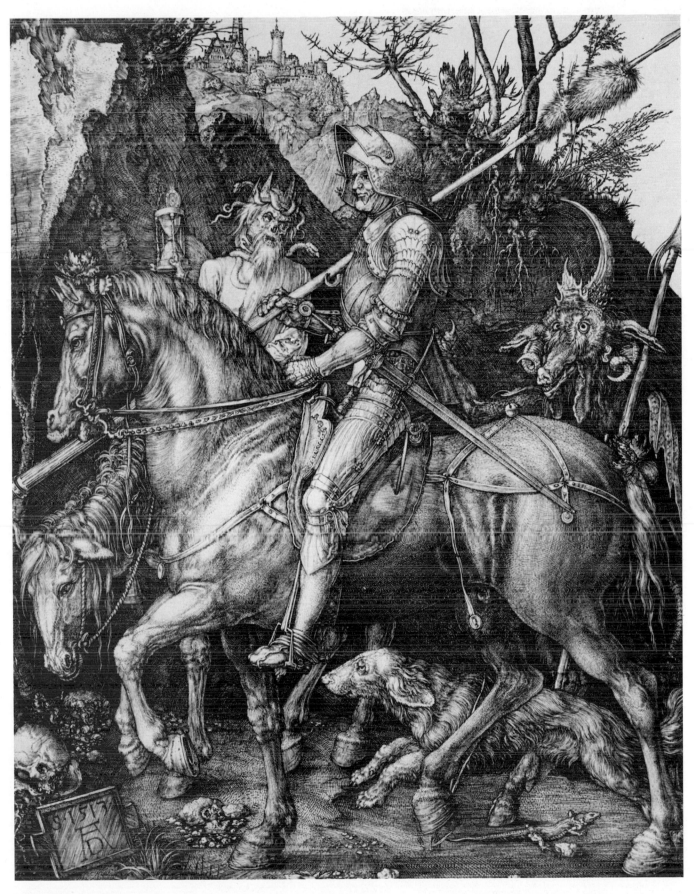

155 Albrecht Dürer.
KNIGHT, DEATH AND DEVIL. 1513.
Engraving. 9¾″ x 7⅜″.
The Brooklyn Museum. Gift of Mrs. H. O. Havemeyer.

image of the Christian soldier going with stead-fast faith to the heavenly city of Jerusalem, seen in the upper background of the print. Here Dürer's print is reproduced close to its actual size so that the complex richness of engraved lines may be seen.

In CHRIST PREACHING, Rembrandt's gentle compassion is evident in the slightly relaxed quality of his etched lines. In the seventeenth century woodcuts and engravings were commonly used to reproduce paintings. Creative printmakers such as Rembrandt preferred etching, often adding lines scratched directly into the plate for additional subtle effects. Such lines are called *drypoint* lines because an acid bath is not used. In his depiction of Christ preaching Rembrandt worked in a wide range of tonal values, creating variety within each value area. The strong light and dark pattern is typical of much of the art of that period (see the discus-sion of Baroque art beginning on page 306) and a major component of Rembrandt's style. It adds clarity and emotional feeling to his por-trayal of the religious story.

Lithography

Lithography is planographic (surface) printing. The process lends itself well to a direct manner of working because the image is drawn on the surface of the stone or plate without any biting or cutting of lines. This directness makes lithog-raphy faster and more flexible than other meth-ods, and difficult to distinguish from drawing.

The image is drawn or painted on smooth, fine-grained, Bavarian limestone or on a metal surface developed to duplicate the character of the stone. An image is created with special litho-

156 Rembrandt van Rijn.
CHRIST PREACHING. c. 1652.
Etching. 6¹/₁₆″ x 8¹/₈″.
The Metropolitan Museum of Art, New York.
Bequest of Mrs. H. O. Havemeyer (1929).

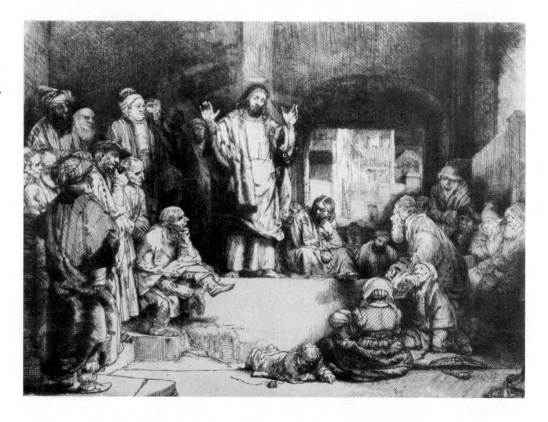

crayons, pencils, or inks containing a greasy substance called *tusche*. The surface is then chemically treated to "fix" the drawing on the upper layer of the stone. The surface is dampened with water, and inked. The ink is repelled by the moisture in the blank areas, but adheres to the greasy area of the image. When this surface is covered with paper and run through a press, a printed image of the original is produced.

Although lithography was a relatively new medium in the early 1800s, it had a major impact on society because of its comparative ease and speed of execution. It provided the visual material for newspapers, posters, and handbills. Honoré Daumier, one of the first great lithographers, made his living drawing lithographs for French newspapers. His personal style was well suited to the direct quality of the lithographic process.

In RUE TRANSNONAIN Daumier carefully reconstructed an event that occurred during a period of civil unrest in Paris in 1834. The militia claimed that a shot was fired from a building on Transnonain Street. Soldiers responded by entering an apartment and killing all the occupants. Daumier's lithograph of the event was published the following day. The lithograph conveyed information in the way photographs do today, but clearly reflects the artist's sentiments. The prone figures and disheveled bedding show the aftermath of violence. Rembrandt's influence is felt in the organization of strong light and dark areas that increase the dramatic sense of tragedy.

157
LITHO STONE OR PLATE.

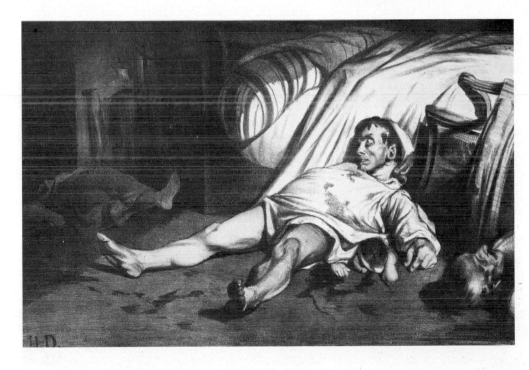

158 Honoré Daumier.
RUE TRANSNONAIN. 1834.
Lithograph. 11¼″ x 17⅜″.
The Cleveland Museum of Art.
Gift of Ralph King.

159
Henri de Toulouse-Lautrec.
JANE AVRIL. c. 1893.
Photograph.

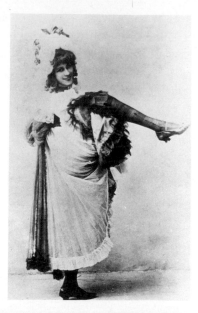

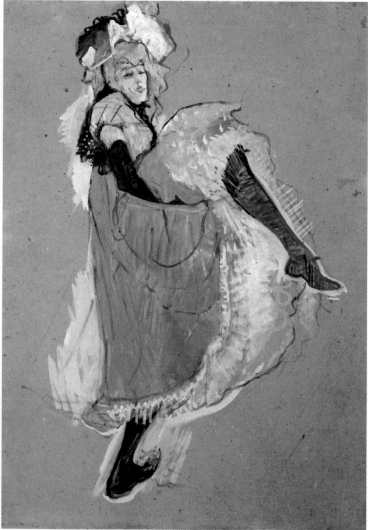

In the space of about 10 years master painter and graphic "designer" Henri de Toulouse-Lautrec created over 300 lithographs. Many of these were posters advertising people and products ranging from nightclub entertainers to bicycles. His posters of cabaret singer and dancer Jane Avril made her a star and simultaneously gave Parisians of the 1890s a firsthand look at "modern art" by a leading artist. The popular lithographic poster shown here appears to have begun with an awkward photograph and came to life in a dynamic and highly colorful oil sketch. The sketch was then incorporated as the key element in a strong lithograph drawn with brush and liquid tusche on the litho stone. Compare the angles of feet and legs in the photograph with the sketch and print. Lautrec used diagonal lines and curves to give a sense of motion to the photo image. In the print the figure is placed in the proper setting, offset by the silhouetted shape of a bass player. Strong black shapes and fluid brush lines retain much of the lively vigor and dramatic pattern of the sketch, and also reflect Lautrec's early love for Japanese prints. (See the discussion of Toulouse-Lautrec on page 339.)

160 Henri de Toulouse-Lautrec.
JANE AVRIL. c. 1893.
Oil study on cardboard. 38″ x 27″.
Private collection.

161 Henri de Toulouse-Lautrec.
JANE AVRIL. JARDIN DE PARIS. c. 1893.
Lithograph printed in color. 48⅝″ x 35⅛″.
The Museum of Modern Art, New York.
Gift of A. Conger Goodyear.

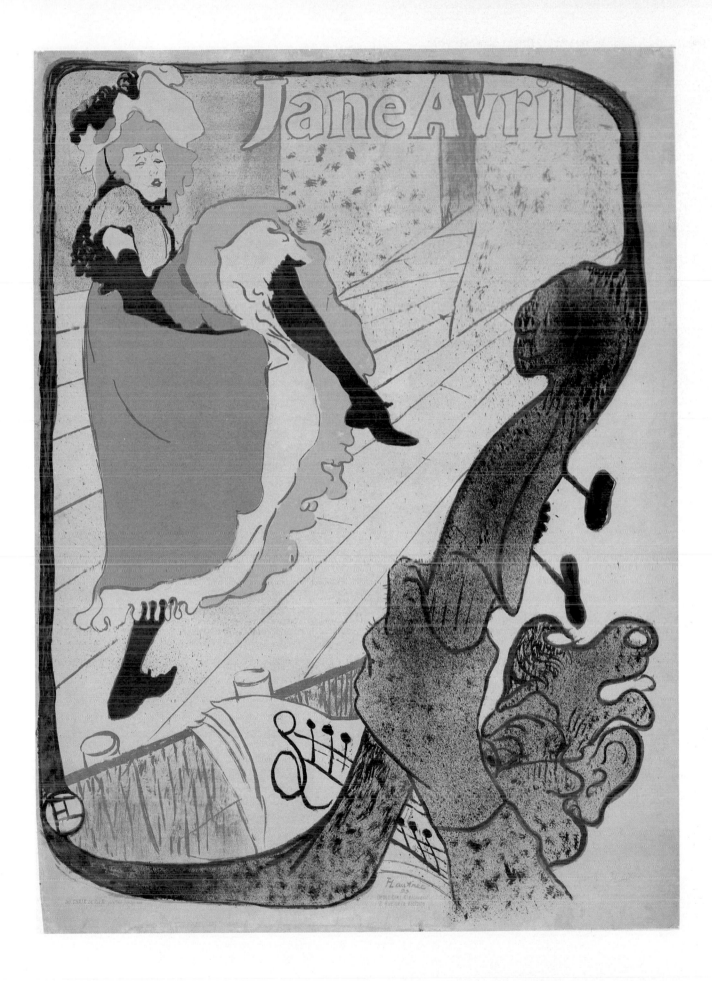

Screen Printing (Serigraphy)

The most recently perfected printmaking process is essentially a stenciling technique known as *screen printing* or *serigraphy*. Common *stencils* are used as a means of transferring letters and other shapes to a flat surface. To make a stencil, an opening is cut in a nonporous material. It is then held firmly against a surface while pigment is brushed through, leaving a corresponding image. Early in this century stencil technique was improved by adhering the stencil to silk fabric stretched across a frame (synthetic fabric is used today). The screen is placed on paper or other material and a rubber-edged tool called a *squeegee* pushes the paint or ink through the open pores of the fabric, printing the design.

Screen printing is well-suited to the production of multiple color images. Each separate color change requires a different screen, but registering and printing are relatively simple. Victor Vasarely's serigraph UNTITLED uses an optical illusion to create an impression of a diagonal cross. Serigraphy met Vasarely's needs for a printing process that would lend itself to the precision his art required. Freer, more expressive images may be made by brushing liquid tusche (the same substance used for drawing in lithography) on the screen to block out areas.

Mayumi Oda employs relatively simple and direct means to produce her colorful multilayered screen prints. Pure colors, fluid lines, and ample curving shapes fill her vigorous and playful compositions. GODDESS COMING TO YOU; CAN YOU COME TO HER? is representative of the joyous exuberence of her work. Her dual Japanese and American cultural background is evident in her integration of traditional art, mythology, and Zen Buddhism with modern concepts of form.

The latest development in screen printing is the photographic stencil or *photo screen*, achieved by attaching light-sensitive gelatine to the screen fabric. A developing solution and exposure to light make the gelatine insoluble in water. The gelatine is exposed to light through a positive image on film. The soluble, unexposed areas are then washed away, leaving open areas in the fabric that allow the ink to pass through to the print surface. Photographic elements in Robert Rauschenberg's mixed media painting TRACER are screen printed on the large canvas (see page 397) as are Andy Warhol's Coca Cola bottles (see page 402).

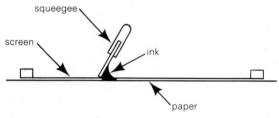

162
SCREEN PRINTING.

163 Victor Vasarely.
UNTITLED. 1967.
Screen print. 23½″ x 23¼″.
Private collection.

Mixed Media Printing

Since the 1960s there has been a virtual explosion of innovations in printmaking. Some printmakers have left their traditional roles as two-dimensional-image makers to create banners and other flexible forms. Many printmakers now use several printmaking processes in one print. Misch Kohn's LABYRINTH is a good example of such mixed media. In it, Kohn employed engraving, aquatint, woodcut, and *embossment*. Embossed areas are created by pressing a raised, un-inked design into the paper with a printing press, which leaves a low-relief impression on the paper.

164 Mayumi Oda.
GODDESS COMING TO YOU;
CAN YOU COME TO HER? 1976.
Screen print. 33" x 24".

PHOTOGRAPHIC AND ELECTRONIC ARTS

Much of our present understanding of the world, the universe, and each other comes from images recorded through lenses of still, motion picture, and television cameras. The camera arts have made a great wealth of information and poetic vision available to us. Yet, if they dominate our visual experience, they can just as easily dull our vision with a preponderance of ready-made images. The extent to which these media influence our lives is unprecedented. Artist's brushes were never the common tools that cameras are today. Recent statistics show that more than 90 percent of American households own at least one camera.

165 Misch Kohn.
LABYRINTH. 1978.
Engraving/aquatint/color woodcut/
embossment. 17½" x 21¾".
Honolulu Academy of Arts
Gift of Mr. Kei Pak Lo.

Photography

Photography is both a scientific process and a relatively new art form. As a science it involves the recording of optical images on light-sensitive or photosensitive surfaces. As an art, this process also reveals the inner vision of the individual who takes—or, better yet, makes—the picture. Ten different photographers working with the same subject will photograph ten different aspects of the subject.

Photograph literally means "light-drawing." The basic concept of the camera preceded actual photography by more than 300 years. A *camera obscura,* or darkened room, was one of several optical sighting devices developed in the sixteenth century as aids for drawing and painting. It was fairly useless until improvements were made, and it became a portable dark box with a lens and an angled mirror to turn over the inverted image for tracing.

The development of the camera was motivated by the fifteenth-century Europeans' desire to portray the physical world in images that were the equivalent of what the eye sees. Because visual perception results from a combination of optical and mental phenomena, this idea can never be fully realized with a mechanical device.

The camera can be compared to a simplified mechanical replica of the human eye. The major differences are that the eye brings a continual flow of changing images that are interpreted by the brain, whereas the still camera depends on light-sensitive film to record an image, and only a single image at a time can be picked up. Pairs of eyes see in stereoscopic vision, in contrast to the monoscopic vision of the camera. Motion picture and television cameras come closer to the human visual experience because they record motion.

The camera is a lightproof box. It has an opening or *aperture* set behind a *lens* to focus or order the light rays passing through it. It also has a *shutter* to control the length of time the light is allowed to strike the light-sensitive film or plate held within the body of the camera.

Photographic *film* is transparent plastic, coated with a layer of light-sensitive emulsion. Exposed and developed print film is called a *negative* because the light and dark areas of the original subject are reversed. Slide film produces a positive image to be projected rather than printed.

In a darkroom a negative is placed in an *enlarger,* which projects and enlarges the negative light image onto light-sensitive paper. The paper, when developed, chemically darkens in those areas where it has been exposed to light, thus producing a photographic positive print.

The changing pupil of the human eye can be compared to the adjustable aperture in the lenses of sophisticated cameras. By changing the aperture a photographer adjusts the amount of light entering the camera, and simultaneously determines the *depth of field* or *depth of focus* in the photograph. A large aperture gives a relatively shallow depth of focus. By closing down the size of the opening, the photographer increases the area in focus as shown in the diagram. The smaller the aperture, the greater the

166
CAMERA OBSCURA.

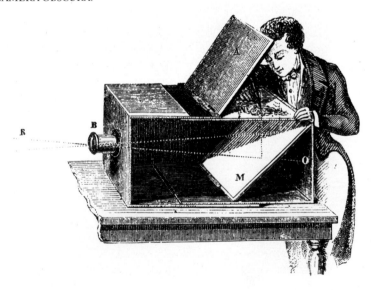

167

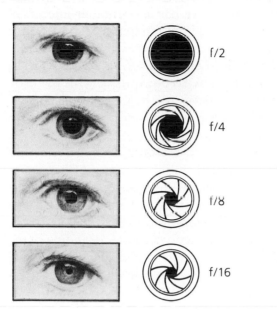

a PUPIL OF HUMAN EYE AND APERTURE OF CAMERA.

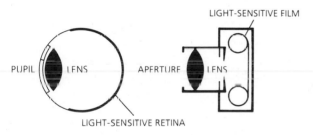

b HUMAN EYE AND CAMERA.

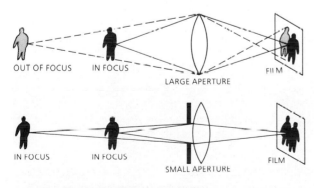

c CHANGES IN DEPTH OF FIELD WITH
 APERTURE ADJUSTMENTS.

depth of field. To understand how this works, hold up your thumb about a foot in front of your eyes and focus your eyes on it. Notice how objects behind it are out of focus. Now curl the fingers of your other hand to make a very small tunnel and hold it up to your eye. The light is reflected off your thumb and passes through the tunnel to your eye. As you look at your thumb through the small opening or aperture, you will notice that both your thumb and what is just beyond it come into sharper focus.

In manufactured cameras of all types the lens is the most important part. Lenses are designed to gather and concentrate a maximum amount of available light in order to produce a sharply focused image quickly. The most versatile cameras allow for interchangeable lenses capable of various angles of view. The adjacent diagram shows the approximate angles of view in normal, *telephoto*, and *wide-angle lenses*. A *zoom lens* permits the focal length of the lens to be adjusted to various distances from close to far.

Selection is an important part of the art process in any medium. In photography the selection of subject, light, angle of view, and final print qualities make the crucial difference between an ordinary snapshot and a work of art. Painters and printmakers edit when they are representing what they see. The photographer, however, must realize that the camera records everything seen within the frame.

A work of art is created by a subtle, complicated process of selection based on knowledge, feeling, and intuition. Michelangelo made thou-

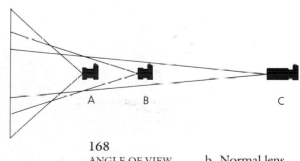

168
ANGLE OF VIEW. b. Normal lens.
a Wide-angle lens. c Telephoto lens.

sands of decisions as he carved a figure from a block of marble. When a photographer like Henri Cartier-Bresson or Edward Weston (see pages 111 and 13) creates a photograph, he makes many important choices in order to arrive at the point at which he releases the shutter and captures a memorable image. Cartier-Bresson calls this the "decisive moment."[7]

To me, photography is the simultaneous recognition, in a fraction of a second, of the significance of an event as well as of a precise organization of forms which give that event its proper expression.[8]

In photography the smallest thing can be a great subject.[9]

In the 1930s the photo essay became an important part of journalism. Factual images presented in the form of series of documentary photographs have had a significant impact on society. Many photographers led the way toward a renewed concern with social reform. Margaret Bourke-White's AT THE TIME OF THE LOUISVILLE FLOOD confronts us with the brutal difference between the glamorous life that advertising promises and the actual reality that people face every day.

The wide range of Bourke-White's creativity is demonstrated by the diversity of her imagery—from social commentary to monumental abstraction. In her photograph CONTOUR PLOWING, the composition combines with subject matter to create a new understanding of the relationship between humanity and nature. The large curving shape dominating the design is made up of richly detailed, rhythmically vibrat-

169 Margaret Bourke-White.
AT THE TIME OF THE LOUISVILLE FLOOD. 1937.
Photograph. *LIFE Magazine,*
©*1954, Time, Inc.*

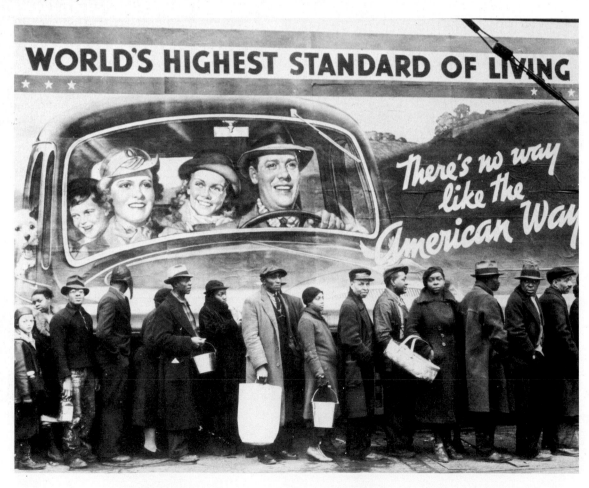

170 Margaret Bourke-White.
CONTOUR PLOWING. 1954.
Photograph. *LIFE Magazine,*
©1954, *Time, Inc.*

ing furrow lines. The tiny scale of the plow adds a human element. Airplanes and space vehicles have provided new vantage points from which to see and record the natural beauty of Earth, as well as the creative and destructive patterns of human enterprise.

Photography provides a way of seeing that extends and expands personal perceptions. Jerry Uelsmann is one of many artists who add new dimensions to the art of photography by altering the straight photographic image. In the darkroom, which is for him "a visual research lab," he combines the images from several separate negatives in one print.

By manipulating the print Uelsmann achieved a mystical, visionary quality with his highly unusual combination of symmetrical design offset by subtle asymmetrical elements. In this untitled print trees float above the reflected image of a giant seed pod, invoking a mood of timeless generative forces.

Major developments in the versatility and accuracy of color film, in the relative longevity of original color prints, and in the processing of color reproductions have led to a great new burst of creative activity in color photography. The addition of color to photography expands expressive possibilities by employing the most emotionally evocative element of visual form. Color can be a catalyst for feeling. Richard Cooke's photograph GRASS IN THE FOG conveys a feeling of tranquility that captures the

171 Jerry Uelsmann.
UNTITLED. 1969.
Photograph.

172. Richard A. Cooke III.
GRASS IN THE FOG, MOLOKAI. 1972.
Photograph.

essence of a particular time and place. Warm accents of dry brown grass produce a subtle rhythmic pattern against the vibrant yellow-green of new growth and the subtle cool blues of the fog laden woods behind. Our attention is drawn to subtleties of nature that often go unnoticed.

A steady stream of new developments is making photographic equipment more accessible and easier to use, thus freeing photographers to respond more spontaneously to the visual experience. Technological breakthroughs are transforming all the camera arts through increasing automation and multiple use of existing equipment. The filmless electronic still camera developed by Sony is an example. Its tiny magnetic images can be shown on a conventional televi-

sion screen or made into color photographs on a special printer. The 1980s have also seen the invention of the disc camera, easy-to-use home color printers, and Polaroid "instant" home-process slide film.

Photography can record personal moments for the family album, the surface of the moon, the interior of the human heart, or the exact visual details of a unique moment in history. It can be used to record, as well as create, images we could never see otherwise, and to reveal the extraordinary qualities of ordinary objects and events. Looking through the camera, the photographer finds significant images within the actual world. By representing (or re-presenting) these images the photographer extends and enriches the vision of others.

Cinematography

Cinematography is the art of making pictures that appear to move. The photographic basis for the motion picture was first discovered in 1877 by Eadweard Muybridge, a photographer who was engaged by Leland Stanford to settle a disagreement Stanford had with a friend. Stanford believed that when a horse gallops there is a point at which the horse has all four feet off the ground; his friend disagreed.

Muybridge lined up twenty-four still cameras beside a race course. Each camera was fixed with a string to be tripped by the horse's front legs, causing the horse to be photographed twenty-four times as he galloped. When Muy-

bridge projected the twenty-four pictures in rapid succession, the horse appeared to move. In settling the disagreement to his satisfaction, Stanford also advanced the revolutionary idea of the motion picture. Others began experimenting with sequences of photographs projected in rapid succession. These investigations led to the invention of the motion picture camera in 1887.

Early newsreels were similar to the reports seen on television today. The first fiction films, however, were quite different from today's movies. Like many new art forms, film in its infancy was not considered respectable. In order to gain public acceptance, early filmmakers tried to make their movies look like filmed theatrical performances. Actors made entrances

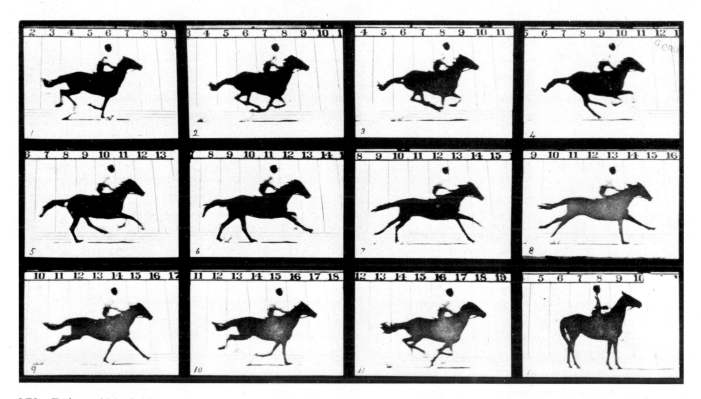

173 Eadweard Muybridge.
GALLOPING HORSE. 1878.
Photograph.
*International Museum of Photography
at George Eastman House, Rochester, New York.*

and exits in front of a fixed camera as though it were the eye of a great audience watching them on stage.

A later concept, the *mobile camera,* was not a kind of camera, but a way of using one. D. W. Griffith took the camera out of its stage-bound setting and filmed on location—outdoors, from moving trains and automobiles, and even from balloons. Between 1907 and 1916 Griffith helped bring the motion picture from its infancy as a nickelodeon amusement to full stature as an art.

Griffith also developed *editing,* the cutting and reassembling of film. During the process of editing, the film goes from raw film footage in the form of separate shots to meaningful sequences, and finally to a total work. As in the other visual arts, selection is a crucial part of the process. A good editor shows us carefully chosen aspects of the subject, timed and ordered to evoke the desired feeling and create experiences for the viewer. A foot-and-a-half of film provides one second of viewing time. To fine tune a motion picture the editor will sometimes add or remove just a few inches of film. The *cutting ratio* tells how much exposed film footage was finally used, as opposed to what was discarded. In the traditional Hollywood movie the ratio is at least 10 to 1, or ten feet thrown away for every foot used. In filming television commercials for national broadcasting, the ratio can range from an average of about 60 to 1 to as much as 1000 to 1. However, it is possible to make an excellent film with a low cutting ratio.

Narrative editing was introduced by Edwin S. Porter in his 1903 film, THE GREAT TRAIN ROBBERY. Porter set up his camera in several locations to film parts of the story. Each camera setup or take is called a *shot.* Porter glued all the shots together and projected them in a *sequence,* or grouping of shots, which was designed to tell a story.

Parallel editing, a refinement of narrative editing, involves switching back and forth between events. Griffith developed this technique

174 Edwin S. Porter.
THE GREAT TRAIN ROBBERY. 1903.
Film.
The Museum of Modern Art,
Film Stills Archive, New York.

and used it to build suspense by comparing events occurring at the same time in different places. We see this frequently in films and on television when we are shown alternate shots of someone in a desperate situation and a would-be rescuer. Griffith also used parallel editing to compare events occurring at different times, as in his film INTOLERANCE, in which he cut back and forth between four stories set in different periods of history. The most recent development in parallel editing is the *multi-image,* in which events occurring in different locations at the same time are presented on sections of the screen simultaneously. This is now common in television.

Quite by accident Griffith discovered the best way to divide films into sequences. His camera operator accidentally let the shutter of his camera close slowly, causing the light to gradually darken. Griffith decided that this might be a good way to begin and end love scenes. *Fading in* or *out* remains the most common transition between scenes. A later refinement of the fade-in, fade-out idea is the *dissolve,* in which the two are overlapped. As the first shot dims or fades out, the next appears behind it and grows clearer. Griffith also introduced the concept of *flashback* and *flashforward* in his films. He admired the novels of Charles Dickens in which the action moved forward or backward in time to tell the story, and he made the same thing happen in movies.

Close-up and *longshot* were also introduced by Griffith while movies were still stagebound. Later he used the concept of the longshot to film whole armies in battle in THE BIRTH OF A NATION, made in 1915.

In filmmaking, the term *montage* refers to the editing together of a number of shots of a single event to give a sense of heightened importance and drama. In montage, a great deal seems to happen in little time, much more than could happen in real life in the same period of time. Griffith used this technique as early as 1916.

Griffith also worked to introduce other elements, which, although not essential to film as art, are nonetheless strong technical additions.

He recognized early that movie screens might be wider. Lacking the means to do that himself, he compensated by masking the top and bottom of some of his shots to give the impression of width. This was the forerunner of today's wide-screen projection.

Griffith pioneered the use of music with films before sound tracks were possible. He helped write the musical score for THE BIRTH OF A NATION, which opened in New York in 1915 accompanied by the full orchestra of the Metropolitan Opera. And he knew that color film photography would someday become a reality.

The coming of sound in 1928 added a new dimension to cinema. Many actors who did well in the silent period failed to make the transition into sound. Sound did not, however, change the fundamental grammar of film art. Color was introduced in the 1930s; the wide screen and a variety of three-dimensional images came in the 1950s; 360-degree projection was first seen by the public in the 1960s; but most of these techniques had been conceived and researched by 1910.

From modest beginnings, cinematography has rapidly developed into one of the world's most powerful visual arts. Film is an international, intercultural language, perhaps the most persuasive of the arts. Viewers can become more involved in film than in any other art form.

I am using a device (the motion picture camera) . . . by means of which I can transport my audience from a given feeling to the feeling that is diametrically opposed to it, as if each spectator were on a pendulum; I can make an audience laugh, scream with terror, smile, believe in legends, become indignant, take offense, become enthusiastic, lower itself or yawn with boredom. I am, then, either a deceiver or—when the audience is aware of the fraud—an illusionist. I am able to mystify, and I have at my disposal the most precious and the most astounding magical device that has ever, since history began, been put into the hands of a juggler.

Ingmar Bergman[10]

175 D. W. Griffith.
THE BIRTH OF A NATION. 1915.
Film.
The Museum of Modern Art,
Film Stills Archive, New York.

176
a Syd Mead. Studies for the light cycles in TRON.

b BRUCE BOXLEITNER ON A LIGHT CYCLE, from the film TRON. ©1982 Walt Disney Productions.

The enormous range of possible manipulations and special effects used in films today has been developed over a period of time, as the technology was invented to implement the ideas of filmmakers. In recent years some of the most outstanding and memorable movies have been science fiction films that take full advantage of special effects made possible by new technology. Teams of artists and technicians work with the director to provide working sketches, models, animation, and sets that are fantastic, yet believable.

Designer and visual futurist Syd Mead is widely known for his masterful illustrations of futuristic architecture, transportation systems, and computerized environments. Mead created conceptual drawings for the fantastic light cycles, and for high tech settings, in Disney's movie TRON. The film features a trip through an imagined electronic landscape inside a computer. Appropriately, much of the movie was animated with advanced computer technology. The computer is a great tool for filmmakers and others who seek to expand and give form to

their imaginative visions. Like the painter and still photographer, the film director is judged on the quality of the film's visual image.

Although cinematography and television have made the photographic image move, the camera continues to be the basic tool. All of the visual elements discussed in Chapter 2 occur in films. The major elements in cinema are light, time, motion, and space.

The fact that film is temporal as well as spatial makes it different from other arts that are experienced in space, and aligns it most closely with theater. Film shares qualities with and gets nourishment from the other major temporal arts, literature and music. Our present-day time consciousness has been heightened by the film medium. Cinema time, like mental time, is flexible. Film can compress and expand time and can go forward and backward in implied time. Its ultimate power is to integrate all time into the present. Film can transport the viewer effortlessly from one time to another and from place to place.

By creating the effect of motion with photographic images, films produce the most vivid appearance of visual reality. Motion greatly increases our sense of participation. When motion is synchronized with sound, two major facets of total sensory experience are joined. Film and television can convince us that we are actually participating in events as they occur in life.

Television/Video/Computer-Assisted Imagery

Television is the electronic transmission of still or moving photographic images with sound by means of cable or wireless broadcast. Today, in the United States, it serves primarily as a distribution system for the dissemination of advertising, news, and entertainment.

Television has its own characteristic advantages and disadvantages. Two of the unique characteristics and limitations of television are its small scale and round-cornered format. Large-screen video projection continues to be too expensive for widespread domestic use, and the projected image lacks the quality available with film. Size, image quality, and the distractions in most households are the key differences between seeing a movie on a large screen in a darkened theater, and seeing the same film on a small television screen at home. Even when we are spared commercial interruption, the captivating illusion of film is greatly diminished as we view movies on TV.

Like photography and film, television uses light impulses collected by a camera. The television camera is unique, however, because it converts lightwaves into electricity. Most of the visual arts produce images manually or mechanically; television produces and transmits images electronically.

Early broadcasts, except for televised movies, were always "live." With the introduction in the 1960s of magnetic videotape, which has the capacity to record audio and visual material simultaneously, it became possible for lightwaves collected and converted by television cameras to be stored for later transmission to receivers.

Now multiple audio and visual input can be mixed instantaneously with live-action elements on television. This, along with the modification of images through such methods as electronic feedback, gives television the potential for even greater flexibility and more complex and immediate forms than film. Television time can incorporate film time and can also bring us events instantly.

The first memorable live television broadcast in the United States occurred in 1939 when President Franklin D. Roosevelt spoke to a gathering at the World's Fair in New York. He appeared on about 100 monitors situated on the fairgrounds and in the city, thus demonstrating a major characteristic of television—its *liveness*. Television has made it possible for the people of the world to share events as they happen.

177
APOLLO 11 ASTRONAUT
NEIL ARMSTRONG TAKING MANKIND'S
FIRST STEP ON THE MOON.
July 20, 1969.
Television image. *CBS News.*

By 1969 it was possible for an estimated 400 million people to see Neil Armstrong as he stepped onto the moon and made the historic statement "one giant step for mankind." People around the world watched as the first moon landing became a milestone in human history. In 1981 an estimated 750 million watched television coverage of the wedding of Prince Charles and Lady Diana. In both cases viewers became vicarious participants, joined together in present time across thousands of miles.

The vast potential of television as a creative medium for world communication has only begun to be understood by the industry, and has barely been considered by any sizable portion of the television audience, by government officials, or by educators. In the television industry, technology continues to outstrip content.

By the early 1980s individual television sets were able to pick up programs direct from communications satellites. Television has the potential to become a crucial tool for achieving and maintaining world peace through mutual understanding.

As adults we have learned to tune out much of the colorful advertising, noise, and high-pressure salesmanship of television, but the medium's pervasive influence continues because we get the information subconsciously whether we want it or not. In the United States television has become the primary source of information about the world. Since our view of reality may be largely shaped by television, how this medium is used is of crucial importance.

The influence of television crime on actual crime has been well documented. A 1976 study completed for the U. S. Congress indicated that the average American child between ages 5 and 15 would view the killing of 13,000 persons on television. By now the figure is higher. Commercial network television must often sacrifice imaginative programming in the public interest for saleability. Ways need to be found to encourage creative programming capable of generating funds that are independent of product advertising.

The term *video* came into use in the late 1960s when it was used to identify television activity by individuals or groups that were not part of the broadcast "establishment." In spite of this, many techniques developed during video experimentation have been successfully applied to commercial television. Video also emphasizes the visual as distinguished from the audio portion of the medium.

Video art became possible on a fairly large scale with the development in the late 1960s of relatively inexpensive portable recording and playback equipment such as the Portapack. Video pioneers using the new equipment were united initially by the common desire to go beyond the bland sameness of broadcast television offered by the major networks. Dominant trends can be seen in their work. One is an emphasis on the direct approach, to meet the need for contact with everyday reality. Lightweight video cameras can be taken into the streets and into the countryside to record people in down-to-earth, "real" situations. An-

other trend involves the search for new dimensions within the electronic nature of the medium itself. This includes producing nonrepresentational light imagery related to the earlier twentieth-century light art by such artists as Thomas Wilfred (see page 63).

Nam June Paik is the foremost pioneer of video art and the first to explore the multiple possibilities of manipulated television imagery. Paik's musical background gives his nonrepresentational, free forms a richness and depth not found in the work of some of his followers. Paik has been the leader in using television technology and craftsmanship as a means of creating imagery. He challenges our assumptions about what television is and can be, and gives a new perspective on its place in our environment. TV GARDEN is one of Paik's most provocotive video installations. Live TV sets nestle among lush tropical foliage as if they were growing in nature. The surprising juxtaposition offers new perspective on television.

178 Nam June Paik.
ELECTROMAGNETIC DISTORTION OF THE VIDEO IMAGE. c. 1965.
Video.
Photograph © Peter Moore, New York.

179 Nam June Paik.
Detail of installation of TV GARDEN. 1982.
Exhibited at the Whitney Museum of American Art, New York, during the exhibition "Nam June Paik," April 30 to June 27, 1982.
Photograph © 1982, Peter Moore, New York.

180 Ed Emshwiller.
SCAPE-MATES. 1973.
Video. 30 minutes.
The Television Laboratory, WNET, New York.

Ed Emshwiller, one of the best known avant-garde filmmakers in the United States, began working in videotape in 1972. He feels that video has greater image-making flexibility than film. This flexibility is demonstrated in SCAPE-MATES, a thirty-minute kaleidoscopic video fantasy blending two dancers with an ever-changing computer-generated environment. The work is a highly effective application of the

latest video technology available in the spring of 1973, when this piece was created. Emshwiller used both video techniques and traditional broadcast tools. His choreography began with black-and-white artwork from which he designed basic shapes and movements electronically with a computer. The dancers were then color-keyed into the environment. Final background and color were added with a synthesizer.

Emshwiller is enthusiastic about the future of computer-assisted video imagery, which until recently has been used primarily for special effects in television commercials. This new medium provides a means for evoking human and visual dimensions that previously could not be expressed.

Television's immense flexibility has made it an important new medium for art. Recognition of its capabilities has coincided with the growing desire of many artists to move away from the idea of art as precious finished object to art as a process. With the video movement television has gone from a passively received distribution system to a more active medium offering personal involvement and heightened awareness.

Historically, people working in each new medium often begin by copying the style and content of the medium's closest predecessor. Early photographers copied the styles of painting that were popular at that time. Filmmakers copied traditional theater, while television has depended heavily on film. This phenomenon is exaggerated by the practical and profit-making applications of new media. Television, like printmaking, has gone from performing a reproduction function to becoming a medium of conscious creativity. Video art combines some of the visual richness of painting, the rhythm of music, and the movement of the performing arts. It adds liveness, immediacy, flexibility, and extraordinary manipulations of form and color to the vocabulary of the visual arts.

Computers play increasingly important roles in modern culture. Some people almost worship the computer, others fear it, and many consider it a toy for nonproductive play. Some artists have recognized the computer as a valuable technological tool for creating imagery. Its possibilities range from producing finished artworks to helping to generate ideas for works that are ultimately made in another medium. Computer graphics and computer-related art are already serving as the catalysts for change in the art world as well as the computer community. Computer-generated video devices, along with new optical technologies, enable new levels of visual exploration. We must realize, however, that tools, by themselves, do not make art or automatically turn their users into artists.

PERFORMING ARTS AND PERFORMANCE ART

In a sense, all the arts are an extension of the inherently expressive qualities of the human body. Following from this, all art can be considered performance, with works of painting, sculpture, and even architecture conceived as frozen performances or records of events.

The performing arts are not usually discussed as "visual" arts, yet a major aspect of these arts is visual. Development of the camera arts led directly to the inclusion of performance as a basic ingredient of film and television, thus broadening the concept of the visual arts.

The expressive material in the performing arts is the human body. In mime or pantomime, an ancient form of silent drama, real situations or persons are mimicked and imaginary events portrayed by means of exaggerated gestures and full body movements, without external help from costumes or scenery.

181
CHINESE SCARF DANCE.
Photograph: Francis Haar.

182 Oskar Schlemmer.
GAME WITH BUILDING
BLOCKS.
Performed by Werner
Siedhoff at the
Bauhaus in 1926.

Dance is another performing art based on the poetry of human motion. The sculptural qualities of the body offer variations in shape and mass, which are extended into space by means of movement and become rhythmically changing patterns. Every culture in the world finds foundations for its art in dance; through body movement, states of mind and dramatic or narrative sequences can be eloquently expressed.

With drama, the art of the written word enters as prose or verse composition, forming the base for performance by actors. Again the facial expressions and gestures of the actors are important ingredients. Makeup, costumes, stage movement patterns, lighting, and set design extend and complement the actor's performance.

Performance art defies simple definition because it is intended to break through the defined limits of art in all its accepted forms. Performance art draws on aspects of painting, sculpture, film, mime, theater, opera, and dance, yet it is none of these. Performance (as it is often called today) began in about 1910 with the Italian Futurists (see page 369) who staged outrageous acts designed to destroy all things solid and serious connected with "Art" and

"Culture." The idea flourished in Zurich as poets, writers, and artists who called themselves Dadaists (see page 372) turned to performance as a way to shake the public out of complacency.

In the 1920s the highly influential Bauhaus school in Germany was a major center for further development of performance art. Painter and sculptor Oskar Schlemmer provided the direction and inspiration. His 1926 performance work GAME WITH BUILDING BLOCKS, seen here in a multiple-exposure photograph, was characteristic of many inventive performances. Geometrically organized movements, and props such as the blocks in this piece gave the overall design a pure simplicity of form that expressed the Bauhaus goal of a synthesis of art and technology.

The Surrealists (see page 376) were among those who helped to keep the idea of performance art alive as a valid expressive medium for visual arts. In the 1950s performance art picked up momentum again with the development of *happenings* in the United States. Artists began to collaborate, each adding his or her specialty to amazing mixtures of music, dance, and theater with sculptural overtones (see page 411).

SCULPTURE

Sculpture, along with other three-dimensional disciplines, is both a visual and a tactile art form. The earliest "art" objects known today are hand-sized prehistoric sculptural pieces that were apparently intended to be held (see the Paleolithic figure on page 237). Although the touch of many hands can eventually wear away a work of sculpture, the tactile dimension is an important consideration for the sculptor.

When sculpture projects from a background surface, it is in *relief*. In *low-relief* (or *bas-relief*) sculpture the projection from the surrounding surface is slight and no part of the modeled form is undercut. As a result, shadows are minimal. In *high-relief* sculpture at least one-half of the natural circumference of the modeled form projects from the surrounding surface (see Nevelson's ROYAL TIDE #1 on page 173). High-relief sculpture begins to look like sculpture that is freestanding. When sculpture enters fully three-dimensional space, our perception of the total form changes as we move around the object. When *freestanding* sculpture is viewed, impressions are picked up from each side as the viewer moves around the piece. The total experience of the work is the sum of its profiles. Freestanding sculpture seems more real than any of the two-dimensional arts because it occupies the same space we do.

A piece of sculpture, such as a coin or a piece of jewelry, may be small enough to hold in the hand and admire at close range. Most coins are works of low-relief sculpture. A high point in the art of coin design was reached on the island of Sicily during the classical period of ancient Greece. Herakleides created the original model for the APOLLO coin, shown here more than twice its actual size. It has a monumental presence in spite of being in low relief and very small.

183
APOLLO. c. 415 B.C.
Greek silver coin. Diameter 1⅛".

Modeling

Traditionally, sculpture has been made by modeling, carving, casting, assembling, or a combination of these processes. *Modeling* is an *additive* process in which pliable material such as clay or wax is built up to a final outer form. In their working consistency, these materials may not have much strength. Sagging can be prevented by starting with a rigid support called an *armature*. Giacometti's emaciated figures are modeled on a metal armature with clay or wax, then cast in bronze (see page 77).

Carving

The process is *subtractive* when sculptural form is created by cutting or *carving* away unwanted material. Michelangelo preferred this method. For him, the act of making sculpture was a process of finding the desired form within a block of stone. In THE AWAKENING SLAVE it seems as if this process is continuing as we watch. As it struggles against the marble that imprisons it, the figure seems to symbolize the human spirit. Close observation of chisel marks on the surface reveals the steps Michelangelo took toward more and more refined cutting.

It takes considerable foresight to use the subtractive process. Each material has its own character and must be approached on its own terms. The stone-carver must apply strength and endurance to unyielding material. In woodcarving, grain presents special problems and unique results. Stone also has grain that, if not taken into consideration, can cause the piece to shatter when it is carved. Both wood and stone must be carefully selected and studied beforehand if the artist is to realize the intended form.

184 Michelangelo Buonarroti.
THE AWAKENING SLAVE. 1530–1534.
Height 9'.
Academy Gallery, Florence.

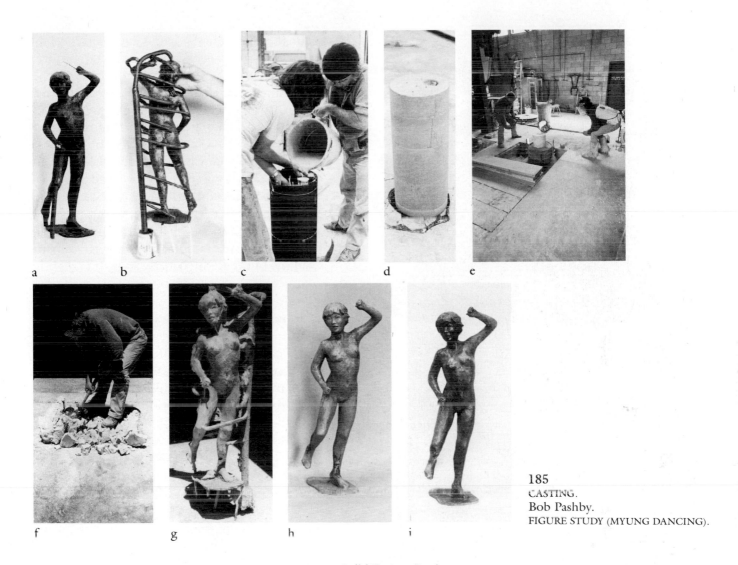

a b c d e

f g h i

185
CASTING.
Bob Pashby.
FIGURE STUDY (MYUNG DANCING).

Casting

Casting processes make it possible to work in an easily handled but perishable medium, then preserve the results in a more permanent media. All *casting* involves the substitution of one material for another with the aid of a mold. For this reason it is also called the *substitution* or *replacement* process. A mold is taken from an original work usually made in clay, wax, or plaster. The process of preparing the mold for casting varies, depending on the material to be cast. Any material that will harden can be used—clay diluted with water, molten metal, concrete, or liquid plastic. When the mold is made and the original material removed, the casting liquid is poured into the resulting hol-

Solid Bronze Casting
a. wax model
b. model with attached cup, vents, and wax sprues (rods)
c. mixture of plaster and sand poured around inverted model to produce investment (mold)
d. investment with pouring cup and vent holes visible on top

Investment is inverted and placed in a kiln where wax is burned out. Sprues and vents allow melted wax to run out, and later provide channels for molten bronze to enter and air to escape.

e. pouring molten bronze into investment
f. breaking away investment from cooled bronze
g. bronze figure with bronze cup, vents, and sprues still attached
h. cleaned figure with cup, sprues, and vents removed
i. completed figure with final finish

low cavity. Some castings are solid and some are hollow, depending on the casting method used.

186
BENIN HEAD. Nigeria. 16th century.
Bronze. Height 9¼".
The Metropolitan Museum of Art, New York.
The Michael C. Rockefeller Memorial Collection,
Bequest of Nelson A. Rockefeller (1979).

If a large object, like Giacometti's MAN POINTING (see page 77) is to be cast in bronze, the process is extremely complicated. In the past, the artist and several assistants did the actual casting. Today, except for small pieces that can be cast solid, most artists turn their originals over to foundry experts.

The process of casting was well known in ancient China, Greece, Rome, and parts of Africa. It has been used extensively in western Europe since the Renaissance. Bronze casting was developed to a high art in Benin, Nigeria, before 1500. The head shown here is a superb example of the Benin courtly style. It is slightly abstracted for expressive purposes. (See the discussion of African art on pages 264–266.)

Some casting processes that make use of piece molds or various flexible materials allow many casts to be made from the same mold; other processes, which use what we know as waste molds, permit only one cast. The method used in Benin permitted only one cast because both the model and the mold were destroyed in the casting process.

187 Pablo Picasso.
BULL'S HEAD. 1943.
Bronze. Height 16⅛".
Galerie Louise Leiris, Paris.

Constructing and Assembling

Before this century the major sculpture techniques were modeling, carving, and casting. Since Picasso constructed his cubist GUITAR in 1912 (see page 358), *assembling* methods have become widely used. Such works are called *constructions*. In some cases preexisting, readily identifiable objects are brought together in such a way that their original identity is still apparent, yet they are transformed in this new context. This subcategory of assembled sculpture is called *assemblage*.

In Picasso's BULL'S HEAD the creative process has been distilled to a single leap of imagination. The components of this assemblage are simply a bicycle seat and handlebars. Almost anyone could have done the actual work of putting them together. Yet the finished work is based on a particular kind of empathy with things that is far from common. The metamorphosis of ordinary manufactured objects into animal form and spirit is magical.

Louise Nevelson began making sculpture out of found wooden objects in 1955. She assembles boxes and assorted objects in a variety of shapes and forms, creating complex structures from carefully selected discards of modern society. Each compartment is both part of the total form and an intriguing composition. Her works are usually wall pieces, viewed frontally as reliefs and painted a single unifying color, such as black, white, or gold. ROYAL TIDE #1 is a good example of her sense of theme and variation.

188 Louise Nevelson.
ROYAL TIDE #1. 1961.
Gilded wood. 8' x 3'.
Collection of Mr. and Mrs. Howard Lipman.

189 Richard Lippold.
VARIATIONS WITHIN A
SPHERE, NO. 10:
THE SUN. 1953–1956.
22k gold-filled wire.
11′ x 22′ x 5½′.
*The Metropolitan Museum
of Art, New York.
Fletcher Fund (1956).*

Since 1930, the cutting and welding of metals to make sculpture has developed and become widespread. Equipment such as the oxyacety-lene torch greatly facilitated these developments. David Smith pioneered in this type of metal construction (see page 403). He used such industrial materials as I-beams, pipes, and rolled metal plate for raw materials and adopted industrial methods of fabrication.

Richard Lippold's VARIATIONS WITHIN A SPHERE, NO. 10: THE SUN is a beautiful and technically amazing piece of work. Its complex linear form is assembled from several thousand feet of gold-filled wire. The 11-foot height puts the center of the structure at about eye level. Light is reflected from the shimmering gold surfaces and planes built up with wire. The pure mathematical precision of this construction adds to its effectiveness as a symbolic image of the sun's radiant energy.

Alexander Calder, along with David Smith, was among those who gave renewed life to the blacksmith's ancient craft. The traditional emphasis on mass is replaced in Calder's work by an emphasis on shape, space, and movement. Calder was also among the first to explore the possibilities of *kinetic sculpture*—sculpture that moves. By 1932 he was designing wire and sheetmetal constructions, such as his FOUR BIG DOTS, which are moved by natural air currents. Marcel Duchamp christened them "mobiles," a word that he had coined for his own work in 1914 (see page 372).

In THE GATES OF SPOLETO, which he called a "stabile," Calder used shapes related to his mobiles. The sheetmetal planes are transformed into lines and back to planes again as one moves through and around the work. Monumental scale and openness invite the viewer to be environmentally involved. Here sculpture becomes architectural.

The finished surface of a piece of sculpture is an important element in its design. Sculptors may choose between highly refined finishes that obscure their tool marks, or finishes that reveal some of the process. The BENIN HEAD (page 172) is a combination of very smooth surface and contrasting intricate patterns. Michelangelo's unfinished AWAKENING SLAVE (page 170) reveals his tool marks, which add lifelike energy to the work and invite vicarious participation in the process. Louise Nevelson finishes her constructions with a unifying coat of paint. Some sculptors design their work to be weathered or oxidized over time, thus allowing for natural change; others cover their pieces with colorful paint or resin. Charles Eames used bright colors to add to the playfulness of his SOLAR TOY (see page 435).

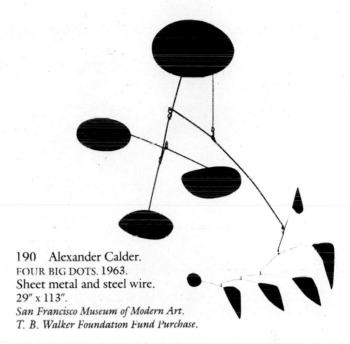

190 Alexander Calder.
FOUR BIG DOTS. 1963.
Sheet metal and steel wire.
29" x 113".
San Francisco Museum of Modern Art.
T. B. Walker Foundation Fund Purchase.

191 Alexander Calder.
THE GATES OF SPOLETO. 1962.
Steel. 65'7" x 45'11" x 45'11".
Spoleto, Italy.

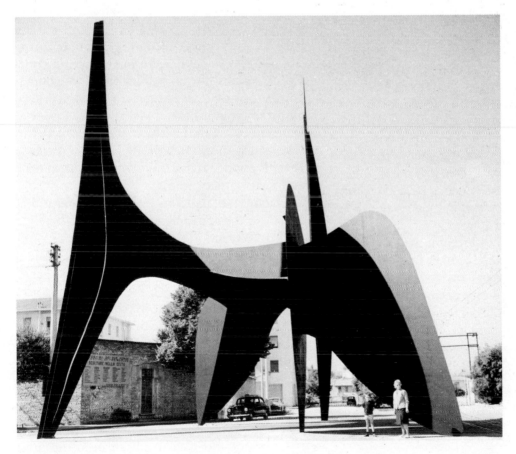

192 Andy Warhol.
CLOUDS. 1966.
Helium-filled mylar. 48″ x 42½″ each.
Leo Castelli Gallery, New York.

Andy Warhol took advantage of a new material and a distinctive surface in his playful dance of floating pillows called CLOUDS. The environmentally inclusive work consisted of helium-inflated containers made of thin sheets of metalized plastic. In the gallery the pillows drifted and bumped against the ceiling and each other, activating the entire space and creating a silent, continually changing interplay in which the viewer became a participant.

Artists such as Robert Smithson and Christo (see pages 414 and 415) have worked with environmental concepts on a vast scale. Their unique sculptural forms deemphasize the materials of the work in order to incorporate features of the surroundings into a total sculptural experience.

CRAFTS: TRADITIONAL AND CONTEMPORARY

All art begins with craft. If a work is not well made, there is little chance that it will be experienced as art; but craftsmanship alone does not make art.

The crafts practiced today link us with a long tradition. Until the Industrial Revolution, artisans made all articles for the sustenance of daily life. A seemingly infinite variety of material goods, such as fabrics and dishes, are now produced in quantity by mechanical methods. This development has made it possible for many people to make handcrafted objects without the pressures of earlier demands for quantity, economy, and practicality.

Since the beginning of civilization crafts were—and in some cultures still are—an integral part of everyday life. Historically, few saw the crafts as separate or "minor" arts, as they are sometimes called today. As much artistic thought probably went into a painting on a Greek vase as into a wall painting. When machines took over weaving cloth, making dishes, and stamping out metal utensils, the close relationship between the maker and the object was lost, and with it much of the beauty. Of course there is good and bad design in both handmade and factory-made items.

Handmade articles can have a quality that enhances the spiritual aspects of life. There is a lasting satisfaction that comes from using one's own hands to create utilitarian objects, and a related pleasure is often felt when we use handmade objects. When we use or buy an object made by someone unknown to us we may want to know more about the maker, wonder where the materials came from, and so forth. Mass-produced items do not evoke such a response. Well-designed, well-crafted works made for visual delight or for both visual and utilitarian purposes seem to be more alive than similar machine-produced objects.

Ceramics and weaving have been the most widely practiced of the crafts, but the recent

revival of interest in handwork has reintro-duced a wide variety of other craft/art including jewelry making, enameling, and glassblowing.

Organizations and exhibitions continue to carry the word "craft," even though a large portion of the works involved could also be classified as sculpture. A high percentage of the works made of traditional craft media have no function other than that of beauty.

Craftspeople often divide themselves into two groups—those who simply try to make a living doing acceptable work, and craft-artists who are more ambitious in their aim to produce objects of artistic merit, regardless of sales value. This second group tends to lead the way in inventive design and media usage. Perhaps because of them, the last several decades have seen an increased mixing of media and tech-niques in nearly all areas of artistic expression. The old boundaries between crafts and fine art have been blurred—painters and printmakers are stitching, potters and weavers are sculpting, and painters and sculptors are performing. Pre-viously accepted limits of traditional materials and techniques have been set aside as artists and craftspeople explore new ideas and means of expression. Artist and art critic Marcia Morse sheds light on the phenomenon:

In the old dichotomy of art/craft, art usually connotes work in which image and message are dominant; craft connotes work in which material and function are first perceived. A fusion of these two aspects, clearly complementary, may create a particular presence or energy that, even if un-nameable, is forceful and clear.[11]

Clay

Ceramics is the art and science of making objects from clay. The earth provides a variety of clays that can be mixed with one another and refined to obtain the desired body and plasticity. Clay has long been a valuable raw material for the human race. It offers ample flexibility and rela-tive permanence because of its capacity to harden when exposed to intense heat.

A person who works with clay is usually called a *potter*. Potters create functional pots or purely sculptural forms using handbuilt meth-ods such as slabs, coils, or pinching, or by *throw-ing* clay—that is, shaping it—on a wheel that may be driven by motor, hand, or foot. It is fascinating to watch a good potter throw a pot. A form is created from a shapeless lump of clay as if by magic. Wheel throwing, which may look effortless, takes time to perfect.

193
SMITH FROM NORTHERN DAHOMEY.
1969.
Photograph: Rene Gardi.

194
SIX STAGES IN FORMING A VASE.

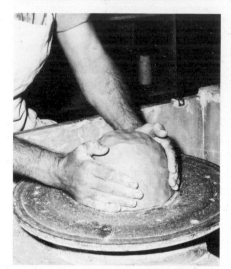

a Placing a ball of clay on the wheel.

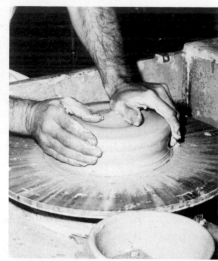

b Centering the clay.

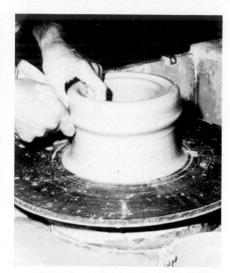

c Opening a cylinder.

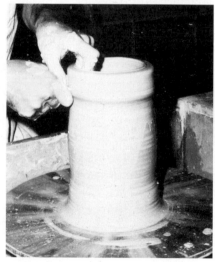

d Pulling up the cylinder.

e Shaping the pot.

f Finishing the neck.

The term ceramics includes a wide range of objects made of fired clay, including tableware, vases, bricks, sculpture, and many kinds of tiles. Most of the basic materials and processes in ceramics were discovered thousands of years ago. Ceramics is one of the oldest crafts, and was highly developed in ancient China and Egypt. Originally, pots were made by pinching or building up with coils. However, since the invention of the potter's wheel in Egypt about 6000 years ago, potters have been able to pro-

duce with greater speed and uniformity. When a piece of pottery is thoroughly dry, it is *fired* in a *kiln*, a kind of oven. Heat transforms it chemically into a hard, stonelike substance. *Glazes* or other decoration may be added for color and textural variation. The silica in the glaze vitrifies during firing, fusing with the clay body to form a glassy, nonporous surface. Glaze can be transparent or opaque, glossy or dull, depending on its chemical composition.

Until the twentieth century, new processes

195 Maria Chino.
CEREMONIAL WATER JAR. 1927.
White clay, decorations in black and red.
11¼" x 13½".
Honolulu Academy of Arts.
Gift of Mrs. Charles M. Cooke, Sr.

evolved very slowly. In recent years new formulations and even synthetic clays have become available to potters. But the biggest changes have come in more accurate methods of firing and improved production techniques and equipment.

Ceramic wares are categorized according to the kind of clay used and the specific firing temperatures. Color variations are caused by different chemical compositions of clays. *Earthenware* is made from coarse surface shale and clay and is fired at low temperatures (under 2100°F). It is usually red or tan in color and has a porous structure. *Stoneware* is made from finer clays and is fired at higher temperatures than earthenware (2100–2300°F). It is gray, tan, or reddish in color—and has a very dense structure.

Most of today's handmade ceramics are either earthenware or stoneware. *Porcelain* contains large amounts of kaolin, a very pure, fine white clay, and feldspar. A high firing temperature (2300–2786°F) is used, producing a completely vitrified or glassy ware. Stoneware and porcelain are waterproof; low-fired wares are not.

These standard categories are not always distinct from one another. Since most clay bodies are a mixture of different clays, some clay bodies fall between these categories. *China*, for instance, falls between stoneware and porcelain in firing temperature, and is semivitreous. Commercial tableware is usually made from china and varies widely in thinness and translucency.

Some ceramicists use ancient methods, baking their pots in open fires that reach only low and generally varied temperatures. Maria Chino of Acoma Pueblo made this CEREMONIAL WATER JAR using the methods of her ancestors. Traditionally, the making of such Acoma vessels takes four or five days, during which the artist eats and sleeps very little. The soul of the artist is said to be united with the spirit of the pot. The pot was hand-built with thick coils that were smoothed as each one was added. The design was applied using red and black oxides, with areas of exposed white clay. No glaze was used. The motifs are the artist's own. In the bands that separate the upper and lower portions of the design breaks are made to allow for the release of the soul after the work is completed.

196 Kathryn Sharbaugh.
TAP DANCE. 1978.
Porcelain. Height 11".
Private collection.

197 Isamu Noguchi.
BIG BOY. 1952.
Karatsu ware. 77/8" x 67/8".
*The Museum of Modern Art, New York.
A. Conger Goodyear Fund.*

Kathryn Sharbaugh's slab-built porcelain teapot employs a use of geometric design that is related to Maria Chino's motif. In both the teapot and the water jar, the outer shape of the pot is echoed in the surface design. The pattern of Sharbaugh's TAP DANCE also shows the influence of the Art Deco style of the 1920s and 1930s. The title emphasizes the staccato beat of the crisp black-and-white design.

To create his expressive sculpture BIG BOY, Isamu Noguchi pinched clay to form the hands, legs, and feet, and rolled out a slab of clay that became the child's garmet. The slab was pressed into the other pieces of clay to form a single unit. Noguchi used modeling, cutting, and assembling to achieve the final result.

Robert Arneson considers all art self-portraiture, and underscores this assertion by making whimsical images of himself. CALIFORNIA ARTIST was made in response to an attack on his work by a New York critic who said that, due to the spiritual and cultural impoverishment in California, Arneson's work could have no serious depth or meaning. Arneson's answer was to create a ceramic self-portrait with gaping holes in place of eyes, revealing an empty head. The inside of the head is even glazed Catalina blue. The figure is the portrait of the artist as a combination cyclist and aging California hippie—complete with the appropriate cliches on and

around the base. Those who think that clay is only for making bricks and dinnerware were acknowledged by Arneson, who put his name on the bricks, as any other brickmaker would. Arneson stated his point of view when he said:

I like art that has humor, wit, irony and playfulness. I want to make "high" art that is outrageous while revealing the human condition, which is not always high.[12]

In the mid-1950s Peter Voulkos and a group of his students in southern California led a movement that broke through barriers of preconception about clay as a medium. Their radical, almost anarchistic spirit opened the way for a whole revitalization that has transformed ceramic art, and touched off new directions in many other disciplines. The monumental UNTITLED SCULPTURE by Voulkos brings the energy of expressionist, nonrepresentational painting into three-dimensional form.

198 Robert Arneson.
CALIFORNIA ARTIST. 1982.
Glazed ceramic. 78″ x 28″ x 21″.
San Francisco Museum of Modern Art.

199 Peter Voulkos.
UNTITLED SCULPTURE. 1958–1959.
Stoneware, handbuilt, white and black slips, unglazed. Height approx. 6′.
Private collection.

200 Toshiko Takaezu.
CERAMIC FORM. 1971.
Height 13".
Private collection.

Peter Voulkos and Toshiko Takaezu have both been influenced by the earthiness and spontaneity of some traditional Japanese ceramics, as well as expressionist painting, yet their work has taken very different directions. Voulkos' pieces are aggressively dynamic, while Takaezu's are subdued, with a more subtle, restrained strength. Takaezu's sculptural forms become the foundation for rich paintings of glaze and oxide. She expresses the love of working with materials felt by many artists:

When working with clay I take pleasure from the process as well as from the finished piece. Every once in a while I am in tune with the clay, and I hear music, and it's like poetry. Those are the moments that make pottery truly beautiful for me.

Toshiko Takaezu[13]

Glass

Chemically, glass is related to some of the materials used in ceramics, especially glaze. As a form-creating medium, however, it offers a wide range of possibilities that are unique to glass. Hot or molten glass is a sensitive, amorphous material. Molten glass can be shaped by blowing or pressing it into molds. Glass solidifies from its molten state without crystallizing.

Glass has been used for 4000 years as a material for practical containers of all shapes and sizes. In recent centuries it has also been used in architecture as clear and stained glass windows and mirrors, and in decorative inlays in a variety of objects, including jewelry. Elaborate, colored blown glass pieces have been made in Venice since the Renaissance. Because our primary contact with glass is with utilitarian objects such as food and beverage containers and windows, we often overlook the fact that glass can also be an excellent sculptural material.

Although it can be said that the character of any material determines the character of the expression, this is particularly true of glass. Hot glass requires considerable speed and skill in handling.

The fluid nature of glass produces qualities of mass flowing into line and into translucent volumes of airy thinness. Glass can be blown, cast, pressed, *slumped* (that is, softened for a controlled sag), or used cold as cut pieces, to be glued, assembled, or painted.

Marvin Lipofsky has been part of the American revival of blown glass, which began in the 1960s. His work, reproduced here, is abstract sculpture in which form and sensuous color unite to tease the senses. This piece was made while Lipofsky was artist-in-residence at the Leerdam Glassworks in Holland. It was made by Lipofsky and Leerdam's master craftsman and reflects both the imagination of the artist and the crisp precision of commercial production technique.

German-born glass artist Ann Wärff studied graphics in Switzerland before she began

working with glass in Sweden. Wärff sees glass as an invisible vehicle for color and design. In the bowl shown here Wärff used etching and sandblasting to create images of male and female figures flying across the curving surface in fluid, overlapping shapes of transparent color.

Stained glass windows have been a major element in Christian architecture since the Middle Ages. It is not known when or where the technique was first used, but we do know that the art was highly developed by the late twelfth and thirteenth centuries, when it was employed extensively in Gothic churches and cathedrals such as CHARTRES (see page 290).

The medieval method of setting pieces of colored glass in lead and iron frames has been revived and augmented with new techniques in our time. Stained glass was a popular feature of Victorian houses built around the turn of the century, and has enjoyed a major revival in recent years. Twentieth-century master painters Matisse and Chagall have created major works in this medium.

201 Marvin Lipofsky.
LEERDAM GLASVORMCENTRUM
COLOR SERIES. 1970.
Off-hand blown glass.
10" x 15" x 13".
Collection Javier Garmendia, New York.

202 Ann Wärff.
BOWL, "HAN FLYGER HEM"
c 1977
Clear glass with layers
of gold, amber, and purple
cased glass; blown,
acid etched, and sand blasted.
Height 7³/4", diameter 10⁷/8".
Honolulu Academy of Arts.
Gift of Mr. and Mrs. Henry B.
Clark, Jr.

Today's stained-glass artists work in a variety of styles. Kathie Stackpole Bunnell's personal imagery is executed with great patience and skill. She says, "I want my stained glass windows to keep implying, unfolding, and changing. They should be revealing through time,..."[14] Bunnell describes the origin of BUCKEYE TREE:

203 Kathie Stackpole Bunnell.
BUCKEYE TREE. 1974.
Stained glass. 61 1/2" x 21".
Zen Center, Muir Beach, California.

The window was inspired by a tree I planted outside my house. It went for a season or two without my paying much attention to it. Then one winter we had a warm spell that brought out the buds at the ends of the branches. Going outside in the warmth and seeing the buckeye with its very bright green leaves made me give up work on one window, start this one, and get caught up in spring.[15]

Metal

Metal has been used for making works of art since ancient times. Strength and formability are the primary characteristics of metals. They can be hammered, cut, drawn out, welded, joined with rivets, or cast. Perhaps the largest number of craft-artists using metal are those who make jewelry.

Self-adornment is universally practiced and limitless in form. Jewelry has been made and worn for beauty's sake, to carry wealth, and to impress others. Jewelry involves such crafts as metalworking, enameling, and stonecutting. Decorative jewelry is a form of miniature sculpture. Ideally, it is designed to enhance the beauty of the wearer. In areas without precious metals, natural materials such as polished stones, shells, carved bone, teeth, and feathers are often used. In the recent crafts revival, many artists have been influenced by works from such areas. Today's jewelry often includes unusual materials, as well as the more traditional metals and precious stones.

Mark Pierce has found ways to create exciting jewelry forms by merging his experience as a painter with his work as a jewelry designer. He is one of many craft-artists who have been exploring uses of new materials and techniques. Through his research, Pierce has developed a polymer-aluminum process for creating unique, colorful jewelry.

Albert Paley began his metalworking career making jewelry, and gradually shifted to larger pieces such as the GATE of the Renwick Gallery.

He enjoys handling a material that physically resists him. Whether he is working on small pieces or large ones, Paley employs a variety of metals, woven together in harmonious interplay. The high energy of his ornamental gates is created by a lively relationship between lines and spaces. The curves have the sensual fluidity of pliable heated metal, while the center verticals recall the strong rigidity of iron and steel. Bundles of straight lines unify and solidify the composition.

Wood

Life and growth characteristics of individual trees remain visible in the grain of wood long after trees are cut, giving wood a vitality not found in other materials. Its abundance, versatility, and tactile qualities have made it a favorite material for human use. The living spirit of wood is given a second life in crafted forms.

Many contemporary designers have been inspired by art from nonindustrial cultures, especially the directness and sensitivity demonstrated in the use of materials and the imaginative ways of meeting practical needs with exciting forms. All over the world traditional peoples have met their basic needs for survival and spiritual fulfillment in the design of articles for daily use. Generations of artisans have refined the design of these objects in order to improve both their practical and their expressive functions (see the COCONUT GRATER on page 263).

Most of the furniture in our homes today is produced by industrial mass-production methods. This does not mean that it cannot be well designed (see the chair on page 191 designed by

204 Mark Pierce.
EARRINGS. 1982.
Polished brass and luminar. 2 1/4" x 1 3/8" x 1/2".

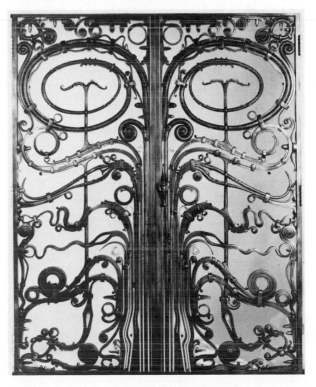

205 Albert Paley.
GATE. 1974.
Forged steel, brass, bronze. 72 1/2" x 90 1/4".
Renwick Gallery, National Museum of American Art.
Smithsonian Institution, Washington, D.C.
Museum Purchase.

Charles and Ray Eames). But those who have the skills to make their own furniture, or are in a position to commission artists to create custom furniture for them, can enjoy the experience of handcrafted furniture in their own homes. Many handcrafted pieces are one-of-a-kind, and others are among a limited number of a given design.

Sam Maloof makes unique pieces of furniture and also repeats some designs he finds particularly satisfying. The forms he uses are expressive of his love of wood and of the hand processes used to shape this material into furniture. Because he enjoys knowing that each piece is cut, assembled, and finished according to his own high standards, he has turned down offers from manufacturers who want to mass produce his designs. Many pieces of furniture are pleasing to look at, and many comfortable to use, but relatively few fulfill both these functions so successfully. Maloof's chairs are not only beautiful to look at, they are exceptionally comfortable to sit in.

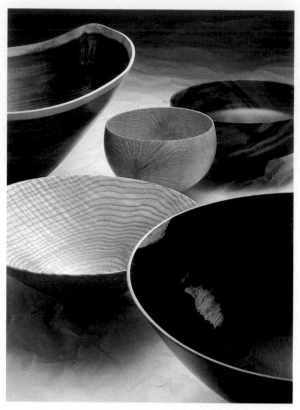

207 Bob Stocksdale.
TURNED WOOD BOWLS. 1982.
Clockwise from top right: ebony, 10¾″ diameter; ash, 8½″ diameter; blackwood, 11¼″ diameter; macadamia, 4½″ diameter; ironwood, 6½″ diameter.
Photograph: Nora Scarlett.

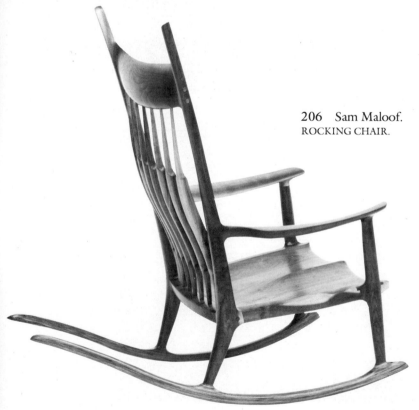

206 Sam Maloof.
ROCKING CHAIR.

The natural warmth of wood, and its rich variety of colors and textural patterns are fully explored by Bob Stocksdale in his bowl forms. Stocksdale works with the grain in each piece of wood, taking full advantage of color variations, knots, and growth rings. Irregularities in the wood become featured design elements.

Fiber

Fiber art includes weaving and a host of other processes that use fiber in both traditional and innovative ways. The field has undergone a major rebirth heralded by a name change from "art fabric" to "fiber art." Modern on- and

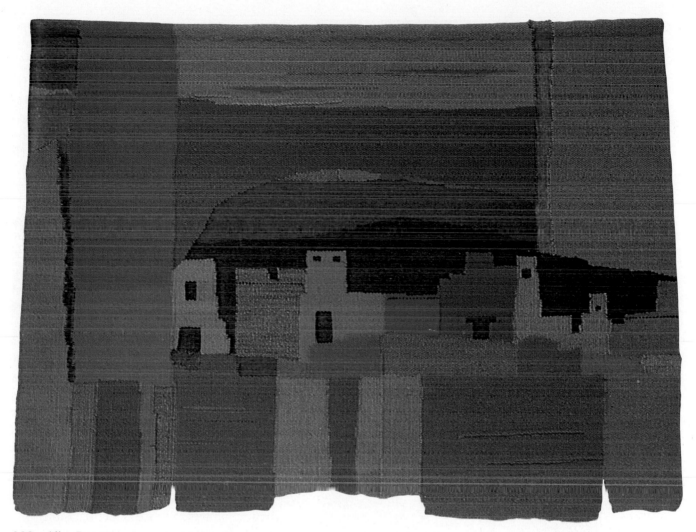

208 Alice Parrott.
MESA VERDE. 1976.
Wool and linen, tapestry and soumac techniques. 48″ x 62″.
Collection of Paul M. Cook, Atherton, California.

off-loom constructions share with other art forms the heritage of art history as well as current trends.

Natural and synthetic threadlike fibers are the basic materials for a variety of forms produced by processes such as weaving, stitching, knitting, crocheting, and macraméing (knotting).

Weaving, like ceramics, developed with the evolution of hunter-gatherer cultures to agricultural communities. When skins were no longer available for warmth, garments made from cloth became a necessity. The basic processes of making cloth, from spinning to weaving, are relatively easy to learn. All weaving is based on the interlacing of lengthwise fibers, *warp*, and of the cross fibers, *weft* (also called *woof*). Patterns are created by changing the numbers and placement of interwoven threads.

Alice Parrott's weaving MESA VERDE uses warm, vibrant colors to create an abstract image of the ancient protected community built high in the overhanging cliff of a Colorado mesa. Such modern wall hangings extend ideas from traditional tapestry and rugmaking into the present.

A variety of looms and techniques are avail-

209 Kay Sekimachi.
SHIRATAKE III. 1965.
Nylon monofilament. 50″ x 12″ x 15″.
Collection of Elena Anger, Stockholm.

able to the weaver. A large tapestry loom, capable of weaving hundreds of colors into intricate images, may require several days of preparation before work begins. In contrast, a small weaving on a simple hand loom may be finished in a few hours.

Kay Sekimachi has developed a technique for weaving multiple layers on a loom. When the works are removed from the loom they become three-dimensional. Transparent nylon monofiliment was loosely woven to create the organic symmetry of SHIRATAKE III. Starting from a single plane, the fabric divides first into two layers, then four. The warps then pass through one another, so that one beginning on the right ends up on the left, and vice versa. The billowing, airy curves allow space to pass through and fill the form.

The recent outbursts of creative work in *off-loom* fiber arts has taken these arts far beyond their traditional roles and functions as crafts. Fiber sculpture is one of the new directions being taken in this area. Marcia Floor uses leather as a medium for sculpture. In NEST leather is twisted and pulled to make it resemble wood; it is also cut into strips and woven, giving it the appearance of plant fiber. The vegetable-tanned cowhide was plaited and formed while wet. NEST has a remarkable presence. The face suggests a nature spirit or wood nymph emerging, or perhaps revealing itself just for a moment.

Fiber forms have warmed us, provided cushioned floor coverings, and offered interior color, texture, and sound control. Pioneering fiber artist Gerhardt Knodel has extended these traditional functions by exploring other environmental possibilities of fabric. Knodel's large hanging work GRAND EXCHANGE, designed for the Cincinnati Bell atrium, has transformed a rather stark and awkward space into a place that is inviting and calming to the employees who go there to relax. The suspended fabric planes suggest stairs, parts of a landscape, or spatial constructions. Knodel applied his sensitivity to light, color, planes in space, and surface textures in the creation of a kind of cloth archi-

tecture. Inspiration for this work came in part from his observation of the magical effects of theater curtains. Other sources of inspiration for Knodel's work include fiber arts seen in such places as Indonesia, India, and Afghanistan. The vital history of fabric is continued as Knodel works to meet the needs of our time.

Much of the fiber that we come into contact with daily is in the form of clothing. Some fiber artists are working to extend the possibilities of wearable art (see page 196). People involved in "art to wear" want the imagination of the artist to have free reign, and not be held back by requirements of mass production or practicality.

210 Marcia Floor.
NEST. 1979.
Leather. 27" x 13¼" x 6".
Collection of the artist.

211 Gerhardt Knodel.
GRAND EXCHANGE. 1981.
Hand-woven fabric, nylon cords, metal framework. Ceiling height 52'.
Cincinnati Bell of Ohio, atrium.
Photograph: Balthazar Korab.

DESIGN DISCIPLINES

Nearly everything we buy and use carries information about our needs, our concerns, and our values. Design shapes as well as transmits material culture. Professional designers create a wide variety of images, objects, and spaces. Their role is to enhance living by applying their developed sense of aesthetics and utility to meet human needs. As the buying public becomes more visually aware, it will look for, and be more likely to find available, an increased variety of well-designed graphics, objects, and living spaces.

The great numbers of people who live in urban areas have brought about a need for effective, aesthetically rewarding designs. From small objects to large buildings, and from personal to public spaces, design is an urgent necessity, not just a cosmetic addition.

Industrial Design

Industrial design is art working within industrial media. Its purpose is to design objects for machine production, to relate technology to human sensibilities and thus to enhance objects

SOME THINGS TO CONSIDER IN A PERCOLATOR DESIGN

212 Richard I. Felver.
SOME THINGS TO CONSIDER IN A PERCOLATOR DESIGN. 1972.

213 Ludwig Mies van der Rohe.
LOUNGE CHAIR (BARCELONA CHAIR). 1929.
Chrome-plated steel bars, leather. Height 29½".
The Museum of Modern Art, New York.
Gift of the manufacturer, Knoll Associates, Inc.

designed primarily for functional purposes. An industrial designer can work on items as simple as a bottle cap or as complex as a computer. Always the designer needs to be able to learn anew. He or she must become familiar with how the object being designed will be fabricated, how the object must work, and how it can become a meaningful, economical contribution to living processes. This means designing so that the relationship between the object and the people who use it is a means, rather than a hindrance, to human fulfillment.

Richard I. Felver's drawing shows a few of the specific details and possibilities that a designer must consider when trying to comprehend the design of any common yet always complex object.

A totally different set of problems must be solved when the designer is working out designs for chairs. In 1929 architect Ludwig Mies van der Rohe designed a chair that has become a classic. His LOUNGE CHAIR is a graceful and comfortable place for one or two people to sit.

Husband and wife Charles and Ray Eames worked together. Ray studied painting with Hans Hofmann (see page 138) and brought to the partnership a feeling for sculptural shapes in space and a sense of color and total design. Charles provided architectural, technical, and scientific skills, as well as a fine sense of design and a very active imagination.

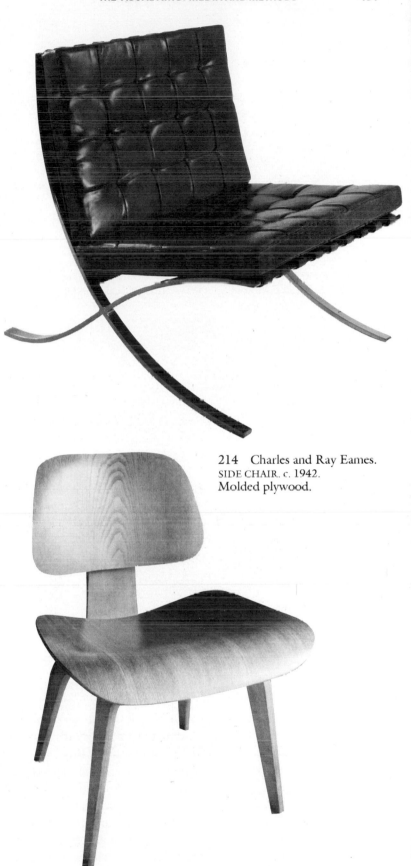

214 Charles and Ray Eames.
SIDE CHAIR. c. 1942.
Molded plywood.

215
DESIGN IN PROCESS ON 1984
CORVETTE. General Motors.

a Conceptual drawing.
b Full scale model.

1960s and 1970s one-half to two-thirds of the purchase price of the average American car was for visual design alone. Retooling the machinery that makes the car is the most expensive aspect of design. Thus it is the change in design, rather than the design itself, that is costly.

American automobile design has had a few peaks of achievement. One of these peaks is the high technology 1984 Corvette. For over 30 years the Corvette has been known for its distinctive design and its engineering innovations. While it has evolved through three basic changes of body shape, the ahead-of-its-time look has always been important. In 1978 Jerry Palmer was given the challenge to create a car that maintained the unique Corvette identity, yet with a new, thoroughly contemporary form. Palmer and his associates worked on all aspects of the car, including the design and placement of equipment under the hood. Integrated bumpers and retractable headlights are part of a built-in rather than added-on approach to design. The interior, with its high-tech instrumentation, is carefully designed to be a pleasant environment that functions well as a driving compartment.

Transportation design has a major impact on life in urban areas today—in many ways it shapes the form of cities. Designers working in this field may deal with anything from solving problems related to automobile improvement to designing mass-transit systems attractive and efficient enough to entice people away from the automobile (see page 228).

They first became known for their innovative chair designs. They saw the potential of the simple material plywood, and were among the first to successfully design both molded plywood and molded plastic chairs for industrial production. Charles and Ray Eames worked with a wide range of media, designing chairs, houses, films, toys, packaging, exhibitions, and a variety of other products.

There can be a considerable difference between redesigning to improve an object's total function and mere exterior restyling to increase sales. It has been estimated that during the

Graphic Design

The term *graphic design* is presently used to refer to applied design on two-dimensional surfaces ranging in scale and complexity from stamps and logos or trademarks to television commercials and packaging designs. Much of graphic design involves designing material to be printed—books, magazines, brochures. *Typography* is the art and technique of composing printed material. Photography and typography are important media for the graphic designer. The typography of this book is the art of graphic designer Bruce Kortebein, who carefully considered and integrated the ideas and requirements presented to him by the publishing staff and the authors.

Graphic designer Ivan Chermayeff, well known for his corporate design work, has also created popular Christmas cards. His ANGEL ON DOVEBACK has the simplicity and jubilance of a Matisse cutout. Over 4 million copies of this card have been sold. Chermayeff believes that design can sell ideas, not just products. When it communicates on this deeper level, design makes a major contribution to life in the twentieth century.

Many designers work in advertising. It has been estimated that the average American adult is assaulted by a minimum of 560 advertising messages each day. The modern world is building up its communications machinery in order to transmit an even greater array of images at an even faster rate.

216 Ivan Chermayeff.
ANGEL ON DOVEBACK. 1970.
UNICEF Christmas card.
4 3/8″ x 3 7/8″.

217
AMERICAN CANCER SOCIETY POSTER.

In advertising the arts frequently work together. Television advertising is a kind of operatic art form that calls upon writers, musicians, and actors, as well as directors, camera operators, and graphic designers. In printed advertising, a writer, a designer, and often an illustrator or photographer work as a team. Both of the accompanying ads offered effective propaganda on two opposing sides of an argument. In the American Cancer Society's poster, the graceless form of the photograph and the typography intentionally contradict the content of the words, creating a blunt contrast to the delicate sophistication of the Eve advertisement.

Often the name, product, or purpose of a company or organization is given a distinctive and memorable appearance by a graphic designer. Such an identifying symbol is a trademark, called a *logo* by designers. When an effective logo is incorporated into a consistent design program for all of a company's need, the business benefits from the resulting public recognition. In 1952 William Golden, then Creative Director of Advertising, designed the eye that for several decades has served well as the Columbia Broadcasting System logo. One variation of the logo is a 5 second computer animated sequence used to announce CBS Saturday Night Movies.

Clothing Design

Clothing designers start with an awareness of the lines, proportions, and movements of the human body, and the ways in which fabric drapes and molds itself to cover selected areas of the body's contours. Ideas begin with vi-

218
EVE CIGARETTE ADVERTISEMENT.

219 John LePrevost, Art Director; Jay Tietzell, Producer.
CBS MOVIE OPENER, 1983.
Computer-generated animation.

sualization and drawings. Line, shape, color, texture, and the fluid motions of the human body are major considerations.

Apparel design includes everything from mass produced clothing of all types to unique custom garments that may cost thousands of dollars. Fashion shows that introduce the new creations of the most famous designers are brought to the public through newspapers, magazines, and television. Although their creations often seem far removed from the real world, fashion designers have a great deal of influence on popular taste and style selection.

Designer Sharon Tate starts with pencil drawings. Her working sketch shown here was modified somewhat by the time the design appeared as a finished garment. Tate creates clothes for the mass market that have a designer look, yet are within the average buyer's price range.

220 Sharon Tate.
CLOTHING DESIGN, 1983.
Courtesy of Mel Naftal.

a. Working sketch.

b. Finished dress.

221 Sandra Rubel.
COAT. 1983.
Silk, painted, pieced, beaded.
Photograph: ©Kathie A. McGinty, 1983.

Sandra Rubel has combined a mastery of color and fiber art with a knowledge of clothing construction in her one-of-a-kind hand-crafted COAT. Deep pleats that penetrate the elaborate yoke create an exciting design for the back of the garment. The pleats fall gracefully and move with the body when the coat is worn. Piping and beads add delicate finishing touches well integrated with the overall design. One almost expects to see a glass slipper peeking out from beneath the hem of this fantastic coat.

Rubel's coat was included in the exhibition "Art to Wear: New Handmade Clothing" at the American Craft Museum II in New York in 1983. The concept of wearable art brings art out of museums and galleries so that it can become a part of an interaction between artist, wearer, and viewer.

With the need to economize, recent nostalgia trends, and concerns over conservation and recycling, many people are proud of wearing only old or second-hand clothes. The intentional wearing of old clothes and variations on blue denim is itself a fashion trend. To capitalize on the trend, the clothing industry has even manufactured replicas of old clothes, such as prefaded blue jeans.

Clothing design is a daily consideration. Clothes protect and conceal the human figure, yet they fulfill their potential when they also enhance the body's inherent beauty. We express ourselves by the manner in which we dress. Clothing is communication. In addition to providing warmth and concealment, clothing indicates individual attitude and character, mood, identity with certain groups or occasions, occupation or profession, socioeconomic position, or all of these. We all like to feel good or right in what we wear.

Textile Design

As media categories, fiber arts and textile design overlap. *Textile design* generally refers to designs to be mass produced, with designs manufactured by either weaving or printing.

In the early 1950s Armi Ratia started the Marimekko company in Finland. Designer Maija Isola joined her, and together they caused a revolution in the textile printing industry. Marimekko broke out of the conventional limitations and domination of floral motifs and monotonous ornamentation. The firm became known for its bold designs using large areas of color. As fabric design moved into the expressive domain enjoyed by painters and graphic designers, Marimekko fabrics were often stretched on frames or hung on the wall

like paintings. Designers, architects, and painters responded enthusiastically to Marimekko designs.

Jack Lenor Larsen has become one of America's best known weavers and textile designers. He is an enthusiastic traveler who finds inspiration in the fabrics he studies and collects in various parts of the world. Larsen says he weaves his experiences into his fabrics. While he uses techniques, colors, and materials from many cultures, he synthesizes them into designs and collections that are uniquely his own. He is a major innovator as well as a sound traditional craftsman.

The majority of Larsen's designs are now woven on power looms, but he continues to weave most of the first samples by hand. Some of his large commissions are woven in places such as India and Africa where the traditional techniques Larsen employs originated. This practice has helped to revitalize ancient crafts and has proved to be of benefit to local economics. In the United States Larsen's fabrics are sold through architects and interior designers.

222 Maija Isola of Marimekko.
SEIREENI. 1964.
Cotton fabric.

223 Jack Lenor Larsen.
LABYRINTH. 1981.
Upholstery fabric, Jacquard "repp," worsted wool and cotton, worsted wool face.
Project Director: Mark Pollack, Larsen Design Studio.

Interior Design

Interior living spaces are designed consciously and unconsciously by those who inhabit them. Professional and amateur interior designers need to have both an awareness of the expressive character of architectural spaces and the ability to visualize how these spaces can be designed to contribute to the life within them. Regardless of who designs them, however, enjoyable interiors are positive expressions determined by the values and lifesyles of the occupants. For this reason, some of the best interior design is done by individuals for themselves.

Putting together enjoyable interiors takes thoughtful planning. Important aspects of the process include developing ideas about the desired atmosphere or mood in keeping with the lifestyle and intended purpose of the space; relating interior and exterior spaces when applicable; organizing rooms, and spaces and objects within rooms, to suit specific needs; selecting and arranging furniture for comfort and ease of circulation; and coordinating space, materials, colors, textures, and objects to create a consistent atmosphere appropriate to the functions of the rooms.

Our immediate environment has an enormous effect on our mental outlook. Visual and spatial qualities of interiors do much to shape the quality of our lives.

Interior designers Robert Bray and Michael Schaible are primarily concerned with spatial qualities. The studio apartment that belongs to Bray was designed to be a beginning, or starting point, to which other elements could be added at a later date. After he started living in the apartment, however, Bray decided that he did not want to add anything—that he preferred the beauty of the walls to the beauty of paintings. The uncluttered simplicity gives a spacious feeling to the small room, and provides a tranquil refuge from the hustle and bustle of Manhattan. A variety of floor levels divides the space, providing visual interest

224 Bray-Schaible Design, Inc.
BRAY RESIDENCE.
Photograph: Jaime Ardiles-Arce.

without making the room appear smaller. The highest level is flush with the window sills, creating a flow between interior and exterior space. The interior space is only minimally interrupted with furniture.

Interior design frequently amounts to interior architecture. When they work with clients, Bray and Schaible begin by paring down to a basic environment on which to build. Such an approach enables clients with limited funds to add furniture and "art" slowly, as budgets permit. This design team feels that getting spaces down to bare, functional essentials is the first and most important step, even when clients already own beautiful furnishings and art objects.

Sam and Alfreda Maloof have created a home that supports and expresses their way of life. Their home and workshop are located in California on seven acres of rural land. Sam designed and built the house—from the supporting structure to the elegant details. Even door latches and hinges are beautifully hand-crafted originals. The house is filled with Sam's handmade sculptural furniture (see his rocking chair on page 186) and with ancient and contemporary art treasures collected by the Maloofs. Persian rugs, and an outstanding collection of American Indian rugs, pots, and baskets, complement the natural wood of the house. In the large kitchen-dining area walls of concrete block painted orange and magenta contrast with walls of rough-hewn redwood.

The house is an ongoing work of love that has engaged the Maloofs for more than 30 years. An affinity with beauty found in both nature and art is evident in this interior. Flowing spaces and the warmth of many textures and colors provide a full and richly personal environment.

Interior designs that work well are in harmony with the character of the architecture and complement the qualities of the exterior landscape or cityscape as viewed through windows. Meaningful, useful, and well-loved personal possessions provide the final touch.

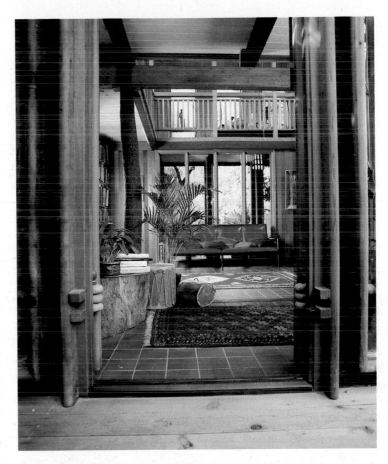

225 Sam and Alfreda Maloof.
MALOOF RESIDENCE.
Photograph: ©Jonathan Pollack, 1984.

ARCHITECTURE

Architecture is the art and science of designing structures that organize and enclose space for practical and symbolic purposes. Because architecture grows out of human needs and aspirations, it clearly communicates cultural values. Of all the visual arts, architecture affects our lives most directly. It determines the character of the human environment in major ways.

Architecture, like sculpture, is expressive three-dimensional form. Both disciplines utilize space, mass, texture, line, light, and color. While sculpture is most often seen from the outside, architecture is experienced from within as well. The sculptural form of a building works best when generated from within—determined by those functions the structure is intended to serve.

To be architecture, a building must achieve a working harmony with the factors that call it into being and that are, in turn, affected by its existence. We instinctively seek structures that will shelter and enhance our way of life. It is the work of architects to create buildings that are not simply constructions but also offer inspiration and delight.

Buildings contribute to human life when they provide durable shelter, augment their intended function, enrich space, complement their site, suit the climate, and stay within the limits of economic feasibility. The client who pays for the building and defines its function is an important member of the architectural team. The mediocre design of many contemporary buildings can be traced to both clients and architects. A more aware public is necessary before we can improve the quality of contemporary architecture.

Sculpture can be small and rarely needs a consistent structural system. Architecture, however, employs structural systems in order to achieve the size and strength necessary to meet its purpose. Methods of support used in architecture determine the character of the final form. These structural methods are based on physical laws and, for that reason, have changed little since people first started to build—even though the materials involved have changed dramatically.

The world's architectural structures have been devised in relation to the objective limitations of materials. Structures can be analyzed in terms of how they deal with downward forces created by gravity. They are designed to withstand the forces of *compression* or pushing (→ ←), *tension* or pulling (← →), *bending* or curving (⌣), or a combination of these in different parts of the structure. There are dozens of basic variations of structural types—shells, folded plates, domes, hanging roofs, tents, and free-form castings. The diagrams here illustrate some of the most common structural systems.

Every development in architecture has been the result of major change in technology. Materials and methods of construction are integral parts of the design of architectural structures. In earlier times it was necessary to design structural systems suitable for the materials that were available, such as wood, stone, or brick. Today technology has progressed to the point where it is possible to invent new building materials to suit the type of structure desired. Enormous changes in materials and techniques of construction within the last few generations have made it possible to enclose space with much greater ease and speed and with a minimum of material. Progress in this area can be measured by the difference in weight between buildings built now and those of comparable size built 100 years ago.

Architects manipulate solids and voids. As solid masses change in form, our feelings about them change. Straight edges tend to feel hard, curving edges soft. The brick and concrete architecture of the Romans was composed of many solid masses (see page 279). In contrast, Gothic masonry has a lighter quality (see page 206). Traditional Japanese houses are built of wood with sliding screens for both interior and exterior walls (see page 258) thus providing flexibility in the flow of space according to seasonal changes and the desires of the householder.

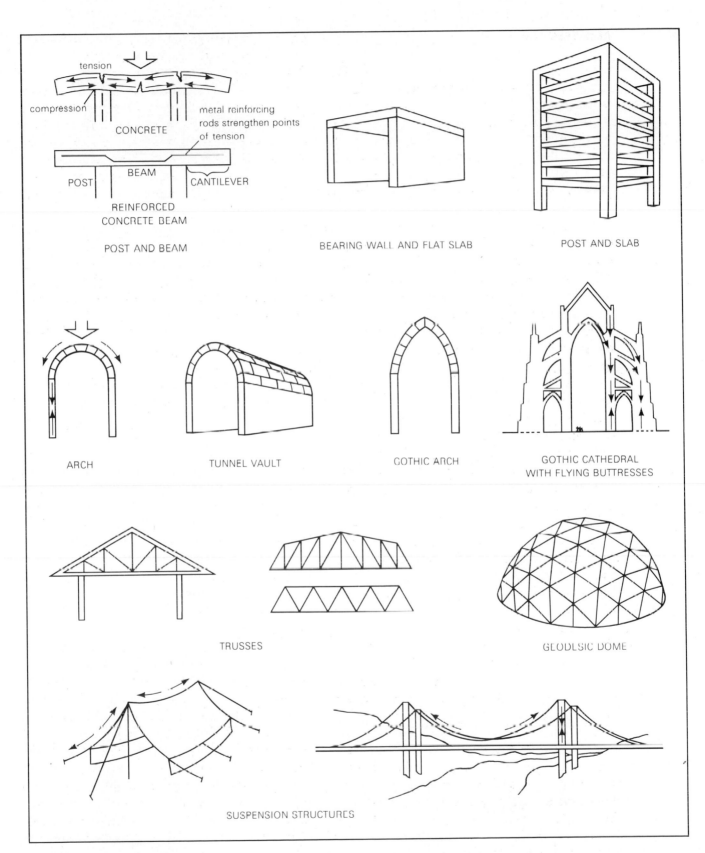

tension

compression

CONCRETE

metal reinforcing
rods strengthen points
of tension

POST BEAM CANTILEVER

REINFORCED
CONCRETE BEAM

POST AND BEAM

BEARING WALL AND FLAT SLAB

POST AND SLAB

ARCH

TUNNEL VAULT

GOTHIC ARCH

GOTHIC CATHEDRAL
WITH FLYING BUTTRESSES

TRUSSES

GEODESIC DOME

SUSPENSION STRUCTURES

226
BASIC STRUCTURAL SYSTEMS.

227 Beverly Hoversland.
ARCHITECTURAL DRAWINGS.

a Plan.

b Elevation.

In order to develop and present their ideas, architects make drawings and models. Architectural drawings include (a) *plans*, in which the structure is laid out in terms of a linear pattern of spaces as seen from above; (b) *elevations*, in which individual exterior walls and major or complex interior walls are drawn to scale as if seen straight on, thus indicating to exact scale such elements as wall heights and window placement; (c) *sections*, in which a slice or cross section is drawn showing details along an imaginary vertical plane passing through the proposed structure; and (d) *perspective renderings*, which give a pictorial rather than diagrammatic view of the finished building as it will appear on the site. Perspective renderings indicate such features as land contours, landscaping, and adjacent streets and buildings, if any.

Today's architecture has three essential components comparable to elements of the human body: a supporting *skeleton* or frame, an outer *skin* enclosing the interior spaces, and *equipment*, similar to the body's vital organs and systems. This equipment includes plumbing; electrical wiring; appliances for light; hot water; and air conditioning for heating, cooling, and circulating air as needed. Of course, in early architecture (such as igloos, and adobe

and stone wall structures) there was no such equipment, and the skeleton and skin were often one. We are again seeing the union of skeleton and skin in such contemporary architecture as folded plates, shell structures, and *pneumatic* or air-inflated structures.

Much of the world's great architecture has been constructed of stone because of its beauty, permanence, and availability. In the past, whole cities grew from the painstaking and arduous tasks of cutting and stacking stone upon stone. Some of the world's finest stone masonry can be seen in the ruins of the ancient Inca city of Machu Picchu, high in the eastern Andes of Peru at an elevation of 8000 feet (see page 260). Inca masonry is characterized by mortarless joints and the "soft" rounded faces of the granite blocks. The openings of doors and windows are made possible through stone beams or lintels thick enough to provide the necessary strength to span the short distances while carrying the weight from above.

c Section.

d Perspective rendering.

Greek temples were also made by placing carved stone upon carved stone without mortar (see page 275). But Greek builders developed a much lighter structure by opening up walls with a *colonnade* or series of columns. Greek temple architecture is an elegant refinement of basic *post and beam* (or *lintel*) construction. Columns are spaced close together and interior spaces are narrow to accommodate the limited strength of stone. With any material, stresses in a beam increase as columns move farther apart. Compression at the top and tension at the bottom of the beam increase as the span lengthens. Stone is weakest when under tension, as in a beam.

A structural invention had to be made before the physical limitations of stone could be overcome and new architectural forms could be created. That invention was the *arch*, a curved structure originally made of separate stone or brick segments. Single-piece arches can now be made with such materials as reinforced concrete or welded steel.

The arch was used by early cultures of the Mediterranean area chiefly for underground drains and tomb chambers, but it was the Romans who first developed and used the arch extensively in above-ground structures. Roman builders perfected the semicircular or true round arch made of separate blocks of stone. As a method of spanning space, the arch makes it possible to carry the structural load fairly evenly throughout, and therefore it can be made of separate parts all under compression. The Roman arch is always a semicircle made from wedge-shaped stones fitted together with joints at right angles to the curve. Temporary wooden supports carry the weight of the stones during construction. The final stone to be set in place is the *keystone* at the top of the arch. When that stone is placed, its weight holds the other stones below it. A series of arches supported by columns is called an *arcade*.

228 Ictinus and Callicrates.
PARTHENON. 447–432 B.C.
View from the northwest. Athens, Greece.

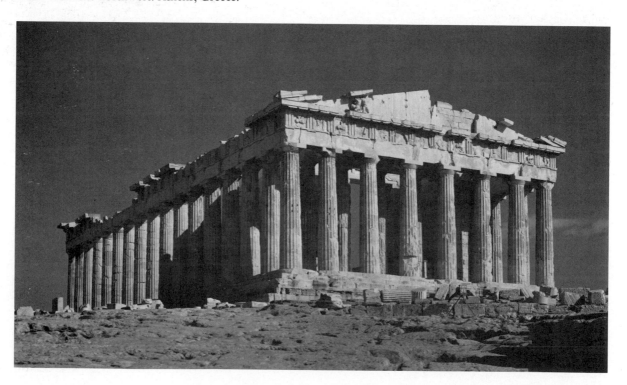

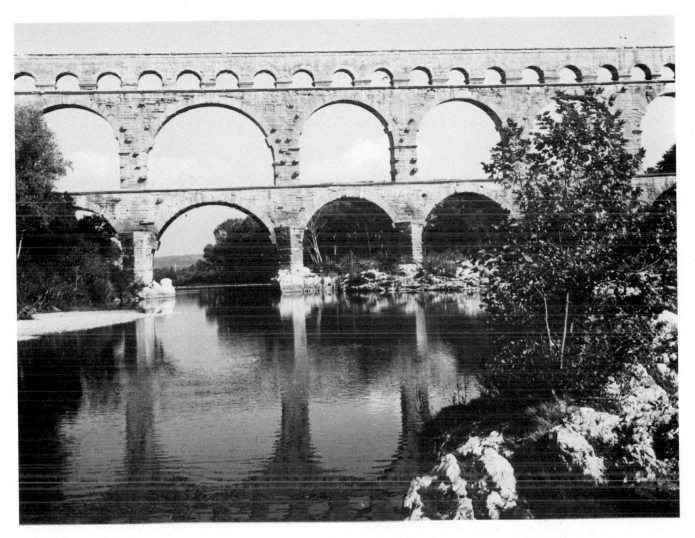

229
LE PONT DU GARD 15 A.D.
Limestone. Height 161', length 902'.
Nimes, France.

The Romans built roads and waterways over much of southern Europe. The aqueduct called LE PONT DU GARD near Nimes, France, is a fine example of the functional beauty of Roman engineering. That it is still standing after almost 2000 years attests to the excellence of its design and construction. Water was carried in a conduit at the top, with the first level serving as a bridge for traffic. The combined height of the three rows of arches is 161 feet.

By extending the arch in depth, the Romans were able to build large, vaulted interiors. Such a structure is called a *tunnel or barrel vault*. During the early Middle Ages, the Roman art of vaulting died out with the loss of the technical knowledge for engineering such structures. In the eleventh and twelfth centuries, the architects of northern Europe, seeking to replace the timber roofs of churches with something less flammable and more dignified, returned to building tunnel vaults based on the Roman arch concept. Until then, arches had been used only in bridges and arcades along the side walls of church interiors and courtyards. The result-

230
ST. SAVIN-SUR-GARTEMPE.
c. 1095–1115.
Choir and nave. Poitou, France.

231
NOTRE DAME DE CHARTRES (below).
c. 1200–1400.
Interior.
Nave, approx. height 122′, width 53′,
length 130′.
Chartres, France.

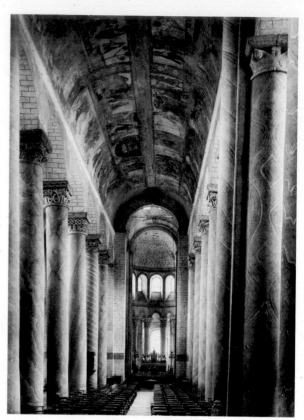

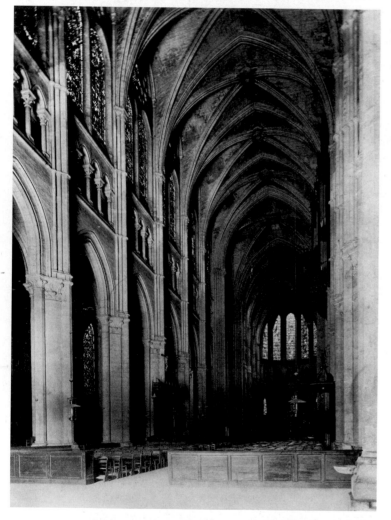

ing style is known as *Romanesque*, signifying its Roman origin. Romanesque architecture is massive and solid, with emphasis on simple geometric form. Because the walls support the roof, windows in churches such as ST.-SAVIN-SUR-GARTEMPE had to be small and thus admit little light into the interior.

The first great structural breakthrough after the semicircular arch was the pointed arch. This seems a small change, but its effect on architectural structure was spectacular. The *pointed arch* is higher and therefore capable of enclosing more volume.

In the mid-twelfth century architects realized that it was not necessary to fill the entire vaulted ceiling with the same thickness of heavy masonry. Thin "rib" arches crossing diagonally between opposite arcades could carry the major weight of a vault downward to the columns. The *rib vault* concept combined with the pointed arch to produce the basic structure of

Gothic architecture (see also exterior of CHAR-TRES CATHEDRAL, page 290). Space was contained in a new way. Walls that no longer carried their own weight and the weight of the ceiling were filled with non-load-bearing *curtain walls* of stained glass. These buildings became open structures because their skeletons were worn largely on the outside, where half-arches or *flying buttresses* carried the weight of the vault downward to the ground (see diagram on page 201).

There was a return to the round arch during the Renaissance (see page 90). This form of arch prevailed until the nineteenth century, when steel beams were first used for wide spans. Since then the arch has largely been relegated to a merely decorative function.

After the Gothic system was developed, no basic structural invention was added to the Western architectural vocabulary until the invention of steel and concrete buildings in the late nineteenth century. Henry Richardson's huge MARSHALL FIELD WHOLESALE STORE occupied an entire city block. The heavy, almost Romanesque, character of its masonry exterior was pierced by superimposed window arcades reminiscent of Roman aqueducts. These thick walls carried their own weight, as did their ancient predecessors. Yet, within the building, an iron skeleton actually supported the seven floors. The logical simplicity and strength of this structure, with its opened vertical window "bays," linked the beauty of ancient stone structures of the past with the uniquely modern architecture that was to follow.

The next major breakthrough in methods of large scale construction came between 1890 and 1910 with the development of structural steel, and steel as the reinforcing material in reinforced concrete. Extensive use of cast-iron skeletons in the mid-nineteenth century had prepared the way for *steel cage construction* in the 1890s.

New building techniques and materials, as well as new functional needs, demanded a fresh approach to structure and form. The architects

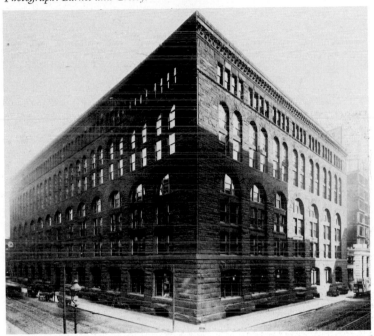

232 Henry Hobson Richardson.
MARSHALL FIELD WHOLESALE STORE.
1885–1887 (demolished 1930). Chicago.
Chicago Historical Society.
Photograph: Barnes and Crosby.

who met this challenge during the last one hundred years were strong, articulate thinkers who developed a philosophy of architecture closely linked in their minds to social reform. The movement began to take shape in commercial architecture, became symbolized by the skyscraper, and found its first opportunities in Chicago, where the big fire of 1870 had cleared the way for a new start.

Leading the "Chicago school" was architect Louis Sullivan. He is regarded as the first great modern architect because he rejected the nineteenth-century practice of borrowing various aspects of historic styles (called *eclecticism*, see page 314). Sullivan did more than anyone to develop the characteristically twentieth-century form, the skyscraper.

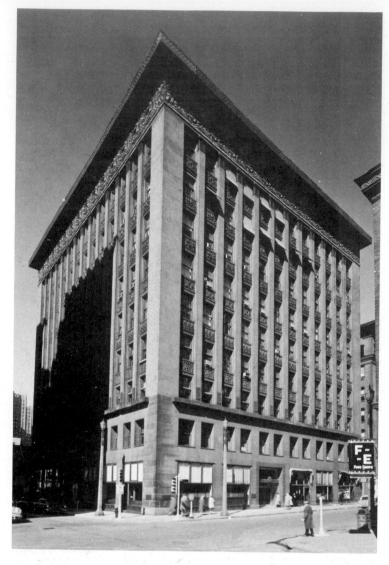

233 Louis Sullivan.
WAINWRIGHT BUILDING. 1890–1891.
St. Louis.

Sullivan demonstrated his sensitivity to the harmony of traditional architecture by dividing the building's facade into three distinct zones. These areas also reveal the various functions of the building, with shops at the base and offices in the central section. The heavily ornamented band at the top acts as a capital, stopping the vertical thrust of the piers between the office windows.

The interdependence of form and function is basic to nature and to all well-designed human forms. Sullivan's observation that "form ever follows function"[16] eventually helped architects break from reliance on past styles and rethink architectural design from the inside out.

In the spirit of Sullivan's ideas on the relationship of form and function, a new international architecture arose in Europe between 1910 and 1930 that rejected all decorative ornamentation, as well as traditional materials like stone and wood, and broke away from the traditional idea of a building as a mass. The principles of Cubist painting and especially the later "pure" geometric planes of Mondrian greatly influenced what came to be called the International Style (see page 367).

With the simple drawing shown here, the young architect, painter, and city planner Le Corbusier demonstrated the basic components of steel column and reinforced concrete slab construction. It is a concept that was to be used

Sullivan's first tall building, the WAINWRIGHT BUILDING in St. Louis, became possible with the invention of the elevator and the development of steel used for the structural skeleton. The building breaks with nineteenth-century tradition in a bold way. Its exterior design reflects the internal steel frame and emphasizes the height of the structure by underplaying horizontal elements in the central window area.

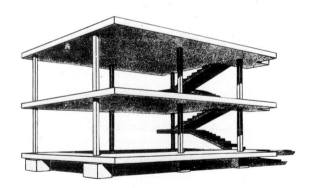

234 Le Corbusier.
DOMINO CONSTRUCTION SYSTEM. 1914–1915.

extensively later in the century as architects adopted the look and sometimes the principles of the then new International Style. Le Corbusier's idea made it possible to vary the placement of interior walls and the nature of exterior coverings, since neither one plays a structural role. His sense of beauty was inspired by the efficiency of machines and a keen awareness of the importance of spaciousness and light.

Walter Gropius carried out the principles of the International Style in his new building for the BAUHAUS, a school of design in Dessau, Germany. The workshop wing, built between 1925 and 1926, follows the basic concept illustrated in Le Corbusier's drawing. Reinforced concrete floors are supported by interior steel columns, allowing a non-load-bearing curtain wall of glass made of the largest pieces of window glass available at that time. There is no feeling of separate mass enclosed by space; space flows through the structure. The exterior and interior of the building are presented simultaneously in a design of opaque and transparent overlapping planes.

In America the skyscraper evolved out of the work of turn-of-the-century pioneer Louis Sullivan and became the notable architectural form of the twentieth century. In the 1920s New York suffered from poor air circulation and a reduction of sunlight as a result of skyscrapers that were built straight up from the sidewalk. By the 1930s the so-called *set-back* law required architects to terrace their structures back from the street to allow sunlight to enter what were becoming dark canyons (see page 386). This zoning law brought in sun; but most of the resulting buildings, constructed for maximum profit, merely complied with the law. The result was a monotonous stepped-back form still common in much of New York.

The idea of solving urban design problems by using a tall, narrow slab fronted by open space came from Le Corbusier. This design was used for the Secretariat Building of the United Nations, which was designed by a team of architects and built in the period 1947 to 1950.

235 Walter Gropius.
BAUHAUS. 1925–1926.
Dessau, Germany.

Sullivan's idea of designing highrise buildings that expressed the grid of their supporting steel structures came to its logical conclusion in New York's SEAGRAM BUILDING designed by Mies van der Rohe and Philip Johnson and built between 1956 and 1958. Non-load-bearing glass walls had been a major feature of Mies' plans for skyscrapers conceived as early as 1919. But it wasn't until the 1950s that he had the chance to actually build such structures. In the SEAGRAM BUILDING interior floor space gained by the height of the building allowed the architects to leave a large, open public area at the base. The vertical lines emphasize the feeling of height and provide a strong pattern, ending with a top planned to give a sense of completion without suppressing the soaring verticality. Mies van der Rohe's famous statement "Less is more" is given form in this elegant austere structure.

Mies was the leading exponent of the *International Style*, which has had an enormous, if somewhat negative, influence on architecture. Around the world it has replaced more suitable regional styles. By mid-century modern architecture had become synonymous with the International Style. The uniformity of glass-covered rectilinear grid structures provided the appropriate formal dressing for the anonymity of the modern corporation.

Buildings using huge expanses of glass became highly fashionable during the building boom of the 1950s and 1960s and were not seriously questioned until the energy crisis of the 1970s. Because of the thin glass skins, the buildings require enormous heating, cooling, and ventilating systems that consume large amounts of energy.

CITICORP CENTER, completed in 1977, has been hailed as a twenty-first-century building.

236 Ludwig Mies van der Rohe and Philip Johnson. SEAGRAM BUILDING. 1956–1958. New York City.

The architects, The Stubbins Associates and Emery Roth & Sons, expanded on the idea of maximizing the amount and quality of ground-level public space. More than 6000 people work in the building, which also houses a subway station, an international marketplace, and a new building for St. Peter's Church. The base of the building and the lowrise market area are a bustle of activity during much of the day. Creative zoning in New York City now allows developers to go beyond height limits in return for creating public space or making other improvements at the base of their building or in the neighborhood.

Energy efficiency was a major consideration in the design of CITICORP CENTER. The square floorplan requires less energy to heat or cool than any plan except a circle. The building's exterior curtain wall has twice the usual amount of insulation and much less glass than conventional office buildings. Other energy saving features include double-deck elevators, a heat reclamation system, and a tower crown designed to utilize solar energy. The sloping roof adds a distinctive element to the Manhattan skyline.

237
a Idea sketches for CITICORP CENTER.

b The Stubbins Associates, Inc. and Emery Roth and Sons.
CITICORP CENTER. Completed in 1977.
Photograph: ©Edward Jacoby.

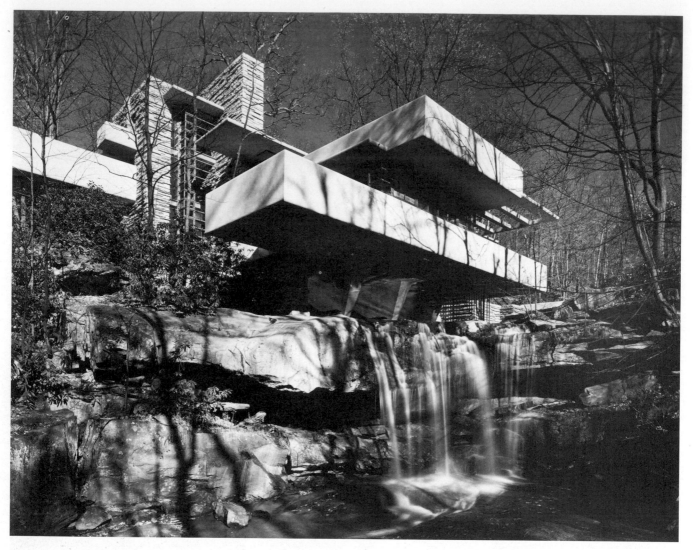

238 Frank Lloyd Wright.
KAUFMANN HOUSE. 1936.
Bear Run, Pennsylvania.

When a beam or slab is extended a substantial distance beyond a supporting column or wall, the overhanging portion is called a *cantilever*. Before the use of steel and reinforced concrete, cantilevers were not used in any significant way because available materials could not extend far enough to make it a viable concept. Early demonstrations of the possibilities of this structural idea include the extensive overhanging roof of Frank Lloyd Wright's ROBIE HOUSE on page 357 and the extended slab in Le Corbusier's drawing of 1914–1915 on page 208. One of the boldest and most elegant uses of this principle occurs in Wright's KAUFMANN HOUSE at Bear Run, Pennsylvania. Soaring horizontal masses cantilevered from supporting piers echo the huge rock outcroppings and almost seem to float above the waterfall. The arrogance of building on such a unique and beautiful location seems justified by the harmony Wright achieved between this bit of nature and his equally inspiring architecture.

Reinforced concrete and steel have provided the raw materials for other new structural forms. The giant roofs of Kenzo Tange's indoor stadiums built in Tokyo for the 1964 Olympics are hung from steel cables, using a *suspension system* used previously for bridge construction. Tange's two OLYMPIC STADIUMS are beautifully interrelated structures. The buildings reveal a unique harmony between the spatial, structural, and functional requirements of the design. In the main building, which houses the swimming pools, Tange and structural engineer Yoshikatsu Tsuboi designed an open interior space with a seating capacity of 15,000. The immense roof is suspended from cables strung from huge concrete abutments at either end of the building.

In spite of this structure's large size, a sense of *human scale* is provided by the proportions of the smaller units to each other and to the entire building. This is noticeable in the diving platforms, seats, and air-conditioning vent pipes on the end wall that become part of the highly sculptural design.

The aerial view shows how the sweeping curves of the buildings unite the two structures and energize the spaces between and around them. The proportions of the many curves, both inside and out, give the complex a sense of graceful motion and balance. Balance in architecture involves bringing actual opposing physical forces into equilibrium as well as working with a visual sense of stability.

a Exterior, natatorium.

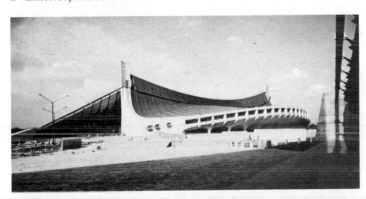

239 Kenzo Tange.
OLYMPIC STADIUMS. 1964.
Tokyo.

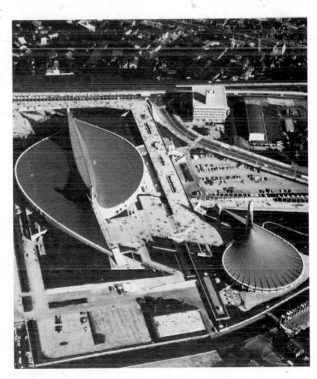

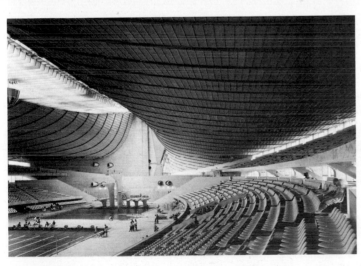

b Interior, natatorium.

c Aerial view.

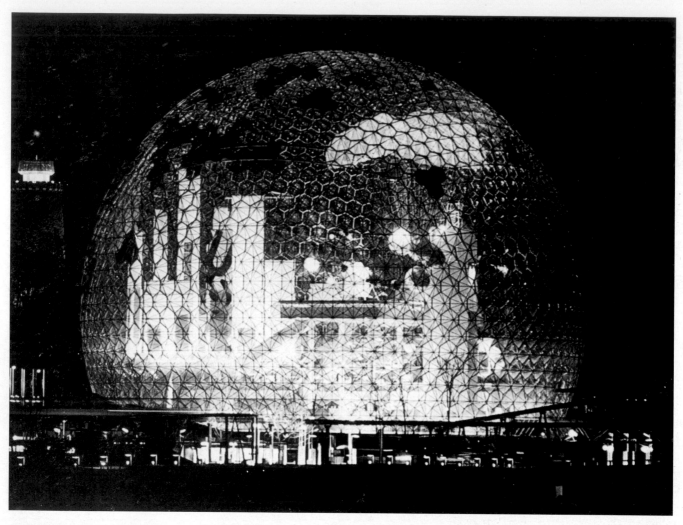

240 R. Buckminster Fuller.
U.S. PAVILLION, EXPO–67. 1967.
Montreal.

Inventor, architect, and structural engineer R. Buckminster Fuller sought to bring about a new era when humanity would consciously cooperate to preserve and enhance life on Earth. He pointed out that a carefully guided technology can provide maximum benefit with minimum cost. Fuller put this concept to work when he developed the principles of the *geodesic dome*, inspired by polyhedrons found in nature. One of Fuller's domes can be erected from lightweight, inexpensive standardized parts in a very short time. Usually a skeleton is constructed of small, modular linear elements joined together to form single planes; these, in turn, join together to form the surface of the dome, as in U.S. PAVILION, EXPO–67. The resulting structure can be covered with a variety of materials to make the enclosed space weatherproof. In contrast to the relatively heavy supports used in traditional vaults and domes, the weight in Fuller's dome is transmitted throughout the structure, producing a high strength-to-weight ratio. Fuller's geodesic domes provide practical shelter and embody his goal of doing more with less. Geodesic domes have served a wide variety of functions including housing, research facilities, and greenhouses.

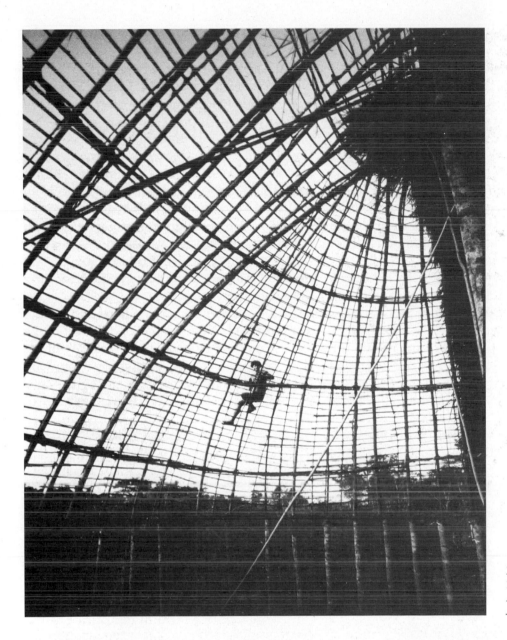

241
KALAPALO INDIANS HOUSE. 1967.
Aifa, central Brazil.
LIFE Magazine ©1967, Time, Inc.

Buckminster Fuller was one of the most forward-thinking men of our time. His ideas for better living and his numerous inventions suggest ways to solve immediate problems. Significantly, the physical projections of his thoughts reached far ahead into the future, yet were in harmony with structures in nature and in the human past. Fuller believed that all aspects of life could come together in a mutually beneficial pattern if the principles of structural design were applied to society as a whole.

As we search for creative solutions to today's urgent problems it is helpful to keep in mind Fuller's idea that we must find ways to do more with less. The low technology, high efficiency buildings of past and present "underdeveloped" societies are a good place to start. The Kalapalo Indians of Brazil, for example, have traditionally built domelike houses reminiscent of Fuller's domes. Over a period of months, saplings are curved and then fastened in an arc to giant posts. Each structure may house several families, each with its own space for hammocks and a cooking fire.

Architect, engineer, and critic Bernard Rudofsky has traveled the world to study the building arts practiced by indigenous peoples. Away from the complexities of urban civilization, simple housing structures are designed to meet basic needs for shelter and comfort. In his book *Architecture Without Architects*,[17] Rudofsky presents a wealth of examples that meet the human need for shelter, while complementing the land and neighboring structures. Such dwellings were and are constructed from available local materials in forms that meet the demands of specific climatic conditions. They grow out of, and therefore blend superbly with, their site. By necessity, the creators of indigenous architecture follow a principle of building in harmony with nature that relates to Frank Lloyd Wright's idea of organic architecture.

Frank Lloyd Wright, one of the most influential American architects of the twentieth century, was the first American architect to use open planning in houses. In a break with the tradition of closed, boxlike houses and rooms, Wright eliminated walls between rooms, enlarged windows, and even placed windows in corners. In so doing he created flowing spaces that opened to the outdoors, welcomed natural light, and related houses to their site and climate.

Wright started with the principle he called *organic architecture*—architecture that acknowledges that we are part of nature, and are happiest when we live in harmony with her laws. Wright felt a building should be of the land, not just on it. In Wright's view, if a building is to be on flat land, it should relate to the flatness; if on a hill, a whole different design is needed. TALIESIN EAST, Wright's home and studio in Wisconsin, is built of local stone. It complements the hill on which it is placed by its location low on the slope instead of on top in a dominating position.

Major influences on modern architecture came through Wright from Japan, where he lived from 1916 to 1922. He saw the asymmetrical balance, large overhanging roofs, and open plan of Japanese architecture as dynamic in comparison to the often static symmetry of Western architecture.

The sharp climb in energy costs following the so-called energy crisis of 1974 motivated leading architects to reexamine their design con-

242 Frank Lloyd Wright. TALIESIN EAST. 1911. Spring Green, Wisconsin. *Photograph: ©Thomas A. Heinz.*

cepts. They began working *with* nature rather than striving to conquer it. After building up around us a mass of costly technology designed to shield us from climatic changes, we are now beginning to realize that our architecture can be designed both to offer comfortable temperatures all year and to take advantage of free, renewable energy sources. The need to find ways of conserving energy has led to a rediscovery of the logic of earlier regional forms.

Since the sun was the only reliable source of heat, it was a matter of comfort and even survival for early societies to understand how to build in good relationship to the sun and the warming and cooling cycles of Earth's daily and yearly movements. The traditional adobe brick of the Southwest evens out extreme temperature changes in the desert. It is the key to success for both ancient Pueblo and contemporary solar structures. New forms of regional architecture designed for specific climates and related to the work of past societies are gradually being worked out.

243
INDIGENOUS ARCHITECTURE,
designed for various climates.

a. Hot, arid climate. The Southwest Indian adobe house absorbs heat by day and releases it by night, to warm the cool evening air.

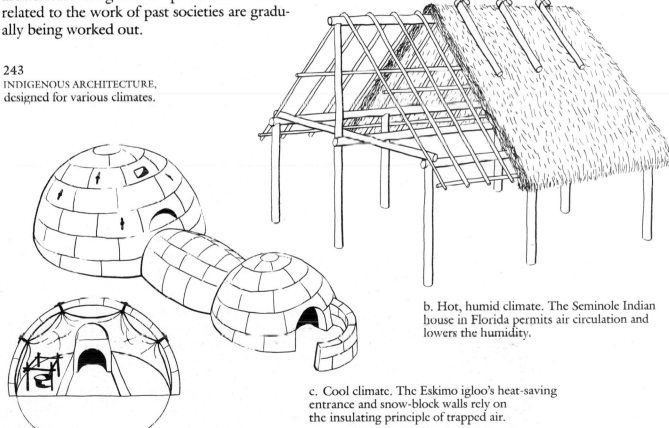

b. Hot, humid climate. The Seminole Indian house in Florida permits air circulation and lowers the humidity.

c. Cool climate. The Eskimo igloo's heat-saving entrance and snow-block walls rely on the insulating principle of trapped air.

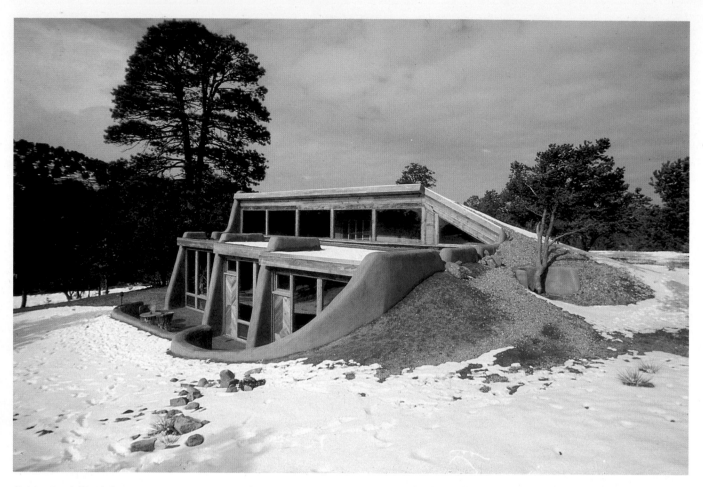

244 David Wright.
SUN CAVE. 1979.
Residence, Santa Fe, New Mexico.

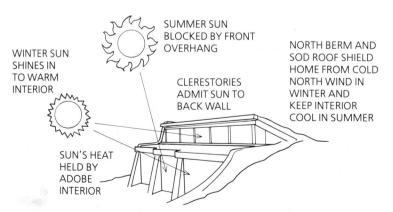

WINTER SUN
SHINES IN
TO WARM
INTERIOR

SUMMER SUN
BLOCKED BY FRONT
OVERHANG

CLERESTORIES
ADMIT SUN TO
BACK WALL

NORTH BERM AND
SOD ROOF SHIELD
HOME FROM COLD
NORTH WIND IN
WINTER AND
KEEP INTERIOR
COOL IN SUMMER

SUN'S HEAT
HELD BY
ADOBE
INTERIOR

Houses based on the concept of using solar radiation from walls were first built in the late 1930s, but they collected too much day heat and lost too much heat at night. The heat storage problem is solved in David Wright's houses by having the mass of the building itself store the solar heat and retain it for long periods with the help of full external insulation.

In 1979 David Wright designed a home called SUN CAVE, which was constructed near Santa Fe, New Mexico, by builder Karen Terry. It is an earth-sheltered house inspired by Southwest Pueblo-style architecture, and based on the concept of a direct-gain passive solar system.

The entire house is a solar collector and heat-storage system. On sunny days heat from the sun is absorbed through south-facing double-glass windows by red brick flooring and

12-inch-thick adobe walls. The floor is the primary heat storage area. After absorbing heat during the day, both floor and walls radiate the collected heat during the night and during overcast periods of daylight. Air circulates naturally to counterbalance day and night and seasonal warming and cooling cycles without the need for mechanical equipment—hence the term *passive* (nonmechanical) *solar system.*

Rigid insulation covers the outsides of solid exterior walls, floor, and roof to prevent heat loss. The building enclosure is capable of storing enough heat to keep the home comfortable for several sunless days. Cooling is provided by good cross ventilation. SUN CAVE comfortably handles temperature changes from below 0°F to 85°F with changes of as much as 50 degrees in a single 24-hour period. The success of this house is largely due to the simplicity of its design.

Jim Pearson designs energy houses for the warm, humid Hawaiian climate, where heating is not required. His basic concept has undergone many design improvements over the last 15 years. The original floor plan, with added refinements, became the basis for a contemporary, environmentally sound cluster of 11 homes nestled in a tropical hillside forest. Each house has its own unique features suited to individual family needs. All take advantage of natural light and ventilation. A solar hot-water heater is a major money saver, and other appliances are selected for their energy efficiency.

The houses are positioned so that the solar panels on the roofs face the noon sun directly. Interior warm air rises and flows out through vents under the ends of the peaked roofs. Large roof overhang and sliding wall panels provide an open air interior, while skylights admit ample interior light. Louvers and movable walls permit the control of tradewinds and can be completely closed against inclement weather. The open wall concept for cooling relates these contemporary Hawaiian homes to the traditional Seminole dwelling designed to work well with Florida's equally warm and humid climate.

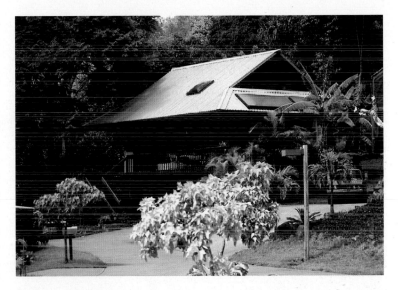

245 Jim Pearson.
ENERGY HOUSE. 1980.
Honolulu, Hawaii.

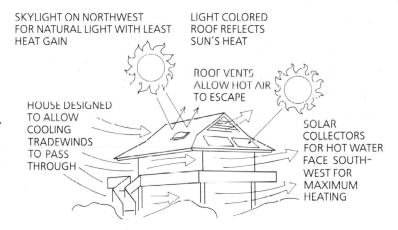

SKYLIGHT ON NORTHWEST FOR NATURAL LIGHT WITH LEAST HEAT GAIN

LIGHT COLORED ROOF REFLECTS SUN'S HEAT

ROOF VENTS ALLOW HOT AIR TO ESCAPE

HOUSE DESIGNED TO ALLOW COOLING TRADEWINDS TO PASS THROUGH

SOLAR COLLECTORS FOR HOT WATER FACE SOUTHWEST FOR MAXIMUM HEATING

246 Remmert W. Huygens.
HOME IN WAYLAND, MASSACHUSETTS.

247 Peter Jefferson.
COTTAGE IN THE BAHAMAS.

One of the first considerations an architect gives to any building is the relationship it will have to the site and its climate. Remmert W. Huygens's HOME IN WAYLAND, MASSACHU-SETTS and Peter Jefferson's COTTAGE IN THE BAHAMAS shown here were built to relate well to their locations. The house in Massachusetts looks, and is, comfortably enclosed against harsh winters. The house in the Bahamas is open in form and reaches out to allow the moderate weather to enter. In both, mass and space work together and with the surroundings to provide settings for enjoyable living.

In the mid-nineteenth century, when stream power was harnessed to run mills, precut standardized lumber caused a revolution in home building. In the United States the framed house became in many ways a modular home. We now buy lumber, plywood, wallboard, and window frames in standard sizes. Elements such as cabinets, which were once handcrafted on the site, are now usually factory-produced. Even an architect-designed, custom-built house may contain many standardized components.

In this century a great deal of effort has gone into the development of prefabricated housing. This is a major aspect in the transition of architecture from handcraft to industrial production. Although prefabrication still offers the best hope for combining quality with low cost, poor design has been common. There remains an urgent international need for high-quality, low-cost housing.

LANDSCAPE ARCHITECTURE

Landscape architecture is the design of land and the objects upon it. It is the art of working with both natural and man-made elements to provide visual enjoyment and refreshing places for relaxation and recreation. Landscape architecture can enhance buildings and help them relate visually to one another. No other art form requires people to work so closely with nature. Landforms, climate, seasonal changes, and vegetation are all factors with which landscape architects work. Approaches range from formal, geometrically organized forms to naturalistic, informal compositions (see pages 312 and 257).

Landscape architects design spaces such as gardens, parks, golf courses, malls, and atriums. Their works range in size from vast projects such as Central Park in New York or Golden Gate Park in San Francisco to tiny gardens.

With increasing urbanization comes decreasing access to rural land. Thus the cultivation of gardens and the designing of large landscaped areas provide a therapeutic balance of calm greenery to the often jarring intensity of the urban scene.

When major construction takes place in densely populated urban areas there is often a debate between those who want more open green space and those who support construction. Architect Kevin Roach came up with a solution to such conflict when he designed the OAKLAND MUSEUM, in Oakland, California. The building is roofed with a series of garden terraces designed by landscape architect Daniel Kiley. Integrated with the plantings are many pleasant places to sit, and fine settings for sculpture.

248 Kevin Roach and Associates.
a. OAKLAND MUSEUM. 1969.
 Oakland, California.

b. Detail of OAKLAND MUSEUM garden.

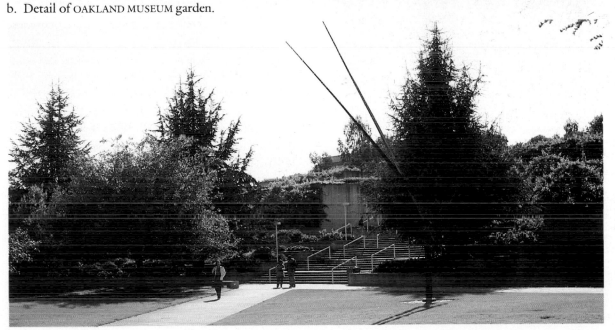

249 Lawrence Halprin
and Associates.
FREEWAY PARK. 1970–1976.
Seattle, Washington.

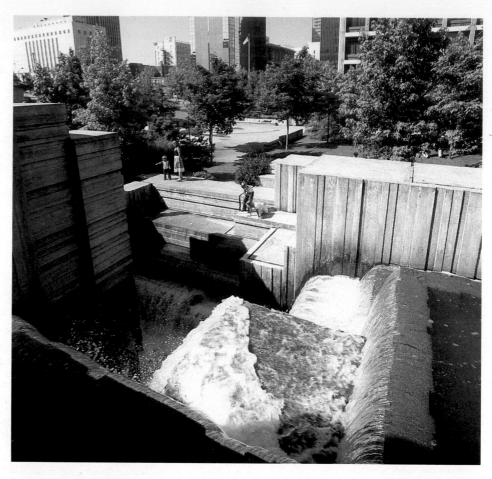

a. Detail
*Photograph ©1981 Joel W. Rogers
Aperture PhotoBank.*

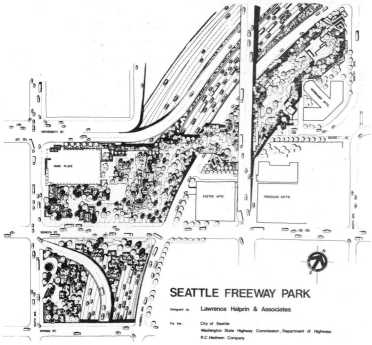

SEATTLE FREEWAY PARK

Designed by Lawrence Halprin & Associates

For the : City of Seattle
Washington State Highway Commission, Department of Highways
R.C. Hedreen Company

b. Plan drawing.

Seattle's FREEWAY PARK was designed by Lawrence Halprin for a seemingly impossible site over and around a major freeway interchange. The 5-acre park is a bridge between areas of the city that were divided by the freeway. It provides opportunities for people of all ages to find active or quiet places. A water canyon is a focal point of the park; the sound of its rushing water blocks out the traffic noise below. Park users are permitted, and actually encouraged, to get into the water.

URBAN/REGIONAL DESIGN

As we look at most American cities, it is apparent that we have generated built environments that are often out of harmony with themselves, with their natural settings, and with Earth's broad ecological systems. Our subjective world—our attitudes about life, ourselves, and others—directly shapes our physical environment—all the objects and places we build or shape. As such, our physical surroundings are a composite environmental design that includes indoor and outdoor spaces and the organization of the objects within those spaces. We build the larger components of this environment to provide shelter from the elements,

c. Aerial view.

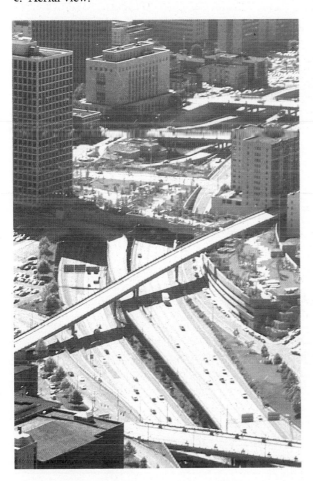

privacy, places for our activities, and for the transportation of people, goods, and utilities.

The relatively new discipline of urban/regional design is a broad category of interdependent disciplines that includes architecture, landscape architecture, transportation design, and social and physical planning. It deals with the design of subdivisions, new towns, and master plans for cities. Regional and urban design plans must complement each other. Some thinkers, such as Buckminster Fuller, have asked us to think of design in a global sense. This does not mean that we should redesign the world. It means that we must think of our designs as part of a total world harmony that begins with the natural order.

The field of *urban design* is quite complex. Urban designers organize the elements of the natural and manufactured environment into an ordered framework in which the social, economic, cultural, and aesthetic needs of society are met in the best possible way.

Without the inclusion of aesthetic concerns, planning is incomplete. The growing complexity of urban fabric must be seen as a whole. Urban designers try to use the highest human sensibilities and applied knowledge to create and interrelate built and natural environments and systems in a way that provides a beneficial setting for human life. They may work with others on all phases of the planning or design process, from initial policy formulations, through development of proposals, to the implementation of final plans. Often the success or failure of the efforts of professional urban designers depends on politics, but public awareness can help change this by providing a broader base of understanding and support.

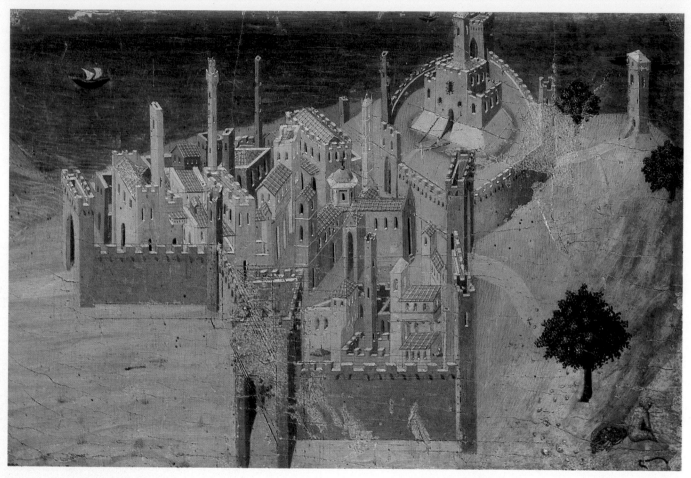

250 Ambrogio Lorenzetti.
VIEW OF A TOWN. c. 1338–1340.
Tempera on wood. 9″ x 13⅛″.
Pinoteca Nazionale, Siena, Italy.

In the past, because population growth was minimal, urban centers grew slowly to meet needs for protection, trade, and communication. Unchanging lifestyles and firm traditions created human-scaled environments, like the one depicted in the painting VIEW OF A TOWN by Ambrogio Lorenzetti.

Our urban areas are rapidly changing and growing. Constructed suburban developments are annexed to cities seemingly overnight, creating rings of residential commuter towns for miles around urban areas. Jammed together in a flattened, treeless landscape, great stretches of identical, stereotyped houses and apartments merge into this pattern of land use known as *urban sprawl*. It is awkward, ugly, distressing, unhealthy, and unnecessary. Better methods of urban development are available, but they are

rarely used because population pressures keep land speculators and developers well supplied with clients who are either too ignorant or too much in need of housing to demand more.

Daly City, just south of San Francisco along the California coast, is an example of the thousands of places where open space has been rapidly devoured. If any life-enhancing order is to come from such frantic growth, planning must be done and put into effect.

Contemporary needs for protection are very different from those of medieval times. Patterns of commerce and methods of communication have changed radically. New transportation systems must be accommodated in ways that are harmonious with the general urban fabric.

Some environmental designers have suggested that we do not need concentrated urban forms, since they no longer offer protection, are not necessary for commerce, and are hardly needed at all for communication. Others point out that dense urban complexes are necessary to save agricultural, recreational, and wilderness land. Some suggest that the design of urban areas take an even denser form than present zoning laws permit.

The old dream of a single-family home near the city is rapidly becoming impossible for many people. Land and building costs have risen to the point where the average income cannot match the purchase price. The growth pattern that results from placing one house on one lot consumes enormous amounts of land, our primary finite resource. If the single-family house in suburbia is affordable, its location offers housing, but not jobs. Most recent developments are not integrated, planned communities that meet all the major needs of their residents in one location. They are bedroom communities, which simply provide a place to sleep and cause huge transportation, air pollution, and energy consumption problems because residents are forced to commute daily to jobs in the city.

Consumption of open land can be minimized in a variety of ways. All these ways are based on the idea of concentrating people in specific communities capable of meeting all their basic daily needs, including stores, services, and job opportunities. With careful planning and design, such forms as townhouses and cluster houses in urban areas can offer not only high density living, but some desirable features that the single-family home cannot. Among these are proximity to stores and other urban amenities. Shared open green space and extensive recreational facilities are included in the best community developments.

Architect Moshe Safdie is designing new forms of stacked modular living units as a possible alternative to the present trend toward urban sprawl and high-rise apartments crowded together. He is motivated by the idea that relatively low-cost housing can be designed in ways that minimize land consumption while providing privacy and a sense of individual living units. This concept is related to traditional multi-unit structures in the Southwest that are energy efficient, climate-related, high-density communities surrounded by open space.

251
DALY CITY, CALIFORNIA. c. 1960.
Photograph: Donald W. Aitken.

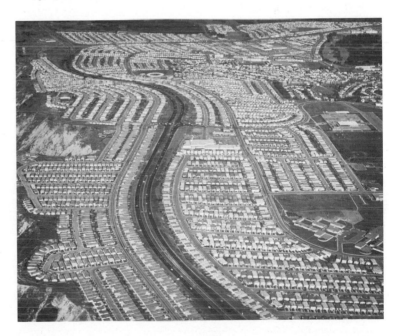

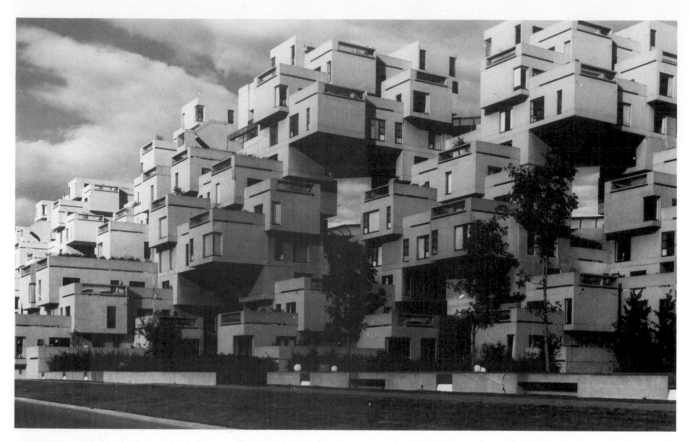

252 Moshe Safdie and David Barott. Boulva Associated Architects.
HABITAT '67. 1967.
Montreal.

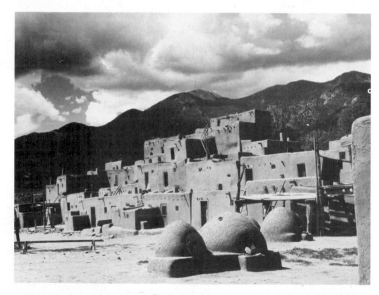

253
NORTH PUEBLO.
Taos, New Mexico.
Photograph: Laura Gilpin.

Safdie's HABITAT '67, built for the World
Exposition in Montreal in 1967, was his first
demonstration of these concepts. Costs were
minimized by prefabricating apartment units in
a factory and stacking them on the site. Al-
though the components are standardized, they
can be placed in a variety of configurations, thus
keeping the total structure from becoming
monotonous. The roof of one unit becomes the
garden for another. Walkways and covered
parking areas are included. The design allows
for a dense concentration of people, yet pro-
vides many of the advantages of single, unat-
tached dwellings. Much of Safdie's philosophy
is summarized in his phrase, "For everyone a
garden."

The visionary drawings of Paolo Soleri por-
tray cities as single, self-contained structures.
While we might not want to live in a structure
such as BABELDIGA, Soleri's ideas help us

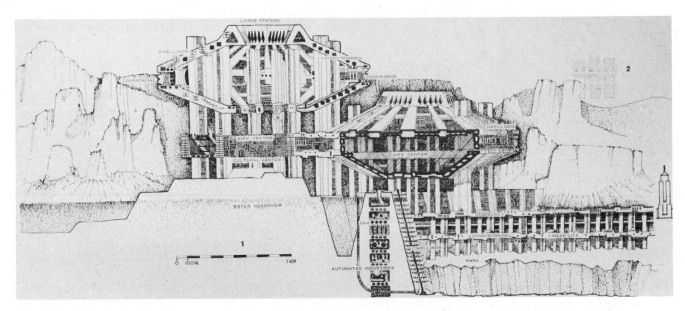

254 Paolo Soleri.
Drawing of BABELDIGA with Empire State Building. 1965.

stretch our perceptions of alternatives to un-controlled horizontal and vertical growth. Soleri uses the term *arcology* to describe his concept, which combines the ideals of architecture and ecology. His designs for vast self-sufficient communities are a response to the problems of overpopulation and urban decay and they express a utopian architectural vision. Soleri included an outline of the Empire State Building on the right side of his drawing to give a sense of the scale of his megastructure.

Two mechanical inventions that have had enormous influence on the design of our environment are the elevator and the automobile. The car has made horizontal growth possible; the affluent have been able to escape into the suburbs, leaving in their path unplanned urban sprawl like that in Daly City (see page 225).

Transportation systems are powerful factors in any urban design, capable of both solving and causing problems. Because such systems may either tie together or separate neighborhoods and towns, transit or transportation design is a major consideration in environmental design.

255 Elliott Erwitt.
FREEWAY. 1968.
Photograph.

256
SUBWAY STATION, NEW YORK CITY.
Photograph taken 1976.

257
SUBWAY STATION, MONTREAL.
Photograph taken 1972.

Huge areas of land have also been appropriated for freeways and interchanges. While they solve some problems related to the movement of vehicular traffic, freeways also become barriers between parts of cities, creating new kinds of ghettos where neighborhoods used to flow naturally into one another.

Henry Ford had little idea of the world his product would help create when he wrote:

I will build a motor car for the great multitude. . . . But it will be so low in price that no man making a good salary will be unable to own one—and enjoy with his family the blessings of hours of pleasure in God's great open spaces.[18]

Until the 1980s the automobile industry in the United States grew until it passed the point where the manufacture rate for cars became double that of the birthrate for humans. Urban areas are frequently designed not by urban designers, but by the needs of the automobile. Cars beget highways and highways discourage other means of transportation in a vicious cycle.

We are now seriously questioning our commitment to the automobile and its accompanying freeways and highways as the major means of ground transportation. The citizens of San Francisco voted to stop all freeway building, turning down millions of dollars in federal and state aid. They even considered tearing one freeway down.

The search for efficient mass transit almost ended in the mid-twentieth century due to the popularity of the private automobile and the lobbying of the oil and highway construction industries. Now, with our immense energy, air, and traffic problems, planners are once again seriously considering the potential of mass transit. We have much to learn from past and present successes and failures. Compare the quality of space in the old New York subway station with the station of the more recent Montreal system. Each station in Montreal is architect-designed to give a unique visual character to that stop.

258 Le Corbusier.
DRAWING FOR A CITY OF THREE MILLION. 1922.

In 1922 Le Corbusier envisioned that constructing high-rise apartment towers on urban land would open space for continuous park areas and make it possible to separate pedestrian space from automobile space. In his plan for a CITY OF THREE MILLION, housing was split between widely spaced tall towers at subway stops, and low-level garden apartments. Industry was banished to the outskirts, and business was to be concentrated in towers at the center. At that time, Le Corbusier saw machine efficiency as the best solution to housing problems. Unfortunately, his ideas led to the vast, sterile housing projects that have become areas of crime and decay. Individuals and families in these areas are caught in barren wastelands cut off from those elements that give identity and safety to traditional dwellings and neighborhoods.

Carefully planned community development based on sound principles of urban design becomes impossible when independent business and political interests conspire to feed explosive urban growth. Uncontrolled growth in a community can be like its counterpart in the human body—a cancer, destroying life in its path.

259
HYGIENIC APARTMENTS IN THE MAN-MADE DESERT.
Photograph by Orlando Cababan.

260
a. WAIKIKI. 1961.

b. WAIKIKI. 1971.

261
SLUM DWELLINGS.

Rapid, unplanned urban development is illustrated by two photographs of Waikiki taken from the same location 21 stories off the ground in 1961 and in 1971. It was during this latter period that Joni Mitchell wrote the song, "They Paved Paradise and Put up a Parking Lot."

Changing the overall design of existing cities is economically impossible and in many cases undesirable. Relatively small changes within cities are going on all the time with some sensitive blending of old and new. Too often there is no blend, and occasionally incredible confrontations occur between the old and the new. The size of many new buildings tends to dwarf older, smaller structures.

The JOHN HANCOCK TOWER on Copley Square in Boston has been widely publicized because of its problems with falling glass window panels. Aside from that issue, many people find it offensive because of its dominating size and incompatible style. Others enjoy its monumental scale and the dramatic contrast of its sheer crystalline form with Henry Richardson's nineteenth-century TRINITY CHURCH. The upper part of the Hancock building reflects the sky and seems to dissolve into it, while the lower portion reflects the church.

Environmental designer Constantinos Doxiadis was concerned with the need for housing the world's growing population. In discussing the accompanying photograph, he pointed out that "the greatest part of humanity lives in conditions similar to these. This is the main architectural problem."[19] It is estimated that 90,000 people live on the sidewalks of Bombay alone. Well over one-third of the people in the world's cities are squatters or slum tenants.

There are many ways in which human communities can expand, change, and diminish without causing the kind of destructive chaos that we so often experience today. The rapid, unplanned growth of human centers needs to be replaced with controlled growth designed to meet actual human needs.

Urban design can be controlled by zoning laws that determine land use and population

262 Henry Hobson Richardson.
TRINITY CHURCH. 1877.
I. M. Pei and Partners.
JOHN HANCOCK TOWER. 1974.
Copley Square, Boston.
Photograph: ©Steve Rosenthal.

density, by open-space requirements, and by such restrictions as height limits on buildings and set-back laws establishing the distance a building must be from property lines.

These are some of the features urban designers work for:

☐ A pattern of development that enhances the preexisting natural features of the site, including land forms, waterways, lakes, and shorelines.

☐ Visual contact with memorable natural and human-made features so that residents and visitors can comfortably find their way around, guided by visual images of the city; this means preserving or creating *view planes* and *view corridors*.

☐ A combination of commercial, residential, industrial, and recreational areas, interrelated as urban functions in healthy, constructive and exciting ways.

☐ *Historic preservation*—restoring and maintaining the best of the old with planned new elements designed to harmonize with them; preservation of special buildings or natural areas can be achieved by establishing special design districts that protect historic, cultural, and scenic assets.

☐ A defined sense of place, giving the people of the city a feeling of the unique character and rhythm of their particular community.

☐ A harmonious blend and flow in everything from such small elements as signs and street furniture to such huge constructions as freeways and street patterns.

☐ Easy accessibility to the best the city has to offer.

☐ Plenty of green open spaces interspersed throughout the city, interconnected whenever possible; *miniparks* make excellent available recreational spaces on small lots; *linear parks* can include foot and bicycle paths and can follow streams and other enjoyable landscape features.

☐ A definite city limit or boundary so that urban growth does not spread haphazardly into other urban areas in endless sprawl; a boundary or planned stopping point for horizontal urban growth can be set by recreational parks, farmland, or wilderness areas joined together to form a *green belt*, offering city dwellers access to nature.

☐ Small-scale, attractive neighborhoods blending openly with the larger urban areas.

☐ Attractive, lively, well functioning business districts.

During the last decade or so, there has been a growing interest in the methodology of environmental design. This has led to several techniques of programming in which an attempt is made to list and respond to as many functional influences on the form as possible. Environmental planner Ian McHarg has suggested computerizing information on everything from bird sanctuaries to mass transit systems before making plans to change existing urban and regional areas.

Environmental design specialists need the support of a public educated in environmental awareness and ready to become involved in *participatory planning*. Without the benefit of the ideas and feelings of those who inhabit our shared environments, plans become constricting and detrimental to life. Well-planned environmental changes are based on geographical, biological, and sociological information and relate to long-term human needs.

The key concept in successful landscape architecture is central to all environmental design. It is the idea of building a positive interrelationship between two different systems. Human creations are one system; nature is another parallel system upon which the human system depends. Too often we begin our designs as if nothing existed. The natural world existed as a highly complex, integrated process long before we came into being. Human tech-

nology is a different sort of system. When the two systems come together in mutually beneficial ways, the result is a harmony that satisfies the soul. When they do not, life is diminished or even destroyed. As part of nature we are just a part of the whole—but we are the thinking part. As such, we are the stewards; we are responsible for the well-being of the biosphere.

A variety of professions deal with the technical details of environment-making. As a social subgroup, these specialists are being confronted with a reexamination of values. They must learn how to incorporate biological criteria into their work in order to meet the requirements of the systems that sustain life on Earth. Ian McHarg has clearly stated this point:

If one accepts the simple proposition that nature is the arena of life and that a modicum of knowledge of her processes is indispensable for survival and rather more for existence, health and delight, it is amazing how many apparently difficult problems present ready resolution.[20]

When fully understood in the environmental design professions, McHarg's reasoning will help generate new approaches to creating forms for human use and improving the condition for life on this planet.

4

Art of the Past

To me there is no past or future in art. If a work of art cannot live always in the present it must not be considered at all. The art of the Greeks, of the Egyptians, of the great painters who lived in other times, is not an art of the past; perhaps it is more alive today than it ever was. Art does not evolve by itself, the ideas of people change and with them their mode of expression.

Pablo Picasso[1]

MAYAN MAN AND WOMAN.
(See page 259.)

Through their art we can know the people of the past—our ancestors. Art history is our history. It is the record of how human beings have lived, felt, and acted in widely separated parts of the world and different periods of time. Through their works, artists both reflect and affect the age in which they live. Art history differs from other kinds of history because works of art from the past are with us in the present. If we can openly experience these works, we can put ourselves in touch with the attitudes, concerns, and experiences of the individuals who made them. Basic communication may occur even when sender and receiver are separated by more then 20,000 years. The artist is the sender, the work is the message, and those who perceived it then and who experience it now are the receivers. This one-to-one communication is what makes our experience of the art of the past so rewarding.

The art of any given period is modern in its time. This is true of the abstract paintings of animals on Neolithic pots of the Near East, and it's true of the cathedrals of medieval France. We call these cathedrals "Gothic," but those who built them called them *opus modernum* or "modern work."

If numbers of years get in your way when studying art history, consider time in terms of generations. Since the beginning of human life on Earth, the average time interval between the birth of parents and the birth of their offspring has increased from about 18 to 33 years. If we figure that roughly 25 years is the average generation, we can come closer to the people of the past by realizing that most of us have three generations within our own families, and many have four. The United States became a country only eight generations ago; the Italian Renaissance occurred just 22 generations ago; Jesus Christ lived 79 generations ago; and Gautama (Siddhartha) Buddha lived only 100 generations ago.

Our awareness of the art of the world grows and changes as contact with other cultures is extended and ancient works are unearthed. Before this century it was not possible to know much about the art of other cultures. Modern techniques of photoreproduction and printing have helped to make such art available to us. Through reproductions we are now able to see more outstanding works of ancient Egyptian and Chinese art, for example, than the people of those cultures were able to see themselves. Of course, we view these works out of context, removed from the life that brought them into being and gave them their original meaning and purpose. Yet, through them, it is still possible for us to share some of the life experiences of those whose lives preceded ours.

We are unique among the animals on Earth. More than a million years ago humans learned to coordinate eyes, hands, and brain in the making of rudimentary tools. From this beginning we developed our ability to reason and visualize: to remember the past, relate it to the present, and imagine possible futures. As we evolved into form-creating creatures, our ability to form mental images—and the development of hands capable of making those images—set us apart from other animals. Imagination is our special advantage. Coupled with the work of hand and eye, imagination has allowed us to live on every continent. We are able to adapt to a wide range of climatic conditions because we can shape our immediate environment. As Jacob Bronowski stated in his book *The Ascent of Man:* "Every animal leaves traces of what it was; man alone leaves traces of what he created."[2]

What we now call prehistoric "art" was evidently made by early humans to help them cope with the sometimes capricious forces of the natural world—with the unknown as well as the known. In this sense art is a kind of magic—a form-creating process intimately related to what we now call "religion." Art still functions in this way, filling the gap between what is known and what is felt. Art has physical form, yet it contains spirit.

Man, with his symbol making propensity, unconsciously transforms objects or forms into symbols (thereby endowing them with great psychological importance) and expresses them in both his religion and his visual art.

Carl Jung[3]

Painting isn't an aesthetic operation; it's a form of magic designed as a mediator between the strange, hostile world and us, a way of seizing the power by giving form to our terrors as well as our desires.

Pablo Picasso[4]

When we speak of "art history" we are usually speaking of the art of Western Europe; but this is a very narrow and misleading view. The history of the art of the world includes many separate histories, which, when seen together, weave a rich and varied tapestry of human expression.

Major differences can be found in art of the same time but in different places, as well as the art of the same place at different times. Major themes—mother and child, for example—appear in many places throughout the world. Within any culture there have been progressions toward the perfection of an idea. Such progressions are followed by changes in attitudes and circumstances that lead to new sequences of development. Such patterns of change may follow one another in cycles. The clearest of these cycles can be seen in a sequence in which geometric abstraction is followed by a shift toward naturalism, which in turn leads to dramatic exaggerations of natural appearances (see pages 272 to 277 and pages 292 to 305).

Our ability to understand other societies is increasing rapidly through the use of modern worldwide communication media. Experiencing the art of other peoples, past and present, enables us to see beyond cultural limitations. The following pages present a few examples of art from societies beyond Europe and modern America, and then trace major periods and changes in Western art. Because we live in a Western culture, the emphasis is Western.

Past art reveals a rich web of diverse points of view, held together by a bond of shared experience. There is no "better" or "best" when comparing the art of different societies, and even the art of different times in the same society. Rather, differences in art reflect differences in point of view.

THE PALEOLITHIC AGE

Roughly 2 million years ago, in east central Africa, early hominids first made crude, stone cutting tools; undoubtedly, they also made objects of perishable materials, which did not survive. The making of tools enabled our ancestors to extend their powers and thereby gain a measure of control over their immediate environment.

About 1 million years ago in Africa, and more recently in Asia and Europe, more refined tools were made by chipping flakes from opposite sides of a stone to create a sharp cutting edge. Present evidence indicates that it was in China that early humans first learned to control fire. It took another 250,000 years or so for people to develop choppers and hand axes that were regular in shape. An awareness of the relation of form to function, and as enjoyable in itself, was a first step in the history of art.

What we call "art" evidently appeared rather suddenly in Europe about 30,000 years ago, toward the end of the last Ice Age. As the southern edge of the European ice sheet slowly retreated northward, hunter-gatherers followed the animals on which they depended for food. Some of the images they made to help them on their hunts have survived. It is interesting to note that researchers have not found any indication of a long evolution leading to the fully developed art forms of this period.

Many hand-sized carvings have been found at prehistoric sites in Europe. The small, some-

what abstract female figure shown here was carved from a tusk of a mammoth, a prehistoric elephant. The exaggerated emphasis on hips and breasts suggests that the figure was symbolic and designed to help ensure human fertility, but we can only guess how it was used.

People who today live in societies that have remained in so-called "primitive" circumstances still demonstrate ignorance of the connection between sexuality and childbearing. Therefore it is assumed that prehistoric people held women responsible for the most evident creative act—the birth of a new person. Current research suggests that these commonly found "venus" figures may actually be the earliest known works of religious art, since they may depict the Paleolithic image of the Creator—Mother of all life. Similar objects, including a few highly abstract male and composite male-female forms, have been found at other Paleolithic sites in Europe and as far east as Siberia. It is assumed that such carvings had a very important function in the lives of Ice Age hunters.

Human figures rarely appear in Paleolithic art. When they do, they tend to be more simplified and abstract than images of animals. Animals portrayed in the sculpture and paintings of this period have an expressive naturalism. HEAD OF A NEIGHING HORSE shows that its maker combined skill with careful observation. The small carving not only gives an accurate portrayal of how the horse looked, but also shows the artist's empathy for the feeling of the frightened, possibly dying animal. A prevailing assumption about naturalistic Paleolithic art is that artists carved or painted the forms of animals in order to bring their spirits into rituals related to the hunt and thus ensure the food supply.

263
PALEOLITHIC FIGURE.
25,000–13,000 B.C.
Mammoth ivory. Height 4³⁄₄".
Museum of Anthropology and Ethnography of the Academy of Sciences, Leningrad.

264
HEAD OF A NEIGHING HORSE.
c. 30,000–10,000 B.C.
Reindeer antler. Length 2".
Le Mas d'Azil, Ariège, France.
Museum of National Antiquities, St.-Germaine-en-Laye, France.

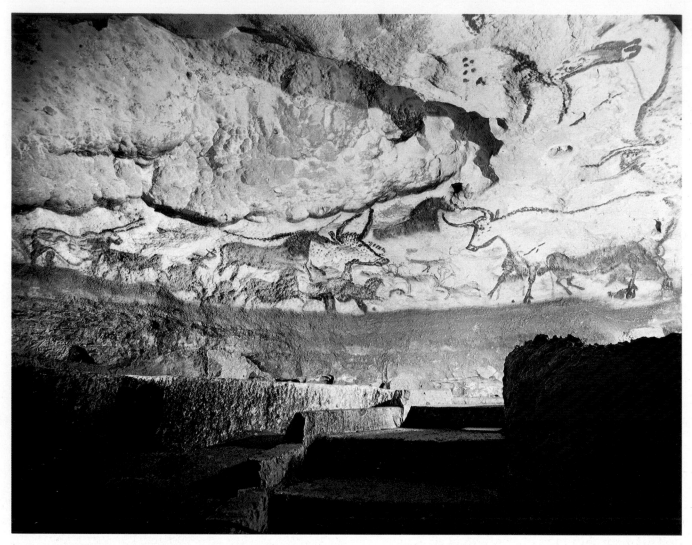

265
LEFTHAND WALL, GREAT HALL OF BULLS. c. 15,000–10,000 B.C.
Polychrome rock painting. Lascaux Caves, Dordogne, France.

The Lascaux Caves in Southern France contain examples of the magnificent art of the late Paleolithic period. These are some of the earliest paintings known. On walls of the inner chambers large and small animals were painted in as many as 13 different styles, from small and delicate to very large and bold. The largest painting of a bull at Lascaux is 18 feet in length. Successive images were painted over earlier images. Each of these vigorous, naturalistic styles was made in a different time period. The images are obviously based on careful observa-tion gained through considerable direct contact with the animals that roamed the land at that time. Since the paintings were made deep inside inner cave chambers, the painters must have had well-developed visual memories.

At Lascaux, and at many other Paleolithic sites, geometric signs or symbols often appear along with the animal and occasional human figures. These intriguing symbols, although indecipherable to us, were undoubtedly full of meaning for the people who made them. Schol-ars believe some of these ancient forms were

documentations of observation, while others indicate awareness of such concepts as time. The art is cognitive as well as emotive, based on knowledge and belief. Thus it is clear that Paleolithic art encompassed what we call science, magic, religion, and art.

THE NEOLITHIC AGE

The transition from Old Stone Age or Paleolithic to New Stone Age or Neolithic cultures marked a major turning point in human history. It seems to have occurred first in the Middle East, between 10,000 and 8000 B.C., when people went from the precarious existence of nomadic hunters and food gatherers to the relatively stable life of village farmers and herders. This major shift from nomadic groups to small agricultural communities stabilized human groups, produced early architecture and other technological developments, and brought changes to all the arts. Out of necessity, people learned to work with seasonal rhythms. Because food had to be stored in order to provide a year-round supply, it is not surprising that clay storage pots are often among the most significant artifacts of Neolithic farmers.

This great shift in living patterns is visible in art. The vigorous, naturalistic art of Paleolithic hunters was largely replaced by the geometrically abstract art of Neolithic farmers. From about 10,000 to 3000 B.C. increasing emphasis was placed on abstract designs for articles of daily use. The *motifs*—the dominant themes— were based on plant and animal forms.

The painted EARTHENWARE BEAKER comes from Susa, the first civilized state of the Iranian plateau. Solid bands define areas of compact decoration. The upper zone consists of a row of highly abstract long-necked birds, followed by a band of dogs (?) running in the opposite direction. The dominant image is an ibex or goat stylized into triangular and circular forms.

266
EARTHENWARE BEAKER.
c. 5000–4000 B.C.
Painted terra-cotta.
Height 11¼". From Susa
The Louvre, Paris.

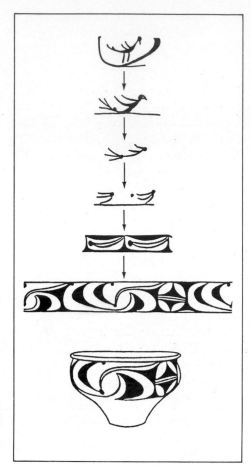

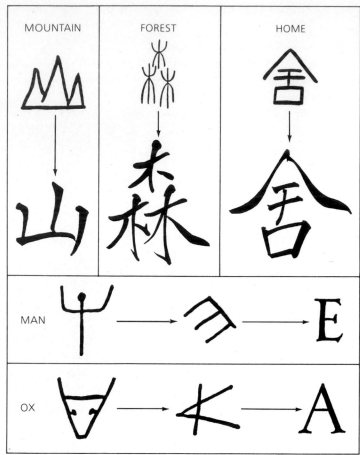

267
a AN EVOLUTION OF ABSTRACTION. From Neolithic pottery, Shensi Provence, China.
b PICTOGRAPHS TO WRITING, EAST AND WEST.

The significant difference between the naturalism of Paleolithic animal art and Neolithic abstract art can be seen when we compare the bulls of Lascaux with the stylized goat on the beaker from Susa. Out of this stylizing came elements of writing and the sophisticated elegance of abstract and nonfigurative decorative designs.

Some Neolithic abstract designs were apparently derived from realistic images. The series of drawings shown here was copied from pieces of pottery found in the Shensi Province of China. As the decorative designs evolved over generations the clearly recognizable bird image became more and more abstract, and eventually formed the basis for the totally nonrepresentational band. We have repeated the band, "unrolled," at the bottom of the sequence. Such playing with figure-ground reversal is also found in modern painting and design (see page 57).

It is quite possible that the nonrepresentational signs often found in Paleolithic caves along with the naturalistic images of animals were meant to communicate specific information. If so, such signs would be predecessors to the later development of writing. Another form of drawn signs that we know led to writing is the *pictograph,* or "picture writing." The pictographic origin of many characters in modern Chinese writing is well known. Less well known is that some letters of the Roman alphabet used in English came from pictographs that stood for objects or ideas.

THE BEGINNINGS OF CIVILIZATION

Artifacts indicate that early civilizations emerged independently, at different times, in many parts of the world. We use the term *civilization* to distinguish cultures, or composites of cultures, that have a fairly complex social order and a relatively high degree of technical devopment. Key elements are food production through agriculture and animal husbandry, metallurgy, occupational specialization, and writing. All of these developments were made possible by the move to cooperative living in urban settlements.

Among the earliest major civilizations were those in four fertile river valleys: the Tigris and Euphrates rivers in Iraq, the Nile River in Egypt, the Indus River in West Pakistan and India, and the Yellow River in Northern China. It is in these valleys that we find evidence of the beginnings of civilization as we know it.

268
BURIAL URN, Kansu type. c. 2000 B.C.
Earthenware. Height 14¹/₈".
Seattle Art Museum.

BEYOND EUROPE

Westerners who seek to understand and enjoy the art of non-Western traditional societies must realize there are differences in the roles art plays in modern Western society and the functions it serves in traditional, religion-centered, non-Western societies. In much of the non-Western world what we call art is considered essential to people's lives, while in Western society many people view art as nonessential and separate from daily life.

India

In the 1930s, excavations in the Indus Valley at the sites of the ancient cities of Mohenjo-daro and Harappā revealed a well-organized society with advanced city planning and a high level of artistic production.

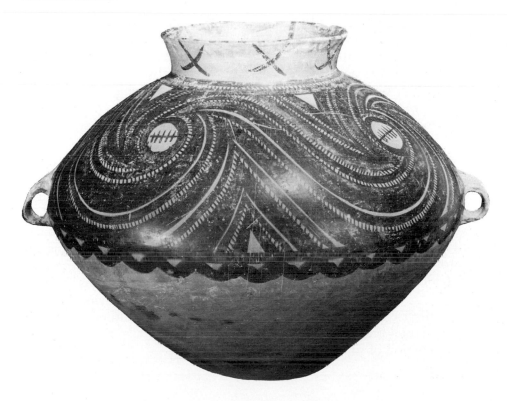

269
MALE TORSO
c. 2400–2000 B.C.
Limestone. Height 3½".
From Harappā.
*National Museum of India,
New Delhi.*
Photograph: Prithwish Neogy.

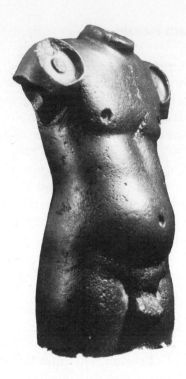

Sculpture from the Indus Valley has a particularly organic naturalism that is basic to much of later Indian art. This quality is clearly seen in the small, masterfully carved MALE TORSO from Harappā. A *plastic* or pliable surface appearance gives the work a feeling of life, as if animated by breath. The figure's protruding abdomen reveals an early understanding of the importance of breath control, which has been kept alive in the ancient tradition of Hatha Yoga. Yoga is still important in India, and has become widely practiced elsewhere in recent years.

Relatively few works of art have survived from the period between the end of the Indus Valley civilization in about 1800 B.C., and 300 B.C., when the earliest-known Buddhist art appears. This period is very important, however, in the development of Indian thought and culture—Gautama, the historical Buddha, and Mahavira, the founder of Jainism, both lived during the sixth century B.C.

Hinduism is the term for a diverse group of religious, philosophical, and cultural practices which evolved in India over a period of some 4000 years. Both Buddhism and Jainism were outgrowths of Hinduism.

Hindu art is a synthesis of indigenous Indian art forms with religious ideas of the nomadic, non-image-making Aryan-speaking people who invaded from the Northwest and conquered India about 1500 B.C. The complex and fascinating pantheon of Hindu divinities depicted in Indian art represents all aspects of human aspirations and experience.

The Hindu KANDARYA MAHADEVA TEMPLE at Khajuraho in North Central India makes an interesting comparison with its Gothic European counterpart, CHARTRES CATHEDRAL (see page 290). KANDARYA was completed about one hundred years before CHARTRES was begun. Like CHARTRES, its design emphasizes a vertical thrust. Both are complex, mystical forms that appear to rise effortlessly from the horizontal countryside as if they were organic and continuing to grow. On the Indian temple a series of small towers builds to a climax in a single large tower. The rounded projecting forms are symbolic of both male and female sexuality.

These forms seem to celebrate the procreative energy found in all of nature and felt or experienced within ourselves. In contrast to CHARTRES, KANDARYA contains not a large space for congregational worship, but a small sanctum for individual worship of the image within. In its solidity, it is like THE GREAT STUPA at Sanchi (see page 246). Indian temples tend to be massive rather than spacious.

Shown here is one of six major erotic scenes from the abundant sculpture on KANDARYA TEMPLE. To the worshiper, union with God is filled with a joy analogous to the sensual pleasures of erotic love. The natural beauty of the human figure is heightened by emphasis on maleness and femaleness. Fullness seems to come from within the rounded forms. The intertwining figures symbolize divine love in human form, an allegory of ultimate spiritual unity.

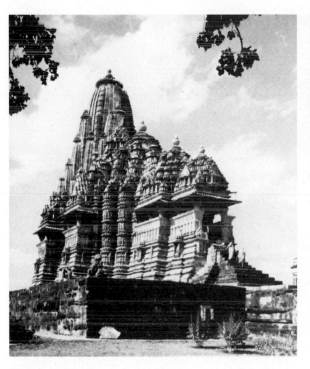

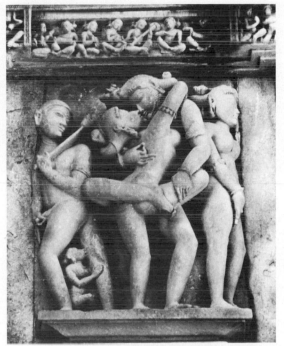

270

a KANDARYA MAHADEVA TEMPLE. 10th–11th centuries. Khajuraho, India.

b Scene from KANDARYA MAHADEVA TEMPLE.

In later Hindu belief Shiva is the Supreme Diety, encompassing the creation, preservation, dissolution, and re-creation of the Universe. For this reason Shiva is given various forms in Hindu sculpture. In this eleventh-century image SHIVA NĀTARĀJA, Lord of the Dance, performs the cosmic dance within the orb of the sun. As he moves, the universe is reflected as light from his limbs. Movement is implied in such a thorough way that it seems contained in every aspect of the piece. Each part is alive with the rhythms of an ancient ritual dance. The multiple arms are used expressively to increase the sense of movement and to hold symbolic objects.

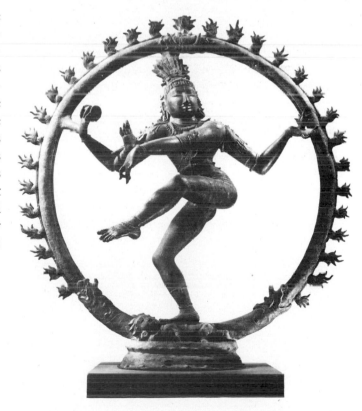

271
SHIVA NĀTARĀJA. 11th century.
Bronze. 43⁷⁄₈″ x 40″.
Cleveland Museum of Art.
Purchase from the J. H. Wade Fund.

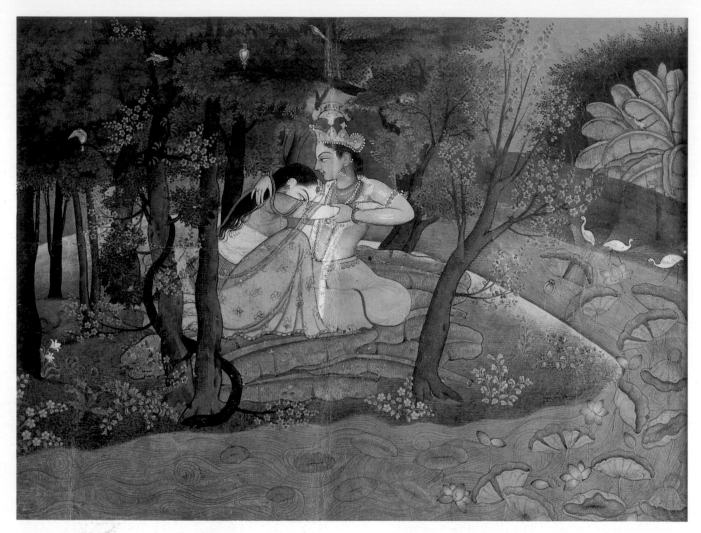

272
HINDU DEITIES KRISHNA AND RADHA IN A GROVE. c. 1780.
Gouache on paper. 123 mm x 172 mm.
Victoria and Albert Museum, London.
Crown Copyright.

In his book *The Dance of Shiva*, historian of Indian art Ananda Coomaraswamy relates the nature of Shiva's dance:

In the night of Brahma, Nature is Inert, and cannot dance till Shiva wills it: He rises from His rapture, and dancing sends through inert matter pulsing waves of awakening sound, and lo! matter also dances appearing as a glory round about Him. Dancing, He sustains its manifold phenomena. In the fullness of time, still dancing, he destroys all forms and names by fire and gives new rest. This is poetry; but none the less, science.[5]

In the seventeenth and eighteenth centuries Northern Indian artists influenced by the miniature painting traditions of Persia (see page 86) developed their own styles of painting. Figures in serene landscapes and religious legends were popular subjects. HINDU DEITIES KRISHNA AND RADHA IN A GROVE is characteristic of the romantic content and gracefully flowing linear style of the painters of the hill state of Kangra. It has some of the sumptuousness and sensuality of early Indian sculpture.

Much of Asian art is Buddhist. Early Buddhism opposed worship of anthropomorphic images. As with Christianity, however, religious practice needed icons as support for contemplation, and eventually images of the Buddha appeared. The style of Buddhist sculpture varies according to the culture that produced it. As Buddhism was introduced from India to Southeast Asia and across Central Asia to China, Korea, and Japan, it influenced (and was influenced by) the indigenous religious and aesthetic traditions with which it came in contact.

This Indian STANDING BUDDHA was carved in red sandstone in the fifth century. The simplified mass of the figure seems to push out from within as though the form was inflated with breath. The rounded form is set off by a sequence of flowing curves that are repeated rhythmically down across the figure. The drapery seems wet as it clings to and accentuates the round softness of the body beneath.

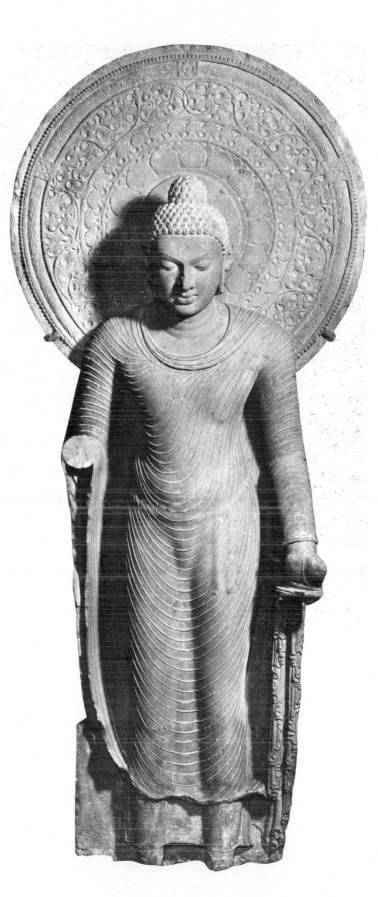

273
STANDING BUDDHA. 5th century.
Red sandstone. Height 5'3".
National Museum, New Delhi.

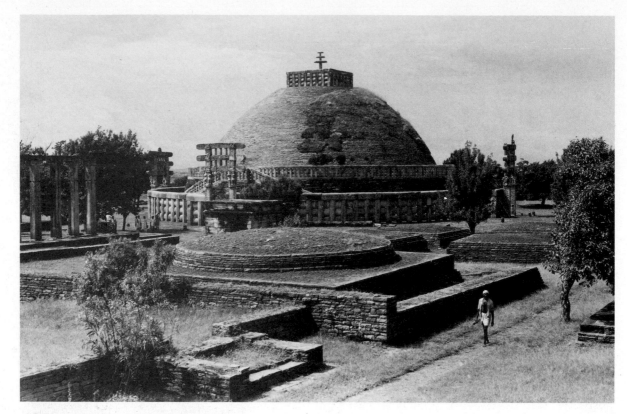

274
THE GREAT STUPA. C. 10 B.C.–A.D. 15.
Sanchi, India.

The solid, domelike Buddhist structures called *stupas* evolved from earlier Indian burial mounds. At THE GREAT STUPA at Sanchi, four gates symbolize North, South, East, and West. The devout individual walks around the stupa in a ritual path, walking the Path of Life around the World Mountain.

One of many connections between the religious arts of Asian cultures is seen in the evolution of Buddhist architecture from its origin in India to its latest manifestation in Japan. Buddhist pagodas developed out of a merging of the Indian stupa form with the traditional Chinese watchtower. The resulting broad-eaved tower structure was in turn modified by the Japanese.

China

Many Westerners realize that China is now the most populous country in the world, but few know of the complexity of Chinese history or of its greatly varied styles of art. It is not possible to speak of Chinese art as though it were a single 5000-year-old style.

In ancient China, during the Shang Dynasty (fourteenth to eleventh centuries B.C.), fine cast bronze objects were produced. The RITUAL VESSEL, like other Shang containers, has a feeling of overall compactness. The surfaces are covered with an intricate composite of animal forms—sometimes in fragments of animals

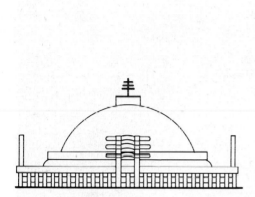
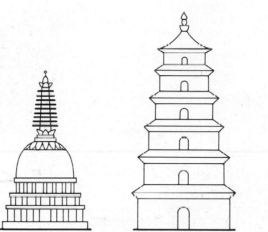

275
EVOLUTION OF BUDDHIST ARCHITECTURE.
a Early Indian stupa.
b Later Indian stupa.
c Chinese pagoda.
d Japanese pagoda.

combined, sometimes complete animals. A deer acts as a handle for the lid; at the back, an elephant's trunk comes out of a tiger's mouth, providing a third support. The man seems about to be devoured, because his head is almost within the ferocious jaw of the bear or tiger spirit; but his hands are relaxed and he is holding on to the animal for protection. Perhaps the most fascinating aspect of the vessel is the contrast between the gentle expression on the man's face, and the aggressive, protective power of the animal.

276
RITUAL VESSEL.
c. 1100–1000 B.C.
Cast bronze. Height 14″.
Musée Cernushi, Paris.

277
FLYING HORSE. Han dynasty, 2nd century.
Bronze. 13½″ x 17¾″. From Wu-Wei.

Recent excavations of the Han Dynasty tombs have revealed outstanding figures, including the magnificent FLYING HORSE (second century A.D.) found at Wu-Wei in Kansu. The sculptor avoided the feeling of weight by balancing the horse on one hoof which rests delicately on a flying swallow. The vigorous horse is typically Chinese in its dynamic, curvacious form.

Through most of Chinese history animals have been the preferred subject for sculptors. The early Chinese were reluctant to represent

the human body in art. When a period of major sculpture based on the human figure did develop in China, it came with the introduction of Buddhism. Chinese artists adopted the idealized, sacred images of India with only minor changes. Some of the finest figures are of the personification of the compassion of the Buddha—known as Avalokitesȳara in India, Kuan Yin in China, and Kwannon in Japan.

The KUAN YIN BODHISATTVA is shown with delicacy, tenderness, and grace. Our example, carved in wood and originally brightly painted and gilded, shows patient acceptance in its relaxed posture; its gentle expression indicates willingness to help.

Chinese painting and sculpture reveal an attitude of great admiration of nature. In contrast to the Western focus on people, nature is the center of Chinese art. The aim of Chinese painting has traditionally been to manifest the spirit residing in every form. Meditation was recommended before wielding a brush in order to achieve a balance between the impression received through the eyes and the perception of the mind. Through the art of painting, individuals nourished spiritual harmony within themselves and revealed the creative power of divine energy to others.

Traditionally, Chinese painters spent years copying the works of earlier artists in order to assimilate fully the long tradition they inherited. It was common to base a composition on the work of an earlier painter, but the artist was also expected to add an individual interpretation to the traditional theme. The brushwork used for both written characters and painted subjects was highly developed. Often poems were included within the painting. The quality of each brushstroke was considered important in the total design. Many different kinds of brushstrokes, each charged with energy, were used. The brushstrokes used for patterns in landscape painting were given descriptive names such as "raveled rope," "raindrops," "ax cuts," "nailhead," and "wrinkles on a devil's face." After prolonged contemplation of nature, the artist produced the painting

278
KUAN YIN BODHISATTVA. c. 1025.
Wood. Height 67″ China,
Northern Sung.
*Honolulu Academy of Arts.
Purchase.*

279 Fan K'uan.
TRAVELERS AMONG MOUNTAINS AND STREAMS. Early 11th century.
Hanging scroll, ink on silk. Height 81¼".
National Palace Museum, Taipei, Taiwan.

from memory. Painters worked with assured skill and speed, with no chance of making corrections. Chinese watercolor technique involves ink and light color on silk or paper.

In Fan K'uan's large hanging scroll TRAVELERS AMONG MOUNTAINS AND STREAMS, the intricate brushwork renders trees and rocks. "Raindrop" and other brushstrokes emphasize the texture of the vertical face of the cliff. Men and donkeys in minute scale travel a horizontal path dwarfed by high cliffs rising sharply upward. The waterfall was made using a wash technique, with the white of the water suggested by the off-white color of the unpainted silk. The vertical emphasis of the composition is set off by the almost horizontal shape of the light area behind the rocks in the lower foreground. Rising mists are suggested at the base of the cliffs that divide the composition into lower one-third and upper two-thirds.

When a vertical line intersects a horizontal line, the opposing forces generate a visual attraction that acts as a strong center of interest in the design. Fan K'uan took advantage of this phenomenon by extending the implied vertical line of the upper falls to bring attention to the travelers. Although the size of the tiny figures serves, by comparison, to indicate the vastness of nature, the figures must be seen in order to give human significance to the painting. The simplicity of the monumental landscape is maintained by grouping the complexity of fine details into a balanced design of light and dark areas.

The painting embodies philosophical ideas of Taoism and Confucianism. Nature is seen as emptiness and substance, interacting passive and active forces (*yin* and *yang*), which regulate all of nature. When humans have humility they are in harmony with these universal forces.

The mountains in many Chinese paintings may appear to us to be fantastic inventions. But in both Central and Southern China there exist steeply eroded, mist-shrouded mountains that have inspired Chinese landscape painters for centuries. In the seventeenth century Li

Li-Weng wrote, "First we see the mountains in the painting, then we see the painting in the mountains." This statement reminds us that while art is dependent on our perception of nature, we may in turn perceive nature in terms of art.

Chan (as Zen Buddhism was called in China) painters in the thirteenth century developed a bold style that used abbreviated references. Compared to the detailed and differentiated representation in Fan K'uan's TRAVELERS AMONG MOUNTAINS AND STREAMS, the priest Yü-Chien's painting of MOUNTAIN VILLAGE IN A MIST shows a simplified calligraphic rendering of landscape. In this painting the relationship of human beings to nature is expressed with tiny figures and barely suggested roof lines in an atmosphere of mist-obscured mountains.

Prior to the twentieth century no European or American artist would have left such large areas unpainted. For traditional Chinese painters, however, space is seen as a ground of possibilities, as positive rather than negative. Forms are suspended, as in Yü-Chien's painting. They emerge and vanish in ambiguous ways. Here the paper refers to sky, clouds, or mist, implying that what cannot be seen at this moment will appear at another moment and then disappear again. Chinese philosophy emphasizes the changing nature of all things.

The same area of silk or paper that can stand for sky or clouds can also be a surface to write upon, as in the left side of MOUNTAIN VILLAGE IN A MIST. The marks of the brush that indicate the landscape are expected to provoke a remembered experience, rather than present what the human eye might see. Meanwhile, the writing can be a poem that also stimulates the memory image. The poem and the painting are parallel devices employed to heighten our experience. Such spontaneous painting was to have great influence on later Japanese Zen painters of the "splash-ink school."

280
HUANGSHAN MOUNTAIN AFTER A RAIN.
Photograph.

281 Yü-Chien.
MOUNTAIN VILLAGE IN A MIST.
13th century.
Ink on paper.
Idemitsu Museum of Arts, Tokyo.

282 Ch'en Jung.
Detail of NINE DRAGONS. Mid-13th century.
Handscroll, ink on paper. Height 46.3 cm.
Museum of Fine Arts, Boston.
Francis Gardner Curtis Fund.

283
MAIN SHRINE AT ISE. c. 685,
rebuilt every twenty years.
Ise, Japan.

Dragons are another major motif in Chinese art. In Christian art the dragon is usually a symbol of evil, but for the Chinese it is a symbol of vitality associated with the sun, water, storms, and the power of Heaven, or the Spirit. In spite of its ferocious appearance, the dragon has been regarded in China as a beneficial power.

Ch'en Jung, China's best-known painter of dragons, had an unusual technique. According to accounts of his time, Ch'en Jung began by blocking in areas of tonal contrast with a cloth dipped in ink. He then used a brush to paint dragons, clouds, water, and rocks. He added rich texture to the surface by snapping the end of his brush to splatter ink over the painting. Forms emerge and disappear in swirls of ink that represent clouds, water, or mist, evoking the mysterious world of dragons. The dragons in the NINE DRAGONS scroll show a marvelous blend of ferocious energy, cunning, and playful—even friendly—beneficence. The number nine may relate to the nine regions of Heaven, or perhaps to the nine animals that dragons—mythical composites of various creatures—are believed to resemble.

Japan

Nature worship was a major practice in ancient Japan. Forests and huge stones were considered holy places where gods dwelled. The Shinto shrines at Ise are on one such site. The present MAIN SHRINE AT ISE, first built by the fourth century, has been completely and exactly rebuilt every twenty years since the seventh century. Wood for the shrine is taken from the surrounding forest with gratitude and ceremonial care. As a tree is cut into boards, the boards are numbered so that the wood that was united in the tree is united in the building. No nails are used; the wood is fitted and pegged. Surfaces are left unpainted in keeping with the Shinto concept of purity. The shrines at Ise combine simplicity with subtlety. Refined craftsmanship, sculptural proportions, and spatial harmonies are rooted in the ancient religious and aesthetic discipline of Shinto.

In a wave of cultural borrowing more than a thousand years ago, the Japanese imported elements that are major factors in their society to this day. Included are Buddhism, the Chinese writing system, and the art and architecture of T'ang Dynasty China.

Buddhism came to Japan by way of Korea in the sixth century. The subsequent conversion to Buddhism stimulated a great outpouring of art. One of the greatest Buddhist artists of Japan was the sculptor Unkei. His portrait-like sculpture of MUCHAKU, a legendary Indian priest, was made of thin pieces of wood that were joined, carved, and painted to produce a feeling of lifelike realism. Wood is a favorite material for sculpture, architecture, and articles of daily use in Japan. The sculpture by Unkei is one of relatively few naturalistic figures known in Asia in which the force of individual personality is used to portray spiritual values. MUCHAKU's face expresses the sublime tranquility sought in Buddhism.

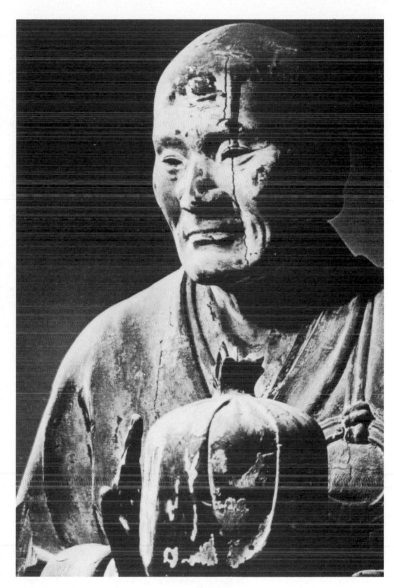

284 Unkei.
Detail of MUCHAKU. c. 1208.
Wood. Height 75″.
Kofuku-ji Temple, Nara, Japan.

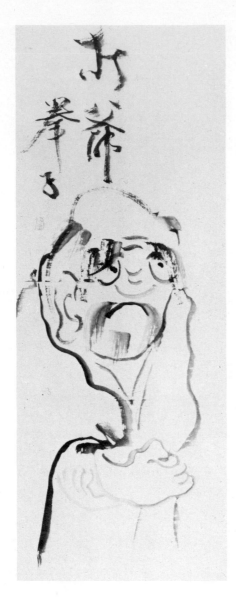

285 Sengai.
THE FIST THAT STRIKES
THE MASTER. C. 1800.
Ink on paper.
41.3 cm x 27.8 cm.
*Idemitsu Museum of
Arts, Tokyo.*

Japanese art can be simple or complex, severe or fanciful, dramatically moving, abstract or realistic. Six centuries after Unkei's sculpture, Zen monk Sengai—known for his spontaneous brush drawings—created a boldly simplified line drawing of a man that is totally different in medium, purpose, and style. In THE FIST THAT STRIKES THE MASTER he illustrates the story of a Zen priest, Rinzai, who found enlightenment and struck his teacher with his fist. Rinzai's gesture was not in anger or frustration, but was an intuitive expression of new insight. Sengai's painting is a kind of calligraphic equivalent of this event.

Many Japanese artists used the format of horizontal handscrolls (thought to have originated in China) as a way of leading the viewer on a journey through landscape. Some scrolls measure as long as 50 feet, and all were meant to be seen, a small section at a time, by only two or three people. In Japan the handscroll was also used for landscape and was found particularly advantageous for long narrative compositions. BURNING OF THE SANJO PALACE is from the HEIJI MONOGATARI, a scroll that describes the Heiji insurrection of 1159. This vivid scene from one part of the scroll can be understood without knowing the incident it depicts. As the scroll was unrolled from right to left, the viewer was enticed into following a succession of events expertly designed to tell the story. The horrors and excitement of the action are connected through effective visual transitions. The story builds from simple to complex events, reaching a dramatic climax in the scene of the burning palace. This is one of the most effective depictions of fire in the history of art. The color of the flames emphasizes the excitement of the historic struggle. The use of parallel diagonal lines and shapes to indicate the palace walls adds to the sense of motion and provides a clear geometric structure in the otherwise frantic activity of this portion of the scroll. Today such epic drama would be presented through the medium of film or television.

Folding screens provide functional art in sparsely furnished Japanese interiors. Artists have been highly original in the ways they used the unique spatial properties of the screen format. Often natural subjects are portrayed life-size, bringing nature indoors. The strong, environmentally affecting presence of a painted screen within the living space of a home is quite different from the window-onto-nature quality of a post-Renaissance European easel painting.

Tawaraya Sōtatsu's large screen painting WAVES AT MATSUSHIMA consists of a pair of six-panel folding screens. (Only one is shown

286
BURNING OF THE SANJO PALACE, from HEIJI MONOGATARI. 13th century.
Section of the handscroll, ink and color on paper. Height 43.3 cm.
Museum of Fine Arts, Boston.
Fenollosa-Weld Collection.

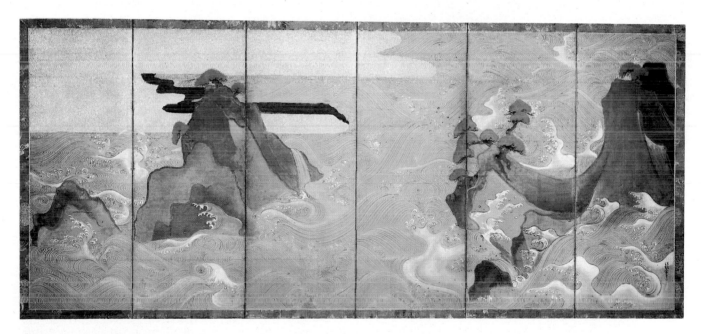

287 Tawaraya Sōtatsu.
WAVES AT MATSUSHIMA. Early 17th century.
Painted screen, paper. Each panel 59⅞″ x 141¼″.
Freer Gallery of Art,
Smithsonian Institution, Washington, D.C.

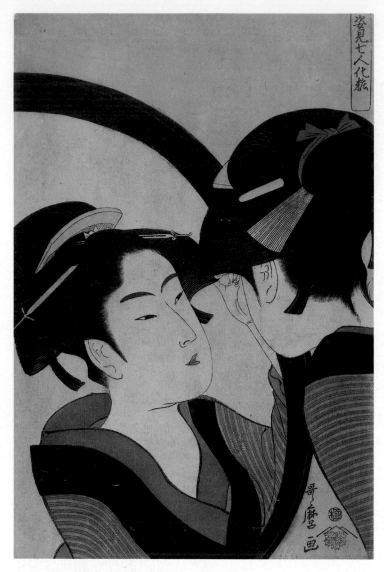

288 Kitagawa Utamaro.
REFLECTED BEAUTY, from the series
SEVEN WOMEN SEEN IN A MIRROR. c. 1790.
Color woodblock print. 14¼″ x 9½″.
Honolulu Academy of Arts.
Gift of James A. Michener.

here.) The screens are designed so that together, or separately, they are complete compositions.

In keeping with well-established Japanese artistic practices, Sōtatsu created a composition charged with the churning action of waves, yet as solid and permanent in its design as the rocky crags around which the waters leap and churn. His loving awareness of natural phenomena was translated into a rich, decorative, abstract design. The spatial ambiguity of the sky and water suggests an interaction that is to be felt, rather than read as a literal transcription of nature. Sōtatsu made no attempt to depict elements of nature in a naturalistic way. Boldly simplified shapes and lines are balanced by highly refined details and eye-catching surprises. Dancing, rhythmic patterns fill much of the surface. A flat, horizontal gold shape in the upper left, accentuated with a black line, signifies a cloud and also reaffirms the integrity of the picture plane. The strongly asymmetrical design, emphasis on repeated patterns, and relatively flat spatial quality is typical of much Japanese painting from the sixteenth to the nineteenth centuries.

By the mid-seventeenth century the art of woodcut printing had evolved to meet the demand for pictures by the newly prosperous merchant class. The Japanese took the Chinese woodcut technique and turned it into a popular art. For the next 200 years, hundreds of thousands of these prints were produced. The prints are called *Ukiyo-e,* which means "floating world." They depict scenes of daily life, particularly as it was lived in the entertainment centers of the time.

In Utamaro's woodcut of a woman looking at herself in a mirror, the ordinary subject is transformed into a memorable image based on bold, curving outlines defining flat shapes. The center of interest is the reflected face of the woman, set off by the strong curve representing the mirror's edge. No shadows are indicated. The figure is thrust in from the right and cut off by the edge of the picture rather than presented completely within the frame as in traditional European painting.

KATSURA PALACE, a seventeenth-century imperial villa, was built in Kyoto beside the Katsura River, the waters of which were diverted into the garden to form ponds. Land, water, rocks, and plants were integrated in a design that blends hand-crafted and natural things. The walls of the palace support no weight. They are sliding screens, which can be opened to allow interior and exterior space to blend.

KATSURA seems humble in contrast to VERSAILLES, another seventeenth-century imperial villa (see page 312). Unlike VERSAILLES, the KATSURA PALACE complex was planned with no grand entrances either to the grounds or to the buildings. Rather, the palace is approached along garden paths. As one proceeds along these paths, unexpected views open up. Earth contours, stones, and waterways are combined to symbolize—on a small scale—mountains, rivers, fields, inlets, and beaches. The tea house, which imitates the traditional Japanese farm house, is constructed of natural, humble materials. It provides the perfect setting for the tea ceremony, which embodies the same attitudes of simplicity, naturalness, and humility that permeate the entire palace grounds.

Domestic architecture has long been an important part of Japanese art. Modest houses and palaces alike have traditionally employed many of the structural and aesthetic principles of Shinto shrines. In the past, Japanese homes were related to the land, and were usually set in or built around a garden. The gardens provided intimacy with natural beauty even in crowded city environments. Gardens are still important to the Japanese, though their size continues to shrink as land becomes increasingly scarce and costly.

289
KATSURA DETACHED PALACE. 17th century. Kyoto, Japan.

a Aerial view.
Photograph: Kyodo News Agency

b Gardens and Teahouse.
Photograph: Drahomir Illik.

Traditional Japanese houses are built using post-and-beam construction, with wood as the basic material. The result is essentially a roof on posts; walls are thus freed to be sliding screens rather than supports. Both outer and inner walls can be moved to expand rooms or to open the house to views and good weather.

The Japanese concept of spatial flow was a major influence on twentieth-century architecture in the West. In fact, Japanese sensitivity to artistic design, and its relationship to nature, has produced art forms that have had a considerable impact on international art in general during the past century.

290
INTERIOR OF A JAPANESE HOUSE.
Photograph: Francis Haar.

Native America

At the end of the last glacial age, while the cultures of India and China were emerging from the Neolithic stage, parallel developments were taking place in Central and South America. The major societies of this region were the Mayan, the Aztec, and the Inca.

The Mayans, who lived in what is now parts of Mexico, Guatemala, and Honduras, developed a written language, advanced mathematics, and large-scale temple complexes of stone. Mayans also made fine ceramic vessels and sculpture. Figures such as MAYAN MAN AND WOMAN stress body volume, natural gestures, and costume detail.

TEMPLE 1 at Tikal was built during the classical Mayan period, 300–900 A.D. It and others like it rise over a great plaza in a Guatemalan rain forest. The temple pyramid is approximately 200 feet high; the summit temple consists of three rooms. A burial chamber similar to those found in Egyptian pyramids was found deep inside a Mayan temple pyramid located in Mexico.

The Aztecs dominated central Mexico from the twelfth century to the early sixteenth century, when they were conquered by the Spanish. Aztec sculpture is characterized by a massive, geometric quality. The figure of TLAZOLTÉOTL, Aztec goddess of childbirth, has been simplified and strengthened by exaggerating some parts and underplaying or omitting others. In spite of its small size, it is monumental in the boldness of its design. The face projects a feeling of defiance and strength.

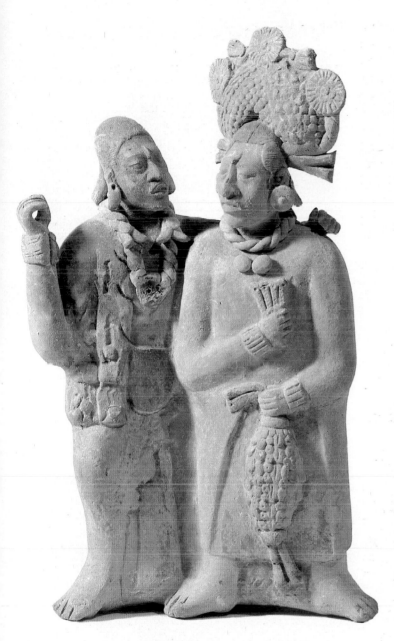

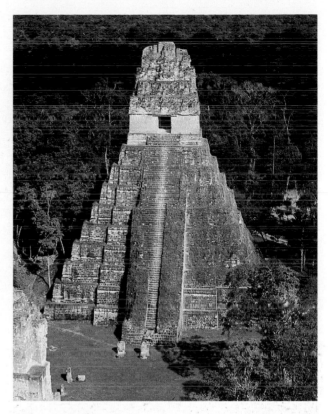

292
TEMPLE 1. c. 300–900 A.D.
Tikal, Guatemala.
Photograph: Hans Namuth.

291
MAYAN MAN AND WOMAN. c. 700.
Buff clay with traces of color. $10^{1}/_{2}''$ x $5^{3}/_{4}''$ x $3^{3}/_{8}''$.
Honolulu Academy of Arts.
Purchase.

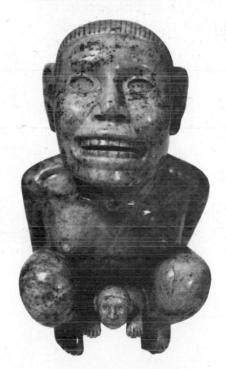

293
TLAZOLTÉOTL, Aztec goddess of childbirth.
c. 1500. Aplite. Height $8^{1}/_{8}''$.
Dumburton Ouks,
Washington, D.C.

294
INCA STONE WALLS.

In the Andes of South America, Inca culture flourished for several centuries just prior to the Spanish conquest in 1532. The Incas made outstanding fabrics and metal works. Unfortunately, most of the creations in gold were plundered by the Spanish. And the craft of Inca weaving has been lost—in fact, modern weavers are unable to duplicate it. The Incas are perhaps best known as supreme masters of shaping and fitting stone. It is believed that each stone was placed in a sling and swung against the adjoining stones until the surfaces were ground to a precise fit. "The lost city of the Incas," MACHU PICCHU, was built on a high mountain ridge in what is now Peru. The city, which escaped Spanish detection, was planned and constructed in such a way that it seems to be part of the mountain.

295
MACHU PICCHU. Early 16th century.
Peru.

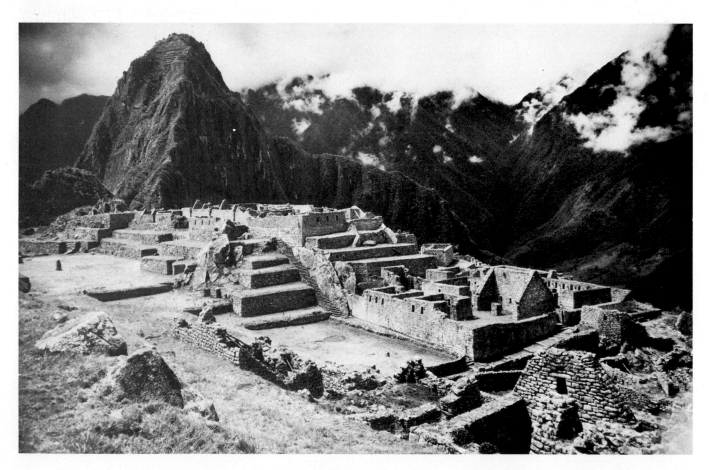

The native art of North America has received less attention than that of the urban cultures of Central and South America. At one time, of course, there were great numbers of North American tribes, each with its own unique culture and style of art. Only a relative handful of these societies survive today, and their arts are rapidly being lost as new generations become assimilated into Western society.

Much of what we know of Native American art is in the form of vessels (see the modern Acoma pottery on page 179). Pomo artists in Northern California created baskets with strong geometric designs. They were woven so tightly—in some baskets one can count 60 stitches to the inch—that they could hold water.

Northwest Coast tribes had a rich art and drama related to their mythology. They were skilled wood-carvers who covered ceremonial poles, masks, canoes, house fronts, and objects of daily use with heraldic imagery telling of family and clan histories, social rank, and mythology.

Tlingit and other Northwest Coast tribes are known for elegant and highly sophisticated abstractions of animal subjects. Their painted relief carvings are reminiscent of the abstract animal forms found on ancient Chinese bronzes (see page 247). On house walls, boxes, and blankets, major features of a totemic animal form are laid out in two-dimensional schematic patterns. The rounded shapes of totemic animals are presented in highly integrated symmetrical designs. These abstract works represent one of the highest achievements of native North American art.

The TLINGIT COMMUNITY HOUSE near Ketchikan, Alaska, is characteristic of the art and architecture of the region. Tlingit totem poles are shorter and thinner than those of other Northwest tribes, and combine original design elements with those borrowed from neighboring tribes.

296
POMO STORAGE BASKET. 19th century.
Coiled basketry. 13½" x 21". California.
*Museum of the American Indian,
Heye Foundation, New York.*

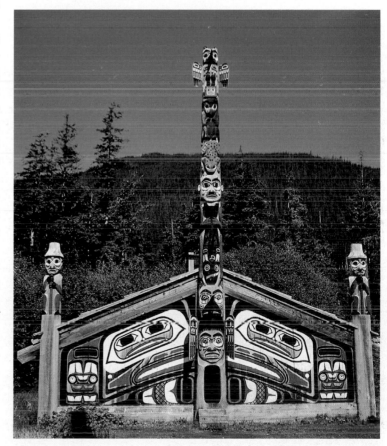

297
TLINGIT COMMUNITY HOUSE.
Ketchikan, Alaska.
Photograph: Steve McCutchan.

Oceania

Oceania is the collective name for thousands of Pacific islands. The term usually excludes the islands of Japan, Taiwan, the Philippines, and Indonesia, whose cultures are closely related to mainland Asia. The islands of Oceania are divided ethnologically and geographically into groups comprising Melanesia, Micronesia, and Polynesia. It is difficult and misleading to generalize about Oceanic art because the cultures, physical environments, and raw materials vary greatly over an enormous area.

Oceanic peoples developed very little pottery due to a shortage of clay, and metal was un-

298
CANOE PROW FIGURE. Collected 1929.
Wood with mother-of-pearl. Height 6½".
Maravo Lagoon, New Georgia, Solomon Islands.
Basel Museum, Basel, Switzerland.

known until it was introduced by traders in the eighteenth century. Tools were of stone, bone, or shell; wood, bark, and small plants were used for houses, canoes, mats, and cloth. Feathers, bone, and shells were employed for utensils and sculpture, as well as for personal adornment.

In the Solomon Islands and New Ireland, part of Melanesia, wood-carvings and masks are designed to serve ritual purposes. In the art of many nonliterate societies birds appear with human figures to act as guides or messengers between the physical world of the living and the spiritual world of deceased ancestors. The bird in the CANOE PROW FIGURE from the Solomon Islands seems to guide voyagers by acting as a protective spirit, watching out for shoals and reefs. The carving is only 6½ inches high, but it looks much larger because of the boldness of its form. Exaggerated nose and jaw help give the head its forward thrust. The wood is blackened and inlaid with mother-of-pearl, which provides white shapes for the eyes and forms the rhythmically curving linear ZZZ bands that unify the design. Like the Chinese bronze vessel on page 247, it expresses faith in the symbolic protective power of art.

In New Ireland, masks are made for funerary rites that commemorate tribal ancestors, both real and mythical. Each of the colorfully painted masks represents a specific ancestor. In this mask the elaborately carved openwork panels are painted in strong patterns that establish large and small rhythms accentuating—and at times opposing—the dynamic forms of the carving. Snail shell eyes give the mask an intense expression. As in the Solomon Islands CANOE PROW FIGURE, a bird is prominently featured.

In contrast to the art of Melanesia, the works made in Micronesia and much of Polynesia are streamlined and highly finished. The Kapinga-marangi COCONUT GRATER is a striking example of the integration of form and function. One sits on the "saddle" of the animal-like form, and grates coconut using the serrated blade at its head. The angle and placement of the blade are

299
MASK. c. 1920.
Painted wood, vegetable fiber, shell.
94 cm x 53 cm.
New Ireland.
UCLA Museum of Cultural History,
Los Angeles.

important to the efficient removal of meat from nut halves. The STANDING FIGURE from Nukuoro Island has the same distinctive spare, elegant quality. While both Kapingamarangi and Nukuoro are in the southern part of Micronesia, they are culturally Polynesian.

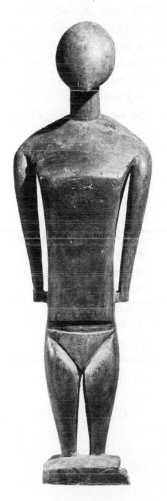

300
STANDING FIGURE. Probably 19th century.
Wood. Height 15⁹/₁₆″.
Nukuoro Atoll, Caroline Islands.
Honolulu Academy of Arts. Exchange,

301
COCONUT GRATER. 1954.
Wood with shell blade attached
with sennet.
Kapingamarangi, Caroline Islands.
Private collection.

Polynesia covers a large, triangular section of the Pacific from New Zealand to Hawaii to Easter Island. It is not surprising that the widely separated Polynesian islands and island groups developed greatly varied arts. These include both delicate and boldly patterned bark cloth, feathered capes and figures, wood-carvings, and huge rock-carvings.

The Hawaiian Islands have a strong tradition of wood-carving. This CARVED MEAT PLATTER (PĀKĪ'I), large enough to hold a small cooked pig or dog, was carved to commemorate the victory of one chief over another. Supporting the meat dish of the conqueror are figures representing the conquered chief and his wife, in servile positions. Their large, open mouths are receptacles for salt or condiments. Hawaiian sculptors gave expressive power to their carvings by making their depictions of the human figure compact, bold in their features, and built up of clearly articulated units.

302
CARVED MEAT PLATTER, (PĀKĪ'I). c. 1785.
Wood. Length 45 1/2". Hawaii.
Bishop Museum, Honolulu.
Princess Ruth Ke'elikolani Collection.

Africa

The traditional arts of black Africa are extremely varied. Styles range from highly abstract to very naturalistic. The principal art forms are masks and figures, usually made for use in religious ceremonies. As in the art of other traditional cultures, much of it was made of perishable material for specific uses, and was not intended to be preserved.

The art of Africa, south of the Sahara, was first known in Europe in the fifteenth century. It attracted little attention, however, until it was rediscovered around the turn of this century by a few European artists and art collectors who were greatly impressed and influenced by its power. Art from Africa eventually came to be known and admired by people in the West for its expressive and highly sophisticated abstract imagery.

Many African tribal groups have shared a number of basic concepts, including *animism*, the belief that all objects, whether animate or inanimate, have a spirit or life force. Sculpture from these areas does not symbolize a spirit; it may actually embody or contain it. Where such traditions still prevail, the carver of sacred objects must be purified before carving. Sculpting tools are also considered sacred because of their purpose.

The Bambara people of Mali are famous for

their carved wooden antelope headdresses which are attached to basketry caps and worn on top of the head during agricultural ceremonies. When a new field is cleared the most diligent male workers are selected to perform a dance of leaps in imitation of the mythical *chi-wara*, who taught humans how to cultivate crops. The dance always includes both male and female *chi-wara* figures. The female is identified by her baby on her back. The male, seen here as a baby, has a stylized mane. These organically abstracted antelope bodies become energized, almost linear forms. Rhythmic curves are accented by a few straight lines in designs that emphasize an interplay of solid mass and penetrating space.

In Central Africa the Bakota create abstract wood and metal funerary sculptures. The use of brass is an indication of the importance of the object, since metal is rare in Central Africa. It is thought that the original meaning of the figures has been lost or changed, but the artists of the tribe continue the tradition of creating figures like this FUNERARY FIGURE for the protection of the dead. A concave ovoid shape represents the face, from which other metal-covered shapes project. The greatly simplified lower body adds a sprightly upturning curve and diamond-shaped open-space that complete and complement the design of the head area.

303
BAMBARA HEADDRESS.
Probably 20th century.
Wood, brass tacks, string,
cowrie shells, and iron.
Height 31¼". Mali.
The Art Institute of Chicago.
Hertle Fund.

304
BAKOTA FUNERARY
FIGURE.
Probably 20th
century.
Brass sheeting
over wood.
Length 70.4 cm.
French Equatorial
Africa.
National Museum
of Natural History,
Smithsonian Institution,
Washington, D.C.
Herbert Ward Collection.

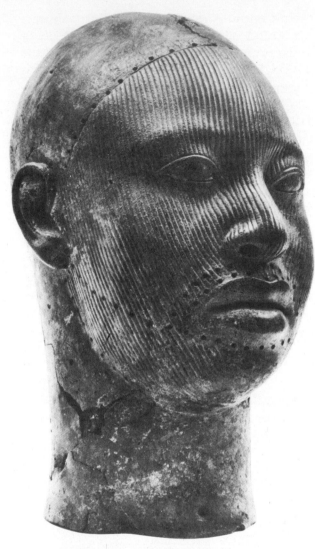

305
MALE PORTRAIT HEAD. 12th century.
Bronze. Height 13½″. Ife, Nigeria.
Collection of the Oni of Ife.

As the Gothic era was beginning in twelfth-century Europe, a highly sophisticated art was being produced for the royal court of Ife, the sacred Yoruba city in Southwestern Nigeria. There, a naturalistic style of courtly portraiture developed that was unlike anything to be found in Europe at the time and was equally unique among the inventive abstract forms created by most African cultures. The MALE PORTRAIT HEAD shown here is a representational portrayal of an individual. The work demonstrates great skill in the difficult art of lost-wax bronze casting. Scarification lines follow contours across the face. Rows of small holes originally held hair and beard, adding to the realism. Bronze artworks of high quality subsequently appeared elsewhere in Africa. Around the fourteenth century a master sculptor from Ife allegedly brought bronze casting to the neighboring Nigerian kingdom of Benin (see page 172).

The traditional arts of Native America, the Pacific Islands, and Africa were greatly varied; yet they have more in common with one another than with the arts of traditional Asia or the modern Western world. For instance, abstraction is far more common than naturalism in all three geographic areas. Most of the art of these places was made primarily to fulfill specific uses other than contemplation or decoration.

In the Americas, the Pacific Islands, and Africa many traditional arts are no longer being practiced. Even for those peoples who are still together in identifiably traditional societies, the arts have largely lost their crucial roles in maintaining meaningful survival and cultural continuity. Although artifacts of varying degrees of integrity are still being produced in some of these areas, the introduction of modern schools, missions, and mass-produced material goods has rendered pointless and sterile the artistic life of most traditional communities. Rather than the former high-quality art, we are now likely to find poor copies and tourist curios being made. It is ironic that museums and private collections of the Westernized world preserve artistic evidence that demonstrates ways of life made impossible by modern culture.

THE ANCIENT MIDDLE EAST AND THE MEDITERRANEAN BASIN

Although the cultures of ancient Mesopotamia and Egypt ran almost parallel to each other in time, they were quite different in style. Urban civilization began to develop earlier in the Tigris-Euphrates Valley than it did in the Nile Valley of Egypt. The Egyptians, who had the protection of a narrow river valley walled off by formidable deserts, enjoyed thousands of years of relatively unbroken self-rule; the Mesopotamians, however, were vulnerable to repeated invasion, and the area was ruled by a succession of different peoples. Because of these and other differences, each civilization developed its own distinctive art forms.

Mesopotamia

The Greeks called the broad valley between the Tigris and Euphrates rivers Mesopotamia, "the land between the rivers." Neolithic cultures had flourished in this fertile area. The Neolithic beaker on page 239 indicates a highly developed sense of design.

An early people who called the area Sumer, and subsequently became known as the Sumerians, developed the oldest known writing. In Sumeria religion and government were one, with authority resting in priests who claimed divine sanction. The people worshiped a hierarchy of nature gods. The place of worship and center of each theocratic city-state was the ziggurat. Most of the ruins of cities in the area are still dominated by eroding ziggurats such as the one at Ur. They symbolized, and perhaps replaced, the sacred mountain. The Tower of Babel mentioned in the Bible, which was believed to have existed in ancient Babylon, is the most famous of these temple towers. The massive ziggurats were earth-filled, with brick outer walls. Two or more successively smaller platforms stood on the solid base, probably with a shrine on the uppermost platform. On these heights the city's gods might dwell, close to heaven, and there the ruling priests could find protection.

306
ZIGGURAT AT UR.
c. 2100 B.C.

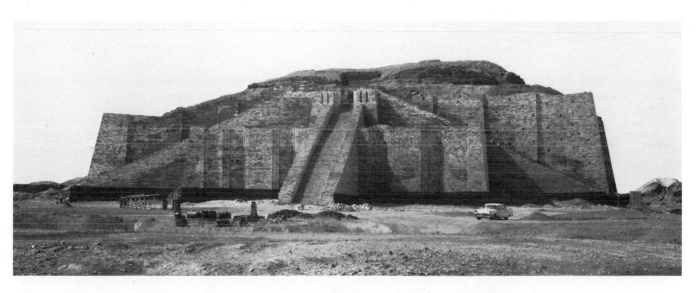

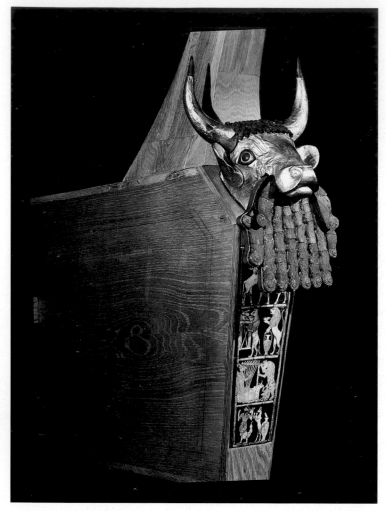

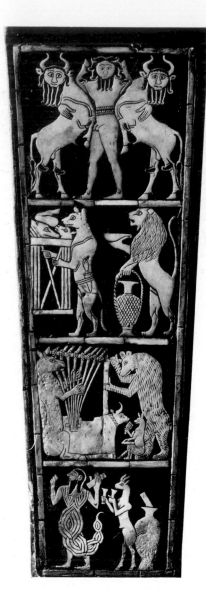

a Detail

307
Fragment of ROYAL HARP. c. 2685 B.C.
Wood with inlaid gold, lapis lazuli and shell.
Soundbox. Height 12".
From the Tomb of Queen Purabi, Ur.
University Museum, University of Pennsylvania, Philadelphia.

b Soundbox
Height 12"

We can imagine the splendor of Sumerian court life by studying the remaining fragment of the beautiful ROYAL HARP found in the tomb of Queen Purabi of Ur. The narrative panel on the front, the bull's head, and the gold-covered posts are all original. The bearded bull's head is a symbol of royalty often seen in Mesopotamian art. In contrast, the bulls and other imaginative animals inlaid on the harp's soundbox are depicted in a simplified narrative style that seems quite humorous to us. They take on human roles, as do the animals in Aesop's Fables. The upper panel, showing a man embracing two bearded bulls, is a type of heraldic design developed by the Sumerians that was to influence the art of many later cultures. Both the top trio and the panel at the bottom, showing a goat attending a scorpion-man, are believed to be scenes from the great classic of Sumerian literature, the *Epic of Gilgamesh.*

Egypt

Deserts on both sides of the Nile precluded outside influences and enabled Egypt to develop distinctive styles of architecture, painting, and sculpture that remained comparatively unchanged for nearly 3000 years. It is astonishing to realize that ancient Egyptian culture lasted 1000 years longer than the time from the birth of Christ to today. All of us alive today were born into very rapid cultural and technological change. It is difficult for anyone conditioned by the concept of "new is better" to conceive of a cultural tradition which remained relatively consistent for several thousand years.

Ancient Egypt, like Mesopotamia, was a theocratic society. Art was devoted to the gods and pharaohs, who were considered god-kings. Egyptian religion was distinguished by its emphasis on life after death. Preservation of the body and care for the dead were considered essential to extend life beyond the grave. Mummies of royalty and their accompanying artifacts, tools, and furniture were buried in great pyramids or in hidden underground tombs. Architecture was the most important of the ancient arts, and, because of the extensive use of written language, the names of ancient Egyptian architects have been preserved.

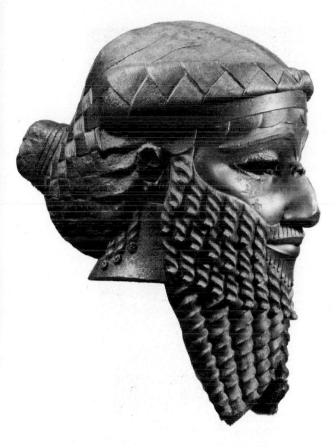

308
HEAD OF AN AKKADIAN RULER. c. 2300–2200 B.C.
Bronze, 12". From Niniveh (Kuyunjik)
Iraq Museum, Bagdad.

About 2300 B.C. the scattered city-states that made up Sumeria had come under the authority of a single Akkadian king. The magnificent HEAD OF AN AKKADIAN RULER portrays such an absolute monarch. Clearly, there was a long tradition behind this fully mature work. The elaborate hairstyle and rhythmic patterning shows the continuation of Sumerian design ideals. Calm inner strength is expressed in the handsome face. Superb blending of formal design qualities with carefully studied naturalism is a characteristic of later Mesopotamian art.

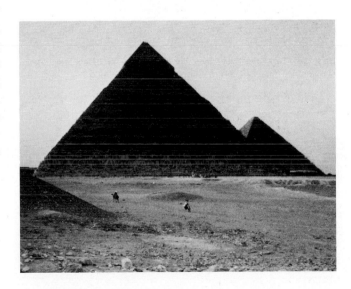

309
PYRAMIDS OF KHAFRE
AND MENKURE.
c. 2560–2525 B.C.
Giza.

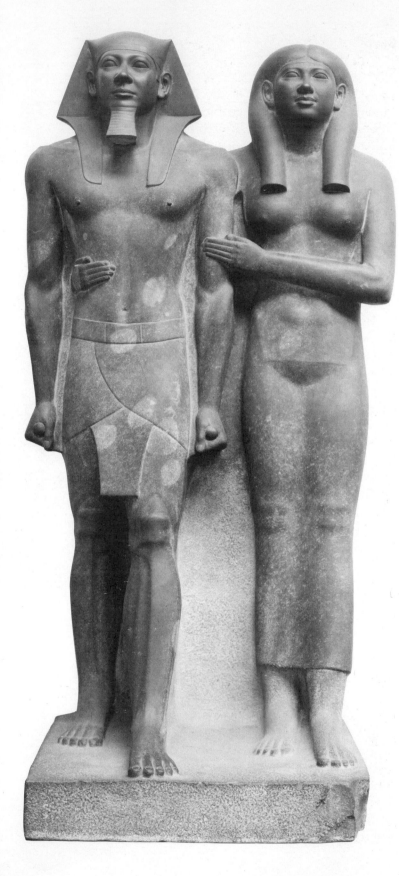

A distinctive feature of Egyptian painting, relief carving, and even sculpture in the round is the presentation of the human figure in either completely a frontal position or in profile. Egyptian artists approached their subject matter conceptually—that is, angles of view and overall composition followed mental concepts rather than visual appearance. Artists represented what was known to be true and most characteristic about a subject rather than merely what was seen, thus avoiding the ambiguity caused by random or chance angles of view.

Egyptian sculpture is characterized by a preference for compact, solidly structured figures that have some of the qualities of strength and geometric clarity found in Egyptian architecture. The final form of a piece of sculpture was determined by an underlying geometric plan that was first sketched on the surface of the block.

The sculptor of KING MYCERINUS AND QUEEN KHAMERERNEBTY paid considerable attention to human anatomy, yet stayed within the traditionally prescribed geometric scheme. The strength, clarity, and lasting stability expressed by the figures result from a particular kind of union between naturalism and geometric abstraction. With formal austerity, the couple stands in the *frontal* pose that had been established for such royal portraits. Even so, the figures express warmth and life energy; the queen touches Mycerinus in a sympathetic, loving way. Typical of the monumental sculpture of the Old Kingdom are the rigid pose with the left foot forward, the false ceremonial beard, and the figures that are still attached to the block of stone from which they were carved. Egyptian emphasis on rectilinear qualities of mass contrasts with the Mesopotamian pref-

310
KING MYCERINUS AND QUEEN
KHAMERERNEBTY. 2599–2571 B.C.
Slate schist. Height 54½".
Museum of Fine Arts, Boston.
Harvard Boston Expedition.

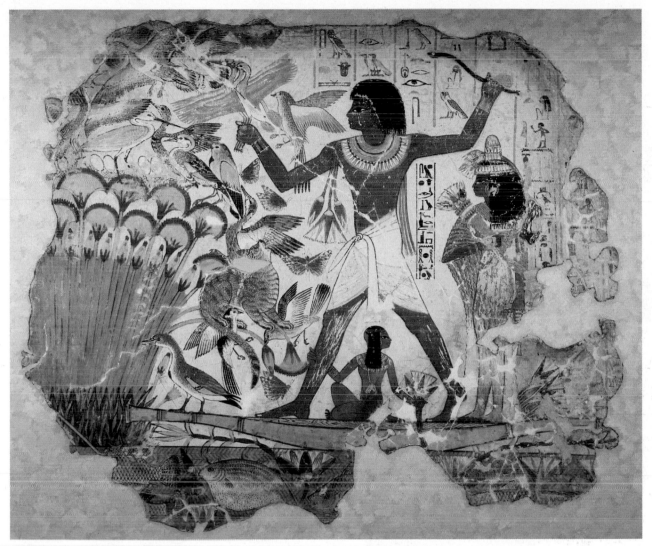

311
WALL PAINTING FROM THE TOMB OF NEBAMUN(?) c. 1450 B.C.
Thebes.
British Museum, London.

erence for rounded, at times almost cylindrical, forms.

The painter of the Egyptian hunting scene in this wall painting followed the traditional practice for such subjects, which made it possible to present a wealth of specific information without making the painting confusing. Egyptian painting style used flat shapes that portrayed basic elements of each subject in the clearest, most characteristic way. The combination of different views is easily seen in the figure of the nobleman who dominates this painting. His head, hips, legs, and feet are shown from the side, while his eye and his shoulders are seen from the front. Such conventions were employed in Egyptian painting and relief sculpture in a continuous tradition going back at least 1500 years prior to the completion of this painting. It continued for another thousand years. (See also A POND IN A GARDEN, page 85.)

In ancient Egyptian paintings, the size of human figures is determined by social rank according to what is called *hierarchic proportions.* Here the nobleman is the largest figure, his wife

is smaller, and his daughter smaller yet. The family is standing on a boat made of papyrus reeds, with plants shown growing on the left at the shore. The entire painting is teeming with life, and the artist has even taken great care to show life below the water's surface. We can identify species of insects, birds, and fish. Two parallel ways of making the presentation have been used. One is pictorial, or visual, and the other is verbal. The written hieroglyphics can be read today by experts, who have deciphered the names of the people portrayed. This painting is a fine example of art that opens a window onto the past.

A sense of realism is particularly apparent in paintings of animals—in this case, the great array of bird species and the amazing hunting cat. The combination of naturalism, and relatively more abstraction for human figures, is reminiscent of Paleolithic art.

Greece

The people who emerged as the culturally unified inhabitants of Greece were distinguished from other peoples of Europe and Asia by their attitude toward mankind. Nature worship evolved into personification; gods assumed human form. Greek gods had human weaknesses, and the Greeks had godlike strengths.

Ancient Greeks regarded humankind as the highest creation of nature—the closest thing to perfection in both physical form and the power to reason. With this attitude came a new concept of the importance of the individual. "Man" was the measure of all things. Greek humanism led to the development of democracy as well as to the perfection of naturalistic images of the human figure in art. Thus, to create the perfect individual—the supreme work of nature—became the Greek ideal. Behind the imperfections of transitory reality was the ideal form.

312
Detail of KORE no. 674.
c. 500 B.C.
Painted marble.
Acropolis Museum, Athens.

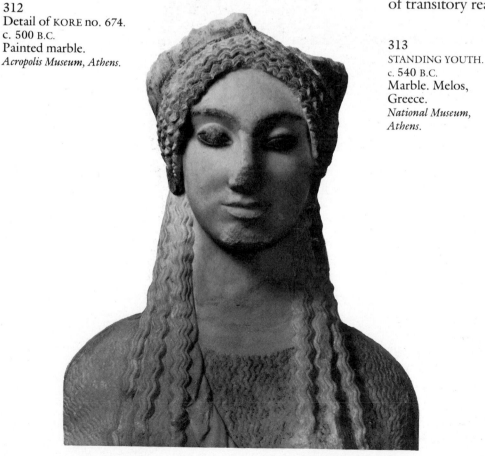

313
STANDING YOUTH.
c. 540 B.C.
Marble. Melos,
Greece.
*National Museum,
Athens.*

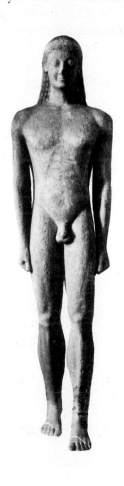

Art of the Archaic period of Greek civilization (from the late seventh to early fifth centuries B.C.) reveals the assimilation of major influences from Egypt and the Near East. Numerous life-sized nude male and clothed female figures were carved and cast during this era.

Sometimes the images were of individual people, sometimes they were idealizations representing gods or goddesses. Often, like this early Greek KORE (maiden), they were dedicated to a god or goddess. Some of the original paint with which much Greek sculpture and architecture was covered remains on the face of this image of a young girl.

Nude athletes probably inspired sculptured nudes. The concept of the supreme athlete appeared early in male sculpture, possibly to commemorate Olympic champions.

Both male and female figures show Egyptian influence. This representation of the male figure, STANDING YOUTH, has a rigid frontal position that is an adaptation of the stance of Egyptian figures. Both the Egyptian sculpture of Mycerinus and this *kouros* (youth) are standing with arms held straight at the sides, fingers drawn up, and left leg forward. Strict frontal symmetry was abandoned slowly by all ancient Mediterranean civilizations.

In spite of the similarity of stance, however, the character of Egyptian sculpture is quite different from Greek. The Egyptians were preoccupied with life after death, while the Greeks were more interested in perfecting physical life and the human body. The *kouros* is carved in the round, not attached to the back slab of the original block as are the Egyptian figures. The so-called Archaic smile on the face of the Greek figure accentuates an overall aliveness not found in Egyptian sculpture.

Within 100 years after the making of the *kouros* figure, Greek sculpture became increasingly naturalistic and began to show figures in motion. Two bronze sculptures of nude warriors were found in the Mediterranean, off the coast of Italy, in 1972. The WARRIOR shown here is a good example of the Classical Greek interest in anatomical naturalism and the idealized male figure.

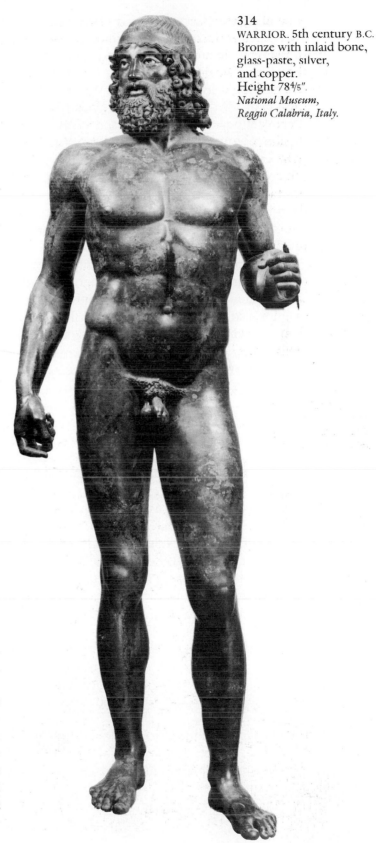

314
WARRIOR. 5th century B.C.
Bronze with inlaid bone,
glass-paste, silver,
and copper.
Height 78⅘″.
*National Museum,
Reggio Calabria, Italy.*

During the Classical period (480–323 B.C.), Greek sculptors did more than reproduce a living model. They infused life into the medium of bronze or marble and into the ideal abstract harmonies of art. As seen in the WARRIOR, the union of idea and material provided balance between the ideal male figure and a convincing image of a man in the prime of life. Naturalistic details included eyes of bone and glass paste, bronze eyelashes applied in a strip, pink lips and nipples of copper, and silver-plated teeth. Stylized beards of Mesopotamia, Egypt, and early (Archaic) Greece have been replaced with a lively rendering of facial hair.

Here the rigid pose of Egyptian and early Greek figures has given way to a more relaxed human stance. The WARRIOR stands with his weight resting on one foot. As a result, the hip and shoulder lines are no longer parallel, but counterbalance one another. This form of balance is known by the Italian word *contrapposto,* meaning "counter-posed." Contrapposto was widely used by the Greeks and Romans to give lifelike qualities. Sculpture that embodied this concept influenced Renaissance artists (see Michelangelo's DAVID, page 301).

The city-state of Athens was the center of ancient Greek civilization when that culture was at its height. Above the city, on a large outcropping of rock called the ACROPOLIS, the Athenians built one of the world's most admired structures. Today, even in its ruined state, the PARTHENON continues to express the high ideals of the people who created it.

This temple, one of several sacred buildings on the Acropolis, was designed and built as a gift to Athena Parthenos, protector of the Athenian navy, goddess of wisdom, arts, industries, and prudent warfare. It expressed the gratitude of the Athenians for naval and commercial success.

When Ictinus and Callicrates designed the Parthenon, they were following a well-established tradition in temple design based on the post-and-beam system of construction. In the Parthenon, the Greek temple concept reached its highest form of development. It was located so that it could be seen against the sky, the mountains, or the sea from vantage points around the city. It was the location of large outdoor religious festivals. Rites were performed on altars placed in front of the eastern entrance. The interior space was designed to house a 40-foot-high statue of Athena. Laymen were permitted to view the magnificent figure through the eastern doorway, but the interior was used only by priests. The axis of the building was carefully calculated so that on Athena's birthday the rising sun coming through the huge east doorway would fully illuminate the gold-covered statue.

The proportions of the Parthenon are based on harmonious ratios. The entire elevation of either end conforms to the Golden Section (see page 106). Below the triangular pediment the proportions are based on a different ratio. The ratio of the height to the widths of the east and west ends is approximately 4 to 9. The ratio of the width to the length of the building is also 4 to 9. The diameter of the columns relates to the space between the columns at a ratio of 4 to 9, and so on. None of the major lines of the building are perfectly straight. The columns have an almost imperceptible bulge above the center that causes them to appear straighter than if they were actually straight-sided, and gives the entire structure a certain grace. Even the steps and tops of doorways rise slightly in perfect curves. Corner columns, seen against the light, are slightly larger in diameter to counteract the diminishing effect of light in the background. The axis lines of the columns lean in slightly at the top. If extended into space, these lines would converge 5856 feet above the building. These unexpected variations are not consciously seen, but they are strongly felt. They give the building its sense of perfection. The subtle deviations from straight horizontal and vertical lines were probably done to correct optical illusions.

The Parthenon exhibits the refined clarity, harmony, and simplicity that comes from the heart of the Greek tradition.

315
a ACROPOLIS.
 View from the southwest. Athens, Greece.

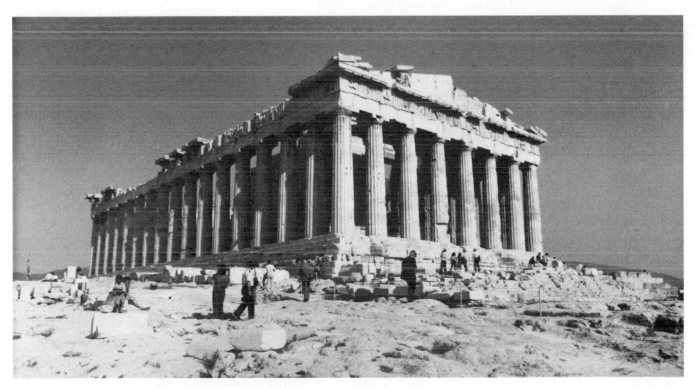

b Ictinus and Callicrates. PARTHENON. 447–432 B.C.
 View from the northwest. Athens, Greece.

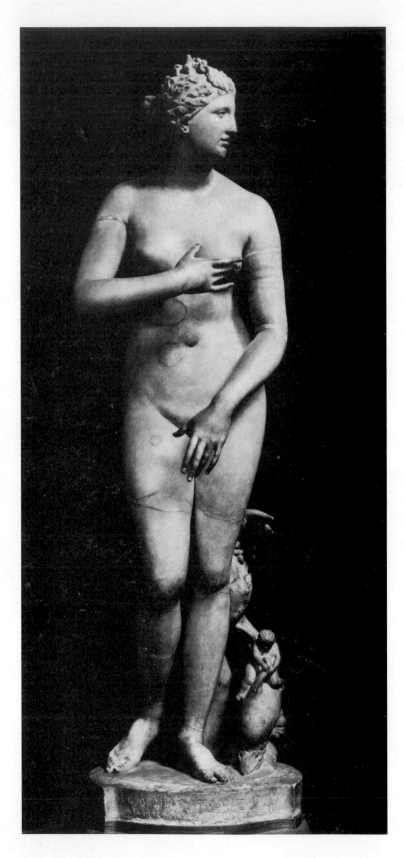

Although we see Greek temples as white marble structures, recent analysis shows that exterior surfaces were painted with colors such as blue and red.

Aphrodite, the Greek goddess of love and beauty, was known as Venus by the Romans. VENUS DE MEDICI is a Roman copy of a fourth century B.C. Greek original. The figure is more ideal than natural because it was made to symbolize a goddess, rather than a real woman. The Classical Greek profile is one of the most obvious features of this idealization of femininity.

After the decline of the Greek city-states at the end of the fourth century B.C., the art of the Mediterranean area is characterized as *Hellenistic,* meaning Greek-like. It was strongly influenced by Greek art and often executed by Greek artists, but usually it was produced for, and according to, the preferences of non-Greek patrons. With the transition from the Classical Greek to the Hellenistic, there was a loss of confidence in the material world as well as a loss of security due to the realization that the gods themselves had failed to sustain the glory of Greece. Thus people turned to the subjective, fallible, and imperfect aspects of life and humanity, rather than the glorified idealizations of the Classical period.

In the Hellenistic period Greek art became more dynamic and more naturalistic. Everyday activities, historical subjects, and portraiture were more common than in the Classical period.

316
VENUS DE MEDICI. 3rd century B.C.
Marble. Height 5'.
Uffizi Gallery, Florence.

A late Hellenistic work is THE LAOCOÖN GROUP. According to the myth, Laocoön was a Trojan priest who opposed bringing the Greek wooden horse into Troy: The gods sought to punish him and sent two large serpents that strangled him and his two sons. The event is presented with dramatic poses, tortured facial expressions, and strained muscles. The rationalism, clarity, and control that were typical of the sculpture of the Classical period are replaced by writhing movement expressing emotional and physical anguish. When this sculpture was unearthed in Italy in 1506 it had an immediate influence on Michelangelo and many of his contemporaries, and became an inspiration for later Baroque art.

Rome

By the second century B.C. Rome was the major power in the Western world. At its height the Roman Empire included the people of Western Europe, North Africa, and the Near East, as well as the shores of the Mediterranean. The process of governing a multitude of unique peoples and cultures was one of the prime expressions of the Roman genius for order and worldly action. Roman culture has affected our lives in many areas—systems of law and government, our calendar, festivals, religions, and languages. We also inherited from the Romans the concept that art is worthy of historical study and critical appreciation.

317 Agesander, Athenodorus, and Polydorus of Rhodes.
THE LAOCOÖN GROUP. c. 150–30 B.C.
Marble. Height 95 1/4".
Vatican Museum, Rome.

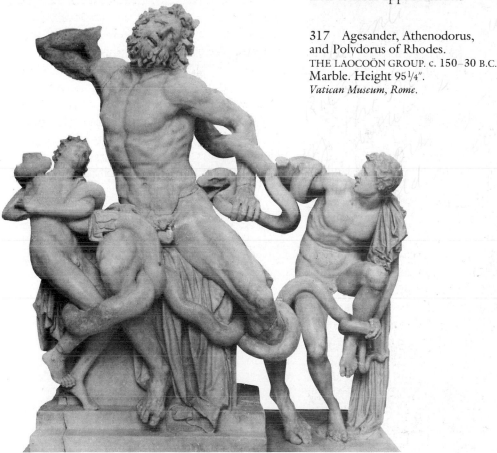

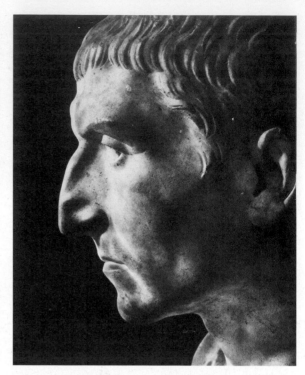

318
FEMALE PORTRAIT. c. 54–117.
Marble. Life-size.
Museo Profano Lateranese, Rome.

319
MALE PORTRAIT. c. 100.
Marble. Life-size.
Capitoline Museums, Rome.

The Romans were a practical, materialistic people, and their art reflects this. They made few changes in the general style of Greek art, which they admired, collected, and copied. But not all Roman art was imitative. Roman portraiture achieved a high degree of individuality rarely found in Greek sculpture. This representational style probably grew out of the Roman custom of making wax death masks for the family shrine. Later, these images were recreated in marble to make them more durable. Roman sculptors observed and carefully recorded those physical details and imperfections that give character and individuality to each person's face.

The Romans' greatest artistic achievement was in civil engineering, town planning, and architecture. They created utilitarian structures of impressive beauty and grandeur that were to influence Western architecture for centuries. The outstanding feature of Roman architecture was the semicircular arch, which the Romans learned from their predecessors, the Etruscans. Arch construction had been used earlier in Mesopotamia, Egypt, and Greece, primarily for underground tombs and waterways, but the Romans developed the idea much further in the construction of domes and vaults. (See the diagrams on page 201 and the aqueduct at Nimes on page 205.) By developing the structural use of concrete combined with semicircular arch construction, the Romans were able to enclose large spaces.

An early type of cement was commonly used in Roman construction, but the quality of cement declined during the Middle Ages and it was not widely used again until redeveloped in the nineteenth century.

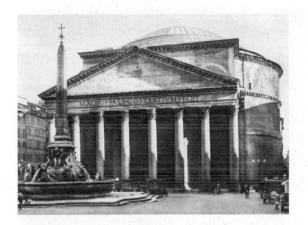

320
PANTHEON. 118–125.
Concrete and marble.
Rome.

321 Giovanni Paolo Panini
INTERIOR OF THE PANTHEON. c. 1740.
Oil on canvas. 50¹/₂″ x 39″.
National Gallery of Art, Washington, D.C.
Samuel H. Kress Collection (1939).

In the PANTHEON, a major temple dedicated to all the gods, Roman builders created a domed interior space of breathtaking scale. The walls of the circular concrete and brick building are 20 feet thick, to support the huge dome constructed of horizontal layers of brick set in mortar. These layers are reinforced by a series of arches that converge in the dome's crown, leaving a central opening called an *oculus* or eye. The oculus, 33 feet in diameter, is open to the sky and provides light and ventilation to the interior. On the inside, the coffered ceiling, which was originally covered with gold leaf, arches above the viewer as a symbol of the dome of heaven.

Simplicity of design and the immense domed interior make the Pantheon a memorable structure. The building is essentially an upright cylinder, capped by a hemispherical dome, with the single entrance framed by a Greek porch or *portico*. This classical porch is reminiscent of the Parthenon. In contrast, however, to the exterior orientation of the Parthenon, the Pantheon has an *interior* orientation. The Romans developed the ability to build large domed and vaulted interiors to accommodate their preference for gathering inside. The Greeks, by contrast, worshiped outside their temples.

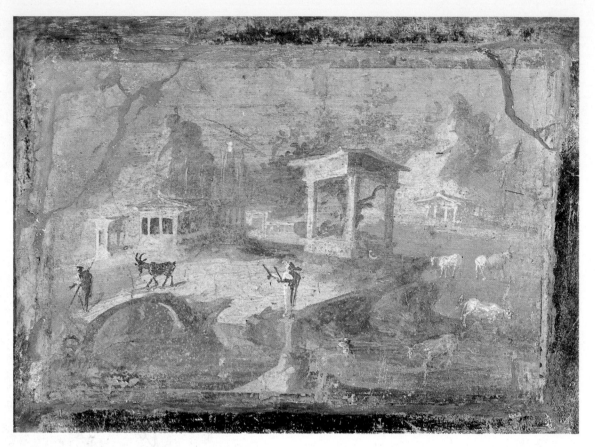

322
SACRED LANDSCAPE. c. 63–79.
Wall painting from Pompeii.
National Museum, Naples, Italy.

Evidently, Roman artists learned a great deal about painting as well as sculpture from the Greeks. Unfortunately, Greek painting is known to us only through references in Greek literature, the minor art of vase painting, and from Greek influences on Etruscan tomb painting.

Roman wall paintings, such as the SACRED LANDSCAPE excavated at Pompeii, contain a wide range of subject matter, from architectural details to still lifes and landscapes. Here a wall was transformed into a window. The idyllic scene, painted as if viewed from a high vantage point, includes people, animals, architecture, and landscape designed to create a natural impression. Although the landscape was imaginary, the artist was aware of the effects of atmosphere on objects seen from a distance.

Roman painters came close to a fully developed perspective system by recognizing the importance of the observer's position in relation to objects as they are seen in space. In SACRED LANDSCAPE the observer's eye level is above the bridge, and below the roof of the small temple. We understand this because the diagonals of the bridge slope upward, and the diagonals of the temple roof slope downward. These sets of perspective lines are not systematically related to each other, however; nor is there a controlled use of the effect of diminishing size relative to distance. As far as we know, ideas of perspective were not further refined and codified in the West until the Renaissance, more than 1000 years later.

THE MIDDLE AGES

Early Christian and Byzantine Art

By the time Emperor Constantine was converted to Christianity in the fourth century, Roman attitudes had changed considerably. The material grandeur of Rome was rapidly declining. As confidence in the material world fell, people turned inward to more spiritual values. Inevitably, this new orientation was reflected in art. The change is expressed in the colossal marble HEAD OF CONSTANTINE, once part of an immense figure located in the Basilica of Constantine. The style of this sculpture developed from conflicting attitudes. The superhuman, heroic head is an image of imperial majesty, which is undoubtedly the way Constantine saw himself, yet the large eyes and immobile features create a symbol of inner spiritual life. The expression of the eyes, very different from the naturalism of earlier Roman portraits, was one of the sources of later Byzantine images.

In 330 Constantine moved the capital of the Roman Empire from Rome to the city of Byzantium, which he renamed Constantinople (it is now called Istanbul). Meanwhile, Western Europe was increasingly dominated by invaders from the north and east whose repeated attacks led to the final collapse of the Western Roman Empire at the end of the fifth century.

During the medieval period from the fall of Rome to the Renaissance, Byzantine civilization flourished in Constantinople. There the heritage of Greece and Rome was preserved, and Christianity was brought to the various peoples of the Byzantine Empire. The Byzantine artistic heritage can be seen today in the mosaics, paintings, and architecture of the Eastern Orthodox Church.

In the first hundred years A.D. the early Christians had been against pictorial—particularly human—representations. This was directly stated in the Old Testament's second commandment, "Thou shall not make unto thee a

323
HEAD OF CONSTANTINE. c. 312.
Marble. Height 8'.
Museo dei Conservatori, Rome.

graven image, nor any likeness of anything that is in heaven above, or that is in the earth beneath. . . ." To make representational images, or to worship such images, might cause confusion of the image with the deity. Such practice, called idolatry, makes a work of art into a fetish. Thus Christ was initially portrayed only with symbols such as the Lamb, the Fish, or the Sacred Monogram I H S. The earliest figural representations of Christ portray him as a young shepherd in the naturalistic Greek and Roman sculptural style.

324
CHRIST AS PANTOCRATOR. c. 1020.
Dome mosaic. Monastery Church, Daphne, Greece.
Photograph: Josephine Powell.

There was no sharp dividing line between early Christian art and the subsequent art of either the Eastern or the Western Church. The art forms of the Early Christian period were affected by an ongoing controversy between those who sought to follow the biblical prohibition against the worship of idols and those who wanted images to help tell the sacred stories.

The art works connected with Constantine's reign served to refuel the old opposition to idolatry. In 726 the Christian Byzantine emperor issued an edict prohibiting the use of representational images, and many representational works were destroyed. As a result, floral patterns and abstract symbols such as the cross

were incorporated into Christian imagery during the next 100 years. Byzantine Christian abstractions stemmed from associations with Eastern religions, particularly Islam, in which flat patterns and nonrepresentational designs were already employed.

Following the Iconoclast period (726–843), the abstract style was integrated with more emotional, figurative imagery. Eastern influence continued in the hierarchical size and placement of subject matter in Byzantine church decoration, with Christ occupying the dome.

During the tenth and eleventh centuries Byzantine artists created a distinct style that expressed Eastern Orthodox Christianity and also met the needs of a lavish court. The clergy closely supervised the iconography and permitted little room for individual interpretation. The effectiveness of an image was dependent on the artist's fidelity to established prototypes. (See also page 45.)

High in the center of the dome of the Monastery Church at Daphne, Greece, there is a Byzantine mosaic depicting CHRIST AS PANTOCRATOR, Lord of the Universe. This awesome religious work, created in the eleventh century, is one of the most powerful images of Christ in existence. The scale of the figure emphasizes its spiritual importance to worshipers. A comparison between the early Christian HEAD OF CONSTANTINE and the Byzantine CHRIST AS PANTOCRATOR shows that both works exhibit a similar emotional intensity. Note particularly the exaggerated size and expression of the eyes in each. The artist who designed the Byzantine image of Christ exaggerated the features of his face with bold, black outlines to create a symbol of patriarchal authority.

A row of windows circles the base of the dome, giving light to the church. The mosaic surfaces depend on the direction of light from the windows and from artificial sources such as candlelight. Each small *tessera*—piece of glass or ceramic tile—was placed on the adhesive surface and tilted to catch the light, thus producing a shimmering luminescence.

Convergence of Nomadic-Barbarian and Greco-Roman Art

When the Romans conquered the lands around the Mediterranean Sea between the first and third centuries B.C., they inherited and assimilated the knowledge and cultural traditions that had been developed by earlier civilizations of the ancient world. The Roman Empire came to include all the lands around the Mediterranean, and northward through what is now France and Britain. As the Roman Empire began to decay from within in the third and fourth centuries A.D., it was simultaneously challenged from without by invading nomadic tribes.

With the notable exception of the Celts, many of these nomadic peoples lived and traveled across the grasslands (steppes) that extend from the Danube River in Europe to the borders of China. The migrations occurred during a long period that began in the second millennium B.C. and lasted well into the Middle Ages. The Greeks labeled these uncivilized nomads "barbarians." The little that is known about them is derived from artifacts and from records of literate cultures in the surrounding areas, to whom the nomads were a menace. Apparently, the migrating tribes had a way of life that exploited and conflicted with the surrounding urban cultures of the Mediterranean, the Near East, and China. The Great Wall of China and Hadrian's Wall in Britain were built to keep out these marauders. Ironically, the materially impoverished culture of the migrating tribes lasted longer than the ancient classical cultures of the Mediterranean they helped to destroy.

A distinctive art, now referred to as the *animal style*, was developed by the nomadic peoples of the steppes. Because of their migrant way of life, their art consisted of small, easily portable objects such as items for personal adornment, pole-top ornaments, horse trappings, and weapons. Their style is characterized by active, intertwining shapes, often depicting wild animals in combat. The vigor of this art reflects the dynamic life of these mobile peo-

ples. While Greco-Roman art used the human figure as its central theme and subject matter, art of the animal style rarely depicted humans; when it did, humans played a subordinate role to animals.

The most widely used material for the animal style was metal of various kinds, and the metalwork often exhibits exceptional craftsmanship. The style was diffused over large geographic areas because of the frequent migrations and the fact that works were durable and much sought after.

Among the best-known art objects of the nomads are the gold ornaments produced by the Scythians, whose culture flourished between the eighth and fourth centuries B.C. The fluid, intertwining shapes of their abstracted animal forms appear to have been adopted by groups such as the Irish, Scandinavians, and Chinese, who were in contact with the nomads. Similar animal forms appeared later in wood- and stone-carving and manuscript illumination as well as in metal.

In the fourth century A.D. waves of nomadic peoples from the north and east invaded the Roman Empire. The era that followed has been called the Middle Ages because it came between the time of ancient Greek and Roman civilizations and the rebirth, or renaissance, of Greco-Roman ideas in the fifteenth century.

The migration was not only of people, but of art and technology. The gold and enamel PURSE COVER found in a grave at Sutton Hoo belonged to an East Anglican king. Its motifs are distinctively varied, indicating that they are derived from different sources. For example, a standing man between confronting animals also appeared in Sumerian art over 3000 years earlier (see page 268), and again the motif is seen in the BRONZE ORNAMENT from Luristan.

A great deal of wood-carving was done in Scandinavia, where the animal style flourished longer than anywhere else in the West. Protective animal spirits like those in both the early Chinese RITUAL VESSEL (see page 247) and the carving from Norway were felt to have power and symbolic significance far beyond the decorative function we may associate with them. We know that Viking law required that figures such as DRAGON'S HEAD be removed when coming into port so that the spirits of the land would not be frightened.

325
SCYTHIAN ANIMAL.
5th century B.C.
Bronze. Diameter 4″.
*Hermitage Museum,
Leningrad, U.S.S.R.*

326
PURSE COVER. Before 655.
Gold and enamel. Length 7½".
From the Sutton Hoo Ship Burial,
Suffolk, England.
British Museum, London.

327
BRONZE ORNAMENT. c. 900–700 B.C.
Luristan.
Honolulu Academy of Arts.
Bequest of Mr. and Mrs. J. Scott B. Pratt III.

328
DRAGON'S HEAD. c. 820.
Wood carving found
at Oseberg, Norway.
© *University Museum of*
National Antiquities,
Oslo, Norway.

hgeneramo

The meeting of the decorative Nomadic-Barbarian traditions with the art of the Mediterranean civilizations can be seen most clearly in the illuminated holy books created in Ireland. The Irish had never been part of the Roman Empire, and in the fifth century they were Christianized without becoming Romanized. Irish monasteries soon became the major centers of learning and the arts in Europe, and produced hand-lettered copies of religious manuscripts in large numbers. The opening initials were gradually enlarged and embellished, and moved first into the margin and then onto a separate page. The CHI-RHO MONOGRAM from the BOOK OF KELLS is an elaborate composition of geometric precision and organic interlace. As we examine the knots and scrolls we notice angels to the left of the X, a man's head in the P, and cats and mice at the base. This splendid initial page is the opening of St. Matthew's account of the nativity.

Islamic Art

Islamic history began in 622 with Mohammed's flight, known as the Hegira, to what is now Medina on the Arabian peninsula. The new religion quickly spread into much of what had been the Eastern Roman and Byzantine empires, then went on to include North Africa, Spain, India, and areas of Southeast Asia.

Initially the Muslims had little art of their own, and adopted the highly developed arts of the countries they overtook. The Islamic style of art that gradually evolved was derived primarily from Eastern Christianity and the earlier art of Persia (now Iran), but also from the Nomadic art of Central Asia.

Because orthodox Islam prohibits the representation of living creatures, an art based on

geometric pattern and floral form developed. Intricate patterns cover entire surfaces of such objects as small utensils, manuscript pages, and walls. The most characteristic Islamic design is the *arabesque,* which is composed of angles and curves, crossed or interlaced. Like the animal style of the nomads, Islamic design fills entire spaces, but Islamic art often has repeated patterns rather than the tangled ambiguity of the animal style. Because of the orthodox prohibition against representation of human figures, Islamic design, even on buildings, uses sacred writing instead of figurative painting and sculpture. Arabic writing developed into many elaborate and elegant calligraphic styles and was integrated into the arabesques. The decorative qualities of arabic scripts combine well with nonverbal abstract design motifs.

As Muslim conquest spread, Islamic architects borrowed both designs and building techniques from older styles. Their architecture consists of buildings directly related to the Muslim religion; even secular constructions

329
CHI-RHO MONOGRAM (XPI). Late 8th century.
Page from the BOOK OF KELLS.
Trinity College Library, Dublin.

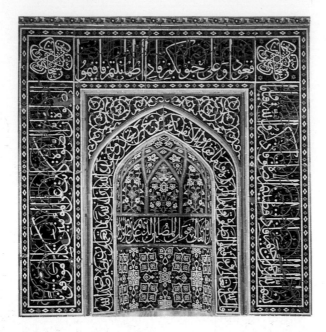

330
MIHRAB. Early 16th century.
Tin-glazed earthenware tiles. Height 6'7".
Iran.
Museum of Islamic Art, Berlin, Germany.

have religious elements. A variety of arch forms have been used by Islamic builders. They found that horseshoe and pointed arches created larger and more open spaces than semicircular arches. Other notable features include onion domes, minarets from which worshipers are called to prayer, and open courtyards for preparing for worship. The MIHRAB, or prayer niche, in a mosque indicates the direction of Mecca, and usually contains a copy of the Koran.

Secular Islamic painting was greatly influenced by the Mongol invasion of the Middle East in the thirteenth century. A highly decorative style of painting emerged in which figures, landscape, and ornament combine in rich two-dimensional compositions (see page 86).

331
SULTAN AHMET MOSQUE. 1609–1616.
Istanbul.
Photograph: Tom Klobe.

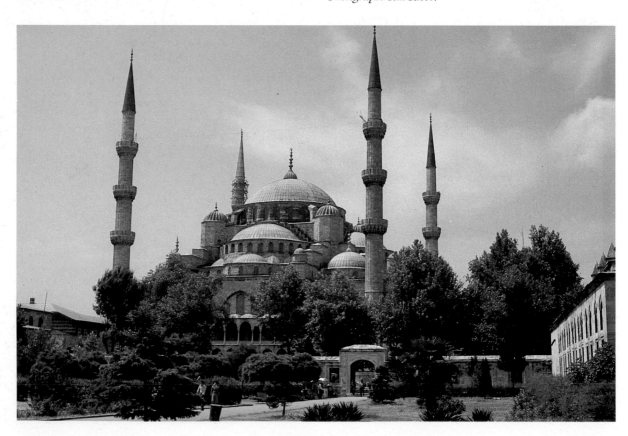

Romanesque and Gothic Art

The stylistic term *Romanesque* was first used to designate European Christian architecture of the mid-eleventh to the mid-twelfth centuries, which revived Roman principles of stone construction, especially the round arch and the barrel vault (see the Romanesque vaulted interior on page 206). The term Romanesque is now applied to all medieval art of Western Europe during that period.

Byzantine art traditions continued in Southeastern Europe, while Romanesque art developed in a Western Europe dominated by feudalism and monasticism. Feudalism involved a complex system of obligations and services based on control, and wars to increase control; monasticism provided shelter from the world, as well as the main sources of education.

The crusades established the Church as a powerful leader of the people. The popularity of pilgrimages brought large groups even to remote places. Romanesque builders greatly increased the size of churches by doubling the side aisles, doubling the length of the nave, and building upper galleries.

Stone vaults replaced fire-prone wooden roofs, thus giving the new structures a close resemblance to Roman interiors. There was a wide variety of regional styles, within which a common feeling of security was provided by massive, fortresslike walls. Small window openings let in little light, causing the interiors to be relatively dark and the walls to appear heavy.

Romanesque sculpture shows a disregard for naturalism and normal human proportions, yet there is an order and an appropriately symbolic form for figures such as CHRIST OF THE PENTECOST. The mystical energy and compassion of Christ is depicted in the relief carving over the central doorway of Saint Madeleine Cathedral at Vézelay, France. As worshipers enter the sanctuary, the image above them symbolizes Christ at the time he asked the Apostles and all Christians to take his message to the world. The swirling folds of drapery are indicated with

precise linear curves and spirals that suggest Christ's cosmic power. The image of Christ is very large in scale to show his relative importance. A monumental quality was achieved by making the head smaller than normal, and by elongating the entire figure.

One of the major differences between the cultures of the East and the West is the restless searching of Europeans, which has resulted in frequent changes in attitude that are seen in Western art. The Romanesque style had lasted

332
Detail of CHRIST OF THE PENTECOST. 1125–1150.
Stone. Height of tympanum 35½".
Saint Madeleine Cathedral, Vézelay, France.

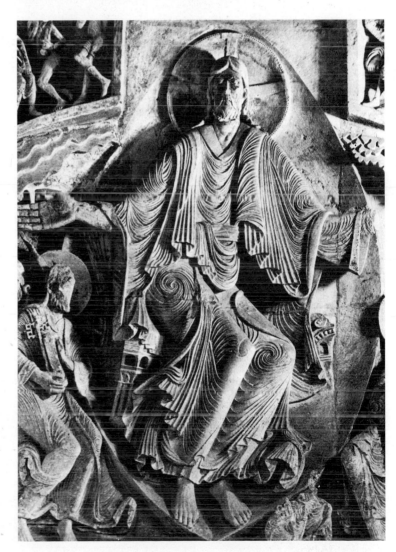

333
NOTRE DAME DE
CHARTRES.
1145–1513.
Cathedral length, 427′;
facade height, 157′,
south tower height, 344′;
north tower height, 377′.
Chartres, France.

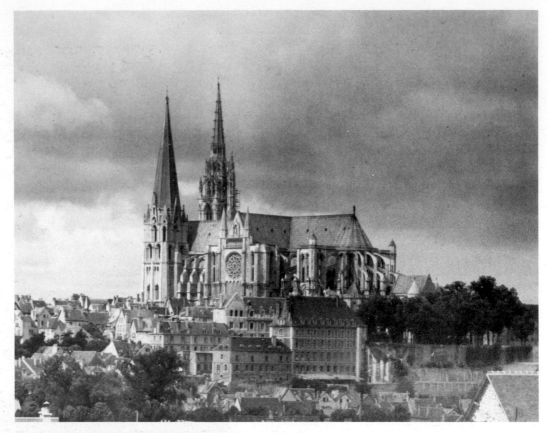

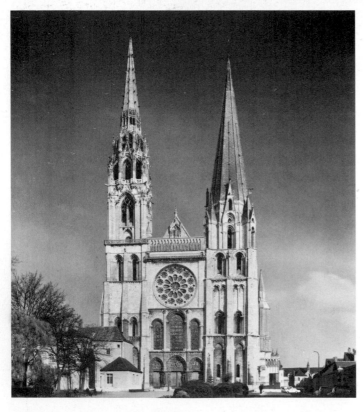

a View from the
 southeast.
b West front.
c Plan of
 cathedral
 based on
 Latin cross.

barely 100 years when the Gothic style began to replace it, in about 1145. The shift is seen most clearly in architecture, as the Romanesque round arch was superseded by the pointed Gothic arch that developed in the mid-twelfth century (see also page 82). Combined with the ribbed groin vault and the flying buttress, the pointed arch allowed for greater interior height and larger window spaces. Gothic cathedrals were made of stones carved and assembled to form thin ribs and pillars; the result is a seemingly weightless structural network. The buttresses carried the tremendous weight of the vault laterally downward to the ground, relieving the walls of some of their load-bearing function, and making possible *curtain walls* of stained glass that filled the interior with rich, luminous color. Inside, the faithful must have felt they had actually arrived at the visionary Heavenly City.

In one sense the change from Romanesque to Gothic architecture is simply a change in the method of vaulting. Yet this tremendous achievement was motivated by, and is expressive of, the communal faith of the people of that time and place. Cathedrals were enthusiastic expressions of a new age of faith that grew out of medieval Christian theology. The upward-reaching forms symbolize the triumph of the spirit over the bonds of earthly life, evoking a sense of joyous spiritual elation.

The entire community worked on NOTRE DAME DE CHARTRES (Our Lady of Chartres). Those who began its construction never saw it in its final form. It continued to change and grow for more than 300 years.

The Cathedral of NOTRE DAME DE CHARTRES was partially destroyed by fire in 1194 and was rebuilt in the High Gothic style (see the plan). It was the first cathedral based on the full Gothic system, and set the standard for Gothic architecture in Europe. In its west facade CHARTRES reveals the transition between late Romanesque and High Gothic architecture. The massive lower walls and round arch portals were built in the mid-twelfth century. The north tower, on the left as one approaches the facade, was rebuilt with the intricate flamelike

d "ROSE DE FRANCE" WINDOW. c. 1233.

or flamboyant curves of the late Gothic style early in the sixteenth century, after the original tower collapsed in 1506.

The magnificent stained glass windows of this period are so well integrated with the architecture that one is inconceivable without the other. Rich light from these windows symbolically illuminates the hearts and minds of those who worship. The scriptures are told in shining walls that transform the sanctuary with showers of color, changing hour by hour. The brilliant north rose window at CHARTRES, known as the ROSE DE FRANCE, is dedicated to the Virgin Mary who sits in majesty, surrounded by doves, angels, and royal figures of the celestial hierarchy.

Gothic cathedrals such as CHARTRES were the center of community life. They were used as meeting places for people doing business, for lovers, for lectures, and for concerts—as well as places of worship.

The statues of the OLD TESTAMENT PROPHET, KINGS, AND QUEEN to the right of the central doorway at the west end of CHARTRES are among the most impressive remaining examples of Gothic sculpture. The kings and queen suggest Christ's royal heritage, and also honor French monarchs of the time. The prophet depicts Christ's mission as an apostle of God. In contrast to the active, unnatural complexity of Romanesque sculpture, the figures are passive and serene. Their typically Gothic, elongated forms allow them to blend readily with the vertical emphasis of the architecture.

Although they are part of the total scheme, the figures stand out from the columns behind them and appear almost to enter the space we occupy. Their draped bodies, and especially their heads, reveal a new interest in portraying human features. Such interest eventually led again to full portraiture and freestanding figures.

In spite of the great differences in form and content between Hindu (see page 243) and Christian architecture and sculpture, their basic purposes are similar. Both the cathedral and temple relate to an idea expressed by Abbot Suger, the man credited with starting the Gothic era. Art historian Erwin Panofsky has translated and paraphrased Suger's concept as follows:

every perceptible thing, man-made or natural, becomes a symbol of that which is not perceptible, a stepping stone on the road to Heaven; the human mind, abandoning itself to the "harmony and radiance" . . . which is the criterion of terrestrial beauty, finds itself "guided upward" to the transcendent cause of this "harmony and radiance" which is God.[6]

e OLD TESTAMENT PROPHET, KINGS, AND QUEEN.
 c. 1145–1170.
 Door-jamb statues from West (or Royal) Portal.

THE RENAISSANCE

In Europe a major shift in attitude occurred as the spiritual mysticism of the Gothic era was increasingly challenged by logical thought and the new philosophical, literary, and artistic movement called *Humanism*. The beginnings of this transition became apparent in the late thirteenth century.

Renaissance, meaning "rebirth," describes the period of the revival of interest in the art and ideas of ancient Greece and Rome. It was a time of discovery—discovery of the world and of the seemingly limitless potential of individual human beings.

New chapters in the course of human history are usually begun by a single person of genius. Such a person was the Florentine painter and architect Giotto di Bondone, known as Giotto. In breaking with medieval Byzantine formulas to give new life to Italian painting, he, more than any other, determined the course of painting in Europe. In retrospect, we see him as a precursor of the Renaissance. Early in the fourteenth century Giotto embodied and made visible the new humanism.

Gothic art, motivated by a belief in a heaven-centered religion, featured an abstracted, flat style of painting. Giotto, anticipating the new vision of the world and humanity's place in it, created the appearance of more naturalistic three dimensional forms. By paying attention to the way light defines form, Giotto gave a feeling of sculptural solidity to his figures. He thus began the development of chiaroscuro (see page 58). In LAMENTATION, Giotto's people appear believable within a shallow, stage-like space. Their expressions depict personal responses to the death of Christ. To show such compassionate awareness of individual human feelings was itself quite new. From Giotto's work came the tradition of a painting as a window looking onto nature. This approach was not radically challenged until the development of Cubism in the early twentieth century.

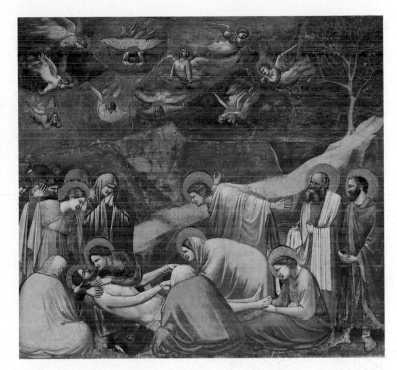

334 Giotto di Bondone.
LAMENTATION, c. 1305.
Fresco. 185 cm x 200 cm.
Arena Chapel, Padua, Italy.

During the fifteenth century new, highly representational styles of painting in Europe revealed a growing interest in the everyday world as seen by human eyes. This depiction of earthly reality began and developed in different ways in Italy and Northern Europe.

In the Northern Low Countries of Belgium, Holland, and Luxembourg, the leading artist was Jan van Eyck, known today as the "father of Flemish painting." He was one of the first to use linseed oil as a paint medium instead of the egg yolk or other protein used in the traditional tempera paintings of the time. The fine consistency and flexibility of the new medium made it possible to achieve a brilliance and transparency previously unattainable. In addition, oil allowed artists to make changes as they worked.

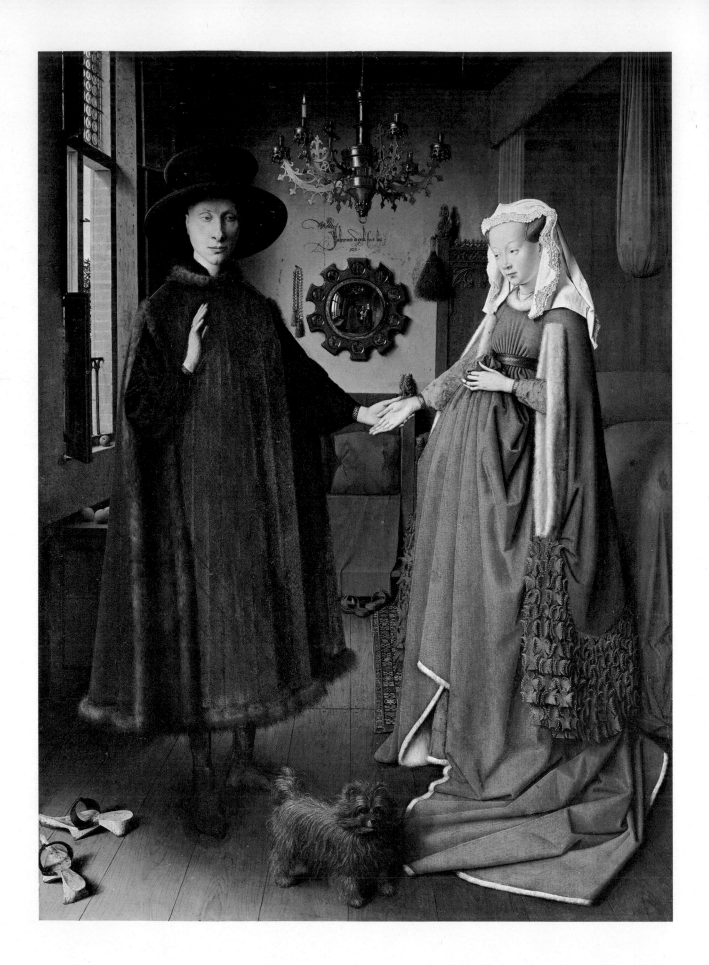

On the same type of small wooden panels previously used for tempera painting, van Eyck painted in minute detail, achieving an illusion of deep space, directional light, mass, rich implied textures, and the physical likenesses of particular people. Human figures and their interior settings took on a new believable presence. In spite of van Eyck's realistic detail, GIOVANNI ARNOLFINI AND HIS BRIDE has a Gothic quality in its traditional symbolism and in the formality and vertical emphasis of the figures.

At the time the portrait painting of the Arnolfini wedding was commissioned, the Church, under certain circumstances, did not require the presence of the clergy for a valid marriage contract. All that was necessary was a *fides manuales* (joining of hands) and *fides levata* (raising right forearm) on the part of the man. Since it was easy to deny that a marriage had taken place, it is thought that van Eyck's painting is a testament to the oath of marriage between Giovanni Arnolfini and Jeanne Cenami. As witness to the event, Jan van Eyck's signature and the date, 1434, are boldly written directly above the mirror. The painting is the prototype of today's wedding photograph.

Today the painting's complex Christian symbolism, well understood in the fifteenth century, must be explained. Many of the ordinary objects portrayed with great care have sacred significance. The lone, lighted candle in the chandelier represents the presence of Christ. The convex mirror, which reflects the images of the couple, and probably the artist, is compared to the eye of God watching over all. The amber beads and the sunlight shining through them are symbols of purity. The dog represents marital fidelity. Also, in a symbolic action, the wooden shoes of the bride and the groom were removed in an allusion to God's commandment

335 Jan van Eyck.
GIOVANNI ARNOLFINI AND HIS BRIDE. 1434.
Tempera and oil on panel. 33″ x 22½″.
Reproduced by courtesy of the Trustees,
The National Gallery, London.

336 Joachim Patiner.
REST ON THE FLIGHT INTO EGYPT. 1515–1524.
Oil on wood. 6¾″ x 8⁵⁄₁₆″.
Koninklijk Museum, Antwerp.

to Moses on Mt. Sinai to take off his shoes when he stood on holy ground. The bride has her hand placed suggestively on her stomach, because at that time it was stylish for a woman to appear to be pregnant as an indication of her willingness to bear children. Green, the symbol of fertility, was commonly worn at weddings.

Almost 100 years after van Eyck, another Flemish painter, Joachim Patinir, helped develop landscape painting as an art form in its own right. In earlier Christian art landscape had been merely background for religious scenes. Patinir's subject in REST ON THE FLIGHT INTO EGYPT is still religious, but the landscape has become more important than the figures of the Holy Family or the abduction of infants from the village.

Patinir emphasized the small scale of people in the natural world in a way that is similar to the earlier Chinese landscape tradition (see pages 249 to 251). But while Chinese painters kept the symbolic, suggestive role of art always apparent, Patinir put emphasis on an illusion of

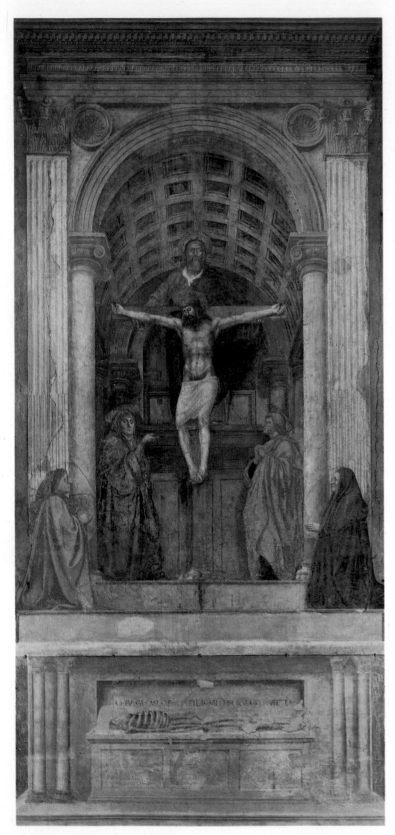

the actuality of landscape and of events taking place within it.

In the foreground of Patinir's painting rock formations tower above the Holy Family; in the middle ground, a village fits comfortably into the land; in the background, sky and water meet behind the distant hills. The deep space and apparent curvature of the earth may express an awareness brought on by the new age of exploration. Atmospheric perspective, heightened by transparent glazes made possible by the oil medium, greatly enhances the sense of space by gradually turning the warm greens and earth tones of the foreground into the light cool haze of the far hills. Patinir helped to establish a tradition of landscape painting that has continued into our time.

Masaccio was the first major painter of the Italian Renaissance. He owed a great deal to the pioneering work of Giotto, the newly worked-out theory of scientific perspective, and the new naturalism already achieved in sculpture. Even in its present deteriorated condition, Masaccio's fresco THE HOLY TRINITY has a vivid quality of realism and austere majesty not found in the work of Northern Renaissance painters such as van Eyck and Patinir.

THE HOLY TRINITY was the first painting based on the systematic use of linear perspective. Masaccio used perspective to organize the image and simultaneously to construct the illusion of space. The single vanishing point is placed below the base of the cross, about five feet above the ground, at the viewer's eye level. Masaccio's perspective measurements were so

337 Masaccio.
THE HOLY TRINITY. 1425.
Fresco. 21' 10½" x 10' 5".
Santa Maria Novella, Florence.

exact that one can actually compute the dimensions of the interior of the illusionary chapel, the interior volume of which is seen as a believable extension of the space occupied by the viewer. The size of each figure is correct according to its position in space in relation to the viewer. The architecture, with the barrel vault, adds greatly to the sense of space, and reveals Masaccio's knowledge of the new Renaissance architecture based on Roman prototypes.

In Giotto's figures the body and drapery appear as one; Masaccio's are clothed nudes, with garments draped like real fabric. Masaccio's work shows two donors (those who paid for the painting) kneeling on either side of an open chapel in which the Trinity appears as God the Father, Christ the Son (on the cross), and the Holy Spirit in the form of a white dove. Below, a skeleton is shown lying on a sarcophagus beneath the inscription which reads "I was what you are, and what I am you shall become." If we view the painting from bottom to top, we move from temporal reality to spiritual reality.

Leonardo da Vinci—painter, architect, musician, engineer, scientist—has become a model of the "Renaissance man." The scope and depth of his interests and achievements gave birth to our concept of the artist/genius. Leonardo's investigative and inventive mind is revealed in his journals in which he documented his research in notes and drawings. The famous ILLUSTRATION OF PROPORTIONS OF THE HUMAN FIGURE shows his concept of the ideal figure in relation to ideal geometric shapes. Leonardo was developing a concept written about by the Roman architect Vitruvious regarding the relationship between human proportions and the circle and the square. Ancient teaching, predating even Roman times, held that the square symbolized the microcosm, or the finite world, and the circle indicated the macrocosm, or the infinite cosmic sphere.

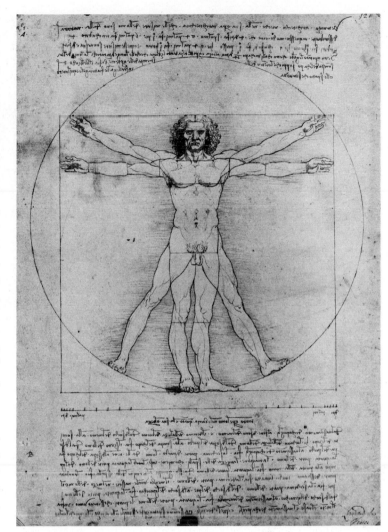

338 Leonardo da Vinci.
ILLUSTRATION OF PROPORTIONS
OF THE HUMAN FIGURE.
c. 1485–1490.
Pen and ink. 13$\frac{1}{2}$" x 9$\frac{3}{4}$".
Academy of Fine Arts, Venice.

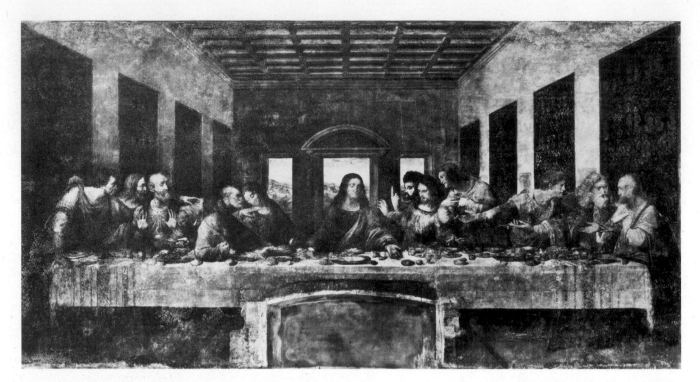

339 Leonardo da Vinci.
THE LAST SUPPER. c. 1495–1498.
Unknown experimental paint on plaster. 14′5″ x 28¼″.
Santa Maria della Grazie, Milan, Italy.

The new spirit of Renaissance humanism is revealed by comparing THE LAST SUPPER by Leonardo da Vinci with the Byzantine mosaic of Christ on page 282. We must look up to the large Byzantine image of Christ, high in a dome; Leonardo's Christ is sitting across the table from us. While the Byzantine mosaic is a stylized icon, Leonardo wanted to paint Christ in an earthly setting; thus he placed the event in a Renaissance interior. In his painting Leonardo made it apparent that the everyday world is one with the world of divine harmony. The style of the work is naturalistic, but there is a hidden geometry similar to that which is so apparent in Leonardo's drawing of human proportions. This geometry is used here to structure the design and strengthen the painting's symbolic content.

The interior space is based on a one-point linear perspective system, with a single vanishing point in the middle of the composition,

behind the head of Christ. Leonardo placed Christ in the center of the symmetrical interior and at the point of greatest implied depth, relating him to infinity. Over Christ's head an architectural pediment suggests a halo, further setting him off from the irregular shapes of the agitated disciples on either side. In contrast to the distraught figures surrounding him, Christ is shown with arms outstretched in a gesture of acceptance, his image a stable triangular shape expressing eternal truth.

THE LAST SUPPER began to deteriorate soon after it was painted because Leonardo used a still unknown experimental paint medium that did not adhere permanently to the plaster wall. Even now, when we can only imagine its original visual quality, the painting has a compelling strength. Numerous inept overpaintings and other restoration attempts over the past 350 years did far more harm than good to THE LAST SUPPER. Only a fraction of the original remains visible today, and this has recently been uncovered and stabilized by the painstaking work of restorer Dr. Pinin Brambilla Barcilon.

This drawing of drapery was rendered with a brush as a black-and-white value study, using the concept of chiaroscuro as Leonardo had developed it. The image represents the manner in which light has revealed the subject. Compare the quality of Leonardo's drawing to Weston's photograph of a pepper on page 13. The concept of photography began with the desire of Renaissance artists and their public for art that looked like the "reality" of the measurable physical world.

Leonardo was one of the first to give a clear description of the *camera obscura* (dark room), an optical device that captures light images in much the same way as the human eye (see pages 152 to 153). This later developed into what we know today as the camera. Leonardo described the principle:

Light entering a minute hole in the wall of a darkened room forms on the opposite wall an inverted image of whatever lies outside.[7]

340 Attributed to Leonardo da Vinci.
DRAPERY STUDY. c. 1475.
Black-and-white brush drawing on linen canvas.
26.6 cm x 23.4 cm.
The Louvre, Paris.

Renaissance artists gave a new sense of realism to their work by studying the way light reveals form, by developing and applying the rules of linear perspective to achieve illusions of depth, and by studying human anatomy. Such investigations greatly stimulated an attitude of free inquiry. Leonardo da Vinci's work epitomized a new partnership between art and science. The science of linear perspective developed as a means to analyze and represent one person's unique relationship to the visual world from a particular position in space and at a particular moment. The modern camera is a further development of this concept.

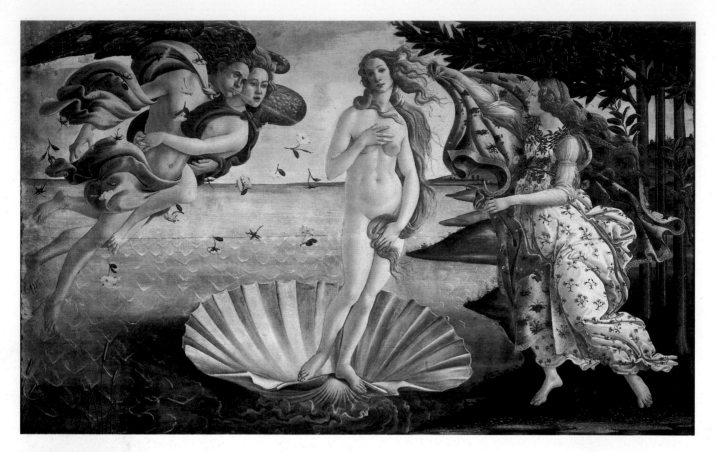

341 Sandro Botticelli.
BIRTH OF VENUS. c. 1490.
Oil on canvas. 5'8⁷/8" x 9'1⁷/8".
Uffizi Gallery, Florence.

In the art of the Italian Renaissance the un-clothed human body again became a major subject for art. Sandro Botticelli's BIRTH OF VENUS depicts the goddess of love just after she was born from the sea. She is being blown to shore by a handsome couple representing the wind. As she arrives, Venus is greeted by a young woman who represents Spring. The large painting, completed by Botticelli about 1482, was one of the first paintings of an al-most life-size nude since Roman times. Botti-celli used the posture and gestures of modesty from a third-century B.C. Greco-Roman sculp-ture of Venus in the Medici family collection (see page 276). Botticelli's Venus is more graceful and lighter than the Greco-Roman work. The contrast between the active wind

gods and Venus's posture of repose and intro-spective expression is an example of the resto-ration of Greek ideal forms in combination with Renaissance interest in human thought and feeling.

Botticelli is noted for his delicate, sensitive style, and particularly for the lyrical beauty of his lines. He kept the background of his paint-ings relatively flat, and used slight modeling and fluid outlines to make the figure appear as in relief. His figures are almost Gothic in qual-ity rather than fully three-dimensional and freestanding as those in Leonardo's LAST SUP-PER and Masaccio's THE HOLY TRINITY.

The beauty of Botticelli's lines may have served as an inspiration to the young Michel-angelo Buonarroti, who began his career by

living and studying art at the Medici Palace, where many of Botticelli's paintings were to be seen. Michelangelo's lifework also shows how Greek attitudes toward the body had come to be considered compatible with Christianity.

The biblical hero David was an important symbol of freedom over tyranny for the city of Florence, which had just become a republic. In 1501, when he was 26 years old, Michelangelo succeeded in obtaining a commission to carve a figure of David from an 18-foot block of marble that had been badly cut and then abandoned by another sculptor years earlier. Other major Renaissance artists had already given the city images of the young David, but it was Michelangelo's figure that gave the most powerful expression to the idea of David as a hero, the defender of a just cause. The sixteenth-century art historian, Giorgio Vasari, said, "As David defended his people, and governed with justice, so should this city be defended with courage and governed with justice."[8]

David's stance, with the weight of the body on the right foot, was taken from Greek sculpture. But the gestures and positions of the hands are coordinated with a tense frown on the face to reveal David's anxiety and readiness for conflict. The hands are extra large, probably to emphasize their importance. The head is also larger than normal in relation to the body in order to make it look normal when seen from the ground. Michelangelo used the Greek ideal, but humanized it to create a superhuman image.

Michelangelo worked for three years on this sculpture. When it was finished and placed in their town square, the citizens of Florence were filled with admiration for both the work and its creator. Michelangelo became recognized as the greatest sculptor since the Greeks. This sculpture is a mighty expression of the Renaissance awareness of what it could mean to be human.

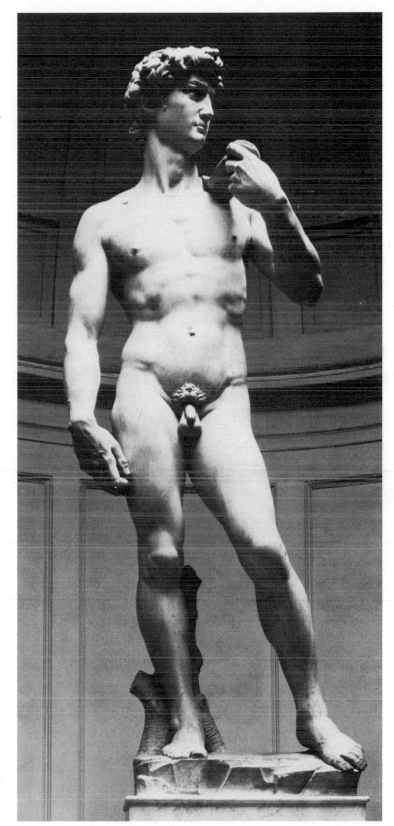

342a Michelangelo Buonarroti.
DAVID. 1501–1504.
Marble. Height of figure 14′3″.
Academy Gallery, Florence.
Photograph: David Warren/Shostal Associates.

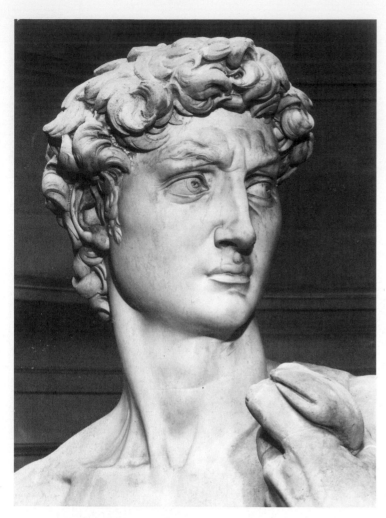

342b Detail of DAVID.

Even now, nearly 500 years later, DAVID continues to evoke great interest and admiration.

Michelangelo's attitude toward himself, his work, and his purpose was shaped by the importance given to Plato's ideas. Plato held that everything that makes up the world as we know it is an imperfect copy of an ideal form that exists in the realm of the spirit. In DAVID Michelangelo demonstrated his knowledge of Greek art and philosophy and his skillful use of the new science of anatomy. DAVID's heroic beauty is Michelangelo's idea of the classical Greek athelete. However, the intense facial expression of concentration is different from Greek sculpture in its portrayal of inner life.

Titian (Tiziano Vecelli) was the outstanding Venetian painter of the Renaissance. In many ways he initiated modern methods of painting. Titian was among the first to use oil paint on canvas. His use of color and visible brush strokes as an integral part of image-making greatly influenced succeeding generations of painters. He gave new life to color areas by accenting grayed tones with touches of pure hue. These areas were often applied in glazes—translucent layers of thin paint. By glazing, sometimes with as many as forty layers, he achieved previously unknown sensations of light and created a wide range of refinements in modeling. Light penetrates glazes, and reflects back from the underpainting, adding luminosity and richness to the surface.

The mythology of classical antiquity was not as much a part of the heritage of Northern European artists as it was for sixteenth-century Italians who looked on the Romans as their ancestors. Titian freed the ancient myths of love and physical pleasure from the calm stability of his predecessors. The gaiety and abandon seen in BACCHANAL OF THE ANDRIANS brings an ancient myth to life in sixteenth-century terms. The painting depicts a Greek legend about a spring on the island of Andros that gushed ambrosian nectar, the wine of immortality, and provided the Andrians with a happy life of perpetual intoxication.

In the early sixteenth century the Renaissance reached its zenith in the cities of Florence and Rome. Three of its artists, Leonardo, Michelangelo, and Raphael, achieved a status comparable to the great scientists of our time. They developed a style of art that was calm, balanced, and idealized. The spirit of the Renaissance was one of reconciliation of Christian theology with Greek philosophy and the science of the day. They had an optimistic view that their society could excel beyond the classical model it had inherited. Renaissance artists set standards that were followed in European art for almost 400 years.

Our coverage of Renaissance art follows the view of Western historians who see history as

linear and the Renaissance as the culmination of a long cultural evolution. But history can also be seen as multidimensional patterns of influence across time and space. In the context of all art history, the Renaissance and its effects represent a small fragment of total human achievement. From the point of view of any of the several ancient traditions in world art, Renaissance naturalism and perspective is but a provincial development.

Much of contemporary art actually contradicts Renaissance forms and purposes. In the art and culture of the twentieth century there is a restoration of ideas that preceded the Renais-

sance and the Greeks, and a reinterpretation of Renaissance concepts, as well as an introduction of art forms from outside the evolution of Western culture.

During the Renaissance architects as well as sculptors and painters went to great lengths to acquire knowledge of Greek and Roman ideas, and to put these ideas to work along with contemporary concepts in the creation of architecture more beautiful than any done by their predecessors. Thus by the sixteenth century it had become increasingly difficult to surpass one's ancestors.

343 Titian.
BACCHANAL OF THE ANDRIANS.
c. 1520.
Oil on canvas, 69″ x 76″.
The Prado, Madrid.

The most learned and influential architect of this period was Andrea Palladio. His famous VILLA ROTUNDA, or round villa, built near Vicenza, Italy, is intentionally unique, to the point of being capricious. It has four identical sides, complete with porches designed like ancient temple facades, built around a central domed hall reminiscent of the Roman Pantheon (see page 279). It is hardly a plan that satisfied the architectural goal of livability, but it was not intended for family living. It was designed for a retired monsignor as a kind of open summer house for social occasions. From its hilltop site visitors standing in the central rotunda could enjoy four different views of the countryside.

Artists of the mid-sixteenth century admired qualities of drama, motion, and emotion found in the late work of Michelangelo and Raphael. The newcomers pushed these qualities, sometimes in contrived or mannered ways, to achieve their own unique variations. Much Italian painting of the sixteenth century is therefore referred to as *Mannerist* in style.

The last, and most original, of the Mannerist painters was Domenikos Theotokopoulos, known as El Greco (the Greek). He was born on Crete, where he became a moderately successful icon painter in the Byzantine style. At 27 he went to Italy, where he learned about light and color from Titian and other Venetian masters. In Rome he studied the mannerist distortions of the human figure inspired by the work of Michelangelo. He finally settled in Spain, where he evolved a highly personal style in which the calm grandeur of Renaissance imagery was transformed into new visions of great mystical and emotional intensity with sinuous, flamelike forms moving rhythmically in space. His figures have mass, but seem intangible. They are embedded in a flickering chiaroscuro that covers the entire surface of the painting. Figures, drapery, and background are of almost equal importance and merge together in elongated vertical shapes. THE VISION OF SAINT JOHN reflects a blending of Venetian color and technique, Spanish mysticism, and Byzantine abstract tradition.

El Greco's writings indicate that he knew exactly what he was doing when he rejected Renaissance perspective and anatomical accuracy. In the margin of his copy of Vasari's *Lives of the Painters,* next to a passage on Michelangelo, he wrote: "He would make his figures nine, ten and even eleven heads long, for no other purpose than the search for a certain grace in putting the parts together, which is not to be found in natural form."[9] Here, in one sentence, is the rationale behind El Greco's mature style and his great appeal for artists of the twentieth century.

344 Andrea Palladio.
VILLA ROTUNDA. Begun 1550.
Vicenza, Italy.

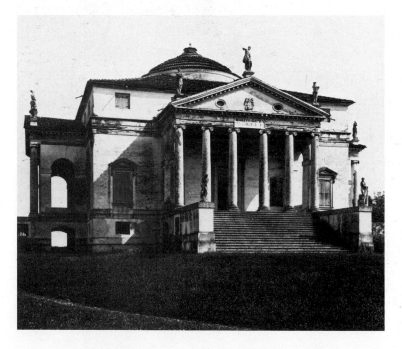

345 El Greco (Domenikos Theotokopoulos).
THE VISION OF SAINT JOHN. c. 1605.
Oil on canvas. 88¹/₂″ x 76″.
Metropolitan Museum of Art, New York.
Rogers Fund, (1956).

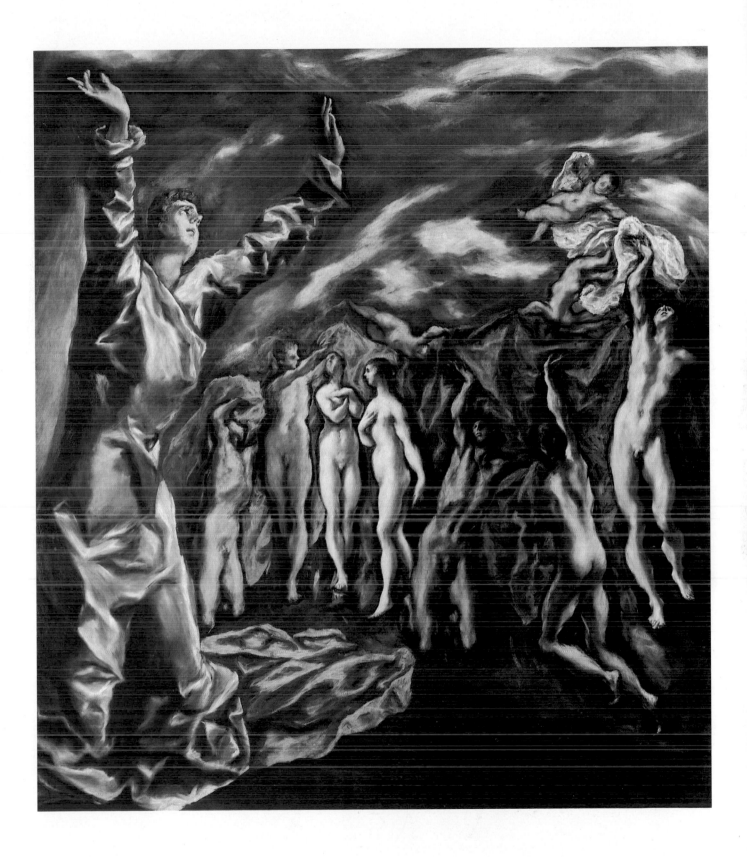

THE BAROQUE AGE

The period known as the *Baroque* includes the seventeenth and most of the eighteenth centuries in Europe. Although Baroque generally refers to a period, the term is often used stylistically to describe the art that arose in Italy around 1600 and spread through much of Europe. The Baroque period had far more varied styles than the Renaissance. Art of the Baroque age is often characterized by exuberance, drama, large scale, energy and movement, and dynamic balance. Many painters used highlights and dark backgrounds to heighten illusions and focus attention. Baroque works often engage the viewer emotionally. There was

346 Michelangelo Merisi da Caravaggio.
THE CONVERSION OF SAINT PAUL. 1600–1601.
Oil on canvas. 100⁹/₁₆″ x 68¹⁵/₁₆″.
Santa Maria del Popolo, Rome.

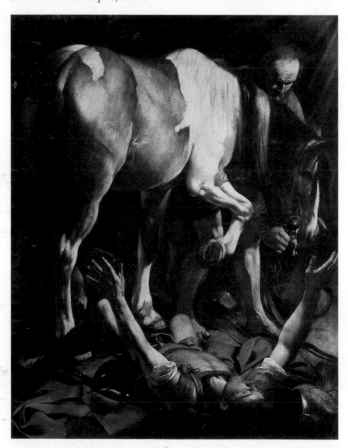

frequent use of curves and countercurves in painting, sculpture, and architecture. A new naturalism in the depiction of light and space developed, and the art of landscape painting came to maturity (see Claude Lorrain's THE HERDSMAN on page 93).

In addition to this very broad Baroque style there was a classical countermovement, and a new level of realism best exemplified by the work of Dutch painters.

Italian painter Michelangelo Merisi da Caravaggio gave the most vivid depiction of actuality of any artist of his time. In concert with his realism Caravaggio developed the use of light as a key element for directing the attention of the viewer and unifying and intensifying the subject matter. Strong contrast between light and dark areas, as seen in THE CONVERSION OF SAINT PAUL, are characteristic of Caravaggio, Zurbarán, Rembrandt, and other Baroque painters (see Zurbarán's ST. SERAPION, page 60). The conversion of St. Paul was an ideal subject for Caravaggio. "And suddenly there shined around him a light from heaven: and he fell to the earth" (Acts 9:3–4). Light creates a blinding flash, symbolizing the evangelist's conversion. Here is a scene in which the major figure is *foreshortened* (represented so the long axis appears contracted because it is turned toward the viewer) and pushed into the foreground, presenting such a close view that we feel we are there.

Although the subject matter is sacred, Caravaggio depicted ordinary people as they would have appeared on the street in his day. He used natural, emphatic gestures, and meticulous detail. In keeping with the supernatural character of the event, Caravaggio gave a mystical feeling to ordinary things. He wanted his paintings to be accessible and self-explanatory and brought to the stories of the Bible the vivid emotional intensity that he experienced in his own life. Some of the clergy for whom he painted rejected his style. His dramatic realism was too direct for people accustomed to aristocratic images demonstrating little more than insincere piety.

The spiritual intensity of Baroque art is vividly apparent in THE ECSTASY OF SAINT TERESA by Italian sculptor and architect Gian Lorenzo Bernini. The work features a life-sized, marble figure of the saint, and represents one of her visions as she recorded it. In this vision she saw an angel who seemed to pierce her heart with a flaming arrow of gold, giving her great pain as well as pleasure and leaving her "all on fire with a great love of God."[10] Bernini makes the experience visionary, yet as vivid as possible, by portraying the moment of greatest feeling. Turbulent drapery heightens the expression of joy on Saint Teresa's face, suggesting strong emotional energy within.

This was the time of the Counter-Reformation, a movement in the Roman Catholic Church that sought to offset the effects of increasing secularism and the Protestant Reformation of the sixteenth century. The dramatic realism of Baroque painting and sculpture was part of the Catholic effort to revitalize the church. Bernini's THE ECSTASY OF SAINT TERESA is a major example. In it Bernini symbolizes spiritual ecstasy by showing physical ecstasy.

If form is thought of as the total of a work's perceivable characteristics, then the environment in which a given work was intended to be seen must be considered, since it modifies the form. Bernini designed not only the figures of St. Teresa and the angel, but their altar setting and the entire CORNARO CHAPEL. The chapel is a monument to Baroque art that has many of the qualities of opera, which came into being during the seventeenth century. Opera was a major musical art form of the Baroque period that combined all the arts in elaborate dramas. An operatic quality is found in much Catholic Baroque art. In Bernini's CORNARO CHAPEL, architecture, painting, and sculpture work together to enliven the drama of the central figures above the altar.

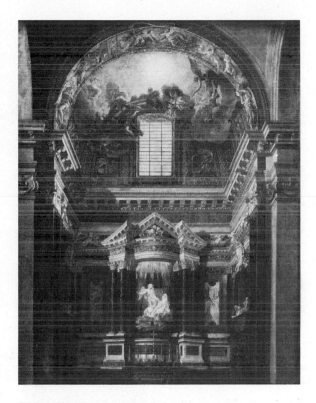

347 Gian Lorenzo Bernini.
CORNARO CHAPEL. 1645–1652.
(18th-century painting by an unknown artist.
Staatliches Museum, Schwerin, Germany.)

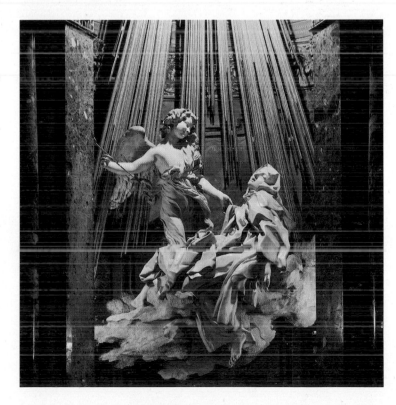

348 Gian Lorenzo Bernini.
THE ECSTASY OF SAINT TERESA. 1645–1652.
Marble. Life-size.
Detail of the altar.
Cornaro Chapel, Santa Maria della Vittoria, Rome.

349 Diego Rodríguez de
Silva y Velázquez.
LAS MENINAS (THE MAIDS OF HONOR).
1656.
Oil on canvas. 10'5" x 9'.
The Prado, Madrid.

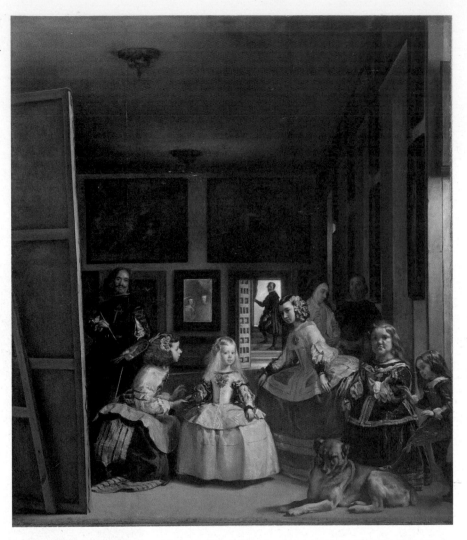

This elaborate theatrical setting established a background underscoring the celestial qualities of St. Teresa's dream. Above the saint and her heavenly messenger sunlight shines through a hidden window, illuminating the work in such a way that it appears to dematerialize the figures.

In box seats on either side of the altar, sculpted figures of the Cornaro family witness the event, making symbolic contact between sacred and secular experience. Bernini intentionally broke the lines usually drawn between architecture, painting, and sculpture, as well as those between illusion and reality.

Naturalism was a major element in Baroque art. The natural human gestures and expres-

sions in Bernini's and Caravaggio's work are also characteristic of the paintings of Diego Rodríguez de Silva y Velázquez in Spain. Like Titian, Velázquez was a great colorist who used various grays activated by touches of bright colors. He painted himself at work on the large canvas now known as LAS MENINAS (THE MAIDS OF HONOR). The Infanta Marguerita, the blonde daughter of the king, is easily seen as the center of interest. Velázquez emphasized her by making her figure the clearest and lightest shape and by placing her near the foreground close to the center. Around her, Velázquez created the appearance of his large studio, in which a complex group of life-size figures inter-

act with the princess and the viewer. We are invited in to become participants in an ordinary moment in the studio. The king and queen also watched, and saw themselves reflected in the mirror on the far wall. Although blurred, these two mirrored figures are a pivotal point for the entire composition.

By controlling light, color, and placement in space of everything in the room, Velázquez leads us through a very intricate composition. This painting gives us not only the artist's view of the court of Philip IV, but his view of the veils of illusion inherent in life itself. Velázquez placed himself in semishadow, brush in hand, his image acting as a kind of signature to the work. The flat, painted illusion and the actual three-dimensional world are masterfully joined in this mind-teasing image. (See the related, yet stylistically very different, portrait painting by van Eyck on page 294).

As we see in LAS MENINAS, Baroque characteristics are found in art that depicts both religious and nonreligious subjects. This was primarily because artists no longer relied wholly on the Church for their support—Velázquez himself was the court painter to the Spanish king. In fact, most art was commissioned by the rising middle-class merchants and bankers and by the aristocracy.

In the Low Countries Jan Vermeer and Rembrandt van Rijn painted portraits of the wealthy, and views of the rich interiors of merchant homes. There was, of course, some religious art in these countries—for example, Rembrandt's etchings of the life of Christ (see page 146).

During his long artistic career Rembrandt also produced many self-portraits. Like a good actor, he found his own face a resource for studying life, the possibilities of facial expression (see page 103), and changes due to age. Most of the time he seemed to look at himself with detachment, and with the same interest that he brought to all his human subjects. His SELF-PORTRAIT of 1658 is brought to life in the eyes, which reveal a man of great depth and penetrating insight. A sequence of highlights

brings out such essential details as hands and face. Rembrandt used the dramatic light and shadow of Caravaggio's style; but, unlike the Italian colorists, he was interested in capturing the quality of light by suggesting forms in space through subtle gradations, from bright highlights to deep shadows. Rembrandt's work has influenced many painters and more recently photographers.

350 Rembrandt van Rijn.
SELF-PORTRAIT. 1658.
Oil on canvas. 33 1/4" x 26".
© *The Frick Collection, New York.*

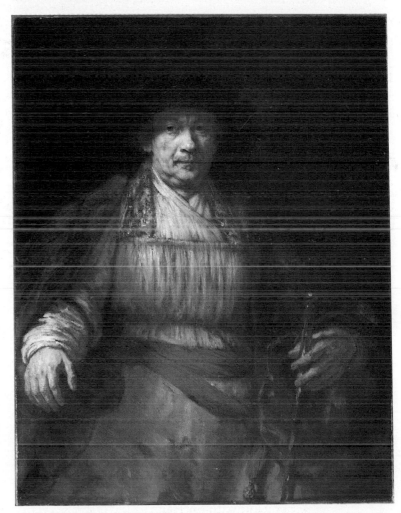

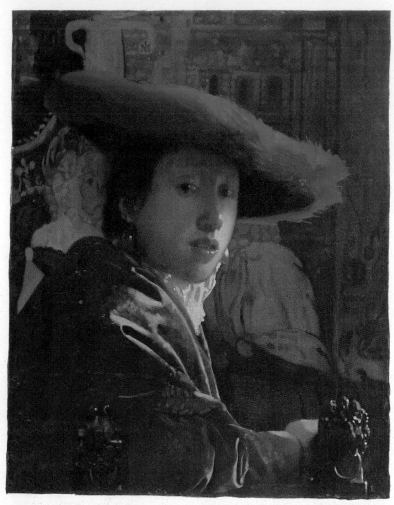

351 Jan Vermeer.
GIRL WITH A RED HAT. c. 1660.
Oil on wood. 9¹/₈″ x 7¹/₈″.
National Gallery of Art, Washington, D.C.
Andrew Mellon Collection (1937).

Jan Vermeer, another seventeenth-century Dutch painter, was also aware of the great importance of light. But his use of light was quite different from Rembrandt's. For Vermeer light seems to have been a unifying force and at times the major subject of his paintings. To see light as it defined the precise character of surfaces, Vermeer probably used a table-model camera obscura (see page 152).

His intimate portrait GIRL WITH A RED HAT has a quality of chance encounter—a vivid moment. The painting is one of Vermeer's early works. It was painted on a small wooden panel

about the same size as the frosted glass on which the image would appear in one type of camera obscura then in use. Vermeer evidently taught himself to see with photographic accuracy by copying images from the ground glass. In GIRL WITH A RED HAT the focus has a narrow range. Only part of the girl's collar and the left edge of her cheek are in sharp focus; everything in front of and behind that narrow band becomes increasingly blurred. The carved lion's head on the arm of the chair in the foreground looks like shimmering light, just as it would appear in an out-of-focus photograph.

For Vermeer the camera obscura was a point of departure, not a crutch. With it he was able to develop his perceptive powers and to give form to his excitement over physical reality as revealed by light. He did not stop at the imitation of surfaces. His own sense of design was behind each brush stroke. The personal order he gave to his compositions gives them their lasting strength.

Vermeer's painting THE ARTIST IN HIS STUDIO may be an idealized self-portrait. Like his Spanish contemporary, Velázquez, Vermeer painted a behind-the-scenes view of an artist's world. The heavy curtain and other dark objects in the left foreground lead into the painting and give dynamic balance to the center of interest created by the black-and-white stripes on the artist's shirt. We look over the artist's shoulder at a painting being worked on, then move left again to the figure of the woman who represents the Muse of History. She holds a book and trumpet, symbols of fame. The plaster cast and the book on the table symbolize the other arts.

Everything in the studio is illuminated by light coming through an unseen window on the left. Vermeer carefully observed all the subtle

352 Jan Vermeer.
THE ARTIST IN HIS STUDIO. c. 1665.
Oil on canvas. 31³/₈″ x 26″.
Kunsthistorisches Museum, Vienna.

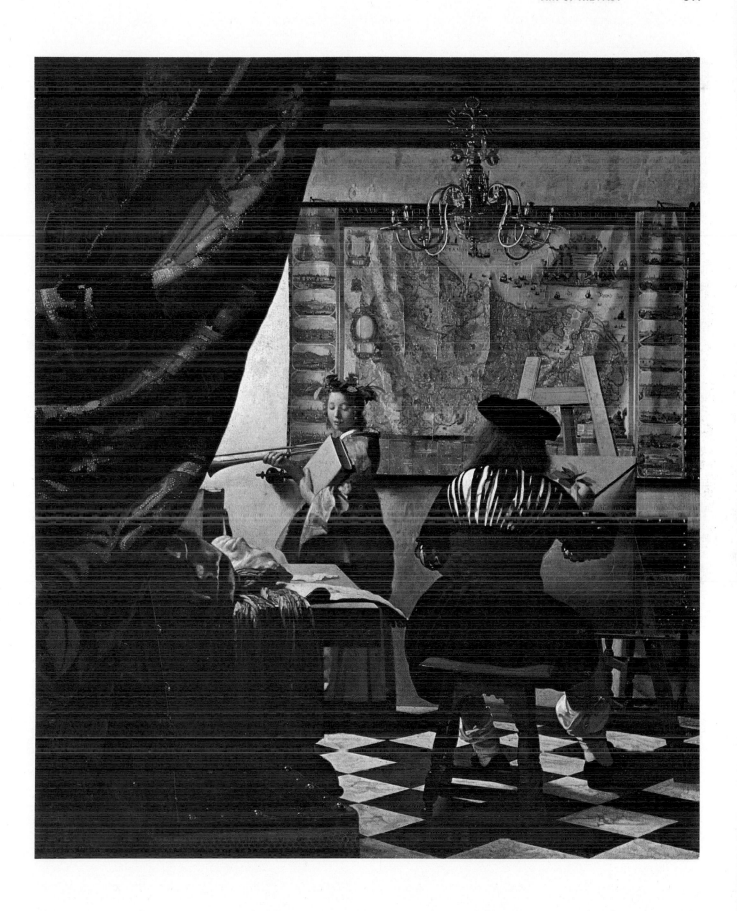

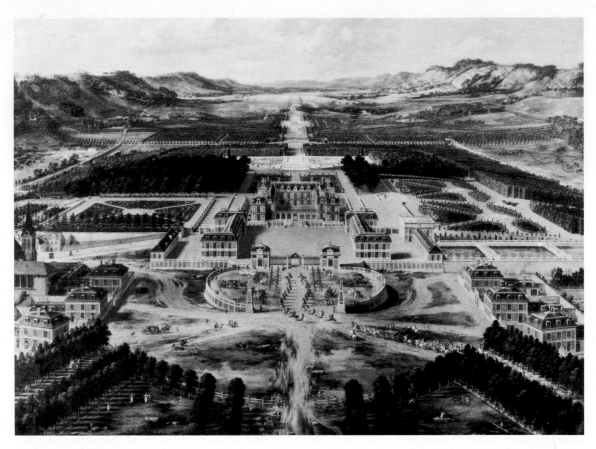

353 VERSAILLES. C. 1665.
Painting by Pierre Patel.
The Louvre, Paris.

variations in the light as it revealed every object in the room. Light and placement of objects are key elements in Vermeer's masterfully designed paintings—in fact, light itself is often the major subject. Vermeer's exceptional awareness of qualities of light and reflected color give his paintings extraordinary luminosity. Vermeer achieved only slight recognition in his lifetime, and was largely ignored by historians until he was rediscovered in the nineteenth century.

During the Baroque period French artists adopted Italian Renaissance ideas, but made them their own. By the end of the seventeenth century France had begun to take the lead in European art.

A different view of seventeenth-century Eu-

ropean life can be seen in the royal architecture and garden design of the French imperial villa of VERSAILLES built for Louis XIV. The architecture of the main palace, with its gardens exemplifies seventeenth-century Baroque classicism in the way cool restraint and symmetry balance Baroque opulence and grand scale.

VERSAILLES expresses the absolute monarch's desire to surpass all others in the splendor of his palace. It is an example of royal extravagance, originally set in 15,000 acres of manicured gardens 12 miles south of Paris. The vast formal gardens with their miles of clipped hedges proclaimed the King's desire to rule even over nature. It is revealing to compare the contrasting attitudes behind VERSAILLES and

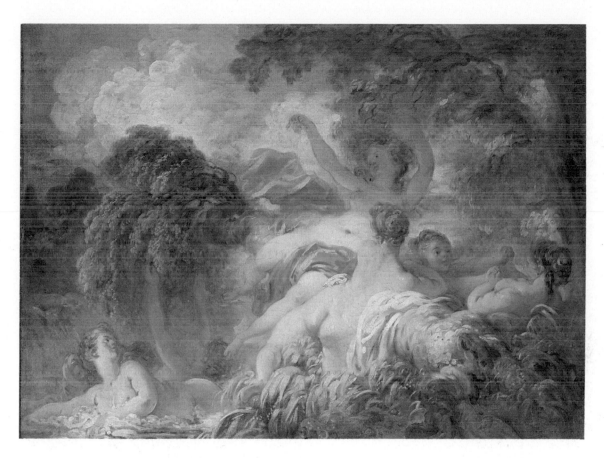

354 Jean-Honoré Fragonard.
THE BATHERS. c. 1765.
Oil on canvas. 25¼" x 31¼".
The Louvre, Paris.

KATSURA, the Japanese imperial villa built during the same century (see page 257).

The heavy, theatrical qualities of Baroque art gradually gave way to the light and airy *Rococo* style in France early in the eighteenth century. Some of the movement, light, and gesture of a Baroque remained, but the effect was quite different. The arts moved out of the marble halls of Versailles into fashionable town houses.

The pastel colors of the Rococo style in France were particularly suited to the frivolous life of the court. Elegantly paneled interiors of palaces and wealthy homes were decorated with golden shells, garlands of flowers, and gay paintings. The word "rococo" itself comes from the French *rocaille*, which refers to the shells and rocks used for ornament in garden grottos. The curved shapes of the shells were copied in architectural ornament and furniture, and influenced the billowing shapes in paintings.

THE BATHERS by Jean-Honoré Fragonard is one of the finest Rococo paintings. There is not a straight line in the entire composition—no hints of horizontal or vertical edges that might tie things down a bit. Compositions during this period were often as visually loose as the subjects were morally loose. It was part of the endless game-playing that took place in the French court.

THE WORLD TRANSFORMED

Neoclassicism

The luxurious life of the French aristocracy ended abruptly with the French Revolution in 1789. French society and economy were disrupted and transformed, and tastes changed radically. One of the men who led the way to revolution was the painter Jacques-Louis David. When he painted the OATH OF THE HORATII, David intentionally used a rational and controlled style that we call *Neoclassical*. The term refers to the style's similarity to the logical clarity of Greek art of the classical period. David rejected what he saw as the frivolous immorality associated with the Rococo style.

The subject of this painting is a story of virtue and readiness to die for liberty, in which the three Horatius brothers pledge to take the sword offered by their father to defend Rome. The heroic sense of duty to defend the homeland had great appeal to the French people. This painting acquired political meaning and was one of the many factors that helped precipitate the French Revolution. Today it is difficult to imagine that a painting could have this much influence.

David's Neoclassicism emphasized a geometric structuring of the composition, creating rational clarity in the painting which is in strong contrast to the vague softness of the Rococo. Even the folds in the garments are more like marble than soft cloth. The three arches set on columns give strength to the design and provide a historically appropriate setting for the Roman figures. The two center columns separate the three major parts of the subject, the stable verticals and horizontals are aligned with the edges of the picture plane. Dramatic use of light emphasizes the figures against the shadowed areas behind the arches.

Eighteenth-century architects adapted features of Greek and Roman architecture as Renaissance architects had done earlier. In both the eighteenth and nineteenth centuries, architects adapted and combined ideas from other earlier traditions as well. The practice of borrowing and combining the best from diverse sources is called *eclecticism*. By the nineteenth century, historic styles had been carefully catalogued so that architects could borrow freely. In church design the Byzantine, Romanesque, and Gothic styles dominated. For public and commercial buildings, Renaissance, Greek, and Roman designs were preferred, and often mixed. This approach lasted well into the twentieth century.

Thomas Jefferson, American statesman and architect, designed his own home, MONTICELLO. The initial building was derived from Palladio's sixteenth-century interpretation of Roman country-style houses (see page 304). When Jefferson went to Europe as Minister to France between 1784 and 1789, he was strongly influenced by surviving examples of Roman architecture. Thus, when his home was rebuilt between 1796 and 1806, the second story was removed from the center of the building and replaced by a dome on an octagonal drum. A large Greco-Roman portico was added, making the whole design reminiscent of the PANTHEON (see page 279). In comparison with the first Monticello, the second version has a monumental quality reflecting Jefferson's increasingly classical conception of architecture. Jefferson also designed the University of Virginia, which was built shortly before his death. Both Monticello and the University of Virginia are examples of the Roman phase of postcolonial architecture, which is often called the *Federal Style*. The city of Washington, D.C., is dominated by this eclectic style of Neoclassical architecture, which can also be found in practically every city in the United States. Jefferson's architecture, however, has an originality in its application of Greek, Roman, and Renaissance forms that makes his work stand above other more imitative works.

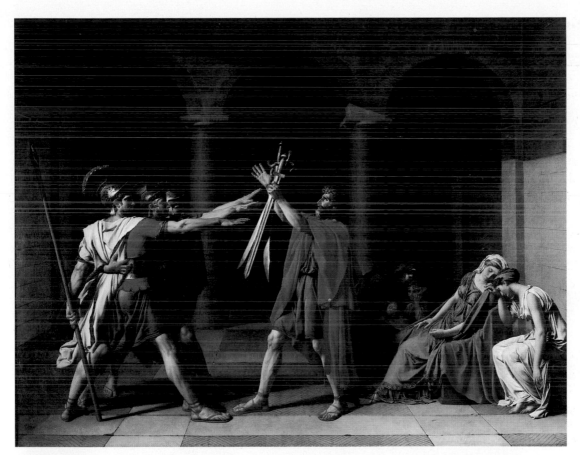

355 Jacques-Louis David. OATH OF THE HORATII. 1784. Oil on canvas. 10'10" x 14'. *The Louvre, Paris.*

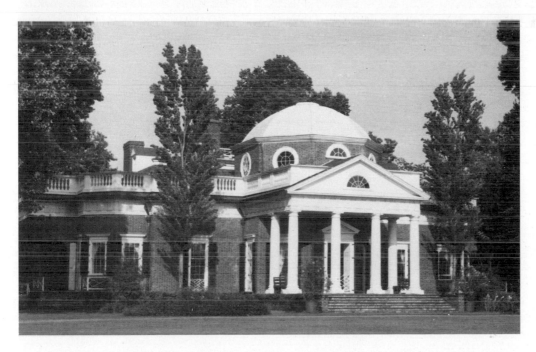

356 Thomas Jefferson. MONTICELLO. 1796–1806. Charlottesville, Virginia.

Romanticism

Romanticism emerged in Europe toward the end of the eighteenth century as a literary and artistic movement. In contrast to Neoclassicism, Romanticism is not a clearly defined or easily recognizable unified style. The motivation behind the movement was a desire to assert the validity of subjective experience and to escape what the Romanticists saw as the Neoclassicist's fixation on classical forms and formulas at the expense of content and feeling. Although the basic aims of the Romanticists varied widely, they shared a concern for the common person, a return to nature, and an emphasis on the senses over reason and intellect.

Spanish painter Francisco Goya was a contemporary of David. He was aware of the French Revolution, and personally experienced

357 Francisco Goya.
THE THIRD OF MAY 1808. 1814.
Oil on canvas. 8'9" x 13'4".
The Prado, Madrid.

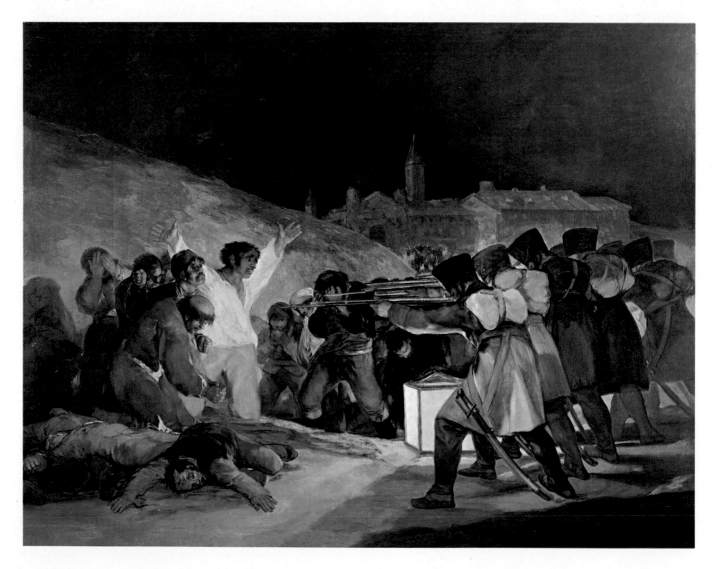

some of its aftermath. Because his sympathies were with the Revolution, Goya welcomed Napoleon's invading army. But he soon discovered that the army of occupation was destroying rather than defending the ideals he had associated with the Revolution. Madrid was occupied by Napoleon's troops in 1808. On May 2 a riot occurred against the French in the Puerto del Sol. Officers fired from a nearby hill and the cavalry was ordered to cut down the crowds. The following night a firing squad was set up to shoot anyone who appeared in the streets. These brutalities were vividly and bitterly depicted by Goya in his powerful indictment of organized murder, THE THIRD OF MAY 1808, painted in February 1814.

The painting is large and yet it is so well conceived in every detail that it delivers its meaning in a single, visual flash. The scene is organized and given impact with a clearly structured pattern of light and dark areas. Value shifts define a wedge shape formed by the edge of the hill and the edge of the brightly lit area on the ground. This wedge takes our glance immediately to the soldiers. From their dark shapes we are led by the light and the lines of the rifle barrels to the man in white. The entire picture is focused on this man, who raises his arms in a final gesture of defiance as more people are forced into the light to be shot. The irregular shape of his shirt is illuminated by the hard, white cube of the soldier's lantern. Mechanical uniformity marks the faceless firing squad, in contrast with the ragged group that is their target.

Goya was appalled by the massacre. Although it is not known whether he saw this particular incident, he did see many similar brutalities. His visual sensitivity, magnified by deafness, made war experience all the more vivid. The painting is neither a heroic reconstruction of history, nor a glorified press photograph. It is a protest against war.

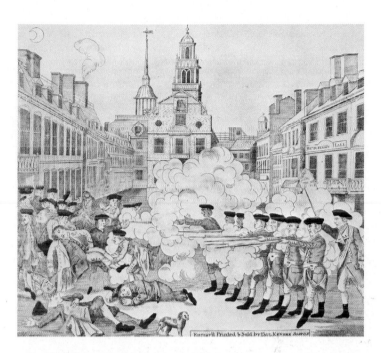

358 Paul Revere after Henry Pelham.
THE BLOODY MASSACRE. 1770.
Metal engraving. 9⅞″ x 8¾″.
Library of Congress, Washington, D.C.

THE THIRD OF MAY 1808 is a painting of a real event that has become universal in its significance. This universality becomes even more apparent when Goya's work is compared to Paul Revere's record of the Boston Massacre, THE BLOODY MASSACRE. The subject of both pictures is the same, but what a difference! The engraving has historic interest to Americans because it was done by a famous patriot, and because of the significance of the event. The directness of its naive drawing adds quaintness to the scene, but Revere's work has little of the lasting impact of Goya's.

359 John Constable.
WILLY LOTT'S HOUSE NEAR FLATFORD MILL.
1810–1815. Oil on paper. 24.1 cm x 18.1 cm.
Victoria and Albert Museum, London.
Crown Copyright.

English painting in the early nineteenth century was dominated by an interest in landscape—brought on in part by the need to escape the growing effects of the Industrial Revolution. Romantic painters John Constable and William Turner (see page 134) were significant in their time, and both led the way to later developments.

Constable was the son of a prosperous country miller. His love of nature and his admiration for masters of European landscape tradition such as Claude Lorrain (see page 93) became the sources for his art. Constable studied art and nature with equal care. Although his final detailed paintings were developed in the traditional way in his studio, they were preceded by numerous oil sketches completed outdoors. Constable was not the first to paint studies on location, but he was unique in the attention he gave to intangible qualities of light and weather. Succeeding generations have delighted in the lyric beauty and accurate perception apparent in his oil sketches. Spontaneous brushwork and directly observed light, color, and form are seen in the study of WILLY LOTT'S HOUSE NEAR FLAT FORD MILL, which was probably referred to by Constable when he painted THE HAY WAIN. We are simultaneously made aware of the fresh qualities of paint color, the process of painting, and the character of the subject being painted.

When THE HAY WAIN was exhibited in the annual Paris exhibition of 1824, French artists were amazed by the English painter's vision of landscape. It is said that Eugène Delacroix was so inspired by the way the sky was painted in THE HAY WAIN that he repainted the sky in one of his own major works in a similar manner. Constable's spontaneous paint application captured a new vibrant quality, with emphasis on mood as determined by sky, light, and weather. Warm sun and cool shadows play off in an image of intimate foreground detail and great implied depth. Constable broke away from conventional formulas of color and technique. His innovative use of broken strokes of varied

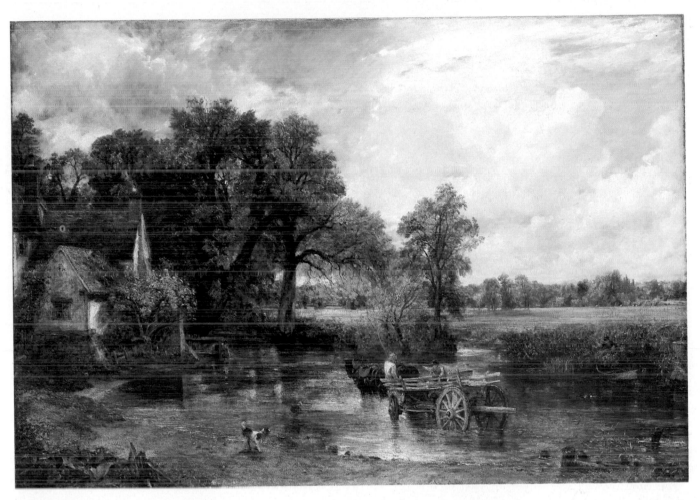

360 John Constable.
THE HAY WAIN. 1821.
Oil on canvas. 50½″ x 73″.
Reproduced courtesy of the Trustees,
The National Gallery, London.

color (rather than the traditional method of laying down continuous areas of a single color) and his use of flecks of white to suggest shimmering sunlight, brought him ridicule from many of his contemporaries and praise from the later French Impressionists.

Turner's freely expressive approach to painting (see page 134) was in some ways more indicative of things to come than Constable's relatively conservative approach. Both painters gave new life to the experience of ordinary as well as exceptional subject matter through their fresh perceptions and imaginative use of light,

color, and paint application. While Constable gave attention to the wonder of so-called ordinary things and humble settings, Turner chose to exaggerate the more awesome and dramatic forces in nature. Turner's interest in light and atmosphere also anticipated and helped to inspire the French Impressionists.

Although the values that formed the basis of Romanticism did not produce a unified style, this fact does not diminish the importance of the movement, which dominated Western European art between 1830 and 1850.

The leading French Romantic painter was Eugène Delacroix. Both Goya and Delacroix used Baroque lighting to heighten the emotional impact of their work. Delacroix's painting THE DEATH OF SARDANAPALUS exhibits the many qualities that distinguish Romanticism from the Neoclassicism of David and his followers.

The turbulent sensuality of this painting is based on Byron's poem wherein the legendary Assyrian ruler watches from his deathbed after ordering that his palace and all its contents be destroyed. The romantic ideal stresses passionate involvement, color (equal in importance to drawing), and spontaneous movement, in contrast to the cool, detached, formal qualities of Neoclassicism. Delacroix's rich color and *painterly* execution (open form, with shapes defined by changes in color rather than line) was greatly admired by later painters, particularly the Dutch expressionist Vincent van Gogh.

Photography

The Industrial Revolution of the nineteenth century brought inventions that changed life forever in Western Europe. One such invention was the camera.

The first vague photographic image had been produced in 1826 by Joseph Nicéphore Niépce by recording and fixing on a sheet of pewter an image made with light. During the next decade the painter Louis Jacques Mandé Daguerre further perfected Niépce's process, and produced the first satisfactory photograph. Images produced by Daguerre's process became known as *daguerreotypes.*

At first photography could only be used to catch images of stationary objects because the necessary exposure times were too long. In Daguerre's photograph of Paris in 1839 the streets appear deserted because moving figures

361 Eugène Delacroix.
THE DEATH OF
SARDANAPALUS. 1827.
Oil on canvas.
12′1¹/₂″ x 16′2⁷/₈″.
The Louvre, Paris.

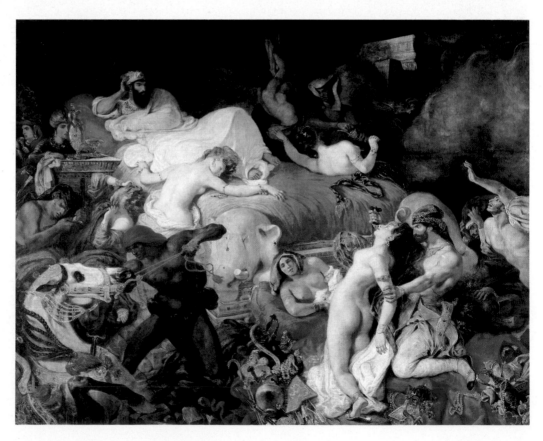

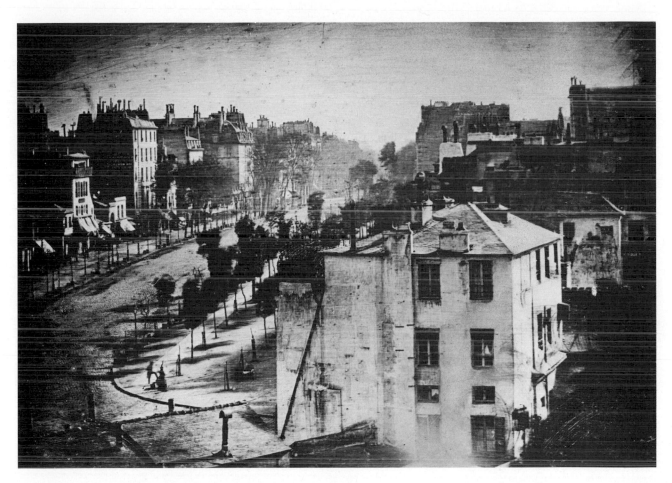

362 Louis Jacques Mandé Daguerre.
LE BOULEVARD DU TEMPLE. 1839.
Daguerreotype.
Bayerisches National Museum, Munich.

made no lasting light impressions on the plate. However, one man, having his shoes shined, stayed still long enough to become part of the image. He is visible in the lower left, the first human to appear in a photograph. It was a significant moment in history. Now images of actual things, including people, could be made without the skillful hand of a traditional artist. Although some painters at the time felt the new medium constituted unfair competition that spelled the end of art, it actually marked the beginning of a period when art would once again become accessible to all. Portraits, which had been symbols of power and authority affordable only to the very rich, became available

for almost everyone. By the mid-nineteenth century it became popular to have one's portrait taken and printed on visiting cards to give to friends.

Photography freed painters from the role of illustrator. The realistic portrayal of subject matter could now be handled by the new medium, giving painters an opportunity to explore dimensions of inner experience scarcely considered previously. At the same time, photography offered new opportunities for fusing images of objective reality with personal visions.

Delacroix was one of the first to recognize the difference between camera vision and human vision. He understood the unique qualities of

each. For him the camera and the photographic process developed by Daguerre were of great benefit to art and artists: ". . . let a man of genius make use of the daguerreotype as it is to be used, and he will raise himself to a height that we do not know."[11]

Delacroix drew and painted from metal daguerreotypes and prints on paper. He set up a painter's composition with a model, then with the help of his friend and colleague the photographer Durieu, he made a photograph. In an essay for students, Delacroix wrote:

A daguerreotype is a mirror of the object, certain details almost always overlooked in drawing from

nature take on in it characteristic importance, and thus introduce the artist to complete knowledge of construction as light and shade are found in their true character.[12]

Thus a photograph rather than a drawing became the basis for a painting.

Delacroix disliked most other inventions of his day, such as the steamboat, and felt man was driven by the devil. He expressed himself strongly and with a good deal of foresight:

Here is another American invention that will let people go faster, always faster. When they have got travelers comfortably lodged in a cannon, so that

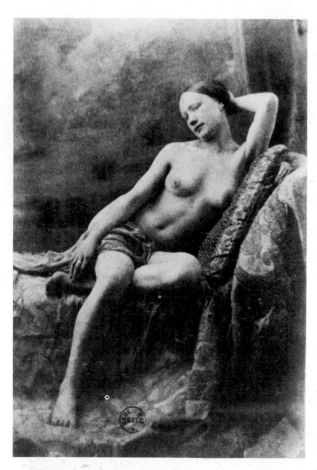

363 Eugène Durieu.
FIGURE STUDY. c. 1855.
Photograph.
Bibliothèque Nationale, Paris.

364 Eugène Delacroix.
ODALISQUE. 1857.
Oil on canvas.
Private collection.

*the cannon can make them travel as fast as bul-
lets ... civilization will doubtless have taken a
long step. ... it will have conquered space but not
boredom.*[13]

Both Neoclassical and Romantic painters of
the mid-nineteenth century period mixed his-
torical, literary, mythical, and exotic subjects.
The French Academy of Fine Arts, L'Ecole des
Beaux Arts, gave official sanction to this narra-
tive approach to painting.

Thomas Couture's huge painting ROMANS
OF THE DECADENCE is a romantic subject in a
Neoclassical setting typical of nineteenth-
century French academic art. Academic art fol-
lows formulas laid down by an academy or
school. This painting represents the dying
gasp of pictorial themes that had been worked
and reworked since the Renaissance. Couture's
painting, which was nominally intended to
criticize Roman decadence, also presented an
eroticism that was appealing in an age of re-
pressed sexuality. Vast changes in art, however,
were about to topple the dominance of the
Academy.

Even photography, the medium so suited to
staying in touch with the actual world, was
pulled into service in the academic manner.
With exceeding care, painter and photographer
O. G. Rejlander combined over 30 negatives to
achieve his ambitious photograph THE TWO
WAYS OF LIFE. The moral content is apparent:
Which way does one choose?

Rejlander was devoted to the new medium of
photography and sought to prove that it was
possible to create photographs equal in impor-
tance to paintings. His opportunity came when
he entered this print in the Manchester Art
Treasures Exhibition of 1857. Queen Victoria,
who was an amateur photographer, purchased
the work.

Realism

The term *realism* is often used to describe a style
used by artists who aim to represent an equiva-
lent to the retinal image. This approach was
used before the nineteenth century, notably in
Roman, Flemish, and Dutch painting. In the
1850s Gustave Courbet reinstated the concept
with new vigor by employing a direct, painterly
technique and objective vision to represent
images of contemporary life. Courbet's realism
broke with the artificial grandeur and exoticism
of the popular and academically acceptable
styles of his day, and paved the way for a redis-

365 Thomas Couture.
ROMANS OF THE DECADENCE. 1847.
Oil on canvas. 15' 1" x 25' 4".
The Louvre, Paris.

366 O. G. Rejlander.
THE TWO WAYS OF LIFE. 1857.
Photograph. 16" x 31".
Royal Photographic Society Collection, Bath.

367 Gustave Courbet.
THE STONE BREAKERS. 1849.
Oil on canvas. 5′5″ x 7′10″.
Destroyed during World War II
(formerly in State Picture Gallery, Dresden).

covery of the significance of everyday visual experience.

In a related development, the new technique of photography began to be used in the mid-nineteenth century by artist/photographers who insisted upon the importance of the ordinary world.

Courbet's THE STONE BREAKERS shows the painter's rejection of Romantic and Neoclassic formulas. Courbet neither idealized the work of breaking stones, nor dramatized the struggle for existence. He simply said, "Look at this."

Portable, slow-drying oil colors became available in 1841 with the invention of the collapsible tin tube. This made it easier for artists to paint outdoors without preliminary drawings or preconceived plans. Courbet was one of the first to work outdoors directly from nature. Previously, most landscape painting had been done in the artist's studio from memory, sketches, and bits of reference material such as rocks and plants brought in from outside. By working directly from the subject outdoors, painters were able to capture their first clear impressions without intervening processes. This shift in practice opened up a whole new style.

Courbet looked at the physical reality of the immediate, everyday world. His subject matches his realism. His figures are neither historical nor allegorical, neither religious nor heroic. They are ordinary road workers, presented almost life-size in a large painting. People wondered how Courbet could make *art*

out of such a mundane subject. When THE STONE BREAKERS was exhibited in Paris in 1850, it was attacked as unartistic, crude, and socialistic. For later expositions, Courbet set up his own exhibits. This laid the groundwork for independent shows organized by artists themselves.

Of his own work Courbet said, "To know in order to create, that was my idea. To be able to represent the customs, the ideas, the appearance of my own era . . . to create living art; that is my aim."[14]

Nineteenth-century Realist painting reached major proportions with the work of American painter Thomas Eakins. In 1866 Eakins went to Paris where he studied for three years with the Academic painter Jean Léon Gérôme. While in Europe, he was inspired by Rembrandt and Velázquez. On his return to America Eakins began painting in the powerful realistic style he continued to employ the rest of his life.

The new technique of photography was making a contribution to the reawakening of direct vision. Eakins combined artistic and scientific interests. By the 1880s he was an expert photographer, and used the camera to study the human body at rest and in motion. His insistence on realism, including the use of totally nude male and female models, caused a controversy that ended with his resignation from his teaching post at the Pennsylvania Academy. A comparison between paintings by Eakins and his teacher, Gérôme, shows the importance of Eakins' realism.

The Greek myth of Pygmalion tells of a sculptor who created a statue of a woman so beautiful that he fell in love with it. Pygmalion prayed to Aphrodite, goddess of love, who responded by making the figure actually come to life. Of course, the pair lived happily ever after. In PYGMALION AND GALATEA, a painting illustrating this myth, Gérôme placed the woman on a pedestal, both literally and figuratively. Thomas Eakins' painting WILLIAM RUSH AND HIS MODEL depicts the sculptor helping his model as she steps down from the stand on which she has been posing. The

368 Jean Léon Gérôme.
PYGMALION AND GALATEA. c. 1860.
Oil on canvas. 35" x 27".
Metropolitan Museum of Art, New York.
Gift of Louis Raegner, (1927).

369 Thomas Eakins.
WILLIAM RUSH AND HIS MODEL. 1907–1908.
Oil on canvas. 35¼" x 47¼".
Honolulu Academy of Arts.
Gift of the Friends of the Academy.

370 Edouard Manet.
LUNCHEON ON THE GRASS. 1863.
Oil on canvas. 84″ x 106″.
The Louvre, Paris.

woman comes down off the pedestal and takes her place in the real world.

Eakins' attitude, which he asked viewers to share, is one of great respect for the beauty of the ordinary human being—and perhaps, by extension, the importance of really seeing so-called ordinary things. Gérôme may have been equally interested in ordinary women, yet he created a painting based on classic/academic ideals. Eakins' painting was based on the way people actually look. Eakins thus escaped from the bondage of stylization imposed by the rules of the French Academy.

The revolution that occurred in painting in the 1860s and 1870s has sometimes been referred to as the Manet Revolution. Edouard Manet was a student of Couture, but Manet rejected most of the artistic ideals of his teacher. Compare Couture's ROMANS OF THE DECA DENCE (page 323) with Manet's LUNCHEON ON THE GRASS. It is difficult to believe that the paintings were done at about the same time. Manet's study of the flat shapes of Japanese prints (see page 256) helped him to minimize illusionary space, giving full power to value and shape. His painterly style and choice of commonplace subjects reflect Courbet's influence. Manet fused Courbet's realism with his own concepts and sparked the enthusiasm for everyday reality that was so basic to Impressionism. If Courbet painted the present, Manet painted *in* the present. He too was free of the conventions of the Academy. Through his interest in light and everyday visual experience Manet led the way into Impressionism.

Manet's painting LUNCHEON ON THE GRASS scandalized French critics and the public because of the shocking juxtaposition of a female nude with males dressed in contemporary clothing. It was painted entirely in his studio, though it is an outdoor scene. There is no hint of allegory, history, or mythology. Use of nudes and clothed figures in landscape derives from a long tradition going back to Renaissance and Roman compositions. In fact, Manet based his composition of the figures on a Renaissance

371 Marcantonio Raimondi.
Detail of THE JUDGEMENT OF PARIS. c. 1520.
Engraving after Raphael.
Metropolitan Museum of Art, New York.
Rogers Fund (1919).

engraving, THE JUDGEMENT OF PARIS by Marcantonio Raimondi, who worked from a lost cartoon by Raphael, who in turn was influenced by Roman relief sculpture. What is new, and even revolutionary, about Manet's painting is his emphasis on shapes like that of the female depicted without chiaroscuro. It is painted directly with colors, rather than developed as a monochromatic study in light and shade, then tinted with colors. We find ourselves beginning to look *at* rather than through or into his paintings.

Transition in Architecture

New inventions of the Industrial Age, which led to a revolution in architecture, came at the same time as the rejection of Academic style by Realist painters. In September 1850 construction began on Joseph Paxton's CRYSTAL PAL-

372 Joseph Paxton.
CRYSTAL PALACE. 1850–1851.
Cast-iron and glass. Width 408′, length 1851′. London.
(Etching. *Victoria and Albert Museum,*
London. Crown Copyright.)

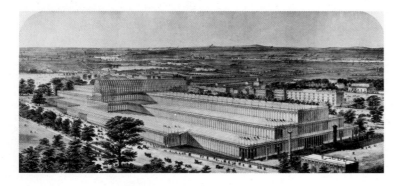

373 Joseph Paxton.
CRYSTAL PALACE. Interior view.
(Etching by Lothar Buchar.
Victoria and Albert Museum,
London. Crown Copyright.)

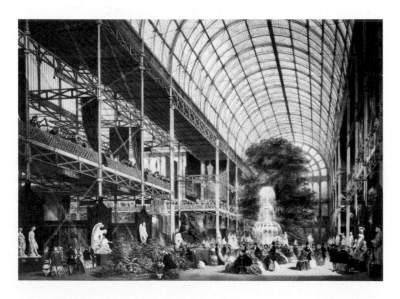

ACE, a large exposition hall designed for the Great Exhibition of the Works of Industry of All Nations, held in London in 1851. There is no eclecticism in this building. Paxton used the new methods of the Industrial Age—prefabricated cast iron, glass, and wooden sections which were assembled at the building site. Paxton's successful innovation was a new application of the concept that "form follows function" expressed earlier by Renaissance architect Leon Battista Alberti, and later made famous by Louis Sullivan. In the CRYTAL PALACE the light, decorative quality of the glass and cast-iron units was created, not by applied ornamentation, but by the structure itself.

In its design the CRYSTAL PALACE was closer to the ideals of Buckminster Fuller than to the works of Paxton's contemporaries or even to Fuller's contemporaries (see page 214). Most significant was the use of relatively lightweight, preformed *modules* or standard-sized structural units repeated throughout the building. They provided enough flexibility for the entire structure to be assembled on the site right over existing trees, and later disassembled and moved across town.

Impressionism

In 1874 a group of young painters who were denied the right to show in the official French Academy exhibit hung their work in a photographer's studio. They found momentary effects of light particularly beautiful. Landscape and ordinary scenes painted outdoors in varying atmospheric conditions and times of day were their main subjects. They were dubbed "Impressionists" by a critic who objected to the sketchy quality of their paintings, exemplified by Claude Monet's IMPRESSION: SUNRISE.

Their work came to be known as *Impressionism,* but they called themselves "illuminists." Impressionism was strongest between 1870 and 1880. After 1880 it was Monet who con-

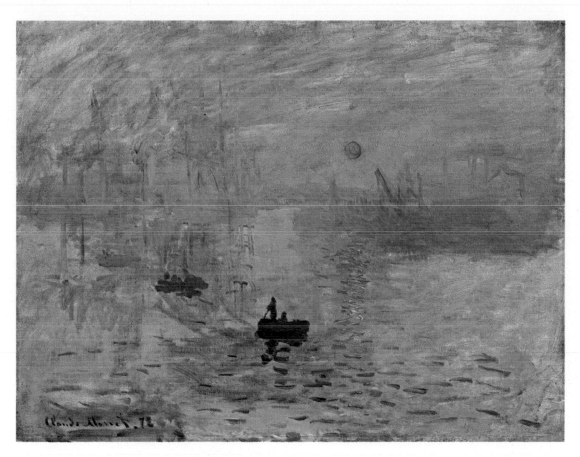

374 Claude Monet.
IMPRESSION: SUNRISE. 1872.
Oil on canvas. 19½" x 25½".
Musée Marmottan, Paris.

tinued for more than thirty years to be true to Impressionism's original ideals. Instead of painting from sketches, he painted outdoors Monet returned again and again to the same subject with different canvases in order to record the qualities of light and mood of each changing hour.

Since Monet painted with some touches of pure color placed next to each other on the picture surface, rather than with colors pre-mixed and then applied to the canvas, the viewer experienced a form of *optical mixing*. In his paintings, a violet area may be made of blue, violet, and touches of pure red. As the viewer's eye mixes the colors, a vibrancy results that cannot be achieved with paint mixed on the palette. The effect was startling to eyes used to the muted continuous tones of academic painting.

Impressionism was an enthusiastic affirmation of modern life. The Impressionists saw the beauty of the world as a gift and the forces of nature as friendly aids to human progress. Although misunderstood by their public, the Impressionists made visible a widely held optimism about the effects of the Industrial Revolution. It was believed that technology was transforming the world into a garden of delights.

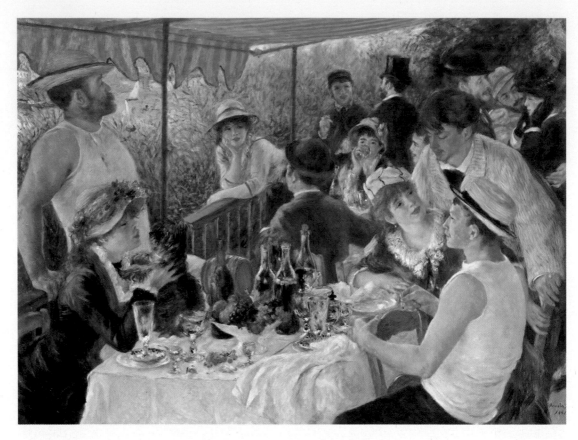

375 Pierre-Auguste
Renoir.
THE LUNCHEON OF
THE BOATING PARTY.
1881. Oil on canvas.
51″ x 68″.
*The Phillips Collection,
Washington, D.C.*

Pierre-Auguste Renoir's THE LUNCHEON OF THE BOATING PARTY is a fine example of Impressionist themes. A group of friends is seen finishing their lunch at a small café situated on the bank of the river Seine a few miles from Paris. By 1881 Renoir had begun to move away from the lighter, more diffuse imagery of the 1870s toward more solid forms and a more structured composition. His disregard for true linear perspective, as seen in the lines of the railing and table top, reflects the declining interest in depicting depth. As in the works of Monet, pure hues vibrate across the surface in delightfully exuberant brushwork. The young men and women in the painting are conversing, sipping wine, and generally enjoying themselves. The Industrial Revolution had created a new leisure for the middle class; people had the opportunity to gather together for pleasure.

Edgar Degas shared with the Impressionists a directness of expression and an interest in portraying contemporary life, but he combined the immediacy of Impressionism with a more structured approach to design. Degas, along with more typical Impressionists, was strongly influenced by the new ways of seeing and imagemaking suggested by Japanese prints and by photography. Conventional European compositions placed subjects centrally; but Degas and others used surprising, lifelike compositions and effects taken from photographs and Japanese prints, which often cut figures at the edge. The tipped-up floors and bold asymmetry found in Japanese prints inspired Degas to create paintings filled with intriguing visual tensions,

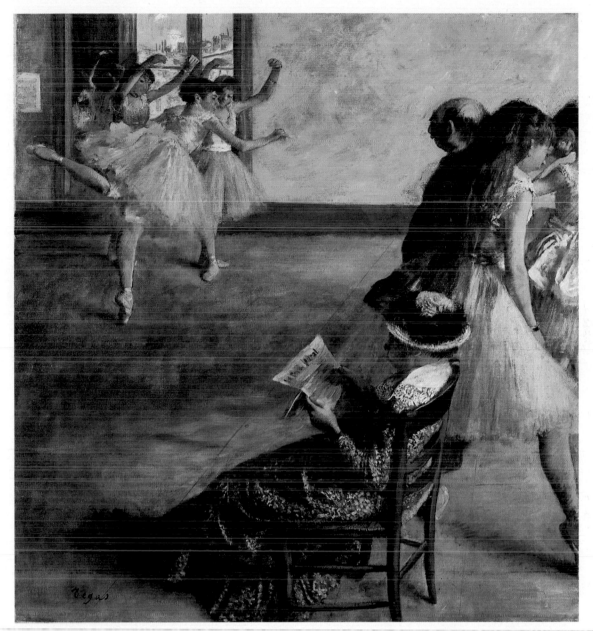

376
Edgar Degas.
THE BALLET
CLASS.
c. 1878–1880.
Oil on canvas.
32 1/8" x 30 1/8".
*Philadelphia
Museum of Art.
Purchased: W. P.
Wilstach Collection.*

such as those seen in THE BALLET CLASS, in which there are two diagonal groups of figures on opposite sides of an empty center.

Degas depicted classes in ballet in ways that revealed their unglamorous character. Often, as here, he was able to turn his great ability to the task of defining human character and mood in a given situation. Degas' painting builds from the quiet, disinterested woman in the foreground up to the right, then across to the clus-

ter of dancing girls following the implied line of sight of the ballet master. The stability of the group on the right contrasts with the smaller, irregular shape of the girls before the mirror. Degas managed to balance spatial tensions between near and far, and to create interesting tensions between stable and unstable, large and small.

Notice how Degas emphasizes the line in the floor, which he brings together with the top of

the woman's newspaper in order to guide the viewer's eye. The angle of the seated woman's foot brings us back around to begin again.

Painters such as Manet, Monet, Renoir, and Degas rejected the artificial poses and limited color prescribed by the Academy. Because they rebelled against acceptable styles, they made few sales in their early years. Critics decried their work with degrading remarks. Many of the painters whom we now consider the key masters of nineteenth-century art were outsiders, cut off from the traditional patronage of church and state and set apart from the acceptable art of their time. The lives of men like Daumier, Courbet, Manet, Monet, Gauguin, and van Gogh gave rise to the idea of the artist as an isolated, often poor, social misfit.

377 Georges Seurat.
SUNDAY AFTERNOON ON THE ISLAND
OF LA GRANDE JATTE. 1884–1886.
Oil on canvas. 81″ x 120⅜″.
The Art Institute of Chicago.

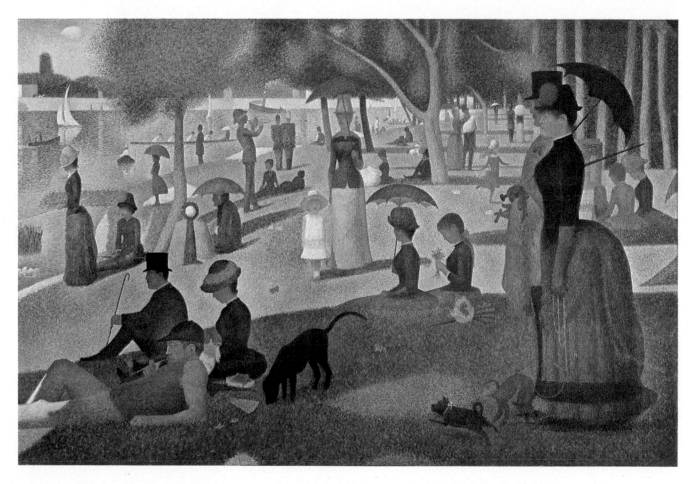

The Post-Impressionist Period

Post-Impressionism refers to the several styles that followed Impressionism after 1885. Many painters who tried Impressionism early in their careers felt that solidity of form and composition had been sacrificed for the sake of fleeting impressions of light and color. Post-Impressionism is a confusing term because it refers to various reactions to Impressionism, rather than to a single style. The two dominant tendencies during the period were expressionistic and formalistic. Four painters whose works best exemplify Post-Impressionist attitudes were Paul Gauguin, Vincent van Gogh, Georges Seurat, and Paul Cézanne.

Gauguin and van Gogh brought to their work emotional intensity and a desire to make their inner thoughts and feelings visible. They used bold color contrasts, shapes with abruptly changing contours, and, in van Gogh's case, vigorous brushwork. The twentieth-century styles of *Expressionism* were greatly influenced by the work of these two painters.

Seurat and Cézanne were more interested in developing significant formal structure in their paintings. Both organized visual form in order to achieve a structured clarity of design.

Seurat's large painting SUNDAY AFTERNOON ON THE ISLAND OF LA GRANDE JATTE has the subject matter, the broken brushwork, and the light and color qualities of Impressionism. But this painting is not of a fleeting glimpse; it is a structural design worked out with great precision. Seurat set out to systematize the optical color mixing of Impressionism and to create a more rigid organization with simplified forms. He called his method *divisionism,* but it is more popularly known as *pointillism.* With it, Seurat tried to develop and apply a "scientific" technique that would make the intuitive approach obsolete. He arrived at his method by studying the principles of color optics that were being discovered at the time. He applied his paint in tiny dots of color to achieve a richly colored surface through optical mixture.

A large number of drawn and painted studies of the subject were made. With them, Seurat carefully studied the horizontal and vertical relationships, the character of each shape, and the patterns of light, shade, and color.

The final painting shows the total control that Seurat sought through the application of his method. The frozen formality of the figures seems surprising, considering the casual nature of the subject matter. Can you imagine how Renoir would have handled this scene? But it is precisely its calm, formal grandeur that gives the painting lasting appeal.

Of the many great painters working in France during the last 20 years of the nineteenth century, Cézanne had the most lasting effect on the course of painting. Because of this, he is referred to as the "father of modern art."

Cézanne, like Seurat, was more interested in the structural or formal aspects of painting than in its ability to convey emotions. He shared the Impressionists' practice of working directly from nature. But in his later works he achieved strong formal images. "My aim," he said, "was to make Impressionism into something solid and enduring like the art of the museums."[15]

Cézanne and Seurat based their work on direct observation of nature, and both used visibly separate strokes of color to build their richly woven surfaces. Cézanne saw the planar surfaces of his subjects in terms of color modulation. He did not use light and shadow in a conventional way, but carefully developed relationships between adjoining strokes of color in order to show the solidity of form and receding space. His paintings are free of atmospheric color effects. Seurat's slow, highly demanding method was not popular among younger artists. Cézanne's looser strokes and his concept of a geometric substructure in nature and art offered a whole range of possibilities to those who studied his later paintings.

Cézanne also gave new importance to the compositional problems that the Impressionists had tended to ignore. Landscape was one of his main interests. He went beyond the reality of nature, organizing it in his own way to create a new reality on the picture surface. In MONT SAINTE-VICTOIRE, we can see how he flattened space. The dark edge lines around the distant mountain stop our eyes and return them to the foreground. He simplified the houses and tree masses into almost geometric planes. Compare this painting with Monet's IMPRESSION: SUNRISE on page 329 to see how Cézanne moved away from Impressionism.

The young painters who were coming to study in Paris at the turn of the century looked to Cézanne's paintings to help them develop new ways of organizing form. Out of their research of Cézanne's analytical approach to painting would grow the new twentieth-century style of Cubism.

Japanese prints were an important influence on European and American painters beginning with Manet and continuing into the twentieth century. The depiction of everyday life and the strong sense of design in prints like Utamaro's REFLECTED BEAUTY on page 256 inspired Western painters to break with the European style. The influence of Japanese prints is readily apparent in the simplicity and bold design of Mary Cassatt's THE BOATING PARTY. Cassatt refined her subject in sweeping curves and almost flat shapes.

With van Gogh, late nineteenth-century painting moved from an outer *impression* of what the eye sees to an inner *expression* of what the heart feels and the mind knows. Vincent van Gogh's intense feeling for life's essential

378 Paul Cézanne.
MONT SAINTE-VICTOIRE.
1904–1906.
Oil on canvas.
25⅝″ x 31⅞″.
Private collection.

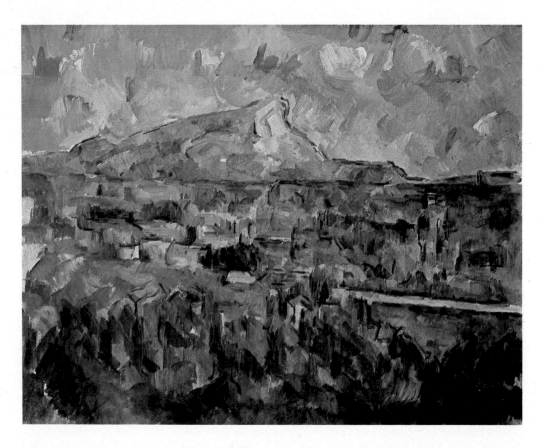

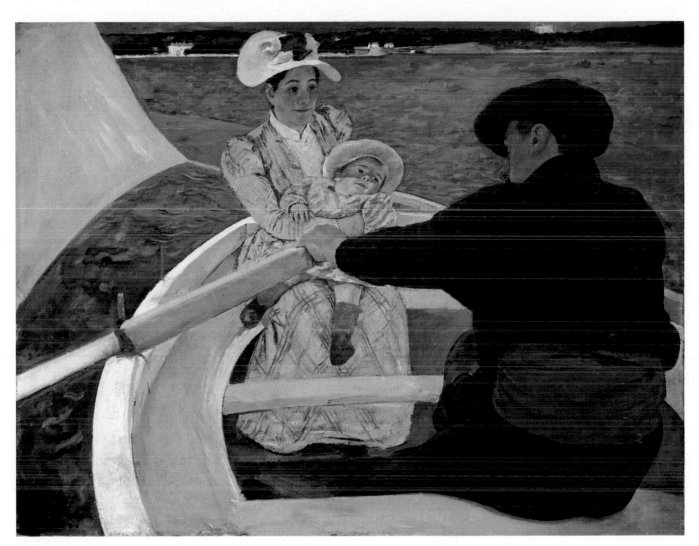

379 Mary Cassatt.
THE BOATING PARTY. 1893–1894.
Oil on canvas. 35½" x 46⅛".
National Gallery of Art, Washington, D.C.
Chester Dale Collection (1962).

truths and his early interest in literature and religion led him to work as a lay preacher for poverty-stricken coal miners, where he fought against the inhuman treatment of industrial society. Dissatisfied with his inability to correct the social injustice he saw, van Gogh turned instead to art. With financial support from his brother Theo, the 27-year-old van Gogh began working as an artist in 1880 and continued to develop his abilities until his suicide ten years later. During these few years he overcame an early clumsiness and produced works of great emotional intensity and spirituality.

From Impressionism, van Gogh learned the expressive potential of divided brushwork and pure color, but the style did not provide enough freedom to satisfy his desire to express his emotions. Without departing from "natural color," van Gogh intensified the surface of his paintings with textural brushwork that recorded each gesture of his hand and gave an overall rhythmic movement to the surface.

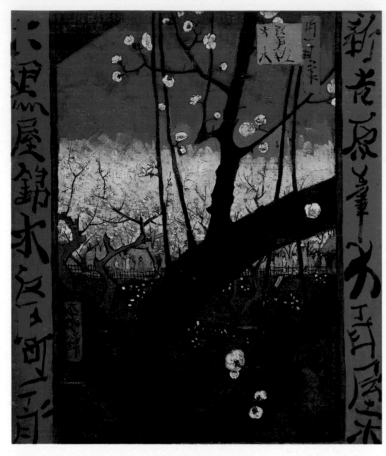

380 Vincent van Gogh after Hiroshige.
JAPONAISERIE: FLOWERING PLUM TREE. 1888.
Oil on canvas. 55 cm x 46 cm.
National Museum Vincent van Gogh, Amsterdam.

Van Gogh began to use startling color in an effort to express his emotions more clearly. He wrote:

Instead of trying to reproduce exactly what I have before my eyes, I use color more arbitrarily so as to express myself forcibly. . . . I am always in hope of making a discovery there to express the love of two lovers by a marriage of two complementary colors, their mingling and their opposition, the mysterious vibrations of kindred tones. To express the thought of a brow by the radiance of a light tone against a sombre background.[16]

Van Gogh developed a new sense of design, partly through studying Japanese prints. His copy of a Hiroshige print is quite accurate. In THE SOWER, van Gogh demonstrated his newly acquired sense of design featuring bold, simple shapes and flat color areas. The wide band of a tree trunk cuts diagonally across the composition as a major shape, its strength balancing the sun and its energy coming toward us with the movement of the sower.

A strong desire to share personal experience motivated van Gogh. After tremendous struggle with materials and techniques, he finally reached the point at which he was able to put the intensity of his vision on paper and canvas. He sought to portray not what he saw, but what he wanted others to see.

. . . I should be desperate if my figures were correct, . . . I do not want them to be academically correct. . . . I adore the figures of Michelangelo though the legs are undoubtedly too long, the hips and backsides too large. . . . [T]he real artists do not paint things as they are, traced in a dry analytical way, but as they feel them. . . . [M]y greatest longing is to learn to make those very incorrectnesses, those deviations, remodelings, changes in reality, so that they may become, yes, lies if you like—but truer than the literal truth.[17]

In THE STARRY NIGHT van Gogh's observation of a town at night becomes the point of departure for an image of great magnitude. Hills seem to undulate in rhythm to tremendous cosmic forces of the sky. The limited scale of human life is presented in the town nestled into the dark forms of the ground plane. The church's spire reaches toward the heavens echoed by the larger more dynamic upward thrust of the cyprus trees in the left foreground. Cyprus is traditionally planted beside graveyards in Europe as a symbol of eternal life. All these elements are united by the surging, rhythmic lines that express van Gogh's passionate spirit and mystic vision.

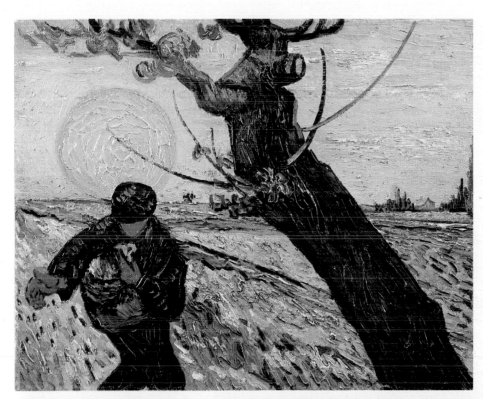

381 Vincent van Gogh.
THE SOWER. 1888.
Oil on canvas. 17³/8″ x 22¹/8″.
National Museum Vincent van Gogh,
Amsterdam.

382 Vincent van Gogh.
THE STARRY NIGHT. 1889.
Oil on canvas. 29″ x 36¹/4″
The Museum of Modern Art, New York.
Acquired through the Lillie P. Bliss Bequest.

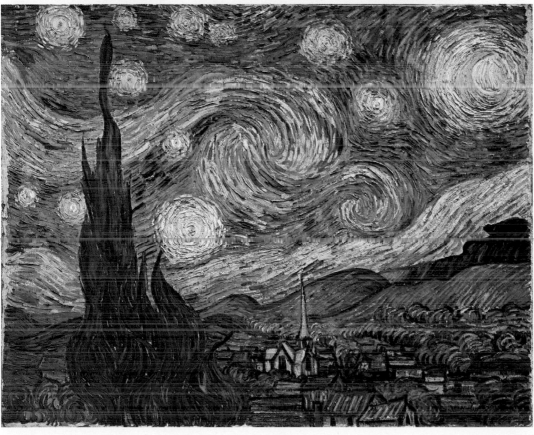

383 Paul Gauguin.
THE VISION AFTER THE
SERMON (JACOB
WRESTLING WITH THE
ANGEL). 1888.
Oil on canvas.
28³/₄" x 36¹/₂".
*National Gallery
of Scotland, Edinburgh.*

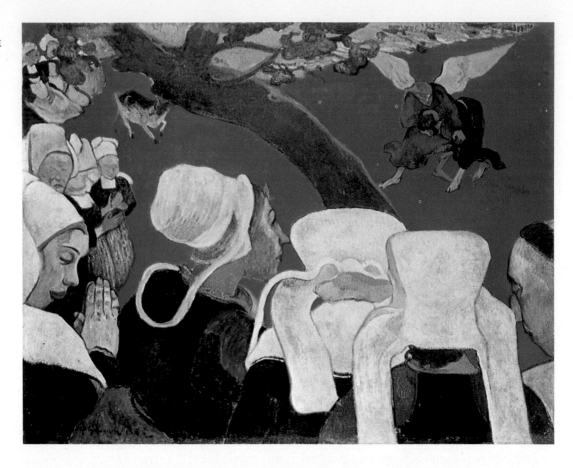

Paul Gauguin began painting on Sundays, working in an Impressionist manner, while making a good living as a stockbroker. Following a crash in the financial world, Gauguin left business—and eventually his family—to devote himself to art. Memories of his childhood in Peru persuaded him that the art of ancient and non-Western cultures had spiritual strength lacking in the European art of his time. Gauguin decided to make his insights clear through an entirely new way of painting. Inspiration came from medieval European art, and from the arts of ancient and non-European cultures that were little known and generally rejected as crude by European society.

Keep the Persians, the Cambodians, and a bit of the Egyptians always in mind. The great error is the Greek, however beautiful it may be.[18]

A great thought-system is written in gold in Far Eastern art.[19]

Gauguin's desire to rejuvenate European art and civilization with insights learned from outside classical Western tradition was shared in the early twentieth century by Picasso, Matisse, and the German Expressionists. They adopted Gauguin's vision of the artist as spiritual leader who could select from the past anything capable of releasing the power of self-knowledge and inner life. For Gauguin art had become above all a means of communicating through symbols—a "synthesis," as he called it, of visual form carrying memory, feelings, and ideas.

In 1888 Gauguin completed THE VISION AFTER THE SERMON, a large, carefully designed painting that was the first major work in his new style. It is an image originating in the mind rather than the eye. With it, Gauguin took a major step beyond Impressionism. In order to avoid what he considered the distraction of implied deep space, he tipped up the

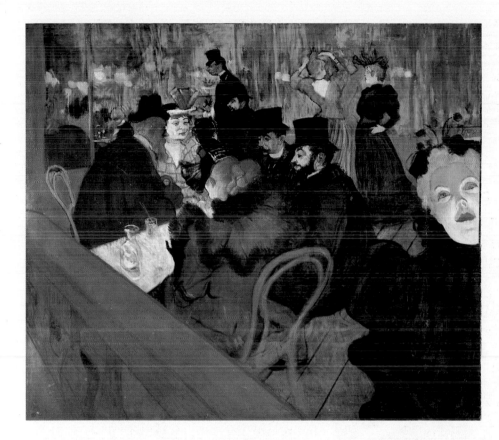

384
Henri de Toulouse-Lautrec.
AT THE MOULIN ROUGE. 1892.
Oil on canvas. 48 3/8" x 55 1/4".
The Art Institute of Chicago.

simplified background plane and painted it an intense "unnatural" vermilion. The entire composition is divided diagonally by the trunk of the apple tree, in the manner of Japanese prints. Shapes have been reduced to flat curvilinear areas outlined in black, with shadows minimized or eliminated. Jacob and the angel are shown as they appear to a group of Brittany peasants in a vision inspired by the sermon in their village church.

Gauguin's use of color had an important influence on twentieth-century painting. His views on color were prophetic. The subject, as he said, was only a pretext for symphonies of line and color.

In painting, one must search rather for suggestion than for description, as is done in music. . . . Think of the highly important musical role which colour will play henceforth in modern painting.[20]

Like van Gogh, Gauguin was highly critical of the materialism of industrial society. This attitude led him to admire the honest life of the Brittany peasants of Western France and then to try to break totally with European civilization by going to Tahiti (see pages 54 and 55).

Henri de Toulouse-Lautrec painted the gaslit interiors of Parisian nightclubs and brothels, frequently catching moments of deep human drama. His quick, long strokes of color define a world of sordid gaiety. In his painting AT THE MOULIN ROUGE, he used unusual angles, photographic cropping of images such as the face on the right, and expressive color to heighten our feelings about the people and the world he painted. His works, like those of Gauguin and van Gogh, influenced the later Expressionists.

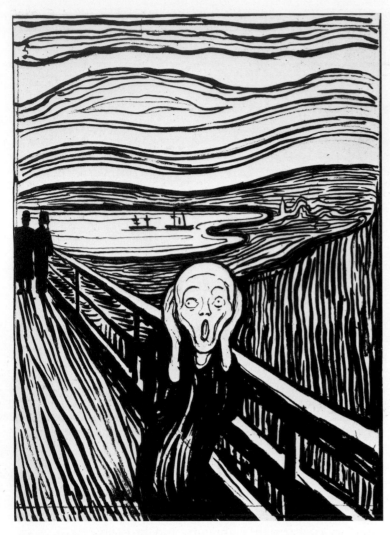

385 Edvard Munch.
THE SCREAM. 1896.
Lithograph, printed in black.
Sheet: 20⅝" x 15¹³/₁₆".
The Museum of Modern Art, New York.
Matthew T. Mellon Foundation Fund.

Another forerunner of Expressionism, Edvard Munch traveled to Paris from Norway to study and view the works of his contemporaries, especially Gauguin, van Gogh, and Toulouse-Lautrec. What he learned from them, particularly from Gauguin's works, enabled him to carry Expressionism to an even greater level of intensity.

His great theme, THE SCREAM, rendered as a painting and as a lithograph, is far from the pleasant delights of Impressionism and takes van Gogh's emotionalism considerably further. It is a powerful image of anxiety. The dominant figure is caught in complete isolation, fear, and loneliness. Despair, carried by continuous linear rhythms, reverberates throughout the picture.

Munch's powerful images explore depths of emotion—grief, loneliness, fear, love (see pages 114–117), sexual passion, jealousy, and death. Munch painted THE SCREAM in 1893, and in 1896 he completed the black-and-white lithograph reproduced here. In the isolated central figure we may see ourselves; THE SCREAM seems to herald a shared awakening to deeper levels of consciousness. This image has been called the soul-cry of our age.

The works of Munch and *naive* French painter Henri Rousseau show different personal expressions of the mysterious psychic world. Rousseau's THE SLEEPING GYPSY seems like a vivid dream. It presents a contradiction of wakeful and dream experience.

Rousseau was an untrained, so-called primitive painter, and not a member of the Paris art community. He did, however, capture the attention of many leading turn-of-the-century artists, including Picasso. Rousseau's naive purity, innate sense of design, imaginative use of color, and his taste for exotic subjects gave his paintings a mysterious magical reality.

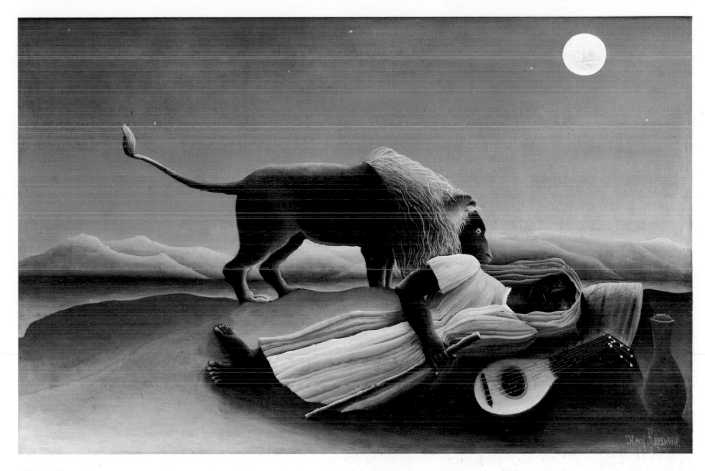

386 Henri Rousseau.
THE SLEEPING GYPSY. 1897.
Oil on canvas. 51" x 79".
The Museum of Modern Art, New York.
Gift of Mrs. Simon Guggenheim.

The invention of photography, with its ability to record appearances, strongly affected the direction of Western art in the second half of the 19th century. Artists renewed their perception of visual reality and sought a deeper reality as they broke away from tradition and from what they saw as the artificial idealism of officially recognized art. The fresh beginning in painting was full of joyous self-assurance, as seen in the optimistic mood of Impressionism. Yet the process of seeing the visual world anew brought with it unsought levels of awareness beyond the visible realm. The appearance of things came to be less important then the unseen relationship between viewer and reality. It became, once again, the artists' task to probe and reveal hidden worlds — to make the invisible visible. Increasing importance was given to the elements of form and to the formal structure of seen and invented imagery. Nature was internalized and transformed in order to portray a greater reality.

5

Art of Our Time: The 20th Century

In every age there is a turning-point, a new way of seeing and asserting the coherence of the world.

Jacob Bronowski[1]

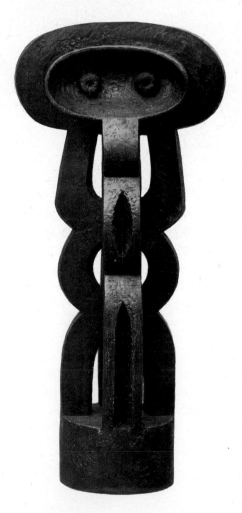

Jacques Lipchitz.
FIGURE.
(See page 362.)

Now that we are approaching the end of the twentieth century, it is fairly easy to identify certain dominant concerns among artists and to see characteristics in their work that reveal the unique features of our age. These features include rapid change, diversity, individualism, and exploration followed by abundant new discoveries. All of these have challenged and transformed the assumptions of the past, while expanding the limits of what we believe to be true and possible. The veritable explosion of new styles in this century follows this continuous challenge and reexamination of traditions. Yet the art we call modern today has its roots in many cultures going far back in time.

It may seem that "isms" soon become "wasms" as styles replace one another in rapid succession. The "isms" of art are terms for movements or styles that have been particularly significant. Such classifications help to define the concepts and characteristics of important trends. It is not our aim, however, merely to help you classify art forms. The goal of this chapter is to enable you to increase your understanding and enjoyment of the art of the recent past as well as the art of today.

The great diversity of group and individual styles that exists today makes meaningful generalizations both difficult and misleading. We are too close to the art of today to know which of it will have meaning for future generations. However, some terms and classifications are becoming well established and some names, applied to significant trends at their inception, are likely to remain.

During the first decade of this century Western views of reality underwent an irreversible upheaval. In 1903 the Wright brothers flew the first power-driven aircraft. In 1905 Albert Einstein changed Western concepts of time and space with his theory of relativity. Matter could no longer be considered solid; it was recognized as a field of energy. Great changes also occurred in art; as past assumptions were questioned new styles came forth in rapid profusion.

Art does not illustrate science but is a parallel creative development dedicated to investigating, revealing, and extending our knowledge and feelings about "reality." Artists went beyond the visible world to reveal inner worlds seen only in the mind. By so doing, twentieth century artists have challenged preconceptions regarding the nature of art in relation to life, and have made new levels of consciousness visible. In 1913 Russian artist Wassily Kandinsky described how deeply he was affected by the discovery of subatomic particles:

A scientific event cleared my way of one of the greatest impediments. This was the further division of the atom. The crumbling of the atom was to my soul like the crumbling of the whole world.[2]

The major transition in early twentieth-century art was the shift from representational to abstract and nonrepresentational art. Similar transitions have occurred in earlier periods. A comparison of THE KISS by Auguste Rodin (page 42) and THE KISS by Constantin Brancusi (page 43) shows the transition from nineteenth- to twentieth-century thinking. Rodin's work is quite naturalistic; Brancusi's is very abstract. Rodin was the great master of sculpture in the second half of the nineteenth century; Brancusi held the same position for the first half of the twentieth.

387 Constantin Brancusi.
SLEEPING MUSE. 1906.
Marble. 6½″ x 12″.
National Museum, Bucharest.

388 Constantin Brancusi.
SLEEPING MUSE. 1909–1911.
Marble. Height, 11½″.
Hirshhorn Museum and Sculpture Garden,
Smithsonian Institution, Washington, D.C.

389 Constantin Brancusi.
THE NEWBORN. 1915.
Marble. 6″ x 8½″.
Philadelphia Museum of Art.
The Louise and Walter Arensberg Collection.

Brancusi's development, like the new century itself, was revolutionary. His SLEEPING MUSE of 1906 has an appearance similar to Rodin's romantic naturalism. In the 1911 version of SLEEPING MUSE the subject was minimized as Brancusi moved from naturalism to abstraction. THE NEWBORN of 1915 has the refined simplicity of a powerful conception stripped to its essentials. Brancusi said, "Simplicity is not an end in art, but one arrives at simplicity in spite of oneself, in approaching the real sense of things."[3]

These three works span nine years of Brancusi's evolution toward the elemental form for which he is known. Seen together they illustrate the transition from representational to abstract art within the work of one individual.

The transition from naturalistic to abstract styles is bridged in another way by Gustav Klimt. In his painting THE KISS there is some of the abstract simplicity that we find in Munch's woodcut of the same name (see page 116), as well as some of the romantic realism we find in Rodin's sculpture. It is unusual to find naturalistic and abstract styles combined so effectively. The heads, hands, and feet are naturalistically portrayed, while the bodies are only suggested beneath a rich color pattern that is organized within simple shapes against a jewellike background.

390 Gustav Klimt.
THE KISS. 1908.
Oil on canvas. 71″ x 71″.
Osterreichische Galerie, Vienna.

THE EARLY YEARS: EXPRESSION, STRUCTURE, AND MOTION

Fauvism

Between 1901 and 1904 the works of Post-Impressionist artists including van Gogh, Gauguin, and Cézanne were exhibited in Paris. Henri Matisse was the leader of a group of young artists who were influenced by these Post-Impressionists. Matisse and others were also influenced by the brilliant colors, calligraphic brushwork, and flattened picture space of Islamic art. The European paintings that resulted shocked the public. A critic of their first show angrily referred to them as *les fauves* ("the wild beasts"). This pleased them greatly, and they adopted the name.

As a distinct style the movement the *Fauves* created lasted little more than two years (1905–1908), yet it was one of the most influential developments in twentieth-century painting. The Fauves extended the symbolic, expressionist color of Gauguin and van Gogh by completely freeing color from its traditional role of describing the natural appearance of an object.

391 Henri Matisse.
LANDSCAPE. Study for JOY OF LIFE. 1905.
Oil on canvas. 46 cm x 55 cm.
Royal Museum of Fine Arts, Copenhagen.
J. Rump Collection.

By so doing they led to an increasing use of color as an independent expressive element.

Henri Matisse, like most leading European painters, had early training in the representational academic style. His painting JOY OF LIFE is a major early work in his long career, and a key masterpiece of Fauvism. Pure hues vibrate across the surface.

A black-and-white reproduction of JOY OF LIFE can merely act as an invitation to see the original. The Barnes Foundation does not permit color reproductions of this painting, but the study Matisse made for JOY OF LIFE indicates the intense color of the final work.

Matisse's seemingly careless depiction of the figures is based on his knowledge of human anatomy and of drawing. The intentionally direct, childlike quality of the form serves to heighten the joyous content.

From 1908 until his death in 1954 Matisse alone remained close to the principles of Fauvism, yet he continued to transform Fauve ideas with his extraordinary sensitivity to the potential of color. His inventive paintings, drawings, and sculptures are among the strongest and most influential statements in modern art (see also pages 29 and 31).

392 Henri Matisse.
JOY OF LIFE. 1905–1906.
Oil on canvas. 68½" x 93¾".
The Barnes Foundation, Merion Station, Pennsylvania.
Photograph ©1985 by the Barnes Foundation.

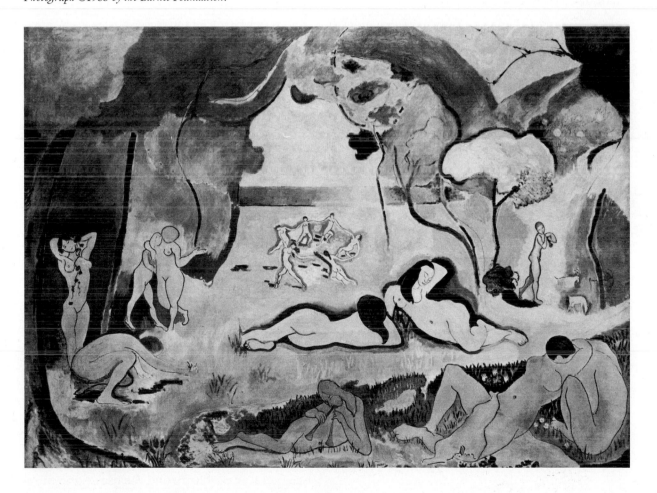

393 Georges Rouault.
HEAD OF CHRIST. 1905.
Oil on paper, mounted on canvas. 39″ x 25½″.
The Chrysler Museum, Norfolk, Virginia.
Gift of Walter P. Chrysler, Jr.

Expressionism

Throughout history there have been times when artists put more emphasis on revealing inner feelings than depicting outer appearances. Such art is characterized as "expressive." As with all such labels, "Expressionism" comes after the fact, and is relative, since all art is by nature expressive.

French Expressionist painter Georges Rouault exhibited with the Fauve group in 1905, but his religious conviction and great opposition to moral corruption and cruelty gave his work a distinctive form and purpose. For many, Rouault was the most important religious painter of this century. A devout Catholic, he has been called the "monk of modern art." As a young man he studied and worked in stained glass and was greatly influenced by the combination of black lead lines and transparent colors in medieval stained glass windows. His HEAD OF CHRIST shows a passionate empathy with the brutal suffering of Christ, evoked through thinly painted areas of strong color and the intense emotional energy of gestural lines.

German Expressionism refers to works by certain German artists who created art that was powerful, symbolic, and sometimes socially critical. Several groups and independent individuals were involved. These artists drew inspiration from many sources, including the work of Gauguin, van Gogh, and Munch, as well as medieval and Slavic folk art, African and Oceanic art, and, later, Fauve and Cubist ideas. The aim of the German Expressionists was to give relevant form to contemporary experience, and to express the vital essence of humanity and nature. Excitement over medieval German woodcuts led artists to resurrect this medium and use it extensively. Emil Nolde's woodcut THE PROPHET on page 144 is a characteristic example.

German Expressionist work frequently addressed moral issues as artists looked at poverty, corruption, loneliness, sorrow, and passion. Exaggerations of form and the use of unnatural

color gave their work an immediate emotional impact. The great range of German Expressionist feeling is seen in the terror and indignation of Otto Dix (page 432), the compassionate depictions of the poor and helpless by Käthe Kollwitz (pages 32 and 33), and the earthy strength of Paula Modersohn-Becker (page 79).

The German Expressionist movement of the early twentieth century was typified by two groups: the Bridge (*die Brucke*) and the Blue Rider (*der Blau Reiter*). Ernst Ludwig Kirchner, architecture student turned painter, was the founder of the Bridge. The group included several of his fellow architectural students, Emil Nolde, and others. They appealed to artists to revolt against academic painting and establish a new, vigorous aesthetic that would form a bridge between the Germanic past and modern emotion. They first exhibited as a group in 1905, which was also the year of the first Fauve exhibition.

Kirchner's painting STREET, BERLIN shows influence from Edvard Munch, African sculpture, and German Gothic art, as well as from Cubism. Kirchner's concern for expressing human emotion gave his work a quality similar to that which he admired in Munch. In his early paintings Kirchner employed the flat color areas of Fauvism, but by 1913 he had developed his own style based on the angularities of Cubism. In STREET, BERLIN elongated figures are crowded together with the use of repeated diagonal lines to create an atmosphere charged with energy. Emotions are heightened by dissonant colors, and rough, almost crude brushwork. Linear elements are set off by flat areas of intense color.

The Blue Rider group was led by Russian painter Wassily Kandinsky, who was more involved with formal theories than were the Bridge painters. Kandinsky lived in Munich between 1908 and 1914, and shared with his German associates a concern for developing an art that would turn people away from false values toward a path of spiritual rejuvenation. He was one of the outstanding innovators in the history of art. Kandinsky's revolutionary

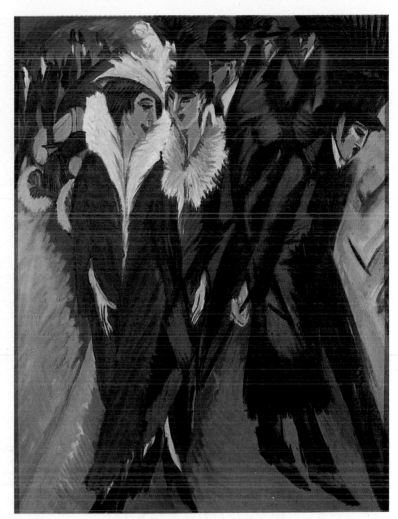

394 Ernst Ludwig Kirchner.
STREET, BERLIN. 1913.
Oil on canvas, 47¹/₂″ x 35⁷/₈″.
The Museum of Modern Art, New York. Purchase.

nonfigurative works played an important role in the development of subsequent nonobjective styles. Paul Klee, Georges Braque, and Picasso exhibited with the group in its second show in 1912. Both the Bridge and the Blue Rider groups were largely dispersed by the devastation of World War I.

Hitler's accession to power finally destroyed German Expressionism. Many of the leading artists had already left the country by then. The Bauhaus, the most influential art school of the twentieth century, was closed by the Nazis in 1933. In 1938 about 5000 paintings and sculp-

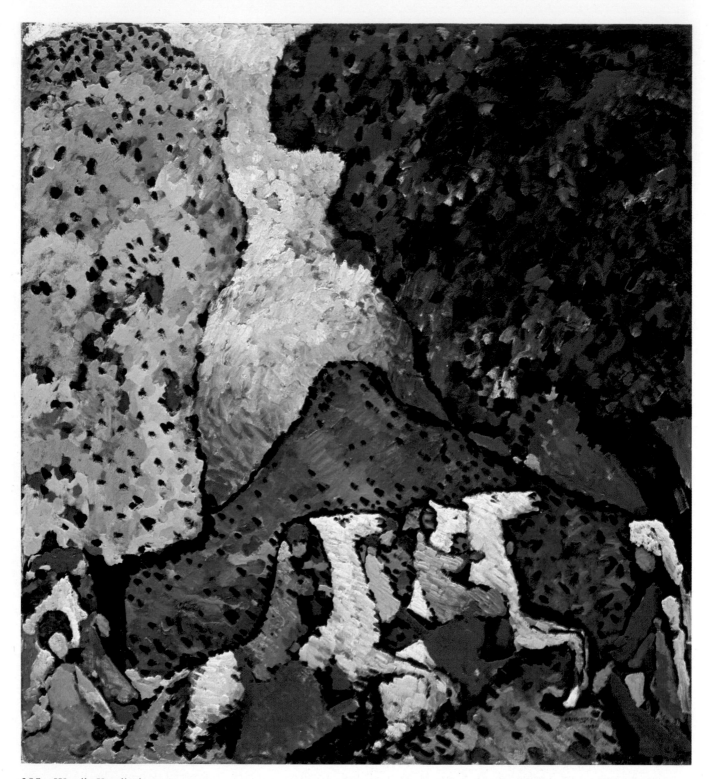

395 Wassily Kandinsky.
BLUE MOUNTAIN. 1908.
Oil on canvas. 42″ x 38½″.
The Solomon R. Guggenheim Museum, New York.

tures and 12,000 prints and drawings were confiscated. Many of the works were sold to foreign museums and collectors by the financially desperate Nazi government. Those not sold or "lost" by 1939 were destroyed. After World War II strong expressionist movements, very different from German Expressionism, emerged in Europe and the United States.

Kandinsky's paintings evolved toward an absence of representational subject matter. He believed that a painting should be "an exact replica of some inner emotion."[4] In BLUE MOUNTAIN, painted in 1908, he created a "choir of colors"[5] influenced by the vivid color of the Fauves. Figures on horseback move through a colorful, imaginary landscape, calling our attention to the pure enjoyment of visual form.

By 1910 Kandinsky had made the major shift to totally nonrepresentational painting in order to concentrate on the expressive potential of form freed from associations with subject matter. Kandinsky stated that the content is "what the spectator *lives* or *feels* while under the effect of the *form and color combinations* of the picture."[6] His purpose was not simply aesthetic. Kandinsky saw his nonrepresentational paintings as a way to lead through an impending period of major catastrophes to a great new era of spirituality.

Kandinsky's efforts were aimed at freeing painting from representation, and in this he sought a visual expression comparable to that which he enjoyed in music. Music does not have to represent something to be enjoyed. In fact, representational music is rare. We enjoy music because of the rhythms, melodies, and harmonies it contains.

By calling his painting WITH THE BLACK ARCH, NO. 154 Kandinsky referred to the dominant visual element in the painting. It is similar to a composer naming a composition "Symphony No. 2 in D Major." Weightless curves float across large free shapes in a painted world of interactive energies.

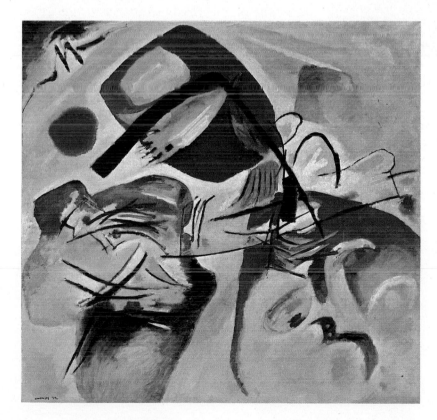

396 Wassily Kandinsky.
WITH THE BLACK ARCH NO. 154. 1912.
Oil on canvas. 74″ x 77⅛″.
Centre Pompidou, Paris.
©ADAGP, Paris 1985.

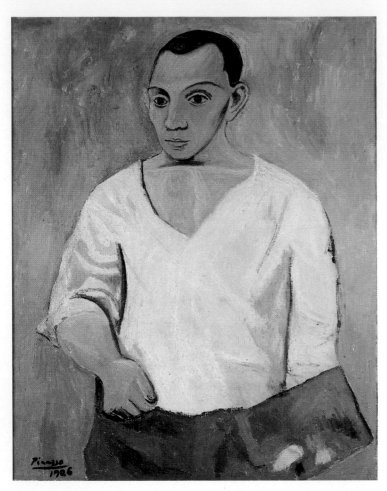

397 Pablo Picasso.
SELF-PORTRAIT WITH PALETTE. 1906.
Oil on canvas. 36¼" x 28¾".
Philadelphia Museum of Art.
The A. E. Gallatin Collection.

Cubism and Its Influence

Pablo Picasso and Georges Braque pursued investigations that led to *Cubism,* the most influential movement of the early twentieth century. It is interesting to trace Picasso's artistic development to see how he came to this break with tradition.

Aided by the careful instruction of his artist father, Picasso mastered basic techniques of representational drawing and painting by the time he was 15 years old. By 1901, when he was 20, he had assimilated the influences of Post-Impressionist painters such as Toulouse-Lautrec, Degas, Gauguin, and van Gogh. Between 1901 and 1904 he painted the poor and suffering people who were his neighbors in blue tones that created a mood of deep sadness. By 1905 a softer, more optimistic feeling appeared in his work. Picasso began painting circus people rather than the destitute. Tints and shades of warm, delicate reds replaced somber blues. Even in the black-and-white drawing of the circus woman and her infant (see page 47), the gentle, lyrical quality of this period is apparent.

The year that Matisse completed JOY OF LIFE (page 347), Pablo Picasso painted SELF-PORTRAIT WITH PALETTE which had a unique quality of simplicity not seen before in his work. At 25 Picasso became fascinated with art forms from outside the Greek and Renaissance traditions of representational accuracy, particularly with the African and Oceanic sculpture Gauguin and the Fauves had "discovered." His SELF-PORTRAIT WITH PALETTE is built with boldly simplified curving lines and planes. There is a new abstract flatness to the design, giving the painting a powerful expressiveness.

Picasso absorbed influences quickly, keeping only what he needed to achieve his objectives. The small painting DANCER was one of several studies made for his monumental, breakthrough painting, LES DEMOISELLES D'AVIGNON. Both show the radical departure Picasso made from tradition. Rejecting the accepted European notion of ideal "beauty," he based his work on the inventive abstraction, vitality, and raw power he admired in African sculpture. He also drew

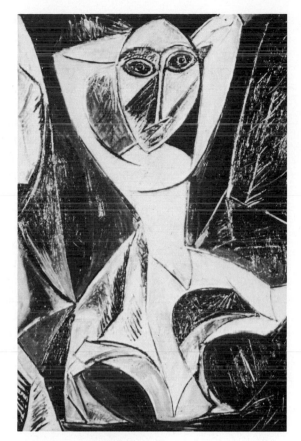

398 Pablo Picasso.
DANCER. 1907.
Oil on canvas, 59" x 39¼".
Private collection.

399
CHIEF'S STOOL.
Probably 19th century.
Wood. Height 21".
From Baluba, Belgian
Congo.
Museum of Man, Paris.

400
BAKOTA FUNERARY FIGURE.
Probably 20th century.
Brass sheeting over wood. Length 70.4 cm.
From French Equatorial Africa.
Smithsonian Institution, Washington, D.C.
Herbert Ward Collection.

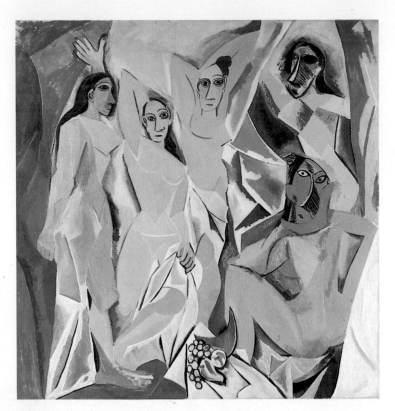

401 Pablo Picasso.
LES DEMOISELLES D'AVIGNON. 1907.
Oil on canvas. 8′ x 7′8″.
The Museum of Modern Art, New York.
Acquired through the Lillie P. Bliss Bequest.

inspiration from El Greco's integration of figure and ground shapes (see page 305), the archaic simplicity of the pre-Christian Iberian sculpture of Spain, and the flattened angular planes of Cézanne's paintings (see page 334).

It was probably his equal emphasis on figure and ground and his willingness to reinterpret ordinary visual reality in order to strengthen pictorial reality that attracted Picasso to El Greco and Cézanne. His new approach astonished even his closest friends. Georges Braque, who did as much as Picasso to develop Cubism, was appalled when he first saw LES DEMOISELLES D'AVIGNON in 1907. Braque commented, "You may give all the explanations you like, but

your painting makes one feel as if you were trying to make us eat cotton waste and wash it down with kerosene."[7]

In LES DEMOISELLES D'AVIGNON the fractured, angular figures merge with the sharp triangular shapes of the ground, activating the entire picture surface. This reconstruction of image and ground, suggesting shifting planes, was influenced by Cézanne's ideas about forms in space. A large retrospective exhibition of Cézanne's work was held in Paris in 1906, the year before Picasso completed this painting.

Cézanne combined direct observation of nature with a way of working based on a new respect for the flat character of the picture plane. European painters since the fifteenth century had been judged on their ability to give the illusion of actual depth on flat surfaces. Now this basic premise was challenged. The beauty and integrity of the surface itself was reaffirmed. Painters in Europe thus rejoined the majority of the world's artists who have worked on flat surfaces without any compulsion to produce the illusion of "real," three-dimensional space.

Manet, Cézanne, and the Post-Impressionists led the way toward abstraction and the idea of a painting as an independent object with its own life. Picasso and many others carried the idea even further. A comparison between Cézanne's painting of a hill town, finished in 1886, and Picasso's painting of a similar subject done in 1909, 23 years later, shows the progression from Cézanne's Post-Impressionist style to the Cubist style developed by Picasso and Braque. Cézanne's late work was an important influence on Cubism, but Braque and Picasso were not colorists as Cézanne was. While Cézanne's paintings were structured with color, the Cubists sought an inner structure apart from color.

Braque combined an understanding of African sculpture with Cézanne's planes and Picasso's figure and ground interaction in HOUSES AT L'ESTAQUE (page 94), one of the first Cubist paintings and the impetus for the move-

402 Paul Cézanne.
GARDANNE. 1885–1886.
Oil on canvas. 31½″ x 25¼″.
The Metropolitan Museum of Art, New York.
Gift of Dr. and Mrs. Franz H. Hirchland (1957).

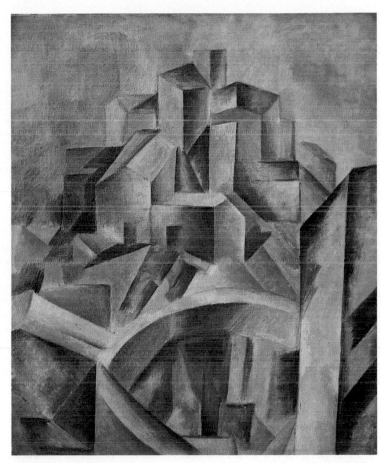

403 Pablo Picasso.
MAISONS SUR LA COLLINE
(HOUSES ON THE HILL),
HORTA DE EBRO. 1909.
Oil on canvas. 31⅞″ x 25¼″.
Private collection.

ment's name. When Matisse first saw this painting he declared it to be a bunch of little cubes. This observation is not descriptive of the style, but before long the term Cubism had become the official name of the movement.

From 1908 to 1914 Braque and Picasso were equally responsible for bringing Cubism to maturity as the most revolutionary change in art since early Renaissance linear perspective. The Cubists were convinced that the pictorial space on the flat plane of a two-dimensional surface was unique—a form of space quite different from natural space. Natural objects were a point of departure for abstract images, demonstrating the realization of the essential unity of forms with the space that surrounds and penetrates them. Cubism is a re-creation of objects in space, based on perceptions of mental

and visual geometry. By looking first at Cézanne's GARDANNE, then at Picasso's MAISONS SUR LA COLLINE, and then at DANIEL HENRY KAHNWEILER (see next page), we can see a progression in which the forms seem to come forward toward the picture plane, then finally spread almost flat across the surface. Cubism, above all, was a reinvention of pictorial form that provided the foundation for most of the significant art of this century.

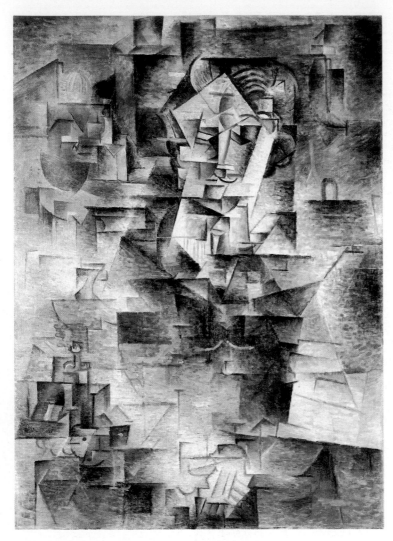

404 Pablo Picasso.
PORTRAIT OF DANIEL HENRY KAHNWEILER. 1910.
Oil on canvas. 39½″ x 28⅝″.
The Art Institute of Chicago.
Gift of Gilbert W. Chapman.

By 1910 Cubism was a fully developed style. Picasso's portrait of art dealer DANIEL HENRY KAHNWEILER is a fine example of what is sometimes referred to as *Analytical Cubism*. The word "analytical" is appropriate because in this phase of Cubism, artists spent a great deal of time analyzing their subjects. Numerous drawings were done from different points of view. These formal studies provided a basis for multiple views of the subject that were spread out, covering the surface with interwoven geomet-

ric planes that often seem both opaque and transparent. Figure and ground became one.

In order to concentrate on the abstract reconstruction of the subject, Picasso and Braque used a limited range of neutral tones. Strong color would be entirely out of place in these intellectual translations of three-dimensional form. Restrained color was a way of emphasizing formal structure. In its emphasis on analysis and structure, Cubism is a rational, formalist counterpart to the subjective emphasis of the Fauves and other Expressionists.

As Picasso and Braque took the steps that led to Cubism, American photographer Alfred Stieglitz was also reconsidering the geometry of design on the picture plane. When Picasso saw Stieglitz's photograph THE STEERAGE he said, "This photographer is working in the same spirit as I am."[8]

THE STEERAGE looked "chopped up" to many people. Some of the artist's friends felt that it should have been two photographs, rather than one. But Stieglitz saw the complex scene as a pattern of interacting forces of light, shade, shape, and direction. Aboard a ship headed for Europe, he saw the composition of this photograph as "a round straw hat, the funnel leaning left, the stairway leaning right, the white drawbridge with its railings made of circular chains, white suspenders crossing on the back of a man on the steerage below, round shapes of iron machinery, a mast cutting into the sky, making a triangular shape. . . . I saw a picture of shapes and underlying that the feeling I had about life."[9] He rushed back to his cabin to get his camera, hoping the composition would remain. It had, and he made the photograph, which he considered to be his best.

Stieglitz succeeded in establishing photography as an art of comparable importance to more traditional media. He also played a major role in introducing contemporary European drawing, painting, and sculpture to America. In 1907 he opened a gallery in New York, and began showing the work of the most progressive artists, including photographers. He was the first in America to show works by Cézanne,

Matisse, Brancusi, Picasso, and Braque. Following the exhibition of work by these pioneers, Stieglitz began to show work by leading American artists, including John Marin (see page 135) and, later, Georgia O'Keeffe (see page 383).

Between 1905 and 1910, as traditional concepts of form in space were being challenged in sculpture, painting, and photography, they were also being transformed in architecture. While Cubism was developing in painting, leading American architect Frank Lloyd Wright was designing "prairie houses" in which walls between rooms and between interior and exterior spaces were removed. Wright invented the "open plan," which has changed the way people live.

In the ROBIE HOUSE of 1909 a striking cantilevered roof reaches out and unifies a fluid spatial arrangement of asymmetrically interconnected spaces in the rooms below. Through Wright's influence interpenetrating geometric masses and spaces became a basic tenet of contemporary architecture. To get a feeling of how far ahead of his time Wright was, imagine the incongruity of the new 1909 horseless carriage that could have been parked in front of the house the year it was completed.

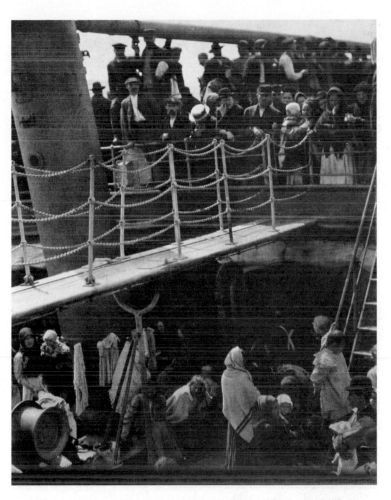

405 Alfred Stieglitz.
THE STEERAGE. 1907.
Photogravure (artist's proof)
from *Camera Work,*
No. 36, 1911.
Size of print: 7³/₄" x 6¹/₂".
*The Museum of Modern Art,
New York. Gift of the artist.*

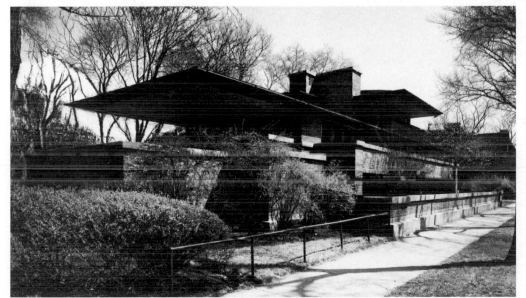

406 Frank Lloyd Wright.
ROBIE HOUSE. Chicago, 1909.

When Picasso constructed his GUITAR out of sheet metal and wire in 1911 or 1912, he began what has become a dominant trend in twentieth-century sculpture. Before GUITAR, most sculpture was carved from stone or wood, or modeled in clay or wax and later cast in metal. Since GUITAR, much of contemporary sculpture has been created by construction methods. Thus GUITAR was a radical break with traditional sculpture, in material as well as form and technique.

In 1912 Picasso and Braque modified Analytical Cubism with textural surfaces, flat cut-out shapes, and use of rich color. This painting style was later called *Synthetic Cubism*. As well as representing surfaces with paint, actual two-dimensional objects were often used. Pieces of newspaper, sheet music, wallpaper, and similar items came into the work—not represented, but actually present. The newspaper in THE VIOLIN is really part of a Paris newspaper. The shapes created by the exposed ground have

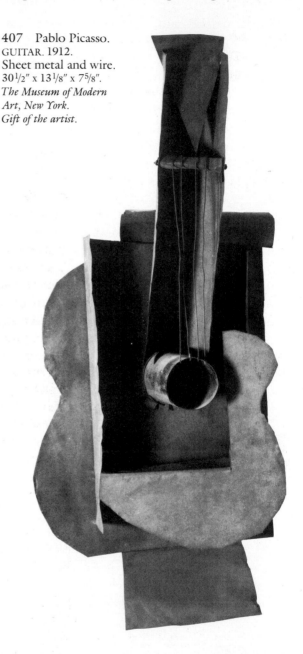

407 Pablo Picasso.
GUITAR. 1912.
Sheet metal and wire.
30 1/2″ x 13 1/8″ x 7 5/8″.
The Museum of Modern Art, New York.
Gift of the artist.

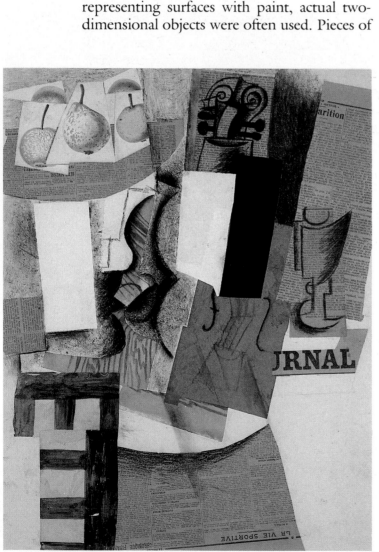

408 Pablo Picasso.
THE VIOLIN (VIOLIN AND FRUIT). 1913.
Paper, charcoal, gouache on paperboard. 25 1/2″ x 19 1/2″.
Philadelphia Museum of Art.
The A. E. Gallatin Collection.

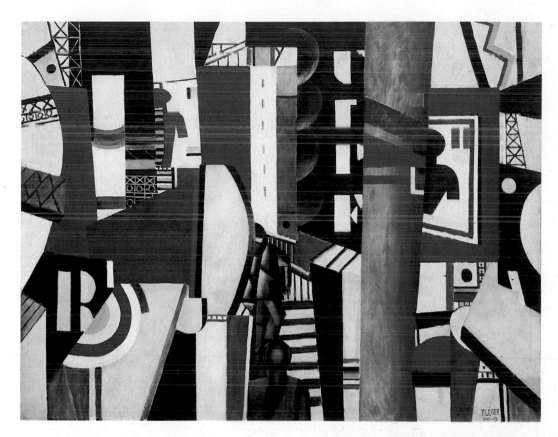

409 Fernand Léger.
THE CITY. 1919.
Oil on canvas,
90³/₄" x 117¹/₄".
Philadelphia Museum of Art.
The A. E. Gallatin Collection.

410
REFLECTIONS. 1972.
Photograph.

been made into major foreground elements; ground becomes figure. Picasso chose traditional still life objects, but rather than draw or paint the fruit he cut out and pasted printed images of fruit. Such compositions were called *papier collé* in French and later became known as *collage* in English.

After the original analytical phase of Cubism, many painters adopted its basic spatial concept. One was Fernand Léger. In his painting THE CITY he used Cubist overlapping planes in compact, shallow space to depict the rhythms and complexity of modern city life.

In today's cities the buildings, signs, people, and traffic crowd together between reflective surfaces in a giant assemblage of overlapping, disjointed forms. To the eye, these phenomena join in a collage experience that is part of the same spatial awareness explored by Cubism. Cubism has given us a relevant way of experiencing the world in which we live.

411 Lyonel Feininger.
THE GLORIOUS VICTORY OF THE SLOOP "MARIA." 1926.
Oil on canvas. 21½" x 33½".
The St. Louis Art Museum.
Purchase: Eliza McMillan Trust Fund.

Lyonel Feininger's painting of sailboats racing in open water, THE GLORIOUS VICTORY OF THE SLOOP "MARIA," shows strong Cubist influence. Geometric shapes, mostly triangles, move over the surface, woven into strong unity by straight lines of force that run from edge to edge across the picture plane. Size difference in the sails adds to the illusion of depth.

THREE MUSICIANS by Picasso is created in the flat, decorative style of Synthetic Cubism. Its form is heavily influenced by the cutout shapes of Cubist collages. Two of the life-size figures are the traditional characters of French comedy—Pierrot, in white, playing a recorder, and brightly costumed Harlequin in the center, playing a guitar. The third figure wears a black monk's habit and a veiled mask, and sings from the sheet of music he holds. Behind the trio a black dog lies with tail raised. Although abstract, the figures have a real presence. The work is solemn, yet whimsical.

Many historians find Picasso's work difficult to deal with because he shifted from style to style, using one approach and then another. THREE MUSICIANS was painted by Picasso at the same time he was working with the style and subject matter of Greece and Rome, creating figures that had the solid appearance of classical sculpture (see YOUNG MAN'S HEAD, page 80). Yet now, as we look back over his career, we see the dramatic shifts in attitude as parts of Picasso's fantastic inventive ability.

412 Pablo Picasso.
THREE MUSICIANS. 1921.
Oil on canvas. 6' 7" x 7' 3¾".
The Museum of Modern Art, New York.
Mrs. Simon Guggenheim Fund.

For sculptor Jacques Lipchitz, "Cubism was essentially a search for a new syntax."[10] He came to Paris from Poland just as the style was developing. His larger-than-life-size FIGURE of the late 1920s, however, is not simply Cubist. The large piece has an awe-inspiring presence and the power we might expect to find in a figure from Africa or the South Pacific. Here the power comes from Lipchitz' sense of his own time. The figure appears as a symbol of humanity in the twentieth century. (Compare Lipchitz' sculpture with Munch's print THE SCREAM on page 340.) A viewer asked Lipchitz to explain his work. "It wouldn't help you," the sculptor answered. "If I were to explain it in Chinese, you would tell me you didn't know Chinese, and I would tell you to learn Chinese and you will understand. Art is harder than Chinese. Anyone can look—you have to learn to see."[11]

413 Jacques Lipchitz.
FIGURE. 1926–1930.
Bronze (cast 1937). 7'1¼" x 38⅝".
The Museum of Modern Art, New York.
Van Gogh Purchase Fund.

Suprematism, Constructivism, De Stijl, and International Style

In 1913 the Russian painter Kasimir Malevich exhibited "nothing more or less than a black square on a white background. . . . It was not just a square I had exhibited," he explained, "but rather the expression of nonobjectivity."[12] Malevich conceived this work as the touchstone of a new movement which he christened "Suprematism," based on a system of "totally pure" geometric abstraction derived from Cubism. The name *Suprematism* comes from Malevich's attitudes toward the supremacy of pure feeling as generated by the most elemental relationships of visual form. He based his work on geometric form and made the painting itself the subject. In later works, such as AIRPLANE FLYING of 1914 and WHITE ON WHITE of 1918 (see page 61), Malevich made significant visual statements relying on minimal means.

By 1922 the Suprematist movement began to have strong influence on European art. Malevich visited the Bauhaus school of fine and applied art in Germany in 1926, and his book *The Non-Objective World* was published there in 1927. Through the Bauhaus these new ideas influenced modern architecture and nearly all areas of design, including graphic, interior, and fabric design.

Constructivism was a revolutionary sculptural movement that began in Russia at the same time Suprematism developed in painting. Vladimir Tatlin was the original leader of this group of Russian sculptors. Tatlin visited Picasso's studio during a visit to Paris in 1913, and there saw Cubist constructions similar to Picasso's GUITAR. These works made of wood, cardboard, sheet metal, and wire were an inspiration to Tatlin, who sought to create art that was relevant to modern life in material, form, and content. Tatlin adopted Picasso's concept but rejected Picasso's subject matter, and began making the first nonobjective sculptural constructions.

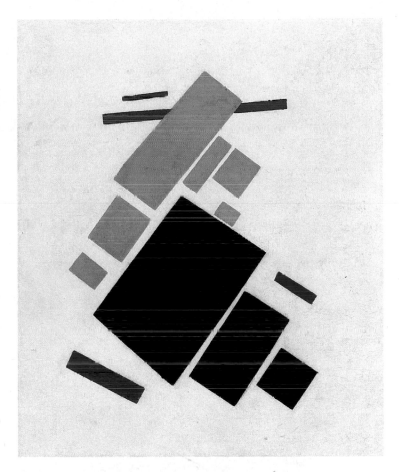

414 Kasimir Malevich.
SUPREMATIST COMPOSITION:
AIRPLANE FLYING. 1914.
Oil on canvas, 22⅞" x 19".
The Museum of Modern Art. New York. Purchase.

415 Vladimir Tatlin.
Replica of the model of the
MONUMENT TO THE THIRD
COMMUNIST INTERNATIONAL.
Original model built in 1920.
Photograph: Boulat.

The Constructivists were in concert with the Cubists in rejecting the traditional idea that sculpture is a static volume defined by mass and created by modeling and carving. The name of the movement came from their preference for constructing planar and linear forms that incorporated a dynamic quality and, whenever possible, contained kinetic elements.

In 1919, two years after the Russian Revolution, Tatlin was commissioned to design a MONUMENT TO THE THIRD COMMUNIST INTERNATIONAL. The result was a model for a slanting tower designed to be made of iron and glass, and reaching a height of 1300 feet. Due to economic and political problems, the monument was never built. It was to be a symbol of twentieth-century technology, and a metaphor for the dynamism of change and revolutionary progress in Russia. The glass units of various shapes were to house meeting rooms that would revolve at different speeds, making complete revolutions once a day, once a month, and once a year.

By 1920 Tatlin and his followers had become increasingly insistent that art had to serve a social purpose—and in Russia that meant that art must work for the Revolution in a practical sense. They felt that artists should devote themselves to engineering and industrial design.

Naum Gabo and his brother, Anton Pevsner, had joined the movement in 1917, the year the Russian Revolution began. After the Revolution there was a split among the Constructivists; Gabo and his group believed that artists should have the freedom to experiment, unimpeded by public pressure and government restriction.

The *Realist Manifesto,* written by Gabo and Pevsner in 1920, stated the rationale behind Constructivist aesthetics and ideas. One section reads:

We free ourselves from the thousand-year-old error of art, originating in Egypt, that only static rhythms can be its elements. We proclaim that for present day perceptions the most important elements of art are the kinetic rhythms.[13]

Few of Gabo's constructions actually employed movement. His works concentrated on space by minimizing mass. Gabo's SPACE CONSTRUCTION C, made entirely of clear plastic, is an example of art based on the dynamics of space and time.

Gabo felt that the *Manifesto* was a summary of what his group was doing, rather than an agenda or doctrine. His writing supported the conviction that the nonobjective paintings and constructions of the group constituted a new reality based on ideas and forms that they felt were more real than works of art that imitated the visual aspects of nature. The document clarifies the issues and concerns with which painters and sculptors had been working since the beginnings of Cubism.

In the early 1920s, when the Russian government decided to tolerate only art that could be understood by the masses, many artists, including Gabo and Kandinsky, left Russia. They realized that, in order to develop freely and promote their ideas, they must work elsewhere. As a result, these Constructivist artists were able to make a major contribution to international sculpture, architecture, industrial design, and to a lesser degree, painting.

Another of the many movements inspired by the logic of Cubism was *De Stijl* (the Style), led by Dutch painter Piet Mondrian. Mondrian gradually went beyond references to subject matter until he arrived at an austere personal style based on the beauty of basic visual relationships (see pages 36 to 38). Between 1910 and 1916 Mondrian did his paintings in sequence, starting with sketches of trees and landscapes, then gradually transforming them into abstract, formal relationships. His personal philosophy of life led him to search for an art that was collective, impersonal, and international. In this, his search for absolute form was the rational opposite of Kandinsky's personal expressionism.

416 Naum Gabo.
SPACE CONSTRUCTION C. c. 1922.
Plastic. 39″ x 40″.
Yale University Art Gallery.
Gift of Katherine S. Drier
for the Collection Société Anonyme.

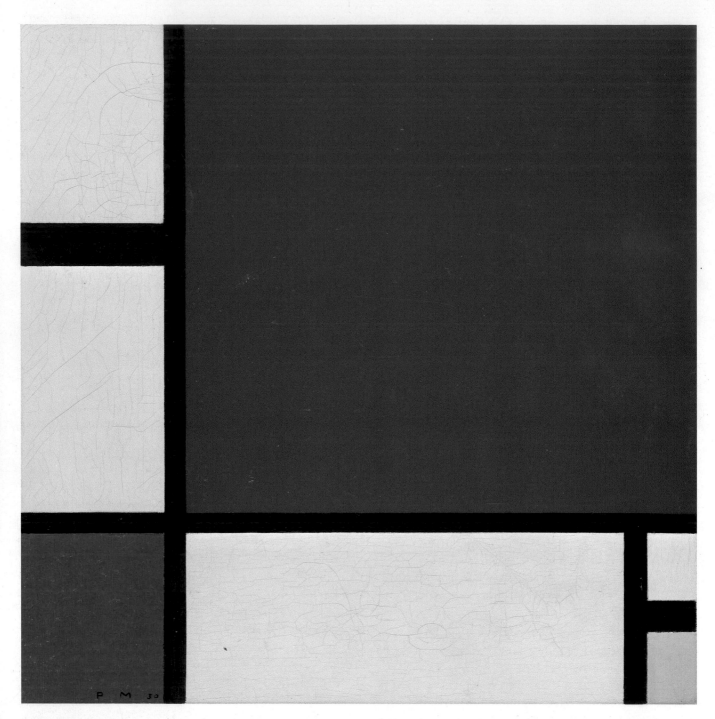

417 Piet Mondrian.
COMPOSITION WITH RED, YELLOW, AND BLUE. 1930.
Oil on canvas. 19″ x 19″.
Private collection.

When he painted HORIZONTAL TREE (page 37) Mondrian concentrated on the rhythmic curves of the branches and on the patterns of the spaces between the branches. He became increasingly aware of the strong expressive character of simple horizontal and vertical lines, defining rectilinear shapes.

From 1917 until his death in 1944, Mondrian was a leading spokesman for a pure art reflecting universal order.

The new art has continued and culminated the art of the past in such a way that the new painting, by employing "neutral," or universal forms, expresses iself only through the relationships of line and color.[14]

For Mondrian, these universal elements were straight lines and primary colors. He reduced painting to four elements—line, shape, color, and space. COMPOSITION WITH RED, YELLOW, AND BLUE, completed in 1930, exemplifies his mature style.

In 1940 Mondrian left Europe for New York, where he spent the last four years of his life. New York was a joy to him because it seemed a celebration of human achievement. He was fascinated by the geometric, technological world, its neon lights, and especially the staccato rhythms of American jazz. He loved to dance; and his enthusiasm, along with his new environment, gave his final paintings, such as BROADWAY BOOGIE-WOOGIE, a pulsing rhythmic energy unlike the simple harmonics of his earlier works. Mondrian's spiritual mind took him beyond the contradictions of modern life which he seemed to embrace. His paintings are icons of elemental harmony, designed to encourage awareness of universal truth.

The search for a language of pure visual form was carried on by architects as well as painters after 1910. Concepts of form developed by Frank Lloyd Wright, the Cubist painters, and the De Stijl artists were carried further by later architects who were stimulated by new structural possibilities of modern ma-

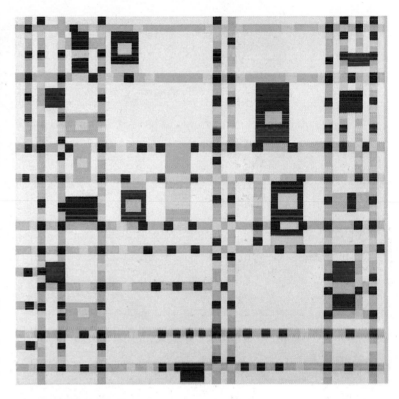

418 Piet Mondrian.
BROADWAY BOOGIE-WOOGIE. 1942 1943.
Oil on canvas. 50″ x 50″.
The Museum of Modern Art, New York.
Given anonymously.

terials including steel, glass, and reinforced concrete.

About 1918 a new style of architecture began to be developed simultaneously in Germany, France, and the Netherlands. Thus it came to be known as the *International Style*. Steel frame curtain-wall construction methods made it possible to build structures characterized by undecorated rectilinear planes that emphasize and define space. Extensive use of glass in non-load-bearing exterior walls provides abundant light to interiors. In many International Style buildings, particularly early ones, an overall asymmetrical design creates a dynamic balance of voids and solids. In contrast to Frank Lloyd Wright, architects working in the International Style consciously separated nature and manufactured forms.

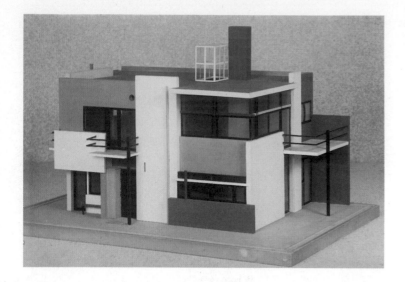

419 Gerrit Rietveld.
MODEL OF THE SCHRÖDER HOUSE. 1923–1924.
Glass and wood. 17³/₈″ x 28³/₈″ x 19¹/₄″.
Stedelijk Museum, Amsterdam.

Dutch architect Gerrit Rietveld was closely associated with Mondrian and De Stijl. His SCHRÖDER HOUSE in Utrecht was an early classic of the International Style. Its design of interacting planes and spaces and use of primary color accents is most clearly seen in the model pictured here.

In 1919 architect Walter Gropius founded the Bauhaus in Weimar, Germany. The school's major goal was to reunite all the arts, particularly the fine and applied arts, under the guiding principles of architecture. Among the leading artists who accepted invitations to teach at the Bauhaus were Klee and Kandinsky. Suprematist, Constructivist, and De Stijl ideas of "pure" geometric abstraction, free of extraneous narration and emotional expression, became central to the Bauhaus philosophy.

Pressure from conservative forces of Weimar society forced the Bauhaus to move to Dessau in 1925. The new International Style buildings, designed by Gropius (see page 209), clearly reflect the concepts of both De Stijl and Constructivism. The spare, functional style that the Bauhaus helped to initiate can still be seen in the design not only of buildings, but also of books, interiors, clothing, and many other articles of daily life.

In France the principles of the International Style of architecture were basic to the early work of leading architect, city planner, and painter Charles Edouard Jeanneret, known by the pseudonym Le Corbusier. He was compar-

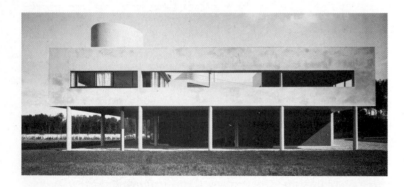

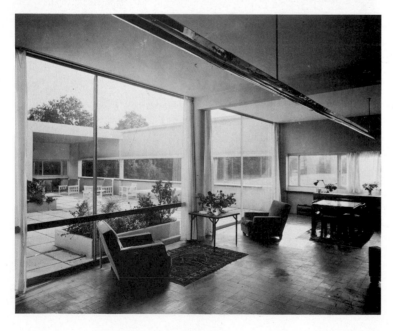

420 Le Corbusier.
VILLA SAVOYE. 1928–1930.
Poissy, France.
a Exterior.
b Interior.

able in stature to Frank Lloyd Wright, and was another major figure in the development of twentieth-century architecture. His most significant early work is the VILLA SAVOYE at Poissy, France, built during 1928–1930. The second-floor living area seems to float on slender reinforced-concrete columns above a smaller, deeply recessed entrance and service area on the ground. A private interior terrace opens to the sky on the upper level, joined to the living room by floor-to-ceiling panels of glass plate, a new idea that is now common in contemporary homes. Le Corbusier called the houses he designed "machines for living."

Futurism and the Celebration of Motion

The Italian *Futurists* were among the many artists who gained initial inspiration from Cubism. They established their interest in the importance of motion and mechanization several years before the Russian Constructivists came to parallel, yet contrasting, conclusions. To the shifting planes and multiple vantage points of Cubism, Futurists such as Giacomo Balla (see page 99) and Umberto Boccioni added a sense of speed, motion, and a celebration of the machine.

In multiplying the image of a moving object, Futurism expanded the Cubist concepts of simultaneity of vision and metamorphosis. In 1909 Marinetti, a poet, proclaimed in the *Initial Manifesto of Futurism:* "the world's splender has been enriched by a new beauty; the beauty of speed . . . a roaring motorcar . . . is more beautiful then the ["Winged Victory"].[15]

The Futurists translated the speed of modern life into works that captured the dynamic energy of the new century. In spite of their statements about the beauty of technology, even war machinery, much Futurist work is based on the dynamics of human figures and animals.

Italian Futurist painter and sculptor Umberto Boccioni climaxed a series of sculptures,

421 Umberto Boccioni.
UNIQUE FORMS OF CONTINUITY IN SPACE. 1913.
Bronze (cast in 1931).
43$^7/_8$" x 34$^7/_8$" x 15$^3/_4$".
The Museum of Modern Art, New York. Acquired through the Lillie P. Bliss Bequest.

paintings, and drawings with a highly abstract depiction of a striding figure. Boccioni insisted that sculpture should be released from the usual confining outer surfaces in order to open up and fuse the object with the space surrounding it. In UNIQUE FORMS OF CONTINUITY IN SPACE muscular forms seem to leap outward in spiraling, flamelike bursts of energy symbolizing the dynamic quality of modern life. During this period human experience was transformed by the development of the automobile, the airplane, and the movies.

In 1912, at the age of 16, French photographer Jacques Lartigue took one of many excellent photographs of his father and friends participating in the excitement of the new technological age. Lartigue's enthusiastic observation of the world around him led him to capture memorable and often humorous images of life in motion. The distortions that heighten the effect of motion in Lartigue's GRAND PRIX OF THE AUTOMOBILE CLUB OF FRANCE were caused by the mechanics of the camera's shutter combined with the photographer's movement of the camera to follow the action. His technique and attitude influenced later masters of the more recently developed small camera, such as Cartier-Bresson (page 111), who lifted "decisive moments" out of the broad spectrum of human lives.

French artist Marcel Duchamp and the Futurist painters of Italy independently brought the dimension of motion to Cubism. Since their pioneering efforts, many artists of this century have continued to create a sense of energy, movement, and rhythm while revealing the invisible continuity of things in motion.

Duchamp's NUDE DESCENDING A STAIRCASE was in part inspired by "chronophotographs" of physiologist Etienne-Jules Marey. Superimposed sequential images photographed by Marey showed each phase of movement related to all other phases of the same action, and revealed the patterns of things in motion.

In one of Marey's books, I saw an illustration of how he indicated people who fence, or horses galloping, with a system of dots delineating the different movements. That's how he explained the idea of elementary parallelism. . . . That's what gave me the idea for the execution of the "Nude Descending a Staircase." I used this method a little in the sketch, but especially in the final form of the picture. . . . At the same time, I retained a lot of

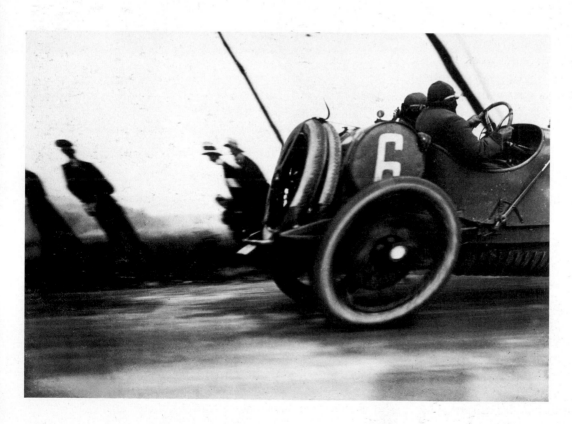

422
Jacques Henri Lartigue.
GRAND PRIX OF THE AUTOMOBILE CLUB OF FRANCE.
Dieppe, France, 1912.
Photograph.

Cubism, at least in the color harmony. From things I had seen at Braque's or Picasso's. But I was trying to apply a slightly different formula. . . . There is no flesh, only a simplified anatomy, the up and down, the head, the arms and legs. . . . Also there was no Futurism, since I didn't know the Futurists.[16]

Duchamp's NUDE DESCENDING A STAIR-CASE works well in a way that film cannot. Through sequential, diagonally placed, abstract images of the same figure, the painting presents the movement of a body through space, seen all at once, in a single rhythmic progression. Because of our sense of gravity, the diagonal placement of the major sequence and the minor elements intensifies the overall feeling of motion. When the painting was displayed at the Armory Show in New York in 1913 it caused cries of dismay, and was seen as the ultimate in Cubist madness. One critic described it as "an explosion in a shingle factory."

After Duchamp painted the NUDE DESCENDING A STAIRCASE he became increasingly dissatisfied with the accepted framework for art. He said, "I have forced myself to contradict myself in order to avoid conforming to my own taste."[17] In his effort to free himself from the past, Duchamp declared all art a swindle, and exhibited his first non-art "ready-made," BICYCLE WHEEL. His rejection of the "high art" of museums cleared the ground for new possibilities in both art and life.

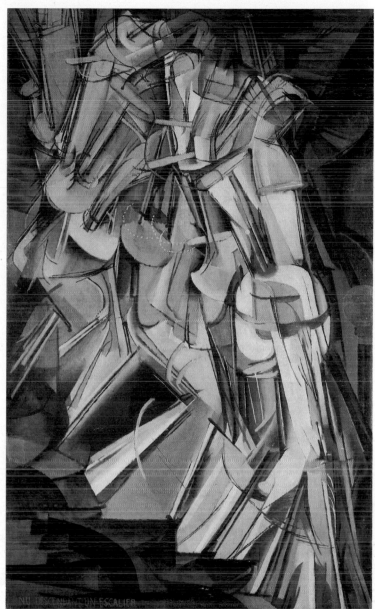

423 Marcel Duchamp.
NUDE DESCENDING A STAIRCASE, NO. 2. 1912.
Oil on canvas, 58″ x 35″.
Philadelphia Museum of Art.
The Louise and Walter Arensberg Collection.

424 Etienne-Jules Marey.
GEOMETRICAL CHRONOPHOTOGRAPH. c. 1883.
Image of runner dressed in black with white lines and points attached.

425 Marcel Duchamp.
BICYCLE WHEEL. 1951
(third version after lost original of 1913).
Assemblage: metal wheel, diameter 25½",
mounted on painted wooden stool, 23¾" high,
overall height 50½".
The Sidney and Harriet Janis Collection.
Gift to The Museum of Modern Art, New York.

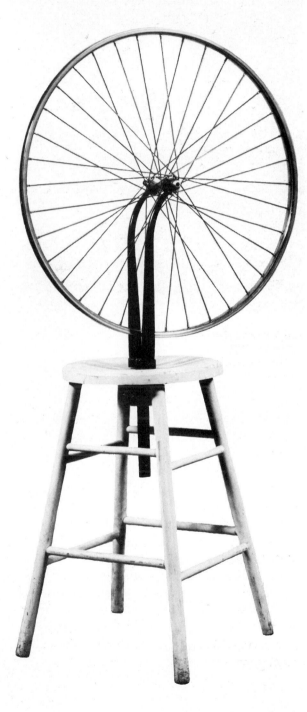

Duchamp felt that art could not be separated from other things made by human beings. Rather, he recognized *selection* as the primary ingredient of art. In his BICYCLE WHEEL assemblage of 1913 he applied both of these ideas to produce a work that has caused considerable controversy, challenging as it did values that had provided the foundations of art. Its components are merely a bicycle wheel and a kitchen stool, and it took only a simple operation to join them. The stool provides a static base for the movable wheel. This is the first mobile of the twentieth century, incorporating motion that is actual, rather than implied, as in NUDE DESCENDING A STAIRCASE.

The wheel and the stool still say whatever they said before, by themselves. Yet this expression is now subordinate to what they communicate as a combined form. Through their new association and by the placement of this work in galleries and museums as an art object, a strong change has occurred in the way we perceive them. Preconceptions related to function have been cleared away, allowing us to see the form itself.

As Europe moved inexorably toward World War I, many artists, including Duchamp, felt compelled to react. When the actual fighting began, artists counterattacked with their art.

ILLUSIONS SHATTERED: WORLD WAR I AND ITS AFTERMATH

Dada

Dada began as a protest and revolt against the horrors of World War I. While many of the leading Dadaists were artists, Dada was not an art movement. It was a violent assault on accepted values by an international group of young writers and artists against what they saw as the destructive absurdity of war.

Dada was not a school of artists, but an alarm signal against declining values, routine and speculation, a desperate appeal on behalf of all forms of art, for a creative basis on which to build a new and universal consciousness of art.

Marcel Janco[18]

The founders of the movement in Zürich chose the word "dada" as a rallying cry. Legend has it that the word, which means "hobbyhorse" in French, was picked at random from a French-German dictionary. The two-syllable baby-talk word was immediately adopted as the perfect term for expressing the essence of their attitude.

Dadaists maintained that mankind had demonstrated that it was without reason. In order to make a new beginning the Dadaists rejected all accepted moral, social, and aesthetic values. They felt it was pointless to try to find order and meaning in a world in which so-called rational behavior had produced only chaos and destruction.

Dada began in poetry and painting, then progressed into sculpture, architecture, photography, film, music, and graphic design. But Dada was more than an art form. According to Duchamp, "Dada was a metaphysical attitude . . . a sort of nihilism . . . a way to get out of a state of mind—to avoid being influenced by one's immediate environment, or by the past; to get away from clichés—to get free."[19]

While the thunder of guns rolled in the distance, we sang, painted, glued, and composed for all our worth. We are seeking an art that would heal mankind from the madness of the age.

Jean Arp[20]

Dada literature and art was based on chance rather than reason and premeditation. Poems were composed by selecting words at random. Artists joined elements in startling, irrational combinations.

For Duchamp, mechanically produced things were a reservoir of potentially un-self-conscious art objects. In this view, a reproduction of the

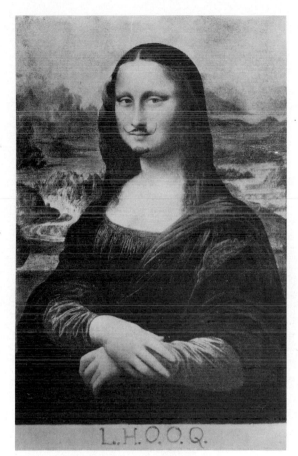

426 Marcel Duchamp.
L.H.O.O.Q. 1919.
"Corrected ready-made."
Private collection.

MONA LISA is a ready-made object, in the same class as bicycle wheels, kitchen stools, and bottle racks.

L.H.O.O.Q. is a "corrected" ready-made by Duchamp. Is it art or vandalism? "Corrections" took the form of a moustache and goatee done in pencil, and a new title. The unusual title provides us with a possible clue to why the MONA LISA has been smiling all these years. It is a pun in French, comprehensible only to those who can say the letters in a flowing sentence with perfect French pronounciation. Translated into English, it reads, "She has a hot tail." Duchamp's outrageous irreverence helps demystify art.

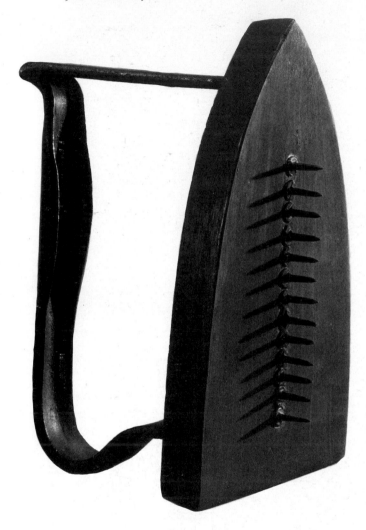

427 Man Ray.
THE GIFT. c. 1958
(replica of 1921 original).
Flatiron with metal tacks.
6⅛" x 3⅝" x 4½".
The Museum of Modern Art, New York.
James Thrall Soby Fund.

Man Ray, an American, was a friend of Duchamp. His Dada works include paintings, photographs, and assembled objects. In 1921, in Paris, Man Ray saw a flatiron displayed in front of a shop selling housewares. He purchased the iron, a box of tacks, and a tube of glue. He glued a row of tacks to the smooth surface of the iron and entitled it THE GIFT. This particular Dada assemblage presents the viewer with an irreconcilable contradiction: a useless utilitarian object.

In the past, the major subjects for art were gods (or God), nature, humans, and the interrelationships among them. It was not until the twentieth century that manufactured things became frequent subjects for art—a natural shift in emphasis in an age when we have surrounded ourselves with machine-made objects. Today we spend more time, thought, and energy on the acquisition, use, and maintenance of manufactured things than we have on God, nature, or ourselves. Twentieth-century artists have used the most unlikely sources of inspiration. They have looked at the most common artifacts of mass production and have found in some of them symbols of materialism and in others universal continuity and spirit. This resulted in what has been called "the art of things." Paradoxically, the "art of things" has developed concurrently with the concept of a work of art as an independent entity, free to express itself without reference to external subject matter.

When Picasso and Braque put actual pieces of rope and scraps of newspapers into their work, they began one development in the art of things—works of collage and assemblage (see page 173). Things are not represented, but are themselves presented in a new context.

Another path leads from collage into photomontage. In THE MULTI-MILLIONAIRE, by the Dadaist Hannah Höch, man, the artifact-making industrialist, stands as a fractured giant among the things he has produced.

Kurt Schwitters was a master of Dada collage. From 1917 until his death in 1948, he created such images as CONSTRUCTION FOR NOBLE LADIES out of timeworn objects discarded by society. By asking us to look again at these cast-off objects, Schwitters has helped us to see the poetry of life even in the most unlikely places.

I could not, in fact, see any reason why one should not use the old tickets, driftwood, cloakroom numbers, wires and parts of wheels, buttons, and old lumber out of junk rooms and rubbish heaps as materials for paintings as well as the colors that were produced in factories.[21]

The Dadaists intended to be anti-aesthetic. Ironically, they created a new aesthetic that has had an enormous impact on art and life in the rest of the twentieth century.

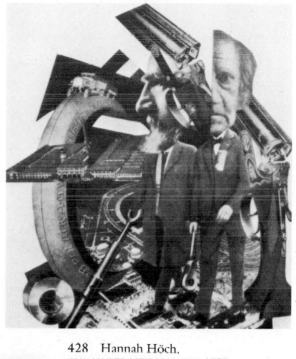

428 Hannah Höch.
THE MULTI-MILLIONAIRE. 1920.
Photomontage.
Location unknown.

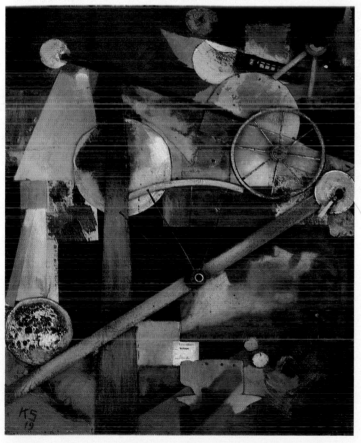

429 Kurt Schwitters.
CONSTRUCTION FOR NOBLE LADIES. 1919.
Assemblage-mixed media: wood, metal, paper, cardboard, and paint. 40½" x 33".
Los Angeles County Museum of Art.

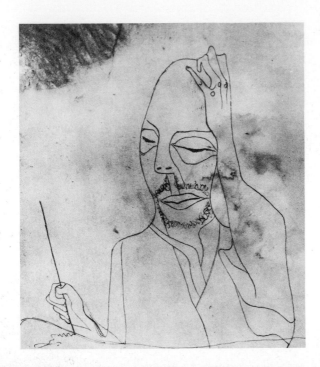

Surrealism

The *Surrealist* movement can be seen as a direct outgrowth of Dada. Surrealism in art and literature took the irrationality of Dada a step further by focusing on the unconscious, particularly the world of psychic experience. The denial of reason was thought to lead to a greater truth—a super-reality, or surreality.

The highly personal and inventive art of Paul Klee provided inspiration for both Dadaists and Surrealists. Although Klee was not an official member of either group, his work

430 Paul Klee.
PORTRAIT OF THE ARTIST.
1919. Colored sheet, pen, and wash. 9″ x 5¼″.
©1984 by COSMOPRESS, Geneva, and ADAGP, Paris.

paralleled both movements and he exhibited with both groups.

Klee gave up a career as a concert violinist to be an artist. As he worked to develop his art, he intentionally freed himself from the accumulation of history in an effort to begin all over again. PORTRAIT OF THE ARTIST, drawn in 1919, goes well with this statement from his diary in 1902:

It is a great difficulty and great necessity to have to start with the smallest. I want to be as though new-born, knowing nothing, absolutely nothing, about Europe; ignoring poets and fashions, to be almost primitive. Then I want to do something very modest; to work out by myself a tiny formal motive, one that my pencil will be able to hold without any technique.[22]

Paul Klee remained an independent artist all his life. He was able to tap the resources of his own unconscious, creating fantastic images years before Surrealism became a group style.

. . . everything vanishes round me and good works rise from me of their own accord. My hand is entirely the implement of a distant sphere. It is not my head that functions but something else, something higher, something more remote. I must have great friends there, dark as well as bright. . . . They are all very kind to me.[23]

In Klee's painting BATTLE SCENE FROM THE COMIC OPERA "THE SEAFARER," Sinbad the Sailor fights three monsters in a battle that suggests the universal human struggle against fear of things both real and imagined. The marvelous line patterns and distinctive use of color are common to Klee's small paintings.

431 Paul Klee.
BATTLE SCENE FROM THE COMIC OPERA "THE SEAFARER." 1923.
Colored sheet, watercolor, and oil drawings. 15″ x 20¼″.
Collection Frau T. Durst Haass, Muttenz, Switzerland.

432 Giorgio de Chirico.
THE MYSTERY AND MELANCHOLY OF A STREET. 1914.
Oil on canvas. 34¼″ x 28⅛″.
Private collection.

Italian metaphysical painter Giorgio de Chirico also influenced the development of Surrealism. THE MYSTERY AND MELANCHOLY OF A STREET, 1914, is one of his finest works. De Chirico used distorted linear perspective to create an eerie space peopled by faceless shadows. The painting speaks the symbolic language of dreams, mystery, and ominous silence. According to the artist:

Everything has two aspects: the current aspect, which we see nearly always and which ordinary men see, and the ghostly and metaphysical aspect, which only rare individuals may see in moments of clairvoyance and metaphysical abstraction.[24]

433 Salvador Dali.
THE PERSISTENCE OF MEMORY. 1931.
Oil on canvas. 9½″ x 13″.
The Museum of Modern Art, New York.
Anonymous gift.

In the 1920s a group of writers and painters gathered to proclaim the omnipotence of the unconscious mind, thought to be a higher reality than the conscious mind. Their goal was to make the unconscious mind visible. The group was indebted to the irrationality of Dadaism and the fantastic creations of Chagall, Klee, and de Chirico. Sigmund Freud's ideas gave impetus and credibility to the movement.

Surrealism was officially launched in Paris in 1924 by the publication of its first manifesto, written by poet-painter André Breton. In it he defined the movement's purpose as

the future resolution of these two states, dream and reality, which are seemingly so contradictory, into a kind of absolute reality, a surreality, *if one may so speak.*[25]

Among the prominent members of the Surrealist group were Salvador Dali and Joan Miró. Picasso took part in the first exhibit, but did not remain in the style long.

Dali's position in modern art has been brought into question by Dali himself. His eccentric self-promotion, unethical practices in his later years, and his love of money have caused him to be viewed with contempt by many critics and fellow artists. One action that appalled the art world was the signing of thousands of blank sheets of lithograph paper—thus casting a shadow on the value of all of his late work. In the latter part of his long and highly productive career Dali was both exploitive of and exploited by those around him. In 1929,

434 Joan Miró.
WOMAN HAUNTED BY THE PASSAGE OF THE DRAGON-FLY, BIRD OF BAD OMEN
(also called NURSERY DECORATION). 1938.
Oil on canvas. 2′7½″ x 10′6″.
Collection of Mr. and Mrs. Richard K. Weil, St. Louis.

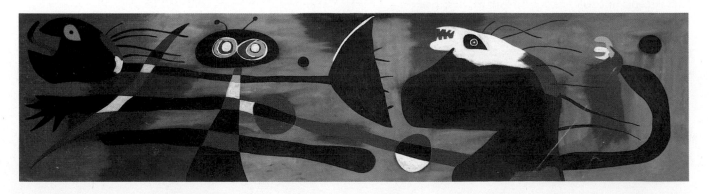

however, Dali was recognized as a leader by the Paris Surrealists.

In THE PERSISTENCE OF MEMORY Dali evokes the eerie quality of dream experience. Mechanical time wilts in a deserted landscape of infinite space. The warped, headlike image in the foreground may be the last remnant of a vanished humanity. It may also be a self-portrait.

Miró and Dali, both Spaniards, represent two opposite tendencies operating in Surrealism. Dali uses illusionary deep space and representational techniques to create near "photographic" dream images to make the impossible seem possible. This approach has been called *Representational Surrealism*. In contrast, Miró uses more abstract, suggestive elements, giving the widest possible play to the viewer's imagination. This style is known as *Abstract Surrealism*.

To probe deep into the unconscious, Miró and others used automatic processes, sometimes called *automatism,* in which chance was a key factor. With adoption of spontaneous and "automatic" methods the Surrealists sought to expand consciousness by breaking through the limits imposed by rational thought. This approach influenced later Abstract Expressionists.

Miró often evokes universal fears of imaginary monsters. The bold organic shapes in WOMAN HAUNTED BY THE PASSAGE OF THE DRAGON-FLY, BIRD OF BAD OMEN are typical of his mature work. The wild, tormented quality, however, is unusual for Miró, and reflects his reaction to the times. This painting was completed within a year of Picasso's GUERNICA (see pages 380–381). Miró has pointed out that his painting was done at the time of the Munich Crisis, which helped precipitate World War II. The work is commonly known as NURSERY DECORATION, which Miró seems to have used as a facetious working title, but later felt was inappropriate.

Belgian Surrealist René Magritte based his work on an illogical form of magical realism, similar to Dali's in surface appearance, but quite different in content. In Magritte's paintings the

435 René Magritte.
PORTRAIT. 1935.
Oil on canvas, 28⅞" x 19⅞".
The Museum of Modern Art, New York.
Gift of Kay Sage Tanguy.

macabre quality found in Dali's work is replaced by wit and playfulness. Everything depicted in PORTRAIT is ordinary. The impact of the painting comes from the strange combination of everyday objects.

Although Surrealism began in poetry, it gained its greatest fame in painting. There was excitement over the birth of Surrealist painting because it made visible serious investigations beyond the limits of conscious, rational thought. Like other revolutionary art movements, Dada and Surrealism did not greatly change the world; but these movements did call attention to the fact that the world was undergoing radical change.

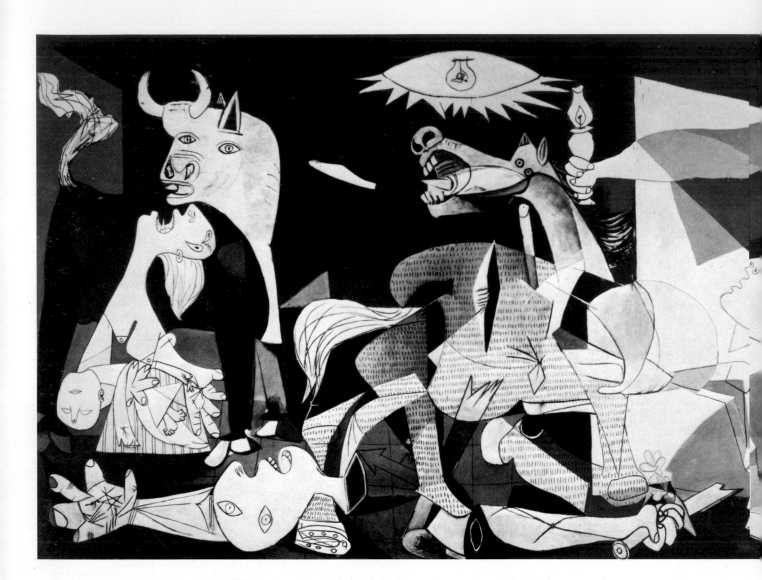

436 Pablo Picasso
GUERNICA. 1937.
Oil on canvas. 11'5½" x 25'5¼".
The Prado, Madrid.

Guernica: Art for Social Change

Picasso continued to produce a great volume of innovative drawings, paintings, prints, posters, and sculptures throughout the 1920s and into the early 1930s. Many of these works were filled with distortions and metamorphoses. In 1937, while the Spanish Revolution was in progress, Picasso was commissioned by the doomed Spanish democratic government to paint a mural for the Spanish government building at the Paris Exposition. For several months he was unable to start work. Suddenly, on April 26, 1937, he was shocked into action by the "experimental" mass bombing of the defenseless Basque town of Guernica. To aid his bid for power, General Franco had allowed Hitler to use his war machinery on the town of Guernica as a demonstration of military power. It was the first incidence of saturation bombing in the history of warfare. The bombing occurred at night. According to witnesses, one out of every seven people in the town was killed.

Picasso was appalled by this brutal act against the people of his native country. In retaliation, he called upon all his powers to create the mural GUERNICA. Although GUERNICA stems from a specific incident, it has universal significance, and is viewed today as a work of tremendous spiritual importance. It is a powerful visual statement of protest against war.

When World War II broke out Picasso sent GUERNICA and a number of other works to be kept at the Museum of Modern Art in New York on extended loan. The works were to be held until the death of Franco and reestablishment of public liberties in Spain. Picasso died in 1973, two years before the death of Franco. In 1981 Picasso's heirs and lawyers agreed that democracy had been restored in Spain, and that GUERNICA should be returned in accordance

with Picasso's wishes. The huge painting is now on permanent exhibition in a specially restored annex of the Prado Museum in Madrid. Ironically, it is displayed behind bulletproof glass.

GUERNICA covers a huge canvas more than 25 feet long. It is painted in somber blacks, whites, and grays, stark symbols of death and mourning. A large triangle embedded under the smaller shapes holds the whole scene of chaotic destruction together as a unified composition. GUERNICA combines Cubism's intellectual structuring of form with the emotional power of earlier forms of Expressionism and Abstract Surrealism. For Picasso Cubism was a tool, not a master. He took the Cubist concept from the early intellectual phase through its synthetic period, and here used it to create a painting of great emotional intensity as well as symbolic and prophetic importance.

During the 1940s, while the Nazis occupied France, Picasso maintained his studio in Paris. For some reason he was allowed to paint, even though his art was considered highly degenerate by the Nazis. The German soldiers harassed him. One day they came to his door with a small reproduction of GUERNICA. They asked, "Did you do this?" Picasso replied, "No, you did." [26]

During the same war years, Picasso made this statement: "No, painting is not done to decorate apartments. It is an instrument of war for attack and defense against the enemy." [27]

Social and Regional Concerns in the Art of the United States

The American public had its first good look at leading developments in European art during the Armory Show held in New York in 1913. The exhibition brought many important examples of the new European styles to America for the first time. Americans, especially young American artists, were able to see key works by the Impressionists, Post-Impressionists, and Fauves—particularly Matisse, who was much maligned by the critics. Also shown were paintings by Picasso, Braque, Léger, and Duchamp, and sculpture by Brancusi. As a result, Cubism and other forms of abstract art spread to America.

In the early twentieth century it was common for American artists to go to Europe to study. Georgia O'Keeffe was an exception. She stayed in New York, yet she was influenced by the revolutionary changes in European art. O'Keeffe's personal style is seen in her majestic paintings of the American Southwest. Although her art developed during her early years in New York, she eventually rejected what she saw as the superficial materialism of the city in favor of country life. In 1929 O'Keeffe began spending her summers in Taos, New Mexico. In 1949 she settled permanently in rural New Mexico, where she continued to find inspiration for her poetic abstractions. In BLACK CROSS, NEW MEXICO the single dominant shape of the cross pushes forward from the infinite vista of subtle glowing landscape behind it. Here, as in much of O'Keeffe's work, a powerful simplicity is achieved through subtle shading and careful design.

437 Georgia O'Keeffe.
BLACK CROSS, NEW MEXICO. 1929.
Oil on canvas. 39" x 30".
The Art Institute of Chicago.

438 Grant Wood.
AMERICAN GOTHIC. 1930.
Oil on beaver board. 29⁷/8″ x 24⁷/8″.
The Art Institute of Chicago.
Friends of American Art Collection.

The political and economic crises of the 1930s helped motivate artists in America to search for a national and personal identity. American artists were caught between a largely indifferent public at home and a feeling, both at home and abroad, that American art was merely provincial. In this atmosphere of cultural inferiority a native American *regionalism* developed, based on the idea that artists in America could find their own identity by focusing attention on subject matter that was uniquely their own. For these artists subject matter was important as a way of making their art relevant to themselves and their audience.

Regional painter Grant Wood turned away from urban culture and also revolted against what he and other American regional artists considered the cultural insignificance of modern art. He sought to participate in the reality of American life in order to develop an art with which people could identify, even though the farm life shown in his paintings was becoming a phenomenon of the past.

Wood's AMERICAN GOTHIC has become a famous national symbol that speaks clearly to many, yet sparks a wealth of different responses. In the early 1920s Wood studied art in Paris. Although he never worked with Cubist or Expressionist ideas, he did identify with the modern trends, and began making freely brushed paintings derived from Impressionism. After years of little success, Wood returned to his birthplace in rural midwestern America. There he let go of the widely held attitude that the Midwest was a cultural desert and decided to dedicate himself to memorializing the unique character of the land, the people, and their cherished, rather insular way of life. Childhood experience as an Iowa farm boy and the perception of his artistic maturity combined to make Grant Wood an astute observer of rural life.

Wood developed a personal style of crisp realism inspired by the paintings of Northern Renaissance masters such as van Eyck, Dürer, and Holbein. He also drew on American folk painting and the stiff, long-exposure portraits taken by late-nineteenth-century photographers. Wood, like van Eyck, calculated every aspect of the design and all details of the subject matter to add to the content of his paintings.

The idea for AMERICAN GOTHIC came to Wood when he saw a modest farmhouse built in Carpenter Gothic style. The restrained color, simplification of round masses such as trees and people, and use of detail are typical of Wood's paintings. The two figures are echoed in the pointed arch window shapes. Vertical lines and paired elements dominate. For example, the lines of the pitchfork are repeated in the man's overalls and shirtfront. The upright tines of the fork seem to symbolize the pair's firm, traditional stance and hard-won virtue.

During the Depression years of the 1930s the United States government maintained an active program of subsidy for the arts. The Works Progress Administration (WPA) commissioned painters to paint murals in public buildings, and the Farm Security Administration hired photographers to record the eroding dustbowl and its work-worn inhabitants. One of these photographers, Dorothea Lange, also documented the helplessness and hopelessness of the urban unemployed in such sensitive photographs as A DEPRESSION BREADLINE, SAN FRANCISCO.

Edward Hopper made several trips to Europe between 1906 and 1910, but his art was largely unaffected by the experience. He remained apart from European avant-garde movements as he portrayed the loneliness that permeated much of American life. NIGHTHAWKS reveals Hopper's fascination with the visual mood of a particular place at a particular time. The haunting effect of his paintings comes largely from Hopper's stark, architecturally structured design and his emphasis on qualities of light. The Impressionists were interested in light, but their paintings seem to be dissolved by it; Hopper's works are structured with light.

439 Dorothea Lange.
A DEPRESSION BREADLINE, SAN FRANCISCO. 1933.
Photograph.
The Oakland Museum.
Dorothea Lange Collection.

440 Edward Hopper.
NIGHTHAWKS. 1942.
Oil on canvas. 30" x 60".
The Art Institute of Chicago.
Friends of American
Art Collection.

441 Berenice Abbott.
EXCHANGE PLACE. 1933.
Photograph.

ACCELERATED CHANGE: ART SINCE WORLD WAR II

Architecture: Rational and Emotional

New York City is the epitome of environments made by industrial civilization. Because it brings together in one place much of the best and the worst of human life, it can be both exhilarating and depressing.

Berenice Abbott made over 300 powerfully conceived photographs that document New York City in the 1930s. The buildings Abbott photographed were constructed during the building boom of the 1920s. The height and density of construction caused streets to become dark canyons, and led to zoning laws that required buildings be stepped back as they increased in height. Those who sought to use every allowable square inch of commercial space constructed buildings that were stair-stepped like wedding cakes. Most of the skyscrapers erected in the United States between 1930 and 1960 followed this pattern.

In the late 1940s and early 1950s a few architects and their clients began to change the pattern by building to provide light and open space for pedestrians. The first such commercial building was LEVER HOUSE, built between 1951 and 1952, designed by Gordon Bunshaft of Skidmore, Owings, and Merrill. Bunshaft was inspired by the ideas of Le Corbusier, Mies van der Rohe, and the Bauhaus.

The vertical office structure occupies only 25 percent of the legally permissible air space. Both the major vertical slab and the horizontal area at the bottom are set on posts, providing

442 Gordon Bunshaft
of Skidmore, Owings,
and Merrill.
LEVER HOUSE.
New York City, 1952.

flow-through pedestrian space at street level and access to an open central court. The concept of a building on legs was first proposed by Le Corbusier as a way of offering visual continuity at the ground level (see VILLA SAVOYE, page 368). The glass windows covering the tower are tinted to avoid glare. Floors are marked off by panels of dark green glass. The harmony of LEVER HOUSE is all the more no-

table when it is compared to the many unsuccessful attempts to imitate it.

The International Style's ideal for a new architecture based on the honest beauty of purely functional forms was not widely put into practice until the 1950s. In the 1960s the style too often went from an ideal to a boring formula for low-cost standardized buildings, because it provided the most economical way to enclose

443 Le Corbusier.
NOTRE-DAME-DU HAUT. Ronchamp, France. 1950–1955.
a Exterior.

large spaces in cities. This is not architecture in its highest meaning; it is merely construction. Highrise buildings were erected with speed and efficiency, yet were devoid of imagination and exhibited nothing more than the regimented sameness of orderbook construction. Around the world, works of appropriate regional architecture were torn down and replaced with International Style structures.

In the late 1940s Le Corbusier made an effort to reverse the trend toward the cold geometric functionality of the International Style, which he had helped to develop. His chapel at Ronchamp, NOTRE-DAME-DU-HAUT, features bold, yet soft and organic free form. The structure was built of reinforced concrete, wood, and plaster. Natural wood, rough concrete, and plaster are contrasted with bright accents of color. Light enters through corner slits and through stained glass windows set in funnel-like openings that emphasize the thickness of the massive concrete walls. The side altars are illuminated dramatically by sunlight slanting through tower openings.

Ideally, architecture is functional sculpture. A primary function of churches and other public buildings is to celebrate an idea. Because the Ronchamp chapel is a pilgrimage site, the building is used for both outdoor and indoor services. Inside and out, in every detail, Le

b Interior.

Corbusier designed a structure of expressive strength. It is one of the most revolutionary and influential pieces of architecture of the mid-twentieth century.

Le Corbusier's highly sculptural building renews and celebrates the human spirit, putting emotion back into contemporary architecture. The International Style is classical in its rational clarity, while NOTRE-DAME-DU HAUT is romantic, mystical, and emotional in its expressive irregularity. However, NOTRE-DAME-DU HAUT, by incorporating some classical qualities within the overall form, also retains a sense of the controlled geometric abstraction and essential purity of form found in Corbusier's earlier work.

c Perspective diagram.

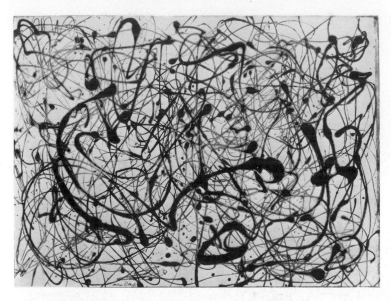

444 Jackson Pollock.
NO. 14. 1948.
Enamel on wet gesso. 23³/₄" x 31".
Private collection.

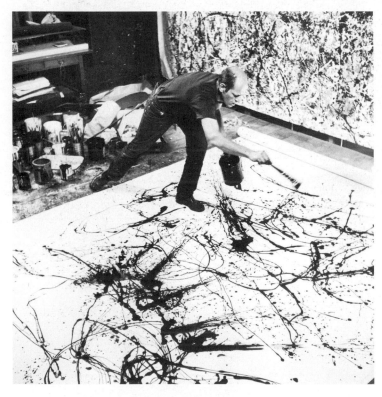

445 JACKSON POLLOCK AT WORK.
Photograph by Hans Namuth.

Abstract Expressionism

Nonrepresentational art came of age in the United States and Europe in the 1940s and 1950s. American versions of nonrepresentational art were stimulated by the presence of European artists who had come to the United States at the time of World War II. In contrast to the geometric abstractions of Cubism, the New York painters proceeded in the direction of nonrepresentational painting (similar to that introduced earlier by Kandinsky) in which nongeometric, rhythmic compositions predominated.

Abstract Expressionism was the result of various influences, particularly Surrealism, Synthetic Cubism, and De Stijl. A great variety of work emerged, all under the term Abstract Expressionism. Abstract Expressionism is characterized by an emotional approach to content and execution that is essentially Expressionist.

The social background of Abstract Expressionism was two disasters—the Depression and World War II. Through the WPA, the Depression provided new opportunities for artists. During the hard years of the late 1930s and early 1940s this developing art movement was marked by signs of emotional stress, anxiety, and despair.

With the outbreak of World War II, the center of artistic activity shifted from Paris to New York as many European artists—mainly abstractionists and surrealists—fled their native countries to find refuge in the United States. One of these, German artist Hans Hofmann, made a major contribution to the new American art both through his painting and his teaching. In the early 1940s he began to apply his paint in free gestures, sometimes dripping and pouring it, and using bold, often intense color in combinations of geometric and freeform shapes. THE GOLDEN WALL, painted in 1961

when Hofmann was 81 years old, shows the strength of his later works (see page 138). The canvas glows with warm color set off by cool accents. Rectangles are played off against irregular shapes.

Jackson Pollock was a principal innovator of Abstract Expressionism. He picked up Hofmann's early drip-and-pour techniques and made them the basis for painted surfaces that moved in overall patterns of continuous energy. His large paintings often go beyond the viewer's peripheral vision as did Monet's late works. Pollock studied the ideas of psychologist Carl Jung, as well as ancient myths and rituals, searching for ways to express primal human nature. The subject of Pollock's paintings became the act of painting itself. A similar emphasis in the work of many of his colleagues led to the term *action painting*. Pollock's NO. 14 was done by flinging paint onto the canvas rather than brushing it on. Because Pollock dripped, poured, and flung his paint, many people felt that he had no control. Actually, he exercised control and selection by the rhythmical, dancing movement of his body.

Whether it happens in a rapid series of dramatic changes or very slowly, each young artist develops ways of working that combine personal insights and concerns with concepts and perceptions of preceding generations. Even Pollock's radical break from the past has roots in the serpentine rhythms of the work of his teacher, Thomas Hart Benton, and in the use of intuition, accident, and chance by the Surrealists.

A dominant element in much of Abstract Expressionism is the presentation of the artist's movement and feeling through spontaneous, gestural line. This can be seen both in Pollock's paintings and in the work of Franz Kline. Kline's HORIZONTAL RUST is painted on a big canvas. The large scale gives Kline's rugged brush strokes the quality of huge, mysterious signs.

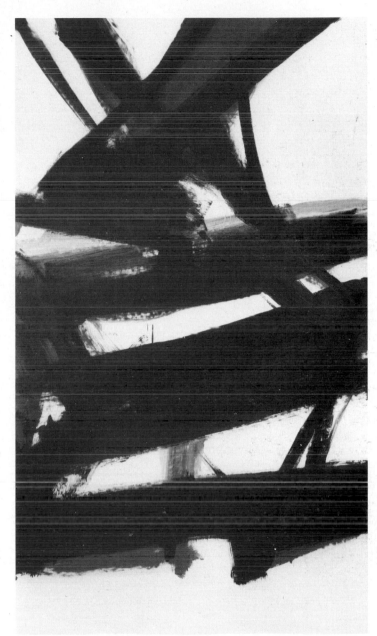

446 Franz Kline.
HORIZONTAL RUST. 1960.
Oil on canvas. 86½" x 49".
Private collection.

447 Yuichi Inoue.
CALLIGRAPHY BUDDHA. 1957.
Ink on paper.
Collection J. Bijtebier, Brussels.

Contemporary painters in Japan have developed their own expressive visual language based on their traditional calligraphy and on influences from New York Abstract Expressionism. CALLIGRAPHY BUDDHA by Yuichi Inouye is an example. When Japanese Buddhist scholar and master calligrapher Kazuaki Tanahashi traveled to New York in the 1960s he felt particularly attracted to the paintings of Franz Kline. There has been a mutual influence between Asia and the West that has been of great benefit to both. The result is a growing international art based on shared interests, yet rich in its own variety.

Helen Frankenthaler's work evolved during the height of Abstract Expressionism. In 1952 she pioneered *staining* as an extension of Jackson Pollock's poured paint. Brush strokes and paint texture were eliminated as she spread liquid oil colors out across unprimed canvas, where they were absorbed in fluid, often amorphous, soft shapes, becoming part of the fabric. The new acrylic paints made it possible to cover huge canvases with thin layers of color, and also to avoid the problem of the eventual breakdown of the raw canvas through contact with oil. Frankenthaler led others to explore the expressive power of color in a direction called *color field painting,* in which large areas of paint provide an environment of color for the viewer. INTERIOR LANDSCAPE does not represent nature as we see it, but renders Frankenthaler's subjective association with forms and colors in nature. Her main concerns were the interaction of colors and shapes, bleeding of tones, and natural overlap—achieved through controlled accidents.

448 Kazuaki Tanahashi.
HEKI. 1965.
Ink on paper. 36" x 28".
East-West Center, Honolulu.

449 Helen Frankenthaler.
INTERIOR LANDSCAPE. 1964.
Acrylic on canvas. 104⅞″ x 92⅝″.
San Francisco Museum of Modern Art,
Gift of the Women's Board.

450 Willem de Kooning.
WOMAN AND BICYCLE.
1952–1953.
Oil on canvas. 76½" x 49".
Whitney Museum of American Art,
New York. Purchase.

It is easy to perceive the influence of earlier Expressionist and Surrealist attitudes in Willem de Kooning's woman series. De Kooning felt no compulsion to banish recognizable images from his work. After several years of working without explicit subject matter, he began a long series of paintings in which rather ferocious female figures appear. His paintings are overpowering because of their size, their design, and the obviously slashing "attacks" by which they were painted. De Kooning began one of these woman paintings by cutting a gleaming artificial smile from an advertisement and attaching it to the canvas for the mouth of the figure. In WOMAN AND BICYCLE, the toothy smile is repeated in a savage necklace capping a pair of tremendous breasts.

As we have seen, certain American artists have made significant contributions to ideas originating in Europe around the turn of the century. Among the regional variations of Expressionism, parallel to and influenced by New York's Abstract Expressionism, were the paintings of a group of California artists who combined vigorous brushwork with careful observations of people, light, and space. Richard Diebenkorn's MAN AND WOMAN IN A LARGE ROOM is geometrically structured with broad areas of color. The mood is one of isolation in a form that combines the physical activity on the painted surface with the illusion of interior and exterior space.

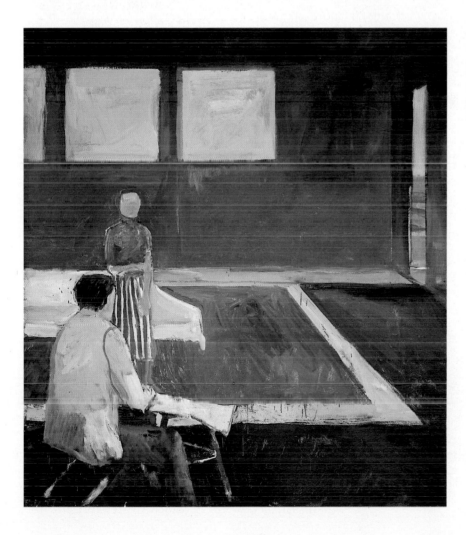

451 Richard Diebenkorn. MAN AND WOMAN IN A LARGE ROOM. 1957. Oil on canvas. 71⅛" x 62½". *Hirshhorn Museum and Sculpture Garden, Smithsonian Institution, Washington, D.C.*

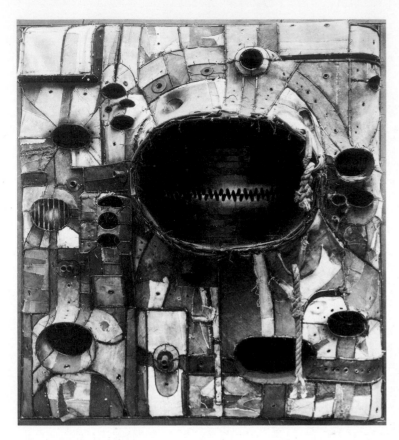

452 Lee Bontecou.
UNTITLED. 1961.
Canvas and welded metal. 72″ x 66¼″ x 26″.
Whitney Museum of American Art, New York.
Purchase.

453 LEE BONTECOU AT WORK.
Photograph by Giulia Niccolai.

Lee Bontecou was one of many outstanding artists of the 1960s and 1970s who worked in independent styles loosely related to Expressionism. She has been distinctly original in her choice of materials and subject matter.

Bontecou's welded steel, wire, and canvas constructions are strong images. She aimed to give the viewer a glimpse of some of the awesome power, ugliness, and mystery that exist in today's world. This untitled work of 1961 is one of many relief sculptures, rectangular and shaped, that contain ominous craterlike openings and huge sets of fierce teeth. During an art festival a little girl holding the string of a helium-filled balloon was forced by the crowd to stand close to a similarly ferocious work by Bontecou. Suddenly there was a loud BANG! The girl looked up at the work, wide-eyed, and wailed, "It bit my balloon!"

During his long career Stuart Davis made Cubism into an American art form that he humorously called "colonial cubism." Through his enthusiasm for neon, billboards, advertisements, and other colorful "jazz" of the modern American cityscape, Davis prepared the way for Pop art. In his painting VISA the key word *champion* came from a matchbook cover. *Else* is provocative, and was chosen for its lack of association. *The amazing continuity* tells of the artist's recognition of the mysterious common factor that unites works of art no matter what the subject matter, style, or cultural origin.

Recent Diversity

Everything imaginable and then some is being done in art today. The complexity of the last several decades has produced an exciting, at times confusing, variety. Some of the artists and trends fit into neat, logical sequences, and some are very much alone. Influences are clearly visible in the works of some artists, and obscure or nonexistent in others.

In the mid-1950s some young artists became dissatisfied with Abstract Expressionism's re-

454 Stuart Davis.
VISA. 1951.
Oil on canvas. 40" x 52".
The Musuem of Modern Art, New York.
Gift of Mrs. Gertrud A. Mellon.

treat from the appearances of the everyday world. Under the influence of composer John Cage's efforts to bring art and life back together, Robert Rauschenberg began incorporating ordinary things in collage paintings that were otherwise Abstract Expressionist in style. Rauschenberg was among those who led the way toward *Pop Art* and other neo-Dada developments. His collage/paintings recall the work of Dada artist Kurt Schwitters (see page 375). About 1962 Rauschenberg began to combine borrowed images from art and documentary photographs with the aid of the new technique of photographic screen printing. These he combined with Abstract Expressionist brushwork and actual objects mounted on large canvases. His TRACER of 1964 is a key work of this period, although it does not include objects.

455 Robert Rauschenberg.
TRACER. 1964.
Mixed media. 84" x 60".
Private collection.

456 Jasper Johns.
TARGET WITH FOUR FACES. 1955.
Encaustic and newspaper on canvas
with plaster casts in wood box
with hinged front. 33⅝" x 26" x 3".
The Museum of Modern Art, New York.
Gift of Mr. and Mrs. Robert C. Scull.

Jasper Johns shared ideas with Rauschenberg and began to create large paintings based on common flat signs such as targets, maps, flags, and numbers (see page 71). In Johns' work, such signs no longer function in their expected way. Like Duchamp's BICYCLE WHEEL (page 372) and Man Ray's THE GIFT (page 374) they are now objects of contemplation. TARGET WITH FOUR FACES seems to emphasize the loss of self in an increasingly impersonal, stereotyped world. Johns' irony relates back to Duchamp and forward to Conceptual art. Both Johns and Rauschenberg were precursors of Pop Art.

Most artists of the 1940s and 1950s avoided any references to the appearance of the environment in which they lived. Except for Stuart Davis, they did not choose to portray the urban scene cluttered with signs and billboards. In their eyes such low art was not art at all; it was a nightmare of shallow banality. In the mid-1950s a few young artists stopped retreating and began to confront the enemy—visual pollution.

It is not surprising that Pop Art emerged at a time when human contact with nature was rapidly being replaced with a flood of manufactured artifacts. Rafael Squirru shed light on this subject in 1963 when he wrote in an article entitled "Pop Art or the Art of Things":

And we should not be surprised that a people that has become alienated from itself through things should seek to recapture its identity through its artists. . . .[28]

Squirru went on to clarify the semantics related to this style by pointing out that what has been called Pop Art in the United States is called *l'art des objets* (the art of objects) in Europe and *el arte de las cosas* (the art of things) in Latin America. Of these designations, "the art of things" may be the most revealing, since it calls attention to the common subject matter included in styles ranging from Synthetic or Collage Cubism to Pop Art. Ideas that emerged in

Collage Cubism, later presented in Dadaism as travesties of the lofty idea of art, became a major source of inspiration for Pop.

Pop Art appeared almost simultaneously in London and the United States. In London a group of young artists began to make collages with images cut from popular, mostly American, magazines. Decades earlier Dada artists such as Hannah Höch (see page 375) had worked with similar raw material. But for the Londoners the purposes were different. In 1957 English artist Richard Hamilton published a list of characteristics for the art of the London group that can be taken as the basic ingredients for the whole Pop Art movement. Hamilton wrote that Pop should be:

Popular (designed for a mass audience)
Transient (short-term solution)
Expendable (easily forgotten)
Low-cost
Mass-produced
Young (aimed at youth)
Witty
Sexy
Gimmicky
Glamorous
Big business[29]

Hamilton's collage JUST WHAT IS IT THAT MAKES TODAY'S HOMES SO DIFFERENT, SO APPEALING? is, in spite of its small format, a major comment on the degenerate culture of the time as shaped by advertising media. In the collage we see the word "pop" as well as the attitude behind the Pop style. Ironically, this collage was made for an exhibition called "This is Tomorrow." Hamilton's visual statement is a hilarious, yet devastating, parody on the superficiality and materialism of modern popular culture.

Pop Art's media sources include the comic strip, the advertising blowup, the famous-brand package, and the visual clichés of billboard, newspaper, movie house, and television. Items from all these elements of the mass media can be seen in Hamilton's collage.

In contrast to the emotional intensity of Abstract Expressionism, such American Pop painters as Andy Warhol and Tom Wesselmann used their skill to create cool, mechanical images that hide all evidence of their personal touch. Pop Art painters often used photographic screen-printing and airbrush techniques to achieve the surface character of machine-made images. Such impersonality links their work to the uniformity of mechanical production.

457 Richard Hamilton.
JUST WHAT IS IT THAT MAKES TODAY'S HOMES
SO DIFFERENT, SO APPEALING? 1956.
Collage. 10¼" x 9¾".
Kunsthalle Tübingen, Philosophenweg, Germany.

458 Bernie Kemnitz.
MRS. KARL'S BREAD SIGN. 1964.
Billboard. 60' x 150'.

459 Tom Wesselmann.
STILL LIFE NO. 33. 1963.
Oil paint and collage on canvas. 11' x 15'.
Collection of the artist.

Commercial artist Bernie Kemnitz' billboard, MRS. KARL'S BREAD SIGN, is an element of the media environment to which Tom Wesselmann has responded with his STILL LIFE NO. 33. In the remote past, when the environment was predominantly nature, art helped people to describe, understand, and gain a sense of control over their surroundings. Today, with our largely manufactured environment, art answers a similar need.

Before the use of aluminum cans the Coke bottle was a common object in much of the world. An archaeologist of the future who digs up the remains of our present civilization will find so many Coke bottles that he or she may assume they were used in some sort of common ritual. Marisol used an actual bottle in her assemblage, LOVE. Others have commented on the Coke culture in photographs, paintings and sculpture.

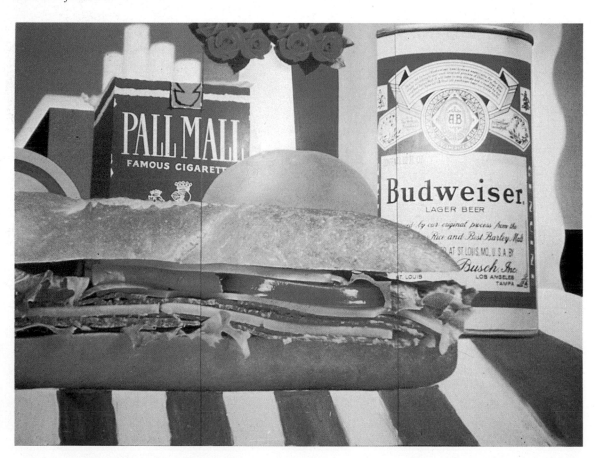

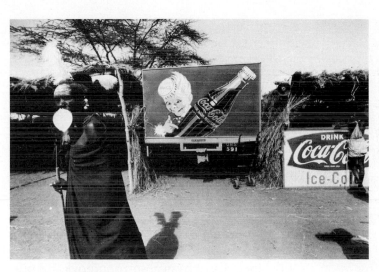

461 Charles Frazier.
AMERICAN NUDE. 1963.
Bronze. Height 7³/4″.
Kornblee Gallery, New York.

460 Ivan Massar.
THE PAUSE THAT REFRESHES. 1964.
Kenya. Photograph.

462 Marisol.
LOVE. 1962.
Plaster and glass
(Coca Cola bottle).
6¹/4″ x 4¹/8″ x 8¹/8″.
The Museum of Modern Art,
New York. Gift of Claire and
Tom Wesselmann.

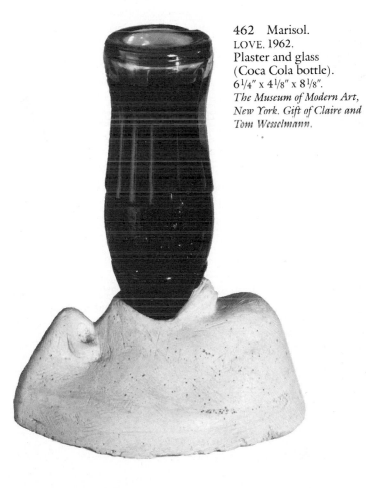

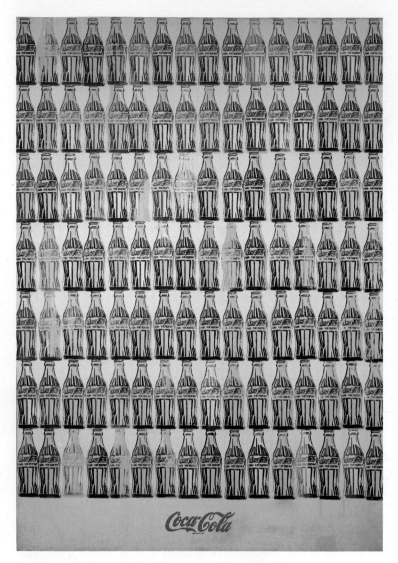

463 Andy Warhol.
GREEN COCA COLA BOTTLES. 1962.
Oil on canvas. 82¼" x 57".
Whitney Museum of American Art, New York.
Gift of the Friends of the Whitney Museum
of American Art.

No American artist in the 1960s sparked public interest and indignation as did Andy Warhol. He began his career as a commercial artist. When he moved into the fine art sphere in the early 1960s, Warhol came as an inventive subversive. GREEN COCA COLA BOTTLES is characteristic of his paintings. With the aid of screen printing, images of common mass-produced objects were mechanically repeated, as if seen on supermarket shelves. In both his art and his life Warhol has called attention to the pervasive and uniformly insistent character of our media environment. The mechanical repetition of mass imagery has become our cultural landscape—our physical surroundings and our myths. The "canned" *pop*ular image is a giant filter and equalizer of everything from processed foods and processed celebrities to common hopes and national tragedies.

It is fairly easy to divide artists into stylistic groups, but the practice is valuable only up to a point. Ultimately, each person gives form to individual experience. Claes Oldenburg can be called a Pop sculptor, but that label merely suggests his point of view. Oldenburg takes ordinary manufactured objects that fill our lives and transforms them in various ways so that we see them as never before. His works are often satirical in content, and powerful in form. In CLOTHESPIN a common household object becomes a significant twentieth-century symbol of the all-important manufactured object. CLOTHESPIN contributes to our experience not because it is merely much larger than expected, but because of its content and the monumental quality of its proportions.

American sculptor David Smith was a leading proponent of assembled metal sculpture. With the contemporary medium of welded

steel, he evolved a way of working that combined psychological, symbolic content with the abstract geometric structuring of Cubism and Constructivism. His late work included the monumental stainless steel "Cubi" series based on cubic masses and planes balanced dynamically above the viewer's head. In CUBI XVII, the scoured surfaces of the steel form reflect light in ways that tend to dissolve their solidity. Smith intended the sculpture to be viewed outdoors in strong light, and set off by landscaping.

Styles in the arts are frequently reactions to the style that precedes them. In this way the new style expresses the changing character of the times.

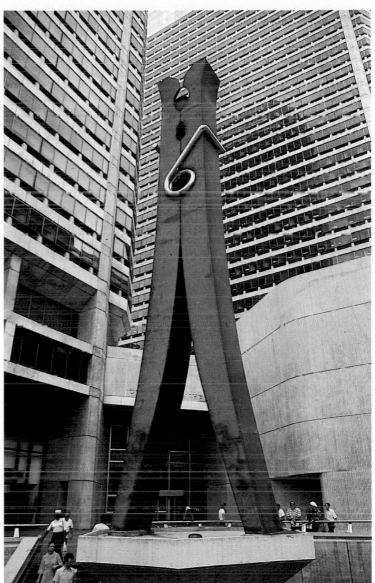

464 Claes Oldenburg.
CLOTHESPIN. 1976.
Cor-ten steel. Height 45'.
Philadelphia.

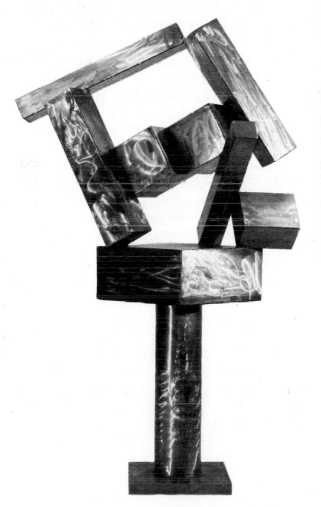

465 David Smith.
CUBI XVII. 1963.
Stainless steel. 107³/₄" x 64³/₈".
Dallas Museum of Fine Arts.
The Eugene and Margaret McDermott Fund.

466 Tony Smith.
DIE. 1962.
Steel. 6' x 6' x 6'.
Private collection.

In the late 1950s and 1960s a number of painters and sculptors reduced their designs to a minimum, concentrating on cool, nonsensual, impersonal, geometric structures presented without interpretation as neutral objects. The approach is called *minimal.*

Former architect and sculptor Tony Smith was one of the first to explore the possibilities of large primary objects. Smith challenged another preconception about the nature of art by removing himself completely from the process. He ordered a 6-foot steel cube from the foundry by telephone. The size, mass, material, and method of DIE produce a heavy visual statement.

Isamu Noguchi's RED CUBE relates to the minimal trend, but the viewer is immediately engaged in the dynamics of balance, bright color, and shaped space. Emphasis is on the huge, simple, geometric mass strong enough to interact with the architecture behind it. Such sculpture vitalizes its surroundings.

As paintings have themselves become objects rather than reflections of objects, they have begun to function as environments in themselves instead of as representations of preexisting environments. Painter Al Held cuts off his shapes at the edge of the picture plane in such a way that they seem even more gigantic than they actually are. The minimal forms of Held's GREEK GARDEN fill an entire gallery wall.

467 Isamu Noguchi.
RED CUBE. 1969.
Painted welded steel and
aluminum. Height 28′.
140 Broadway, New York City.

468 Al Held.
GREEK GARDEN. 1966.
Acrylic on canvas. 12′ x 56′.
Collection of the artist.

469 Frank Stella.
HIRAQLA 1. 1968.
Polymer and fluorescent
polymer paint on canvas.
10′ x 20′.
Private collection.

*My painting is based on the fact that only what
can be seen there is there. It really is an object. . . .
All I want anyone to get out of my paintings, and
all that I ever get out of them, is the fact that you
can see the whole idea without any confusion. . . .
What you see is what you see.*

Frank Stella[30]

In the late 1940s Ben Cunningham, a precursor of Op Art, went beyond the usual rectangular format in his first CORNER PAINTING. Cunningham's manipulation of color relationships in precise perspective planes gives a fascinating illusion of depth. He mastered in one painting the spatial effects of color as transparent film, as hollow volume, and as impenetrable surface.

Cunningham sought to dematerialize color, as Renaissance painting had dematerialized the picture plane and Cubism had dematerialized mass. Cunningham's color explorations employ a variety of themes—simultaneous contrast of colors, afterimages, depth illusion created with color rather than linear perspective, the illusion of light coming from within the painting, color as temperature, and colors that do not exist except by implication. One can look at, through, and into Cunningham's paintings.

Josef Albers severely limited all variables except color in the design of his major series of paintings called HOMAGE TO THE SQUARE. The painting reproduced here shows his basic format, in which squares are set one within another. With this limitation Albers was able to concentrate his attention and ours on the relative nature of color.

Artists have sought to capture a feeling of motion since prehistoric people painted cave walls. In this dynamic century of change many artists, styles of art, and new media have made it possible for us to enjoy a wealth of art that incorporates both implied and actual motion. Clearly, the most popular kinetic forms are film and video, but more esoteric examples can be disovered. *Op Art,* for example, is based on the quality of image motion evoked in the perception of the viewer.

Ever since Cubism broke with the Renaissance concept of illusionary deep space, some painters have tried to push the limits of flatness rather than depth. In HIRAQLA Frank Stella interwove bands of intense day-glo color which pull together into a tight spatial sandwich. Although most of the colors tend naturally to appear either to advance or recede, each is pulled to the surface because of its placement in the overlapping visual weave. A more apparent feature of Stella's painting is its outer profile. By eliminating the traditional rectangular format, Stella removed the last remnant of the painting-as-a-window idea. There are no illusions in his work.

470 Ben Cunningham.
CORNER PAINTING. 1948–1950.
Oil on canvas. 25¹/₂″ x 36¹/₂″; 25¹/₂″ x 21¹/₂″.
Collection of Mrs. Ben Cunningham.

471 Josef Albers.
HOMAGE TO THE SQUARE. 1959.
Oil on masonite. 17¹/₄″ x 17¹/₄″.
Collection of Anni Albers.

Op Art is in strong contrast to the ideas of personal emotional involvement recorded on the lively surfaces of Abstract Expressionist paintings. Op painters pushed surface movement even further by developing images based on optical illusions. The dynamic tension of their images exists only in the eye of the beholder. A primary aim is to stretch vision by producing involuntary visual sensations.

The Op artist's emphasis is on scientific exploration of optical phenomena. Painters like Vasarely (see page 150) and Bridget Riley explore the field of pure optical experience with the cool precision and anonymity of engineers. In CREST Riley combines the movement of the diagonal edges of the picture plane with the dynamic energy of linear surface rhythms.

In the mid-1960s the counterculture produced a vibrant, emotional style of art that appeared most frequently in posters advertising rock music concerts and in the accompanying light shows. The flamelike curvilinear

472 Bridget Riley.
CREST. 1964.
Emulsion on board. 65 1/2″ x 65 1/2″.
Private collection.

473 Wes Wilson.
THE SOUND. 1966.
Screen print poster. 36″ x 20″.

forms of turn-of-the-century art provided inspiration for artists such as California poster designer Wes Wilson. Eye-teasing *psychedelic art* was the popular informal partner of Op.

The use of light in art is not a new idea. Twenty-five centuries ago Pythagoras conceptualized the silent motion of the luminous heavenly bodies as visual music and called it "the music of the spheres." Isaac Newton speculated on a possible connection between the vibrations of sound and light in an art of "Color Music." Thomas Wilfred, however, was one of the first to conceive of light art as an independent aesthetic language (see page 63). In the twentieth century artificial light has been a large element in our daily environment. Thus it's not surprising that light became an important art medium in the 1960s.

The color and rhythm of contemporary American signs are the basis of Chryssa's sculpture. In FRAGMENT FOR THE "GATES TO TIMES SQUARE" she translates the medium used for neon advertisements into art. The pattern of repeated blinking neon tubes adds depth and surprise.

Kinetic art is art that moves as you look at it or touch it. The term applies to a wide range of styles in which actual motion is an important element. Ideas in contemporary kinetic art range from the cool precision of Chryssa's work to the happy absurdity of Jean Tinguely's mechanical junk sculpture.

474 Chryssa.
Detail of FRAGMENT FOR THE "GATES TO TIMES SQUARE." 1966. Neon and plexiglass. 81" x 34½" x 27½".
Whitney Museum of American Art, New York. Gift of Howard and Jean Lipman.

475 Jean Tinguely.
HOMAGE TO NEW YORK:
A SELF-CONSTRUCTING,
SELF-DESTRUCTING WORK
OF ART. 1960.
Photograph: David Gahr.

Swiss sculptor Tinguely creates machines that do just about everything except work in the manner expected of machines. In 1960 Tinguely built a large piece of mechanized sculpture that he put together from materials gathered from junkyards and stores in the New York City area. The result was a giant assemblage designed to destroy itself at the turn of a switch—which it did in the courtyard of the Museum of Modern Art in New York on March 17, 1960. The environmental sculpture was appropriately called HOMAGE TO NEW YORK: A SELF-CONSTRUCTING, SELF-DESTROYING WORK OF ART.

Another usually environmental art form that came into prominence in the early 1960s was the *happening*. Happenings are cooperative events in which viewers become active participants in partly planned, partly spontaneous performances with loose scenarios and considerable improvisation. Strictly speaking, Happenings are drama with "structure but no plot, words but no dialogue, actors but no characters, and above all, nothing logical or continuous."[31] Unlike Dada and Surrealist events, the first Happenings were frequently nihilistic, without a relieving sense of humor. No help was given the viewer, who was expected to find his or her own answers.

The term Happening was first used by Allan Kaprow. There were no spectators at Kaprow's happening, HOUSEHOLD. At a preliminary meeting, participants were given parts. The action took place at an isolated rural dump, amid

smoldering piles of refuse. The men built a wooden tower on a trash pile while the women constructed a nest on another mound. During the course of a series of interrelated events the men destroyed the nest, and the women retaliated by pulling down the men's tower. Then a car covered with jam was licked by the participants. By bringing ordinary things into unexpected relationships participants gained a new perspective on life in our time.

In Kenneth Dewey's Happening, MUSEUM PIECE, a high point was reached when Rose-Marie Larsson "married" an automobile. As she walked down the aisle Ms. Larsson wore an enigmatic 180-foot history-of-the-world-in-rags train.

476 Allan Kaprow.
HOUSEHOLD.
Happening commissioned by Cornell University, performed May 1964.
Photograph: Solomon A. Goldberg.

477 Kenneth Dewey.
Detail of MUSEUM PIECE.
Happening performed at the Modern Art Museum, Stockholm, April 7, 1964.
Photograph: ©Ingemar Berling, Pressens Bild AB.

478 ANTI-AUTO POLLUTION DEMONSTRATION.
New York, 1971.
Photograph: Horst Schafer.

479 Gilbert and George.
THE RED SCULPTURE.
First shown in Tokyo in 1975.

Street protests can also work as Happenings, as frequently was the case in the 1960s. If the participants in the event have a sense of symbolic drama, the result can be effective, aesthetic communication.

Abstract Expressionism emphasized the act of painting by making images that were records of the process itself. In Happenings the activity was everything. The major record was in the remembered experience of the participants and in a few photographs. Happenings in turn led to more controlled and focused types of performance activity. British Performance artists Gilbert and George create precisely orchestrated works. Their physical presence and their involvement in ordinary, every-day activities is the material of their "living sculpture." Gilbert and George conduct their entire lives with self-awareness and alert detachment. Everything they do, from pouring a cup of tea to installing an exhibition, becomes sculptural. Their public performances are seen as part of the continuum of their lives. Art critics are baffled, yet remain intrigued.

Happenings are not the only forms of participatory art. Some works "assume" the viewer as part of the piece. Larry Bell's large glass constructions provide abundant visual interplays. THE ICEBERG AND ITS SHADOW is comprised of 56 panels of clear and dark glass that can be installed in endless combinations (the sculpture has been presented in different ways in various museums and galleries). The large translucent panels transform space into a three-dimensional environment that reflects and merges with itself in transparent overlays. The spectator becomes part of a reflective, luminous maze. As one moves around within the work, the kaleidoscopic reflections of the panels absorb the viewer in a disorienting interweaving of planes in space reminiscent of Cubism.

With the advent of Dada, the concept of

480 Larry Bell.
Detail of THE ICEBERG
AND ITS SHADOW.
1975.
Plate glass. 56 sections.
Varying heights x 60" x ³/₈".
Collection of the artist.

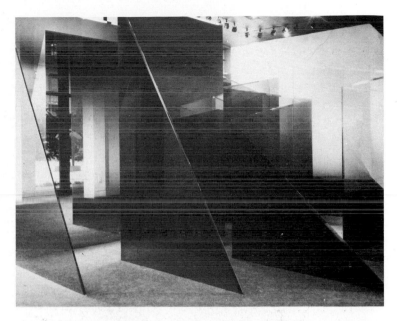

permanence—long a major concern in the visual arts—lost importance. In the Renaissance, paintings were carefully made to last for centuries; but the use of new materials and construction techniques combined with the purposeful breaking of tradition contributed to works whose life could be numbered in years (or, as with Happenings, in minutes).

In the late 1960s many artists rejected the commercialism of the art market with its galleries, dealers, patrons, and museums. One group, seeking to create works that could not be bought or sold, presented concepts themselves as art. A notable *Conceptual* work was "Ice" by Rafael Ferrer. In 1969 Ferrer put together an assemblage of ice blocks and autumn leaves on the Whitney Museum's entry ramp. When collectors complained about the ephemeral nature of his creation, Ferrer suggested that the iceman's bill might be collected as a kind of "drawing."

One form of noncollectable work is known as *Earth Art*. For Dennis Oppenheim, art is significant both as idea and as process. CANCELLED CROP stimulates awareness of the extra-ordinary quality of ordinary places and events.

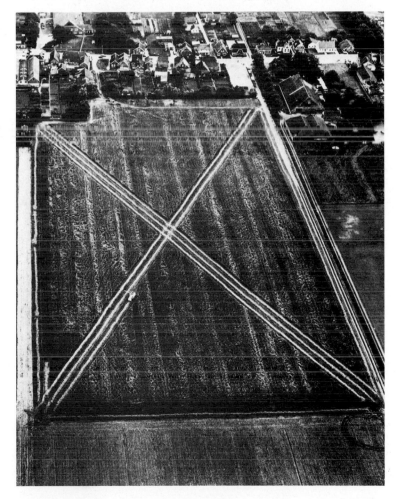

481 Dennis Oppenheim.
CANCELLED CROP. 1968.

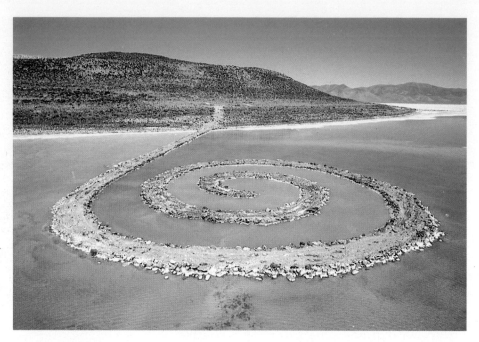

482 Robert Smithson.
SPIRAL JETTY. Great Salt
Lake, Utah. 1970.
Length 1500′, width 15′.
*Photograph: ©1984
Gianfranco Gorgoni/
Contact Press Images, Inc.*

Robert Smithson's earthwork SPIRAL JETTY, completed at Great Salt Lake in 1970, has since been submerged by the rising water. Its natural surroundings emphasized its form as willful human design. Although our society has no supportive, agreed-upon symbolism or iconography, we instinctively respond to universal signs like the spiral, which is also found in nature and in ancient art.

Bulgarian artist Christo was first known in Europe as a gifted portrait painter. In the late 1950s he gained notoriety when he closed off a Paris alley with a wall of 50-gallon oil drums. Thus began the work of an artist who makes the world his gallery. After the oil drums, Christo literally wrapped objects ranging in size and complexity from a bicycle to a mile of sea cliffs in Australia. One of his most ambitious projects, however, was RUNNING FENCE, a temporary environmental art work that was as much a process and an event as it was a work of sculpture. The 18-foot-high white nylon fence ran from the ocean at Bodega Bay in Sonoma County, California, through 24½ miles of agricultural and dairy land. RUNNING FENCE was a unique environmental event, ultimately involving thousands of people. The project required agreement of landowners, political action, and the help of hundreds of volunteers. Christo raised the huge sum of money necessary to erect the fence by selling preliminary drawings and collages of the work.

The seemingly endless ribbon of white cloth gave shape to the wind and caught the changing light as it stretched across the gently rolling hills, appearing and disappearing on the horizon. The simplicity of RUNNING FENCE reminds us of Minimal Art, but the fence itself was not presented as art. It was a work of art to the extent that it stood for the rich interweaving of people, process, object, and place. The fence resembled monumental earthworks such as Smithson's SPIRAL JETTY, but here the work altered the environment only temporarily. Christo's work is conceptual in the way it calls attention to the fact that art is experience before and after it is anything else. As an idea, RUNNING FENCE may help protect not only the land it temporarily graced, but other landscapes as well. Christo's ideas may help people to become more aware of the beauty and character of open countryside. RUNNING FENCE celebrated landscape, light, and vision.

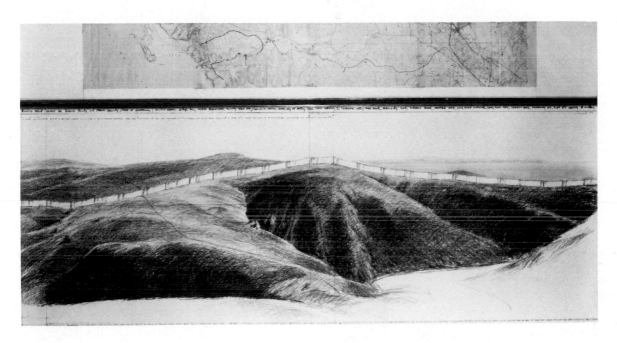

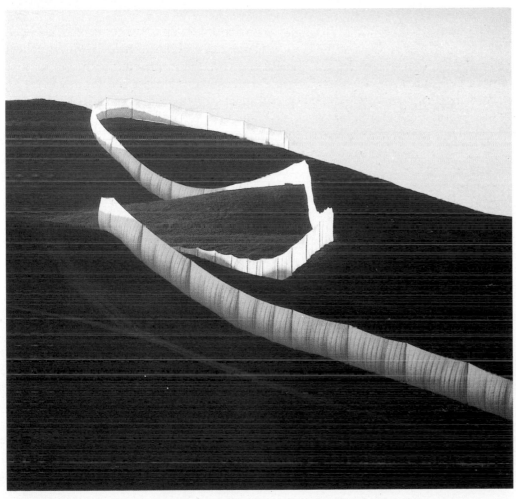

483 Christo.
RUNNING FENCE. SONOMA
AND MARIN COUNTIES,
CALIFORNIA. 1972–1976.
Nylon fabric and steel poles.
18′ x 24½ miles.
a Drawing in two parts.
 Pencil and map. 1973.
 14″ x 96″, 36″ x 96″.
b Completed installation.
 Photograph: © *Wolfgang Volz.*

484 Walter De Maria.
THE LIGHTNING FIELD. 1971–1977.
400 stainless steel poles, average height 20′ 7″;
land area 1 mile x 1 kilometer. New Mexico.
Photograph: John Cliett, ©DIA Art Foundation 1980.

Walter De Maria's THE LIGHTNING FIELD is an earth sculpture designed to be viewed over a 24-hour period. The work consists of 400 stainless steel poles arranged in a rectangular grid over an area measuring 1 mile by 1 kilometer in West Central New Mexico. The sharpened tips of the poles form a level plane, a kind of monumental bed of nails. Each of the poles can act as a lightning conductor during the electrical storms that occur frequently over the desert. Actual strikes are rare, however. Early and late in the day the poles reflect the sun, creating accents of technological precision in sharp contrast to the otherwise natural landscape. Purposely isolated from the art-viewing public, THE LIGHTNING FIELD combines aspects of both Conceptual and Minimal Art. Viewers, who must arrange their visits through the DIA Foundation that commissioned the piece, are left to study the work and come up with their own interpretations.

Many contemporary artists are addressing themselves to the crucial questions of our time. Environmental artist Alan Sonfist calls attention to one of them—the significance and outcome of our relationship to nature. During his childhood in the densely populated, violence-prone South Bronx, Sonfist found refuge in a small but heavily wooded remnant of the virgin forest near his home. He recognized rocks, trees, and twigs as his friends, and began to draw and paint them. A continuing affinity

with nature became the basis for his art. Sonfist seeks to provide contact with nature for city dwellers. His environmental works vary widely in form; each is designed for its particular site.

One such work is TIME LANDSCAPE. It consists of a replanted area of native forest on a piece of expensive real estate in the heart of lower Manhattan. Sonfist based this work of art on descriptive notes and comments written by the first Dutch colonists. He believes that the natural environment, which is part of the city's history, should have as much importance and care as the architectural environment to which it provides balance. The replanted forest will grow and change as it continues to fulfill its promise as a cooperative project between people and nature.

The communicative form of a work of art is usually determined by the artist in relation to a specific context. For example, all aspects of the visual form of a painting are conditioned by the size and shape of the canvas on which the painting is developed. The painting itself, however, can be placed in a variety of environments. The same is true of most art objects—from sculpture to films. Architecture and landscape architecture are two exceptions; these forms are most often designed to fit a particular site. In recent years a number of leading artists have expanded the idea of sculpture by executing works that become part of a specific place. In these site-specific works the artist's sensitivity to the whole location determines the composition, scale, medium, and even the content. Such environmentally inclusive work has been created by Oppenheim, Smithson, Christo, De Maria, and Sonfist.

In this brief survey of twentieth-century art we have barely mentioned the most popular, and often most characteristic arts of our time: photography, film, and television. The temporal nature of films and television, which suits our fast-paced, complex way of life, cannot be effectively illustrated in a book.

485 Alan Sonfist.
TIME LANDSCAPE. 1965–1978.
Laguardia Place and Bleeker Street, New York City.
a Conceptual drawing.
b Aerial view, 1983.

486 Don Eddy.
PRIVATE PARKING X. 1971.
Acrylic on canvas.
66″ x 95″.
*Collection of Mr. and Mrs.
Monroe Myerson,
New York.*

One of the many influences of photography on painting can be seen in the impersonal quality that is central to the recent style of painting descriptively called *Photorealism*. This style, which began in California, is represented here by Don Eddy and Richard Estes.

It was inevitable that after all the different movements rejecting subject matter in favor of "pure" nonrepresentational form, art would eventually return to some aspect of its earlier role as recorder of appearances. There is a major difference, however, between the works of the leading Photorealists and most earlier representational painters. The Photorealists are not telling stories. Their subjects are often as insignificant as possible. The cool banality is related to earlier Pop Art, but Photorealism does not use Pop's mass-media subject matter.

Don Eddy's PRIVATE PARKING X was painted on a large canvas with flawless airbrush tech-

nique. He worked from his own black and white photographs, using a grid pattern, and sketched in the image with charcoal before he started to paint. The subject matter recalls his past experience working in his father's car-painting shop, and the color was inspired by the work of Hans Hofmann. Eddy is excited about what he can discover and make happen in terms of unique spatial tensions. On the flat, painted surface, these tensions couple with ambiguous reflections to create rich visual sensations.

Richard Estes photographs and then paints detailed images of common cityscapes, often devoid of people but full of the artifacts of contemporary life. In contrast to the impersonal quality of Eddy's airbrush work, Estes's HORN AND HARDART AUTOMAT was painted with a traditional brush, giving the surface an active and personal paint quality when viewed at close range.

487 Richard Estes.
HORN AND HARDART AUTOMAT. 1967.
Oil on masonite. 48″ x 60″.
Collection of Mr. and Mrs. Stephen D. Paine, Boston.

488 George Segal.
WALK, DON'T WALK. 1976.
Museum installation, with viewer.
Plaster and mixed media.
Whitney Museum of American Art, New York.

489 John DeAndrea.
MAN WITH ARMS AROUND WOMAN. 1976.
Polychromed vinyl. Life-size.
Collection of the artist.

In the twentieth century the human image has at times all but disappeared from the mainstream of art. In the face of Cubism, Surrealism, and more recent minimalist forms, where are the images of ourselves? Some have observed that representation of the human figure and other recognizable subject matter has occurred at those times and in those places where humans have felt most threatened. Generalizations are only partially valid, but this one may help to explain the significant increase in human figures in art since 1975. There are other equally revealing explanations, the clearest being that many young artists, schooled in the ideas of nonrepresentational art, found these modes to be inadequate to communicate their most urgent concerns.

With works such as WALK, DON'T WALK, George Segal makes it possible for us to contemplate the nature of life today. Segal combines manufactured objects with life-size plaster figures in every-day settings. The expressionless

490 John DeAndrea.
Several works, including
CLOTHED ARTIST WITH MODEL,
and live viewer.
*Photographed 1976 in storeroom of
OK Harris Gallery, New York.*

white figures are types of people rather than individuals. Segal enables the viewer to become part of the work by making an open-ended situation, rather than one that is separated from us by a pedestal, frame, or clearly defined space. We are of the same size and find ourselves in the same context as Segal's anonymous figures.

A sculptural counterpart to Photorealism can be seen in the work of John DeAndrea. His *super-realist* figures, cast in polyester and fiberglass, then painted in minute detail, are unsettling when experienced face-to-face. During a special tour of the OK Harris Gallery a group of students was taken into a storeroom. Behind the huge racks of paintings stood several unclothed models who appeared to be waiting to be cast by a sculptor who seemed to be in the process of making a cast. It took many seconds for the students to realize that the entire group, including the sculptor in plaster-covered blue jeans, was actually sculpture rather than live people. The experience was unnerving because of the effective illusion.

Sculptor Marisol uses the human figure in another way. The humble folks in her relief sculpture THE FAMILY are seen as if sitting for a family photograph. Typical of Marisol's work is the combination of actual common objects such as shoes and doors with careful carpentry, carving, casting, drawing, and painting. A wry sense of humor is often apparent. (See also LOVE on page 401.)

491 Marisol.
THE FAMILY. 1962.
Painted wood and other
materials in three sections.
6'10⅝" x 65½".
*The Museum of Modern Art, New York.
Advisory Committee Fund.*

492 Marianna Pineda.
SLEEPWALKER. 1950.
Bronze, unique cast.
Height 38".
Private collection.

493 Luis Jiménez.
THE AMERICAN DREAM. 1967–1969.
Fiberglass resin, epoxy coating,
first of five castings. Height 3'.
Collection of David Anderson, Roswell, New Mexico.

Today's sculpture has many contrasts. The poignant personal feelings expressed in the SLEEPWALKER by Marianna Pineda contrast strongly with the neutrality of cast-from-life sculpture such as DeAndrea's and Segal's works. The cool, blank anonymity of Segal's unpainted figures is also in contrast to the Pop-related plastic color of sculpture by Luis Jiménez. The slick-surfaced epoxy resin of THE AMERICAN DREAM emphasizes media-created woman as sex object and America's love affair with the automobile (see also page 411).

Romare Bearden's subjective visual poetry is very different from the neutrality of Photorealist painting, despite the fact that he often uses parts of photographs in his works. Bearden depicts life as he has experienced it; he says he paints out of the tradition of the blues. Life in the rural south and the urban north is represented with vibrant colors and dynamic interacting shapes in a paint and collage technique. He uses qualities of dream and ritual which lend an air of mystery. Bearden focuses on the joys and sorrows of those who have persevered against terrible odds. While works such as THE PEPPER JELLY LADY are nostalgic, Bearden's

494 Romare Bearden.
THE PEPPER JELLY LADY. 1981.
Collage. 18″ x 24″.
*Collection of Dr. and Mrs. Larry Silverstein,
North Woodmere, New York.*

495 David Hockney.
GREGORY LOADING HIS CAMERA.
Tokyo, February, 1983.
Photographic collage. 21″ x 14″.
©David Hockney 1983. Courtesy Petersburg Press.

formal, almost ceremonial style ensures that his images are not overly sentimental. A sensitivity to design gives strength and unity to his narrative subject matter. Bearden's study of art history led him to admire Dutch masters Vermeer and De Hooch, and they are among the many important influences on his work. His photocollages, alive with references to Bearden's own heritage, go considerably beyond that to communicate experiences we all share.

Southern California's light, color, and lifestyle have been major elements in English painter David Hockney's paintings. Their straightforward clarity and smooth, nonpainterly surfaces were a natural lead-in to Hockney's use of photography. For Hockney the camera has long been an important means of noting

times, places, and friends. In the early 1980s it became a tool for the construction of complex images made up of many Polaroid photographs.

GREGORY LOADING HIS CAMERA recalls early Cubist paintings and the multiple views of Muybridge's photographs (see page 158). Hockney's collage of photographs is about both the subject and the process of seeing. Our perception is not like a single photograph, in which everything is seen all at once. Rather, it is a process of impressions accumulated over time and unified in the mind's eye. With a composite of images of the same subject we come a step closer to the dynamic process of perception. Hockney's works help us to realize a little more about the nature as well as the rewards of this process.

496 Gaylen Hansen.
LADY ON TRAPEZE. 1980.
Oil on canvas. 72½″ x 71″.
Monique Knowlton Gallery, Inc., New York.

Gaylen Hansen was an early exponent of the *Neo-Expressionist* movement of the late 1970s and early 1980s that reemphasized subject matter and expressionist modes of painting. Hansen uses a deliberately naive, folk-art style to depict dreamlike encounters between people and other creatures. Hansen lives in rural Washington state and nature is a major aspect of his work. Danger, mystery, and humor are central to many of his paintings, including LADY ON TRAPEZE.

The art of our time leads us forward, and at the same time shows us our connection to the past. The immediate power of Jonathan Borofsky's RUNNING PEOPLE sweeps the viewer into the painting. Borofsky has gone directly to the essence of his message. The running figures are among the many potent images that result from his practice of drawing quickly after dreaming, then enlarging the drawings on wall surfaces.

Compare this 1979 painting with a prehistoric painting of marching figures, painted 5000 to 10,000 years ago. While the sizes of the two paintings are vastly different (the recent painting is 28 feet long, while the prehistoric one is 9 inches across), each tells us about human experience in its context. The media and content of art have changed considerably since prehistoric times, but the primary fact of being alive and human remains.

As we approach the last decade of the twentieth century, artists continue to find ways to challenge and augment our experience. The heavy gold frame and the pedestal that set art apart from the viewer are things of the past. Some artists, whose works would traditionally be found in galleries, museums, and the homes of wealthy collectors, are creating works designed for public indoor and outdoor spaces and for the homes of people with moderate incomes. This move away from exclusive art circles has been helped by the growing patronage of corporations and by the production of original prints that can be sold at prices many people can afford. Growing interest and greater participation in craft/art has increased involvement in the visual arts.

Much contemporary art is harsh, mechanical, confusing, and just plain ugly—just like much of contemporary life. It is natural to feel more comfortable with the art of the past, which has been around long enough to be understandable, and therefore enjoyable. It is often difficult to look the present in the eye.

Works from the past that we consider great have been made available for our appreciation through favorable criticism, careful preservation, and frequent reproduction. It is easier to understand, and therefore enjoy, works of art from the past because they fulfill well-established preconceptions concerning the nature of art and reality.

Works of poor quality from the past have generally not been saved, and are therefore removed from consideration. In contrast, we have a full array of works—good, bad, and indifferent—from our own time and the recent past. We are as uncomfortable with some of these as we are with our own unsorted lives and times. But sometimes a work of art speaks to something in ourselves, setting off a new chain of ideas or wordless excitement. Then we can see that it is not necessary to "know" what "art" is in order to enjoy it; the art itself can speak to us directly.

Society takes what it wants. The artist himself doesn't count, because there is no actual existence for the work of art. The work of art is always based on the two poles of the onlooker and the maker, and the spark that comes from that bipolar action gives birth to something—like electricity. But the onlooker has the last word, and it is always posterity that makes the masterpiece. The artist should not concern himself with this, because it has nothing to do with him.

Marcel Duchamp[32]

497 Jonathan Borofsky.
RUNNING PEOPLE AT 2,616,216. 1979.
Latex paint on two walls and ceiling beams. 14′ x 18′.
*Installation, Portland Center for Visual Arts,
Portland, Oregon.*

498 WARRIORS.
c. 8000–3000 B.C.
Approx. 9″ wide.
Gasulla Gorge, Castellon, Spain.

6

Art for Today
and Tomorrow

In order to regain the indispensible benefits of art, we need to think of those works as the most evident results of a more universal effort to give visible form to all aspects of life. . . . The artists of our time have gone a long way in making the old categories inapplicable by replacing the traditional works of the brush and the chisel with objects and arrangements that must merge in the environment of daily life if they are to have any place at all. One more step, and the shaped setting of all human existence becomes the primary concern of art. . . .

Rudolf Arnheim[1]

Charles Eames.
Detail of SOLAR TOY.
(see page 435.)

The preceding chapters have introduced the nature of art, its purposes, media, and history. How does all this apply to the art of the present? And how can we, as individuals, bring art to life? These final pages are written as an epilogue. Our purpose is to conclude by focusing attention on the crucial role art can play in determining the quality of life.

To give meaningful answers to these questions we must be active partners in the process of art-as-an-idea. We must realize art as a way of living—a way of perceiving, a way of being, a way of becoming. Works of art are the physical evidence of this process. The visual arts enrich life today by serving as windows on the past, by revealing the present, and by helping us to visualize and shape the future.

ART IS A WINDOW ON THE PAST

Great nations write their autobiographies in three manuscripts: the book of their deeds, the book of their words and the book of their art. Not one of these books can be understood unless we read the two others, but of the three, the only trustworthy one is the last.

John Ruskin[2]

Works of art are reliable vehicles for messages from the past because, of all forms of historical evidence, they are the least corrupted by the errors and biased alterations of intervening generations. The visual arts and literature of earlier generations are our major direct link with human history. They provide us with access to our own past, and to other cultures, both past and present. Images such as the Egyptian hunting scene (page 271), the Persian mosque (page 86), the Chinese landscape (page 250), the Dutch interior (page 108), and the American street scene (page 419) show us glimpses of life as it was perceived and depicted in times and places far from one another.

Our contact with historic works has been determined by the evaluation and reevaluation of previous generations. We continue this process as we decide what is significant, what to keep and care for, and what to discard. Such evaluation is necessary; but it is not always carried out with care, knowledge, and the interest of future generations in mind.

As the world changes, the world's art is reevaluated. Few famous artists have had unchanging reputations. For example, the works of El Greco, who painted in Spain in the late sixteenth and early seventeenth centuries, fell into obscurity after his death. It was only in the twentieth century that he became widely celebrated as one of the greatest visionary artists of all time (see page 305). The popularity of particular styles and artists from the past, as well as of certain artists working today, is a good indicator of current values.

Art of the past is always seen removed from the life that created it. Much of what we see is physically damaged as well—from natural deterioration or from neglect, abuse, or aggression. Most works from the distant past have ceased to exist. Works that are badly damaged are experienced very differently than when they were complete. We can reconstruct only part of the life context for past art, but there have been some notable successes with conservation and restoration of ancient works, and even of large areas of buried cities.

Much of the art of the past that we enjoy today would have perished but for those people in each generation who have taken care to protect, preserve, and restore selected works. It is enlightening to know something about the current situation regarding these efforts. Restoration is a difficult, time-consuming, and sometimes impossible task. Today's art restoration experts are professionally trained to follow scientifically exacting procedures.

Restorers today know that they don't have all the answers. They are careful to make as few additions as possible, and to use substances that can be easily removed in case future technology

provides better solutions. (It is ironic that the high-tech societies able to support specialized restoration technology are also those societies in which air pollution from industrial production and traffic is rapidly destroying some of the world's finest art.)

In the past restoration was often so ill-conceived that it did more harm than good, either by adding to and altering the original, as was done with Leonardo's LAST SUPPER (see page 298), or by adding materials that caused new problems, as in the use of iron rods in the PARTHENON (see page 275).

The history of the Parthenon illustrates some of the ways human values and actions have affected creative works of earlier peoples. Since its construction more than 2400 years ago the Parthenon has been subjected to the ravages of human history. Conquering Romans used it as a brothel; Christians turned it into a church; the Turks refurbished it as a mosque, then stored explosives in it while they fought the Venetians. In 1687 a Venetian artillery shell exploded the Turks' store of gunpowder, causing major damage to the structure. From 1801 to 1803, while Greece remained under Turkish rule, Lord Elgin, the British ambassador to Turkey, was permitted to remove a large number of Greek sculptures, including many from the friezes of the Parthenon.

Early in this century ignorant would-be restorers inserted iron bars between the stones of the Parthenon's columns as reinforcements. The original Greek builders had been smart enough to use lead plugs for this purpose. In the sea air the iron soon corroded, causing many stones to split. But nothing in its history has been as hard on the Parthenon as twentieth-century air pollution.

The marble of the Parthenon and other buildings on the Acropolis is being eaten away by sulphur dioxide made when fuel exhaust combines with moisture. Sulphur dioxide converts marble into a soft, chalky substance called gypsum. Driving rain, windblown sand, and dirt now cause greater damage to the fragile surfaces of these structures in one year than weathering previously did in a century.

Ironically, the works removed by Lord Elgin have been protected not only from the possible ravages of war, normal weathering, and neglect, but also from the more insidious process of corrosion from air pollution by being housed in the British Museum.

The destruction of the art of the past takes many forms. In the American Southwest and in numerous other areas around the world works of art created by earlier cultures are suffering irreparable damage from grave robbers, vandals, and other uncaring people.

It is natural that there are substantial losses from the art of earlier peoples; yet important works from the past continue to be discovered, restored, and preserved. One such example is the Greek bronze figure recovered at Riace, Italy, in 1972 (see page 273); another is the cave paintings at Lascaux, France. These caves (see page 238), which were not discovered until 1940, were closed to the public in 1963 because their prehistoric paintings were being damaged by the growth of algae on their surfaces. Human-made changes, such as electric lights and the presence of over 200 visitors a day, had upset the fragile ecological balance that had preserved the paintings for some 17,000 years. The problem became how to preserve the paintings while enabling visitors to experience the wonder of Lascaux. The unusual solution was to make a replica of the cave complex near the original caves. After years of construction by artists and craftsmen the life-size facsimile was opened to the public in 1983.

In spite of losses, the people of the late-twentieth century are in a unique situation regarding the art of the past. Modern technology makes high-quality reproductions of art from all over the world available at minimal cost. Most of these reproductions are made from works now carefully preserved in museum collections. Museums themselves are dedicated to making art accessible to the public. Through conservation, exhibitions, and educational programs they provide inspiration and knowledge for both artists and nonartists.

ART IS A WAY OF REVEALING THE PRESENT

Artists discover or create new vantage points that we can add to our perspective of the world. Art can nourish and restore the childlike sense of wonder and awe often lost or forgotten by adults. Both creating and experiencing art intensifies involvement with life, making experiences more vivid and meaningful by stimulating our capacity to feel and respond. By expressing life, art fulfills life.

Art provides a way to improve the quality of our awareness. Works worthy of being called art always cause a shift in the viewer's perception. With their art, artists are saying, "Look at this; notice what I have seen." Art provides a way of seeing through another person's eyes, a way of getting beyond the limitations of our habitual ways of looking at things. This is why it refreshes our vision. If you can see through another's eyes, you can see the validity of another's point of view, as well as your own. At times what we see in a work of art affirms our own way of seeing and feeling, letting us know that our sensibilities are shared by others. Either way, art is a means for recognizing the importance of each person's unique perception.

Any work of art precedes the theories and explanations applied to it, terms that help to analyze it, and names that classify it. As we view significant new works and encounter new styles and media, our attitudes determine the quality of the experience.

When we are shocked by some of the new works of literature, music, and the visual arts, it is because they do not match our expectations. It often appears that avant-garde artists in all fields wish to shock us with their work. Yet it is helpful to realize that much of what we now accept as standard fare in the arts was at one time thought to be either scandalous, or at least very strange. For instance, in the 1870s the paintings of the French Impressionists were considered radical and unacceptable by art critics as well as the general public.

When we are confronted by something unexpected in the arts it is important to set aside judgments long enough to respond openly and honestly to what is before us. Today's art includes a wide variety of forms, from traditional and naturalistic, to surprising works that challenge and extend what we believe to be the limits and possibilities of art. Art helps us to be open to experience by challenging our assumptions, and causing us to reevaluate them. Art can also help us make sense of sensory experience.

The ability of early humans to identify with their environment and to act out the drama of life in drawing, carving, mime, and song must have calmed their fears and intensified their joy. Creating art required imagination, memory, and skill. Emotional, intellectual, and spiritual needs demanded some outlet for expression and communication. Human nature has not changed over the centuries. Today we have the same basic needs and abilities as did early humans.

It often seems as if artists are ahead of their time, but actually they can be among the few who are truly with their time.

A creator is not in advance of his generation, but he is the first of his contemporaries to be conscious of what is happening to his generation.

Gertrude Stein[3]

It is not surprising that the often abrasive quality of modern life has found full force in contemporary art. Consciously or unconsciously, artists speak for themselves and for their age. There is a continual process of give and take, of creative people forming and being formed by the quality and values of their time. By reading the art of our time we can become aware of what is happening in the contemporary world.

499 Red Grooms and the Ruckus Construction Company.
RUCKUS MANHATTAN. 1976.
Mixed media installation.
Marlborough Gallery.

a Detail of street scene.

b Detail of subway, with live viewers.

Most artists communicate their insights about the present. A glance at the final pages of Chapter 5 will confirm this, and will also suggest the great variety of individual interpretations of life in the twentieth century. Representational works are the easiest to understand in these terms; but nonrepresentational or extremely abstract works are also very much part of, and an indication of, our time.

Recent realist artists have represented, with cool precision, the mechanical repetition and amazing character of today's mundane urban scene. Others show us the comic or tragic aspects of similar everyday subject matter.

Red Grooms was one of the first artists to put on Happenings in the mid-1950s. Grooms has also produced films, under the trademark of Ruckus Films. "Ruckus" is defined by Grooms as "a beautiful southern word meaning a 'disorderly commotion.'"[4]

RUCKUS MANHATTAN, a refreshing, wildly humorous construction, was put together by Grooms, his wife Mimi, and a group called the Ruckus Construction Company. The elaborate sculptural extravaganza featured caricatures of many of the most famous landmarks of New York City, including a 30-foot high version of the World Trade Center, a subway train, the

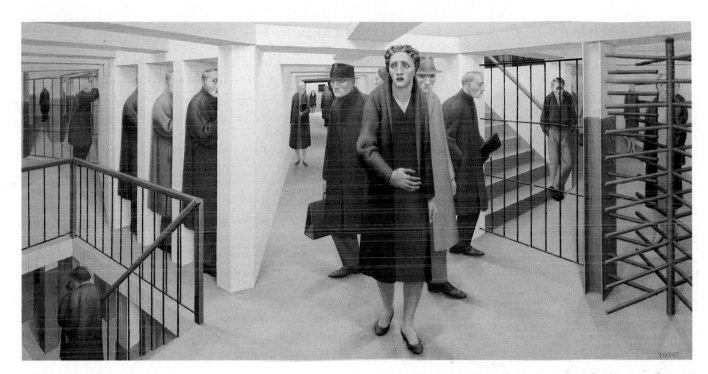

500 George Tooker.
THE SUBWAY. 1950.
Egg tempera on composition board. 18¹/₈″ x 36¹/₈″.
Whitney Museum of American Art, New York.
Juliana Force Purchase.

Woolworth Building, a Times Square porno shop, a Staten Island ferry one could "ride" on, and the Statue of Liberty in red platform shoes, holding a cigar in her raised hand. The show was a marvelous cartoon mix of theater, circus, carnival, parade, and amusement park. Realistic details were everywhere—even steam puffing out of manholes.

Viewers became participants, and even part of the work, as they mingled with papier-mâché and cutout figures in a complex of walk-in buildings, shops, roads, and bridges—all constructed in Manhattan's Marlborough Gallery in the summer of 1976. As the live people and the papier-mâché people blended in the chaos of the mini-city, one began to wonder if all Manhattan and all the world were really just a giant cartoon.

A very different view of New York is presented by George Tooker. The prison-like spaces of old New York City subway stations became the symbolic environment in Tooker's painting THE SUBWAY. The painting makes a powerful statement about how it feels to be afraid, surrounded by strangers, and alienated by a mechanistic cityscape. The atmosphere of entrapment is created by Tooker's use of complex linear perspective, an oppressively low ceiling, anxious and depressed facial expressions, and repetition of jail-like bars. The artist has exaggerated the character of a common New York scene in order to communicate a pervasively sinister mood of alienation and paranoia.

501 Otto Dix.
WOUNDED SOLDIER. 1924.
Etching. 7³/₄" x 5¹/₂".
Galerie der Stadt. Stuttgart.

Some artists summon all their resources to let others know that they have witnessed something so terrible that it should never be repeated. In such cases we are asked to find ways to avoid similar experiences. The artist makes it possible for us to learn without having to live through such horrors ourselves. An example of work in this vein is WOUNDED SOLDIER by Otto Dix, who served in the German army for four years during World War I. In the economically and politically troubled 1920s he criticized his society for its decadence. His book of drawings and prints, published in 1924, is simply titled *War*. With terrifying clarity Dix documented how it felt to be in a world gone mad, surrounded by the mass murder of war. He revealed the brutalities of gas and trench warfare with unrelenting honesty. When the Nazis came to power in the 1930s, they dismissed him from his position at the Dresden Academy, and forbade him to exhibit. Much of his work was labeled degenerate and politically undesirable, and was subsequently destroyed.

Perhaps the most decisive issue for the foreseeable future is the threat of nuclear war and the way in which we deal with this danger. Artists are especially qualified to wake people up to the grim reality of the situation, and to envision ways to avoid what so many see as the likelihood of a life-destroying nuclear holocaust.

On August 6, 1945, a relatively small atomic bomb exploded in mid-air above the city of Hiroshima, killing about 100,000 people. Another 150,000 have died since, and countless others are disfigured or diseased as a result of the explosion.

In 1974 an elderly survivor drew a picture of his experience of the atom bomb. The Japan Broadcasting Corporation asked other survivors to portray their memories of the horren-

502 Painting by Yoshiko Michitsuji,
from THE UNFORGETTABLE FIRE.
©1977 by NHK.
Courtesy of Hiroshima Peace Culture Foundation.

dous event. The response provided the corporation with a collection of 2300 images, most of which were made by people with no previous drawing or painting experience. As they looked at the pictures the survivors responded as they had earlier to photographs of the bombing aftermath. They said, "No! It was not like this. This is only one ten/thousandth of what it actually was!"[5]

Yoshiko Michitsuji who made the painting reproduced here described her experience:

Everywhere was a sea of fire. . . . The clothes which we earlier had dipped in water had already dried so much that they were almost to the point of burning. There was no time to lose. We dipped our clothes in the water that was stored in an air-raid shelter, and dashed through the fire desperately.

"Awfully hot! Is this the end of my life? . . . Oh God! . . . Help me!" I murmured and prayed.[6]

Some artists work from their own experience; others depict things they can imagine, but have not actually experienced firsthand. Robert Arneson, best known for his whimsical self-portraits (see page 181), has recently created works in clay and on paper that deal with nuclear holocaust. The self-awareness and satire that have become Arneson's trademark have shifted to a concern for the victims of our misused technological powers. Works such as NUCLEAR WAR HEAD are not likely to be popular among buyers of art; they are created out of the artist's sense of social responsibility.

Otto Dix and Yoshiko Michitsuji depicted experiences of the two world wars, while Arneson represented humanity's desire to avoid a third and possibly final world war. Others in our time have, through their works, emphasized a new awareness of positive, creative human potential. The themes of destruction

503 Robert Arneson.
NUCLEAR WAR HEAD. 1983.
Acrylic, oil sticks, alkyd on paper. 43″ x 53″.
Collection of the artist.

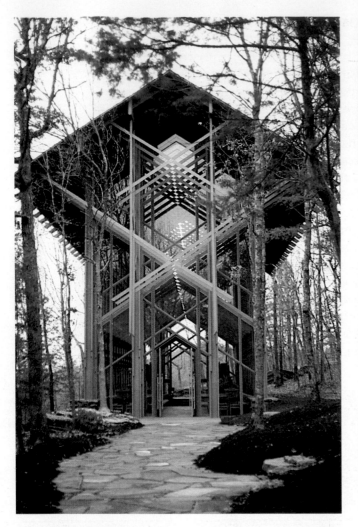

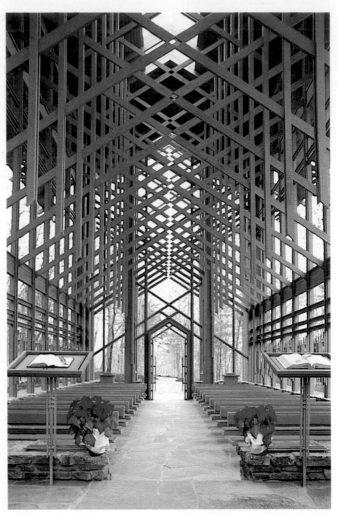

504 E. Fay Jones & Associates.
THORNCROWN CHAPEL. Eureka Springs, Arkansas. 1980.
Photographs: Thomas England.

and degeneracy so often found in twentieth-century art are countered by playful and uplifting works, including imaginative examples of recent sacred architecture that symbolize a new spiritual awakening.

THORNCROWN CHAPEL, designed by E. Fay Jones, was built in 1980 near Eureka Springs, Arkansas. The nondenomenational Christian wayfarers' chapel is located in a secluded spot along a wooded trail high in the Ozark Mountains. Jones knew that heavy earth-moving construction equipment would damage the wooded setting; therefore the whole structural concept was worked out to require only materials that could be carried by two men along a narrow hillside path. The architect points out that the structure is a kind of reverse Gothic construction. Gothic cathedrals are supported by an exterior structure in compression, while THORNCROWN CHAPEL is held together by lightweight interior timbers in tension. A ridge skylight allows a constant play of light to come through the branchlike web of braces. The chapel's diagonal trusses combine with soaring verticals to create a sculptural structure filled with light, space, and energy. There is no added

decoration. The elegant pattern of supporting timber and transparent glass is both the engineering and the art. The structural design and gray stained wood cause the building to blend well with the surrounding woods, creating an atmosphere of peace, inspiration, and communion with God and nature.

505 Charles Eames.
SOLAR TOY. 1959.
Plastic and aluminum. Approx. 42″ x 26″.
Aluminum Company of America.

ART IS A TOOL FOR SHAPING THE FUTURE

Artists deal with issues that affect all of us. In some cases works of art represent the artist's response to what has happened or what is taking place. At other times artists draw on their insight and foresight to suggest prospects for the future.

Charles Eames' SOLAR TOY, completed in 1959 for Alcoa, suggests a bright, productive future in its early use of solar energy and lightweight modern materials. Eames chose to emphasize the playful, positive potential of human creativity.

Both art and science take us beyond the differences and conflicts caused by separate political, economic, and religious systems. Art speaks on a deep level to the human spirit. In this time, when so many things are pulling people apart, art provides ways to recognize that which unites us all.

It is more than a hope . . . that the artists among us will help us all to measure our strengths rather than our fears and weaknesses, will help us to discover and define what we, as citizens of the whole world, have in common, rather than in contention.

Charles Champlin[7]

Artists have a major role to play in alerting people to the choices before them. Art can help us to recognize what it means to be fully human. Awareness of our shared humanness is the key to life, hope, and genuine progress in the nuclear age.

To fulfill their purpose, artists design relationships capable of carrying the qualities or meanings they wish to express. Of importance in the art process are the interrelationships within the art work itself and the equally crucial relationship between the work of art and the viewer. We have already suggested ways art can enhance and signify the creative quality of an individual artist's relationship between inner self and outer world; we have also looked at how works of art can communicate person to person, and even globally from people to people. From this point on we will focus on the potential for employing art as a way of improving our manufactured environment and as a means of forming more positive relationships between ourselves, the places in which we live, and planet Earth.

Necessity encouraged early humans to develop and apply their imaginations. They began to make things in order to meet the needs for food, shelter, and protection. From these beginnings we have gone on inventing and constructing at an ever-increasing rate, building up around ourselves an accumulation of artifacts that has set us apart from what Walt Whitman called "the primal sanities of nature."[8]

Only within the moment of time represented by the present century has one species—man—acquired significant power to alter the nature of his world.

Rachael Carson[9]

Our environmental changes, including the accumulation of chemical and industrial waste products, have caused the extinction of hundreds of species of animals, and now threaten many more, including human beings. A major force working against the harmonious relationship between humanity and nature, and art and life, is the set of values that has developed in today's industrial nations to perpetuate economic growth based on technology. Regardless of political ideologies, these values include setting a high priority on production, with emphasis on technical expediency—too often at the expense of more human considerations such as concern for the aesthetic aspects of life. There are assumptions that we must exploit the environment so that it will provide us with immediate "necessary" resources. These values produce a lifestyle that appears strikingly rich in every aspect except that of cultivation of the human spirit.[10]

Tools extend our power. Today's tools give us the awesome power to transform the world, greatly magnifying the impact of our choices. With the ability to make environmental change comes the responsibility to make constructive change. Our next step is to use this power to make our environment a work of harmony and delight, capable of promoting rather than destroying the health and well-being of all who share it.

Chaos and ugliness are both the symptoms and causes of cultural disease. Given the array of environmental problems facing us today, it is no wonder that many of us feel despair. Yet when despair interferes with positive action it magnifies problems. Perhaps worse than despair is the illusion that we can escape by abandoning our wasted places for fresh ones. Another kind

of escape is the withdrawal that can occur when the environment becomes so bad that it pollutes our senses and anesthetizes our perception. Without sensitivity we cannot recognize the changes that are needed. Our ability to adapt can work against us. We become increasingly desensitized to surroundings that deny our basic human needs. It is difficult to turn around such a destructive cycle.

Art may contribute to the quality of human life by nurturing creativity, by training perceptions, and by guiding the process of form-making. Sensory experience can provide the awareness and imagination necessary for value changes. Intense aesthetic experiences break the habit of taking things for granted, and thus are an important tool for developing new perceptions.

All the arts are "environmental" in the sense that they help to determine the quality of our living areas. The discussion on environmental design in Chapter 3 shows some of the ways professional designers affect the environment on a large scale. Such professionals include architects, who design buildings and groups of buildings; landscape architects, who plan open green spaces; industrial designers, who design a range of manufactured objects from street furniture to transportation systems; and urban and regional designers, who plan ordered relationships between each of these diverse physical elements.

Even the best design professionals cannot solve environmental problems alone. Success or failure of their efforts is determined by economic, political, and social forces in the society as a whole. In the sense that our actions and activities change our surroundings, each of us is involved in, and ultimately responsible for, environmental design.

The belief that we are not able to affect change in our surroundings is both a cause and a result of today's environmental problems. Whether we are conscious of our impact or not, our daily life itself has an effect on the environment. What we choose to buy, to live with, and to create indicates our states of mind and our values. This is why it is important to become aware of our environment, to see what kinds of forms we have created. If we do not like what we see, we need to find ways to make changes. As we become aware of how our surroundings and our relationships to them affect our day-to-day feelings and even our health, we can decide to take a more active, conscious role in helping to improve the quality of our living places and the larger environment we share with others. Such action affirms and strengthens the best in us, and begins a constructive cycle of give-and-take between ourselves and our community. Here are a few examples of ways each of us can make a difference.

☐ Make decisions and take action regarding the parts of your surroundings that you would like to preserve or restore and those you would like to see changed. You could start with your personal possessions and home surroundings and perhaps carry the process into a cooperative effort in your community, county, or state. Some national and global awareness is also needed.

☐ Support existing organizations involved in art or environmental activities. You can simply join, adding your name to a membership list, or you can actively participate in educational programs, community improvement projects, or other activities.

☐ Lend your support and patronage to businesses whose practices and products you find beneficial to the quality of life, and withhold your support from those you don't. The process of buying things involves selection. In a free society, taste and public demand play a large part in determining how products are designed. Everything we wear or use, from toasters to transportation systems, is designed with the consumer in mind. By deciding *not* to buy a product because it is unattractive or is environmentally unsound, you are affecting its design and even its future existence. Those with money to invest

make a major impact on our shared environment by their investment choices.

☐ Be aware of your environmental impact. Whether you occasionally walk instead of drive, or become involved in planning or lobbying for improved transportation systems, you are affecting the environment.

In the cities of the world there is a continuing attempt to accommodate growth and change by adding on to what already exists. This approach worked in earlier times when both population growth and changes in technology occurred slowly. Today it is not enough to patch, renovate, and add on. It is now imperative that we plan for growth and learn to manage it, and control it where necessary. On a small scale, the accidental city has intriguing variety and complexity; but, in a large and rapidly expanding metropolitan area, haphazard growth can be

506 Lawrence Halprin and Associates
(Angela Danadjieva Tzvetin, Project Designer).
AUDITORIUM FORECOURT CASCADE (PEOPLE'S FOUNTAIN). 1972.
Portland, Oregon.

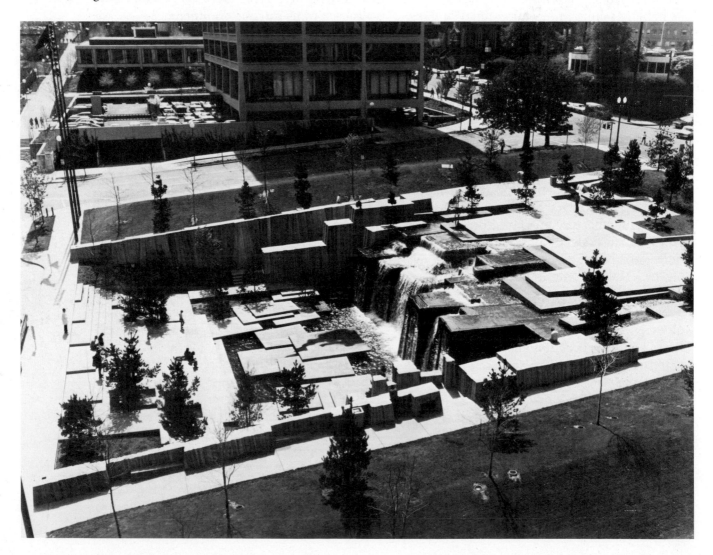

dehumanizing and dangerous. As master planner James Rouse points out, far too often

our cities grow by sheer chance, by accident, by the whim of the private developer and public agencies. A farm is sold and the land begins to sprout houses instead of potatoes. Forests are cut. Valleys are filled. Streams are turned into storm sewers. An expressway is hacked through the landscape. Then a cloverleaf, then a regional shopping center, then office buildings, then high-rise apartments. In this way, the bits and pieces of a city are splattered across the landscape. By this irrational process, non-communities are born, formless places without order, beauty or reason, with no visible respect for either people or the land.[11]

If the values behind architectural and urban design cause them to satisfy individual greed and lust for power, no amount of "beautification" will help. Application of a concealing cosmetic will only delay the process of solving deeper problems. On the other hand, if genuine humanitarian concern and creative imagination are employed for the good of all, functional and aesthetic excellence will result.

The purpose of urban design is to take chaos and discomfort out of the human environment and to add efficiency, beauty, and delight. Effective urban design can take advantage of the great variety of personal preferences, while giving the whole community a harmonious form. To design means to give workable, meaningful structure to a plan. Many cities have been laid out or planned in a two-dimensional sense, but only a few have been designed in a fully three-dimensional, interactive way.

The drama of architecture is a major element in the form of a city. People and businesses want to be in the heart of a city only if it is a good place in which to live and work. Here the arts play a decisive role. They can make a city more lively, beautiful, and satisfying than most cities are today. The key is to support urban design that incorporates and enhances the other arts.

Good design has been around for a long time. It has nothing to do with when, or in what style something was designed. Recent years have seen a reexamination of the urban renewal concept. Economic factors as well as social concerns have led away from the wholesale demolition of neighborhoods. The new trend includes the restoration and reuse of old buildings, thus preserving the character of existing neighborhoods. This is more than historic preservation. Buildings may serve the same purpose for which they were originally designed, but many times the intended functions are no longer needed, and such structures are converted to meet current needs. Many old buildings have been destroyed simply because nobody was able to visualize their potential.

SITE is an interdisciplinary architecture and environmental arts organization which explores new ideas for urban and suburban buildings and spaces. Its work includes concepts for recycling buildings. SITE draws on sources outside traditional architectural conventions as it seeks to increase the communicative level of buildings and public spaces. The group is committed to the sociological and psychological content of architecture, and to architecture as art.

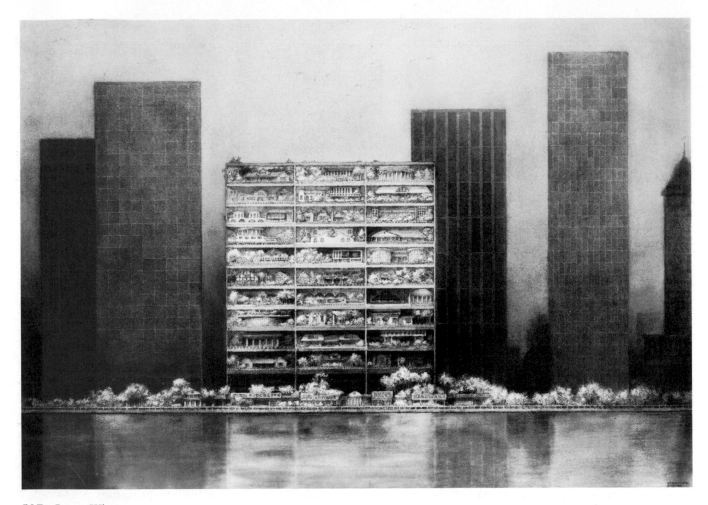

507 James Wines.
WATER'S EDGE.
Drawing for HIGHRISE OF HOMES, SITE Projects, Inc. 1981.
Ink and charcoal. 24″ x 30″.
Collection of Laura Carpenter, Dallas, Texas.

The *Highrise of Homes*[12] is a SITE research project presented as an exhibit and a book. It is based on the premise that architects are obliged to provide individual housing choices within the highrise context. SITE looks at stacked and clustered housing from a historical perspective, and reviews recent and former traditions in highrise construction. Fantasies and technological innovations are also explored in a search for alternatives to the monotonous visual consistency of the International Style aesthetic. The *Highrise of Homes* project is a way to stimulate imaginative thinking that could lead to breakthroughs in housing design.

The structure shown in WATER'S EDGE, made of concrete and steel, supports a community of private homes, each of a design selected by its inhabitants. The separate houses are serviced by an elevator and a mechanical core. A portion of one of the floors or platforms could be purchased in the same way one purchases parcels of land. This would cut land costs while it provided custom housing in the heart of the city. The drawings made for *Highrise of Homes*

arc intended to suggest the possibilities of the assemblage of architecture which could be created by the inhabitants. The concept is being developed for both new construction and for re-use of old industrial buildings.

This thought-provoking proposal offers an alternative to the anonymity of today's highrise apartments. It would provide its inhabitants with the individuality of a house and garden, and the advantages of city life.

The regular occurrence of open spaces combined with vegetation can help meet the city dweller's need for relief from pollution of the senses. Plant life cools and refreshes the air and relaxes the eyes. Green areas can be developed between and even on city buildings. Some highrise structures have been designed to be covered with vines, and other buildings have elaborate roof gardens (see page 221). Parking garages can have parks on their roofs.

Generations ago towns were built around an open area known as the village square or common. Most of our cities have sizable parks, established long ago by planners who recognized the need for open green space within a metropolitan area.

As cities increase in size and population the need for park space grows, yet land in the city continues to become more expensive. The concept of small or "vest-pocket" parks has evolved to meet this need in a practical way. Such parks can be liberally sprinkled throughout the city. When an old building is torn down, a tiny park can be built on one lot. In business districts such parks provide a refuge for workers and tired shoppers. In residential areas they provide recreation and play areas easily accessible to nearby residents.

508 Thomas Wells, architect.
PALO ALTO. Vine covered apartment building. 1969. Honolulu.

509 M. Paul Friedberg and Associates.
VEST-POCKET PLAYGROUND
AND NATURE STUDY CENTER. 1968.
29th Street, New York City.

510
Hideo Sasaki, landscape architect.
GREENACRE PARK. 1979.
421 East 51st Street, New York City,
Owned and maintained by
the Greenacre Foundation.

GREENACRE PARK is a delightful little haven in the middle of New York City. It was designed by Hideo Sasaki, former chairman of the Harvard University Department of Landscape Architecture, as a place for the public to relax away from increasing urban noise, concrete, and monotony. Most urban public parks are city owned and maintained, but GREENACRE PARK is owned and maintained for public use by the Greenacre Foundation.

The refreshing sounds of falling, flowing, and dripping water help to minimize traffic noise. In the central area small tables and movable chairs are placed in a grove of honey locust trees. In cool weather the covered terrace sitting area is warmed by heating elements in the roof. A snack bar is located in an unobtrusive service niche at the entrance to the park, and a custodian is on duty at all times. During the lunch hour the park is so heavily used that people sit on steps and railings rather than go elsewhere, thus demonstrating the great need for such well-designed and well-maintained urban parks.

Lake and ocean shorelines, rivers, and streams are important natural resources that communities can preserve and enjoy. Towns and cities all over the world have grown up beside water sources. The present city of San Antonio, Texas, began as a small settlement on the banks of the San Antonio River. As was customary, the river functioned both as watering place and waste disposal system. After a major flood in 1921 there was serious talk of covering the small river with concrete and making a street above. Fortunately, a flood prevention plan was begun instead, and by 1938 the full aesthetic potential of the river was recognized. Citizens and government officials worked with

511a BACKYARD SLUM.
San Antonio River bank, c. 1935.

511b RIVER WALK, SAN ANTONIO RIVER PARK. c. 1969.
Photograph: Zintgraff, Inc.

landscape architect Robert H. H. Hugman to transform what had become a backyard slum into a front yard garden and riverfront linear park. The natural beauty of the river is augmented with arched bridges, as well as walkways, restaurants, and boating facilities along its banks.

If we are to stand the stresses of urban life, some direct contact with wilderness may be vital to us. The need for protected areas was understood as early as 1898 by John Muir, naturalist, conservationist, spokesman for the national parks, and co-founder of the Sierra Club.

Thousands of tired, nerve-shaken, over-civilized people are beginning to find out that going to the mountains is going home; that wildness is a necessity; and that mountain parks and reservations are useful not only as fountains of timber and irrigating rivers, but as fountains of life.[13]

Ansel Adams was a leader in photography and environmental protection for over 50 years. Through his words and his photographs Adams spoke eloquently for the preservation of wilderness. MOON AND HALF DOME is one image from a lifetime of photographs that have inspired others to cherish the Earth.

The arts are concerned with what we call the quality of life. What we call *life* is an interaction between ourselves and our surroundings. It is a *relationship*. The quality of that relationship determines whether there will be life or death, and if there is life, whether it will be worthwhile.

512 Ansel Adams.
MOON AND HALF DOME, YOSEMITE NATIONAL PARK, CALIFORNIA. c. 1960.
Courtesy the Ansel Adams Publishing Rights Trust.

Design, the act of putting constructs in an order, or disorder, seems to be human destiny. It seems to be the way into trouble and it may be the way out. It is the specific responsibility to which our species has matured, and constitutes the only chance of the thinking, foreseeing, and constructing animal that we are, to preserve life on this shrunken planet and to survive with grace.

Richard Neutra[14]

Art provides the means for going beyond mere survival. The ideas, values, and approaches that constitute the basis of the visual arts can continue to help transform our lives and our surroundings into something more viable and satisfying. Art encourages and puts to good use our expanding awareness. As the creatures with the most advanced consciousness, we have been described as nature becoming aware of itself. We form art. Art forms us.

513 EARTH.
Photograph courtesy of NASA.

30,000	20,000	10,000	5000	3000	2000	1000	500	250	BC 0 AD	200	400	600	800

AMERICAS
MAYAN
Temple 1
Man & Woman

RUSSIA
Female Figure

NORTHERN EUROPE
SCYTHIANS ANIMAL STYLE
VIKING
Purse Cover
Dragon's Head
Head of Neighing Horse
Le Pont du Gard
Book of Kells

SOUTHERN EUROPE
Lascaux Cave Paintings
CHRISTIAN ERA BEGINS
POMPEII BURIED

MEDITERRANEAN
CLASSICAL
Parthenon Warrior
ROMAN EMPIRE
Pantheon
Division of Empire
Fall of Western Empire
Head of Constantine
ARCHAIC
Kore Kouros
HELLENISTIC
Laocoon
BYZANTIUM

AFRICA
OLD KINGDOM
Mycerinus Pyramids
NEW KINGDOM
Qennefer Tomb Paintings
Mummy Portrait
IFE

MIDDLE EAST
NEOLITHIC REVOLUTION BEGINS
SUMERIAN CITIES
Bull-headed Harp
Ziggurats
"GILGAMESH EPIC"
BRONZE AGE BEGINS •
AKKADIANS
Head of Ruler
Luristan bronzes
BIRTH OF CHRIST
BIRTH OF MOHAMMED 570

INDIA
INDUS VALLEY CIVILIZATION
Harappa Torso
BIRTH OF BUDDHA 563
Great Stupa
• INDIA VISITED BY ALEXANDER
Standing Buddha

CHINA
SHANG CHINA
Burial Urn
Ritual Vessel
Great Wall
BUDDHISM SPREAD TO CHINA
Flying Horse
• PAPER INVENTED
CHAN (LATER ZEN) BUDDHISM
•
PRINTING DEVELOPED

JAPAN
BUDDHISM SPREAD TO JAPAN
Ise Shrine

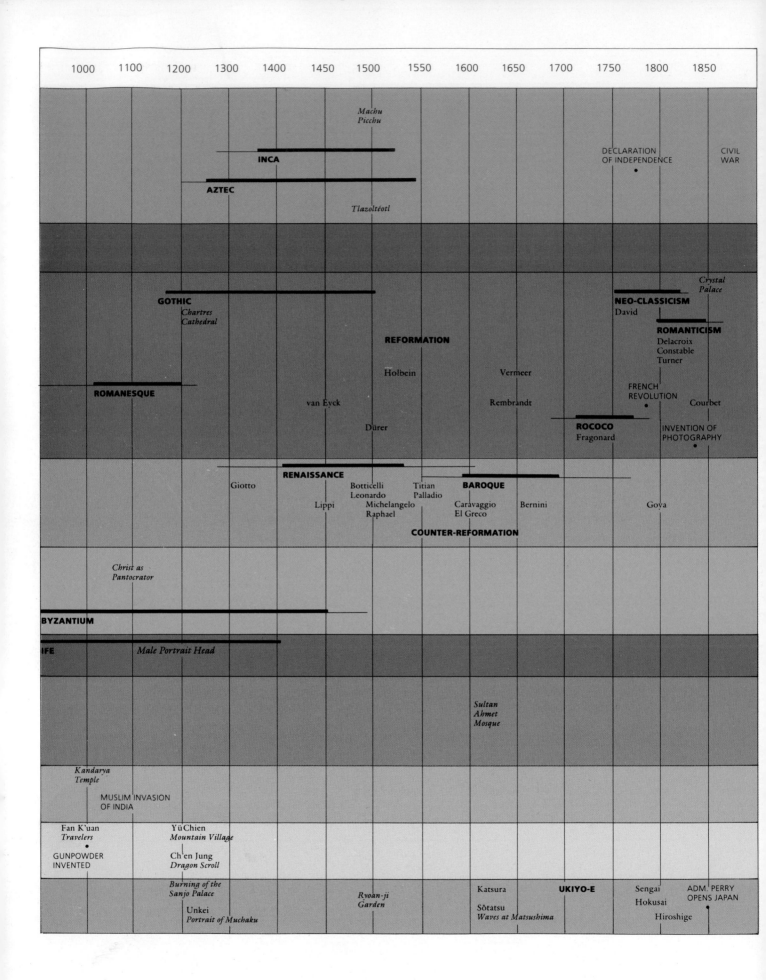

| 1000 | 1100 | 1200 | 1300 | 1400 | 1450 | 1500 | 1550 | 1600 | 1650 | 1700 | 1750 | 1800 | 1850 |

Machu Picchu

INCA

AZTEC

DECLARATION
OF INDEPENDENCE

CIVIL
WAR

Tlazoltéotl

Crystal Palace

GOTHIC

Chartres Cathedral

NEO-CLASSICISM
David

REFORMATION

ROMANTICISM
Delacroix
Constable
Turner

Holbein

Vermeer

ROMANESQUE

van Eyck

Rembrandt

FRENCH
REVOLUTION

Courbet

Dürer

ROCOCO
Fragonard

INVENTION OF
PHOTOGRAPHY

RENAISSANCE

Giotto

Botticelli
Leonardo
Lippi
Michelangelo
Raphael

Titian
Palladio

BAROQUE

Caravaggio
El Greco

Bernini

Goya

COUNTER-REFORMATION

Christ as Pantocrator

BYZANTIUM

IFE

Male Portrait Head

Sultan Ahmet Mosque

Kandarya Temple

MUSLIM INVASION
OF INDIA

Fan K'uan
Travelers

Yü Chien
Mountain Village

GUNPOWDER
INVENTED

Ch'en Jung
Dragon Scroll

Burning of the Sanjo Palace

Katsura

UKIYO-E

Sengai

ADM. PERRY
OPENS JAPAN

Ryoan-ji Garden

Hokusai

Unkei
Portrait of Muchaku

Sōtatsu
Waves at Matsushima

Hiroshige

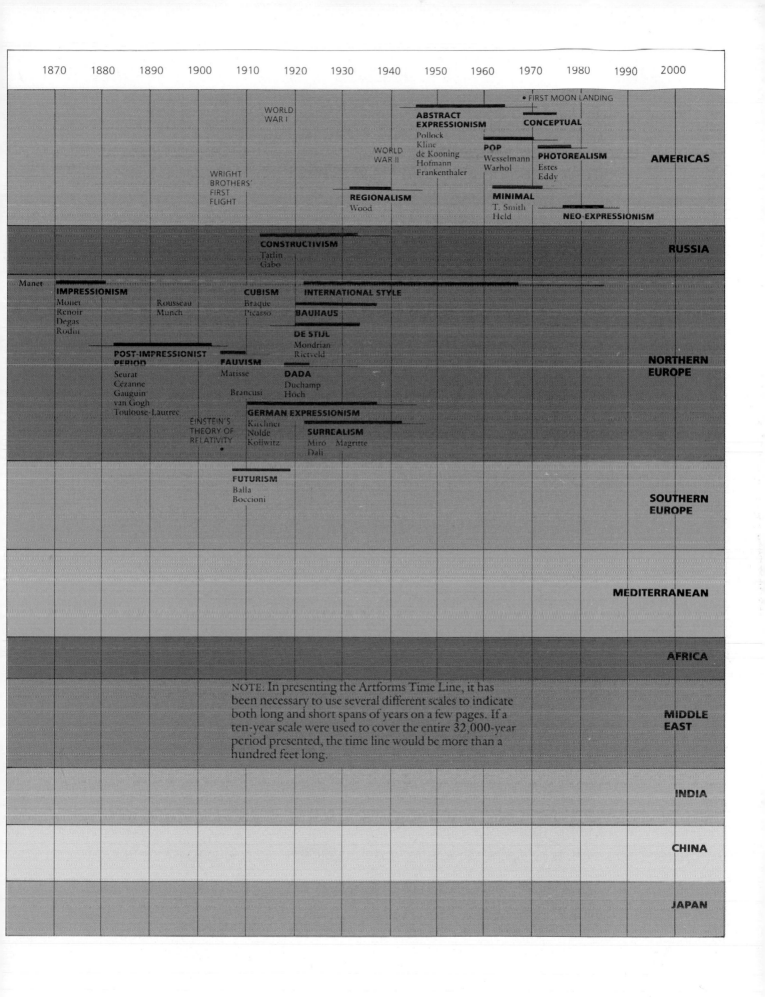

| 1870 | 1880 | 1890 | 1900 | 1910 | 1920 | 1930 | 1940 | 1950 | 1960 | 1970 | 1980 | 1990 | 2000 |

• FIRST MOON LANDING

ABSTRACT EXPRESSIONISM
Pollock
Kline
de Kooning
Hofmann
Frankenthaler

CONCEPTUAL

POP
Wesselmann
Warhol

PHOTOREALISM
Estes
Eddy

WORLD WAR I

WORLD WAR II

WRIGHT BROTHERS' FIRST FLIGHT

REGIONALISM
Wood

MINIMAL
T. Smith
Held

NEO-EXPRESSIONISM

AMERICAS

CONSTRUCTIVISM
Tatlin
Gabo

RUSSIA

Manet

IMPRESSIONISM
Monet
Renoir
Degas
Rodin

Rousseau
Munch

CUBISM
Braque
Picasso

INTERNATIONAL STYLE

BAUHAUS

DE STIJL
Mondrian
Rietveld

POST-IMPRESSIONIST PERIOD
Seurat
Cézanne
Gauguin
van Gogh
Toulouse-Lautrec

FAUVISM
Matisse

Brancusi

DADA
Duchamp
Höch

EINSTEIN'S THEORY OF RELATIVITY
•

GERMAN EXPRESSIONISM
Kirchner
Nolde
Kollwitz

SURREALISM
Miró Magritte
Dali

NORTHERN EUROPE

FUTURISM
Balla
Boccioni

SOUTHERN EUROPE

MEDITERRANEAN

AFRICA

NOTE: In presenting the Artforms Time Line, it has been necessary to use several different scales to indicate both long and short spans of years on a few pages. If a ten-year scale were used to cover the entire 32,000-year period presented, the time line would be more than a hundred feet long.

MIDDLE EAST

INDIA

CHINA

JAPAN

Appendix

GLOSSARY

These terms are defined according to their usage in the visual arts.

abstract art Art based on objects in the physical world in which the usual form of the object is modified or changed in order to emphasize *content* not otherwise apparent. Recognizable references to original appearances may be very slight. The term is sometimes incorrectly used to describe art that is *nonrepresentational*.

Abstract Expressionism A style (or styles) of painting that originated primarily in America during the last years of World War I. It is characterized by spontaneous action recorded in free *calligraphic* forms, exploitation of the accident, and strong color/value patterns that express personal intuitive awareness. Large canvases become their own environment and give impact to these images.

Abstract Surrealism See *Surrealism*.

academy An official school of art, primarily found in Italy during the sixteenth century and in France from the seventeenth through nineteenth centuries. By the late nineteenth century, the conservatism of the French Academy made it the center of opposition to all new ideas in art. The term *academic* has come to mean conservative and traditional. "Academic" also refers to a style sanctioned or promoted by an official institution, academy, or school.

achromatic Having no color (or hue); without identifiable hue. Black, white and gray are achromatic.

acrylic (acrylic resin) A clear plastic used as a *binder* in paint and as a casting material in sculpture.

action painting A style of *nonrepresentational* painting that employs the elements of chance by using such gestural techniques as dripping and splattering. Dynamism is often created through the interlaced directions of *pigment* impact. A subcategory of *Abstract Expressionism*.

additive color mixture Mixture of colored light is called additive because when light colors are combined (as with overlapping spot lights) the mixture becomes successively lighter. When combined, light primaries create white light.

additive sculpture Sculptural form produced by adding, combining, or building up material from a core or *armature*. Modeling in clay and welding steel are additive processes.

aesthetic Pertaining to the sense of the beautiful and to heightened sensory perception in general.

aesthetics The study and philosophy of the quality and nature of sensory responses related to, but not limited by, the concept of beauty.

afterimage A visual image that occurs after the initial stimulus is removed.

air brush A small-scale paint sprayer that can project a fine, controllable mist of paint.

analogous colors or analogous hues Closely related *hues*, especially those in which we can see a common hue; hues that are neighbors on the color wheel, such as blue, blue-green, and green.

Analytical Cubism See *Cubism*.

aperture In photography, the *camera* lens opening and its relative diameter. Measured in "F stops," such as 5.6, 8, and 16. As the number increases, the size of the aperture decreases, thereby reducing the amount of light passing through the lens and striking the film.

aquatint An *intaglio* print process in which rosin dust sprinkled on the plate is used to resist the biting action of acid; used to produce value areas, rather than lines on a print. Also, a print made by this process.

arcade A series of arches supported by columns or piers.

armature A rigid framework serving as a supporting inner core for clay or other soft modeling material.

assemblage Sculpture using pre-existing, recognizable objects that contribute their original identity to the total content of the work.

asymmetrical Not symmetrical.

atmospheric perspective See *perspective*.

automatism The act of drawing, painting, or writing without conscious control, in order to express subconscious ideas or feelings.

avant-garde A group of people (especially in the arts) regarded as leaders in the invention and application of new concepts in a given field. Radical leader(s) of any new movement.

axis An implied straight line in the center of a form along its dominant direction.

balance An arrangement of parts achieving a state of equilibrium between opposing forces or influences. Major types are symmetrical, asymmetrical, and radial.

Baroque A period in European arts dominant during the seventeenth century; characterized in the visual arts by dramatic light and shade, turbulent composition, and exaggerated emotional expression.

barrel vault See *vault*.

bas relief See *relief sculpture*.

binder The material used in paint that causes *pigment* particles to adhere to one another and to the *support*.

buttress A support, usually exterior, for a wall, arch, or vault that opposes the lateral forces of these structures. A *flying buttress* consists of a strut or segment of an arch carrying the thrust of a *vault* to a vertical pier positioned away from the main portion of the building. An important element in Gothic cathedrals.

Byzantine art Styles of painting, design, and architecture developed from the fifth century A.D. in Byzantium. Characterized in architecture by round arches, massive domes, and extensive use of *mosaic*; characterized in painting by formal design, frontal and stylized figures, and rich use of color, especially gold, in generally religious subject matter.

calligraphy The art of beautiful writing. Broadly, a controlled, flowing use of line referred to as "calligraphic."

camera A mechanical device for taking photographs. It generally consists of a light-proof enclosure with an *aperture,* which allows a controlled light image to pass through a shuttered *lens* and be focused on a photosensitive material.

camera obscura A dark room (or box) with a small hole in one side through which an inverted image of the view outside is projected onto the opposite wall, screen, or mirror.

cantilever A beam or slab projecting a substantial distance from a post or wall, supported only at one end.

capital In architecture, the top part, cap stone, or head of a column or pillar.

caricature A distorted representation in which the subject's distinctive features are exaggerated.

cartoon A humorous or satirical drawing. Also, a drawing completed as a full-scale working drawing, usually for a fresco painting, mural, or tapestry.

carving A *subtractive* process in which a sculpture is formed by removing material from a block or mass of wood, stone, or other material using sharpened tools.

casein A white, tasteless, odorless milk protein used in making paint as well as plastics, adhesives, and foods.

casting A process that involves pouring liquid material such as molten metal, clay, wax, or plaster into a mold. When the liquid hardens, the mold is removed, leaving a form in the shape of the mold.

ceramic An object made of clay that is hardened into a relatively permanent material by firing or baking.

chiaroscuro The gradations of light and dark in *two-dimensional* imagery, especially in those works in which forms are determined by the meeting of lighter and darker tones, rather than by sharp outlines.

cinematography The art and technique of making motion pictures, especially the work done by motion-picture-camera operators.

Classical The art of ancient Greece and Rome. In particular, the style of Greek art that flourished during the fifth century B.C. Classical can also mean any art based on a clear, rational, and regular structure, emphasizing horizontal and vertical directions, and organizing its parts with special emphasis on balance and proportion. The term "classic" is also used to indicate recognized excellence.

closed form A self-contained or explicitly limited form; having a resolved balance of tensions, a sense of calm completeness implying a totality within itself.

cluster houses Housing units placed close together in order to maximize usable exterior space in the surrounding area, within the concept of single-family dwellings.

coffer In architecture, a decorative sunken panel on the underside of a ceiling.

collage From the French *papiers collés*, or pasted papers. A work made by gluing various materials, such as paper scraps, photographs, and cloth, on a flat surface.

colonnade A row of columns usually spanned or connected by beams.

Color Field Painting A trend that grew out of *Abstract Expressionism*, in which large stained or painted areas provide the viewer with an environmental or overall field of color.

complementary colors Traditionally, two *hues* directly opposite one another on the color wheel which, when mixed together in proper proportions, produce a neutral gray. The true complement of a color can be seen in its *afterimage*.

composite shape A single shape composed of two or more interlocking smaller shapes.

composition The combining of parts or elements to form a whole; the structure, organization, or total form of a work of art. See also *design*.

Conceptual Art An event or work of art conceived in the mind of an artist. Conceptual works are sometimes produced in visible form, but often presented only as a mental concept or idea. A trend that developed in the late 1960s partially as a way to avoid the commercialization of art.

content Meaning, contained and communicated by form.

contour The edge or line that separates one area or mass from another;

a line following a surface drawn to suggest volume.

contrapposto The counterpositioning of parts of the human figure about a central vertical axis, as when the weight is placed naturally on one foot causing the hip and shoulder lines to counterbalance each other in opposite directions.

cool colors Colors whose relative visual temperature makes them seem cool. Cool colors include green, blue-green, blue, blue-violet, and violet.

crosshatching See *hatching*.

Cubism A major development and style of early twentieth-century art that began in 1907 with the work of Picasso and Braque. The early mature phase of the style, called Analytical Cubism, lasted from 1909 through 1911 and was based on limited color, shifting points of observation, disintegration, and geometric reconstruction of the subject in flattened, ambiguous pictorial space; figure-ground relationships merge into one interwoven surface of shifting planes. By 1912 the later, more decorative phase called Synthetic or Collage Cubism began to appear; it was characterized by fewer, more solid forms, conceptual rather than observed subject matter, and richer color and texture.

curtain wall A non-load-bearing wall.

curvilinear Formed or characterized by curving lines or edges.

Dada A movement in art and literature founded in Switzerland in the early twentieth century that ridiculed contemporary culture and conventional art. The Dadaists shared an antimilitaristic and anti-aesthetic attitude, generated in part by the horrors of World War I and in part by a rejection of accepted canons of morals and taste. The anarchic spirit of Dada can be seen in the works of Duchamp, Arp, Miró, and

Picasso. Many Dadaists later became Surrealists.

design Both the process and the result of structuring the elements of visual form; composition.

De Stijl A Dutch purist art movement begun during World War I by Mondrian and others. It involved painters, sculptors, designers, and architects whose works and ideas were expressed in *De Stijl* magazine. De Stijl, Dutch for "the style," was aimed at creating a universal form language that would be independent of individual emotion. Visual form was pared down to primary colors plus black and white, and rectangular shapes. The movement was influencial primarily in architecture.

divisionism See *pointillism*.

dome A generally hemispherical roof or vault. Theoretically, an arch rotated 360 degrees on its vertical axis.

drypoint An *intaglio* printmaking process in which lines are scratched directly into a metal plate with a steel needle. Also, the resulting print.

Earth art; Earthworks Sculptural forms of earth, rocks, or sometimes plants, often on a vast scale and in remote locations. Some are deliberately impermanent.

eclecticism The practice of selecting or borrowing from earlier styles and combining the borrowed elements, rather than originating new forms. Eclecticism was frequently used in architecture until the mid-twentieth century.

edition In printmaking, the total number of prints made and approved by the artist, usually numbered consecutively. Also a limited number of multiple originals of a single design in any medium.

elevation In architecture, a scale drawing of any vertical side of a given structure.

embossing A technique for producing raised designs on paper, metal, or leather. In printmaking embossed areas are created by pressing a raised, un-inked design into the paper with a printing press.

encaustic A painting medium in which pigment is suspended in a *binder* of hot wax.

engraving An *intaglio* printmaking process in which grooves are cut into a metal or wood surface with a sharp cutting tool called a burin or graver. Also, the resulting print.

etching An *intaglio* printmaking process in which a metal plate is first coated with acid-resistant wax, then scratched to expose the metal to the bite of nitric acid where lines are desired. Also, the resulting print.

expressionism The broad term that describes emotional art, most often boldly executed and making free use of distortion and symbolic or invented color. When used more specifically, Expressionism refers to individual and group styles originating in Europe in the late nineteenth and early twentieth centuries.

eye level The height of the viewer's eyes above the ground plane.

facade In architecture, a term used to refer to the front exterior of a building, but also to other exterior sides when they are emphasized architecturally.

Fauvism A style of painting introduced in Paris in the early twentieth century, characterized by areas of brilliant, contrasting color and simplified shapes. The name *les Fauves* is French for "the wild beasts."

figure Separate shape(s) distinguishable from a background or *ground*.

flamboyant Any design dominated by flamelike, curvilinear rhythms. In architecture, having complex, flamelike forms characteristic of fifteenth and sixteenth century Gothic style.

flying buttress See *buttress*.

foreshortening The representation of forms on a *two-dimensional* surface so that the long axis(es) appears to project toward the viewer.

form In the broadest sense, the total physical characteristics of an object, event, or situation.

format Basic layout or proportions of a work.

fresco A painting technique in which *pigments* suspended in water are applied to a damp lime-plaster surface. The pigments dry to become part of the plaster wall or surface.

frontal An adjective describing an object that faces the viewer directly, rather than being set at an angle or *foreshortened*.

Futurism A style of art that originated in Italy in the early twentieth century which represented and interpreted a dynamic, modern, machine-powered world. Futurists endeavored to represent movement and speed.

geodesic A geometric form basic to structures using short sections of lightweight material joined into interlocking polygons. Also a structural system developed by R. Buckminster Fuller to create domes using the above principle.

gesso A mixture of glue and either chalk or plaster of Paris applied as a *ground* or coating to surfaces in order to give them the correct properties to receive paint. Gesso can also be built up or molded into *relief* designs, or carved.

glaze In ceramics, a vitreous or glassy coating applied to seal and decorate surfaces. Glaze may be colored, transparent, or opaque. In oil painting, a thin transparent or translucent layer brushed over another layer of paint, allowing the first layer to show through but altering its color slightly.

Gothic Primarily an architectural style that prevailed in Western Europe from the twelfth through the fifteenth centuries, characterized by pointed arches, ribbed *vaults,* and *flying buttresses,* which enabled buildings to reach great heights.

gouache An opaque, water-soluble paint.

green belt A strip or belt of planned or protected open green space, consisting of recreational parks, farm land, or uncultivated land, which is used to define and limit the boundaries of a community and control its size.

ground The background in two-dimensional works—the area around and between figure(s). Also, the surface onto which paint is applied.

Happening An event conceived by artists and performed by artists and others, usually unrehearsed and without a specific script or stage.

hard-edge A term first used in the 1950s to distinguish styles of painting in which shapes are precisely defined by sharp edges, in contrast to the usually blurred or soft edges in *Abstract Expressionist* paintings.

hatching A technique used in drawing and linear forms of printmaking in which lines are placed in parallel series to darken the value of an area. Crosshatching is drawing one set of hatchings over another in a different direction so the lines cross.

high key Exclusive use of pale or light *values* within a given area or surface.

horizon line In linear *perspective,* the implied or actual line or edge placed on a *two-dimensional* surface to represent the point in nature where the sky meets the horizontal land or water plane. The horizon line matches the eye level on a two-dimensional surface. Lines or edges parallel to the ground plane and "moving away" from the viewer appear to converge at vanishing points on the horizon line.

hue That property of a color identifying a specific, named wavelength of light such as green, red, violet, and so on.

humanism A cultural and intellectual movement that occurred during the Renaissance following the rediscovery of the art and literature of ancient Greece and Rome. A philosophy or attitude that is concerned with the interests, achievements, and capabilities of human beings rather than with the abstract concepts and problems of theology or science.

icon An image or symbolic representation (often with sacred significance).

iconography Visual images or symbols used by a given culture.

impasto In painting, thick paint applied to a surface in a heavy manner, having the appearance and consistency of buttery paste.

Impressionism A style of painting that originated in France about 1870. (The first Impressionist exhibit was held in 1874.) Paintings of casual subjects were executed outdoors using divided brush strokes to capture the light and mood of a particular moment.

intaglio A printmaking technique in which lines and areas to be inked and transferred to paper are recessed below the surface of the printing plate. The plate is coated with ink, then wiped clean, leaving ink only in the cuts. The ink is transferred to damp paper by pressure, using a printing press. *Etching, engraving, drypoint,* and *aquatint* are all intaglio processes.

intensity The relative purity or saturation of a *hue* on a scale from bright to dull.

intermediate color A *hue* between a primary and a secondary on the

color wheel such as yellow-green, a mixture of yellow and green.

International Style An architectural style that emerged in several European countries between 1910 and 1920. Related to purism and *De Stijl* in painting, it joined structure and exterior design into a noneclectic form based on rectangular geometry and growing out of the basic function and structure of the building.

kiln A large oven in which pottery or *ceramic* ware is fired (baked).

kinetic art Art that incorporates actual movement as part of the design.

kore Greek for "maiden." An archaic Greek statue of a standing clothed maiden.

kouros Greek for "youth." An archaic Greek statue of a standing nude young male.

lens The part of a *camera* that concentrates light and focuses the image.

linear perspective See *perspective*.

lithography A planographic printmaking technique based on the antipathy of oil and water. The image is drawn with a grease crayon or painted with *tusche* on a stone or grained aluminum plate. The surface is then chemically treated so that it will accept ink only where the crayon or tusche has been used. The surface is inked, and the image transferred to damp paper using pressure.

local color The actual color as distinguished from the apparent color of objects and surfaces; true color, without shadows or reflections.

loom A device for producing cloth by interweaving fibers at right angles.

low key Consistent use of dark *values* within a given area or surface.

lumia The use of actual light as an art *medium*.

Mannerism A style that developed in Italy in the sixteenth century as a rebellion against the classical rationality and balanced harmony of the High Renaissance. Characterized by distortions of perspective, scale, and proportion (especially elongation of figures) and exaggerated color.

mass *Three-dimensional* form having physical bulk. Also, the illusion of such a form on a *two-dimensional* surface.

mat Border of cardboard or similar material placed around a picture as a neutral area between the frame and the picture.

matte A dull finish or surface, especially in painting, photography, and ceramics.

medium (*pl.*media) A particular material along with its accompanying technique. A specific type of artistic technique or means of expression determined by the use of specific materials. Also, in paint, the fluid in which *pigment* is suspended allowing it to spread and adhere to the surface.

megastructure A very large building complex combining many functions in a single structure.

Minimal Art A style of mid-twentieth-century sculpture and painting, usually severely restricted in the use of visual elements and often consisting of relatively simple geometric structures.

mobile A type of sculpture in which parts are moved by air currents. See also *kinetic art*.

modeling Working pliable material such as clay or wax into *three-dimensional* forms. A type of *additive* sculpture. In drawing or painting, the effect of light falling on a three-dimensional object so that the illusion of its mass is revealed and defined by *value* gradations.

module A standard unit of measure

in architecture. The part of a structure used as a standard by which the rest is proportioned.

monochromatic A color scheme limited to variations of one *hue*; a hue with its tints and/or shades.

montage A composition of pictures or parts of pictures previously drawn, painted, or photographed. In motion pictures, the combining of separate bits of film of a single event.

mosaic An art *medium* in which small pieces of colored glass, stone, or ceramic tile called *tessera* are embedded in a background material such as plaster or mortar. Also, works made using this technique.

mural A painting executed directly on a wall, usually very large in size. *Fresco* is a medium often used for mural paintings.

naturalism A style of *representational art* that presents a close approximation of optical appearances, with room for personal interpretation.

nave The tall central space of a church or cathedral, usually flanked by side aisles.

negative shape A background or *ground* shape produced by interaction with foreground or figure shape(s).

Neoclassicism A revival of classical Greek and Roman forms in art, music, and literature, particularly during the eighteenth and nineteenth centuries in Europe and America. It was part of a reaction against the excesses of *Baroque* and *Rococo*.

neutral color A color not associated with any single *hue*. A neutral can be made by mixing complementary hues.

nonobjective See *nonrepresentational art*.

nonrepresentational art Visual

form without reference to anything outside itself.

offset printing Planographic printing by indirect image transfer from photomechanical plates. The plate transfers ink to a rubber covered cylinder, which "offsets" the ink to the paper. Also called photo-offset and offset lithography.

oil paint Paint in which the *pigment* is held together with a *binder* of oil, usually linseed oil.

opaque Impenetrable by light; not transparent or translucent.

Op Art (optical art) A style of *two-dimensional* art that uses lines, or shapes of contrasting color to generate optical sensations not actually present in the initial image.

open form A form whose contour is irregular or broken, having a sense of unfinished growth, change, or unresolved tension; form in a state of becoming.

optical color mixture Apparent rather than actual color mixture produced by interspersing brush strokes or dots of the *hues* to be "mixed" instead of physically mixing them. The implied mixing occurs in the eye of the viewer and produces a lively color sensation.

painterly Painting characterized by openness of form in which shapes are defined by variations in color, rather than by outline or contour.

performance art Art done by visual artists (as distinguished from theater artists such as actors and dancers) in which the medium consists of the body of the artist, along with clothing and/or various props.

perspective The depiction of *three-dimensional* space on a *two-dimensional* surface or picture plane in order to produce the same or similar impression of distance and relative size as is received by the human eye when observing the natural world. Linear perspective is the most con-

sistent system for portraying an illusion of the three-dimensional world on a two-dimensional surface. Linear perspective is based on the fact that parallel lines or edges appear to converge and objects appear to grow smaller as they recede into the distance. Atmospheric perspective (aerial perspective) creates the illusion of distance by reducing color saturation, value contrast, and detail in order to imply the hazy effect of atmosphere on distant objects.

perspective rendering A view of an architectural structure drawn in linear perspective, usually from a three-quarter view or similar vantage point that shows two sides of the structure in great detail.

Photorealism A style of painting based on the cool objectivity of photographs as records of subjects.

pictorial space The implied or illusionary space in a painting or other *two-dimensional* work as it appears to recede backward from the *picture plane*.

picture plane The *two-dimensional* picture surface.

pigment A coloring agent used in paints, inks, crayons, and chalks.

plan In architecture, a scale drawing in diagrammatic form showing the basic layout of the interior and exterior spaces of a structure, as if seen in a cutaway view from above.

plastic In the visual arts, capable of being formed; pertaining to shaping or modeling.

pointillism A system of painting using tiny dots of color; developed by French artist Georges Seurat in the 1880s. Seurat called the technique divisionism. He systematized the divided brushwork and optical color mixture of the Impressionists.

polychromatic Having many colors; random or intuitive use of color combinations as opposed to color

selection based on a specific color scheme.

Pop Art A style of painting and sculpture that developed in the late 1950s and early 1960s, primarily in the United States; based on the visual clichés and subject matter of mass media.

positive shape A *figure* or foreground shape, as opposed to a *negative* ground or background shape.

post and beam system (post and lintel) In architecture, a structural system that uses two uprights or posts supporting a member called either a beam or lintel which spans the space between them.

Post-Impressionism A general term applied to various styles of painting that developed from 1880 to 1900 in reaction to the formlessness and indifference to subject matter of *Impressionism*. Post-Impressionist painters were concerned with the significance of form, symbols, expressiveness, and psychological intensity. These concerns have continued to engross twentieth-century artists. The Post-Impressionists were broadly separated into two groups—*expressionists,* such as Gauguin and van Gogh, and *formalists,* such as Cézanne and Seurat.

prehistoric art Art created before written history. Often the only record of early cultures.

primary colors Those *hues* that cannot be produced by mixing other hues. Pigment primaries are red, yellow, and blue; light primaries are red, green, and blue. Theoretically, primaries can be mixed together to form all the other hues in the spectrum.

prime In painting, a primary layer of paint or sizing applied to a surface that is to be painted.

print (artist's print) A multiple original impression made from a plate, stone, wood block, or screen by an artist or made under the art-

ist's supervision. Prints are usually made in *editions,* with each print numbered and signed by the artist.

proportion The size relationship of parts to a whole and to one another.

realism *Representational art* in which the artist attempts to depict things as closely as possible to the way the eye sees.

reinforced concrete (ferroconcrete) Concrete with steel mesh or bars embedded in it to increase its tensile strength.

relief printing A printing technique in which the parts of the printing surface meant to carry the ink are left raised while the remaining areas are cut away, resulting in a surface design. The raised surface is inked and the ink transferred to paper. Wood cuts and linoleum prints (linocuts) are relief prints.

relief sculpture Sculpture in which *three-dimensional* forms project from the flat background of which they are a part. The degree of projection can vary and is described by the terms high relief and low relief or bas relief.

Renaissance Period in Europe from the fourteenth through the sixteenth centuries that was characterized by a renewed interest in human-centered *Classical* art, literature, and learning.

representational art Art in which it is the artist's intention to present again or re-present the appearance of a particular subject.

reproduction A mechanically produced copy of an original work of art.

rhythm In the visual arts, the regular or ordered repetition of elements or units within a design.

rib In architecture, a slender arch or projecting arched member of a vault.

ribbed vault See *vault.*

Rococo From the French *rocaille* meaning "rock work." This late *Baroque* (c. 1715–1775) style used in interior decoration and painting was characteristically lighthearted, pretty, and morally and visually loose; based on the use of pastel colors and asymmetrical arrangement of curves. Rococo existed primarily in France and southern Germany.

Romanesque A style of European architecture prevalent from the ninth to the twelfth centuries, influenced by Roman architecture.

Romanticism A literary and artistic movement originating in Europe in the late eighteenth century, aimed at asserting the validity of subjective experience as a countermovement to the often cold formulas of *Neoclassicism*; characterized by spontaneity and intuition rather than carefully organized rational approaches to form.

saturation See *intensity.*

scale The size or apparent size of an object seen in relation to other objects, people, or its environment or *format.* Also used to refer to the quality or monumentality found in some objects regardless of their size. In architectural drawings, the ratio of the measurements in the drawing to the measurements in the building.

screen printing (serigraphy) A printmaking technique in which stencils are applied to fabric that is stretched across a frame. Paint or ink is forced with a squeegee through the unblocked portions of the screen onto paper or other surface beneath.

secondary colors Pigment secondaries are the *hues* orange, violet, and green, which may be produced in somewhat diluted form by mixing two primaries.

section In architecture, a scale drawing of part of a building as seen along an imaginary plane that passes through the building vertically.

serigraphy See *screen printing.*

setback The legal distance that a building must be from property lines. Early setback requirements often increased with the height of a building, resulting in steplike recessions in the rise of tall buildings.

shade A *hue* with black added.

shape A *two-dimensional* or implied two-dimensional area defined by line or changes in value and/or color.

shutter In photography, the part of the *camera* that controls the length of time the light is allowed to strike the photosensitive film.

silk screen See *screen printing.*

silverpoint A drawing technique seldom used today, in which a silver-tipped "pencil" is used on paper covered with a white or lightly tinted *matte* coating, producing silver-gray indelible lines that darken as the silver tarnishes.

size Any of several substances made from glue, wax, or clay, used as a filler for porous material such as paper, canvas, or other cloth, or wall surfaces. Used to protect the surface from the deteriorating effects of paint, particularly oil paint.

still life A *two-dimensional* work of art representing inanimate objects such as bottles, fruit, and flowers. Also, the arrrangement of these objects from which a drawing, painting, or other work is made.

stupa The earliest form of Buddhist architecture, probably derived from Indian funeral mounds.

style A characteristic handling of *media,* techniques, and elements of form, giving a work its identity as the product of a particular person, group, art movement, period, or society.

subtractive color mixture Mixture of colored *pigments* in the form of paints, inks, pastels, and so on.

Called subtractive because reflected light is reduced as pigment colors are combined.

subtractive sculpture Sculpture made by removing material from a larger block or form.

support The physical material that provides the base for and sustains a two-dimensional work of art. Paper is the usual support for drawings and prints; canvas or panels are supports in painting.

Suprematism An offshoot of *Cubism*; the style was invented by Kasimir Malevich (c. 1913) as a pure, geometric, nonrepresentational art.

Surrealism A style of painting that developed in the early twentieth century; derived from *Dada* and *Cubism*. Based upon dreams, the irrational, and the fantastic, Surrealism took two directions: representational and abstract. Magritte's work, with his use of impossible combinations of objects painted in a realistic manner, typifies representational Surrealism. Miró's work, with his use of abstract and fantastic shapes and creatures, is typical of abstract Surrealism.

symbol A form or image implying or representing something beyond its obvious and immediate meaning.

symmetry A design (or composition) with identical or nearly identical form on opposite sides of a dividing line or central axis; formal balance.

Synthetic Cubism See *Cubism*.

tempera A water-based paint that uses egg, egg yolk, glue, or *casein* as a *binder*. Many commercially made paints identified as tempera are actually *gouache*.

tessera Bit of colored glass, ceramic tile, or stone used in a *mosaic*.

texture The tactile quality of a surface or the representation or invention of the appearance of such a surface quality.

three-dimensional Having height, width, and depth.

throwing The process of forming clay objects on a potter's wheel.

tie-dye Fabric dying technique in which portions of the fabric are sewed, knotted, or tied so that such parts will absorb little or no dye.

tint A *hue* with white added.

townhouse One of a row of houses connected by common side walls.

truss In architecture, a structural framework of wood or metal based on a triangular system, used to span, reinforce, or support walls, ceilings, piers, or beams.

tunnel vault (barrel vault) See *vault*.

tusche A greasy substance used to draw or paint images on a *lithographic* stone or plate.

two-dimensional Having the dimensions of height and width only.

typography The art and technique of composing printed material from type.

unity The appearance of similarity, consistency, or oneness. Interrelational factors that cause various elements to appear as part of a complete form.

value In art, the lightness or darkness of tones or colors. White is the lightest value; black is the darkest. The value half-way between these extremes is called middle gray.

vanishing point In linear *perspective*, the point on the horizon line at which lines or edges that are parallel appear to converge.

vantage point The position from which the viewer looks at an object or visual field; also called "observation point" or "viewpoint."

vault A masonry roof or ceiling constructed on the principle of the arch. A tunnel or barrel vault is a semicircular arch extended in depth; a continuous series of arches, one behind the other. A ribbed vault is a vault supported by masonry ribs.

vehicle Liquid emulsion used as a carrier or spreading agent in paints.

video Television. The term "video" emphasizes the visual rather than the audio aspects of the television *medium*. The term is also used to distinguish television used as an art medium from general broadcast television.

visualize To form a mental image or vision; to imagine.

volume Space enclosed by and defined by mass.

warm colors Colors whose relative visual temperature makes them seem warm. Warm colors or *hues* include red-violet, red, red-orange, orange, yellow-orange, and yellow.

warp In weaving, the threads that run lengthwise in a fabric, crossed at right angles by the *weft*. Also, the arranging of yarn or thread on a loom so as to form a warp.

wash A thin, transparent layer of paint or ink.

watercolor Paint that uses water-soluble gum as the *binder* and water as the *vehicle*. Characterized by transparency. Also, the resulting painting.

weft In weaving, the horizontal threads interlaced through the *warp*. Yarn to be used for the weft. Also called woof.

woodcut A type of *relief print* made from an image that is left raised on a block of wood.

NOTES

Front Matter and Introduction

1. Ralph Graves, ed., "The Master of the Soft Touch," in *Life* 67, no. 21 (November 21, 1969): 64c.

Chapter 1

1. Leo Tolstoy, *What Is Art* (London: Walter Scott, 1899), p. 50.

2. C. L. Barnhart and Jess Stein, eds., *The American College Dictionary* (New York: Random House, 1963), p. 70.

3. Caroline Thomas Harnsberger, ed., *Treasury of Presidential Quotations* (Chicago: Follett, 1964), p. 22.

4. Elizabeth-Ellen Long, "Navajo Sand Painting" in *Arizona Highways* 34, no. 8 (August 1958): 33.

5. Don Fabun, *The Dynamics of Change* (Englewood Cliffs, New Jersey: Prentice-Hall, 1968), p. 9.

6. Carroll Quigley, "Needed: A Revolution in Thinking?" in *The Journal of the National Education Association* 57, no. 5 (May 1968): 9.

7. Henri Matisse, "The Nature of Creative Activity," in *Education and Art,* ed. Edwin Ziegfeld (New York: UNESCO, 1953), p. 21.

8. Mike Samuels, M.D., and Nancy Samuels, *Seeing with the Mind's Eye* (New York: Random House and Berkeley, California: The Bookworks, 1975), pp. 5–6.

9. Rev. Paul Osumi, *Honolulu Advertiser,* November 26, 1976, p. F-11.

10. Edward Weston, *The Daybooks of Edward Weston,* 2 vols., ed. Nancy Newhall (Millerton, New York: Aperture, 1973), vol. 2, p. 181.

11. Weston, *Daybooks,* p. 154.

12. Douglas Davis, "New Architecture: Building for Man," in *Newsweek* 77, no. 16 (April 19, 1971): 80.

13. Betty Burroughs, ed., *Vasari's Lives of the Artists* (New York: Simon & Schuster, 1946), p. 191.

14. Abraham H. Maslow, *Toward a Psychology of Being* (New York: Van Nostrand Reinhold, 1968), p. 136.

15. Bergen Evans, *Dictionary of Quotations* (New York: Delacorte Press, 1968), p. 340.

16. Samuels and Samuels, *Seeing with the Mind's Eye,* p. 239.

17. Courtesy of the Committee for Simon Rodia's Towers in Watts.

18. John Holt, *How Children Fail* (New York: Pitman, 1964), p. 167. Reprinted with permission.

19. Henri Matisse, "Notes of a Painter," trans. Alfred H. Barr, Jr., in *Problems of Aesthetics,* ed. Elised Vivas and Murray Krieger (New York: Holt, Rinehart & Winston, 1953), p. 256; originally printed as "Notes d'un peintre," in *La Grande Revue* (Paris, 1908).

20. Matisse, "Notes of a Painter," p. 260.

21. Matisse, "Notes of a Painter," pp. 259–260.

22. Piet Mondrian, in *Artists on Art,* ed. Robert Goldwater and Marco Treves (New York: Pantheon Books, 1945), p. 428.

23. From "Notes d'un pientre sur son dessin," in *Le Point,* IV, XXI 1939, p. 14.

Chapter 2

1. Jean Schuster, "Marcel Duchamp, vite," in *le surréalisme* (Paris), no. 2 (Spring 1957): 143.

2. "Interview with Roger Reynolds" [December 1961] in *John Cage* [catalogue] (New York: Henmar Press, 1962), p. 47.

3. Interview with Jean vanden Huevel, "Straight from the Hand and Mouth of Steinberg," in *Life* 59, no. 24 (December 10, 1965): 59.

4. D. T. Suzuki, "Sengai, Zen and Art," in *Art News Annual* 27, pt. 2, no. 7 (November 1957): 118.

5. Faber Birren, *Color Psychology and Color Therapy* (New Hyde Park, New York: University Books, 1961), p. 20.

6. Albert E. Elsen, *Purposes of Art* (New York: Holt, Rinehart & Winston, 1967), p. 437.

7. Lawrence Halprin, *The R.S.V.P. Cycles* (New York: George Braziller, 1969).

8. Ray Bethers, *Composition in Pictures* (New York: Pitman, 1949), p. 163; originally printed in the *Manifesto of the Futurist Painters,* Italy, 1910.

9. Henri Matisse, "Notes of a Painter," trans. Alfred H. Barr, Jr., in *Problems of Aesthetics,* ed. Elised Vivas and Murray Krieger (New York: Holt, Rinehart & Winston, 1953), p. 259; originally printed as "Notes d'un peintre," in *La Grande Revue* (Paris, 1908).

Chapter 3

1. Vernon Blake, *Art and Craft of Drawing* (London: Oxford University Press, 1927), p. 234.

2. Frederick Franck, *The Zen of Seeing: Seeing/Drawing as Meditation* (New York: Vintage Books, 1973), p. 6.

3. Betty Edwards, *Drawing on the Right Side of the Brain* (Los Angeles: J. P. Tarcher, Inc., 1979).

4. Anthony Blunt, *Picasso's Guernica* (New York: Oxford University Press, 1969), p. 28.

5. Ichitaro Kondo and Elsie Grilli, *Katsushika Hokusai* (Rutland, Vermont: Charles E. Tuttle, 1955), p. 13.

6. André Malraux, *Museum Without Walls,* trans. Stuart Gilbert and Francis Price (Garden City, New York: Doubleday & Co., 1967), p. 12.

7. Henri Cartier-Bresson, *The Decisive Moment* (New York: Simon & Schuster, 1952), p. 1.

8. Cartier-Bresson, *The Decisive Moment,* p. 14.

9. Cartier-Bresson, *The Decisive Moment,* p. 6.

10. Andrew Sarris, ed., *Interviews with Film Directors,* trans. Alice Turner (New York: Avon Books, 1969), p. 35.

11. Marcia Morse, review of "Hawaii Craftsmen '83," in *The*

[Honolulu] *Sunday Star-Bulletin and Advertiser,* October 9, 1983, p. C-13.

12. Henry Hopkins, *Fifty West Coast Artists* (San Francisco: Chronicle Books, 1981), p. 25.

13. John Coyne, "Handcrafts," in *Today's Education* (November–December 1976): 75.

14. Otto B. Rigan, *New Glass* (San Francisco: San Francisco Book Co., 1976), p. 105.

15. Rigan, *New Glass,* p. 105.

16. Louis Sullivan, "The Tall Office Building Artistically Considered," in *Lippincott Monthly Magazine* (March 1896): 408.

17. Bernard Rudofsky, *Architecture Without Architects* (Garden City, New York: Doubleday, 1964).

18. Peter Blake, "The Ugly American," in *Horizon* 3, no. 5 (May 1961): 6.

19. Constantinos A. Doxiadis, *Architecture in Transition* (New York: Oxford University Press, 1968), p. 35.

20. Ian L. McHarg, *Design With Nature* (Garden City, New York: Doubleday, 1971), p. 7.

Chapter 4

1. Marius de Zayas, "Pablo Picasso, An Interview," in *Artists on Art,* ed. Robert Goldwater and Marco Treves (New York: Pantheon Books, 1958), p. 418; originally printed in *The Arts* (New York, May 1923).

2. Jacob Bronowski, *The Ascent of Man* (Boston: Little, Brown, 1973), p. 42.

3. Carl G. Jung et al., *Man and His Symbols* (New York: Doubleday, 1964), p. 232.

4. From the film *The Eye of Picasso,* written and produced by Nelly Kaplan, Cythere Films, Paris, 1969.

5. Ananda Coomaraswamy, *Dance of Shiva* (New York: Noonday Press, 1965), p. 78.

6. Erwin Panofsky, *Meaning in the Visual Arts* (Garden City, New York: Doubleday, 1955), p. 128.

7. Beaumont Newhall, *The History of Photography* (New York: The Museum of Modern Art, 1964), p. 11.

8. Robert Coughlan, *The World of Michelangelo* (New York: Time-Life Books, 1966), p. 93.

9. Jonathan Brown, "El Greco and Toledo," in *El Greco of Toledo* (Boston: Little, Brown, 1982), p. 131.

10. Albert E. Elsen, *Purposes of Art* (New York: Holt, Rinehart & Winston, 1967), p. 183.

11. Eugène Delacroix, *The Journal of Eugène Delacroix,* trans. Walter Pach (New York: Covici-Friede Publishers, 1973), p. 314.

12. Beaumont Newhall, "Delacroix and Photography," in *Magazine of Art* 45, no. 7 (November 1952): 300.

13. Tom Prideaux, *The World of Delacroix,* eds. of Time-Life Books (New York: Time, Inc., 1966), p. 168.

14. Margaretta Salinger, *Gustave Courbet, 1819–1877,* Miniature Album XH (New York: Metropolitan Museum of Art, 1955), p. 24.

15. *Cezanne and the Post-Impressionists,* McCall's Collection of Modern Art (New York: McCall Books, 1970), p. 5.

16. Vincent van Gogh, "To His Brother Theo," in *Artists on Art,* ed. Goldwater and Treves, pp. 383–384.

17. Vincent van Gogh, *Complete Letters* (Greenwich, Connecticut: New York Graphic Society, 1959), vol. 2, p. 401.

18. Paul Gauguin, in *Artists on Art*, ed. Goldwater and Treves, p. 369.

19. John Russell, *The Meanings of Modern Art* (New York: Harper & Row, 1974), p. 35.

20. Ronald Alley, *Gauguin*, The Color Library of Art (Middlesex, England: Hamlyn Publishing Group, 1968), p. 8.

Chapter 5

1. Jacob Bronowski, *The Ascent of Man* (Boston: Little, Brown, 1973), p. 20.

2. Wassily Kandinsky, "Reminiscences," in *Modern Artists on Art*, ed. Robert L. Herbert (Englewood Cliffs, New Jersey: Prentice-Hall, 1964), p. 27.

3. Alfred H. Barr, Jr., ed., *Masters of Modern Art* (New York: The Museum of Modern Art, 1955), p. 124.

4. William Fleming, *Art, Music and Ideas* (New York: Holt, Rinehart & Winston, 1970), p. 342.

5. Fleming, *Art, Music and Ideas*, p. 342.

6. Fleming, *Art, Music and Ideas*, p. 342.

7. Georges Braque in Roland Penrose, *Picasso: His Life and Work* (New York: Schocken Books, 1966), p. 125.

8. Nathan Lyons, ed., *Photographers on Photography* (Englewood Cliffs, New Jersey: Prentice-Hall, Inc., 1966), p. 133.

9. Beaumont Newhall, *The History of Photography* (New York: The Museum of Modern Art, 1964), p. 111.

10. Barr, *Masters of Modern Art*, p. 86.

11. "Venerable Giant of Modern Sculpture Bares Views," in *Honolulu Star-Bulletin*, August 24, 1971, p. F-2.

12. Barr, *Masters of Modern Art*, p. 121.

13. *Gabo: Constructions, Sculpture, Paintings, Drawing, Engravings.* With introductory essays by Herbert Read and Leslie Martin. (London: Lund Humphries, 1957), p. 151.

14. Robert Goldwater and Marco Treves, eds., *Artists on Art* (New York: Pantheon Books, 1958), p. 427.

15. Joshua C. Taylor, *Futurism* (New York: The Museum of Modern Art, 1961), p. 124.

16. Jasper Johns, "Marcel Duchamp (1887–1968)," in *Artforum* 7 no. 3 (November 1968): 6.

17. Barr, *Masters of Modern Art*, p. 137.

18. Hans Richter, *Dada 1916–1966* (Munich: Goethe Institut, 1966), p. 22.

19. Barr, *Masters of Modern Art*, p. 137.

20. Hans Arp in Paride Accetti, Raffaele De Grada, and Arturo Schwarz, *Cinquant'annia Dada— Dada in Italia 1916–1966* (Milano: Galleria Schwarz, 1966), p. 39.

21. Kurt Schwitters in Accetti et al., *Cinquant'annia Dada*, p. 25.

22. Paul Klee, "Notes from His Diary," in *Artists on Art*, ed. Goldwater and Treves, p. 442.

23. Barr, *Masters of Modern Art*, p. 131.

24. Fleming, *Art, Music and Ideas*, p. 346.

25. André Breton, *Manifestos of Surrealism.* Translated from the French by Richard Seaver and Helen R. Lane. (Ann Arbor, Michigan: University of Michigan Press, 1972), p. 14.

26. Lael Wertenbaker, *The World of Picasso*, eds. of Time-Life Books (New York: Time, Inc., 1967), p. 130.

27. Herbert Read, *A Concise History of Modern Painting* (New York: Praeger, 1959), p. 160.

28. Rafael Squirru, "Pop Art or the Art of Things," in *Americas* 15, no. 7 (July 1963): 16.

29. Richard Hamilton. [Catalogue of an exhibition at] the Tate Gallery, 12 March–19 April 1970 (London: Tate Gallery, 1970), p. 31.

30. Bruce Glaser, "Questions to Stella and Judd," in *Art News* 65, no. 5 (September 1966): 59.

31. Calvin Tomkins and the editors of Time-Life Books, *The World of Marcel Duchamp* (New York: Time, Inc., 1966), p. 162.

32. Tompkins, *Marcel Duchamp*, p. 171.

Chapter 6

1. Rudolf Arnheim, *Visual Thinking.* (Berkeley: University of California Press, 1969), p. 295

2. John Ruskin, from the Preface to "St. Mark's Rest," 1877, in *The Complete Works of John Ruskin* (New York: National Library Association [n.d.]) vol. 22.

3. Gertrude Stein, *Picasso* (Boston: Beacon Press, 1959), p. 30.

4. Grace Glueck, "Odd Man Out: Red Grooms, the Ruckus Kid," in *Art News* 72, no. 10 (December 1973): 27.

5. Hiroshima Appeal Committee, *The Unforgettable Fire* (slide-tape presentation), 1977.

6. Japanese Broadcasting Corporation (NHK), *The Unforgettable Fire* (New York: Pantheon Books, 1977), p. 29.

7. Charles Champlin, "The Role of Art in an Age of Anxiety," in *The* [Honolulu] *Sunday Star-Bulletin & Advertiser,* October 23, 1983, p. H-23.

8. Walt Whitman in Charles A. Lindbergh, "The Wisdom of Wilderness," in *Life* 63, no. 25 (December 22, 1967): 8.

9. Rachel Carson, *Silent Spring* (Boston: Houghton Mifflin, 1962), p. 5.

10. Robert L. Heilbroner, *An Inquiry into the Human Prospect* (New York: W. W. Norton & Company, 1974), p. 77.

11. Michael Demarest, "He Digs Downtown," in *Time* 118, no. 8 (August 24, 1981): 46.

12. SITE. *Highrise of Homes.* [text, Patricia Phillips, James Wines] (New York: Rizzoli, 1982).

13. *Sunset* editors, *National Parks of the West* (Menlo Park, California: Lane Magazine and Book Co., 1965), p. 11.

14. Richard Neutra, *Survival Through Design* (New York: Oxford University Press, 1954), p. 6.

CREDITS

The authors and publisher wish to thank artists, owners, museums, galleries, and other institutions for supplying photographs and permission to reproduce them. In addition to those named in the captions, we would like to acknowledge the following:

Alaska Pictorial Service, Anchorage, Alaska: 297.

Alinari/Art Resource, New York City: 33, 105, 107, 184, 314, 316, 317, 320, 339, 342b, 344.

Reproduced by permission of Alpine Book Company. From *Scythian Art* by Georges Charrière. New York: Alpine Fine Arts Collections, 1979, p. 33: 263.

Reproduced by permission of American Craft Museum and the photographer. From the exhibition "Art to Wear; New Handmade Clothing" at the American Craft Museum II, International Paper Plaza, New York City, 1983: 221.

Ampliaciones y Reproducciones MAS, Barcelona, Spain: 498.

Wayne Andrews, Grosse Pointe, Michigan: 356.

Archaeological Survey of India, Government of India, New Delhi: 274.

Reproduced by permission of Julian Bach Literary Agency, New York City. © 1945 by Saul Steinberg: 1; © 1960 by Saul Steinberg: 42.

Bauhaus Archives, Berlin: 182.

Big Red: 480.

Black Star, New York City: 460.

Bonino Gallery, New York City: 98.

Reproduced courtesy of the Trustees of the British Museum: 103, 139, 141, 311, 326.

Bruckmann KG Bildarchiv, Munich: 367.

Caisse Nationale, Paris: 79, 231, 333c, 333e.

Camerafoto, Venice: 338.

Leo Castelli Gallery, New York City: 66, 192, 453, 455.

Chesterwood, a Property for the National Trust for Historic Preservation: 52a and b.

A. C. Cooper (Colour) Ltd., London: 160.

Cordier & Eckstrom, New York City: 494.

Reproduced courtesy of Paula Cooper Gallery. Photograph by Jon Borofsky: 497.

Reproduced by permission of the Thomas Y. Crowell Company, Inc. From *The Arts in the Classroom* by Natalie Robinson Cole. Copyright © 1940 and 1968 by Natalie Robinson Cole, published by The John Day Co., Inc. Photograph by C. K. Eaton: 35.

Derse Advertising Company, Milwaukee, Wisconsin: 458.

Reprinted by permission of Doubleday & Company, Inc. From *Who Designs America* by Laurence B. Holland. Copyright © 1966 by the Trustees of Princeton University for the Program in American Civilization at Princeton University: 259.

Reproduced by permission of Doxiadis Associates International, Athens, Greece. From *Architecture in Transition* by Constantinos A. Doxiadis, published 1968 by Oxford University Press, New York: 261.

Durand-Ruel, Paris: 116.

Edita S.A., Lausanne, Switzerland: 159.

Editions Denise Rene: 163.

From *Drawing on the Right Side of the Brain* by Betty Edwards. Los Angeles, California. J. P. Tarcher, 1979. Reproduced by permission of the author: 127a and b.

The estate of Eliott Elisofon: 305.

Elsevier Nederland B. V. and Museum Voor Landen Volkenkunds, Rotterdam. Photograph by Yoshio Watanabe: 283.

Andre Emmerich Gallery, New York City: 468.

Fogg Art Museum, Harvard University: 84.

Fotoatalier Gerhard Howald, Berne, Switzerland: 90.

Fourcade, Droll, Inc., New York City: 466.

Allison Frantz, Princeton, New York: 228, 312, 313.

Amy Fukinaga, Honolulu: 508.

From *African Crafts and Craftsmen* by Rene Gardi. New York: Van Nostrand Reinhold, 1969. Reproduced by permission of the author: 193.

From *Henri-Matisse: Dessins* by Waldemar George. Paris: Editions des Quatre Chemins: 125.

Giraudon/Art Resource, New York City: 403.

Graham Gund, Boston: 469.

Reproduced by permission of the artist, Steve Handschu. From the "National Exhibition of Art by the Blind," University Museum, University of Pennsylvania, 1976. Photograph by Bezushko: 6.

Robert Harding Picture Library, Ltd., London: 277.

O.K. Harris Gallery, New York City: 489.

Reproduced by permission of Harvard University Press. From *Art East and West* by Benjamin Rowland. Cambridge, Massachusetts: Harvard University Press, 1954: 332.

Hedrich Blessing, Ltd.: 233, 238, 406.

Lucien Herve, Paris: 420a and b.

Hans Hinz, Basel, Switzerland: 265, 431.

Hirmer Photoarchiv, Munich: 183, 306, 308, 323.

Nancy Hoffman Gallery, New York City: 486.

Holle Bildarchiv, Baden-Baden, West Germany: 270b.

Claude Horan, Kaneohe, Hawaii: 194.

Hans Huber Publishers, Berne, Switzerland: 45.

From *The Great Architecture of Japan* by Drahomir Illik, published 1970 by Hamlyn Publishing Group, London. Reproduced by permission of the author-photographer: 289b.

Imperial Household Agency, Tokyo, Japan: 289a.

Courtesy of the Indian Museum, Calcutta: 273.

Institute of Texan Culture, San Antonio, Texas: 511a.

International Museum of Photography, George Eastman House, Rochester, New York: 166.

Phokion Karas, Cambridge, Massachusetts: 246.

A. F. Kersting, London: 333b.

Tom Klobe, Honolulu: 331.

From *Malerei, Photographie, Film* by Laszlo Moholy-Nagy. Reproduced by permission of Florian Kupferberg Verlag, Mainz, West Germany: 428.

Mrs. Albert Lasker, New York City: 446.

Permission granted by Liggett Group Inc. to use the EVE advertisement. All rights reserved: 218.

Lars Lohrisch Photograf, Bremen, West Germany: 76.

Poem "Navajo Sand Painting" by Elizabeth-Ellen Long, from *Arizona Highways* (August 1958): 33. Reproduced with permission of the author: page 7.

Los Angeles County Museum of Art. Purchased with funds provided by Mr. and Mrs. Norton Simon, the Junior Arts Council, Mr. and Mrs. Frederick R. Weisman, Mr. and Mrs. Taft Schreiber, Hans de Schulthess, Mr. and Mrs. Edwin Janss, and Mr. and Mrs. Gifford Phillips: 429.

Reproduced with permission of the Macmillan Company. From *Creative*

and Mental Growth by Victor Lowenfeld and W. Lambert Brittain. © 1970 by the Macmillan Company: 13, 16.

Magnum Photos, Inc., New York City: 25, 26, 27, 114, 255.

From *Movement* by E. J. Marey. New York. D. Appleton and Co., 1895, p. 61: 424.

Marlborough Gallery, New York City: 499a.

Pedro Meyer, Mexico City: 148.

Malcolm Mekaru, Honolulu: 220b.

From *Arcology: The City in the Image of Man.* by Paolo Soleri, © 1969 by M.I.T., Cambridge, Massachusetts. Reproduced by permission of M.I.T. Press: 254.

Allen Mitchell, New Canaan, Connecticut: 432.

Lucia Moholy, Zurich, Switzerland: 235.

Osamu Murai, Tokyo: 239a, b, and c.

Photograph from the Museum of Modern Art, New York City: 434.

Prithwish Neogy, Honolulu: 80, 270a; 443a.

New York Public Library: 140.

From *Goddesses* by Mayumi Oda. Berkeley: Lancaster-Miller, 1981. Reproduced by permission of the artist/author: 164.

Christopher Parfitt, Herts, England: 17.

Ryzard Petrajtis, Gdansk, Poland: 106.

Phaidon Press, London: 318, 319.

Philadelphia Museum of Art. Reproduced by permission of the owners: 378, 426.

Photo Researchers, New York City: 292, 294, 295.

Photo Trends, New York City: 478.

Photograph by Axel Poignant. From *Oceanic Mythology* by Roslyn Poignant, published 1971 by the Hamlyn Publishing Group, London. Reproduced with permission of the author and photographer: 298.

Portland Chamber of Commerce: 506.

Duane Preble, Honolulu: 14, 15, 51, 53, 54, 61, 124, 167, 200, 210, 214, 245, 260a and b, 275, 301, 309, 315a and b, 410, 448, 464, 467, 485b, 488, 490, 499b, 510.

Alfred Roth, Zurich, Switzerland: 417.

Simone Roubier, Paris: 230.

SCALA/Art Resource, New York City: 64, 111, 121, 322, 333d, 334, 337, 341, 346, 348.

Joseph Schopplein, Pro-Foto, San Francisco: 199.

Joseph E. Seagram & Sons, Inc., New York City: 236.

SEF/Art Resource, New York City: 229.

Service de Documentation Photographique, Paris: 86, 113, 266, 340, 353, 354, 355, 361, 365, 370, 396.

From *China: Land of Charm and Beauty.* Shanghai: The Shanghai People's Fine Arts Publishing House: 1964: 280.

From *Highrise of Homes* by SITE. New York: Rizzoli International, 1982. Reproduced by permission of SITE: 507.

Photograph by G. E. Kidder Smith. From *The New Churches of Europe* by G. E. Kidder Smith. Reproduced with permission of the author/photographer: 443b.

Sonnabend Gallery, New York City: 479.

From *Monastery and Cathedral in France* by Whitney Stoddard, published 1966 by Wesleyan University Press. Middletown, Connecticut. Reproduced with permission of the author: 333a.

© Ezra Stoller, Mamaroneck, New York: 247, 442.

Stubbins Associates, Inc., Boston: 237a.

From *Life* magazine © 1954 Time, Inc., New York City: 169, 170.

From *Life* magazine © 1967 Time, Inc., New York City: 241.

Time Pix Syndication, New York City: 415.

Trans World Airlines, New York City: 78b.

Eduard Trier, Bonn, Germany: 191.

Reproduced courtesy of the Board of Trinity College Library, Dublin, Ireland: 329.

From *The Arts and Man,* © UNESCO, 1969. Reproduced by permission of UNESCO: 18.

Photograph courtesy of the Vatican Museums: 102.

John Weatherhill, Inc., Tokyo: 122.

Charles Weber, Honolulu: 267a.

Verlag Galerie Welz, Salzburg, Austria: 390.

West Baffin Eskimo Cooperative, Ltd., Cape Dorset, N.W.T., Canada: 49.

Zintgraff Photographers, San Antonio, Texas: 511b.

Works by Braque and Klee © 1985 by COSMOPRESS, Geneve, and ADAGP, Paris.

Works by Arp, Braque, Brancusi, Calder, Chagall, Duchamp, Giacometti, Kandinsky, Magritte, and Miro: © ADAGP Paris, 1985.

Works by Bonnard, Escher, Klee, Monet, Matisse, Mondrian, Le Corbusier, Léger, Picasso, Renoir, Rodin, Rouault, and Vasarely: © S.P.A.D.E.M., Paris/VAGA, New York, 1985.

SUGGESTED READING

1 Why Art?

Arnheim, Rudolf. *Art and Visual Perception*. Berkeley: University of California Press, 1954.

Arnheim, Rudolf. *Visual Thinking*. Berkeley: University of California Press, 1980.

Barron, Frank. *Creativity and Personal Freedom*, rev. ed. New York: Van Nostrand Reinhold, 1968.

Cole, Natalie Robinson. *The Arts in the Classroom*. New York: John Day, 1940.

Dewey, John. *Art as Experience*. New York: Capricorn Books, 1958.

Flam, Jack D., ed. *Matisse on Art*. New York: Phaidon, 1973.

Gregory, R. L. *Eye and Brain: the Psychology of Seeing*, 2d ed. New York: McGraw-Hill, 1972.

Hall, Edward T. *Silent Language*. New York: Fawcett World Library, 1969.

Jung, Carl G., et al. *Man and His Symbols*. New York: Doubleday, 1964.

Lowenfeld, Victor. *Creative and Mental Growth*, 4th ed. New York: Macmillan, 1964.

May, Rollo. *The Courage to Create*. New York: W. W. Norton, 1975.

McKim, Robert. *Experiences in Visual Thinking*, 2d ed. Monterey, California: Brooks/Cole, 1980.

Samuels, Mike, M.D. and Nancy Samuels. *Seeing With the Mind's Eye: The History, Techniques and Uses of Visualization*. New York: Random House; Berkeley, California: The Bookworks, 1975.

Segall, Marshall H., Donald T. Campbell, and Melville J. Herskovits. *Influence of Culture on Visual Perception*. Indianapolis: Bobbs-Merrill, 1966.

Steichen, Edward. *The Family of Man*. New York: Simon & Schuster, 1967.

2 Form and Content

Berger, J. *Ways of Seeing*. New York: Viking, 1972.

Doczi, Gyorgy. *The Power of Limits: Proportional Harmonies in Nature, Art and Architecture*. Boulder, Colorado: Shambala, 1981.

Friend, David. *Composition: A Painter's Guide to Basic Problems and Solutions*. New York: Watson-Guptill, 1975.

Itten, Johannes. *The Art of Color*. New York: Reinhold, 1973.

Kepes, Gyorgy. *Language of Vision*. Chicago: P. Theobold, 1944.

Nelson, George. *How to See*. Boston: Little, Brown, 1977.

Ocvirk, Otto G., et al. *Art Fundamentals: Theory and Practice*, 4th ed. Dubuque, Iowa: William C. Brown, 1981.

Poore, Henry R. *Pictorial Composition and the Critical Judgment of Pictures*. Salem, New York: Ayer, 1979 (reprint of 1903 ed.).

Potter, Norman. *What Is a Designer?: Things, Places, Messages*. rev. ed. London: Hyphen Press, 1980.

Shahn, Ben. *The Shape of Content*. New York: Random House, 1957.

Taylor, John F. *Design and Expression in the Visual Arts*. New York: Dover, 1964.

Varley, Helen, ed. *Colour*. London: Mitchell Beazley, 1980.

3 The Visual Arts: Media and Methods

Arnheim, Rudolf. *Film as Art*. Berkeley: University of California Press, 1957.

Bacon, Edmund N. *The Design of Cities*, rev. ed. New York: Penguin Books, 1976.

Cartier-Bresson. *The Decisive Moment*. New York: Simon & Schuster, 1952.

Caudill, William W., et al. *Architecture and You: How to Experience and Enjoy Buildings*. New York: Watson-Guptill, 1978.

Ching, Francis D. K. *Architecture, Form, Space & Order*. New York: Van Nostrand Reinhold, 1979.

Constantine, Mildred and Jack Lenor Larsen. *The Art Fabric: Mainstream*. New York: Van Nostrand Reinhold, 1980.

Coynik, David. *Film: Real to Reel*. Evanston, Illinois: McDougal, Littell, 1976.

Davis, Phil. *Photography*, 4th ed. Dubuque, Iowa: William C. Brown, 1982.

Donhauser, Paul S. *History of American Ceramics*. Dubuque, Iowa: Kendall/Hunt, 1978.

Edwards, Betty. *Drawing on the Right Side of the Brain*. Los Angeles: J. P. Tarcher, 1979.

Fathy, Hassan. *Architecture for the Poor*. Chicago: University of Chicago Press, 1973.

Franck, Frederick. *The Zen of Seeing: Drawing as Meditation*. New York: Random House, 1973.

Gardi, René. *African Crafts and Craftsmen*. New York: Van Nostrand Reinhold, 1970.

Goldstein, Nathan. *The Art of Responsive Drawing*, 3d ed. Englewood Cliffs, New Jersey: Prentice-Hall, 1984.

Halprin, Lawrence. *Cities*. New York: Reinhold, 1963.

Held, Shirley E. *Weaving: A Handbook of the Fiber Arts*, 2d ed. New York: Holt, Rinehart and Winston, 1978.

Hibshman, Dan. *Your Affordable Solar Home*. San Francisco: Sierra Club Books, 1983.

Holden, Donald, ed. *Art Career*

Guide, 4th ed. New York: Watson-Guptill, 1983.

Ivins, William M. *Prints and Visual Communication*. New York: Plenum, 1969.

Januszczak, Waldemar, ed. *Techniques of the World's Great Painters*. London: Chartwell Books, 1980.

Kahn, Lloyd, ed. *Shelter: Dome Book 3*. Bolinas, California: Shelter Publications, 1973.

Knight, Arthur. *The Liveliest Art*, rev. ed. New York: New American Library, 1979.

Life Library of Photography. 17 vols. New York: Time-Life, 1970–1983.

Mayer, Ralph. *The Artist's Handbook of Material and Techniques*, 4th rev. ed. New York: Viking, 1981.

Munari, Bruno, translated by Patrick Creagh. *Design as Art*. Baltimore: Penguin Books, 1971.

Nelson, Glenn C. *Ceramics: A Potter's Handbook*, 4th ed. New York: Holt, Rinehart & Winston, 1978.

Nicolaides, Kimon. *The Natural Way to Draw*. Boston: Houghton Mifflin, 1975.

Oka, Hideyuki and Michikazu Sakai. *How to Wrap Five Eggs*. New York: Harper & Row, 1967.

Rasmussen, Steen E. *Experiencing Architecture*. Cambridge, Massachusetts: M.I.T. Press, 1962.

Rudofsky, Bernard. *Architecture Without Architects: A Short Introduction to Non-Pedigreed Architecture*. New York: Doubleday, 1964.

Rudofsky, Bernard. *The Unfashionable Human Body*. New York: Doubleday, 1974.

Sachs, Paul J. *Modern Prints and Drawings*. New York: Knopf, 1954.

Safdie, Moshe. *For Everyone a Garden*. Cambridge, Massachusetts: M.I.T. Press, 1974.

Saff, Donald and Deli Sacilotto. *Printmaking: History and Process*. New York: Holt, Rinehart & Winston, 1978.

School of Visual Arts. *Careers in the Visual Arts*. New York: Visual Arts Press, 1975.

Sommer, Robert. *The Behavior Basis of Design*. Englewood Cliffs, New Jersey: Prentice-Hall, 1969.

Wilson, Forest. *The Joy of Building: Restoring the Connection Between Architect and Builder*. New York: Van Nostrand Reinhold, 1979.

Youngblood, Gene. *Expanded Cinema*. New York: E. P. Dutton, 1970.

4 Art of the Past and
5 Art of Our Time: The 20th Century

Arnason, H. H. *History of Modern Art: Painting, Sculpture, Architecture*, rev. ed. New York: Abrams, 1977.

Barr, Alfred H., Jr., ed. *Masters of Modern Art*. New York: Museum of Modern Art, 1955.

Blunt, Anthony. *Picasso's Guernica*. New York: Oxford University Press, 1969.

Bronowski, J. *The Ascent of Man*. Boston: Little, Brown, 1974.

Clark, Kenneth. *Civilisation: A Personal View*. New York: Harper & Row, 1969.

Coke, Van Deren. *The Painter and the Photographer*. Albuquerque: University of New Mexico Press, 1964.

Coomaraswamy, Ananda. *The Dance of Shiva*. New York: Farrar Straus, 1937.

De la Croix, Horst and Richard Tansey. *Gardner's Art Through The Ages*, 7th ed. 2 vols. New York: Harcourt Brace Jovanovich, 1980.

Dwyer, Jane P. and Edward B. Dwyer. *Traditional Art of Africa, Oceania and the Americas*. San Francisco: The Fine Arts Museums of San Francisco, 1973.

Encyclopedia of American Art. New York: E. P. Dutton, 1981.

Fine, Elsa H. *Women and Art: A History of Women Painters and Sculptors from the Renaissance to the 20th Century*. Montclair, New Jersey: Allanheld & Schram, 1978.

Fleming, William. *Art, Music and Ideas*. New York: Holt, Rinehart & Winston, 1970.

Forge, Anthony. *Primitive Art in Society*. New York: Oxford University Press, 1973.

Giedion, Siegfried. *The Eternal Present: The Beginnings of Architecture*. Princeton, New Jersey: Princeton University Press, 1964.

Goldwater, Robert and Marco Treves, eds. *Artists on Art*. New York: Pantheon, 1958.

Gombrich, E. H. *The Story of Art*, 13th ed. New York: Praeger, 1983.

Hauser, Arnold. *The Social History of Art*. 4 vols. New York: Random House, 1957–1958.

Herbert, Robert L., ed. *Modern Artists on Art*. Englewood Cliffs, New Jersey: Prentice-Hall, 1964.

Holt, Elizabeth Gilmore, ed. *A Documentary History of Art*. 3 vols. New York: Doubleday, 1957–1966.

Hughes, Robert. *The Shock of the New*. New York: Knopf, 1980.

Janson, H. W. *A Basic History of Art*, 2d ed. Englewood Cliffs, New Jersey: Prentice-Hall, 1981.

Johnson, Ellen H. *American Artists On Art: From 1940–1980*. New York: Harper & Row, 1982.

Kandinsky, Wassily. *Concerning the Spiritual in Art and Painting in Particular*. New York: George Wittenborn, 1966.

Kaprow, Allan. *Assemblage, Environments, and Happenings*. New York: Abrams, 1966.

Lee, Sherman. *A History of Far Eastern Art*. New York: Abrams. 1982.

Liberman, Alexander. *The Artist in His Studio*. New York: Viking, 1960.

Malraux, André, translated by Stuart Gilbert and Francis Price. *Museums Without Walls*. Garden City, New York: Doubleday, 1967.

Michener, James A. *The Floating World*. Honolulu: University of Hawaii Press, 1983.

Munsterberg, Hugo. *Art of India and Southeast Asia*. New York: Abrams, 1970.

Munsterberg, Hugo. *Art of the Far East*. New York: Abrams, 1968.

Newhall, Beaumont. *The History of Photography*, rev. ed. New York: Museum of Modern Art, 1982.

Peterson, Karen and J. J. Wilson. *Women Artists: Recognition and Reappraisal from Early Middle Ages to the Twentieth Century*. New York: Harper & Row, 1976.

Richter, Hans. *Dada: Art and Anti-Art*. New York: Abrams, 1970.

Rickey, George. *Constructivism: Origins and Evolution*. New York: Braziller, 1967.

Rose, Barbara. *American Art Since 1900*. New York: Praeger, 1975.

Russell, John. *The Meanings of Modern Art*. New York: Museum of Modern Art and Harper & Row, 1981.

Smagula, Howard. *Currents: Contemporary Direction in the Visual Arts*. Englewood Cliffs, New Jersey: Prentice Hall, 1983.

Sonfist, Alan, ed. *Art in the Land: A Critical Anthology of Environmental Art*. New York: E. P. Dutton, 1983.

Wichmann, Siegfried. *Japonisme: The Japanese Influence on Western Art in the 19th and 20th Centuries*. New York: Harmony Books, 1981.

Britz, Richard. *The Edible City Resource Manual*. Los Altos, California: William Kaufmann, 1981.

Ehrenzweig, Anton. *The Hidden Order of Art*. Berkeley: University of California Press, 1976.

Leckie, Jim, et al. *More Other Homes and Garbage: Designs for Self Sufficient Living*, rev. ed. San Francisco: Sierra Club Books, 1981.

Lynch, Kevin. *A Theory of Good City Form*. Cambridge, Massachusetts: M.I.T. Press, 1981.

McHarg, Ian L. *Design With Nature*. Garden City, New York: Doubleday, 1971.

Moholy-Nagy, Sibyl. *Matrix of Man: An Illustrated History of Urban Environment*. New York: Praeger, 1968.

Neutra, Richard. *Survival through Design*. New York: Oxford University Press, 1969.

Porter, Eliot. *In Wilderness Is the Preservation of the World*. San Francisco: Sierra Club Books, 1967.

SITE. *Highrise of Homes*. New York: Rizzoli International, 1982.

Sommer, Robert. *Street Art*. New York: Links Books, 1975.

6 Art for Today and Tomorrow

Blake, Peter. *God's Own Junkyard: The Planned Deterioration of America's Landscape*. New York: Holt, Rinehart & Winston, 1979.

INDEX

ABOUT THE AUTHORS

Duane and Sarah Preble live at the edge of a tropical forest overlooking Honolulu and the Pacific Ocean. They have taken active roles in environmental preservation in Hawaii. Duane has served on the boards of various government and environmental organizations. He is on the Board of Trustees of the Honolulu Academy of Arts, and is a frequent consultant to art, environmental, and educational organizations.

After completing his BA in painting, graphics, and sculpture at UCLA, Duane received his Master of Fine Arts degree from the University of Hawaii. Since 1961 he has been a member of the art faculty at the University of Hawaii as well as an exhibiting artist. He has taught a wide variety of courses including introduction to the visual arts, art history, photography, drawing, and design. In 1975 Duane was selected for listing in *Outstanding Educators in America.*

Sarah studied art and psychology at St. Lawrence University and the University of Hawaii. After receiving her BA in psychology and Masters of Library Science from the University of Hawaii she became a reference librarian.

Now that their children are grown Sarah and Duane look forward to spending more time traveling, working on their edible landscaping, and pursuing individual interests in the visual arts— Sarah in ceramics and research, and Duane in photography and painting.